Pinning Down the Past

Archaeology, Heritage, and Education Today

T0324357

HERITAGE MATTERS

ISSN 1756-4832

Series Editors
Peter G. Stone • Peter Davis • Chris Whitehead

Heritage Matters is a series of edited and single-authored volumes which addresses the whole range of issues that confront the cultural heritage sector as we face the global challenges of the twenty-first century. The series follows the ethos of the International Centre for Cultural and Heritage Studies (ICCHS) at Newcastle University, where these issues are seen as part of an integrated whole, including both cultural and natural agendas, and thus encompasses challenges faced by all types of museums, art galleries, heritage sites and the organisations and individuals that work with and are affected by them.

Pinning Down the Past

Archaeology, Heritage, and Education Today

Mike Corbishley

THE BOYDELL PRESS

First published 2011
The Boydell Press, Woodbridge
Paperback edition 2014

ISBN 978 1 84383 678 0 hardback
ISBN 978 1 84383 904 0 paperback

The Boydell Press is an imprint of Boydell & Brewer Ltd
PO Box 9, Woodbridge, Suffolk IP12 3DF, UK
and of Boydell & Brewer Inc.
668 Mt Hope Avenue, Rochester, NY 14620-2731, USA
website: www.boydellandbrewer.com

The publisher has no responsibility for the continued existence
or accuracy of URLs for external or third-party internet websites
referred to in this book, and does not guarantee that any content
on such websites is, or will remain, accurate or appropriate.

A CIP record for this book is available
from the British Library

Designed and typeset in FF Scala and Scala Sans by
David Roberts, Pershore, Worcestershire

Contents

Heritage Issues

Illustrations

Tables

Graphs

The author and publishers are grateful to all the institutions and individuals listed for permission to reproduce the materials in which they hold copyright. Every effort has been made to trace the copyright holders; apologies are offered for any omission, and the publishers will be pleased to add any necessary acknowledgement in subsequent editions.

Foreword

This is not simply a conventional book tracing the history of a sub-discipline, or a text book providing best practice, or a theoretical review of the underlying concepts of the role archaeology can play within education. It is, in fact, a little of all of these but also much more – it is an explosion of knowledge, understanding and experience offered to the reader by one, if not *the*, pioneer of the relationship between archaeology and education in the UK over the last four and a half decades.

From his first teaching position in 1966 Mike Corbishley has been at the forefront of grappling with the way archaeology can be used to enhance the curriculum at all levels of education. This book is the result of these four and a half decades of work at the coalface. While Mike's current position classifies him as an academic, his whole approach is, and always has been, one of practical involvement: teaching, experimenting, writing, filming, enthusing, and encouraging. He has little time for those who 'talk the talk' but have scant practical understanding; always a doer, Mike constantly searches for innovation firmly rooted in experience. As an education officer for the Council for British Archaeology and then English Heritage he knew that part of the way to earn the respect of teachers was to show that he understood their problems – because he had faced them himself as a classroom teacher. He also knew that this was not enough: to become confident users of archaeology in their lessons, Mike constantly argued that teachers needed to be taught by someone with experience and expertise in archaeology or associated disciplines. 'I've been in that position, I've done this, and it works. Try it with confidence.'

Mike's career path was not straightforward, for when he began working in the mid-1960s, there was no clear career in archaeological education – other than as a university academic. Thus, while teaching classics, archaeology and history in a secondary school, Mike also worked as a part-time tutor in archaeology for the Workers' Educational Association – for many years the bastion of adult education in the UK. In 1977 he then became the first education officer for the Council for British Archaeology, a position he himself had to help to create with external project funding from Lloyds Bank and the Leverhulme Trust. In 1984 he joined the newly created Education Service in English Heritage, first as a regional education officer and then – for fifteen years – as Head of Education, where he remained until 2003. At that time English Heritage restructured and realigned its approach to education to concentrate on a few high-priority sites to the effective exclusion of the rest of the country's heritage. This was an approach that was anathema to Mike. As soon as Peter Ucko, then Director of the Institute of Archaeology at UCL, heard of his difficult position he immediately stepped in with characteristic zeal and offered Mike a post at the Institute. Peter shared Mike's disdain of talking about things rather than getting on and doing them and Peter encouraged Mike to develop a module on archaeology and education in his newly restructured suite of MA programmes. He also commissioned this book.

My own career has been heavily influenced by Mike. As a newly qualified history teacher working in a tough school in South Yorkshire, Mike's encouragement from the CBA allowed me to keep alive my hopes for integrating archaeology into my

history teaching. In 1988 Mike appointed me to be a regional education officer in his English Heritage team and then, between 1995 and 1997, as education officer with a national brief for working with further, adult, and higher education. We have kept in contact and I unashamedly called on and exploited Mike's expertise as I set up the MA in Heritage Education and Interpretation here in Newcastle. The programme is considerably the better for this input.

This book does not provide you with a step-by-step guide to working in archaeological education. It will, however, lift the veil on the history of the relationship between archaeology and education, and will constantly stimulate and provoke you to think about the implications, pitfalls and opportunities of using archaeology in education. Sit back and enjoy.

Peter Stone
Professor of Heritage Studies
Newcastle University

Preface

This book is dedicated to Peter Ucko, who died in the summer of 2007. Peter saved me from a life of cutting the grass and redecorating the house when I was retired from English Heritage: he commissioned me to write this book and offered me the opportunity to teach a Masters course in heritage education at the Institute of Archaeology, University College London. I had known Peter for many years – we worked together while I was Education Officer at the Council for British Archaeology. Our shared vision was to see archaeology as an accepted subject in schools in Britain and to include archaeological evidence in National Curriculum subjects. This book outlines what has been achieved so far. I benefited from Peter's searching questions about the book and its contents but sadly he died before I could deliver a final manuscript to him.

Pinning Down the Past has taken a long time to reach this stage. One of the problems in writing the book over a period of time has been the need to review information about the various organisations included. For example, all the figures and activities included in the case studies have been updated annually and I am very grateful for all those individual and organisations who have patiently checked my analyses. Several organisations, especially government ministries, have had their names changed by incoming administrations. Of course, the process of final editing, design and printing dictated a strict timetable. The final cut-off date selected was Spring 2010, after which I could make no more changes. The fact that the Council for British Archaeology (CBA) has, since then, been required to reduce its educational work because of heavy cuts in its core funding is, therefore, not included in my review of its work. However, I must record my thanks to the CBA for giving a publication grant for this book – a grant which has helped to lower the price of the book.

I am grateful to Peter Stone for accepting this book into the Heritage Matters Series which he has developed at the International Centre for Cultural and Heritage Studies at Newcastle University. We worked together in the Education Department at English Heritage and I have also worked with him and his colleagues at the Centre since then.

Mike Corbishley
Spring 2010

Acknowledgements

I am grateful to a number of people for supplying information, sources and illustrations and for commenting on sections in draft: Lucie Amos, Andy Agate, Duncan Allan, Andy Beer, Nick Brannon, Melanie Brown, Gabrielle Chadwick, Stella Chryssoulaki, Trudie Cole, Louise Cooke, Tim Copeland, Gill Corbishley, Ian Coulson, Nina Crummy, Phil Crummy, Sarah Dhanjal, Gail Durbin, Pekka Elo, Meg Faragher, Roxana Ferllini, Jennie Fordham, Rosie Fuller, Ken Glen, Adrienne Goodenough, Marion Green, Cornelia Hadziaslani, Susanne Haselgrove, Sandra Hedblad, Don Henson, Peter Herring, Liz Hollinshead, Gaigysyz Jorayev, Jackie Keily, Marjaana Kohtamaki, Carrie Mason, Aron Mazel, Alan McPherson, Jezz Meredith, Sue Mitchell, Ian Mitford, Theano Moussouri, Margarita Nazou, Kevin O'Connell, Dai Owen, Mike Parker-Pearson, Dimitra Petrou, Angela Piccini, Mike Pitts, Marka K. Poniros, Dominic Powlesland, Elizabeth Pye, Nelly Robles, Coral Sealey, Colin Shearer, Virginia Simpson, Angela Stewart, Peter Stone, Fraser Swift, Wendy Terry, Artemis Tsipi, Sjoerd van der Linde, Sean Waterman, Tim Williams, Roger White, Sean Whittle and Danae Zaoussi. Thanks also to Isabel and Lily Whittle, two children who never objected to having their photographs taken at ancient monuments and in museums, and to Ayjan Joraev for not eating all the Victoria sponge cake. Finally, I must record my thanks to Chris Whitehead and Catherine Dauncey, the editor and publications officer at Newcastle University, for their skill and their patience and to Peter Stone for writing the Foreword to my book.

The publishers are grateful to the Council for British Archaeology for their generous financial support.

Abbreviations

ADS	Archaeological Data Service
AED	Acropolis Education Department
AS	Archaeology Scotland
BBC	British Broadcasting Corporation
CABE	Commission for Architecture and the Built Environment (merged with the Design Council in April 2011)
CAT	Canterbury Archaeological Trust
CBA	Council for British Archaeology
CCT	Churches Conservation Trust
CLOtC	Council for Learning Outside the Classroom
CoE	Church of England
DCMS	Department for Culture, Media and Sport
Defra	Department for the Environment, Food and Rural Affairs
DfEE	Department for Education and Employment (later became the Department for Education and Skills, then the Department for Children, Schools and Families and finally renamed the Department for Education in 2010)
EH	English Heritage
Euroclio	European Standing Conference of History Teachers' Associations
FHW	Foundation of the Hellenic World
HCT	Historic Chapels Trust
HLF	Heritage Lottery Fund
HMCT	Hellenic Ministry of Culture and Tourism
HS	Historic Scotland
ICCHS	International Centre for Cultural and Heritage Studies, Newcastle University
ICCROM	International Centre for the Study of the Preservation and Restoration of Cultural Property
ICOMOS	International Council on Monuments and Sites
ICT	Information and communications technology
IFA	Institute for Archaeologists
ILN	Illustrated London News
INTERPOL	International Criminal Police Organization
IoA	Institute of Archaeology, University College London
IOL	Institute for Outdoor Learning
ITT	Initial Teacher Training
LAARC	London Archaeological Archive and Research Centre
MA	University masters' courses
MAPS	Moscow Architecture Preservation Society
MOLA	Museum of London Archaeology
MORI	Market and Opinion Research International

MSC Manpower Services Commission
NCPE National Council for Preservation Education
NGO Non-Governmental Organisation
NIEA Northern Ireland Environment Agency
NT National Trust
NTS National Trust for Scotland
Ofsted Office for Standards in Education, Children's Services and Skills
PGCE Postgraduate Certificate of Education
QCA Qualifications and Curriculum Authority (subsequently renamed
 Qualifications and Curriculum Development Agency)
SAA Society for American Archaeology
TWAM Tyne and Wear Archives and Museums
UCL University College London
UNESCO United Nations Educational, Scientific and Cultural Organisation
USP Unique Selling Proposition
WHS World Heritage Site
WMF World Monuments Fund
YAC Young Archaeologist's Club

1 Introduction: Making Connections

Archaeology is now a popular pursuit for individuals, families and children in many countries – whether through visiting excavations and ancient monuments, experiencing interactive exhibitions and events, watching programmes on television, or reading about new discoveries in books and magazines. In some countries people can join societies to experience the thrill of uncovering archaeology for themselves. There are also clubs and special weekend and holiday activities for children, in museums and at heritage sites, and a national club for children in Britain – the Young Archaeologists' Club. The use of archaeological evidence has also been introduced into curricula for students of all ages, usually within the history curriculum, whether that curriculum is defined by a state or through common practice in schools.

This book is for all those who engage in, or who would like to engage in, any form of archaeology and education. It is for education officers in local, national and commercial archaeological and heritage organisations and museums, for students on heritage studies courses and teachers in schools, further education and universities. It is, unashamedly, a view of archaeology and heritage seen through the eyes of an experienced educationalist. The book shows the various ways in which the existence, survival and presentation of past landscapes, structures and objects may be used as a valuable resource for educating people from toddlers on an outing with their parents to groups of students or to adults visiting an ancient site during their holidays.

Why will this book be useful for both practitioners and students? Because it outlines the state of archaeological education today with examples of what I believe to be good practice from educators and archaeologists. This best practice, evident in practical sessions for teachers and learners of all ages at archaeological excavations, ancient monuments, museums and in the classroom, is truly original and creative. While the exercises and suggestions for activities in this book were created for specific age groups, I have tried and tested them with children, students and adults. The test of a good activity, in the classroom or out of doors, is whether it can be adapted across age groups and internationally.

The focus of the good practice outlined here comes mainly from the UK, but I have also chosen a small number of examples from other countries, where good practice is particularly effective in promoting the past in other cultural situations. For example, Greek archaeologists and heritage managers have used the opportunity of new metro lines to preserve and present ancient remains *in situ* (see p. 30). In the UK this kind of presentation to the public (outside of protected ancient monuments and museums) is in its infancy.

The main principles behind this book are that:

▶ Archaeologists must explain what they do, why they do it and why they think it important. If they do not, then someone else may – and that someone may be a Hollywood producer or a treasure hunter. They must all learn to present themselves well, or at least influence the picture presented by others in a variety of media.

▶ Archaeologists and heritage managers, whether working as paid employees or in voluntary groups, should start from the point of view of the people they want to influence. One of the things archaeologists do is to look and think – why is that where it is? What does it mean? What do I need to do to understand it better? Leading children or adults, by a series of stepping stones, from their familiar world to where you want them to be (perhaps from their school to an alien world such as a Roman bathhouse) is familiar to teachers and many examples of this process are presented in this book.

▶ Archaeologists must understand what teachers do – the methods of teaching and learning and the curricula or textbooks available to them (or imposed by the state).

▶ If archaeologists are to influence classroom teachers, they should treat them as professionals – listen to them, engage with them in instituting educational programmes and in the production of teaching and learning resources.

▶ Archaeologists should consider including education programmes in all archaeological projects.

▶ Connections should be made between the two very different worlds of archaeology and education. Both have gone through, and are still going through changes, sometimes radical changes. Since I first became involved in archaeology in the mid-1960s it has become transformed by technology and part of it has been subsumed into 'heritage'. School education in many countries has also undergone important changes. In Britain this includes the introduction of the National Curriculum, new styles of teaching and learning and an almost continuous stream of (often ill-thought through) initiatives by politicians. As archaeologists we should be used to assessing change and take note of Susan Pearce's words: 'The cultural heritage is in daily motion as it shifts in relation to difficult pressures and perpetually creates new constructions. It is important both analytically and politically to stress that culture is not a completed artefact suspended in an artificial state of preservation, but rather a continuing process of self-realisation' (Pearce 1998, 9).

This book outlines the opportunities which all those interested in archaeology should eagerly seize upon to promote what they believe in. If there is a local problem over the acceptance of the importance of an archaeological discovery or the imminent destruction of an historic site or building, then archaeologists will want to raise public awareness. Too often the power of education as part of any campaign is not considered. It is true that the presence of children may simply attract the attention of the media, but a sustained project with school groups may lead to both a successful campaign in the short term *and* to a long-term effect on children (our future citizens) and their parents.

The book also takes the view that all aspects of archaeology and its transmission into the various forms of presentation, from newspaper reports of new discoveries to children's books, from guides to ancient monuments to TV series, can be a valuable resource for archaeological educators to promote their subject.

Learning archaeology should be about experiencing the past through the study of evidence. Teachers should offer their classes hands-on learning experiences which encourage critical thinking skills. Museums and some archaeological

My rusty Roman nail

The date is July 1953 and a coach-load of primary school pupils are heading north out of London for St Albans in Hertfordshire. It is the annual school trip. With my fellow pupils I am to visit the museum, the ruins and the excavations at the Roman town of Verulamium. After sandwiches in the park we are released to wander around the town on our own without our teachers. Later, in a history lesson at secondary school, I could not quite recall the well-preserved Roman theatre or the splendid museum. What I did remember was the exciting bustle of the excavations and the bent and rusty Roman nail I bought for a penny – as part of a small-scale campaign to raise money and awareness, I guess. I would have liked to have illustrated this book with that Roman nail, especially as I later became convinced (wrongly) that I had actually bought it from Sir Mortimer Wheeler himself. My mother threw it away in one of her Herculean cleansings of my bedroom. She claimed it was just a rusty nail: 'Your father can give you a new one.' Nevertheless, despite, or perhaps because of this trauma, I went on to dig in my teens, study and teach archaeology and become a working archaeologist.

Has that basic attraction changed much since the 1950s? Inspiring though some of my teachers were, the 'trip' was probably not part of any curriculum-based work, though we did have to write the obligatory 'What I did on the outing to St Albans' when we got back to school. But what I can still remember is being able to hold a real Roman object, even if it was only a rusty old nail.

organisations provide opportunities for child-centred learning which is a form of constructivism. This is often delivered through the many interpretations of the past (Copeland 2004). This book offers a number of examples of this constructivist approach.

How this book is structured

The book takes in turn areas in which archaeologists, heritage professionals in historic sites and in museums, those in the media and teachers present archaeology to the public and those in formal and informal education. It investigates and presents some of the methods which may be used to further a public understanding of the work of archaeology. Each section contains specific projects for teachers to use in presenting the evidence from the past as a learning opportunity. Through my own work with teachers, children and the general public I have shown that these methods can be easily adapted and used throughout the world. I have carried out, or been responsible for, a number of projects and long-term work in Britain, elsewhere in Europe, in America and in Central Asia.

The main sections include case studies as examples of successful and varied projects and organisations which have been carried out by archaeologists and educators. I have been involved with all the organisations represented in these case studies. The layout of the book is as follows:

1 *Introduction: Making Connections*

This chapter outlines the scope and structure of the book and introduces some of the issues, such as heritage and citizenship, which will be discussed in more detail in later sections.

The Public and the Past

This section explores the way in which people find out about the past, through visits to archaeological and historic sites and through the media.

2 *Accessing the Past*

This chapter looks at the ways in which people in many countries are able to access, learn from and enjoy the preserved remains of the past. It examines what is available, from tourist guidebooks to digital access and from events on ancient monuments to archaeological displays in metro stations.

3 *Archaeology and the Media*

More people find out about archaeology by watching television than by visiting the surviving ruins of the past. This chapter examines the ways in which archaeology has been represented in print, on television and on the radio and in cinema films.

Case studies: The section ends with two case studies, the first about the outreach work of the Colchester Archaeological Trust, the second about the International Centre for Cultural and Heritage Studies at Newcastle University.

Archaeology and Education

This section examines the history of archaeology in education from its antiquarian roots to its inclusion in formal education in a number of countries.

4 *The Development of Archaeology and Education*

This chapter outlines the ways in which education gradually became a part of what archaeologists did and details the education policies and programmes of the leading heritage organisations in the UK.

5 *Archaeology in School Curricula: a World View*

What is the place of archaeology which, if it exists at all, is usually subsumed into the subject of history in national curricula around the world? There is a special subsection in this chapter about the creation and reworking of the national curricula in England.

6 *Learning Resources for Archaeology and History*

More frequently than not, from the 19th century to today, resources, from school textbooks to books about the past for young children, have been inadequate in their use of evidence (archaeological and historical) to present the stories of the past, especially the prehistoric past. This chapter surveys what has been available to teachers and parents in the UK to help children learn about archaeology and the past.

7 *Archaeology across the Curriculum*

Until relatively recently teachers in primary and secondary schools failed to use the incredible resource which archaeology offers to teach a range of subjects, not just history. This chapter examines each of the major subjects taught in schools and offers tested ideas for using archaeology as a cross-curricula subject, from language to science and from art to geography.

Case study: The concluding case study looks at the education and outreach work of the Museum of London.

Investigating Evidence

This section examines the concept of the archaeologist as a detective and applies it to learning activities both on-site and in the classroom.

8 *Archaeologists as Detectives*

This chapter looks in detail at the developments in police detection since the 19th century and the modern use of forensic science. It then shows how these practices may be applied to observation and analysis by education groups at archaeological sites and monuments.

9 *Learning Outdoors*

This chapter outlines current practice in outdoor learning and its value for outdoor pursuits organised by schools and environmental centres. It investigates various experiential learning activities which can accompany the organisation of on-site group visits to historic sites and excavations. Included are activities for each of the main elements of a curriculum-based visit – what to do in the classroom before a visit, what kinds of activities are suitable at the ancient site and how a teacher might best follow-up the visit back in the classroom.

10 *Learning from Objects*

Objects are now frequently used as teaching tools in both school classrooms and museums. This chapter looks at the ways in which objects may be used in the development of skills, knowledge and concepts.

Case studies: There are two case studies. The first case study is a summary of the work of three archaeology and education organisations in Greece which use ancient monuments for visiting school groups. The second outlines the creation of a project at Ancient Merv in Turkmenistan to promote curriculum-based visits to a World Heritage Site and discusses the value of learning resources ands teacher training.

Heritage Issues

This section examines various environmental and social issues.

11 Recycling Past and Present

Archaeologists are well aware of the way in which past cultures commonly recycled objects and structures, from repaired pots to Roman tombstones reused in building walls. This chapter outlines the history of recycling, discusses the reuse of historic buildings today and presents exercises and questions for education groups, in the classroom and on site.

12 Citizenship and the Historic Environment

This chapter investigates the way citizenship curricula, which include issues of archaeology, history and heritage, have been established in a number of countries – curricula designed to help pupils play an active role as citizens. A number of concerns are raised – for example, the conflicts between 'professional' and the 'public' and between those who would redevelop buildings which have a violent history and those who suffered the violence themselves. Exercises and discussion topics are suggested for citizenship curricula.

Case studies: The section concludes with three case studies, concerning: (1) the education work of the Churches Conservation Trust, which looks after and presents redundant Church of England churches; (2) the Garbology Project, which was developed for schools in the east of England by a county council archaeology service; (3) an educational project from Finland, which shows approaches to promote citizenship through issues about World Heritage Sites and the local historic environment.

13 Conclusions: Celebrating Archaeology in Education

This concluding chapter draws together all the strands outlined above and asks whether archaeologists can be optimistic that they are getting their message across. It presents successful ideas and projects which have been used in a number of countries to encourage the greater and better use of the presented past by parents and governments.

Case study: The final case study looks at ways in which students and staff at the Institute of Education at the University College London have been widening participation in archaeology.

Definitions

This book takes the broadest possible view of archaeology, which must, in my view, encompass all the physical evidence for the whole history of all the peoples of our earth, from our earliest appearance right up to today. The physical evidence for archaeology includes, of course, moveable objects as well as sites, monuments and landscapes. The relationship between archaeology (what archaeologists do and what they have found out about the past) and education is explored. How has this relationship changed over time? The Prime Minister, Herbert Asquith, addressed the Classical Association in 1908 and was reported as saying that 'The pen has become the servant of the spade. But to the student of ancient literature,

archaeology must not occupy the foreground and dominate the scene. Amidst all the digging and scratching and scraping that had been going on during the last 20 years on all sides of the Mediterranean, it was disappointing, though perhaps not surprising, that so few of the lost literary treasures of the ancient world had been recovered' (Manchester Guardian 1908, 10).

When I was teaching 17-year-olds studying A-level archaeology in the 1970s, the debate between archaeologists and historians was still going on. What was most important – the evidence produced by archaeology or the literature of past civilisations? Yet today we see archaeologists using a full range of evidence, both physical and documentary in their researches and historians acknowledging the value of supporting physical evidence for their interpretation of the past.

Archaeology is not just about the remote past and ancient civilisations where we can trace no personal family connections. In Britain the term 'industrial archaeology' was conceived in 1955 (Minchinton 1983, 125). A 2007 newsletter from the Construction History Society excitedly reported the 'UK's Oldest Multi-Storey Garage at Risk of Demolition' (CHS 2007, 1). The Botanic Gardens Garage, in Glasgow, built *c.* 1906–11, with an impressive façade of green and white glazed tiles is a now protected, listed building. On a more homely level, the Northampton Archaeology Unit reported on their survey of pre-fabricated bungalows which were built in 1930 (Upson-Smith 2004). Nearer our own times, the remnant of the Berlin Wall, constructed between 1961 and 1989, is a protected ancient monument and the Sydney Opera House, completed in 1973, was declared a World Heritage Site in 2007. The American Embassy in London was constructed in 1957–60 as part of America's Cold War strategy to build new embassies across the world. It is now a listed building.

It must be admitted that the public sometimes find that the protection given to more recent buildings does not fit in with their ideas of 'historic sites'. An example of this is Centre Point, the concrete and glass skyscraper built in central London, 1963–6, which was one of the modern buildings proposed for listing in 1995. The government's Secretary of State for heritage asked the public what they thought about protecting such buildings. There was an outcry in the newspapers and from other commentators who condemned the idea of the same protection being given to 'ugly modern buildings' as to treasured ancient remains of the past. However, in 2006 there were angry protests against the de-listing of the Commonwealth Institute building in London, which was completed in 1962 – protests led by architects and some heritage organisations (Twentieth Century Society 2006).

Heritage

Merriman (2004, 88) tells us the 'heritage boom' occurred in the 1970s and 1980s and Hewison's influential book *The Heritage Industry: Britain in a Climate of Decline* claimed that 'the growth of a heritage culture has led not only to a distortion of the past, but to a stifling of the culture of the present' (Hewison 1987, 10). A character of the novelist Kate Atkinson, in *Behind the Scenes at the Museum*, says 'There's too much history in York, the past is so crowded that sometimes it feels as if there's no room for the living' (Atkinson 1996, 352).

The steam the heritage industry raised then has certainly carried it forward until today, and shows no sign of running out. Aplin (2002, 7–8) poses a number

of questions such as 'is an ancient cave painting or grave site part of your heritage, even if it is in France or Spain?' People may choose to recognise this example as 'history' or 'archaeology' while keeping the word 'heritage' for their own area, traditions or culture.

But heritage has got itself a bad name in the archaeological world. Fowler (1992) effectively dealt with some of its more bizarre aspects, such as the fondness of marketing managers for describing places in 'heritage' terms – Nottingham is the 'City of Lace and Legend'; the Scottish Highlands are home to 'Britain's oldest monster, Nessie'. In the world of tourism Nottinghamshire is still 'Robin Hood Country' and Warwickshire can only be 'Shakespeare Country'.

Where will it all end?

Julian Barnes' satirical novel *England, England* (1998) describes a company which buys the Isle of Wight, complete with the royal family, and turns it into a one-stop tourism venue for heritage holidays. The island is remodelled to provide a wide range of heritage landscapes, buildings, events – complete with heritage food (fish and chips or pie and mash) and continuous re-enactment of past glories (Robin Hood and his Merry Men). Perhaps this is what we want? Do we yearn to preserve what we think makes up our identity and are we frightened about future changes to our environment? Prince Charles is famous for his support for 'traditional' architecture and described the new extension to the National Gallery in Trafalgar Square, London, as 'a monstrous carbuncle on the face of a much-loved and elegant friend' (Charles 1989, 7).

Heritage and citizenship

The subject of citizenship is useful in presenting some of the issues which face archaeologists and heritage managers. The traditional meal of pie and mash mentioned above was on offer at the first 'new citizens' days' being organised by local authorities across England. They have been designed to promote a strong sense of citizenship and to celebrate national and local heritage. The UK government's Border and Immigration Agency in the Home Office requires new immigrants to pass an examination to qualify for citizenship. Questions are based on a booklet, *Life in the United Kingdom: A Journey to Citizenship*, published in 2005. In it is a potted history of Britain which, apart from being littered with historical errors (apparently the Romans did not have 'control of Wales and the north' (Home Office 2005, 18)), *entirely* omits the prehistory of Britain. Prehistory is often similarly ill served by formal education and textbooks. Government education authorities in England still refuse to include prehistory in the statutory history curriculum, yet those in Wales, Scotland and Northern Ireland see prehistory as an essential part of the story of our pasts.

The past *is* a foreign country

The much-quoted first sentence of L. P. Hartley's 1953 book, *The Go-Between*, 'The past is a foreign country: they do things differently there' (Hartley 1958, 7) is fundamental to the introduction of archaeology and history to everyone, whether to children or adults. We have to look for ways to get people to step back into the

past. This should not be a problem. As archaeologists, we know that what we do is exciting and that other people soon get to understand this too. Archaeologists have to use their imaginations to construct a picture of the past for a variety of different groups of people. They have to take them on that journey into the 'foreign' past. They have to lead them, through the presentation of evidence, and admit that the presentation is our own interpretation. They have to be the go-between.

> 'First of all', he said, 'if you can learn a simple trick, Scout, you'll get along better with all kinds of folks. You never really understand a person until you consider things from his point of view – '
>
> 'Sir?'
>
> '– until you climb into his skin and walk around in it.'

> Atticus Finch talking to his daughter, Scout, in Harper Lee's 1960 novel *To Kill a Mockingbird* (Lee 1974, 35)

The Last Routemaster

On 9 December 2005 the last Routemaster bus travelled on route 159 from Streatham to Marble Arch. The Transport for London authority had withdrawn these big red London buses which were easy to jump off and on, illegally and dangerously, while they were still moving. Personally, I never fell off one and I travelled on them in the 1950s and 1960s, first daily to my secondary school and later as an escape route from suburbia to the West End. I was there in 2005, watching, taking photos and, yes, shedding the odd tear – this was part of my heritage. However, if on that day I was worrying about their preservation, I need not have had any fears. On the same day it was announced that a few red Routemaster buses would be travelling on 'Heritage Routes' in London.

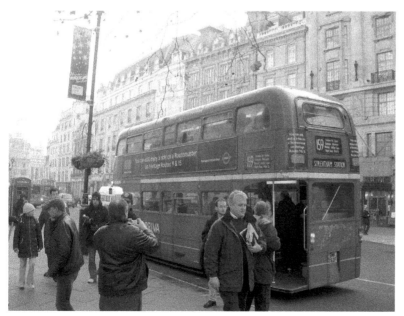

Fig. 1.1 Enthusiasts in Oxford Street enjoying the 'last' journey of the 159 double-decker bus

The Public and the Past

2 Accessing the Past

It is clearly in the interests of archaeologists and heritage managers to encourage the public to take an interest in what they do. Places such as ancient monuments open to the public and museums may depend on a financial return from visitors (if only from the shop or tearoom), while state-funded sites are usually given a visitor target to be reached in return for grant aid from public funds. For this reason websites for heritage organisations and museums are usually best at providing information on location, access, opening hours and entry fees.

This chapter looks at two areas in which the public, including schools, find out about archaeology and the heritage, either intentionally or otherwise. First I have reviewed methods of searching for information. The value of visiting sites, attending re-enactment events and coming across archaeological displays while travelling is explored. Another important part of what might be called 'intellectual' access to the past is interpretation and part of this chapter also looks at the use of interpretation and events at historic sites for education projects.

People are constantly interpreting the environment around them in order to make sense of it. People try to make the world about them more meaningful by drawing on their repertoires of experience (Uzzell 1994, 294).

Defining our public

Archaeologists, and many other interest groups, talk about the 'public' or 'people', whether the general public or the interested public. This generally means those people whom we wish to influence in some way, perhaps to support what archaeologists, to provide them with increased visitor figures or to prove to others (perhaps our funders) that they really are sharing their interests. Some archaeological and heritage organisations are better than others at defining whom they can influence best. In the UK, heritage and environmental groups find it relatively easy to get media coverage for their causes in 'liberal' newspapers but are aware that they are not reaching the majority of the 'general public' who do not take these newspapers. Ucko published figures from research carried out in 1987/8 which showed the percentages of readers of selected British national daily newspapers who visited sites, monuments, historic buildings and museums.

Table 2.1 After Ucko 1994, xx

Newspaper	Circulation of newspaper	Archaeological sites	Historic houses & castles	Museums
Independent*	992,000	20.4%	45%	53.4%
Times*	1,170,000	13.9%	43.4%	51.5%
Guardian*	1,403,000	19.2%	43.4%	56.5%
Sun	11,324,000	3.1%	14.9%	19.6%
Express	4,392,000	6.5%	27.8%	30.1%

* 'quality' newspapers – see p. 60

Pearce defined, from an archaeological curator's viewpoint, the general public:

> The term 'general public' is capable of a range of interpretations, not all of them flattering, but here it is taken simply to mean all those people who do not regard themselves as professional curators or archaeologists, and therefore constitutes, as we should never forget, the huge majority of the population. (Pearce 1990, 133)

And went on to present 'three fairly distinct groups':

> The greater proportion of the adults includes those who have no regular commitment to the past, or whose interest takes a form which professionals often consider unfortunate or improper. The smaller section embraces those adults who do take an informed interest in the past. The third group are the children, whose interests are not yet fixed. (Pearce 1990, 133)

McManamon (1991, 121) pointed out that the Society for American Archaeology had a range of individuals and organisations in their sights to help fulfil its goals – from 'private people concerned with archaeology, all levels of government' to 'schools, historical museums, newspapers, television stations, film producers and national magazines'. His article discussed the five sections of society which should be targeted to help the cause of American archaeology: the general public; students and teachers; the congress and the executive branch; government attorneys; managers and archaeologists and Native Americans (McManamon 1991, 121).

But this model will not apply universally (nor was it intended to). Each country's archaeologists and other heritage workers need to reach their own definitions. As a heritage educator at English Heritage my broad aim was to reach and influence people with authority to change attitudes of the general public and the young people who will become adult members of our society, that is: teachers/tutors influencing pupils/students/adults (already members of the public); media professionals influencing their readers/viewers; legislators influencing the government/government bodies and the general public; other professionals in ginger groups/charities/government bodies.

But there are plenty of other categories. Aplin (2002, 32–3) notes that urban and rural dwellers may have different perceptions of the heritage and that overseas tourists may need more and differentiated interpretative material. A definition of the 'general public' is not simply a list of categories. For example, a particular grandmother taking her grandchildren to a heritage site might want to educate them or want somewhere to go as an outing. She may herself have a slight interest in the past or be able to access information easily because she is a teacher. She may also happen to be an elected local councillor with a professional interest in seeing whether this heritage site is being run properly.

Targets for audiences or visitors, as well as financial targets, are set by the UK government for those heritage bodies it funds or by other funding bodies, such as the Heritage Lottery Fund.

Audience/visitor research

Polls, together with focus groups, can help the heritage manager define who the public are and what they want. Research undertaken by the polling organisation MORI for English Heritage in 2000 was partly published in *Power of Place: The Future of the Historic Environment*. The poll showed that, from a representative 3,000 people in England:

▶ 98% think that all schoolchildren should be given the opportunity to find out about England's historic environment

▶ 96% think that the historic environment is important to teach them about the past

▶ 87% think it plays an important part in the cultural life of the country

▶ 76% think that their own lives are richer for having the opportunity to visit or see it.

When people were asked by MORI how they would spend £100 on one aspect of the heritage, by far the most popular choice, for 22%, was education programmes for schools (English Heritage 2000, 4, 23).

Since then a survey of the state of England's historic environment called Heritage Counts each year (English Heritage 2009) helps to inform both government and the profession. According to Heritage Counts there were 44.3 million people visited historic sites and there were 1.63 million educational visitors.

Reaching these 'publics'

How can we decide what we might do, as heritage managers, to reach out to this 'general public' and encourage them to take notice of our organisations and to visit, support or buy from us? Above all, we need to be clear about what our organisation really wants to achieve – often called a mission statement – and then research those audiences we want to reach; start from where they are (or what they are interested in); develop our own USP (Unique Selling Proposition), but above all use language and reading levels appropriate for our target group and get rid of jargon associated with our profession.

Archaeologists, like any other profession, easily slip into jargon – after all, it is the language of communication with other professionals, in both oral and written communication. Zimmerman puts it well: 'For all the fine writing we may do as professional archaeologists, the public mostly finds our writing boring, or at least overly complex. For people who have never seen or tried flint knapping, no written explanation is sufficient to help them understand the process' (2003, 109).

Teachers and the public alike now have much better access to information about the past, as well as the actual surviving evidence for it. Museums and heritage sites are, generally, much better at defining their specific educational audiences and targeting them with appropriate resources and services. Those in charge of historic sites increasingly seem to understand that visitors have specific needs which include more than loos and food. It is disappointing when you visit a complex site which has no interpretation to help the visitor. There are also a variety of ways in which the story of a site may be presented to visitors. At

Sutton Hoo in Suffolk, for example, the famous Saxon ship burial, cared for by the National Trust, can be accessed through a new visitor centre (with loos and food) which presents an interpretation of the site itself, complete with audio tours. Volunteers are on hand to help answer questions. On most days guided tours are available. Access for visitors with special needs is catered for by guides available in Braille and large print versions and sign interpreter may also be booked.

The site itself is sensitively displayed, fenced off (but accessible on tours) yet with well-designed interpretation boards to help the visitor. Appropriate events on site are a regular feature each month through the year which include discovering more about the site itself and the wildlife and landscape around, and 'Family Fundays'. Material from Sutton Hoo can also be viewed in exhibitions in the British Museum and in the Ipswich Museum, Suffolk and the National Trust publishes information for teachers and students on its website and provides on site teaching linked to National Curriculum subjects. There is even a novel based on the original excavations, called *The Dig* (Preston 2007).

Acting the past

Eastern Angles is the regional touring theatre company for the east of England since 1892. Each spring it tours village halls, community centres and schools throughout East Anglia, usually with a newly commission play on a regional theme or subject. In 1993 the company asked Peppy Barlow to write *The Sutton Hoo Mob*, which was first performed in Woodbridge Community Hall on 17 February 1994. The play was revived for another tour in 2006. Mrs Edith May, Sutton Hoo's owner, asked the curator of Ipswich Museum, Guy Maynard, to provide an excavator for her. He recommended a local self-taught archaeologist, Basil Brown, who began excavations in June 1938 (Carver 1998, 4–5). The play traces the often stormy relationships between competing archaeological interests but the author wrote that 'For me the play has always been about Mrs Pretty and her journey towards understanding the nature of the burial and the way it related to her grief at the loss of her husband three years earlier' (Barlow 2006). John Preston's novel *The Dig* portrays the same events in the summer of 1939, seen through the eyes of Basil Brown, Edith Pretty and Peggy Piggott, with a piece from 1958 by Robert Pretty, Mrs Pretty's son, who had been present at the original excavation (Preston 2007). The book's reviewer liked, as I did, the gentle unfolding of the story, but picked up on the author's statement that 'certain changes have been made for dramatic effect'. But what was not liked were, for example, two seasons of excavation rolled into one and the mistakes concerning the number of mounds excavated and the location of individual finds (Lovata 2008). These are criticisms often heard about films and television representations of the past.

Digital outreach

The internet has revolutionised the way in which we can gain access to archaeological information and services. One example, of a newspaper story, provides evidence of that change. In October 2009 the science correspondent of *The Guardian* wrote a story about the discovery and analysis of a female skeleton, named Ardi by the researchers, from Ethiopia. She was said to be 4.4 million years old and 'belongs to a new species *Ardipithecus ramidus* and may be the earliest human ancestor that was capable of walking upright' (Sample 2009). While the newspaper itself had text and artists' impressions, the newspaper's website contained much more for the interested reader. The text was tagged with more information about Ethiopia and evolution. There was also a link in the article to an article in the journal *Science*, which was to be published the following day. *The Guardian* website also had more artists' impressions, drawn reconstructions of the skeleton to show how Ardi may have walked upright and detailed photographs of the bones. There was a ten-minute video to watch and four audio pieces giving background about the discovery and the evolutionary position of Ardi. As with many other websites, there was an opportunity for readers to post their own comments.

Most people who are interested in visiting an historic site expect to find a range of information available to them, from opening hours to historical or archaeological background. Some, but by no means all, heritage organisations present good quality sites which are easy to navigate. Some historic sites now offer virtual tours to encourage visits *and* to allow those who may not be able to visit a chance to see what the site is like, for example English Heritage provide a panoramic access to several of its sites. More ambitious are the opportunities provided by Google to navigate through a reconstructed Rome in AD 320 (Google Earth 2010).

Some ongoing excavations now provide access for the public to follow progress on their websites. Since 2007 the magazine *British Archaeology* has published reviews of archaeological websites. Caroline Wickham-Jones (2009) reviewed a number of sites including the Whitehall Villa excavation, which has blogs, photographs and video (Whitehall Villa 2010). Podcasts are now a frequent tool for getting people interested in museum collections and services; for example, the Museum of London has created audio description podcasts of a number of objects to enable visually impaired visitors to better access the collections. Most sites and museums now have links to social networking sites (e.g. Twitter, Facebook) and some encourage links to YouTube.

Research and teaching

There are now a number of specialist sites for the researcher and the teacher to collect and store information for projects or to gather ideas for making visits. Some museums now provide online access to their collections (see pp. 247–8). The excavations at Silchester being conducted by the University of Reading have produced a wealth of information and resources for teachers to make use of. There is a complete illustrated report and analysis of the Victorian excavations of 1893 online (Clarke *et al.* 2001) in its Town Life Project.

The Archaeological Data Service (ADS) safely preserves a broad range of digital data (e.g. excavation archives) in the long term for archaeological research (ADS 2010). The website has a Learning and Teaching section with an image memory bank and a range of online tutorials and teaching modules for further and higher education. English Heritage, largely through initiatives taken through its National Monuments Record (NMR), now has an impressive number of such sites (NMR 2010). *Images of England* has over 300,000 photographs of listed buildings recorded by volunteers in the late 20th century, *PastScape* has information, maps, plans, photographs and sources of evidence for over 400,000 records held in the NMR's national historic environment database and *Heritage Gateway*, created in association with Association of Local Government Archaeological Officers and the Institute of Historic Building Conservators, has over 1.5 million records of listed buildings, archaeological excavations and photographs (historic and contemporary) pulled together from local historic environment records and those held by English Heritage. For the teacher there are *Heritage Explorer*, which provides images by themes with a range of teaching resources and activities including those created for whiteboards, and the Learning Zone in *Images of England* which has case studies for local projects, National Curriculum related 'albums' and activities linked to curriculum subjects and learning skills.

Sites for kids

Some of the more enlightened archaeological organisations are using the web to reach and interest children in archaeology. *Texas Beyond History* (2010) is a public education service provided by the University of Texas at Austin with 14 partner organisations. It does an excellent job of promoting the archaeology of Texas itself but it also provides a mass of resources for teaching about the past and the techniques of archaeology – from lesson plans (see the lesson plan for excavating a 'Jello mould' on p. 210) to period information. The 'Kids Only?' section is both fun and informative. The Society for American Archaeology (SAA) is full of useful information for archaeologists, the public, teachers and children – I like the 'Mystery Artifact' section (SAA 2010). The US National Parks Service (NPS) has a site for children 'Archaeology for Kids' with good quality information and photos about archaeologists and what they do (NPS 2010). 'The Mysteries of Çatalhöyük' is one of the interactive sections of the website of the Science Museum of Minnesota (SMM 2010) where you can tour the site and find out about the archaeological investigations, do online activities such as 'Read the Baby Burial Comic' – even listen to why the excavator Ian Hodder thinks particular objects are important. Cobblestone Publishing, in association with the Archaeological Institute of America, produce 'dig – the archaeology magazine for kids' which is for sale but the website (Cobblestone 2010) has interesting information and activities for children, parents and teachers. The British Broadcasting Corporation (BBC) has a site devoted to history for children (BBC 2010a) which includes interactive investigations such as 'Iron Age Celts' with games, information and activities (e.g. 'Build a hillfort') as well as background information and ideas for teachers and parents. *Show Me* is a website with educational games and resources created by museums and galleries in the UK (Show Me 2010). Each topic covered (such as prehistory, ancient civilisations and the Vikings) has interactive activities, teaching ideas and classroom resources. Beyond interactive games for children

on websites, Economou in 2007 looked at four electronic games which presented some aspect of the past (Economou 2007).

Among the many, often violent, commercial computer games which may not be created for children but can easily be accessed by them, are a few with an historical base. Schadla-Hall and Morris review a few which cover ancient Egypt. Some relate to movies such as *The Mummy Returns* (2003, 212–14).

Tourist guidebooks

Although the word 'guidebook' seems to have been used first in the early 19th century, guides for tourists have been around since ancient times – for example, Pausanias, a Greek doctor who became a travel writer. His *Guide to Greece*, was written in the second century AD, when Greece was part of the Roman empire. His work was published in ten books and included descriptions of buildings and statues but also covered the myths, religion and history of the ancient Greeks. His books are still a valuable source for archaeologists and historians today (Pausanias 1979) but above all they were the guidebooks of his time:

> The place most worthy of seeing at Piraeus [the port of Athens] is the Sacred Enclosure of Athene and Zeus. (Pausanias Book I, 10)

> The Epidaurians have a theatre in their sanctuary that seems to me particularly worth a visit. The Roman theatres have gone far beyond all others in the whole worlds ... but who can rival Polykleitos for the beauty and composition of his architecture. (Pausanias Book II, 195)

> There are twice as many women at Patras as there are men: and if ever women belonged to Aphrodite, they do. They mostly make their living with the flax which grows in Elis, which they weave into the nets which ornament women's hair, and into all sorts of clothing. (Pausanias Book VII, 284)

Guides to popular sites, in Britain and abroad, were being published in the 19th century. Thomas Wright was the first excavator of Wroxeter Roman City in Shropshire and began work in 1859. In the same year he published his guide in which he wrote:

> It is the aim of the following pages to give the degree and kind of popular information believed to be wanted by the numerous visitors to the excavations at Wroxeter, who have no Guide to explain what they see, and are not possessed of that amount of minute antiquarian knowledge which would enable them to understand everything without such explanation.
> (Wright 1859, iii)

Wright also had something of the showman about him. His public lecture on 'Anglo-Saxon Antiquities' was given to a very large audience in the Philharmonic Hall in Liverpool and 1500 copies of his lecture were printed and distributed to those attending (White 1988, 120). The figure (Fig. 2.1) here shows the hand-painted image of the antiquities which formed the subject of his public lecture.

In 1820 the publisher John Murray launched a series of guides, called *Murray's Handbooks*, which covered many parts of the world. The John Murray archive can now be investigated through the National Library of Scotland (Murray 2010).

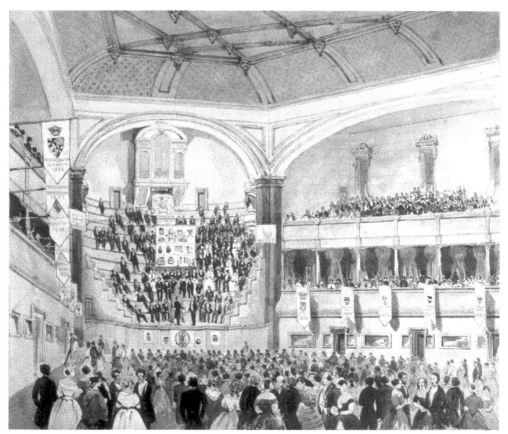

Fig. 2.1 A public lecture on 'Anglo-Saxon Antiquities' given by Thomas Wright in Liverpool in 1854

Karl Baedeker modelled his guidebooks on those published by Murray. The model assumed a literate tourist who was interested in history and antiquities. There were sections on how to get to a place, where to stay, what to see and when it was open:

> Most sightseers are usually hurried through by guides in 2 hrs., but an adequate idea of the ruins [Pompeii] cannot be obtained in less than 4–5 hrs. Luncheon should be brought; drinking water is supplied by many of the fountains which have been restored. Public lavatory at the excavators' office, mention on p. 439. (Baedeker 1928, 429–30)

Baedeker lived 1801–59 but guidebooks carrying his name continued to be published and, like Pevsner's *Buildings of England* series, his books were updated by others after his death. The first English editions of Baedeker were published in 1861. The term 'Baedeker raids' in 1942 described German reprisal air-raids on English cathedral cities which were starred in the Baedeker guidebook.

Before and after World War II, tourism was popular for those who could afford it, both in this country and abroad. A useful series for the holiday maker interested in both the natural and the historic environment was the Ward Lock series of 'Illustrated Guide-Books' which had photographs and decent pull-out maps, as well as the usual travel and accommodation information, which was also available in advertisements.

At the Conference on the Future of Archaeology, held in the Institute of Archaeology in London in 1943, T. D. Kendrick (then the Keeper of British and Medieval Antiquities at the British Museum) said:

> I now come to the real need in this country for a properly edited series of Guides to British Towns and Counties. We talk about archaeology and education, but we so often ignore the most important and potent means of making the public familiar with archaeological problems and results. A person buys a guide, not because he wants to learn about archaeology, but because he wants to know the number of bedrooms in the local public-house, but incidentally he comes across archaeology.
>
> Use Guides as a means of conveying to the world that we are dealing with the whole of our past. If, in your town, as in Market Harborough, an important building happens to be the Gas Works, put it in.
>
> We must produce these guides or we must find a publisher like Murrays, [John Murray] or we must see that an adequate team of experts is at hand to give advice and help. We want people who are expert in pictures, furniture and folk-lore and place-names to form an editorial board with the architects and archaeologists. (Institute of Archaeology, 1943, 16–17)

But the direct descendant of the Murray and Baedeker guides were the *Blue Guides*. They gave the usual practical information as well as the history and antiquities (well researched) and were laid out in the same way as a Baedeker – history in italics, places in capitals, in bold and starred according to excellence. The 1984 edition of the *Blue Guide for Southern Italy* had this information for visitors to Pompeii:

> The *Official Guardians*, stationed in different quarters of the town, open the closed houses on application and give all necessary information. They are not supposed to accept gratuities or accompany visitors. At least 4 hours are necessary for an adequate visit. Luncheon may be obtained at the *Posto di Ristoro* (near the Forum). In hot weather the absence of shade is noticeable; flat shoes, preferably rope-soled, are the most serviceable for the uneven paved streets. (Blanchard 1984, 156)

Other types of guide began to be published which added other information which tourists might want, in addition to the history and the antiquities. For example, *Fodor's Travel Guides*, from an American company, included in its 1984 edition of a guide to Rome, sections on nightclubs, shopping and fast food. Now bookshops are awash with a range of new guidebooks – the *Lonely Planet Guides* (described by itself in a 1993 edition as a 'travel survival kit') are perhaps the modern versions of Murray and Baedeker, while the Dorling Kindersley *Eyewitness Guides* include high quality artists' impressions to help the tourist understand ancient monuments and historic buildings.

Tourist leaflets

Most organisations, small and large, produce a publicity leaflet. Tourist leaflets are printed in vast numbers and there are regular ways of distributing them. Specialist commercial companies will distribute your leaflet to hotels and guest houses, supermarkets and shopping precincts, Tourist Information Centres

and libraries, museums and other attractions. A useful and amusing appraisal appears in Fowler's book *The Past in Contemporary Society: Then, Now,* in which he gives some splendid examples of the way 'heritage' is woven into tourist leaflets in Scotland, for example:

> The Scottish Highlands and Islands tourist leaflet enjoins you in Argyll and the isles to 'visit pre-historic standing stones; go cruising in waters saints and Vikings have sailed'; in the Heart (what else?) of the Highlands it offers 'Britain's oldest monster, Nessie' then, indiscriminately changing gear to hype, 'she may also be the shyest but could well pop out to see you'.
>
> <div align="right">(Fowler 1992, 123)</div>

Interpretation on site

> We shall never know how the flowers smelt in the garden of Epicurus, or how Nietzsche felt the wind in his hair as he walked on the mountains; we cannot relive the triumph of Archimedes or the bitterness of Marius; but the evidence of what these men thought is in our hands; and in re-creating these thoughts in our minds by interpretation of that evidence we can know, so far as there is any knowledge, that the thoughts we create were theirs. (Collingwood 1994, 296)

> The historian's business is to narrate them, to re-create them [past events and happenings]. To do that he needs to be an artist. The process of historical re-creation is not essentially different from that of the poet or novelist, except that his imagination must be subordinated sleeplessly to the truth. He must consent to be ruled by the evidence and never once go against it. It is an austere, a searching vocation. (Rowse 1946, 112)

Archaeologists know that the evidence they collect, in any form, can only provide a picture of what may have happened in the past at a particular place. However, we also realise that at some point we must make a decision as to the best interpretation of past events. Many times, on historic sites, in books, newspapers, on television and in films, people other than archaeologists interpret the evidence, often incorrectly.

For the philosophy behind interpretation many interpreters today look back to Freeman Tilden's principles as a starting point:

1 Any interpretation that does not somehow relate what is being displayed or described to something within the personality or the experience of the visitor will be sterile.

2 Information, as such, is not Interpretation. Interpretation is revelation based upon information. These are entirely different things. However, all interpretation includes information.

3 Interpretation is an art, which combines many arts, whether the materials presented are scientific, historical or architectural. Any art is in some degree teachable.

4 The chief aim of Interpretation is not instruction, but provocation.

5 Interpretation should aim to present a whole rather than a part, and must address itself to the whole man rather than any phase.

6 Interpretation addressed to children (say, up to the age of twelve) should not be a dilution of the presentation to adults, but should follow a fundamentally different approach. To be at its best it will require a separate program. (Tilden 1977, 9)

However, some believe that the word 'interpretation' may be applied to all types of interaction with the public and visitors to historic sites: 'Interpretation is taken here to include any form of presentation of factual material and interpreted meaning about a site or other heritage item, whether on site or off site. Brochures, web sites, media coverage, and advertising campaigns all involve interpretation according to this definition' (Aplin 2002, 30).

All forms of interpretation are clearly 'biased', mainly perhaps because they reflect the period in which they were devised: 'Despite sincere attempts at authenticity, neither those who provide interpretations of the past nor those who receive them can avoid loading them with their own twentieth century perspectives' (Uzzell 1994, 295).

Presentation of any material to visitors to historic sites cannot be 'value-free' (Aplin 2002, 30). A job advertisement in *The Guardian* on 2 July 2007 for an Interpretation Project Officer for the National Trust had this as a headline: '*Yesterday's stories, retold for today*'.

Wyke claims that interpretation is what people are going to be given, whether they want it or not:

However, the desire to bring the ancient city back to life has not left us. We can listen to the lurid stories of the tourist guides, look at the pictures of reconstructed houses and 'real life Pompeians' on display in the souvenir shops that litter the streets around the site, or press the keyboard of a computer to simulate a peaceful walk through the 'original' buildings and gardens of the city. Soon, no doubt, we will be able to experience Pompeii as 'virtual reality' and putting on our space-age helmets and goggles, we'll be able to find ourselves back in the past, experiencing both the delights of Pompeian life and the terrors of the sudden volcanic eruption.

 (Wyke 1994, 12)

The processes of interpretation on historic sites have been published and discussed in detail (e.g. Uzzell 1989a, 1989b; Hems and Blockley 2006) and the forms of interpretation range from site guide booklets to simple information signage and illustrated interpretation panels, from audio guides to people guides or demonstrators (sometimes in costume and sometimes in role) to virtual tours available on websites, from physical 'reconstructions' to events with re-enactors (Risk 1994). Several books provide case studies of interpretation at particular sites – for example, Tabraham's analysis of Skara Brae, Orkney (2006, 63–6).

Managed historic sites and buildings will usually offer visitors the chance to buy or be given a variety of site guides. The Greek Ministry of Culture gives away, with the entry ticket for its major sites, a well-designed folded single-sheet guide. In addition, at most of these sites there is a well-written and authoritative 'souvenir' guide on sale. One problem facing museums, but which can equally apply to sites, was raised by Susan Pearce: 'The biggest single problem facing such museum

Panels and audio tours

Most visitors need some sort of interpretation to help them understand what they are looking at (see Fig. 2.2). Some sites provide, or allow, guided tours. Guide books and leaflets may help but most sites now provide some interpretations panels, at least. Advances in technology have meant that audio tours are now digital and are easier to use, can contain much more information and be produced for a range of different audiences – for example, for children and visually impaired visitors or basic learners. Experiments with smartphones show that visitors will be able to access web-based media to help them understand more about a site, perhaps by downloading an artist's impression of a site too small or remote to warrant the expense of a fixed interpretation panel (Anderson 2010).

Fig. 2.2 This interpretation panel at Framlingham Castle, Suffolk, has missing buildings and wall construction drawn over a photograph of the curtain wall opposite.

publications is that one booklet often has to do a range of jobs, serving at once as an exhibition guide, a souvenir of the visit, and a general introduction to the archaeology of the area' (Pearce 1990, 195).

Ruins and museums

A few museums actually inhabit an ancient building; for instance, Colchester Castle Museum was constructed inside the town's Norman castle which was built from the remains of the Roman Temple of Claudius (see p. 270). Where the ruins of previous buildings have been excavated or survive above ground within the grounds of museums, it is possible to extend interpretation to the interior of the museum – for example, under the new Acropolis Museum (see Fig. 2.3).

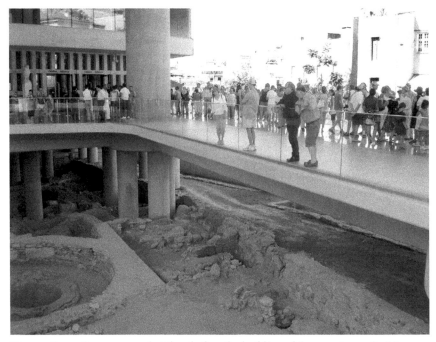

Fig. 2.3 Excavations were undertaken before the building of the new Acropolis Museum in Athens. Some of the remains from the 4th to the 7th centuries AD have been preserved and may be seen from the first floor of the building.

Walls and foundations of the Roman baths can be seen from the Jewry Wall Museum in Leicester (Leicester Museums and Galleries 2010). In Turku, Finland, part of the medieval quarter of Aboa Vetus (Old Turku) has been excavated and preserved under a new museum (Aboa Vetus Ars Nova 2010) with archaeology and modern art galleries. Visitors can see and tour both the preserved remains and see archaeologists at work. In 2010, children will be able to take part in these excavations.

Artists' impressions

Artists' impressions have long been used successfully to help the public understand a site and for archaeologists to try out interpretations of their findings – for example, see the excavated Roman church in Colchester (see Figs. 2.4 and 2.5). For many years 'reconstruction drawings' have been used to describe these useful views. Some have objected to the word 'reconstruction', both for drawings and physical reconstructions, on the grounds that it is not really possible to 'reconstruct' something where the evidence is not completely secure. Stone and Planel (1999, 1) state the case very well when they wrote: 'The past in fact cannot be *re*-constructed as it actually happened, but rather it is continually *constructed* by individuals or groups who, for whatever reason, choose to interact with it.'

Stone showed in the redisplay of the museum in Avebury, which was linked to the English National Curriculum, the different ways in which the evidence may be presented. A full-size Neolithic figure was deliberately dressed in two halves: one half shows a rather raggedly dressed man 'coping with his existence' (1994,

Fig. 2.4 The remains of the Roman church in Butt Road, Colchester, excavated by the Colchester Archaeological Trust

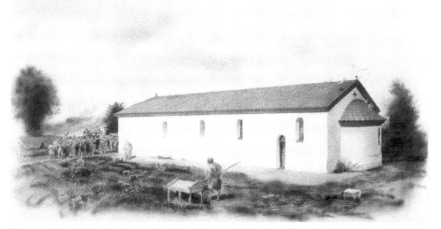

Fig. 2.5 A painting by the artist Peter Froste of the church as it might have looked in *c.* AD 330

198); the other half shows a much more colourful figure – his body is painted and tattooed, his clothes are much better made, and he wears jewellery – using evidence from other Neolithic sites.

But some people do not like the use of 'artists' impressions'. Mark Sorrell wrote that, although he didn't much like the term 'reconstruction drawing', he argued that:

> We never entitle 'The Crucifixion' 'Reconstruction of the Crucifixion', but accept it as a thoughtful opinion of the artist, based on as much literary and historical evidence as was available. And so it should be in archaeology ... even worse than 'reconstruction' is 'Artist's impression', which suggests something fuzzy and completely undependable.　　(Sorrell 1981, 25–6)

Alan Sorrell is famous for his impressions of some of the most famous ancient monuments in Britain. Good introductions to his life and works are given by Dykes

(1980) and Sorrell (1981). His first published impression of an archaeological site was the Roman forum in Leicester and appeared in the *Illustrated London News* in 1937. Many other fine artists have produced their own interpretations of excavated or extant ancient sites, most usually guided by the archaeologists who excavated or investigated the sites. Artists' impressions have long been used for helping children understand the past through textbooks (see pp. 132, 134–5).

Books of artists' impressions matched to photographs of the surviving ruins or buildings are published for a number of places across the world. One type, particularly useful for visitors at large sites, such as Rome (Staccioli and Equini 1962), Pompeii or Delphi, have artists' impressions which can be lifted to show a photograph of the actual site. Some places now produce hologram postcards which can cleverly be bent to reveal the artist's impression.

Fig. 2.6 Pompejanum in Aschaffenburg, Germany. Although part of the inside looks like a Pompeian house, other 19th-century features were added, including an upper storey, outside staircase and viewing platform for the king.

Reconstructed buildings

There are a number of concerns and issues surrounding reconstruction of archaeological monuments and historic buildings (issues raised by Cleere 1984). The Pompejanum in Aschaffenburg, Germany, is a good example of the problems which might arise (see Fig. 2.6). Excavation of the streets and the buildings at Pompeii in the 19th century created enormous interest in a number of countries. Inspired by this excavation, King Ludvig I of Bavaria wanted to build a replica of a Roman house next to the Johannisburg Palace in Aschaffenburg. The house was based on the Pompeian House of Castor and Pollux and was completed by 1843 and its interior walls painted by 1850 (Helmberger and Wünsche 2006).

But recreating whole ancient buildings is now a popular and effective way of presenting one aspect of past cultures (Stone and Planel 1999). Colomer (2002, 85) has no doubt about the value of reconstructions as 'the best interpretative tool for delivering representations of that "broken" past to the public'. No one could surely deny that one way for the public to understand the prehistoric settlement at Biskupin in Poland is by examining and walking into the long wooden buildings reconstructed from the1970s. Understanding what a Roman fort may have looked like is easier when you approach the main gate of the reconstructed fort of the Lunt in Warwickshire (see also reconstruction at Arbeia on Hadrian's Wall, p. 71).

There are a number of archaeological parks or open air museums where reconstructed buildings, based on excavated examples, may be seen – for example, the Irish National Heritage Park, Ferrycarrig, Country Wexford; the Roman Open Air Museum at Hechingen-Stein, Germany; the Archäologisches Freilichtmuseum, Oerlinghausen, Germany; the Scottish Crannog Centre, Kenmore, Perthshire, Scotland and Colonial Williamsburg, USA. Experimental archaeology has sometimes led on to the presentation of full-size replica buildings to the public by archaeologists.

There are early examples of archaeological experiments leading to sites open to visitors. The Historical-Archaeological Research Centre at Lejre in Denmark (Lejre 2010). The project has its origins in experimental reconstructions of prehistoric houses in Europe in Allerslev in 1956–8 (Coles 1979, 152) and the centre has been functioning since 1964 (Rasmussen and Grønnow 1999). Its 106 acres (43 ha) includes 'the Iron Age village, the Stone Age camp, the Viking market, the 19th century farm cottages' as well as a variety of animals such as wild boars, aurochs, sheep and goats. Experiments, demonstrations, workshops and activities for the public including families and education groups are organised.

The Anglo-Saxon village at West Stow in Suffolk, UK, was fully excavated between 1965 and 1972. The excavations revealed nearly 80 buildings dated from about 420 to 650 AD (West 1985). Some of the archaeologists who worked on the excavations experimented with Anglo-Saxon construction techniques and from the mid-1970s began to open the site to the public (Crowthers 2008). It is now set in a country park with eight buildings (see Fig. 2.7), a museum and interpretation centre, on-going experimental work, demonstrations and events open to the public (West Stow 2010).

Butser Ancient Farm, Hampshire, UK, started as an experimental centre in 1972 with Iron Age specialist Peter Reynolds as its first director (Reynolds 1979; Reynolds 1999). His work on grain storage pits and the construction of wooden and daub houses has progressed our understanding of the period enormously.

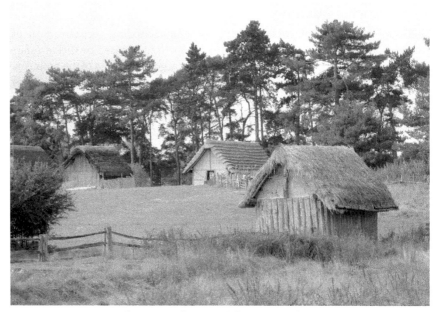

Fig. 2.7 West Stow Anglo-Saxon Village, Suffolk. A view of some of the reconstructed houses on the site of the original village.

Experiments were also carried out with agricultural practices. The houses were based on a number of excavated examples and the farm is now part of the county council's Queen Elizabeth Country Park. A wing of a Roman villa has now been added to the buildings at Butser, funded by the Discovery Channel (Gallica 2010).

Reconstructions often form part of displays in museums or in archaeological parks (Colomer 2002) or heritage centres – for example, the gate at Arbeia Roman Fort (see p. 71). The Museum of London (see p. 156) has constructed part of a house in its new medieval gallery. Education projects around reconstructions and experimental archaeology can form part of work in the science curriculum (see pp. 171–2). A few reconstructions and experiments have been created specifically for the educational use of schools and colleges, most notably the Ancient Technology Centre in Cranborne, UK. Keen, who founded the centre, describes how education groups were able to take part in building prehistoric houses – for example, at a place which provided 'a learning environment in which children can explore in a practical way the means by which human beings from the earliest times have discovered how to survive' and 'provide a resource to facilitate an integrated approach to humanities, science, environmental studies and technology' (Keen 1999, 232–3).

Jones shows how the Jorvik Viking Centre grew out of excavations in York and its offshoot, DIG (formerly called the Archaeological Resource Centre), was specifically set up to be 'accessible and interesting to visitors of all ages and backgrounds' and its visitor figures show that visits by children, either in family or education groups far outnumber adult visitors (Jones 1999, 261 and 267; DIG 2010). Mytum (2000a) shows how the reconstructions at the Iron Age site of Castell Henllys in Pembrokeshire and the Museum of Welsh Life at St Fagans, Cardiff, are used as resources for schools as part of Welsh National Curriculum history studies.

Events: recreating the past ... exactly as it was?

If there are arguments about whether it is possible to recreate a drawing or a structure from incomplete archaeological evidence, or even whether it should be attempted at all, then there is real controversy surrounding events at historic monuments and houses. Most managed historic sites and museums have an events programme. It helps fulfil the requirements to reach out to the public, to educate and, usually, to raise revenue. Events, though, are not new: General Pitt-Rivers held events at the Larmer Grounds (see p. 80) and St Augustine's Abbey in Canterbury hosted a concert, dancing and fireworks in the summer of 1836 (Scoffham 1988, 23).

Events come in all shapes and sizes and, unfortunately, are carried out with varying degrees of authenticity (Sansom 2000, 131; Appleby 2005), starting with pageants and tableaux (see Fig. 2.8). Historic sites and museums arrange a number of events in their yearly programmes for a wide range of visitors which might be lectures, discussions, debates and workshops for the public and education groups; storytelling and theatre for families, children and education groups (Maddern 1992; Bridal 2004); living history and re-enactments of battles, for public entertainment and education groups (Wallace 2007).

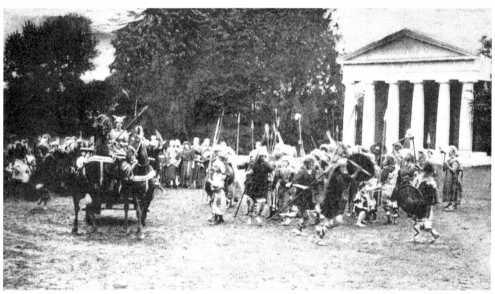

Fig. 2.8 A contemporary postcard of the Colchester Pageant created in June 1909. It told the story of the history of Colchester in six specially written plays, with music, each three hours long. 3,000 people attended the plays.

'Re-enactment' is the term most often used 'to cover a wide range of activities, to include the restaging of battles, military displays, everyday life through the ages, living history encampments and scenarios, and entertainments' (Giles 2010). There are now large numbers of re-enactment groups, in particular in Britain and the USA. Photographs and film of them at events are often used in books and television documentaries, as well as in site guidebooks and interpretation in museums and at historic sites. Giles explains that:

Many years after the American Civil war of 1861–65, camps and gentle 're-enactments' were organised for the veterans of both sides, who would take part together without any animosity towards their once deadly enemies. These continued until the old soldiers had faded away and become part of the history they had made. (Giles 2010, 2–3)

Britain's first re-enactment group, The Sealed Knot, was formed in 1967; its members still stage English Civil War events. The mid-1980s saw a fast rise in these historic events in Britain, partly because English Heritage employed Howard Giles, already an experienced re-enactor, as one of its presentation officers (later called interpretation officers). He staged the organisation's first on-site events in 1985 and in 1987 set up English Heritage's Special Events Unit (Griffin and Giles 1994). Events are still staged at many of its sites.

Anything presented to the public at historic sites will reflect the values of the organisation which cares for the site. This must apply to information the visitor receives in a guidebook, an interpretation panel, a family workshop activity, an audio (or otherwise) guided tour and re-enactments and events. Research has showed that heritage tourists identified a number of experiences which made their visits 'enjoyable and satisfying' including that the 'attraction must have its integrity and authenticity maintained' (Timothy and Boyd 2003, 172).

Outsites

A relatively new phenomenon for archaeologists and museums are the number of outsites which are now appearing. 'Outsites' is the name now most often used to mean displays of archaeological work, usually with objects, normally at or near their place of discovery. A variety of venues have been used – from shopping malls to metro stations and airports. (The Rijksmuseum has a satellite gallery at Schiphol Airport.) At the Clacket Lane service station on the M25 motorway around London the Surrey County Archaeological Unit has set up information about excavations in advance of the service station's construction with some of the finds on display (see Fig. 2.9). An example of more extensive displays of archaeological discoveries can be found in an underground carpark in Worden, Holland (see Fig. 2.10). Keily (2008) has made a study of them in London in particular, but has listed others. Metro stations driven through and under historic centres will almost inevitably reveal past occupation and, as well as Athens, there are examples in Amsterdam, Lyon, Mexico City, Naples, Paris, Porto, Prague, Rome, and Vienna, with others planned for Istanbul, Sofia and Thessaloniki (Keily 2008, 34, quoting Rohde 2007; Haack 2008).

Several Athens Metro stations (see Fig. 2.11), as well as the new railway station at Corinth, have archaeological displays (opened in 2000 and 2005). The Athens International Airport (AIA) has a permanent display (opened in 2003) of archaeological finds, plans and models from excavations conducted on the site of the new airport at Spata (AIA and Hellenic Ministry of Transport and Communications 2003; AIA 2010). This small museum had about 260,000 visitors in 2008, of its 16.5 million passengers (AIA 2009, 31).

I found few people actually looking at the outsites which I am familiar with in London, on the M25 or in Athens. Perhaps we need to do more than just put them up and forget them. The researcher of London outsites (Keily 2008, 37)

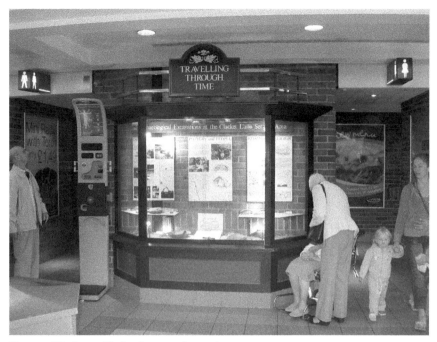

Fig. 2.9 Display at Clacket Lane service station

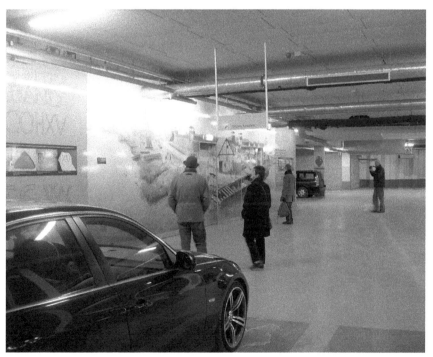

Fig. 2.10 Woerden, Holland. Large-scale excavations ahead of a new shopping precinct in the centre of the town revealed part of a Roman quay and a sunken barge which had been carrying building materials. Information and some finds have now been displayed on two floors of the underground car park for shoppers.

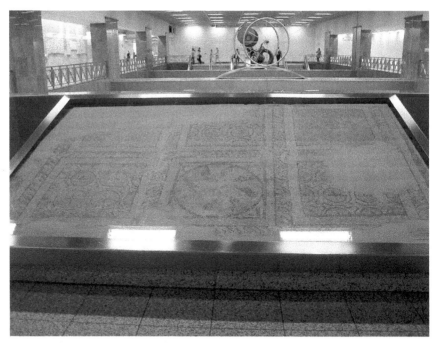

Fig. 2.11 The most extensive displays are at Syntagma metro station in Athens, which has remains *in situ* and displays of objects with information for visitors.

Fig. 2.12 Liverpool Street Station, London. Some might argue that the location of this sensitive memorial is not ideal, placed as it is just at the entrance to a McDonalds with its often litter-strewn environment, but perhaps these are just the travellers we should be targeting?

commented on an art installation with objects (delftware tiles and a medieval pot) set into the pavement at Bishop's Square, in Spitalfields: 'Lunchtime in the city, but does she notice or know about the archaeological find set in the pavement at her feet?' The one which I enjoyed most was the Kindertransport display outside Liverpool Street station in London. The original display was a moving memorial to the Jewish children who travelled to safety in Britain (Association of Jewish Refugees 2010). However, the original material in the cases was considered to have been displayed in insecure and environmentally damaging conditions. The cases were removed and a new sculpture created (see Fig. 2.12).

Education and interpretation

A visit to an historic site will display a variety of interpretative techniques which may be used as a basic resource for investigation by education groups. Some other examples of curricula links are in the chapter on p. 153–4. The areas covered below look at the attempts made to inform and educate different groups of visitors and how authentic interpretation should be.

One project might be to base a discussion on various definitions or comments, using those in this section and these below:

> The new vogue for historical re-enactments, not simply battles and sieges which license historicist hooliganism on Bank Holiday weekends, but the urge to recreate aspects of our former lives, from the Iron Age to the iron foundry, is evidence of the persistent fantasy that it is possible to step back into the past. (Hewison 1987, 83)

> There is one issue in interpretation which rarely seems to be regarded as problematic by interpreters: whose interpretation? Whose view of the world are we presenting and re-presenting? Stories are told and relationships are revealed as if they are objectively true, as if there is only one way of understanding an issue, place or event. History is continually being re-presented, re-worked and re-interpreted. (Uzzell 1989c, 43)

> There is no escaping the fact that most heritage sites have been sanitised, and in a sense 'made ready for the visitors' and therefore have created idealised pasts. Heritage providers may run the risk of offending some visitors if they try to make conditions as close to reality as possible in modern times. (Timothy and Boyd 2003, 255)

Education or visitor attraction?

One project might be to analyse how well the site managers present the ruin, house, castle, abbey, historic landscape or working archaeological site to a range of visitors, asking:

▶ Is the presentation overtly 'educational' or is the atmosphere akin to an entertainment venue?

▶ Does the site cater for a range of visitors – for example, educational parties, disabled people, adults arriving in coaches, families or the single interested visitor arriving by bicycle?

▶ Are the facilities adequate for a rural site – lavatories and tearoom?

▶ Is there a shop? Can this be considered part of the site's interpretation strategy or could it simply be located in any high street? Make comparisons, say, between the souvenirs which could be bought by Roman spectators at their games or chariot races and those which visitors today can buy at similar ruined sites. The findings could then be compared to souvenirs bought at a football stadium today or at the club's shop in town.

Many sites have an introductory display, or even a museum, which can set the site in its historical and geographical context. The display will usually include panels and, in addition, there are likely to be panels which are designed to help visitors understand what they are looking at. These may provide the resources for a number of exercises.

▶ Look at the overall design. Does it help or hinder the panel to do its job of providing information?

▶ The text itself can be analysed. Is it easy to read? Is there too much text? Several manuals for professional interpretation designers contain useful examples of what to do and what not to do (Serrell 1996; McManus 2000b; Ravelli 2006).

▶ Are there illustrations (map/plan, artist's impression)? Are they essential to help the visitor understand the site?

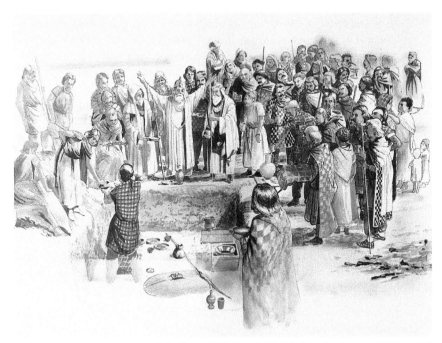

Fig. 2.13 An imagined view of the burial of a warrior buried in the late 1st century BC, excavated at Stanway near Colchester. This impression, created by the artist Peter Froste working with the archaeologist Philip Crummy, uses the excavated evidence from the grave. (Crummy 1993; Crummy et al 2008, 33)

Panel images

Another point to consider is whether the visitor is given the opportunity to question an interpretation or, at least, told that there are varying and perhaps opposing, interpretations or points of view: 'Too often, a crowd only listens to a guide or reads a descriptive panel. Apart from question time, the visitor remains mostly silent' (Garton Smith 1999, 135). One of the interpretation panels at Lullingstone Roman Villa in Kent shows two artists' impressions and asks the visitor to consider the differences based on the different analyses of the excavated evidence. One impression is by Alan Sorrell drawn in 1961 and the other by Peter Dunn nearly 40 years later.

Artists' impressions

In *Primary History: Using the Evidence of the Historic Environment* (Corbishley 1999b, 24–27) I looked at physical reconstruction and an artist's impression using a case study of the 7th-century Lindisfarne Priory, where English Heritage's resident reconstruction artist, Peter Dunn, worked from the remains themselves, documentary evidence, records left by investigators and information and opinions from archaeologists and historians. Rough sketches were gradually refined into a full colour aerial view. Walmsley (1999b) explains the importance of artists' impressions in presenting a view of a monument in the past, in particular adding parts and features now missing, how an artist uses various effects (such as colour or light and shadow) to create a view and whether the view is an aerial one or not. Aerial views are often used for introductory panels and eye-level views for visitors looking at a particular building, feature or room. Perhaps the most important educational point to make from an artist's impression is that the drawing is created from archaeological evidence *and* the interpretation of that evidence (see Fig. 2.13).

Artists' impressions are good to hand to students for work on site without interpretation panels. Walmsley suggests a number of specific activities for younger students, such as:

> On site, your first activity could be to get pupils to find the exact place where the artist made his impression, and then to say:
>
> ◆ What is still there
> ◆ What is only partly there
> ◆ What is missing.
>
> Once pupils have identified the evidence you can ask them to make comparisons between life then and now. Ask:
>
> ◆ What do we have which people in the past did not have?
> ◆ What did people in the past have which we do not have?
> ◆ What do we share with people from the past?
>
> (Walmsley 1999b, 8)

Authenticity

The question of authenticity is raised elsewhere in this book but it is pertinent to any form of interpretation presented to the public and more so to school groups. Those who recreate a building or a drawing of a site always claim accuracy but the levels of authenticity open to debate (Timothy and Boyd 2003, 237–56). The claim of authenticity is often made for events. The first chief executive of English Heritage wrote: 'We have a responsibility to work to the highest standards of scholarship. It is something to which we should aspire whether in living history presentations we commission, the exhibitions we mount or in the popular guides we publish' (Rumble 1989, 27).

Criticism of English Heritage events, from both inside and outside the organisation concerned two main issues. First, the predominance of military events – from Roman to World War II soldiers. Second, the appropriateness of staging events at historic sites where there was no evidence that such activity ever

'Historicist hooliganism on Bank Holiday weekends'

The hand of history weighed lightly on an event I witnessed on Bank Holiday Monday in 2006 at Hedingham Castle in Essex. The 'Jousting Tournaments' were crudely carried out without regard to authenticity with loudspeakers blaring out either *Carmina Burana* or Queen's *We Will Rock You* (probably inspired by the film *A Knight's Tale*), a pageboy being 'punished' in a leather sack dragged behind a knight's horse and a jester who warmed up the crowd by making animals out of balloons (see Fig. 2.14). The commentary was often, how can we say?, inappropriate for families. But my granddaughters (7 and 4 years) did enjoy the spectacle – I can only hope that they've forgotten it by the time they do the medieval period in school.

Fig. 2.14 Hedingham Castle 2006. A knight spears a football.

took place. For example, the American British Brigade was brought over to Britain by English Heritage in 1987 to fight American Civil War battles at such places as Audley End House in Essex; and the following appears in a tourist leaflet for Kenilworth Castle in 1993: 'Roman Life. Watch as gladiators engage in combat for your entertainment, their fate will rest in your hands, or rather your thumbs! Plus Roman activities for all the family. Not for the faint hearted!' (English Heritage 1993a).

If using real evidence is an important criterion in teaching history, then making fundamental mistakes about a site's history is something that must draw the severest of criticism. But at the very least this could be used as an education project or discussion, contrasting this lack of 'working to the highest standards of scholarship' to investigating the appropriate use of events at other heritage sites and museums, where the events, of all sorts, are clearly linked to collections, displays and the mission of the organisation.

Role-play

Role-play could be used to create dramatic situations in the classroom based on events. An outline of live interpretation used for educational events is given by Robertshaw (2006). You could introduce students to first and third person interpretation.

> A 'first person' interpreter adopts the role of a historically documented or fictional character who lives in the past.
> A 'third person' interpreter function as interpreters of the past rather than representatives of the past. They may dress and act as if they are living in the past but they do not adopt an historic role. (Sansom 2000, 128)

Summary

▶ An essential first step for archaeologists is to define and work out strategies for reaching the public.

▶ There are a number of ways to present the historic environment to the public including printed material, on-site interpretation, physical reconstructions and digital access.

▶ There are a number of interesting examples of archaeological displays in public spaces, such as motorway and metro stations.

▶ Re-enactments are common at ancient monuments and in museums.

▶ The educator may use interpretations as teaching exercises.

Conclusions

There are many examples, given in this chapter, of excellent approaches to access and presentation by heritage organisations, on sites, in museums and in public places. While there is a wide range of different ways of providing intellectual access to the historic environment, some sites and organisations have a long way to go. There are still too many places around the world where the visitor, having arrived at an ancient site, is faced with no interpretation or just a guidebook which has apparently been written by an ancient academic for other ancient academics. Many heritage organisations are reluctant to embrace new technology or, having had a website created for them, do not update their information for visitors. Some websites are incredibly frustrating to navigate: even finding information you know is there can prove impossible. There are too few websites for children who are excited by archaeology and want to find out more. In fact few organisations bother to provide anything for children on their websites, even where they have formal education programmes.

Organisations responsible for preserving, conserving and presenting the remains of the past in their care still find physical reconstructions problematical. Yet, where this has been done with proper research and to high standards (e.g. West Stow Anglo-Saxon Village), they have proved popular with both other archaeologists and, more importantly, with their visitors. Costumed, and, more often than not, armed re-enactors seem now to be ubiquitous on sites and in museums. While some groups take enormous care over the authenticity of dress and behaviour, there are others (see the Hedingham Castle experience above) where they are clearly not overly concerned with authenticity.

The next chapter looks at the dissemination of information about the past through print media, on the television and radio or at the cinema.

3 Archaeology and the Media

> We cannot escape media; it is all around us, permeating the practices through which our intelligibility of the world transpires. We cannot stop this mediation: it has no off switch; it lives and feeds upon our own *necessity* to communicate; we cannot escape media. (Brittain and Clack 2007b, 15)

There can be few working archaeologists, in charge of some aspect of an excavation, field survey or laboratory work across the world, who have not had to deal with the media. While Ascherson (2004, 145) claims that professional archaeologists in Britain are successful at exploiting media opportunities, this *may* apply more to the printed press than other media outlets. It seems to me more difficult to find many archaeologists who have good words to say about the way in which their profession or interest is invariably presented, especially on television or in films. O'Connor (1986, 31) complained that journalists often 'failed to grasp what to an archaeologist may seem a glaringly obvious deduction, and the consequent media report becomes a source of amusement, and embarrassment, not to mention misinformation.' Archaeologists are often equivocal about the exposure the media brings – wanting people to know what they do but often not liking the outcome. Ashworth (2004), reviewing the BBC's *Restoration* series, where support groups presented endangered buildings in need of funds, wrote 'I do not know whether to cheer, laugh or cry, and watching the programmes I did plenty of all three.'

This chapter investigates the way in which the profession of archaeology, as well as stories about the ancient past, is portrayed in print, at the cinema, or transmitted directly to our homes through our televisions and radios. Included in this chapter are surveys of the newspaper coverage of two archaeology projects.

Understanding the media

Archaeologists need to understand the media and media professionals if they want to use them as a means of communicating with the public. Most major archaeological organisations have their own media contacts and some have made specific efforts to help archaeologists cope with the media: the Society for American Archaeology publishes a useful fact sheet for journalists and sample press releases for archaeologists, and Klesert (1998) has written in detail about promoting archaeology in local newspapers in the USA, for example.

A survey carried out in 1999 for the Society for American Archaeologists showed that the public in America learnt about archaeology (Ramos and Duganne 2000, 16–17) from television (56%), magazines (33%) and newspapers (24%), but that 60% of people 'with a high level of interest in archaeology learn about archaeology through television'. Nichols (2006, 38) records that television has a similar ranking in Australia, but that in Canada people find out about archaeology via museums before television. Pokotylo's survey of opinions of first-year undergraduate students aged 25 or under who were taking an 'Introduction to Anthropological Archaeology' at the University of British Columbia showed that the students had: 'a less accurate idea of what archaeology is and are three times more likely than the general public to hold a romantic perspective of the discipline

– Indiana Jones (and/or Lara Croft) is alive and well in the minds of nearly one in every 10 students surveyed!' (2007, 18).

A more recent survey investigated viewers of 162 heritage programmes on 25 television channels in Britain over a 12-month period. The survey showed that 98% of adults saw at least one heritage programme and 20% saw at least 99 programmes during the year and that 37% of adult viewers choose to watch documentaries about history (Piccini and Henson 2006, 4 and 11). However, the 'heritage' programmes included programmes about antiques/junk selling and valuation (from *Antiques Roadshow* to *Flog It!*). The archaeological programmes in the survey ranged from *Egypt* to *Time Team* (see below). Holtorf discusses other surveys which attempt to record people's attitudes to archaeology and archaeology on television (2007a, 51–61).

Magazines

Information about archaeology may be found in two types of magazine. One consists of magazines produced commercially which are about or include archaeology and history. The *Illustrated London News*, from its foundation in 1842, published well-researched articles about major archaeological discoveries from around the world (noted in Peters 1981, 200). *National Geographic Magazine*, from 1888, also specialised in great archaeological sites and discoveries. Gero and Root (1994) have critically analysed the magazine's coverage of archaeology and some have found it presents too glamorous a picture of our pasts. However, the well-illustrated and in-depth articles, often with artists' impressions, whose subjects or events were not commissioned by archaeological organisations or publishers, have been a useful resource for teachers.

The other type of magazine is produced, in a number of countries, by archaeologists or archaeological organisations, specifically to promote archaeology to the general public and archaeologists. The publishers of magazines such as these hope to sell them on the news-stands as well as by subscription but they are not always successful.

In Britain there have been several attempts to provide popular magazines on archaeology. *Popular Archaeology* was first published in the early 1980s with the archaeologist Professor Barri Jones as editor. It was renamed *Archaeology Today* but folded at the end of the 1980s. Neither magazine reached the shelves of newsagents. One that has survived is *Current Archaeology* (published since 1967) and the more recent addition of *Current World Archaeology*. Both are available only on subscription. The Council for British Archaeology publishes its own magazine, *British Archaeology,* which is available at some newsagents. According to the editor of *British Archaeology*, both his magazine and *Current Archaeology* each have (unaudited) circulation figures of about 20,000 (Pitts 2010). The members of the main British heritage organisations are introduced to archaeology through their own magazines. Based in Scotland, *Past Horizons* is a web-based archaeological magazine which calls itself the 'Online Journal of Volunteer Archaeology and Training' and has articles from Britain and across the world about excavations, fieldwork and key sites. It has comment pages and a recipe in each issue and, because it is on line, articles can be linked with other digital content – for example, a video link to the Bamburgh Research Project in the May 2009 issue (Past Horizons 2009).

Newspapers

Articles and short notes about archaeology often appear in local, regional and national newspapers and internet-accessed news bulletins. Archaeologists are quick to criticise journalists – for example, see Ascherson 2004, 148–50. Pitt-Rivers, in an address to the Archaeological Institute in Dorchester in 1897 said: 'If ever a time should come when our illustrated newspapers take to recording interesting and sensible things, a new era will have arrived in the usefulness of these journals' (quoted in Wheeler 1956, 218).

Although journalists and newspaper owners, in the main, treat archaeology and heritage issues in a serious way in the examples given below, it is worth remembering that journalists are looking for a 'story' or an 'angle' which in some newspapers is soon translated into 'the oldest', 'the unique' or 'the spectacular'. Stories will often reflect a real pride in a country's or a region's past and the issues of illicit looting and the trade in antiquities are covered in many newspapers. Benz and Liedmeier surveyed in detail the reporting of archaeology in German newspapers between 2000 and 2004 and found that, although 'print media interest in archaeology is high', '... readers are thought to be interested not so much in the hard facts of archaeological science as in sensational discoveries – the glitter, glamour, and power of ancient civilisations' (Benz and Liedmeier 2007, 171).

Holtorf writes that newspaper reports 'do not predominately educate about the past but celebrate the work of archaeologists mainly in terms of clue-hunting, discoveries, mysteries and revelations' (2007a, 50).

My review of online reporting, from November 2006 to January 2007, listed on the website of *Archaeologica* (2010) showed four main categories of stories (see Table 3.1).

News of excavations at Stonehenge were released by the National Geographic Society, the principal funders. The story about the discovery of a builders' settlement and their 'feasts and rituals' was picked up in the USA by eight national newspapers and five broadcasting organisations, in the UK by six national newspapers and the BBC. All the stories were reported seriously with the exception of the UK's *The Sun* whose headline was 'UGG A DO-DO-DO: Stonehenge builders had massive parties, dig reveals' (Wells 2007). Pitts looked at the effect the Stonehenge excavation had on search patterns on Google Trends (Google 2010) showing distinctive activity associated with activity by the National Geographic Society in the form of press releases, the trailing of a television film and a cover story in its magazine (Pitts 2008, 13).

Local papers will usually cover excavations and, sometimes, fieldwork – for example, *Hackney Gazette*, London: 'Museum experts to lead dig in the park' (Anon 2005).

But in both local and national papers in Britain the stories tend to fall into these categories: *significant discoveries*, such as 'Holy Land's "oldest church" found at Armageddon' (McGreal 2005); *quirky stories*, such as Roman soldiers' clothes: 'They came, they saw, they wore socks with sandals' (Ward 2005); *conservation concerns*, such as walkers erode World Heritage Site: 'New enemy menaces Hadrian's Wall' (Alberge 2005); and *World Heritage Site concerns*, such as 'The curse of Stonehenge will remain until it is handed back to the Druids' (headline); 'This world heritage site is a national disgrace. Consultants

Table 3.1 Review of news stories from *Archaeologica*, November 2006 to January 2007

Articles	Examples
Monuments and heritage	'Cuba: World and National Heritage in Sancti Spiritus', *Escambray*, Cuba, 09/01/2007
	'Vikings to invade Ireland' (reconstructed Viking ship to sail from Roskilde to Dublin), *The Copenhagen Post*, Denmark, 18/12/2006
	'Imperial tombs open for research', *The Korea Herald*, 04/01/2007
Looting & illicit trade	'Greece gets UN boost on artifacts', *Katherimini*, Athens, Greece, 05/12/2006
	'Art thieves threaten to erase Mexico's past', *The Guardian*, London, 24/11/2006
	'Swiss forge deal with Peru over stolen goods', *Neue Zürcher Zeitung*, Switzerland, 29/12/2006
	'Repatriation hearings resume over cultural artifacts', *Honolulu Advertiser*, 05/01/2007
Discoveries at home	'Iron Age Scots fur farm clue', *Daily Record*, Scotland, 27/11/2006
	'Bulgaria's year of discoveries: what lies beneath', *Sofia Echo*, Bulgaria, 08/01/2007
	'Iron Age pottery and bronze relics unearthed in Gilan', *Islamic Republic News Agency*, 01/01/2007
	'Archaeologists find cradle of china in north China', *People's Daily*, China, 18/12/2006
	'"India's Pompeii" discovered', *Hindustan Times*, India, 09/12/2006
	'Ancient Jewish-Christian settlement found in Mishmar David', *Jerusalem Post*, Israel, 03/12/2006
Discoveries abroad	'Peruvian archaeologists excavate first "tumi" knives from pre-Inca tombs', *International Herald Tribune*, USA, 21/11/2006
	'Gallipoli sub to be studied', *The Australian*, 06/11/2006
	'Humble brass was even better than gold to a 16th-century tribe in Cuba', *New York Times*, 16/01/2007

have made millions but achieved nothing in 20 years' (sub-heading) (Jenkins 2006).

Some British 'broadsheet' or 'quality' newspapers raise concerns about national monuments on a regular basis. *The Guardian* covers archaeology and heritage issues but also other environmental issues such as global warming, waste disposal and other societal issues such as social care issues and poverty. It has devoted a large amount of space to the war in Iraq generally and has reported on the destruction of parts of Babylon by military camp building, vandalism and looting. *The Guardian*'s edition of 15 January 2005 covered these events in 210 column inches with main reports ('Months of war that ruined centuries of history' (2005a) and 'Babylon wrecked by war: US-led forces leave a trail of destruction

and contamination in architectural site of world importance' (2005b)), comments ('Cultural vandalism' (2005c) and 'American graffiti' (2005d)) and readers' letters (America's destruction of Babylon).

Ascherson (2004, 149 and 151) gives two examples, from a regional and a national newspaper, of the treatment of archaeological discoveries in Britain. The headline of one was 'Cradle of civilisation is found in Flixton' from the *Yorkshire Evening News* (11 May 1998) about the discovery of 'stone age sophisticates'; the other was a story in the *Daily Mail* (21 January 1997) about the chance find of a Roman statue and headlined 'Roar for a lion after 1,600 years in mud'. Karol Kulik studied the British press coverage of the 1998 find of fossil remains at Sterkfontein in South Africa. She found that eight out of the ten national newspapers she researched found the story worth covering (Kulik 2007). Two other case studies are outlined below.

Under the sludge

Archaeologists often collect press cuttings of their own sites but the results are rarely published. Lesley and Roy Adkins excavated Beddington Roman Villa between 1981 and 1983 and in their popular booklet *Under the Sludge* included a review of press coverage in their first chapter entitled 'Bawdy Scenes'. They listed the local and trade publications which reported the rescue excavations they carried out at Beddington Sewage Works, but wrote: 'Publicity, though, is a two-edged sword that cuts both ways; it can attract help, but it can also attract vandalism. This possibility was not diminished by the local newspapers' fixation with "treasure" – a word used to describe just about anything except actual treasure' (Adkins 1986, 17). Journalists used these words and phrases to describe their excavations: treasures, treasure-trove, buried treasure, the treasure of time; civilisation; property hunt and the site was even hailed as: 'Up Pompeii in Beddington: Bawdy scenes like those in "I Claudius", "Up Pompeii" and "Caligula" could probably be seen on our doorstep – in Beddington' (*Sutton Borough News* 3 September 1982 quoted in Adkins 1986, 20).

But there is an appreciation of the archaeologist as past detective as this quote shows:

> *It's really amazing – you've got to admire those archaeologists!*

> Show them a piece of broken rock and it's part of an elaborate Roman mosaic. Show them a piece of worn pottery and it's the rim of a centurion's favourite cup. You suspect, such is their level of professional expertise, they could even name the dog whose 1,500 year old jawbone they might find on some deserted excavation [reference to a headless dog they excavated]. (*Wallington and Carshalton Advertiser* 28 January 1982, quoted in Adkins 1986, 19)

I have analysed the newspaper cuttings for this project which I was engaged in.

The Suffolk Garbology Project

Suffolk County Council's Garbology Project (see case study p. 304) began in January 2005 as a joint project between the county's Archaeological Service and the Waste Management Service with the aim of pioneering the use of rubbish

from recent centuries in Suffolk as a heritage and environmental awareness learning resource. The year-long project was funded by the Heritage Lottery Fund and the Waste Management Service. A former primary school head from Suffolk was employed, within the Archaeological Service, as the Garbology Officer, the first in the country.

Encouraged by one of its archaeological staff, the local council issued a press release about this new project and were surprised, not always pleasantly, by the response (Table 3.2).

The Garbology Project staff built on the good relations with regional and local press which had previously covered archaeological discoveries and heritage issues on a regular basis (Table 3.3).

This good local press coverage proved useful in convincing county councillors of the benefits of archaeological and waste management education projects and the Garbology Project was extended beyond its original timescale.

Newspaper reports of archaeological discoveries and issues may be used in educational programmes – in particular in citizenship or media studies and, as examples of the use or misuse of English, literacy.

Table 3.2 National and regional news coverage of the Garbology Project job

	Headline & Quotations	Assessment
The Guardian, 12/11/2004	*Dirty work £23k job in rubbish studies* 'Where there's muck there's lessons to be learned ... School trips to landfills have been ruled out, but the children will conduct soil-sieving experiments and study retrieved objects ... There are important lessons you can learn about now by looking in the past.'	Reporter read the press release and job description carefully and carried out interviews. Slightly tongue in the cheek tone but a comprehensive report of what the project proposed.
Daily Telegraph, 12/11/2004	*Rubbish job* [entire article]: 'Suffolk county council is advertising for a £500-a-week "garbologist" to teach children about the history of waste disposal over 2,000 years.'	Just a filler note but the tone suggests it is a bit of a waste to spend £500 a week on the project.
Daily Express, 12/11/2004	*Rubbish! Council is spending £30,000 on a 'garbologist'* 'The bizarrely-titled official will be paid £23,313 to look for interesting "archaeological" facts in waste from the 1950s or earlier ... But Shadow Culture Secretary, John Whittingdale criticised the latest in a long line of barmy National Lottery funded projects ... Suffolk County Council said it was delighted to grab the Lottery's cash, which at least protects Council Tax payers from being hit in the pocket ... A spokesperson for the Heritage Lottery	Article used an example of what they clearly saw as a 'barmy' project to attack the government and one of its agencies. The comments quoted above were interspersed with straightforward statements about the value of the project issued by Suffolk County Council.

	Headline & Quotations	Assessment
	Fund said: "Garbologists are heritage detectives who use the things which people have discarded as clues to how we used to live." ... Other projects paid for by the National Lottery's various funding pots have included £420,000 for Peruvian farmers to help breed fatter guinea pigs for human consumption ... and Scottish prostitutes were awarded £81,533 to fund an advice centre, including aromatherapy massages, for vice girls.'	
East Anglian Daily Times, 11/11/2004	*New council position is a rubbish job. Officer to promote our waste heritage* 'The authority is recruiting a bizarrely-named garbology officer, who will have a slightly less glamorous job working with rubbish ... Yesterday, a spokeswoman for the council said: "It's being funded by the Heritage Lottery Fund, so it's not money that comes from council tax ... It's a more hands-on way for children to learn about history and archaeology but with recycling and environmental issues as well. We are really excited about it."'	Straightforward article which promoted the project as sensible and with useful outcomes.
BBC News online, 11/11/204	*Council seeks expert in rubbish* 'The successful candidate will need to know about rubbish and its effects on society today and in the past ... The officer will visit schools to talk about how our policy to rubbish and waste disposal today will affect future generations.'	Story treated seriously but not in any depth.
Gulf Daily News online, 13/11/2004	*UK council seeks 'garbology officer' A mad, mad world ...* 'We think this is a great opportunity to start looking at archaeology and at the same time deliver an environmental message', said Jezz Meredith, council archaeology project officer ... Thought to be the first such post in the UK, a garbology officer's duties include helping children sift through and sort rubbish.'	Story picked up from UK newspaper or agencies in a section which deals with 'bizarre' stories from around the world.
Australian Broadcasting Corporation online, 13/11/2004	*Council seeks 'Garbology Officer'* 'A UK council is seeking applicants for one of the country's newest and quirkiest jobs – Garbology Officer ... Although the post requires no formal qualifications, Mr Meredith said the cross between archaeology and rubbish merited a formal course of study.'	Almost word for word with the *Gulf Daily News.*

Table 3.3 Local and regional coverage of the Garbology Project.

	Headline & Quotations	Assessment
East Anglian Daily Times, 12/07/2005	*Garbage in, but it's certainly not garbage out!* 'Since his appointment in January, the garbology officer has visited around 1,500 pupils in 20 Suffolk schools raising children's awareness of their own heritage by looking at archaeological artefacts from the distant, and not so distant, past ... Jane Docherty is headteacher at Hollesley Primary, "Duncan got the children involved and interested. They were all totally engrossed in what they were doing, even the children that sometimes struggle academically. It's been tremendous. They have all learnt so much." So far, Suffolk's headline-grabbing garbology project has been well-received.'	Well researched, sensible and supportive article with large photos and 30 column inches of text.
East Anglian Daily Times, 21/09/2005	*Children unearth the recent past* 'Children unearthed secrets of the past as they took part in an archaeological dig on a field near the A12 bypass at Saxmundham ... Finds included bottles, a plastic mini van, a shoe thought to date back to the 1950s, and a leather bottle holder with the bottle inside. Children made clay models of footwear inspired by their shoe find.'	Follow-up article to the EADT 21/07/2005 for local interest in another part of Suffolk.
Times Educational Supplement, 28/10/05	*All muck in* '"Garbology" may be an ugly word, but it represents a step forward in the teaching of history. It's about learning from primary sources, using rubbish from the recent past to help to explore their heritage. It raises questions about conservation, recycling, and the disposal of rubbish. It offers children to interpret evidence.'	TES is in every school staff room in the country so this an important vehicle for promoting the project.
Archaeological coverage	Articles written by the project for *Council for British Archaeology, East Anglian Region Newsletter (Issue 2 Autumn 2005)* and *Rescue News (Autumn 2005)*.	

Archaeology in the cinema

The cinema, and television, are both powerful media for portraying the past. Wyke examination of favourite Hollywood subjects (Spartacus, Cleopatra, Nero and Pompeii) concluded that 'Cinema can offer a visual archaeology of the past, and, moreover, bring it to a vivid life before the eyes of its fascinated spectators' (Wyke 1997, 192).

There are two major pieces of published research into the presence of archaeology in cinema films: Day (1997) reviewed 127 films from 1912 to 1994; Membury (2002) reviewed over 100 films from the 1920s to 2000. Their general conclusions were that the majority are concerned with ancient Egypt, in particular mummies, what Day (1997, 43) calls 'The abiding magnetism as a movie setting' – for example, *The Mummy* (1932). They are largely adventure stories with archaeologists looking for 'treasure', tombs of the famous or historically important ruins of ancient civilisations – for example, *Raiders of the Lost Ark* (1981). Archaeologists are drawn as specific types, partly based on the period of the film – for example *The Tomb* (1986) – and that almost none bear any close resemblance to real archaeology.

Screen archaeologists have been male, apart from Lara Croft in the *Tomb Raider* computer games and films (from 1996) and the Egyptologist Evelyn Carnahan in *The Mummy* (1999) and later, when married to the hero, becoming Evelyn Carnahan O'Connell in *The Mummy Returns* (2001). Some of these conclusions were also reached in research about archaeology on television (see below). Other authors, as well, have looked at the question of authenticity and the ways in which film fiction is presented as film fact and influences what the public think of as archaeology and history. Watson, writing about *Braveheart,* complained that 'its creators were not worried about mere historical fact getting in its way' and 'The more distant past is regarded as fair game by both film-makers and the public because, so it is believed, we don't really know what happened anyway' (Watson 1998, 131, 137). James, writing about *Ben Hur*, demonstrates that the practice of chaining slaves in galleys did not exist in the Roman Empire, but that the modern portrayals seemed to have originated with Lew Wallace's 1880 novel, *Ben-Hur, a Tale of Christ* (James 2001).

There is also the question of national sensitivities concerning films. Oliver Stone's epic *Alexander* caused offence to many Greek people on its release in 2004. *The Guardian* reported (Smith 2004) that the Greeks were considering suing Warner Brothers for portraying Alexander as gay, demanding that the film-makers issue a statement that the film is based on fiction.

In the eyes of many people across the world, Indiana Jones, more than any other movie character, is synonymous with what it is to be an archaeologist. Archaeologists are always hoping to correct this view, although it is often a useful starting point for discussion in school classrooms and in university seminars.

Forget the bull whip

It might have got Indiana Jones out of a scrape or two, but then Indiana Jones has little if anything to do with real archaeology. Excavators these days are far more likely to be armed with a theodolite and laptop than a whip and pistol, so if you are working on the assumption that archaeology equals glamour you're going to be sorely disappointed. (Sussman 2006)

Archaeology on the radio

Today we assume that there will be some coverage of archaeology on radio
and television, both in the news and as documentary programmes. In Britain
a number of archaeological communication initiatives can be traced to the
1940s. A conference was held in London in 1943 to 'provide an opportunity for
the discussion of a number of problems connected with post-war archaeology'
(Institute of Archaeology 1943, 4). The question of promoting archaeology to
schools through radio was raised by a primary school teacher and archaeologist,
Mrs Dina Dobson:

> Perhaps the most important method of presenting archaeological
> information is by school broadcasts. Two years ago [1941] a new series of
> lessons on the subject was started, and dealt with the geological evolution
> of the earth and its creatures up to the appearance of man, with prehistory,
> and then with the ancient civilisations. The broadcasts took the form of
> talks between the curator of a museum and two children who asked him
> questions. On each occasion a B.B.C. observer was asked to go back into
> the past and describe what he saw. In every case care was taken to answer
> the question: 'How do we know?' Explanations were given to show how the
> archaeologist had obtained his evidence and how he had used it to make
> the past tell its story. Over 1,000 schools now listen to these broadcasts. In
> many places local museums and libraries co-operate by putting on show
> suitable exhibits and books. In some ways broadcasting has proved itself to
> be the most hopeful method for teaching archaeology in elementary schools.
>
> (1943, 85)

Archaeology on radio, 1946–2010

▶ 1946: Glyn Daniel launched a radio programme called *The Archaeologist* on
Sunday evenings on the Third Programme. Fifteen-minute talks were given by
archaeologists such as Mortimer Wheeler, Graham Clarke and Gordon Childe.
The programme series lasted for nearly 50 years.

▶ 1967: a new radio series called *Archaeologists on Site* had on-site recording of
archaeologists at work.

▶ 1968: *The Changing Past* was a magazine programme, with new discoveries
and scientific techniques. This series plotted the story of Rescue the Trust for
British Archaeology and rescue archaeology through the 1970s.

▶ 1977: *Origins* was launched and covered the world of archaeology with Professor
Barry Cunliffe being a frequent contributor.

BBC Radio programmes about archaeology have continued up to the present.
One-off programmes have been broadcast – for example, *A Secret Museum* (about
a new exhibition of erotic wall paintings from Pompeii in 2002), the series *The
Dark Origins of Britain* (about the 'Dark Ages' in 2003) and *Battle for Babylon*
(the damage caused by the US military base in Iraq broadcast in 2006). New
discoveries, controversies or events are often covered in national, regional and local
news bulletins – Festival of British History (formerly National Archaeology Week),
for example (see p. 108). Regional BBC radio stations often have programmes

which promote a local event, such as the series *Getting Involved*, which in 2006 broadcast a piece about Dig Manchester.

Discussion programmes have also included pieces about archaeology. *Woman's Hour* has broadcasted several archaeology items – for example, 'How the Romans invented the bikini' in 2006. Melvyn Bragg's popular discussion programme *In our Time* often covers archaeological and historical topics such as 'Archaeology and Imperialism' in 2005. In 2005 Laurie Taylor's series *Thinking Aloud* included a discussion with archaeologists on 'The "New" Archaeology'.

BBC journalists often present archaeological topics, either as one-off programmes or in a series. For example, the seasoned archaeological correspondent Malcolm Billings' 2006 series *Trench Warfare: The Politics of Archaeology* included the programme 'Jerusalem's Volatile Archaeology', and in 2007 he presented a piece called 'Albania's Long-Lost Roman City' in the weekly series *From Our Own Correspondent*. Sue Cook's series *Making History* covered the ethical, archaeological and legal issues of excavating human remains in 2003.

Archaeologists are often commissioned to broadcast or present programmes. Colin Renfrew discussed the connections between art and archaeology in the arts programme *Front Row* in 2005. Julian Richards presented his *Mapping the Town* series from 2005, which looked at the origins of a number of towns across Britain. In 2006 Francis Pryor reported in *The Boy who Bought a Field* on an archaeology graduate who had bought a field which he thought contained the remains of a lost medieval town. A new series, *The Voices who Dug up the Past*, began on BBC Radio 4 in February 2010. These excellent programmes, written and presented by Mike Pitts, an archaeologist and editor of *British Archaeology*, look at such topics as metal detecting, excavating Iron Age forts and Sutton Hoo.

A major new series, also on BBC Radio 4, also began in early 2010. Neil MacGregor, the Director of the British Museum, has written and presented *A History of the World in 100 Objects*, talking about one object in each of the 100 programmes broadcast in during January, May and September 2010. The story began with a chopping tool made in Olduvai Gorge 1.8–2 million years ago, to a solar-powered lamp made in China in 2010. The 15-minute programmes are grouped in particular themes – for example, five objects are chosen to address world history from 2 million to 9000 BC in 'Making Us Human'. MacGregor invited comments from a range of museum curators and archaeologists. He also interviewed people who were able to comment on specific aspects of individual objects – for example, Seamus Heaney, the poet who translated *Beowulf*, on the Sutton Hoo Helmet, and Dame Helena Kennedy, the human rights lawyer, on the Suffragette-Defaced Penny. The series was hugely popular with up to 3.9 million listeners. The series and the book which followed (MacGregor 2010) won acclaim from media critics, archaeologists and museum professionals and, more importantly, with the general public. These radio programmes are linked to the CBBC series called *Relic: Guardians of the Museum*, which follows a group of children who 'unlock the mysteries behind 13 of the objects featured in the series' (CBBC 2010). The series has links with a number of other museums and provides more information and links on the BBC website (see p. 17).

Archaeology on television

But it was television which has had the most impact on the public in Britain. An American show called *What in the World?*, which was first broadcast in 1951, was on air for 14 years. Museum objects were presented to a panel of experts who had never seen them before and were asked to identify them and assign a period and location to them. In 1952 it won the Peabody Award for 'a superb blending of the academic and the entertaining'. British television copied this programme with *Animal, Vegetable, Mineral?*, which was launched in 1952 by the producer Paul Johnstone, with Glyn Daniel in the chair (Jordan 1981). Sir Mortimer Wheeler was voted British TV Personality of the Year in 1954. There was also, from 1959, a programme called *Buried Treasure* which featured Daniel and Wheeler.

These earliest television programmes showed that archaeology had to be entertaining as well as factual – Norman (1983, 27) wrote that he called his programme, *Chronicle*, a show because 'we are in the entertainment business – not the archaeology business', a point still not fully understood by archaeologists even today (see below).

In 1966 the first controller of BBC2, David Attenborough, commissioned the series *Chronicle*. It was hugely influential in providing good quality, authoritative and exciting documentaries on a range of archaeological subjects under its editor, Bruce Norman. *Chronicle* came to an end in 1991, after his death. Some *Chronicle* programmes from 1966–79, including the new excavations into Silbury Hill, shown in 1968 (see Fig. 3.1), are now available on BBC Archive (BBC 2010b). Bruce Norman was also an editor on *Horizon* which is still being broadcast and producing some archaeological films (Norman 1983).

1977 saw the broadcasting of a programme which is still remembered, and disliked, by some archaeologists. *Iron Age Village* was an attempt to re-enact living in the past (in a re-created Iron Age settlement) and see if people could survive it in 1977. Many archaeologists found the villagers' attempts pathetic and felt that they could have done much better. They probably could have, but then they ought to have known the right thing to do as it was based on excavations and the interpretation of evidence. Peter Fowler wrote:

> 'Iron Age Village'. Built in 1977, destroyed in 1978, its meteoric three-dimensional life attempted a sort of past with really living-in, live people, here today, gone tomorrow. Whatever the producer's ambitions, the BBC was primarily interested in good television, and indeed the nation watched as its naïve contemporaries struggled and floundered and generally made meal of reinventing the wheel. The interest was human rather than archaeological; the past was used to provide an unusual setting for an otherwise familiar tale of uncountry folk in unfamiliar circumstances coping with problems and showing true British grit while so doing. (1992, 16–17)

There was the same reaction to the *Castaway* series in 2000, when 36 people tried to survive for a year on Taransay in the Hebrides.

The BBC revived the idea of 'Iron Age Village' in 2000 with a programme called 'Surviving the Iron Age'. It was filmed at the reconstructed Iron Age village of Castell Henllys (Castell Henllys 2010). The programme was less an attempt to carry out genuine archaeological experiments than a vehicle to present a 'Big Brother' house set in the past. Inhabitants seemed to have been chosen to cause

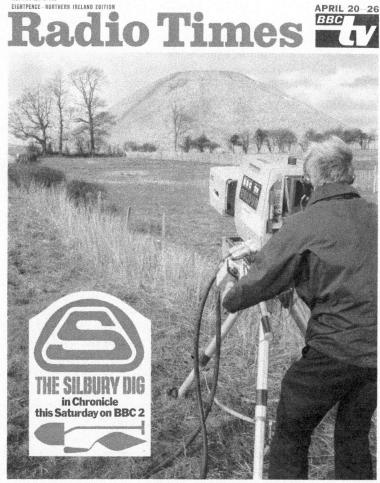

Fig. 3.1 'The Silbury Dig', featured in a 1968 *Radio Times* which listed all BBC television and radio programmes. The *Chronicle* series used outside broadcasts normally reserved for sport and ceremonial occasions.

conflict, were incompetent in practical matters (they undercooked chicken and poisoned themselves) and escaped to the pub on several occasions.

In 1981 Michael Wood first came to British screens with the BBC's *In Search of...* series, with his programme on the Dark Ages and followed it up by several others. His programmes were hugely popular and attracted fan clubs of young archaeologists at universities in the UK.

When Channel 4 started broadcasting, it felt that archaeological programmes were important and has commissioned a number of archaeological programmes ever since. It broadcast *Blood of the British*, a history of the British Isles from the ice age to the Norman conquest in 1984. Its presenter, archaeologist Catherine

Hills, also appeared in Channel 4's magazine programme *Down to Earth*, which lasted from 1990 to 1992. This was the year when a pilot for *Time Team* was made, following a programme by archaeologist Mick Aston called *Time Signs*. *Time Team* programmes were first made in 1993 and broadcast from 1994 onwards on Channel 4. It was this programme which made the change from simply filming archaeological discoveries, new ideas and techniques to creating the archaeological excavation to be filmed. It fits in well with other DIY-type/makeover programmes which, some claim, followed *Time Team* (West 2004, 117).

The BBC tried to hit back against the popular *Time Team* with its own *House Detectives*, but it never reached anything like the other's viewing figures. It was successful with a new show in 1998 called *Meet the Ancestors*, starring the archaeologist Julian Richards. West (2004) has outlined and discussed other archaeology programmes on television in the UK.

The BBC's series *Coast* investigates the landscape and the remains of the past around the coast of the UK, with some forages abroad. Since 2005 Neil Oliver has led a team of three people with various backgrounds in archaeology, one zoologist and one historical geographer in presenting a hugely popular 'hybrid magazine-travel-documentary' (Bailey 2009, 52). The series is co-produced by the Open University which provides a wealth of background information and links on its website and in free booklets (Open University 2010a).

Seven Ages of Britain is also a joint BBC/Open University production scheduled to coincide with the launch of *A History of the World in 100 Objects* on the radio. It is presented by David Dimbleby and he 'charts a landmark history of Britain's greatest art and artefacts over 2000 years' (Open University 2010b). Unfortunately the chart begins with the Romans whom Dimbleby described in the first programme as 'bringing order to the barbarian chaos of the British Isles' (see p. 143). How can such a short phrase contain so many misunderstandings about our prehistoric past? The programmes are a rush through history – for example, Romans to 1066, with two sites per period.

The only long-lasting survey of archaeology programmes on British television was carried out in 2005–6 for the Council for British Archaeology. This survey (Piccini and Henson 2006) reported that on the five terrestrial channels for 2003 there were 498 hours on history, but that there were:

> 185 hours on archaeology and ancient history, and
>
> 90 hours on heritage issues, in
>
> 41 original series
>
> 21 repeated series
>
> 24 new single programmes
>
> 5 repeat single programmes.

Nichols (2006) carried out a detailed survey of archaeology documentaries on Australian television, sampling 24 programmes broadcast in the second half of 2003, and concluding that people's perception of archaeology was that it was concerned with discoveries abroad (mainly Classical and Egyptian civilisations) and that it was synonymous with excavation. Schadla-Hall and Morris (2003) have assessed the impact of a continuing fascination with Ancient Egypt on television (and computer games) in the UK.

Archaeologists can find out about and read reviews of TV programmes about archaeology in magazines, such as *British Archaeology*, or online for American programmes (Archaeological Institute of America 2010).

Entertainment or education

'The purpose of television history is to entertain, educate and excite. If it can throw some intelligent light on the past through an engaging narrative while encouraging viewers to think more deeply about the subject, it's doing its job' (Hunt 2003).

Educating through entertainment is something that Henson (2006) commends and rightly points out that exciting programmes, albeit about 'great civilisations', will command huge viewing figures (*Pompeii – The Last Day*, shown in 2003 had nearly 10 million viewers).

The overriding problem, at least for archaeologists, is that they generally expect current archaeological programmes to be 'educational' and that what most archaeologists mean by this is that programmes present a true picture of how archaeologists work and an accurate account of their findings and introduce viewers to the issues which confront society in respect of, for example, the destruction of evidence without recording and the long-term future of national and international sites. The programmes encourage the public to take an interest in archaeology, whether in the field, the museum or through literature and websites and that they will produce a better informed public who will, at the least, speak up for archaeology.

Unreasonable as these views may be, we still expect television programme commissioners and makers to consult archaeologists at every stage. But, while the UK has no true public service broadcasters, television companies need to provide programmes which they can sell, both to their viewers and to their sponsors (advertisers, individual programme sponsors or government subsidisers).

Other interest groups portrayed on television soap operas, reality or make-over shows – for example, police, spies, soldiers, lawyers and judges, nurses and doctors, vets, gardeners and cooks – tend not to complain in their professional journals as archaeologists do. However, documentaries about the work done by professional groups sometimes cause public comment and raised eyebrows.

Here social workers were interviewed for *The Guardian*'s Society supplement, after watching the first two episodes of the fly on the wall documentary series, *Someone To Watch Over You*, which was broadcast on BBC1. Contrary to the view that social workers are simply child snatchers, the programme shows the complexity and challenges of working with damaged individuals and families, demonstrates that social workers are human, and captures the hostility that many encounter. However, by focusing on a children and families team, the programme explored only one area of social work. Resource implications were acknowledged in terms of the impact of staff shortages. Yet the stories appeared as stand-alone dramas, and perhaps it would have been more realistic to show the swaths of paperwork, telephone calls and meetings that provide the stressful backdrop to casework (Benjamin 2004).

Yes, but paperwork, telephone calls and meetings do not make for exciting television shows – and shows, as Norman wrote – is what they are. But one television archaeology 'show' did manage to be entertaining and educational

without the drawbacks of either. *Tales from the Green Valley* (Lion TV for BBC Wales), broadcast in 2005, showed archaeologists and historians live out a year on a restored medieval farm. It was as accurate as any good archaeological experiment could be, based on solid archaeological and historical evidence which the participants, in costume but as third-person interpreters, explained to the audience. This programme was popular with viewers (and archaeologists) and further programmes were commissioned – *Victorian Farm*, *Edwardian Farm* and *Victorian Farm Christmas*.

Some television companies and channels choose to merge entertainment with education through humour. The comedian Terry Jones has an enthusiastic interest in history and created an amusing but interesting and educational series called *Terry Jones' Medieval Lives*, broadcast in 2004. On the other hand Vision TV's *The Naked Archaeologist* was embarrassing to watch as he 'brushed away the cobwebs and burst academic bubbles' (as the online press release says) (Vision TV 2010) while mixing belly dancing and fast driving with archaeology of Biblical times.

The producer's search for a programme which can be seen as 'educational' and entertaining often leads to the 'solve-a-mystery' approach. At a time when viewers had been offered a number of documentaries such as *The Domesday Code* (in 2005) and *The Real Da Vinci Code* (in 2006), Channel 4 produced its *Codex* series (in 2006–7). Shot in the British Museum, the show's contestants follow a trail of five objects each week to crack the intellectual activity quiz based on an ancient or historical period such as Mesopotamia. Less concerned with archaeological ethics was the BBC series *Hidden Treasure* which was about objects recovered by treasure hunters. At the beginning of each programme the presenter speaks about the 'serious money to be made' from metal detecting and in the programme called *Cup of Gold* the viewers were asked to wait 'to find out whether it makes Cliff [the treasure hunter] as rich a man as the Bronze Age millionaire who first drank from the Ringlemere Gold Cup'. The answer clearly lies in the £270,000 paid by the British Museum for the 'treasure' from donations (£40,000 from the Friends of the British Museum, £45,000 from the National Art Collections Fund and £185,000 from the Heritage Lottery Fund).

Presenting archaeological programmes

One of the frequent complaints about documentaries on archaeology is the role and the personality of presenters – complaints from television critics and archaeologists. This is a view from the writer Alan Bennett with which many archaeologists would agree:

> The few archaeologists I have come across in life were shy, retiring and mildly eccentric. The archaeologists on television are loud, unprepossessing and extrovert – their loudness and over-enthusiasm to be accounted for, I suppose, by the need to inject some immediacy into a process which, if properly undertaken, is slow, painstaking and, more often than not, dull. Sir Mortimer Wheeler probably started the rot and then there was Glyn Daniel and his bow ties and today it's Tony Robinson [*Time Team* presenter] capering about professing huge excitement because of the uncovering of the (entirely predictable) foundations of a Benedictine priory at Coventry.

His enthusiasm is anything but infectious and almost reconciles one to the
bulldozer. (Bennett 2005, 264–5)

Some English presenter-archaeologists such as Catherine Hills (Channel 4's
Down to Earth and *Blood of the British*), Julian Richards (BBC's *Meet the Ancestors*)
and Francis Pryor (Channel 4's *Britain BC* and *Britain AD*) managed good
reviews by both television and archaeological critics. Others, such as Ptolemy
Dean and Marianne Suhr, the 'experts' in BBC's *Restoration*, annoyed many
audiences and failed to convince them that they were experts at all; Victor
Lewis-Smith, the television critic of the London daily evening paper *The Evening
Standard* complained about 'yet another twenty-something autocutie without
a single thought in their head' compared with experts who didn't present their
personalities before their subjects (Lewis-Smith 2003). Piccini *et al.* (2005, 45)
complained about Simon Thurley presenting his series *Lost Buildings of Britain*
and quoted a television critic of the *Daily Telegraph* who wrote 'you get the
impression that Thurley – a well-spoken chap with sensible shoes and a side-
parting – wouldn't have minded being a TV historian 20 years ago'. Holtorf
writes amusingly about the dress code for archaeologists as television presenters
(2007b).

Reality TV shows and archaeology

In Britain more and more television programmes about archaeology have tried
gimmicks to grab the attention of their audiences. Sometimes this involves setting
up situations which an archaeologist, or group of archaeologists, can tackle.
Extreme Archaeology (broadcast in 2004) has a team of 'experts' led by a caver-
climber-diver which includes one archaeologist. 'Many archaeological locations
are beyond the reach of your average archaeologist' says the series website
(Channel 4 2010) so the team has to go into 'inaccessible' caves, mountains and
under water with 4×4 vehicles, a lot of ropes, special equipment and technology.
The actual archaeological investigations were, thankfully, minimal.

Reality shows have dominated our television screens for years, both in Britain
and in the USA, and often have huge audiences and wide criticism. One new
category of entertainment programme was particularly under attack whoever
produced them – so called 'reality TV' shows such as *Castaway 2000*, *Big Brother*
and *I'm a Celebrity, Get Me Out of Here*, which exploited melodramatic settings,
and which critics considered morally repugnant. Yet they attracted huge audiences,
and the revelations (edited exposures) of the people taking part in them, some of
whom were said to have been left emotionally distressed, fascinated psychologists.
The programmes gave a new connotation to the word 'reality' at a time when
'virtual reality', once so creatively explored, was losing out (Briggs and Burke 2005,
262).

Reality make-over programmes have been popular for several years but are
now dying out on British television. The BBC's *Ground Force* tackled the redesign
and planting of gardens while the owners were away. Alan Bennett wrote:

And there's always a spurious time limit, thus making it another version of
'Ground Force', where a transformation [of a garden] has to be wrought in
the space of three days. The timetable of the Resurrection would just have
suited the programme-makers; the angel appearing to Mary Magdalene in

the garden was probably Alan Titchmarsh [chief TV gardener in 'Ground Force].
 (Bennett 2005, 265)

Reality archaeology in Britain means *Time Team*. The set format involves a small team of archaeologists, led by TV comic actor Tony Robinson, excavating small trenches in large sites against a timetable (Time Team 2010). Many archaeologists have complained about *Time Team*, including Henry Cleere (2000) and see below. James Mower (Institute of Archaeology, University College London) and Mick Aston (University of Bristol and *Time Team* chief archaeologist) argued out their respective views (Mower and Aston 2000). Others support it, claiming that it has won over millions to become dedicated followers of archaeology. Holtorf says that *Time Team* is successful because it combines archaeology as a solver of past mysteries with television personalities (2007a). The programmes are always introduced and led by Tony Robinson, whom British viewers know from playing Baldrick in the historical comedy series, *Blackadder*. Brittain and Clack also discuss *Time Team* in the context of archaeology on television (2007b, 15–18). The *Time Team* production company went on to make a number of *Time Team Specials* which looked in more detail at individual sites and where their team were still involved in a small amount of excavation (see Colchester circus case study p. 63).

When the team decided to launch 'The Big Dig' and get the public to dig 1,000 holes 1 metre square in their back gardens, on wasteland, allotments and school grounds, the project was widely condemned by individual archaeologists and the professional association, the Institute of Field Archaeologists, as a ludicrous way to carry out archaeological research. Alex West wrote:

> At the time it began, Time Team faced harsh criticism from some quarters in the discipline. Academics criticised the way it portrayed archaeology as a treasure hunt against the clock. Some also criticised the way it portrayed archaeologists as slightly eccentric bearded men who loved to run around fields. There were also the ethical issues of digging on scheduled monuments, of curation and publication. For the critics, Time Team did not do 'it' the way it was meant to be done – it demeaned the subject and turned it into a gameshow. Yet it proved to be the most successful archaeological programme ever made. It is one of Channel 4's highest rated factual shows, it has won prestigious awards, and spin off-books and pamphlets have sold out to a loyal following who maintain their interest via unofficial websites.
> (2004, 117)

A 'big' site tackled by *Time Team* was digging at the currently used royal palaces: 23.5 hours of live television dig over the August Bank Holiday weekend in 2006. It got mixed reviews both by archaeologists and critics. Mike Pitts, archaeologist and editor of British Archaeology wrote:

> It should have been dramatic television. Why did it prove such a washout? The Big Royal Dig bit off too much. There was no coherent story to be unravelled, and, perhaps for security reasons, there were none of the detailed maps and plans that usually make sense of everything. (Pitts 2006)

Authenticity

The movies: The question of authenticity is frequently raised by archaeologists and historians about the portrayal of the past in films, television programmes and novels. Recently published research (Schablitsky 2007) counters several Hollywood genres – such as portrayals of 'Wild West' towns and pirates – with documentary and archaeological evidence, usually excavated evidence. One of the contributors to this book, in a chapter on Chinatowns, showed that:

> Chinatowns were not simply, as Hollywood has asserted, lawless and foreign nations with a nation. There is no conclusive evidence for opium dens, tunnels, or brothels at the Market Street Chinatown [in San Jose, California]; however, we know from historical documents, photographs, and similar archaeological work that these places existed.
>
> (Williams and Camp 2007, 217)

But George MacDonald Fraser justifies this by writing:

> Well. Hollywood is not a school for teaching history; its business is making money out of entertainment, and history needs considerable editing and adaptation (which can, in some cases, justifiably be called distortion and falsification) before it is submitted to the paying public. (Fraser 1988, xv)

A controversy raged around Mel Gibson's film about the Mayans, *Apocalypto*, which was released in December 2006. While many critics found the film exciting, most questioned the level and frequency of its gratuitous violence. Fraser (2007, 26) describes the 'Mad Max of the jungle' as a 'disgusting Mayan slasher movie'. Anderson wrote '*Apocalypto* is unquestionably the most reprehensible, brain-dead and offensive movie I've seen all year' (2006). But it was the inaccuracies of Mayan civilisation which offended some movie critics and several archaeologists. Fraser went on to write 'Perhaps he [Gibson] and co-screenwriter Farhad Safinia once conducted some research, but they seem to have discarded it.' Archaeologist critics cited major inaccuracies. Evidence from different periods of Mayan history are conflated into a single period, 'The equivalent, in Britain, of setting one story in a time stretching from the Roman occupation to the death of Queen Elizabeth I, disregarding changes in language, religion and culture' (Graham 2007, 27). Mayans are not recognised as farmers, but live in flimsy huts, while evidence from other periods, peoples and places are used to 'colour' the picture of the Mayans, such as labrets from the Aztecs and nose piercings from Yanomana women (Stone 2007). Finally, the Mayans are portrayed as 'noble savages' in need of Christian conversion – a 'blatantly colonial message that the Maya needed saving because they were rotten at the core' (Ardren 2006).

Although Ardren and Stone are angered by the film's inaccuracies, as well as its violence: 'A gore-fest of the first order ...' (Stone 2007), both seem to accept that because this is a movie and not a documentary there is little to be done – 'When has a period film ever aspired to purity?' writes Stone, and Ardren comments 'no one expects historical dramas to be accurate ...'. Perhaps we, as archaeologists, should be more critical and say that there ought to be no reason why an accurate portrayal of the past should be less exciting than an inaccurate one, whether in film, on television, in novels or as events at historic monuments or in a museum. Since *Apocalypto* had a budget of 40 million, research and accuracy should not

have been a problem. Perhaps the best example of non-authenticity was *One Million Years BC* (1966), starring Raquel Welch where blonde blue-eyed Aryan Palaeolithic hunters battle against fellow earth-dwellers, the dinosaurs.

Television: The question of authenticity in programmes is a constant issue for archaeologists and historians (discussed in detail in Piccini 2007). Historians often complain that the programme takes only a small part of a particular event or period in history. Archaeologists complain about the incorrect physical representation of say, a Roman house or the clothes worn by prehistoric hunters. Piccini *et al.* (2004, 41) wrote about the 'competing desires' of the archaeologist consultant and the programme makers of *Seven Ages of Britain* (Channel 4) being 'ill-concealed', with gaps in the prehistoric section and the sensationalising of evidence.

If the programme is portrayed as a drama then there is another criticism which is also based on the question of authenticity. The presenter-historian Michael Wood stirred up a controversy around the programme *Boudica*. The scriptwriter Andrew Davies struck back:

> Historical dramas are in the news again just now, with the BBC's *Charles II*, aired last night [16 November 2003] on BBC1. And as might be expected, out trot the popular historians to give their views on its historical accuracy or otherwise.
>
> *Charles II* seems to have got off relatively lightly, but Michael Wood (you remember him – he's the one with the jeans) used the occasion to take a side swipe at *Boudica*, which was shown on ITV1 in the autumn with a script by me.
>
> 'Off-the-wall period hokum' says Wood. Then the great historian gets down to detail. 'The first few minutes said it all', he says. (One wonders whether that was all he saw of it.) 'Long-haired Ancient Britons roaring like England football fans, knocking back beer, muddy faces daubed in woad, loose sexual morals ... you know the sort of thing. Not the remotest inkling of what an Iron-Age society might really have been like'.
>
> ... what we are about is drama, not history lessons. We are interested in how these stories can speak to us today, and the truth we are after is human truth and dramatic truth.
>
> But let us be gracious about this subject. Live and let live. Some like the past dished up as thrilling, witty, spectacular drama. Some prefer it mediated through pictures of chaps in tight jeans prancing around the landscape. I think there's room for both, don't you? (Davies 2003)

Yet amongst much of the dross of archaeology on TV there are some glimmers of hope. *Tales from the Green Valley* (see above) was exemplary. Aubrey Manning, in *Talking Landscapes* and *Landscape Mysteries* (made by the Open University and broadcast by the BBC 2001/2) presented, in a quiet authoritative way, a puzzle in the landscape, investigated it with a range of experts and reached a conclusion. Ray Mears' *Wild Food* (broadcast on the BBC in 2007) investigated prehistoric food using archaeological research into landscapes, flora, fauna and food processing. Ray Mears, who is well known for programmes and books about survival skills and bushcraft, observed the modern hunter-gatherers of Arnhem Land, Australia with a paleoethnobotanist, Gordon Hillman.

... and then there was Bonekickers

Supposedly a television drama series about a fictional university archaeological team solving a mystery each week, it was viewed with disbelief by television critics: 'only a syllable short of bonkers' (Banks-Smith 2008); '*Bonekickers* lurches from the awful to woeful' (McLean 2008); and 'a script apparently fashioned from the corpse of a yak' (Dempster 2008). The online newsletter of the Society of Antiquaries of London reported that Cambridge Professor Boyd Hilton called the character of Professor Gregory 'Dolly' Parton 'borderline demented'.

> Obviously Boyd has never encountered our Fellow Mark Horton, adviser to the series and the model for the Parton character: says Mark of the critical panning 'the critics simply don't get the jokes or the inherent fun and drama there is in archaeology'.　　　　　(Salon 2008)

Other archaeologists were as appalled as I was. Angry letters arrived at the offices of British Archaeology complaining about the inaccuracy of and the misinformation about the techniques employed by archaeologists today – '*Bonekickers* is not about archaeology at all. It is all about treasure hunting' and:

> I can't recall ever seeing such utter rubbish presented as archaeology ... endless drivel. Whoever acted as consultant to this ridiculous farce should be ashamed and embarrassed. On top of this we have a disastrous script and appalling amateur dramatics, it has to be the worst TV I have seen in a very long time.　　　　　(British Archaeology 2008, 13)

The consultant, Mark Horton, hit back in a long article, 'Don't mess with me, I'm an archaeologist!' in *Rescue News*, complaining that some critics were being too critical, that they had to dig a pretend site in December, that the skeletons had to be plastic for ethical reasons and that the pulling a piece of the 'True Cross' from the ground 'in a very un-archaeological fashion was quite deliberate, a joke that archaeology students know little about the practicalities of digging!' He claimed that some viewers thought it 'a cult series which took hokum to new levels, but which also showed grit and reality to archaeology that rarely emerged in serious documentaries' (Horton 2008). *Bonekickers* was not given a second series.

Influencing the media

There remains the question of the possibilities of getting across an archaeological point of view in the media. There is a general assumption that the media will be interested in what we have to say if only we could get them to listen. Catherine Hills makes a general point which applies to print, TV and other media and journalism:

> Many archaeologists believe, and try to convince others, that archaeology has something to say, that it is fun, useful, interesting, even essential. These days the way to do that is through pictures, not words. There is still a two-way barrier between academics and professionals and 'the media'; this in turn forms a barrier between archaeologists and the wider public. There is a general perception of academics and professionals as being too boring

to be able to communicate properly to a wider audience. Professional writers, journalists and media experts are expected to transmit the material.

(1993, 222)

In terms of newspapers, Sparks argues that there are three categories of newspapers in Britain: 'popular, middle and quality' (1992, 43). He explains that popular newspapers are more interested in sport, local human interest stories and individuals, while the quality press may concentrate more on institutions, politics, economics and international affairs (1992, 38–9). But there are other differences, where popular (now more usually called 'tabloid') newspapers may dwell on the sensational and the sexual nature of events. Sparks cites (1992, 40–1) the different ways that *The Sun* (popular) and *The Times* (quality) dealt with a prison riot in 1990. *The Sun*'s first headline was '12 DEAD IN JAIL DRUG RIOT', followed by other headlines during the same week which included 'SEX PERVERTS BUTCHERED IN THEIR CELLS'. *The Times*, on the other hand, led with 'Three feared dead in riot at blazing jail'.

Each week in Britain people buy over 40 million national and local newspapers and 35 million are distributed free. The 'quality' newspapers in Britain which are most likely to cover archaeology (daily circulation figures in brackets) are, at the beginning of 2010: the *Daily Telegraph* (525,000), *The Times* (522,000), *The Guardian* (313,000), *The Independent* (200,000). Even these sales, of around 1.5 million copies, does not equal *The Sun* (2.8 million), or the *Daily Mail* (2.1 million).

Learning what kinds of stories or angles different newspapers are interested in is important for archaeologists. Quality newspapers may well cover an archaeological event or issue in detail but the temptation is simply to accept that those readers do not need convincing. But archaeologists need to reach those readers of popular newspapers in particular. Merriman (2004) reminds us of the need to understand our 'public' and communicate with them better. Finn writes that: 'a constant irritation among archaeologists is this journalistic tendency to snag interesting facts on a contemporary hook, but then discard a follow-up which makes more sense of the evidence' (2001, 263), but rightly reminds us that news has to be 'new'.

Using film and television for teaching

Archaeology on film and television can be a rich resource for presenting and learning about the past. As a schoolteacher in the 1970s I used 16 mm films on loan from the county's film library as well as direct from other suppliers as an aide to presenting periods of the past, such as the Roman Empire or the Egyptians, and the techniques used by archaeologists in the field. I produced a list of archaeological films for distribution to schools by the CBA's Schools Committee (see p. 93) and this list was later enlarged and included in resource books for teachers (Corbishley 1979 and p. 139) but with few films (Henson 1996). The task for 11-year-old secondary school students in Lyme Regis, Dorset, set out below (Tucker 2005) is a good example of how a film can be used to teach interpretations of history. The film, *Pompeii – The Last Day*, was a 2003 made-for-TV film released on DVD in 2005. It is a dramatised recreation of the 'destruction' of Pompeii and Herculaneum by the eruption of the volcano Vesuvius.

Table 3.4 Class exercise on interpretation in history (after Tucker 2005)

Essay: How accurately does the film *Pompeii – the last day* reconstruct what happened to Pompeii AD 79?			
You have examined the archaeological evidence, an eyewitness account and a range of secondary evidence about the destruction of Pompeii AD 79. This task is designed to test your understanding of how and why different interpretations can be made of the available evidence to explain this historical event.			
Read through this list before you start. After completing your work, go through the list again and put ticks in the columns according to how you think you have done.			
Have you done these things …?	*Yes*	*Partly*	*No*
Written an introduction to explain why events in Pompeii AD 79 can be interpreted in different ways			
Given examples to show what is accurate about the film			
Given examples of weakness or inaccuracies in the film			
Explained each example carefully			
Considered how useful the film would be to an historian studying what happened to Pompeii in AD 79			
Divided your essay into paragraphs			
Included accurate factual detail in your account			
Considered the reliability and limitations of the primary evidence			
Written a conclusion to say whether you think the film was accurate or not. What was your most important reason and why?			

Summary

▶ Understanding what the media do is an essential first step.

▶ Newspapers provide wide coverage of a range of archaeological stories but are interested especially in significant discoveries.

▶ Research into newspaper reports on local sites and projects showed that local papers are often interested in covering the stories over a considerable period of time.

▶ Cinema films have a traditional interest in the big historical events of the past.

▶ Radio programmes treat archaeological subjects more accurately than television programmes and producers are less interested than television producers in gimmicks.

▶ Although most of the television programmes about archaeology used to be documentaries there is now an increasing number of reality shows.

▶ Authenticity is an issue for most media when covering archaeological subjects and is a serious concern for archaeology and heritage educators.

Conclusions

The main conclusion to reach from archaeology's presentation in the media is that, from journalists on local newspapers to Hollywood directors, the past is just another story to be 'sexed-up'. Understanding how the media behave is as vital to archaeologists as understanding what schools need or what local politicians expect or what local residents would like from an archaeological project in their area. Perhaps the real problem is that communication with schools, politicians and local residents is far easier than with producers, whose priority is always the eye-catching aspects of the subject.

But it is by no means all bad. Radio archaeology in the UK is something for us, as a profession, to be proud to listen to. Television continues to provide some excellent commentaries on the principles and results of archaeological projects around the world. My own research on local and national coverage of two archaeological projects (Colchester's Roman circus and the Garbology project) showed that, while most of the reporting was accurate, reports were invariably headed by a slick, inaccurate headline. Archaeologists ought to keep a full record of media coverage. Suffolk's Garbology Officer found his archive very useful in promoting recognition within the local authority.

An underlying problem is that most archaeologists see themselves as missionaries for their subject. They genuinely expect what they say to be reported accurately and sympathetically. Experience should tell us that this is not always the case, and I have given comparative examples from other professions. I admit to being a missionary; however, I do like the Indiana Jones films (though I don't see many archaeologists like that in the Institute of Archaeology at University College London). Some films, however, are grossly and blatantly inaccurate (see *Apocalypto* above), or distort or ignore the evidence.

This chapter on the media closes the section 'The Public and the Past'. The section's aim has been to put the relationship between archaeology and formal education into a broader context. The four chapters that make up the section that follows are concerned with archaeology and education in the curriculum, the various kinds of learning resources available to teachers and children and the ways in which archaeology may be taught as part of curricular subjects.

Two case studies follow. The first outlines the work of the Colchester Archaeological Trust and details the public open days which were organised around the discovery of Britain's first Roman circus; it includes an analysis of the press coverage of the discovery and follow-up work with schools. The second case study explains the public education work carried out by graduate students at the International Centre for Cultural and Heritage Studies at Newcastle University as they plan, create and evaluate family fun days at two Roman forts on Hadrian's Wall.

Outreach in action:
Colchester Archaeological Trust

Background

The town of Colchester in north-east Essex has a long and complex prehistory and history (Crummy 1997). Camulodunum was a the tribal centre of the Catuvellauni in Iron Age Britain and it was here that the Roman invasion force, under the Emperor Claudius, headed in AD 43 to establish a new province of the Roman empire. The Roman army's Twentieth Legion was garrisoned on a hill overlooking the capital of the Catuvellaunian centre until AD 48–9. The military garrison was then replaced by a *colonia* – a place where veteran soldiers were settled and a model urban centre could promote Roman life in the new province. The new Roman town of Camulodunum was now called *Colonia Victricensis*. The Roman town and its Iron Age predecessor have been continuously occupied ever since.

Colchester's past has long been studied: the first scholarly work was published in 1748 by Philip Morant, the rector of the church of St Mary-at-the-Walls (Morant 1748). Local antiquarians collected finds and investigated sites through the next century: the first large scale excavations took place in 1842. Some antiquities were stored in the Town Hall in 1846 and then transferred to Colchester Castle in 1860 to join two other important collections. The first collections of antiquities were opened to the public in September 1860.

Excavations continued to be undertaken in the town, especially on Roman sites: Dr R. E. M. Wheeler (later Sir Mortimer Wheeler) excavated Roman houses and streets in Castle Park in 1920. Rex Hull, the energetic curator of the town's museum in the castle, published an account of all the discoveries and work so far in 1958 (Hull 1958). The Colchester Excavation Committee was set up in 1928 to carry out excavations in the centre of town, another in 1930 and a third in 1950. This committee was revived in 1963 to counter the threat to the archaeological deposits in Colchester and is now called the Colchester Archaeological Trust. The history of archaeological investigation in Colchester has been published in detail (Crummy 1979, 3–23).

Colchester is genuinely proud of its long past. A sign saying 'Britain's Oldest Town' greets visitors. The Castle Museum has one of the most important collections of Roman finds in the country and much of its Roman wall and very many medieval buildings survive above ground (see Fig. 3.2). The borough council, through its museum, and the Colchester Archaeological Trust have displayed and interpreted for the public the town walls, the Roman theatre and other important Roman monuments.

The Colchester Archaeological Trust and outreach

The Trust's main aim is to investigate, preserve where possible and promote the archaeological remains in Colchester. It is a registered charity and a company limited by guarantee. Promotion includes academic publication of papers in archaeological journals and conference proceedings and also a respected series of research volumes which it publishes itself. The director, Philip Crummy, has also written books for the general public (noted above but for more details see Chadwick and Crummy 2006, 129) to interest them in Colchester's archaeological past. As well as the usual lectures to archaeological societies, Trust staff give, on average, talks to non-archaeological groups (such as the Women's Institute) about once a month, reaching about 1,000 people each year. Work experience is provided for students at local schools (about four to six students a year) and opportunities are provided, where possible, for volunteers to get involved in excavation and finds processing. All published and unpublished reports from the Trust are now freely available online (Colchester Archaeological Trust 2010a).

The first major outreach project was founded by the author and the Trust's director in 1977 – the Friends of Colchester Archaeological Trust and has had for some years now between 450 and 500 members, largely from the Colchester area and East Anglia, but with some members further afield in Britain and abroad (Chadwick and Crummy 2006, 132). A regular and illustrated newsletter, called *Catalogue*, was first published in 1977 and replaced with an annual magazine *The Colchester Archaeologist*, which was, and still is, available on sale to the general public. The Friends now also receive regular newsletters from the Trust.

Apart from annual lectures about the latest work of the Trust, the Friends have organised regular outings to ancient monuments, churches and museums. Large numbers of Friends visit open days for the Trust's excavations. Wherever possible (allowing for health and safety and access considerations) the Trust has organised special days for the public to see their excavation sites, events which have attracted large numbers: 2,700 in 1978, over 3,000 in 1997 and over 3,000 in 2000 (Crummy 2005). These days have always been promoted and reported in the local and regional newspapers. During the 1970s and 1980s the Trust put on regular exhibitions of finds and photographs in the Castle Museum. Information and finds from the Trust's discoveries are now included in permanent museum displays.

Colchester's Roman circus

While the people of Colchester have become well used to finding out about Roman discoveries in their town, they are also used to these discoveries making headlines. When evidence for one of the gates to the Roman town was discovered in 1944 during excavations for an electricity fusebox, the headline in the local paper (*Essex County Standard* 1944) read 'THIS HAS THRILLED ARCHAEOLOGISTS MORE THAN ANYTHING IN 20 YEARS'.

The discovery of a *circus* outside the walls of Roman Colchester provoked huge interest from archaeologists and the public and not surprisingly excited headlines such as, 'Oh, what a circus! Revealed: what life was like at first Roman chariot-racing arena to be found in Britain' (Parkes 2005b). The Trust in association with RPS (who were managing the archaeological project for Taylor Woodrow)

Fig. 3.2 The large and continuous numbers of visitors were given guided tours of the remains at four separate points around the site, plus an introductory talk near the entrance. A makeshift frame of bamboos demonstrated the way the seating might have been arranged.

had been carrying out investigation and excavations during the development of the new 'urban village' of Abbeyfield on former army garrison land south of the walled town.

Although parts of the circus had been found in 2000 and 2002 it was not until 2004 that the significance of the remains was realised. The publication of the story was carefully managed. Taylor Woodrow, RPS Group and the Trust put out a press release on 5 January 2005. Taylor Woodrow have been very helpful to the archaeologists throughout this project and were enthusiastic in their press release. Their regional managing director was quoted as saying, 'The excavation of the Roman circus is a fantastic discovery for Colchester and has caused a great deal of excitement. We are delighted to have supported the Colchester Archaeological Trust in revealing such significant finds and will endeavour to preserve as much of the remains as possible for future generations'.

Circus Open Day

An open day for the general public to see part of the circus was organised for 22 January 2005. On the same day the new issue of *The Colchester Archaeologist* was published and sold to the public or given to the Friends. The day (open 10 am until 4.30 pm) attracted 2,350 visitors (see Fig. 3.2). Other open days followed later in January and February while the excavations were still open. In all, about 5,000 visitors attended the circus open days. At the main circus open day there was organised car parking with stewards, an exhibition, book stall, a refreshment van (hired by Taylor Woodrow) and guided tours.

Crowd management was needed and organised by the Trust, whose volunteer staff and diggers worked hard in cold, unpleasant conditions. There were long queues in chilly weather, but the interested visitors didn't seem to mind. There was an exhibition of finds, Trust staff, Rob Masefield of RPS and Friends gave explanations, refreshments were available and from time to time there was entertainment from re-enactors in a chariot and on horseback. Comments to reporters of the *Evening Gazette* included 'It was well worth coming. It brings it to life for you and does need explanation and expert interpretation ... The people giving the explanations were very interesting because they kept it simple and we could all understand it'.

Table 3.5 Visitor survey in the circus open day

Numbers		Travelling from	
Families	17	Colchester residents	125
Individuals	141	20 mile/32 km radius	68
Couples	57	East Anglia	5
		Elsewhere in UK	4
		Abroad	1

All comments in the book were complimentary, with only three people mentioning the long queues. Forty visitors mentioned the well-organised tours, and 33 expressed strong views about the possible future preservation of the site. It was not surprising to find that most visitors came from Colchester and its surrounding districts. The day had been widely advertised in local press and radio stations, as well as to all Friends.

Press coverage

An analysis of the newspaper coverage is shown below, but the articles projected an image of archaeology as a discipline with 'experts' reaching interpretations based on careful work over a period of time and altering their conclusions when new evidence came to light. Headlines did not show archaeology as a treasure hunt – the headlines were restrained, in fact rather dull, although three nationals (*The Times*, *Daily Telegraph* and *Guardian*) talked about 'Boy Racers' and the headline in the *East Anglian Daily Times* (17 March 2005) was 'Done Roman: A day at the chariot races' (Ashworth 2005). *Ben Hur* was only mentioned in four of the 28 articles. The newspapers highlighted strong local support for the circus finds and the local MP was quoted as saying that 'Colchester's already strong case for inclusion in the UK list of applications [as a World Heritage Site] has been dramatically boosted with this latest discovery which is of international significance' (Parkes 2005a).

Channel 4's *Time Team* backed further excavation of the circus in 2005 and then made *Britain's Lost Roman Circus: A Time Team Special*, which was broadcast on 20 June 2005. The programme included some new artists' impressions of the site and 3D computer-generated images. A special racing chariot was researched, constructed and tested as part of the programme.

Table 3.6 Circus press coverage: 28 articles with 306 column inches.

Media	Circus excavations	Time Team programme
Local papers	15	4
Nationals	6	1
Magazines	2	

Public display

At the time of writing, Taylor Woodrow, working closely with the Colchester Borough Council, intend to play their part in preserving the remains. Their public statement, issued to visitors on the first open day stated:

> The section of the Circus located on Taylor Woodrow land remains our responsibility. The most considerate way to respect this vitally important piece of British history is to preserve the existing foundations. We are in consultation with English Heritage to discuss the preservation and conservation of the discovery. It is likely that we will rebury what has been unearthed and maintain visible sightlines to indicate where the structure originally stood. Preservation means not building on top of the remains or doing anything to destroy what is there. Having identified the location of the Circus, Taylor Woodrow has safeguarded the site from future development. Further building will be designed around it.

The public could for some years later see a special exhibition about the Roman circus in the Marketing Suite (now taken down and removed) for the Bryant Homes 'Urban Village' on the site. The display was small but very well designed and presented with a model of the circus, artists' impressions, photos of the excavation, some finds and explanatory text. The display was commissioned by Taylor Woodrow and prepared by the Trust. The Trust's director has published updates of the circus excavations (Crummy 2006a; Crummy 2007; Colchester Archaeological Trust 2010a).

Mosaic project

Discussions about the future of the circus itself are underway. Meanwhile, Peter Herring, a volunteer at the Colchester Archaeological Trust, is the voluntary project manager for an unusual display – the creation of a modern Roman-style mosaic. The Heritage Lottery Fund, under their Local Heritage Initiative, has funded the project, through the Trust, with additional help and materials from local businesses and organisations. Peter Froste, well known in Colchester for his artist's impressions of archaeological sites and monuments investigated by the Trust, has designed the mosaic. The 6 × 3 metre mosaic has been constructed by local school children and local volunteers and is intended to be on permanent display on the circus site (Crummy 2006b). The tesserae were cut from modern tile materials and fixed onto the artwork (see Fig. 3.3). The whole mosaic was then fibre-glassed and further strengthened with a honeycomb backing (Herring 2006). The army, which has a large garrison in Colchester, helped with lifting and

transportation the two halves of the mosaic and also its final consolidation. The mosaic was completed in just 11 months.

The largest group to work on the 200,000 tesserae for the mosaic was about 1,000 pupils from Colchester secondary and primary schools (Herring 2006 and 2007). Apart from providing workers for laying the tesserae, the schools have enthusiastically taken the project into their curriculum studies, providing work in a range of curriculum subjects, with over 60 students designing and creating their own mosaic panels as submitted examination projects.

The final resting place of the mosaic is yet to be decided. Meanwhile, in January 2008, with funds provided by the Essex Heritage Trust and the East of England Co-operative Society, the completed mosaic was unveiled by Griff Rhys Jones. The Trust set it up for public display on the line of the south stand of the circus, where a large information panel gives the background to the mosaic and its manufacture and provides the visitor with an overview of the circus itself.

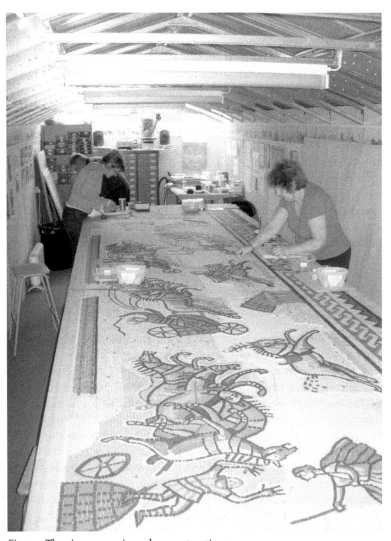

Fig. 3.3 The circus mosaic under construction

Family fun days at Roman forts: International Centre for Cultural and Heritage Studies

Background

The International Centre for Cultural and Heritage Studies (ICCHS) at Newcastle University provides postgraduate training, research and consultancy services in management, education and interpretation in heritage organisations, museums and galleries. The Centre works closely with a number of national, regional and local heritage organisations and museums both for teaching and research. Students work on projects with some of these organisations for their dissertations and course assignments (ICCHS 2010). This case study looks at an assignment for a group of students working with Tyne and Wear Archives and Museums.

Tyne and Wear Archives and Museums

Tyne and Wear Museums has recently merged with Tyne and Wear Archives to provide a joint service. Tyne and Wear Archives and Museums (TWAM) is a managed federation of 12 museums, galleries and heritage sites which were created at different times from 1829 (Hancock Museum) to 2000 (Segedunum Fort, Baths and Museum) and is funded by a range of grants (government and others), admissions, sales and income from the archaeological unit's work. It leads the North East Regional Museums Hub (which includes Beamish: the North of England Open Air Museum, the Bowes Museum and Hartlepool Museums) through the Government's 'Renaissance' programme. The stated vision of TWAM is:

> Our vision for the future is for everyone in Tyne & Wear to have access to museum provision in Tyne & Wear, to use this access and to value it for the significant and positive impact that it makes upon their lives. We will provide worldwide access to museums and their collections.
>
> (TWAM 2010a, 7)

TWAM has a commitment to free admission where possible and also carries out a number of outreach projects. TWAM has set a number of 'Priority Areas' which were developed from strategic priorities set by local and national government fund providers and current education practice in museums. Their six priority areas for 2009–14 are:

1 Children and Young People
2 Environment, Economy, Enterprise and Regeneration
3 Safer, Stronger and Healthier Communities
4 Lifelong Learning for All
5 Learning, Leading and High-Performing Organisation
6 Collections Stewardship and Access. (TWAM 2010b, 3)

For each of these priority areas TWAM set out its corporate objectives. In Priority 1: Children and Young People, for example, the first objective is to 'continue to invest in interpretative learning, and experiential and outreach programmes aimed at young people', and in Priority 4: Lifelong learning for All, with its aim to 'maximise formal learning opportunities for children and young people' a priority is to 'provide and promote a curriculum focused learning service encouraging and developing the use of museums and collections' (TWAM 2010b, 4 and 7). TWAM then set out, in the corporate plan, strategic aims and key objectives for each of its museums, galleries and sites. Overall visitor attendance at TWAM's 12 outlets has risen in recent years to 1,450,752 in 2008/09 the 'number of children in organised educational activities' was 145,435 in the same period (TWAM 2010a, 48).

Family Activity Days

One of the priorities of TWAM is to 'promote our services by working with further and higher education institutions, and informal learning providers' (Corporate Object C8.3 TWAM 2010b, 7). An activity booklet for children visiting Arbeia Roman Fort written by a Museum Studies student at the University of Leicester on work placement was subsequently published (Arvanitidi 1996). The International Centre for Cultural and Heritage Studies (ICCHS) has a long-standing and on-going agreement with TWAM for students to carry out assignments at some of their sites. As an external examiner at ICCHS I read some of the students' assignments and later gained permission to quote from their work.

As an example of this work a group of five ICCHS students were given an assignment to plan, execute and evaluate family activity days at two sites, on the same day in March 2005, as part of the museums' programme of events for the British Association for Science's 'National Science Week' (now called National Science and Engineering Week; see British Science Association 2010). The activity days were created for the forts of Segedunum and Arbeia (see Fig. 3.4). Segedunum Roman Fort at Wallsend was the most eastern fort of Hadrian's Wall and its remains can be viewed from a specially built tower. Museum displays present a representation of life at Roman Segedunum and the story of the site's occupation by mine buildings and miners' houses in the 18th and 19th centuries. Part of Hadrian's Wall also survives here and a section has been reconstructed close by to the level of the wall walk at 3.5 m high (Griffiths *et al.* 2008, 19). Also reconstructed is the fort's bath-house.

For both sites, groups of students worked with museum and site education staff. The assignment for students was to investigate family activities in museums and on sites and to devise a number of activities based on themes which emerged from the sites themselves as well as the museum collections (see Fig. 3.5). The students discussed their assignment with TWAM education staff and then carried out a SWOT (Strengths, Weaknesses, Opportunities, Threats) analysis. They created activities and publicised the events. The students managed the project themselves, producing information and activity sheets. They created evaluation feedback forms for children and adults, evaluated the projects and wrote reports.

The activities were designed to produce generic learning outcomes rather than fulfil the requirements of National Curriculum subjects. The final agreed activities, which all had clear aims and objectives were:

Fig. 3.4 Arbeia Roman Fort was built on high ground on the south side of the River Tyne, probably to guard the mouth of the river which was the main supply route for the Wall. The fort's west gate (seen here), commandant's house and one barrack block have been reconstructed full-size and visitors can also see museum displays, a Roman garden and, often, archaeologists at work (TWAM n.d.).

Fig. 3.5 One family at Arbeia making a sundial

At Arbeia

Sundial

Aim: to learn about and interact with Roman time and numerals.

Objectives:

- To create a Roman sundial out of easily accessible materials;
- To write and understand Roman numerals;
- To relate to the sun's movement and how it is used to tell the time;
- To learn about drawing angles.

Treasure Hunt – to explore the site itself using orientation skills.

Water Clock – to learn about another method used by the Romans for telling time.

Volcano – to learn about a geological phenomenon which has occurred in Roman and modern times.

At Segedunum

Cheating! – making dice from card, experimenting with materials and shapes.

Science and Ladders – joining in a giant game of snakes and ladders which used facts from science, engineering and technology.

Ancient Measuring – using knotted string to investigate ancient measuring techniques.

Fun with Clay – making a replica Lewis Chessman or snake with modelling clay.

Juggling – making balls from balloons filled with dried lentils and attempting juggling.

Target Toss – throwing bean bags at a target for under-fives.

Colouring – colouring in a Lewis Chessman.

Evaluation

Numbers of participants were recorded for each activity and evaluations carried out in two ways through evaluation feedback forms and observations by facilitators.

The evaluation results were matched against the generic learning outcomes and included in the students' reports in the form of charts and discussion. One student (Taylor 2005, 2) recorded some of the children's comments in answer to the evaluation question 'The worst bit was ...'

'All good'

'It was all good'

'No worst bits. Enjoyed it all!'

'(The worst bit will be) going'

'Nothing'

'Losing at Snakes and Ladders – wish I could have used my cheating die'.

Each year a new set of students from ICCHS devise activities for the British Science Association's annual event. For example, in 2007 the activities at Arbeia were *Make a Column! Explorer Trail* and *Games to Play* (such as make up a story about an object children have discovered on site). Other activities were for families to try at home – *Hold a Roman Feast* (recipes provided) and *Search for Columns where you Live*.

Archaeology and Education

4 The Development of Archaeology and Education

The historian George Macaulay Trevelyan wrote: 'If historians neglect to educate the public, if they fail to interest it intelligently in the past, then all their historical learning is valueless except in so far as it educates themselves' (quoted in Wheeler 1956, 219).

This chapter shows the various ways in which the practices, discoveries and concerns of archaeologists past and present, are used in various aspects of formal education. There is detailed examination of the most important and influential heritage organisations in the UK. The place of informal education is discussed; in particular the increasing number of community archaeology projects and the foundation and achievements of the national Young Archaeologists' Club.

Defining archaeology

The Renaissance, the European revival of learning from the 14th to the 17th centuries, was largely about an interest in past Classical civilisations. Travellers brought back antiquities from the Mediterranean and the Near East. Others worked in their own country, studying monuments and collecting artefacts. Some clearly disapproved of this; when in 1586 William Camden produced *Britannia*, the first general guide to the antiquities of Britain, he wrote in defence of his work: 'Some there are which wholly contemne and avile this study of Antiquities as a back-looking curiositie ...' (quoted in Daniel 1967, 35).

But though there were many, in different countries, looking for the remains of the past, it was difficult to make sense of it all. John Aubrey (died in 1697), the first person to do serious field survey at Stonehenge and Avebury, wrote:

> This inquiry, I must confess, is groping in the dark; but although I have not brought it into clear light, yet can I affirm that I have brought it from an utter darkness to a thin mist, and I have gone further in this essay than anyone before me. (John Aubrey quoted in Daniel 1964, 22)

Rasmus Nyerup (died in 1829), one of the pioneers of Danish prehistoric archaeology, also saw that the ancient past needed light shed on it:

> Everything which has come down to us from heathendom is wrapped in a thick fog; it belongs to a space of time we cannot measure. We know that it is older than Christendom, but whether by a couple of years or a couple of centuries, we can do no more than guess. (Quoted in Daniel 1964, 29)

Daniel goes on to say that 'The archaeologists, struggling for historical truth, could as yet offer no prehistory – nothing but obscurity, oblivion – thick fog.' Archaeologists and antiquarians were held back by doctrine such as the Church's belief in the creation of the world by God in 4004 BC and, therefore, an unwillingness to grasp the immense length of the world's past, an inability to sort out their discoveries into a sensible timeline and the application of often crude and non-scientific methods of archaeological work. Gradually, though, archaeologists began to make sense of the past – scientific excavations helped – and could by

the 19th century start to define their discipline. The first Disney Professor of Archaeology at the University of Cambridge, the Reverend John Marsden, wrote in his inaugural lecture in 1852: 'Archaeology, then, may be defined in general as an investigation of all that remains to us of the ancient works of *man*; with a further limitation to such of those works as are *material*, – visible and tangible, – objects of sense' (Marsden 1852, 5).

There is at least one definition of archaeology in any modern book on the subject, whether an academic volume or a series of reminiscences. Compare the above quotation with this one:

> Archaeology is partly the discovery of the treasures of the past, partly the meticulous work of the scientific analyst, partly the exercise of the creative imagination. It is toiling in the sun on an excavation in the deserts of Central Asia, it is working with living Inuit in the snows of Alaska, it is diving down to Spanish wrecks off the coast of Florida and it is investigating the sewers of Roman York. But it is also the painstaking task of interpretation so that we come to understand what these things mean for the human story and it is the conservation of the world's cultural heritage – against looting and against careless destruction. (Renfrew and Bahn 2004, 12)

Sharing archaeological discoveries

Taking the broad view of education we can see that antiquarians and early archaeologists wanted to share their discoveries, and their excitement with others. 'Others' here meant those who were educated and probably also interested. Levine published research (1986, 178) showing the following 'social and intellectual commitments of active archaeologists, historians and antiquarians, 1838–86':

Table 4.1 After Levine 1986, 178

	Archaeologists	Historians	Antiquarians	Museum employees	Total
Active in archaeological & historical societies	56%	23%	49.5%	50%	44.7%
Clerics or ordained	18.8%	23%	21%	14.3%	19.3%

Publications varied from locally printed books to national magazines, such as the popular *Gentleman's Magazine*, established in 1731, which often published accounts of excavations with illustrations. Philip Morant, who published *The History and Antiquities of the most Ancient Town and Borough of Colchester* in 1748, wrote:

> It being my lot to be fixed in the Town of Colchester; and finding that it abounds with many curious Materials, which, if digested, might be of use to present and future generations, I thought I could not better employ my leisure hours, than in compiling this book, which I now offer the Reader.
> (Morant 1748, iii)

The Society of Antiquaries was formed in 1717, and by the mid-19th century there were many county and national archaeological societies who published regular reports and held meetings and conducted excursions, visits and excavations (Piggott 1976, 171–95; Daniel 1975, 113–15). Levine (1986, 182–3) records 61 county and local societies founded in England between 1834 and 1886. This tradition of sharing the results of local researches and, later, excavations continues today in local and county journals in Britain. Added to these archaeological and historical societies, there are a number of 'friends' groups which support museums, archaeological units and historic sites.

This dilettante method of archaeology was prevalent in Britain in the 18th and 19th centuries. Burial mounds became a favourite sport for antiquarian investigation. One energetic archaeologist, the Reverend Bryan Faussett, held the record for excavating 31 barrows on 29 July 1771. Barrow digging provided an entertainment for groups of ladies and gentlemen, as the antiquary Thomas

Recent important excavations at Pompeii

More popular reports also began to appear in the press. The *Illustrated London News* led the field in features on monuments and sites, reports of the meetings of national societies and in revealing new discoveries. This is part of a piece 'From our Correspondent' entitled and dated Naples, 18 May 1846:

> I do not intend to put on the toga because I happen to be at Pompeii; but I shall give you a simple, unaffected account of what I did, and what I thought.
>
> I had scarcely finished my sketch when I heard the rattle of advancing carriages. On my arrival in the Street of Fortune, I found a committee of gentlemen had just alighted from their hackney coaches in the middle of the forum! They were the appointed inspectors of excavation. I joined them as we proceeded towards the nameless street running into that of the theatres. Operations were here commenced, when one of the workmen exclaimed, 'Bones and money!' 'Clear the way!' shouted half a dozen excited antiquaries, as they rushed into a small apartment. Here were the bones of three skeletons, very perfect; and, near the hand of a young male, were found 37 pieces of silver, and two gold coins.

The article goes on to describe seeing a portable kitchen in another house which had been partially excavated for a visit from the Empress of Russia and finishes with:

> With this event ended one of the most pleasing days at Pompeii I ever remember; ... The Committee left whilst I lighted a very bad cigar, and returned to revise my sketches; but not without my chattering guide! Who I was obliged to send to sleep with some brandy and water, to enable me to enjoy that profound silence which forms the eloquence of Pompeii.
>
> I returned to the railroad with two Italian artists, now employed in restoring the House of the Tragic Poet to its original glory. Tshuc! Tshuc! – a horrid scream! – and we are off for Naples: the old world is forgotten: I am once again in the howl and hum of the noisiest city in Europe.
>
> (EWB 1846, 381–2).

Wright described an outing in Snodland in Kent in his book *Wanderings of an Antiquary* published in 1854:

> Our party at the 'digging' consisted of our kind and hospitable host and hostess, Mr and Mrs Charles Whatman of the Friars, Lord Albert Conyngham, the Rev. Lambert B. Larking of Rymarsh, the Rev. Mr Phelps of Snodland, and two or three other ladies and gentlemen from the neighbourhood.
>
> As the barrow was of large dimensions, we had engaged some twelve or fourteen labourers … It was the labour of four long days to cut entirely through the barrow; but we who were not absolutely diggers contrived to pass our time to the full satisfaction of the party. We hired one of the boats which were used in this part of the country for carrying the amateur toxophilites along the Medway to their archery meetings … A plentiful supply of provisions had been procured for pic-nicing on the hill, and we remained by the barrow all day, watching and directing the operations.
>
> (Quoted in Jessup 1961, 73–6)

Marsden deals with this archaeological trend in detail and includes a list ('not exhaustive') of 22 barrow-diggers and barrows dug (only 18 or more barrows listed), between 1803 and 1900. The total was 2,505 of which 1,855 were published in some way (Marsden 1974, 118).

Popularising archaeology

Two archaeologists, above all, were passionate about popularising their own work and the subject in general: General Pitt-Rivers and Sir Mortimer Wheeler.

Lieutenant-General Pitt-Rivers, who had inherited huge estates in Wiltshire and Dorset, became an outstanding field archaeologist – indeed he is often described as the creator of modern excavation techniques. He excavated meticulously and privately published his major work, *Excavations in Cranborne Chase*, in four volumes between 1887 and 1898, writing in the first volume that 'excavators, as a rule, record only those things which appear to them important at the time' (Pitt-Rivers 1887, 1). He went on to be appointed the first Inspector of Ancient Monuments in 1883, following the passing of the first Ancient Monuments Act the year before. He believed in the educational value of antiquities and at the opening of the Dorset County Museum said: 'Although a county museum is not strictly an educational establishment, yet, if it is admitted that one of its chief functions should be the instruction of the public, the same principles must apply to these collections that apply to a school' (Pitt-Rivers 1884, 10).

He was determined that the public share his interests and discoveries. He opened a museum of agricultural implements, handicrafts and antiquities at Farnham in Dorset but realised that he needed to persuade the public to come:

> I hold that the great desideratum of our day is an educational museum in which the visitors may instruct themselves … It is to the larger and smaller tradesmen that such things as museums appeal but they must be supplemented by other inducements to make them attractive. Within a short distance of the museum I have formed a recreation ground …
>
> (Pitt-Rivers 1892)

In this recreation ground Pitt-Rivers provided brass bands, bowls, skittles, picnic areas and arrangements for those coming by bicycle. There was also a zoo, a golf links and a small hotel. His visitor figures were extraordinary for a remote spot:

> *Grounds*
>
> 1887: 15,351
>
> 1889: 44,417
>
> *Museum*
>
> 1888: 5,706
>
> 1889: 12,611

(Thompson 1977, 79–80)

Sir Mortimer Wheeler perhaps did more than anyone to publicise archaeology in more recent times. His exuberant enthusiasm for his subject came over in his Pathé newsreels at his excavations in Verulamium from 1930–33 and his appearances on *Animal, Vegetable, Mineral?* on BBC in the 1950s (see p. 50). His clear view about what archaeology is, is still relevant today – he wrote in 1966:

> Individual after individual, learned society after learned society, year after year, we are prosaically revealing and cataloguing our discoveries, and are excessively content. We dig up mere things, forgetful that our proper aim is to dig up people. It is they that matter, not their penknives and their trouser-buttons.
>
> The only thing that really matters in our work is the re-creation of the past. (Wheeler 1966, 111–12)

Wheeler was responsible for setting new standards in archaeological excavation and recording but he seized opportunities to further the cause of archaeology in a number of other ways. In 1926 the *Daily Mail* financed his excavation of the amphitheatre of the legionary fortress of Caerleon in Wales and published regular news reports. During his excavations (1935–7) at the Iron Age hillfort of Maiden Castle, Dorset, he held weekly press days, arranged tours of the excavations and sold souvenirs. Jacquetta Hawkes' biography (1982) is well subtitled 'Adventurer in Archaeology'. He was forthright in his views and wrote in a direct way: 'In a simple direct sense, archaeology is a science that must be lived, must be "seasoned with humanity". Dead archaeology is the driest dust that blows' (Wheeler 1956, 13).

By the 1970s the view which Wheeler described (1956, 231) of an archaeologist who 'wears corduroy shorts, strides about on draughty landscapes with a shovel and an odorous pipe, and is liable to be an undergraduate' was being replaced. This was the age of the archaeologist on television, working with demolition teams, often part of a local council administration. It was the age of rescue archaeology and of the organisation Rescue. *Rescue Archaeology* was the first book to set out some of the challenges and principles of rescue archaeology; in 1974, this was written, 'The public are entitled to know the results, problems, and the limitations of the archaeologist, for after all the pitch on which he is playing is their heritage' (Thomas and Arnold 1974, 241).

Visiting excavations

The public have often been interested in seeing archaeologists at work, especially in towns and cities. London office workers, on their lunch breaks, gazed at work in progress on large building sites in the immediate post-war period. In 1954 this interest was extended to the excavation of the Temple of Mithras when, on one day alone, 35,000 visitors queued for a mile and then stood and stared at the archaeologists at work. Many archaeological excavations are now equipped with public viewing platforms. Excavations which are extensive and long-lasting can provide opportunities for more formal arrangements for public visits. For example, the Viking Dig (1976–81) provided visitors with the chance to see the discoveries as well as a film, an exhibition and the finds. The York Archaeological Trust also provided guided tours and explained the archaeological processes. In 1988 and 1989 a large area in the centre of Worcester was excavated in advance of commercial development. The Deansway Archaeological Project, carried out by the Hereford and Worcester Archaeological Service, provided the now usual guided tours and a chance to see the progress of the excavation in exhibitions, but also ran a formal education service for schools and put on evening classes for adults. The Big Dig at Whitefriars, Canterbury, was one of the largest excavations to be carried out in the city by the Canterbury Archaeological Trust; work began in 2000 and a visitor centre was opened in 2002 to allow visitors to see what the archaeologists were doing and a large digital screen presented recent discoveries (see Fig. 4.1). In all over 55,000 people had visited the Big Dig when it was completed in 2003. The Big Dig also gave an opportunity to put on displays for the public, with hands-on activities for family and school groups (see pp. 91–2).

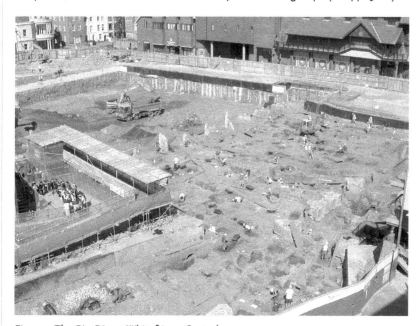

Fig. 4.1 The Big Dig at Whitefriars, Canterbury

In 1975 Tim Schadla-Hall was more specific:

I ... resorted to the CBA/Rescue credo of involving the public ... for three very simple reasons:

1) because, unless I point out the rapidly disappearing sites many people never see them, and if they are interested they should know about them;

2) because I need the public's help to rescue what is disappearing;

3) because, by increasing awareness of the problem, public pressure on responsible authorities may result in less future destruction and more preservation of the historic and prehistoric landscape in the area.

(Schadla-Hall 1975)

What other indications were there of increased public education in archaeology? I helped to found Young Rescue in 1972, still going strong as the Young Archaeologists' Club. Many archaeological units created their own 'friends' groups and held events and published magazines. The first *Observer's Book of Ancient and Roman Britain* was published in 1976 and Boy Scouts could take a badge in Archaeology from 1975 – a Girl Guides badge was created slightly later.

Archaeology and formal education

Archaeologists began to look at the place of their subject in the formal school curriculum early in the 20th century. One of the earliest references is from O. G. S. Crawford, the air photography pioneer who in 1921 argued the case for more respect for the archaeologist and the inclusion of the archaeologists' results in the history syllabus. He wrote that history teachers 'select an arbitrary starting point, after discussing 'the ancient Britons' in a few lines; they confront the student with a *fait accompli* – Britain at the first, second or third conquest usually – with barely a hint of which preceded' (Crawford 1921, 32).

Macalister, addressing the Royal Society of Antiquaries of Ireland, in 1925 forcibly urged that archaeological series of textbooks should be 'put on the curriculum of every school in the land' (1925, 15). In 1928 the Historical Association took up the cause of teaching prehistory, and Diana Dobson wrote: 'Pre-History ... opens up a tremendous field ... This has always been taught to some extent, but usually from the point of view of the Romans themselves, so that the Gauls have formed the beginning, instead of the end of the tale' (1928, 2).

1943 saw the important Conference on the Future of Archaeology, held at the Institute of Archaeology (IoA) in London. The organisers stressed that it was 'essential that plans should be made soon, to coincide with post-war reorganisation of other cultural and educational activities' (IoA 1943, 4). Several speakers during the discussion outlined the contribution to archaeological fieldwork which could be made by schoolchildren. One entire session of the conference was given over to Archaeology and Education. The speakers, however, were by no means unanimous in their support for archaeology to be included in the curriculum. Diana Dobson, who spoke for Elementary Schools, was enthusiastic for its inclusion at this primary level while Philip Corder, for Secondary and Public schools, said that 'no-one would claim that archaeology should be taught as a school subject' (IoA 1943, 85). He went on to argue the case for archaeology as the 'hand-maid of history and geography' in schools. Stuart Piggott disagreed and said:

'I certainly think prehistory should be taught in schools, as a valuable corrective to the detailed study of British (or American) history. From the archaeologist's point of view it should also condition the public to recognise the value of research, and so ultimately paying for it (IoA 1943, 95).

Philip Corder's view was dismissed in characteristic fashion by Wheeler when he wrote that 'the traditionalist view of Archaeology as the "Hand-maid of History" belongs to the era of the Dodo' (Wheeler 1966, 95). In 1954 Jacquetta Hawkes wrote: 'Our subject has social responsibilities and opportunities which it can fulfil through school education, through museums and books and through all the instruments of what is often rather disagreeably called "mass communication" – the press; broadcasting, films and now television' (quoted in Wheeler 1956, 219).

In 1956 the Council for British Archaeology and the London Institute of Education organised a one-day conference on Archaeology and Schools. A very large number of teachers attended and the programme covered archaeology's place in the curriculum, field survey work and excavation for schools. Some speakers and participants agreed that archaeology should be taught as a subject in its own right while others reflected previously held views that it would be useless, if not impossible, to add a new subject to an over-crowded curriculum.

But despite these conferences and reports, the attempts to establish archaeology as a school subject failed. The situation began to change in the 1970s. First, many archaeologists, looking at their discipline, would then claim, like Professor Evans in 1975, that: 'Archaeology has now reached a stage in its development where it has a contribution to make to education in its own right, as a mature discipline with its own standpoint and methodology' (Evans 1975, 5).

Resources for teachers

Archaeologists began to produce resources for teachers during the 1970s and 1980s. Two projects based in university archaeology departments took quite different approaches to introducing archaeology into formal school education. However, both directly influenced a large number of teachers.

The organisation Archaeology in Education was created in 1980. Keith Branigan at the Department of Archaeology and Prehistory, University of Sheffield, launched it to promote archaeology to teachers and encourage them to make use of its resources in their teaching. At first there were about 30 teachers who subscribed to the service, but it quickly grew to about 120–50, mostly secondary-school teachers. A sharp increase in subscribers in 1990 took the total to 250. There were also subscribers from abroad, the furthest flung from the USA, Hong Kong, New Zealand and Australia.

The main activity of Archaeology in Education was an annual conference where about 30 teachers (numbers were restricted because of facilities) were presented with a mixture of talks which brought them up to date with the latest archaeological discoveries and theories. The conference also had hands-on sessions such as flint knapping and handling objects. Smaller one-off sessions were also held – for example, for visiting school groups to the department in Sheffield, a five-day event for an American School in London and talks in schools. A one-day meeting was held in Stafford when teachers from the county's 70 primary schools listened to a talk on Roman Britain and were shown how to use the Roman villa teaching kit (see below). For many teachers, the usefulness of this

service was the specially created resources which subscribers could purchase. The resources were

▶ *Teaching packs*: Four packs were produced on *Prehistoric Britain, Roman Britain, Anglo-Saxon Britain* and *Reconstructing the Past*. Each pack had 12 sheets with information on each topic, illustrations, places to visit and things to do. The pack on reconstruction had 12 artists' impressions of monuments, from prehistoric to medieval, with information about how the 'reconstructions' had been arrived at.

▶ *Air Photo packs*: Each pack contained sets of five aerial photos for use in class, with an interpretative plan and commentary. The sites themselves, as crop or shadow marks for example, included henges, hillforts, Roman villas, trackways and settlements.

▶ *Artefact Kits*: Four kits were produced – *Roman Villa, Prehistoric Technology* and two on *Papyrus*. For the Roman and prehistoric kits there was information and replica objects.

▶ *Replicas*: Individual or sets of replicas were sold ranging from prehistoric to Egyptian and Viking antiquities and from Iron Age to Roman coins.

▶ *Slide sets*: Slides (35 mm) in sets of three included sites from prehistoric to medieval Britain, excavated archaeological features (post-hole, for example) and human bone.

▶ *Videos*: Videos were produced on the Roman countryside, Roman towns, a Bronze Age farm, excavation and dendrochronology.

▶ *Briefings*: were available from time to time on topics such as Roman medicine. The briefings contained activity suggestions as well as information.

The range and quality of these resources which were provided by archaeological experts were a very welcome addition to those offered by commercial companies. However, despite the service offered, Archaeology in Education was wound up in May 2000. In his final newsletter to subscribers, Professor Branigan noted that the introduction of the National Curriculum had encouraged a range of providers with the 'quantity and quality of resources now available for the primary school teacher compared to twenty years ago', resources which his service could not match (Branigan 2000, 1–2).

Archaeology and Education, a pilot project to introduce archaeology and prehistory into primary schools, led by the Department of Archaeology at the University of Southampton, was so successful that it received funding in 1985 from the Manpower Services Commission. (MSC was a non-governmental public body funded by the government to carry out youth training schemes set up in 1973. For many years a number of archaeological projects benefited from its funds.) For the next two years, until MSC funding rules changed in 1998, the MSC doubled the available funding to create a team with 22 staff. The project's founder, Peter Stone, wrote that:

> For archaeology, an increased awareness of the physical heritage that would hopefully come from a wider use of the subject in school could only be seen as a bonus. Misuse and abuse of the physical heritage can never be stamped

out fully by legislation, but only by raising the level of awareness of the general public through education. One of the most influential forces on the public today are their children – themselves the general public of tomorrow.

(Stone 1985)

The Archaeology and Education team set out to achieve three aims:

1 To make teachers and children (and their parents) aware of the existence and destruction of an archaeological landscape (of all periods) everywhere around them.

2 To stimulate the above groups to become interested in, aware of, the past, especially the prehistoric past.

3 To demonstrate the educational suitability of using archaeological methodology and prehistoric evidence in primary, middle, and lower secondary schools. (Stone 1986a, 8)

To achieve these aims, four objectives were identified for all projects carried out by the team:

To demonstrate that there is evidence of the past in the physical environment everywhere around us;

To show that this physical evidence of the past is under continual threat from ever-present and ever-changing human interaction with the environment;

To integrate this unique category of evidence into the study of the past in local schools;

To develop material that is in keeping with the 'enquiry' based curricula now favoured in many schools. (Stone 1990, n.p.)

The project team worked with schools across Hampshire. In the original project, a year group (usually about 60 or 70 children) from a primary school investigated archaeology through work in the classroom, visits to prehistoric monuments, and practical experimental work. Before the project could be taught, members of the team provided in-service training for those teachers who were to be involved. The classroom work set the scene for the project and team members worked alongside classroom teachers to introduce contemporary understanding of prehistory. On the day's site visit (to the prehistoric monuments centred on Avebury in Wiltshire) small groups of about eight children were each led by one of the team's members. Interaction with the monuments, the landscape and the team members was key to the children's learning and activity sheets were not used except in the museum at Avebury. The idea of the day was rather for the children to observe the scale of the monuments and to think about the effort that must have gone into creating them, and the social organisation that would have been necessary to allow their construction. The experimental work was usually carried out on the school's grounds and would involve flint knapping, making baskets and hurdles, making and firing pottery, spinning and weaving, chalk carving, shelter building, pit digging and stone moving (Stone 1986a, 9; Stone 1990).

A survey across 244 primary schools in Hampshire in 1984 showed that 'only 23% had used archaeology in their teaching on a regular basis' (Stone 1986b, 3).

One of the teachers involved in the project explained that teachers wanted more of this involvement with archaeological evidence and that 82% of the children properly understood the 'function of West Kennet Long Barrow, and all but one of the children correctly ascribed the Avebury monuments to the Neolithic' (Richardson 1990, 284).

One of the long term aspirations of the Team was to leave a record of its work. The project's funding from the MSC allowed ten publications to be produced for teachers to use buildings and the wider historic environment in Hampshire as a basis for both curriculum-based site visits and cross-curricular learning in schools. These publications were all based on the extensive successful project work with schools by the Archaeology and Education team. The publications included, for example, 'Southampton's Town Walls' (Stone 1986c), 'The Deserted Medieval Village of Hatch' and 'Portchester Castle'. Also in the series was a teacher's guide to graveyard recording called 'Dead Men Don't Tell Tales?' which was highly praised by one of the teachers who took part in the 'Graveyard and Death Project' which preceded this publication. She reported that, although she was personally very interested in the theme of the project, she would not have felt confident enough to tackle it with her eight-year-olds without the expertise of the team (Porch 1987, 6). It is clear to me that these publications can 'serve as models for wider use' beyond schools in Hampshire (Clack 1988, 21).

Archaeology and education today

At the forefront of encouraging teachers to include archaeology and the study of evidence in learning in schools have been a number of archaeological organisations and museums who have employed qualified teachers and archaeologists to produce teaching and learning resources. The best, in my view, are those which support teachers (or children and families) to carry out visits, on their own, with their own pupils. Selig writes about 'the multiplier effect' of archaeologists and anthropologists running training programmes for schoolteachers, pointing out that they can, potentially, reach '108,000 high school students for every class of 30 teachers that he or she reaches' (Selig 1991, 3).

Archaeology in the Classroom – It's About Time! (Limerick Education Centre 2005) provides teachers with interesting and workable resource information and ideas for using archaeology across a range of curriculum subjects (see pp. 149–50). All local authorities should produce something like this. The key is to follow up with providing learning opportunities for the teachers themselves – in in-service courses and on-site sessions, especially for newly qualified teachers.

An initiative by the Council for British Archaeology and the Higher Education Academy (Ward and Walmsley 2005) has encouraged more archaeology graduates into school teaching, highlighting and attempting to counter two problems: that few archaeology graduates are accepted onto Initial Teacher Training (ITT) courses and that archaeology is not seen as a strong enough component of history teaching in schools, at either primary or secondary level (a problem also raised by Pretty 2000). The pamphlet is full of praise for the skills which archaeology graduates bring to teaching – praise from headteachers and school governors as well as from university and college lecturers. But the problem is not just the absence of archaeology graduates as teacher trainees. The problem also lies with the almost near absence of ITT lecturers with enough experience and

Supporting archaeologists

In 1993 English Heritage Education began to fund education staff at specific archaeological excavation and fieldwork projects. These were at Battle Abbey, East Sussex (1993), Heslerton, North Yorkshire (1995), Boxgrove, West Sussex (1995–1996), Yarnton, Oxfordshire (1996), Silchester Roman Town, Hampshire (1997–1999), Whitby Abbey and headland, North Yorkshire (1998–9) and Cawthorn Camps, North Yorkshire (2000). Some of these projects are described in detail in Corbishley *et al.* 2008. The staff worked with teachers in pre- and post-visit sessions and with groups of children on site. These programmes were always accompanied by resource material for teachers which, apart from giving the history of the site and practical arrangements, provided information about the archaeological process and ideas for curriculum-based work in the classroom.

Supporting teachers

The Educational Department of Fine Arts in the province of Seville, Spain, is an official institution made up of teachers from various levels in education, with wide experience in teaching and in the regional historic environment. The department provides a teacher's course and resources to encourage schools to incorporate archaeological sites into the teaching of history. Up to 2008 almost 3,000 teachers from the province have attended these courses (Caro *et al.* 2008). The resources cover a range of sites (prehistoric, Roman and medieval), historic buildings and museums. They include books for teachers which promote the use of on-site and classroom activities and the books for students (aged between 12 and 16) have information, artists' impressions and plans to answer a number of questions – for example, 'When were megaliths built?' and 'How did they build them?' These resources are very popular with teachers. The student's book on the Roman town of Itálica sold 125,000 copies, in four editions, from 1987 to 2008 (see Fig. 4.2).

confidence to teach history using the physical evidence of the past. The timetable for both a three-year degree in education and for a one-year Postgraduate Certificate of Education (PGCE), in the view of many archaeologists, includes too little experience of evidence and virtually no experience of outdoor learning in history. Copeland (1999, 85) reported that his PGCE (Primary) course included a minimum of 15 hours 'teaching about the past in primary school' for trainees.

Who provides archaeological education today?

The last major work to outline the state of archaeological education in Britain (Henson *et al.* 2004) revealed the scope of work being carried out, mainly in terms of formal education, by a range of organisations. There were, however, some national organisations which were missing – for example, the National Trust. These omissions have been rectified in the case study below.

Professional organisations concerned with archaeology and the heritage *ought* to be involved in education – indeed it should to be one of their core functions. But education only features strongly in a few of them. Of course many engage with the public, with visits or lectures, and create exhibitions in local or national museums.

EL ALCANTARILLADO
(CLOACA)

Antes de comenzar la construcción de las casas había que hacer la red de alcantarillado (**CLOACA**) y de conducción de agua (**AQUAE DUCTUS**).

Las cloacas recogían todas las aguas sucias de la ciudad y las llevaban lejos, hacia el río.

Bajo todas las calles discurre una cloaca que, como mínimo, puede ser recorrida por un hombre encorvado.

A B C

Arriba te hemos presentado tres tipos de cloacas de las existentes en Itálica.

Acércate al cruce de cloacas.

¿A qué tipo corresponden las que estás viendo?

 ❏ *A los tipos A y B*
 ❏ *A los tipos A y C*
 ❏ *A los tipos B y C*

Los cruces de cloacas eran señalizados con una piedra rosa que no permitían error de localización. Ninguna de ellas ha llegado a nosotros.

Fig. 4.2 From the book for students on Itálica. Roman lavatories and sewage systems are explained with simple questions for students.

'Friends' organisations which support archaeological trusts and museums are a good way of creating a local support base. Members of these friends groups may raise money, perhaps for small digs but more usually for publications. Friends groups will often receive a newsletter or magazine either produced by their own members or by trust or unit staff. Some professional units, though, go out of their way to reach a wider public through ephemeral publications, such as newspapers and magazines, some on subscription, some freely available. Essex County Council's Heritage Conservation Branch publishes a wide range of local history books and archaeological reports. It also produces annually, as a supplement to the newspaper the *Essex Chronicle*, a digest of its heritage and archaeology work, *Essex Past and Present*. Chichester District Council produces an annual report on all its heritage projects in *Past Matters*. York Archaeological Trust publishes, twice a year, its own magazine *Yorkshire Archaeology Today*.

Each of these publications, and others, include the education projects in which the various organisations have been involved.

One of the most exciting and innovative ways of getting the message across was, I think, the late Professor Barri Jones' promotion of his excavations in Manchester in 1978. He talked the national daily newspaper, the *Daily Mirror*, into printing an eight-page supplement, *Roman Mirror* (see Fig. 4.3). Its bold headlines imitated the national paper and told the story of the way the archaeological team was uncovering the past on the redevelopment sites in the city centre. His team also created on-site presentation boards, site tours for the public, public lectures and a dedicated programme for school groups.

In the *Yearbook and Directory 2009* for members of the Institute for Archaeologists, out of the 60 registered organisations, 49 provide 'public outreach, participations and events' as one of their services (IFA 2009, 92). Yet very few archaeological units have developed curriculum-based projects and resources. A few archaeological units in England have education services. Some have specific staff to carry out community archaeology work such as talks, guided visits, exhibitions, excavations and events for families (e.g. see Tees Archaeology 2010) and some, particularly those units which are part of a county council, provide curriculum-based resources. Buckinghamshire County Archaeological Service (BCAS) provides resource sheets, glossary terms and five educational packs for teachers, including one on 'Archaeological Skills and Concepts', which is linked to the history and geography curricula, and can be used with one of their interactives called 'Virtual Excavation' (BCAS 2010). The South Yorkshire Archaeology Service (SYAS) has some excellent resources for teachers on the archaeological process and, in particular, the Romans through a comic book for children: 'The Romans are coming!!' which can be downloaded from their website (SYAS 2010). Several museums and heritage sites now have simulated excavations for children and school groups to take part in, for example, Tyne and Wear Museums' Arbeia Roman Fort, Museum of London and DIG in York (DIG 2010). Hawkins (2000) and Chiarulli *et al.* (2000) both discuss simulated excavations.

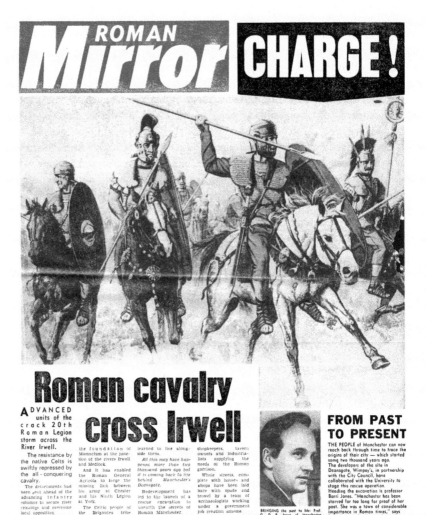

Fig. 4.3 The front page of the *Roman Mirror*

The Canterbury Archaeological Trust

The educational work of this archaeological unit is by no means the only unit which takes on commercial work but it does have a reputation for having a long-lasting commitment to promoting its work in formal and informal education.

Canterbury in Kent was originally a defended settlement in the Pre-Roman Iron Age and became a tribal capital under the Romans from the 1st century AD. It later developed into an important medieval town with an abbey, cathedral and castle. It contains some of the best-preserved timber-framed buildings in England. Like many other historic cities and towns in Britain, Canterbury has a long history of archaeological investigation and a concern for its historic buildings. Important excavations were carried out by the Canterbury Excavation Committee after World War II on areas of the town which had been bombed. In the 1960s and 1970s increased pressure from building development produced the funds for full-time archaeological units in Britain and a unit was established in Canterbury in 1976. The Canterbury Archaeological Trust (CAT) now employs around 60 field archaeologists, specialists and administrative staff. The Trust carries out all sorts of archaeological fieldwork, research and consultancy advice work. Its staff regularly provide lectures and presentations about its work and, wherever possible, organise public viewings for its excavations. It encourages volunteers to work with the Trust and has a support group, the Friends of the Canterbury Archaeological Trust, which has publicised and raised money for the Trust since 1984.

Fig. 4.4 Object handling and recording in school

The Trust has employed a part-time Education Officer since 1990 (following the work of an honorary Education Officer) in pursuit of its principal objective, namely 'to promote the advancement of public education in the field of archaeology' (CAT 2010a). Over the years the Education Officer, Marion Green, has organised a number of projects for different levels of both formal and informal education and produced a wealth of resources. The 'Archaeology in Education Service' is characterised by its firm belief in supporting teachers to take on archaeology as part of their normal curriculum work across a range of subjects. The service has: given lectures and presentations to adult groups; worked with local teachers' centres and the Education Department of Canterbury Christ Church University to run in-service courses for schoolteachers and has worked with students and lecturers at the University of Kent; offered sessions in schools on Canterbury's archaeology and the principles of archaeological work; arranged school visits to excavations with finds handling (see Fig. 4.4); provided work experience for secondary school students including, where possible, hands-on experience of working on a dig; publicised new national education initiatives (such as the National Curriculum) and offered advice to local teachers; published books, booklets and teacher resource packs about Canterbury's history and archaeology, for example, on Roman and medieval Canterbury (Harmsworth 1992 and 2001), *Discovering Archaeology in the National Curriculum* (Green 1997) and *Roman and Anglo-Saxon Canterbury Reconstructed: A Teacher Resource Pack* (Green 1998); participated in national and international education initiatives, such as National Science, Engineering and Technology Week, National Archaeology Weeks and Schools Adopt Monuments; worked with English Heritage on a citizenship project for schools as part of an English Heritage Education national initiative (Spicer and Walmsley 2004); supports the local branch of the Young Archaeologists' Club; and has set up an easy-to-use website with advice and information for teachers and lecturers (see CAT 2010a).

In addition the Trust now provides 'CAT KITS', funded by the Heritage Lottery Fund in 2005. These are handling collections of archaeological objects for the 60 schools in the Canterbury district. Each kit contains pottery sherds, animal bone and building materials of Iron Age, Roman, medieval and post-medieval date together with a booklet identifying the finds and giving teaching ideas for the classroom and links to the Trust's website for related images. The kit also has special pottery measuring chart and 'Feely Bag'.

CAT KIT training sessions were held for teachers and each school was given a kit and the opportunity to discover its educational potential. These kits provide a useful resource for teachers to introduce archaeology into a variety of curriculum subjects in schools.

Supporting archaeology in education: national organisations in Britain

There are a number of national organisations in Britain today who have, quite rightly, education departments to promote what they do in education and outreach work. Some are government-funded organisations with specific responsibilities for the day-to-day care for a number of state-protected monuments and buildings – for example, Historic Scotland. Some are charities which own properties and landscapes, for example the National Trust. Others are organisations which have been set up by archaeologists, for example the Council for British Archaeology. What follows is an assessment of the education services of these organisations carried out in February 2010.

Council for British Archaeology

The Council's prehistory lies in the formation of the Congress of Archaeological Societies by the Society of Antiquaries in 1888 to consider 'the better organization of antiquarian research, and the preservation of ancient monuments and records' (Grimes 1955, 1). In 1943 British archaeologists realised the magnitude of the threat to the archaeological heritage posed by the reconstruction and redevelopment that would follow the end of World War II. During the spring and summer of 1943, meetings were held about the formation of a new national organisation, the Council for British Archaeology (CBA). In August of that year a Conference on the Future of Archaeology was convened at the Institute of Archaeology in London (Institute of Archaeology 1943). Its suggestions for post-war educational needs are discussed elsewhere in this book. The CBA was formed and its first meeting held in March 1944. Its constitution declared that it existed to represent archaeological opinion in Britain and, amongst its aims, was a commitment 'to obtain recognition of archaeology in education'. For a fuller history of the Council see CBA 2010c.

Much of the CBA's work has been carried out through specialist committees, boards and working groups, as well as by its permanent staff. Its education work was given a boost by the reorganisation of the structure of the CBA in 1975 when an Education Board co-ordinated the work of three committees covering schools, universities and adult education. The Schools Committee, of which I was a member, was 'made up of teachers, advisers and archaeologists known to have experience of or an interest in teaching archaeology in schools' (Pretty 1979, 3) and met regularly between 1975 and 1992. The Schools Committee was active in its promotion of archaeology in schools and was soon producing information and resource guides for teachers, archaeologists and university students. I was appointed the CBA's first Education Officer in 1977. The first issue of its twice-yearly 'Bulletin of Archaeology for Schools' was published that year. The first of four resource handbooks for teachers was published in 1979 (Corbishley 1979 and 1983; Halkon *et al.* 1992; Henson 1996). There were other publications for teachers, including the 'Archaeology for Schools' series, sponsored by Lloyds Bank, in 1982 and 1985 and a research report in 1986 (Cracknell and Corbishley 1986).

The CBA's Schools Committee had always promoted the use of archaeological evidence in teaching a range of subjects including, of course, history. Members of the Committee, and the Education Officer, were involved in secondary school public examinations in archaeology (A-level, A/O-level, CSE, GCSE and in 1988 the development of the new A and A/S-level). Discussions about the establishment of the first national curriculum in England and Wales led to the production of discussion documents, and meetings with government departments. In 1989 the CBA's proposals 'Archaeology for ages 5 to 16', for the consideration of archaeology in the first Order for History and other subjects (see pp. 119–20) were published (Corbishley 1989b). The introduction of the first National Curriculum (and its subsequent changes) encouraged the CBA to produce guides and case studies for teachers (Corbishley 1992; Howell 1994; Henson 1997).

The current work of the CBA centres around three main areas of work – campaigning, publications, and conferences and workshops – carried out by a Head of Education and, at present, two short-term contract Project Officers.

Campaigning is, arguably, the CBA's most important educational role and continues the strategy first discussed by the Schools Committee in 1975. The seemingly endless attempts to change the education system in England and its National Curriculum since 1988 have led the current Head of Education to make frequent submissions to government consultation exercises. The CBA provides a continuing service to archaeology and museum education officers by analysing and publicising these changes, usually in its regular 'Newsletter'. Representation was made, on behalf of British archaeology, to stop the abolition of GCSE Archaeology and the difficulties archaeology graduates were having entering teacher training. This successful campaign led to new information being issued by the CBA with the support of the Higher Education Academy (Ward and Walmsley 2005). More recently the CBA has been involved in an advisory capacity on the Department for Culture, Media and Sport's built environment education initiative, 'Engaging Places' (CABE 2010b) and has played an important in the direction of the new Council for Learning Outside the Classroom (see p. 219). The Head of Education at the CBA has played a key role in the Heritage Alliance (formerly Heritage Link) as their Education Co-ordinator and is able to represent over 80 national voluntary organisations in education matters.

Publications have continued to play an important part in the CBA's education work. Some of this work has been directed towards the ways in which archaeologists can help teach teachers and provide them with resources, ideas and services (Pearson 2001) or in academic books (Henson *et al.* 2004; Henson and Davidson 2004c). As with many archaeological organisations today, the CBA now provides much of its education resources and contacts via its website (CBA 2010d). Very useful teaching material and ideas are available to download from the Young Archaeologists' Club section of the website (CBA 2010b).

Conferences and workshops: After the formation of the Schools Committee, a national conference was held in Reading in 1978 which 80 teachers and archaeologists attended. Since then there have been over 40 conferences which the CBA has organised in some way. The largest have been the very successful 'Archaeology and Education' conferences held every two years which regularly attract over 100 participants.

Archaeology Scotland

The Council for Scottish Archaeology was, in 1950, the Scottish Group of the Council for British Archaeology, but in 1988 became an independent voluntary body. Its history and activities up to 2004 are outlined in Henson and Davidson 2004. In 2008 the Council changed its name to Archaeology Scotland.

Archaeology Scotland (AS) has set itself clear objectives, of which the first is 'Education, both formal and informal, concerning Scotland's archaeological heritage' and its first strategic objective for 2009–13 is to 'bring archaeology to a wider audience in Scotland through an expansion of the education and outreach programme' (AS 2010a, 8).

The Education and Outreach Team of AS, which comprises staff and volunteers, supports other organisations in Scotland which are engaged in formal and informal learning, providing practical workshops at public events such as science festivals and environmental fairs and running a local programme of archaeology workshops in both mainstream and special education schools (AS 2010c). The Team provide useful teaching ideas, such as the 'Dustbin Game' and 'Bury a Time Capsule' as well as three 'Artefact Investigation Kits' and guides to simple surveying techniques which are linked to school curriculum subjects (AS 2010d).

AS runs the Young Archaeologists' Club in Scotland and has 12 branches there, supported by the Council for British Archaeology who run YAC in the UK. Since 2006 Archaeology Scotland has been running the Adopt a Monument Scheme (see p. 293) and has 11 active projects on the go (Bradley 2009).

Commission for Architecture and the Built Environment

The Commission (CABE) was founded in 1999 and was the government's adviser in England on architecture, urban design and public space. As part of comprehensive cuts in government funding, CABE was first closed down and then merged with the Design Council in March 2011. It ran a number of campaigns and published advice on improvements to our built environment. For example, one of its strategies up to 2011 was to provide 'advice to help improve the quality of school design to deliver the best possible learning environments for children' as a result of the government's intention to rebuild or refurbish every secondary school in England over the next 15 years (CABE 2010a, 10). It worked with community groups as well as architects, planners, designers and developers. It also had an active education programme with the aim of 'every school in the country having access to high quality, curriculum-linked, educational resources which support teaching and learning through the built environment' (CABE 2010a, 23).

CABE's laudable aims included encouraging young people to understand more about their built environment, question what is around them and demand more and play an active role in making improvements (CABE 2010b). Its campaigns were supported by a regular magazine, an education network to keep teachers in touch and grants to schools. One of their early publications was a really useful guide for primary teachers to help them use the 'ordinary' environment around their schools of their own pupils as an 'extraordinary' learning resource (Williamson and Hart 2004). There was also a range of teaching resources such as 'How Places Work', a teacher's guide to help their secondary school students

understand what makes a place work. A recent major campaign carried out with English Heritage was 'Engaging Places' which encouraged schools to use the whole built environment, from grand buildings to streets, as a teaching resource (CABE 2010c). Research, commissioned by the government, showed a good level of awareness and enthusiasm for using buildings and local places in teaching and that they provided good opportunities for cross-currricular work (Kendall *et al.* 2007).

CABE's work beyond schools included, for example, helping communities improve their own public spaces (CABE 2010d) and 'Spaceshaper' which aimed to get young people from 9 to 14 years old involved in improving the places which they use regularly – local parks, streets and playgrounds (CABE 2010e). Since the closure of CABE an archive of its publications has been created (CABE 2011) but this is no alternative to a campaigning organisation which achieved much of what it had set out to do.

English Heritage

English Heritage is the UK government's adviser on all aspects of the built environment in England. It was established as the Historic Buildings and Monuments Commission for England by the National Heritage Act 1983. It took the public name of English Heritage (EH) when it began work in April 1984. EH reports to the government's Department for Culture, Media and Sport (DCMS), which has overall responsibility for heritage policy in England. In April 1999 English Heritage merged with the Royal Commission on the Historical Monuments of England to become the lead body in the heritage sector.

Education: State heritage education had begun before 1984 under the Department of the Environment with one Education Officer who covered England and Wales. When English Heritage was founded, a Department of Education was created with a Head of Education, four Education Officers and a half post for administration. At this time Education was placed in the newly formed Marketing Department, with the Head of Education reporting directly to the Marketing Director. By 1999 the department had full-time education officers working in each of its nine regions, an officer responsible for further and adult education and an officer based at the National Monuments Record, together with administrative and support staff in the main London office and in its regional offices. By 2005 this number had been reduced to five learning managers and an education officer at the National Monuments Record. In the absence of any serious consideration being given to the strategic aims of education with English Heritage by senior staff, the Education Department, as a team, had written its own mission statement: 'English Heritage Education is the national leader in heritage education. We aim to influence teachers and those involved in education at all levels to make effective use of the historic environment, encouraging active participation, raising respect, understanding and awareness' (English Heritage 1989).

The department set out to promote the whole historic environment to educators rather than confining itself to the promotion of the sites in English Heritage's care. The mission statement was followed by an annual plan which set out targets for its work and educational visit numbers (which later became incorporated into Funding Agreement Targets with the DCMS). It had been the policy of previous

government departments that education visits to the archaeological sites and monuments in the care of the state (about 400) should be free. From 1986 this was extended beyond schools and colleges to other educational groups such as the Young Archaeologists' Club and the Scouting and Guiding movements. However, during the first few years of English Heritage, this free access principle was questioned by some of the Commissioners. The number of pupils and students, with their teachers, coming on free visits to English Heritage sites was increased from 25,000 in 1984 to 405,000 in 2001.

Perhaps the main context in which English Heritage Education operated from 1984 until 2005 was defined by the curriculum. A major part of its policy was to ensure that the historic environment was presented as a vital resource for learning in schools, not just in history but in other subjects, including, at post-16 level, Leisure and Tourism studies. English Heritage Education had a formal relationship with the government's Qualifications and Curriculum Authority, the Department for Education and Skills and, separate from English Heritage itself, with the Department for Culture, Media and Sport.

One of the ways of achieving the mission was to provide resources and services free of charge, wherever possible, or at a subsidised cost. English Heritage Education seized an opportunity to include the historic environment in all National Curriculum subjects and teachers (from pre-school to further and higher education) were supported in four main ways: through resources (see p. 139), teacher training, help beyond the classroom and support for understanding archaeology. English Heritage has often claimed, as here, that 'learning' is central to its work. However, there has always been, from 1984 until today, a tension between caring for over 400 properties, which it presents to the public and increasingly sees as a source of income, and its broad conservation and advisory work in archaeology and the built historic environment. The Peer Review commissioned by the DCMS in 2006 stated this quite bluntly:

Tension between commercial and policy objectives

2.1.17 EH's new commercial and customer-driven approach to its business operations (particularly its property portfolio) has undoubtedly improved their ability to generate revenue.

2.1.18 However internally, the commercial focus of some arms of the organisation – e.g. marketing – can be in conflict with others concerned with the more theoretical aspects of heritage – such as the arm responsible for the collections displayed in the properties. Although both have a role to play, the compromises reached are at times unsatisfactory to both sides.

(EH 2006, 12)

The other tension which English Heritage staff and any of those individuals and organisations were well aware of was the almost constant change of both direction and staff, often caused, possibly, by the inability of the most senior staff to make decisions, from 1984 onwards. The biggest change which affected most of English Heritage and certainly its education policies and strategy came with a new chief executive in 2002. Education was now to be one half of Education and Events with a new director who was promoted from the Events department. A new education policy for schools in English Heritage was to concentrate its work on properties in care of the organisation, to emphasise the importance of 'British' history at a time

when education in the UK and elsewhere, but particularly in Europe, was looking to non-nationalist approaches to learning about and through the evidence of the past. Later the new policy introduced, for the first time, a scheme for charging schools for 'Discovery Visits' where sessions are 'run by costumed interpreters or specialist educators, the sessions include guided tours, role-play and storytelling amongst others' (Anon 2006, 4). There are also 80 'educational volunteers' at 12 English Heritage properties. At the same time an Outreach team was appointed and an ambitious programme was launched in 2003. This team now work within marketing and their work has been refocused from non-properties to English Heritage properties. The new policy of concentrating on its properties also raised concerns for the peer reviewers:

> 3.2.12 English Heritage should change its policy of focusing its education and outreach work on its properties.

> 3.2.13 There is considerable scope for partnership working to extend the range of education and outreach opportunities.

> 3.2.14 EH has the capacity to educate as well as to entertain, and should ensure it continues to produce resources and publications that cater to its varied audiences – from general interest to academic. (EH 2006, 17–18)

Finally, English Heritage's work and policies in education has more recently come under the scrutiny of Parliament's Public Accounts Committee. The Committee was particularly concerned about public access to EH's sites. The Committee chairman, Edward Leigh MP, wrote:

> There was certainly no point in the Department's setting targets to widen participation when it did not know how achievable they were, had little understanding of the different factors affecting participation and had no way of measuring the impact of its own actions or those of English Heritage. This Committee supports the principle that the nation's heritage should be accessible to all. A crucial factor in developing a lifelong interest in historic sites is to be taken to see them as a child. English Heritage should aim to reverse the decline in free educational visits by children to its own sites, establish a way of measuring progress and report back to this Committee by April 2010 on what has been done. Furthermore, the historic environment can be experienced and enjoyed by walking down the street, visiting a local church, watching television or using the internet. Building stronger public support will depend on taking an inclusive approach to what constitutes our heritage and in particular on developing an interest in heritage in children of all backgrounds. English Heritage has assured us that it will reverse the concerning downwards trend in educational visits to its own sites.
>
> (Houses of Parliament 2010a)

The figures presented to the Committee by English Heritage showed a 100,000 decline in the number of free educational visits (Houses of Parliament 2010b) since 2004. In fact the figures are now lower than those achieved in 2001/2 (EH 2009).

Historic Scotland

Historic Scotland (HS) was made a non-governmental organisation in 1984 and an executive agency of the Scottish Government in 1991. It delivers advice and policy on Scotland's historic environment on behalf of the relevant Scottish ministers of the government. It has the same statutory function as English Heritage over scheduled ancient monuments and listed buildings. Like English Heritage and Cadw it has a number of properties which it cares for and opens to the public, at present over 345 ancient monuments and historic buildings.

The broad educational work of HS fits most closely to one of the National Outcomes of the National Performance Framework of the Scottish Government: 'We value and enjoy our built and natural environment and protect and enhance it for future generations' (HS 2010a, 3).

Education: An account of its education work was published in 2004 (Mitchell 2004) but its now more extensive programme achieved 76,000 educational visitors in 2009 with a measured quality satisfaction rating of 98.25% (HS 2010b, 42). The Education Team comprises a head of education, five education officers and three administration staff. Two education officers are based at Edinburgh Castle and Stirling Castle. The other three have a regional remit – a base in the south at Longmore House, Edinburgh, a central base at Stanley Mills near Perth, and a base in the north at Fort George near Inverness. There are also eight Local Learning Officers who work on a freelance basis at sites across Scotland, as diverse as Melrose Abbey in the Borders and the Blackhouse at Arnol on the Isle of Lewis. They work with the learning community to develop and deliver resources and activities for learners of all ages. They encourage regular and repeated use of the sites and their surrounding environment, often with a focus on creative writing and the expressive arts. Two of them have a specific remit for Gaelic language development.

The Team provide an extensive service for schools and the community (HS 2010c). Free educational visits are welcomed at all HS's sites, though two of the most visited are excepted in the spring and summer months. The Team also offers an impressive number of sessions, some of which schools have to pay for across a range of sites and topics, all of which are firmly linked to the Scottish Curriculum for Excellence (see p. 117):

> For Early Years and Primary groups – for example, 'A Day in the Life of a Monk' at Arbroath Abbey, 'Time Detectives' at Caerlaverock Castle and 'Creepy Cathedral Capers' at Elgin Cathedral
>
> For Secondary groups – for example, 'Your Country Needs You' at Edinburgh Castle and 'A Developed Tourist Attraction' at Stirling Castle for Travel and Tourism students. (HS 2010d; 2010e)

Sessions are led by education staff, local learning officers, costumed interpreters or by others with a particular specialism such as art, storytelling or science and technology. Other initiatives include Discovery Sessions for schools to use sites as a focus for a curriculum topic, or can be specifically tailored to the needs of the group and Junior Guide Tours where pupils from local primary schools have been trained to lead school groups around a site. Historic Scotland's Ranger Service, based in Edinburgh, Linlithgow and Orkney, also delivers environmental

education in a heritage context using ancient monuments, the landscape and the shoreline.

Teachers are offered a range of Continuing Professional Development Courses, loan boxes (e.g. the Skara Brae Handling Box for Orkney schools, HS 2010f) and an enormous list of printed resource material which can also be downloaded for free (2010g). All these resources include information, links to curriculum subjects and topics and ideas and activities for use in the classroom and on site – for example, a teacher's book on 'Investigating Abbeys and Priories in Scotland', a long list of books for teachers about individual Historic Scotland site and a series of resource material written for pupils called 'Homework Helpers'.

Historic Scotland also works in partnership with the National Trust for Scotland and the Royal Collections to provide activities for schools and has an outreach programme for primary schools which includes drama, role-play and debate.

Cadw

Cadw, the Welsh word meaning 'to keep', is an appropriate name for the historic environment service of the Welsh Assembly Government. Its functions are broadly the same as English Heritage and Historic Scotland, and it was also founded in 1984 as a non-governmental organisation (Cadw 2010a).

Education: Besides its responsibilities for scheduled ancient monuments and listed buildings, Cadw cares for 127 sites which are open to the public and to educational groups. Of the total number of visitors to Cadw sites in 2008–9 (1,074,817), 8% (86,956) were educational visitors. There were no education staff employed in Cadw from the mid-1990s to 2007. The Education team in 2010 now has three full-time staff, but much of its work is carried out by contracted freelance staff.

Free visits are offered to schools, other educational institutions and formal learning groups. A range of (short) introductions to types of site (such as thirteenth-century castles) and individual sites (such as Caerwent Roman Town) are available to print from the website (Cadw 2010b). New educational resources will be available to download during 2010. Discovery visits are offered to schools at four Cadw sites (sessions have to be paid for). Each involves costumed interpreters leading sessions at Castell Coch, Caerphilly Castle and the Winding House Museum in New Tredegar (the Caerphilly County Borough Museum). Local providers are hired to put on educational sessions.

Other education projects included training teachers at some primary schools on Anglesey to use animation and sound software, storytelling and role-play in schools and a visit to a prehistoric site. The outcome was four films shown at a public event in July 2009 (Cadw 2010c). Storytelling and literacy projects were run in primary schools across Wales and festivals for Adult Learner's Week.

Northern Ireland Environment Agency

The Northern Ireland Environment Agency (NIEA) is one of the agencies with the government's Department of the Environment. It has the remit of providing advice to, and implementing, the government's policies and strategies relating to environmental protection, the natural and built environments. Its work with

the built environment is broadly similar to that carried out in English Heritage, Historic Scotland and Cadw. Two of its stated outcomes in the Corporate and Business Plan for 2009–12 are 'improved conservation and protection of our built environment and better public awareness and understanding of the environment' (NIEA 2010a, 4). NIEA has in its care 185 ancient monuments, 60 nature reserves and 15 visitor centres.

Education: The education service provided to teachers by the NIEA covers all three elements, its remit providing, for example, curriculum resource material on castles, mini beasts and composting. It offers a free visits scheme to all the natural and built sites in its care, with a range of resources for teachers and pupils (NIEA 2010b).

There were 25,748 education visitors to sites which have to be booked by schools in 2008–9. It has a range of printed publications in colour which are all free to download. The resources for the built environment of Northern Ireland include:

▶ *Teacher's books*, such as *Carrickfergus Castle: Information for Teachers*, which has information about the site and its history and educational approaches to a range of curriculum subjects, with photographs, plans and child-friendly artist impressions.

▶ *'Let's Explore'* series of resources for pupils for on-site and classroom work containing information, illustrations, games and activity sheets. 'Let's Explore' series about types of sites (*Anglo Normans in Ireland*) or periods (*Life in Early Times*).

▶ *Factsheets* for teachers and older secondary pupils on historic monuments. (Two counties have been completed so far.)

A separate list of seven factsheets was developed as a result of the government's State of the Environment report 2008. One factsheet is for the built environment. This factsheet has information, links to the History curriculum (primary and secondary), GCSE History and Travel and Tourism Studies. It is also an ideal starting point for teachers in Northern Ireland to introduce the built environment into citizenship studies.

National Trust

The National Trust (NT) was founded in 1895 to help to secure for the nation threatened landscapes, coastlines and buildings in Britain. For example, it bought its first house in 1896 (Alfriston Clergy House in Sussex), two acres of Wicken Fen near Cambridge in 1899 and 1400 acres (566.5 ha) of farmland around Stonehenge in 1927. Since the late 19th century the Trust has gradually acquired an enormous estate:

▶ In 1945 – 112,000 acres (45,326 ha) of land and 93 historic buildings

▶ In 1995 – 580,000 acres (234,726 ha) of land, 545 miles of coast, 230 historic houses and 130 gardens

▶ In 2010 – 627,000 acres (253,747 ha) of land, 709 miles of coastline and over 350 historic houses, ancient monuments, gardens, nature reserves and parks.

Most of the land owned by the Trust is inalienable, that is it cannot be compulsorily acquired by government departments, local authorities or any other agency with the approval of Parliament (NT 2010b). In 1980 Marion Shoard investigated the problems of the countryside in Britain in her seminal book *The Theft of the Countryside* and concluded that the Trust was 'already our "core" countryside' and that then at least it owned '23 per cent of the Lake District National Park among other important acquisitions' (Shoard 1980, 150). These holdings give the Trust the ability to change public opinion about the issues which confront the world today – climate change, the destruction of natural habitats and so on. In 2007 Vidal wrote that 'The National Trust has more members than Britain's main political parties, armed forces, prisoners and teachers combined; now it wants to become the world's most important environmental group' (2007, 9). In fact in 2010 the Trust has a number of groups who can be influenced by its holdings and its activities, beyond its 3.5 million members (NT 2010c). In 2009 it had 100 million visits to its properties and the coastline it looks after, 49,000 NT volunteers, about 5,000 members of staff, as well as about 500,000 school visits to its properties.

Education: A brief outline of the Trust's education intentions for the period 2007–10 is published as *A Vision for Learning* (NT 2010d). Learning includes its visitors and volunteers as well as its formal education programmes at its properties. There are no details about its policies and strategies for its formal education work in its Annual Report for 2008/9 (NT 2010b). It now publishes no nationally based resources for teachers to use. The last that I know of is their resource for sustainable development, *Trust in the Future*, published in 2001 together with the Field Studies Council (Gillingham *et al.* 2001). It is a good resource for primary and secondary teachers, clearly linked to the curriculum and to visits outside the classroom.

The Trust has a regional structure in which education is devolved to the regions, most often to property level where Learning Officers are employed to deliver guided tours and activities for booked school groups, as well as workshops and events for families. There seems to be no requirements for experience or qualifications in teaching for Learning Officers. At present there are 25 learning and interpretation advisers and around 100 staff across the Trust who have some educational remit as part of their jobs. The Trust provides learning opportunities for adults and families as well as for schools.

Schools are offered Education Group membership, which ranges from £32 p.a. for schools with fewer than 50 pupils, to £79 p.a. for schools with over 500 pupils. Although they do not discourage school groups who wish to go on self-guided visits, the thrust of the Trust's provision and resources is based on taught sessions and guided tours which are often delivered by re-enactors as role play or talks. Curriculum links are suggested in the education programmes offered to schools. For example, the programmes which primary school groups might take at Sutton Hoo includes 'Burial Mound Tour', linked to History and English subjects and 'Sandtray Archaeology', linked to Maths. Resources for teachers and students are also provided on their website (NT 2010e) which have been written by local teachers. The Sutton Hoo site has the usual NT shop and small café but also a new interactive exhibition building and a Learning Centre. In line with some other heritage organisations and museums, the National Trust

has developed a range of 'fun' activities, quizzes and games in Tracker Packs, for families with children at many of its sites (NT 2010f) and an article in Primary History gave details about the one used at White Horse Hill in Oxfordshire (Searle 2009).

Conservation education: In my view the more important resource for teachers lies with the countryside and environment section of the Trust's work (NT 2010g). There the teacher will find policies and information about a range of issues and activities from archaeology to conservation, from climate change to trees and woods. Attempts have clearly been made in the past judging from the 2001 'Position Statement on Countryside Education' still available from a former version of their website (NT 2010h). Detailed information (and a national not just regional basis) would allow teachers in primary and secondary schools to make the Trust's conservation work part of curriculum- and evidence-based teaching and learning in a wide range of subjects but in particular citizenship (see pp. 290ff).

National Trust for Scotland

Established in 1931, the National Trust for Scotland (NTS) has similar statutory powers and carries out similar activities to the National Trust but is an independent organisation. It now has 128 properties and 18,780 acres (7,600 hectares) of land. In 2005 it reported that 'over 100,000 young people benefit from specially arranged educational visits' (NTS 2005, 3). The Learning Services Department deals with education, events and interpretation.

Education: Its education staff include two Learning Managers who develop and deliver resources and events while some properties have Learning Managers and Learning Officers who deliver the schools programmes. NTS has a school membership scheme based on the same principles as than the National Trust (NTS 2010). The department organises events, programmes and resources for schools, such as:

▶ *Programmes* at popular sites. For example, at the site of the Battle of Culloden two sessions are offered as a way of finding out about the battle itself through wearing period costume, visiting the exhibition in the visitor centre and going on a guided tour of the battlefield. A further two sessions look at the archaeological evidence for the battle where pupils can do a table top excavation, handle replica and real artefacts, visit the exhibition and tour the battlefield.

▶ *Resources* (teacher's resource pack and activity sheets) are available at a few of the sites to accompany taught sessions offered by Learning Officers and volunteer guides.

Reaching out to the public: informal education

Public archaeology, community archaeology and outreach are now part of the modern face of archaeology. Merriman points out that the first widespread use of the phrase 'public archaeology' was by McGimsey in 1972 (Merriman 2004, 3). The two seminal *One World Archaeology* volumes (Stone and MacKenzie 1990a; Stone and Molyneaux 1994) referred to elsewhere in this book contain numerous

examples from around the world. Merriman's book *Public Archaeology* (2004) has sections on public archaeology in the United States (Jameson 2004) and in Brazil (Funari 2004). Schadla-Hall provides a recently updated assessment of public archaeology (2006).

In the early days of large-scale rescue archaeological excavations in Britain during the 1970s and 1980s, archaeologists were keen to share what they did with local people, by holding open days, using volunteers on digs and giving public lectures. Marion Blockley wrote about involving the public and schools in excavations in Prestatyn in Wales in 1984–86 (Blockley 1986). The change, I think, is that it is taken more seriously now by more archaeologists and more archaeological organisations. Public archaeology is now studied as part of an archaeological degree in many universities and, sometimes, linked to formal education programmes in schools.

Community archaeology

Community archaeology is the term most often used to describe any outreach aspect of an archaeological project but it can mean a number of different types of project and involve a range of 'publics'. The Sandwell Project in the West Midlands followed a pattern of the involvement of school groups as the initial part of a programme which drew in members of the local community (Hodder 1986; Waller 1998). There are many good individual community initiatives by archaeologists but few local or regional archaeological organisations are able to sustain a long term programme of public or educational involvement in their day-to-day work. Part of the problem may be due to a reliance on developer funding for specific archaeological projects which will often exclude community involvement, presentation of the site to the public or, indeed, *any* physical access to the site. Yet there are organisations which have overcome these problems.

The Canterbury Archaeological Trust (see above) has been able to sustain a long term programme of community involvement and Redhead outlined the community involvement in the work of the Greater Manchester Archaeological Unit over the last 20 or so years (Redhead 2005). The Leicester Community Archaeology Programme, pioneered by the county's senior archaeologist, Peter Liddle, has long-established fieldwork groups of local people around Leicestershire and Rutland and an archaeological network of local wardens appointed by parish councils to monitor local archaeology. They also provide talks, tours and field trips and run a branch of the Young Archaeologists' Club. Peter Liddle's book *A Guide to 20 Archaeological Sites in Leicestershire* (1983) provides a useful and unique source of information, with plans and artists' impressions of some classic scheduled monuments in the area. The county's Environment and Heritage Services 'vision' is: 'To play a significant and sustained role in the improvement of local community wellbeing, to protect and enhance the county's environment and heritage, and to improve access to recreational and learning activity and resources, for the people of Leicestershire, its visitors and for future generations' (Leicestershire County Council 2009, 2).

The Museum of London (see case study p. 191) has created community digs which, although they are chosen to answer research questions, are deliberately set up for local communities (including schools) to take part. The Museum of

London has a good record of providing opportunities for young people to take part in excavations (see Fig. 7.11 on p. 198). Today there are a number of community archaeology projects carried out by a wide range of archaeological organisations. The Institute for Archaeologists (IFA) publication, *The Archaeologist*, often contains reports of community work and its yearbook for 2006 included 22 projects, from excavations to fieldwork recording and from presentation to education programmes carried out by commercial organisations, county or local units, national heritage organisations and local societies (IFA 2006, 19–35). Over 1,000 small heritage and archaeology projects, *all* with community involvement, were funded through the Local Heritage Initiative of the Heritage Lottery Fund at a cost of £163m (Heritage Lottery Fund 2005). For example, the Colchester Mosaic Project (see case study pp. 67–8) was funded by the HLF as was a community field survey project in North Yorkshire reported in *The Archaeologist* (Oswald 2007, 20–21). More recently a survey of community archaeology projects in the UK and in the USA showed that the projects provided entertainment and social activities, increased awareness of archaeology and created political interest but were often not sustainable (Simpson 2008, 10–13).

Community archaeology in the United States seems to be more widespread and includes interesting approaches which would easily transfer to Britain and elsewhere in Europe. Derry and Malloy's book *Archaeologists and Local Communities: Partners in Exploring the Past* (2003) cites a number of examples, mainly from the United States. For example, the 'Tour de Digs' was a 60-mile bike trail in Alexandria, Virginia, which took in historic sites 'thus combining archaeological interpretation with recreation and alternative transportation (Cressey *et al.* 2003, 9–10). The authors outline the various steps needed to ensure that community archaeological projects actually work and are also quite clear about why they do what they do – one of its 16 points in its mission statement is, '*Instilling* through heritage resource research and education *a sense of community identity* as well as *enjoyment* and *collective ownership* of the past for all Alexandrians' (Cressey *et al.* 2003, 15).

Inclusion

More and more, archaeologists and society demand that people are not excluded from projects. Museums have been at the forefront in arguing for and making their institutions 'agents of social inclusion' (Newman and McLean 1999; 2002). The Widening Participation case study (see p. 331) makes clear the intentions behind the educational initiatives in the Institute of Archaeology, University College London – to include sections of society which are currently seen as excluded from archaeology. Smith (2003) outlined a number of socially inclusive archaeological projects in two London boroughs. One was with the Hackney Building Exploratory and a local primary school and was designed around the concept of a 'sense of place'. The other was to set up workshops and a stall promoting archaeology as part of the Stockwell Urban Festival in Lambeth.

The Iron Age and Roman town at Silchester in Hampshire has long been investigated by antiquarians and archaeologists. A long-running programme of archaeological excavation and fieldwork is being carried out by the Department of Archaeology at the University of Reading. As part of this project the university runs a summer training school for beginners in archaeology. They encourage

visits from school groups and a resident education officer was funded in the late-1990s by English Heritage Education who introduced schools to the concepts of archaeology on site, encouraged teachers to include the visit in a curriculum-based project in the classroom and produced information for teachers (Planel 1998). The excavators at Silchester were concerned to allow greater access to their work, both virtual and physical access, and in 2003 began the Silchester 'Town Life' project with a £50,000 grant from the Heritage Lottery Fund. The funding (which lasted until 2005) enabled the excavators to remove the financial barriers to attending the summer training school. Most participants in the school were local young people over the age of 16. In addition to the visits from schools there were two open days and the Silchester Funday each season. The 2003 season, lasting six weeks, attracted around 3,800 visitors. Evaluation on the 2003 season, through questionnaires, showed that most of the visitors were White British with no previous archaeological experience and 65% were first-time visitors. This evaluation showed that the free bus to the Funday increased the number of non-White visitors to the site. The project's access officer began to target organisations and institutions who might feel excluded from participating (Stewart *et al.* 2004). The Archaeology Department at the University of Reading conducted research into inclusion over a number of years and has developed guidelines for including disabled students in archaeological fieldwork training (Phillips and Gilchrist 2009; IAA 2010). The Community Archaeologist at Greater York Community Archaeology Project reported on the success of working in partnership with the York Youth Offending Team when four young offenders joined the volunteers working on the excavations in Hungate (Kenny 2007).

Young Archaeologists' Club

One of the big success stories of archaeology in Britain has been the foundation and development of the only UK-wide club for all children interested in archaeology. Dreamt up and founded by the archaeologist Kate Pretty in 1972, it was run by a committee for its first 21 years. In 1987 the running of the club was taken over by the York Archaeological Trust. Since 1983 it has been run from the Council for British Archaeology (CBA) which employs permanent staff to help run the club. The club was originally called Young Rescue and was the youth branch of Rescue, the British Archaeological Trust. Central to that committee were Kate Pretty, Katharine Chant and myself. The club's history has been outlined twice (Pretty 1999; Henry 2004) and the latest information is available online from the CBA (CBA 2010b). The club publishes a regular magazine for its UK members (from 1972), organised annual fieldwork holidays for UK members (from 1975 to 2009), promotes its Young Archaeologist of the Year Award (from 1978 to 2009) and has over 70 local branches across the UK with archaeological activities run by volunteers from a wide range of backgrounds. YAC members consistently tell their leaders that what they really want to do is to excavate although there are few opportunities for this (Dhanjal 2008, 54–60, but see Fig. 4.5). A rare chance to dig, and process finds, was given to the branch at the Institute of Archaeology in London when they visited the University's training dig (see Fig. 4.5). In total there are approximately 3,000 YAC UK and local branch members. YAC UK members receive an annual YAC Pass which allows them free or discounted entry to over 170 independent heritage sites as well as deals with all the national

Fig. 4.5 YAC members enjoying real archaeological excavation at the Institute's training dig at West Dean in West Sussex. Excavating with groups of young people requires a higher than normal level of supervision by archaeologists, as here.

heritage bodies and a range of companies such as the British Museum Press, the Adventure Company and the Professional Association of Diving Instructors!

In the early days, one of the committee's bright ideas was to persuade working archaeologists to open up their sites to Young Archaeologists – to work on and to visit. The first list, negotiated through the Council for British Archaeology's 'Calendar of Excavations', was published in 1973. The first family activity day was organised with the London and Middlesex Archaeological Society in 1979 and in 1981 the first Action Days were launched where five sites agreed to put on activities for families. This was followed by National Archaeologists' Day in 1990 and National Archaeology Day in 1992. It was so popular that it became two days the following year (Henry 2004, 93). From Young Rescue's small beginnings in public outreach, the Action Days became first National Archaeology Week and now the Festival of British Archaeology. In 2007 National Archaeology Week had 395 different events and activities which included: 182 for families, 24 working on real archaeological excavations and 78 giving hands-on experience in techniques such as finds work and surveying.

In 2009 the Festival of British Archaeology had 560 events, which included 255 for families, 45 archaeological excavations to visit and 124 giving hands-on experience in techniques such as finds work and surveying (including five real digging opportunities and 14 mini or simulated digs).

Summary

▶ Attempts were being made to popularise archaeology from the 18th century.

▶ The first steps to introduce archaeology into formal education were made in the early 20th century followed by more intensive campaigning after World War II.

▶ The 1980s saw a rise in the services and resources offered by campaigning groups, non-governmental heritage organisations and academic bodies.

▶ More effort is being made now by archaeological organisations to involve the public in community schemes.

▶ The Young Archaeologists' Club has proved itself an important means of involving young people in archaeology.

Conclusions

Formal and informal archaeology and education projects in the UK come from a long tradition of enthusiastic antiquarian studies and a long public interest in the past. Archaeologists began to suggest archaeology as a formal school subject in the early 20th century. This has never been achieved and, indeed, that may not even be desirable. Other chapters in this book demonstrate that archaeology *is* part of school history curricula, its support learning materials and a common feature in museum and site programmes for school and family groups.

Campaigning is, or rather should be, an essential part of any archaeological organisation's work, from local archaeological groups to state-funded heritage organisations. There is demonstrable support for education from archaeologists. Many units have set up education programmes and published resources for

teachers on their own initiative because they believe this is what they *should* do. The outstanding organisations in the UK are the Council for British Archaeology and its counterpart in Scotland, Archaeology Scotland – their influence on teachers, archaeologists and the government cannot be underestimated.

National archaeology and heritage organisations have all supported archaeology in formal and informal education. Naturally they have done this in their own ways and some have made more effort and had more effect, both nationally and locally than others. From the 1980s onwards the trend, led by English Heritage, was to invest in resources for teachers and in training teachers to make their own use of the greater historic environment with their own pupils. They could then make curriculum-based visits to and projects about local as well as visiting famous monuments a coach ride away. The trend now is to provide sessions for school parties, as many museums do, at a few 'important' sites and to ignore the rest of the historic environment. Sometimes what passes for an on-site session is for pupils to be talked to by a man dressed as a Roman centurion while the teachers stand at the back.

The next chapter discusses the place of archaeology in world curricula. It includes a study, or perhaps a warning to others, of the sometimes bizarre history of the establishment in England of National Curriculum History.

5 Archaeology in School Curricula: a World View

Archaeologists everywhere bemoan the fact that archaeology is not a regular school subject – and we are right, but only up to a point. But we must not confuse the absence of the *word* 'archaeology' with the concept and practice of evidence-based learning in the teaching of history in schools.

This chapter investigates the way national curricula in a number of countries treat the subject of history and how some manage to incorporate archaeological evidence into their history curricula. Until relatively recently the UK did not require its schools to follow a state-written national curriculum. All the constituent countries in the UK now have their own unique curriculum. The English National Curriculum was the first to be created, and the story of the history curriculum is told here.

Archaeology is included in various curricula but it often needs to be teased out by archaeologists and heritage managers who should deconstruct the curriculum if necessary, certainly provide resources and promote it – especially to the teachers themselves who often do not know that it is in the curricula they are required to use. Another problem for archaeology is that where curricula are set by the state, evidence-based learning may not be available to all the nation's children. Podgorny, for example, notes that archaeology was mentioned in the syllabus of only one province in Argentina (2000, 152). In the USA it is each state government which is responsible for education which provides oversight and guidance to local school boards and sets broad policies for school curricula and textbooks (International Affairs Office 2010).

National curricula

National curricula for schools are common across the world. But governments, or government-appointed educational bodies, have different views about what constitutes a national curriculum and its underlying philosophy. Examples of two recently published national curricula illustrate this point. The Finnish National Board for Education explains it as: 'The underlying values of basic education are human rights, equality, democracy, natural diversity, preservation of environmental viability and the endorsement of multiculturalism. Basic education promotes responsibility, a sense of community, and respect for the rights and freedoms of the individual' (FNBE 2004b, 7).

In 1995 the South African government began to develop a new curriculum for schools to address:

> The scale of change in the world, the growth and development of knowledge and technology and the demands of 21st Century required learners to be exposed to different and higher level skills and knowledge than those required by the existing South Africa curricula. Second, South Africa had changed. The curricula for schools therefore required revision to reflect new values and principles, especially those of the Constitution of South Africa.
> (Education Department of the Republic of South Africa, 2008, 2)

Some countries are content to define their views about the role of education in their societies, leaving the schools or their teachers to decide what they should teach their pupils. Others take a more authoritarian point of view and impose a detailed curriculum, sometimes specifying the number of hours to be given to the various aspects of each subject. This type of curriculum tends to overload both teachers and pupils, leaving little or no time for new subjects or initiatives. Creating a new curriculum can be a painful process, especially for teachers (see the English National Curriculum below). Politicians and government bodies tend to dominate the thinking and the process. Bognár explained that the original new core curriculum for Hungarian schools in 1995 'devoted much attention to the so-called cross-curricular areas: communication, health education, information and communication technology, technical/practical skills, environmental protect etc.' (Bognár 2006, 45) but that a change of government in 1998 brought in a new regulation in 2000 which 'reverted to the traditional prescription of educational content along the lines of individual subjects, specified the compulsory number of lessons in each subject, and maximised the daily workload of students' (Bognár 2006, 52). Regular changes to the curriculum and the structure of education is also something that many governments impose on teachers and their students. The history of the English National Curriculum is a case in point and is discussed below. In Finland, too, regular but more thoughtful and less frequent core curriculum changes have occurred in 1975, 1985, 1994 and 2000 (Halinen 2006).

Defining history

National curricula tend to cover only those subjects which a state deems to be right, or sufficient, for its schools. Although it is possible to consider the place of archaeology and prehistory in a range of subjects (see p. 149), history is the most relevant and the most important to consider. However, a society's definition of what constitutes history will, inevitably, define what history teaching in schools actually is:

> The aims and objectives for school history are broadly the same everywhere in Europe. Almost everywhere we can find that history education is supposed to enhance citizenship, democracy and critical thinking skills and should help students to understand the world they live in. During the last decade these aims have gained much ground, whereas the traditional aims of strengthening national identity and patriotism have lost their prime position to the purpose of history in the curriculum.
>
> (Leeuw Roord 2004, 22)

It is, perhaps, this link between history and citizenship that often includes history as part of social studies in national curricula. Generally in the USA, for example, social studies may include geography, ethics and religion as well as history. In Sweden history is part of social studies alongside geography, religious education and civics. Up to the introduction of the new National Core Curriculum in Finland in 2004, history and social studies were taught together.

A view from South Africa

What is the purpose of history?

A study of history builds the capacity of people to make informed choices in order to contribute constructively to society and to advance democracy. History, as a vehicle of personal empowerment, engenders in learners an understanding of human agency, which brings with it the knowledge that, as human beings, they have choices, and that they can make the decision to change the world for the better.

A rigorous process of historical enquiry:

> encourages and assists constructive debate through careful evaluation of a broad range of evidence and diverse points of view

> provides a critical understanding of socio-economic systems in their historical perspective and their impact on people

> supports the view that historical truth consists of a multiplicity of voices expressing varying and often contradictory versions of the same history

(Education Department of the Republic of South Africa 2008, 7).

History in the curriculum

In the past little research has been carried out on the place of history in European schools, but a review by Cooper drew on her own work and Council of Europe (CoE develops Europe-wide common and democratic principles) seminars in the 1990s show which historical periods were being studied by six-year-olds and ten-year-olds in England, Finland, Greece, Holland and Romania (Cooper 2000a, 167–9). Six-year-old pupils in Greece and Holland were more likely to study prehistory than in the other countries, while in Finland and England prehistory was the topic for ten-year-olds. Cooper also showed that the sources of evidence for learning history were most likely to come from visits, closely followed by books. However recent research (over 44 countries) carried out by Euroclio – the European Standing Conference of History Teachers' Associations (Leeuw Roord 2004) shows in general: that history begins to be taught at school when pupils are ten years of age but that some countries consider it to be an important subject for even the youngest children; that studying history is assumed to enhance students' understanding of democracy and citizenship, and critical thinking skills; that 'traditional' teaching methods and a chronological approach have declined but are still strong in many countries and that, during the period for the research (1989 to 2003), only a few countries in Western Europe have exercised more control over the history curriculum than they did previously. The countries are Iceland, Sweden, England, Wales and Northern Ireland and Italy.

Georgescu showed how the 'traditional' and 'modern' curricula differ, partly quoted below:

Table 5.1 After Georgescu 2006, 88

'Traditional' curriculum	*'Modern' curriculum*
Focus on inputs	Focus on outputs and learning outcomes
Focus on teacher and academic subjects	Focus on learners
Subject-divided and subject-driven	Defined through broad learning areas and cross-curriculum approaches
Rigid in structure and centralised	Flexible in structure and time allocation
Excessively directive and central ised	Allows for flexibility, based on different types and levels of local autonomy in the framework of some common principles and quality standards

Governments tend to control *what* children are learning and *how* teachers are teaching. Control is usually exercised in three ways:

▶ by issuing statutory documents to schools which set out the periods to be covered in the history curriculum;

▶ by giving statutory instructions to history teachers on how they may teach the subject and help students to develop skills and understanding;

▶ by the state issue or authorisation of textbooks which may be out-of-date or politically biased.

Periods covered in national curricula: The common feature of history curricula across the world is the requirement for the study of both national and world history, although governments usually put more emphasis on and insist on more time being devoted to national history. For example, the California state curriculum for History-Social Science (CDE 2005) requires the study of American history (and related subjects, see below) in six grades and world history in three grades. In the English history curriculum, eight sections are devoted to the history of the United Kingdom and three to world history (DfEE/QCA 1999a; 1999b) and even this split was the cause of great controversy (see below). European countries will often stress the need for school children to understand that they are living in a European community. In the Hellenic Ministry of Education, Lifelong Learning and Religious Affairs included this statement as one of its priorities for teachers: 'To assist the development of European awareness, while preserving national identity and cultural awareness' (HELR 2003, 10).

Developing skills and understanding: Increasingly statutory national curricula are being revised to include instructions for teachers in order to help them develop historical skills and understanding. For example, the Finnish curriculum published in 1994 listed five single-sentence objectives for the study of history and social sciences (FNBE 1994, 115) in a document comprising 125 pages. The curriculum document revised in 2003 was 261 pages long; history and social studies are separate subjects, much more instruction is given about objectives as well as outlines of each period covered (FNBE 2004a, 180–6) giving 'strong guidelines' to teachers (Halinen 2006, 73).

The power of the textbook: The question of textbooks is difficult where the state requires *only* the use of state-approved textbooks (see also the Turkmenistan

case study p. 261). State textbooks and state control are discussed in the Euroclio report (Leeuw Roord 2004) and in several articles in Stone and MacKenzie 1990a: 50–60 (dealing with the political manipulation of history in Venezuela), 99–108 (apartheid distorting the past for South Africa's pupils), 252–61 (archaeology and prehistory marginalised in Polish primary schools and museums); Roberts 2004, 140–60 (the changing nature of school textbooks in Poland, Russia and Serbia since 1989); Stone and Molyneaux 1994, 326–37 (archaeology in schools and museums in Cameroon), 398–407 (the representation of ethnic groups in school textbooks in Colombia) and by Phillips 2000, 10–23 (the relationship between the state and history teaching and curricula in Britain). However, most teachers welcome, and in many countries are encouraged to use, both additional resource materials and the opportunity for themselves and their pupils to take part in interesting projects – whether or not the period in question is part of their national curriculum history (see Finnish case study p. 317).

Is school history a problem for prehistory and archaeology?

One of the problems is that history is too often defined in its narrowest, though traditional, sense – that is the period in the past for which written evidence is available. But prehistory represents over 99% of human activity, during which world-changing discoveries and advances were made. Nevertheless, if a society considers prehistory to be less important, say, than studying 20th-century history, then this vital subject will not figure as an important part of a child's education. Research carried out in 1993 'identified that books used in Turkish primary education describe prehistoric periods in 120 words, and Anatolia's prehistoric heritage is discussed in 15 words – that is, 400,000 years of history in a total of 135 words' (Doughty 2007, 140).

Another problem is the position of history in the whole curriculum. In England, history is just one of a number of subjects which have to be taught in schools. Government-issued documents apparently give equal weight to most school subjects. But there is a subject hierarchy in England which makes English (and literacy), maths (and numeracy) and science more important for pupils to learn. The problem may be overcome by accepting and implementing three propositions.

A broad view of the past: education authorities and governments must adopt the broad view of the past which does not exclude periods arbitrarily. There is a problem with a 'starting date' for history teaching and an 'end date'.

> There are vast areas of the study of the past that are almost totally ignored in school curricula. In Europe the prehistoric past is relegated to providing a starting point for what is regarded as 'proper' history. The past is only considered worth studying at the point when 'civilisation' has developed.
> (Stone and MacKenzie 1990b, 2)

Kasvikis *et al.* (2007, 130–2) show us that the myths, gods and the architectural glories of ancient Greece constitute the most important parts of the history curriculum and, therefore, the state-approved textbooks. But at least prehistory forms part of teaching in Greek primary and secondary schools. English students are denied this opportunity (see below p. 122) yet their nearest neighbours in the British Isles, in Wales, Scotland and Northern Ireland, are required to study the

prehistoric periods of their countries. Other countries, too, do not see prehistory as a problem area for students. In Finland, for example, in the compulsory course called 'Man, the Environment and Culture', students in upper secondary schools start with the Palaeolithic world (FNBE 2004a, 181).

The 'end date' problem is more widespread. Just as society in general is confused about where history 'ends', so education authorities are inclined to define which period or date students should reach at the end of their history teaching. For example, for a time in National Curriculum history in England the government required that teachers should not cover the last 20 years (see below p. 120). In China, 12–15-year-olds study history from the earliest humans to the end of the Cultural Revolution and 15–18-year-olds from the Opium Wars to 1999.

Evidence-based learning: Evidence-based learning of all periods of the past must be encouraged. Although the Euroclio research showed that active methods and teaching to enhance critical skills is on the increase, there is still an over-reliance on traditional teaching methods and textbooks. While many countries talk about innovative approaches, the research shows that there is often a gap between curriculum requirements and classroom practice. Seven years after the new National Minimum Curriculum was introduced in Malta, doubts remain 'whether the analytical thinking skills that history – including prehistory – teaching can impart to young students will be allowed to flourish and develop' (Vella *et al.* 2007, 137). However, examples do exist of states encouraging the study of evidence-based learning. In France, schoolchildren aged 9–11 are required to study prehistory through the use of local sources:

> By relying particularly on local resources, it is possible to move nearer to prehistory through the traces that it has left behind. This can be achieved by studying the way in which they have been discovered and interpreted and the places where they have been preserved (sites, human remains and animal fossils, tools, wall paintings and carvings). (CNDP/Xo 2002, 208)

Planel (2000, 147) explained that some French schools use residential visits to sites and experimental archaeology centres to introduce archaeology and evidence to their students. In Greece 6–8-year-olds should 'learn how to recognise and investigate historic evidence (e.g. pictures, photographs, movies, TV programmes, plays, songs, written texts, museum exhibits or copies, oral evidence, buildings and landscapes etc)' (HMER 2004, 7). In Italy 11–14-year-olds should be able to use different kinds of historical evidence including those from archaeological sites (MPI 2007, 85).

In England, the history curriculum *requires* the study of a range of sources, although visits are not obligatory. The statutory curriculum, published jointly by the Department for Education and Employment (DfEE) and the Qualifications and Curriculum Authority (QCA) (DfEE/QCA 1999a; 1999b) specifically listed 'artefacts, historic buildings and visits to museums, galleries and sites' in its non-statutory examples of ways the teacher may help historical enquiry as part of a pupil's learning, from the ages of five to 14 years. The California Department of Education provides a good example of a carefully thought through public schools curriculum, showing the clear input of classroom teachers and teacher trainers, as well as other educationalists. Their *History-Social Science Framework* has

been prepared to help teachers deliver the statutory curriculum. The *Framework* contains three categories:

> Knowledge and Cultural Understanding, incorporating learning from history and other humanities, geography, the social sciences;

> Democratic Understanding and Civic Values, incorporating an understanding of our national identity, constitutional heritage, civic values and rights and responsibilities;

> Skills Attainment and Social Participation, including basic study skills, critical thinking skills, and participation skills that are essential for effective citizenship. (CDE 2005, 10)

The *Framework* explains how teachers may help their students achieve Historical, Ethical, Cultural, Geographic, Economic and Sociopolitical Literacy. For example, 'Students should learn that historical events usually have multiple causes and effects and that historical interpretation of these causal relationships is open to change' (CDE 2005, 13).

Curricula documents in other countries also bring out this important point about the various interpretations of the past. For example, a requirement in Finland for 11–12-year-olds in history is 'to familiarize the pupil with the nature, acquisition, and basic concepts of historical knowledge' and that pupils will 'know how to distinguish fact from opinion' and 'know how to distinguish a source from an interpretation of that source' (FNBE 2004b, 169–70). In England 5–7-year-olds 'should be taught to identify different ways in which the past is represented' (DfEE/QCA 1999a, 104). In France 6–7-year-olds 'have to be able to be curious about the traces of the past, and interpret them with the teacher' (CNDP/Xo 2003, 115). In New South Wales one of the outcomes in the mandatory history syllabus expects 10–15-year-olds to 'recognise different perspectives about individuals, groups, events and issues, with some guidance' (Teaching Heritage 2010).

How well this key element of learning history is taught is questioned, at least in England, by a government report from schools' inspectors, *History in the Balance*, which found that: 'One required skill, "interpretation" (which deals with how the past is represented and interpreted in different ways), is barely developed at all' and schools should 'give pupils opportunities to explore how history is used and presented in the modern world by the media, tourist and heritage industries' (Ofsted 2007, 9, 34).

The chronological approach: Most countries have adopted the chronological approach to teaching history; that is from the earliest to modern times. The problem with the traditional chronological approach is that it can require very young children to study the earliest periods of human history and never revisit prehistory. However, a spiral or concentric curriculum allows particular periods to be studied again when pupils are older, perhaps from a different point of view. Another way of mitigating against this approach is to adopt both the study of periods and topics or themes.

The Irish Republic has teaching areas at primary level in which History is part of Social, Environmental and Scientific Education, together with Geography and Science. Teachers are required to help children acquire of range of historical skills (such as 'using evidence') but through a number of 'strands':

Myself and my family

Story

Early people and ancient societies

Life, society, work and culture in the past

Eras of change and conflict

Politics, conflict and society

Continuity and change over time (NCCA 1999a).

In the very useful, teacher-friendly guidelines it is stated quite firmly that: 'The teaching of historical topics in a strictly chronological manner is not recommended in the curriculum because [for example]: a strictly chronological study from the Stone Age to the present does not necessarily guarantee that children will acquire an understanding of the relative periods involved' and the guidelines recommend, for example, that: 'children's historical work begins with their own past and that of their family and community' (NCCA 1999b).

In Scotland history is included in Social Studies divided into three areas:

People, past events and societies

People, place and environment

People in society, economy and business

 (Learning and Teaching Scotland 2010a).

Scottish teachers use a number of 'curriculum outcomes and experiences' to plan their teaching and assessment in history – for example, 'I am aware that different types of evidence can help me to find out about the past. By exploring places, investigating artefacts and locating them in time, I have developed an awareness of the ways we remember and preserve Scotland's history' (LTS 2010b).

Some countries, for example England and France, despite taking a broadly chronological approach to history, have included local history in the curriculum, which allows teachers to approach the past in a different way.

The development of the curriculum in England

Although there had been a few monastic schools in England in Anglo-Saxon times (as well as those during the Roman occupation of Britain), many were closed during the Reformation. At this time, in the 16th century, charities were set up to provide 'petty schools for the children of the poor but especially grammar schools for the sons of the better off' (Lawson and Silver 1973, 104). Schools at this time had a curriculum which in petty schools focused on teaching spelling and reading and in grammar schools included a range of subjects – reading and writing; some, but not much, arithmetic; Latin; classical history and mythology; geography and rhetoric. Girls were less fortunate in this century (as in other centuries and other cultures) – poor girls could attend petty schools but often did not, rich girls were educated at home. By the 17th century, parish schools were widespread in England and along with it the standard subjects of Reading, Writing and Arithmetic. Late in this century the Society for the Promotion of Christian Knowledge began to found a number of charity schools. A recommendation to the Board of Trade in 1697 saw the introduction of workhouse schools and

the General Workhouse Act of 1723 meant that many poor children began to be taught.

The 19th century saw a significant increase in education in England and the beginnings of a formalised, but not statutory, curriculum in schools founded by religious organisations, the 'ragged school' movement and industrial schools (for vagrant children). The Sunday School movement, which began in the 1780s, allowed working class children to receive an education on the day when their labour was not required in the factories and by 1787, 69,000 children were enrolled in over a thousand Sunday Schools. By 1818 the number had risen to 18,000 schools teaching about 500,000 children (Midwinter 1970, 20). By 1851 there were 2.4 million children enrolled (Lawson and Silver 1973, 281). The population in England and Wales in this year was 18 million.

The Education Act of 1870 created the opportunity to build secular day schools all over the country. School Boards were established in most districts (about 2,500 between 1870 and 1896) and built public elementary schools, many of which still survive today as primary schools (see Fig. 5.1). Later Acts of Parliament put education on a more secure footing: the 1902 Education Act established uniform administration and extended secondary schooling; the 1918 Fisher's Education Act abolished fees in state schools; and the 1944 Education Act which laid down a statutory duty on Local Education Authorities to make adequate provision of primary and secondary schools.

Fig. 5.1 Holland Road Junior School, Essex, in 2010. The carved stone plaque records the building of the school by the Clacton Urban District School Board in 1903 and lists all seven members of the board, the clerk, the architect and the builder. It was originally called Holland Road Schools as it had 360 mixed pupils (senior and junior pupils) and 200 infants. It is now Holland Road Junior School. Many board schools built after 1870 were designed in the Queen Anne style in red brick, sometimes with terracotta or stone ornament and prominent shaped or 'Dutch' gables, as here. Large white painted sash windows were also a feature, allowing better light into the classrooms and halls.

The school curriculum

Although it is possible to find references to the various subjects taught in the past (see above), there was no officially agreed curriculum which applied to all schools. The New Code, introduced in 1879, set out what each child should know in Reading, Writing and Arithmetic in Standard I (6-year-olds) to Standard VI (11-year-olds). Other regulations forced schools to allow a certain number of hours per week for teaching particular subjects – in 1904, for example, four and a half hours were specified for English, History and Geography. The introduction of the School Certificate in 1917 partly defined what subjects had to be taught, as did examination syllabuses later on. The philosophy and practice of a school curriculum was discussed, of course, and in 1964 the then Department for Education and Science set up the Schools Council for the Curriculum and Examinations. It was not until 1988 that the British government decided to set up a statutory National Curriculum for all state primary and secondary schools.

National curriculum history

The first national curriculum in Britain was born with the passing of the Education Reform Act 1988. The complex history of the establishment of this national curriculum has been published in detail (Graham with Tytler 1993). The authors pull no punches in criticising both the process and the personalities involved. Working groups for each subject were set up in 1988 and each subject report was subjected to fierce criticism and lobbying, but no subject more so than history (Corbishley 1999a; Phillips 2000). This was written about the formation of the group for history:

> They [the government] did not want pressure groups operating within the working group or to end up with a report which would cause political embarrassment as had happened with mathematics and English. The appointment of Commander Saunders Watson, a former chairman of the Heritage Education Trust and owner of Rockingham Castle in Northamptonshire, to chair the group was extraordinary. He appeared to be an eccentric choice inspired by Baker [then the Secretary of State for Education] after the two men had met at a reception and found they had a mutual interest in history. Saunders Watson's only obvious credentials were that he ran a stately home which was used by many schools and as a result had a keen but practical interest in history and education.
>
> (Graham with Tytler 1993, 64)

Other members of the History Working Group seemed to also have been appointed with as little thought. One member, in answer to a question at a public meeting about the absence of prehistory in the draft proposals, said that this was not surprising because 'prehistory was the time before man'. But before the group was formed, the Council for British Archaeology's Schools Committee (I was a committee member) decided to publish its own National Curriculum for Archaeology. We did not seriously expect to see archaeology as a discrete National Curriculum subject but we were concerned, together with others who wanted an evidence-based curriculum, that our point of view should be seen and that the new history curriculum would not be defined exclusively by secondary history

teaching, based as it was then, almost exclusively on documentary evidence. We wrote:

> Archaeology is the study of past human societies from the study of material remains. The definition of material remains is not restricted to those objects dug out of the ground; it includes any physical evidence which is below the surface of the ground or water as well as above ground. Archaeologists use written evidence to help their research as well as comparative modern material. (Council for British Archaeology 1989, 3)

The proposals went on to argue the case that archaeology introduces the belief that a society needs to understand its past; presents a view that archaeology is about citizenship; insists that understanding must be based on evidence; and can give pupils useful life skills.

By June 1989 the History Working Group sent its Interim Report to the Secretary of State for Education. It did establish that pupils needed to study a wide range of evidence and even said that visits should form a 'central part of the history curriculum' but the Group's members restated what some would call the old 'hand-maid of history' view that 'archaeology offers valuable assistance to school history' (DfES and Welsh Office 1989, 81). While much of the report was sensible and acknowledged the good work already done by teachers of history in primary and secondary schools, the absence of prehistory in the curriculum was unforgivable.

This Interim Report produced howls of protest from all sides – teachers and other educationalists, archaeologists, historians and those working in the heritage. In 1990 the Group produced its final report after consultation. The government did not like the 1990 report and the new Secretary of State for Education, John McGregor, sent it off to the Schools Examination and Assessment Council for a second opinion. More emphasis on dates and 'facts' were required and more British history. The Prime Minister, Margaret Thatcher, was said to have her own set of historical 'facts' which she wanted to see included. Finally in 1991 the government issued the *Order for History* which now had an added section which stopped 14–16-year-old pupils being taught any history of the last 20 years – added by yet another new Secretary of State for Education, Kenneth Clarke: 'Clarke had taken the gravest exception to history including present day events. This was not history, it was current affairs. Clarke, it appeared, was quite convinced that teachers could not be trusted to teach modern history in an even-handed way' (Graham with Tytler 1993, 69).

Some of us thought at the time that this effectively stopped any discussion in schools of aspects of the Tory government such as the miners' strike of 1984–5. The teaching of history was now considered to be highly political. Phillips quotes the angry comments from some members of the House of Lords and some newspapers, while the Labour opposition party called for a debate on this issue in parliament and the Historical Association forcibly argued that 'The Gulf Crisis, the Common Market, changes in the Welfare State and the coming general election all depend on a good understanding of the recent past for people to make sense of them' (Phillips 1998, 106).

The basic argument, I think, was to do with a view held by many people in authority that schools were about teaching facts and passing off opinions as indisputable rather than pupils learning from evidence and questioning opinions.

Each stage in the creation of the history curriculum has caused howls of protest which were, in summary:

▶ from teachers who have consistently complained about the amount of paperwork involved and the number of historic periods the students are expected to cover;

▶ from politicians that the curriculum is not 'British' enough and that history must be 'fact-based';

▶ and from newspapers that 'new' teaching methods simply 'dumb down' the subject.

In May 1994 the London *Evening Standard* (May 1994) told its readers: 'The teaching of history has to be based on imparting facts. Without the basic framework of constitutional and political history – that is to say, kings and queens, battles and parliaments – even a rudimentary understanding of the subject is not possible' and went on to accuse 'the people who drew up the curriculum' of:

> recommending a curriculum which is heavily dependent on social trends, economic development and non-European cultures. One knows, of course, what this will involve: imaginative compositions about home life of Anglo-Saxon villagers, coloured drawings of the domestic implements of medieval Londoners, subjective accounts of his experience as a young protester at Peterloo ... Of course it's much easier to let children speculate about everyday life in the remote past than to teach them, say, about the Reformation. (Evening Standard 1994, 9)

What they might more simply have written was 'We want teachers to tell children facts and make them memorise them (just as we did at school)'; that is teaching, not learning.

National Curriculum History was revised in 1995. In 1998 the next government decided that primary schools needed to concentrate on literacy and numeracy and could choose whether to follow the National Curriculum requirements in design and technology, history, geography, music, art and physical education. This order was to last two years. In 2000 the newly revised curriculum appeared. In history there was less for the pupils to get through and, unfortunately, it was no longer compulsory for history to be taught from the age of 14. Each subject is set out in a uniform way for both primary and secondary schools (DfEE/QCA 1999a; 1999b) in two parts. 'Knowledge, skills and understanding' has five areas specifying what has to be taught at each stage. In history these are:

▶ 'Chronological understanding' – putting events, people and places in periods, using dates and correct terminology;

▶ 'Knowledge and understanding of events, people and changes in the past' – features of different periods and societies, changes over time;

▶ 'Historical interpretation' – recognising the different ways the past has been, and is, interpreted;

▶ 'Historical enquiry' – using a range of sources to enquire about, ask questions, select and record information about the past;

▶ 'Organisation and communication' – organise historical information, use historical vocabulary, communicate in a variety of ways.

The second part, 'Breadth of study', specifies which periods of history should be studied, which covers large areas of British history, both local and national, mostly confined to the periods between the invasion of the Romans to the 20th century, but there are some requirements to choose studies of European and World cultures.

The government, through its Qualifications and Curriculum Authority, issued advisory guides for teachers, called Schemes of Work, which promote evidence-based teaching and visits to historic sites. For example, for primary schools the history Schemes of Work include 'What were homes like a long time ago?' (QCA/ DfEE 1988) and for the curriculum subject of art & design 'Visiting a museum, gallery or site' (QCA/DfEE 2000), which provides teachers with specific guidance on using a visit to develop ideas and skills in using objects from the past, both in the classroom and on the visit itself.

All change ... again

In 2007 the government issued a consultation document which suggests changes to all National Curriculum subjects.

Primary curriculum: A major review of the primary curriculum began in 2008 and the outcome is a New Primary Curriculum which is to become statutory in 2011. This new curriculum has three broad aims which 'should enable all young people to become':

successful learners who enjoy learning, make progress and achieve;

confident individuals who are able to live safe, healthy and fulfilling lives;

and *responsible citizens* who make a positive contribution to society
(QCDA 2010a).

Replacing the curriculum subjects are six 'areas of learning'. History is part of the area called 'Historical, Geographical and Social Understanding' (which some teachers might remember as Humanities). Each learning area has specified 'Skills' and 'Elements of Knowledge'. Teachers are encouraged to use the various statements and documents to create their own curriculum to meet the needs of their children.

Luckily for educators in archaeology and museums there is much left from the previous curricula. The skills children are expected to acquire include undertaking investigations (e.g. through visits to 'historic buildings, museums, galleries and sites' and studying artefacts) and making interpretations from different types of evidence, for example. The 'Breadth of learning' 'should include aspects of local, British and world history' and 'children should study the past in outline and in depth, covering different societies and periods of history from ancient times to modern day' (QCDA 2009, 4). Previous history curricula had always specified which period of history had to be taught – for example, the Romans, Anglo-Saxons and Vikings in Britain for 7–11-year-olds.

Secondary curriculum: A new secondary curriculum was published by the government in 2007 (QCA 2007) and implemented at the beginning of the new school year. It aimed to create a more coherent and less prescriptive curriculum as a whole but the subjects were slimmed down to allow teachers to create their own curricula, similar to primary schools. Key concepts of this new curriculum were to identify 'the big ideas that underpin the subject' for 11–14-year-olds.

History now contains six 'Key concepts' – 'Chronological understanding, Cultural, ethnic and religious diversity, Change and continuity, Cause and consequence, Significance, Interpretation' (QCDA 2010b, 112–13). The 'Key processes' identify the skills needed for these young historians: 'Historical enquiry' for example, 'reflect critically on historical questions or issues'; 'Using evidence' for example, 'use a range of historical sources, including ... artefacts and the historic environment'; 'Communicating about the past' for example, 'using chronological conventions and historical vocabulary' (QCDA 2010b, 114).

This new curriculum for history really differs from the previous one in the section called 'Range and content'. Previous curricula, back to the first discussions in 1989, always specified exactly which periods of the past had to be studied at which stage in school. History for 11–14-year-olds meant that they had to study Britain in the period 1066 to 1900. The new curriculum requires teachers to teach history 'through a combination of overview, thematic and depth studies', while 'all pupils should be taught aspects of history, including [for example] the development of political power from the Middle Ages to the twentieth century'. 'Range and content' includes British history and European and world history' (QCDA 2010b, 115).

Summary

▶ National curricula are common throughout the world.

▶ Most countries define in detail which periods of the past have to be studied and, increasingly, insist that schools develop pupils' skills and understanding in learning about history.

▶ Many countries still require teachers to use state-approved textbooks.

▶ The first National Curriculum was introduced into the UK in 1988 and has been altered several times since then. Curricula in the constituent countries of the UK have developed in different ways.

▶ Archaeology is not a recognised curriculum subject but may be introduced into history teaching.

Conclusions

The importance and rank of each subject in national curricula will naturally vary from country to country. Many curricula are well thought through, clearly reflecting the dialogue the state departments of education have had with ordinary teachers. I used the example of South Africa because I felt that its history curriculum expressed the purpose and importance of history to the nation extremely well.

In the UK the purpose of history in relation to the National Curriculum was discussed prior to its establishment in 1988. It has been rediscussed by each new government at regular intervals, sometimes several times during their periods of office. Having said that, the use of archaeological and historical evidence is now firmly part of the way history teachers teach their subject, especially at primary level.

> *The curriculum approaches taken before and after the introduction of the state curriculum in the UK have been reflected in the textbooks and resources offered to teachers and the range of resources from the 19th century onwards. This is the subject of the next chapter.*

6 Learning Resources for Archaeology and History

Today teachers of history in schools in Britain have a variety of teaching resources at their disposal, some produced specifically to address sections of national curricula. But this was not the case in the 19th century and large parts of the 20th century. This section will address a number of questions about teaching resources and will:

▶ review the periods of the ancient past covered

▶ note whether archaeological investigation is credited for discoveries about ancient or modern times

▶ investigate the use of evidence for statements made by resource writers

▶ assess the design of teaching resources, the use of illustrations, and writing styles employed

This chapter also includes a section on the ways in which the authors of textbooks and children's books have treated prehistoric peoples, often resorting to outright racism and contempt for their 'savage' ways.

Analysing the resource

Instructional books for children were published from the 17th century, the most famous of which was John Commenius' *Orbis Sensualium Pictus*, a picture encyclopaedia which was published in 1658 in Nuremburg and translated into English in 1659. By the 18th century, publishers were producing a range of instructional books for children, including picture books, stories, ABCs, reading and writing books and magazines. After the Forster (Education) Act of 1870 (see p. 118), there were many more textbooks published for teachers to use. Some of these were specifically produced for Sunday Schools (Thwaite 1972, 53). From the mid-19th century, children's books began to be readily available in public libraries. For example, larger cities such as Manchester had children's sections in their libraries by the 1860s and Nottingham opened a separate library for children in 1882 (Thwaite 1972, 97). However, both popular and establishment views of geological time and the focus on the history of the Middle East and the Holy Land influenced what was available in the history sections of libraries.

From the point of view of archaeology, the use of evidence and prehistory, little research has been carried out. Textbook researchers have tended in the main to concentrate on how more modern nation states present themselves (e.g. History Workshop 1990), in particular contrasting important studies of textbooks and curricula in European, Soviet and ex-Soviet countries and the United States (e.g. Schissler and Soysal 2005). As part of the 'Education for All' initiative of the United Nations Educational, Scientific and Cultural Organisation (UNESCO), various research projects were carried out on textbooks, looking at standards, availability, spend per country and political or economic influences (Braslavsky 2006).

Two important studies touch on the areas with which this section deals:

Chancellor's *History for their Masters* (Chancellor 1970), in which she investigated 164 school textbooks (divided equally between primary and secondary school books) under headings expressed by authors about social class, politics, religion and England's place in the world and Thwaite's *From Primer to Pleasure* (Thwaite 1972), where she reviewed the history of children's books from the invention of printing to 1914. Mitchell has studied both text and illustrations in history books from 1830 to 1870 (Mitchell 2000).

Other research on textbooks is contained in journals – for example, published by the Historical Association (Herne 1957; Whitting 1957), and more recently the *International Journal of Historical Learning, Teaching and Research.* Booklists for teachers and archaeologists have been published by the Council for British Archaeology (Kewley 1976). Burtt analysed 29 children's books about prehistory, published between 1953 and 1986, and showed that they were 'clearly biased in terms of gender representation' (1987, 171).

Two more recent research reports have been published on history teaching across Europe which have contained analysis of school textbooks: the Koerber Foundation and Euroclio published papers which examined textbooks in Poland, Russia and Serbia (Roberts 2004, 140–60), and Euroclio published a series of facts and figures about the state of history teaching which included a section on textbooks (Leeuw Roord 2004, 33–42).

Contested pasts

One topic is frequently investigated – that of the way a particular period of history is represented in contrasting countries – for example, in Germany and Great Britain (Berghahn and Schissler 1987, 51) – or political bias in textbooks dealing with recent events – for example, representations of the Nazi period (Sobański 1962). Textbooks continue to be controversial. A new history textbook for 11-year-olds was condemned in 2007 for its revisionist views about two sensitive periods in Greek history – the 1821 War of Independence against the Ottoman Empire and the enforced flight of Greeks in 1922 from Smyrna.

Gasanabo (2006) studied the connection between textbooks and conflict in Rwanda from 1962 to 1994. History was originally taught by oral tradition, but during the colonial period (1894–1962) the subject was not officially taught at all and no textbook was published, though one was discussed in 1961. After independence, Gasanabo's research (2006, 395) showed that textbooks 'on the history of Rwanda placed more emphasis on the differences between the Twa, the Hutu and the Tutsis than on their points of resemblance'. History has not been taught as a school subject since 1994.

Crawford outlines the actions taken by Japan's Ministry of Education to censor comment on sensitive events in the country's history, such as the Nanjing Massacre of Chinese soldiers and civilians in 1937 and the women taken from Korea and other Asian countries as 'comfort women' to soldiers on the front. One textbook writer took the ministry to court over this censorship in 1982. (Crawford 2006, 54–62)

Types of resources

From the mid-19th century, teachers in the UK have been able to use three main types of resources for teaching history. These are: *textbooks* purchased in quantity for each pupil, or small groups, to use in class; *supplementary* teaching resources specifically produced for teachers to use with their pupils; and *other materials*, such as books or pamphlets, on historical periods or historical/archaeological methods or educational approaches from which the teacher might upgrade knowledge to use in teaching history.

To these we must now add the large quantity (but not always the quality) of resource material available on the internet and on other electronic media (such as CDs) which provides teachers with ready access to information and photographs, as well as lesson plans produced by education authorities, teachers and those working in, or for, heritage organisations. Heyneman (2006) and Naumann *et al.* (2006) also define and explain the various types of teaching and learning material available to schools.

Textbooks

Textbooks may be defined as books specifically produced by publishers for teachers to use as class books. These books have been very influential in defining a curriculum, before the introduction of a statutory national curriculum. It could be said in Britain that the curriculum now defines the textbooks. But textbooks present the view to pupils, via the school, which a society wants to present. Hanna Schissler wrote:

> How people imagine the world, construct historical time, and position themselves and society in time and space has changed over time, sometimes dramatically so. Ways in which the past has been constructed have always provided plenty of reasons for disagreement and conflict. Curricula and textbooks have been major battlegrounds for these conflicts, because it is there that societies write their own histories and project themselves into the future. (2005, 228)

Crawford goes further:

> Embedded in textbooks are narratives and stories that nation states choose to tell about themselves and which, it has been decided, offer a core of cultural knowledge which future generations are expected to both assimilate and support; to think about the content of textbooks and how they are authored, published and used is to think about the purpose of schooling. (2003, 1)

However, research by Chancellor (1970, 8) showed that there were comments about the bias in school history textbooks from the early 19th century in Britain. Many countries exert political pressure, or complete control, over both the curriculum and textbooks. For example, Rojo and Batista (2006, 284–8) show that Brazil's National School Textbook Programme publishes recommended lists of textbooks from which schools must choose. The Russian Federation has an official Federal List of textbooks which schools must use, despite there being a free market in textbook publishing since the end of the 1990s (Borovika and Barnashora 2006, 322–7). Pakistan's school textbooks 'must be approved by the

Curriculum Wing of the Ministry of Education' and textbooks 'authored and altered during the eleven years of General Zia-ul-Haq's military rule between 1977 and 1988, are still in use in most schools – they are decidedly anti-democratic and inclined to dogmatic tirades and are characterised by internal contradictions' (Yosser 2006, 180).

For the most part publishers in the USA have to submit their textbooks to individual states for inclusion on the 'approved' lists. Foster and Crawford give this example of the situation in Texas where legislation asserts that a textbook will:

> Promote citizenship and understanding of the essentials and benefits of the free enterprise system, emphasizing patriotism and respect for recognised authority, and promote respect for individual right ... Finally, textbooks approved for use in Texas shall not encourage lifestyles deviating from generally accepted standards of society.
>
> (Foster and Crawford 2006b, 9, quoting from Delfattore 1992, 139)

In England one of the earliest textbooks was Mrs Markham's very influential *A History of England*, which was first published in 1819. The author was actually an Elizabeth Penrose, who died in 1837. This popular history book was still being printed in the latter part of the century. The book was written in a chatty style, telling a story which is addressed directly to Mrs Markham's three children, Richard, George and Mary – the title page declares the book to be 'For the Use of Young Persons'. The book is illustrated throughout with a few engravings (in the 1886 edition, of 528 pages, there are 87, not very informative, illustrations). The book's intentions were to 'relate, with as much detail as might be allowable, the most interesting and important parts of our history' and to avoid 'saying the worst of a character, because few people are in reality so bad as they are often made to appear' (Markham 1886, v).

At the end of each chapter is a 'Conversation' where the children ask their mother questions. For example, at the end of chapter 1, 'The Invasion of Britain by Julius Caesar', we find:

> George: But is history of any use, besides being very entertaining?

> Mrs M: The older you grow, and the more you read of it, the better you will be able to understand its use. I shall only say now, that the greatest and best use of it is to show us, by observing events, as they follow, the greatness and wisdom of God, and 'how wonderfully He ordered the affairs of men'.
>
> (Markham 1886, 4)

A History of England begins with Caesar's first invasion to the period of publication (in the 1886 edition it is 'down to the year 1860'). Apart from the high moral tone of presenting the story of the past in terms of progression from boorish prehistory to occupation by a civilised and civilising culture, this history throughout the book is given as a series of 'factual' statements which must be accepted by the 'young person'. So chapter 3, which deals with 'The Coming of the Saxons', starts 'When the Romans quitted Britain, the poor helpless inhabitants were left without leaders, or magistrates, like so many wild animals, without reason and without laws' (Markham 1886, 8–9).

The publisher John Murray produced a number of *Mrs Markham's Histories* including those of France and Germany, as well another popular history for

children, *Little Arthur's History of England* by Lady Callcott, which first appeared in 1834. Several other history books for children were written by women reflecting, I think, the publishers' knowledge that mothers were educating their children at home at this time. These books included *Stories from English History* by Mrs Hack (1820), *The History of England, Written for Young Persons* by Mrs Trimmer (1849), *A First History of England* by Mrs Ransome (1903), *The Tree Dwellers, Early Cave Man, Late Cave Man* and *The Early Sea Peoples* by Katharine Dopp (from 1904) and *Our Island Story* by Henrietta Elizabeth Marshall (1905).

The broad sweep of history

By the 1920s a pattern which was to last well into the 1960s began to emerge in school textbooks. From the 1920s to the 1940s, textbooks published in a series contained the broad outlines of ancient history which sometimes began with the 'Stone Ages' (Breasted and Jones *c.*1927) but sometimes began with the Sumerians and took the pupils on a journey through Babylonia, Assyria, Egypt, Greece and Rome. *A Brief History of Ancient Times* (Hamilton and Blunt 1924) is a good example of this pattern. These books were very 'wordy' but had at least some drawings, photos and maps. However, the tone of the books was one of a printed lecture to the young readers in which a series of 'factual' statements by the authors were to be accepted by both teachers and their pupils. It was to be a long time before sources of evidence were presented. Many of the textbooks also had a teacher's reference book to accompany the series.

Many textbooks concentrated solely on the history of Britain, or even just on England. These were available for primary and secondary schools. Authors of secondary school history tended to be usually from public schools. A case in point was *British History from the Earliest Times to the Present Day with a History of the Overseas Dominions* published in 1914 by two teachers at St Paul's School and one from Colet Court. The book's preface begins 'This book is intended mainly for use in Schools, but it is also hoped that it may be found useful as a text-book by men reading Modern History at the Universities' (Smith *et al.* 1914, v).

Many school textbooks which had been written around the turn of the 20th century were revised and reissued in the 1930s. Although the broad sweep of history was still covered, the books themselves became more varied in this decade, often with livelier illustrations and informative captions. *Life in Early Days* (Fraser 1932) exemplifies the change. Another innovation is seen in the presentation of information about each period from the point of view of a child in books such as *A Glastonbury Boy Wakes Up* or *A Roman Girl at Home* (Titterton 1931). Sometimes characters, such as the two sisters, called Dika and Gyrinno, from *c.*580 BC Lesbos in the textbook *Boys, Girls and Gods* (Mitchison 1931) were given names. Some publishers produced textbook series which could be used from primary through to secondary school. Nelson published a series called *The House of History*, in which the first book is *The Basement: From the Earliest Men to the Fall of Rome* (Edwards-Rees 1934). The first to the four 'storeys' cover the 'middle ages' to modern times.

The beginning of class involvement in learning

Publishers then began to include specific questions, exercises and modelling activities for the class, at the end of each chapter. Some history textbooks for young pupils in primary schools in particular were for 'silent reading' in class.

> *A Story the Romans told the Britons.*
> Hundreds of years ago there was a princess in an old town in Italy who had two sons. They were called Romulus and Remus.

This is the way one chapter begins in *Why and When* (Madeley 1938, 9). 'The Kingsway Histories' listed these stories quite specifically, *A Story for Silent Reading: Paulinus and the Old Man* (Power c. 1940, 100). This book also contains class activities such as poems and scenes to act.

Old books, new pupils

Textbooks tended to have a long shelf life: I used the 1905 edition of Linklater Thomson's *A First History of England* at primary school in 1952 and Cyril Ransome's 1919 edition of *A Short History of England* (which had originally been published in 1895) at secondary school in 1958. Textbooks produced in the 1920s and 1930s were still being used in classrooms in the late 1960s and 1970s. In 1972 I handed out copies to my classes of the reprinted but not revised 1951 edition of *Everyday Life in Rome* (Treble and King 1930) which had been written originally in 1929. Some textbooks were, probably deliberately, undated to allow them to appear always as freshly written texts for schools (see also below for other resources). Revised editions of textbooks did not always mean that new discoveries were incorporated into the text or that attitudes towards past peoples had been amended.

During the 1950s and 1960s there were a number of textbooks for primary pupils which dealt with themes through history – for example, the way people lived or worked. Children featured heavily in books in these decades, both in illustrations and text. Their everyday life was described or stories were related, based on created characters, such as Lucius, a boy in Roman London in *Awake to History: From Caves to Cities* (Bareham 1964, 133). This had 'Supplementary Readers' clearly intended as silent reading to improve the pupils' English. There were many of these supplementary readers on historical topics which were specifically produced for teachers to use in class as an extension of English reading books. The publisher E. J. Arnold produced several series about heroes of the past and the *Children of Other Days* series.

Cavemen to spacemen

Some of the books being used by schools in the 1950s and 1960s seem extraordinarily bad, both from an educational and archaeological or historical point of view. The *Modern School Visual Histories* published by Evans for secondary school use have simplistic, and often incorrect, text and illustrations. For example, the Romans brought peace to Britain and the 'Barbarians tried to destroy Buildings, Christianity and Learning' along with activities ('For Your Notebook') such as 'Write down in a sentence the names of three barbarian peoples who attacked the Roman Empire' (Patchett and Rose 1951, 8–13, first published in 1947).

But the author who made more impact than any other from the 1950s onwards was R. J. Unstead. He wrote literally hundreds of school textbooks, mainly for the primary school, on history from the 'cavemen' to modern times. Many people in Britain today remember his books from their school days. He wrote a few books on non-history topics such as *See Inside a Space Station*. The style of writing employed comes from a long tradition of simple, often simplistic, text written in clear, short sentences with simple vocabulary. 'Thousands of years ago, Britain was covered with thick forests' is the opening sentence of *From Cavemen to Vikings* originally written in the 1950s (Unstead 1974, 5). Two modern teacher trainers like the Unstead approach: 'Unstead talked directly to the pupils in a friendly and concerned way. Unstead's authorial intentions led him to tell stories to an audience of children, to provide a clear narrative and to paint pictures in words that would link to the pictures on the page' (Nichol and Dean 2003, 9).

But Purkis voiced many teachers' and archaeologists' views about his style and content.

> History teachers everywhere would agree that for more than 20 years our brand leader has been R. J. Unstead, some of whose early works the publishers A. & C. Black are now reissuing. Although some of the material has been rearranged, for example, making what was originally one book into two by adding photographs, maps, an index and sometimes a bibliography – the text remains substantially what it was in 1959; using pictures to illustrate rather than as evidence is symptomatic of Unstead's out-of-date approach. To him history is about facts; not opinions about evidence. His approach is structured, safe and conventional, using a chronology that traditional teachers, especially those non-specialists teaching in primary schools, remember from their own schooldays. He emphasises the long-running, happy and glorious success story of the great (white) British people (Purkis 1980, 34).

Most textbooks for primary pupils contained questions and exercises. Some authors, especially in the 1950s, introduced the teacher to the idea of making models to support classroom learning. Harry Sutton, in particular, encouraged model-making in history lessons and in his *History Workshop* series used photographs to show how a model might be constructed from the now familiar egg boxes and cornflake packets (Sutton and Lewis 1970, 47).

New content, new presentation

Important changes were made to the style and content of textbooks during the 1970s which in some ways reflected the higher profile archaeologists were taking with the public. The key change, many commentators would now agree, was carried out by the Schools History Project (SHP 2010) and its publications. It started with the funding in 1972 by the SHP of a project: 'History 13–16'. Initially the project was based at the University of Leeds but in 1979 was transferred to Trinity and All Saints College, Leeds. As David Sylvester wrote:

> In doing so it challenged the view of history as a 'received subject' which had dominated since 1900. Instead, history in school was to be as similar as possible to history as philosophers conceived it and as the best professionals practised it. Pupils were 'to do' history, not merely receive it. They were to

learn about the human past by looking in a chronological context at the
sources, both primary and secondary, which historians use when they tell
the story – the history – of the past. (Sylvester 1994, 16)

The Schools History Project moved from pamphlets and packs of source material
to the publication of textbooks with Holmes McDougall, which included several
titles on archaeological themes (e.g. SHP 1976 and their major series *What is
History?*). In the 1970s and 1980s other publishers began to produce textbooks
which presented evidence-based history for pupils, in particular secondary school
pupils. In 1979 Blackwell commissioned the *Evidence in History* series from the
teacher trainer Jon Nichol (Nichol 1979), but unfortunately the series is marred
by factual errors.

Textbooks, written by experts in their subjects and periods, began to change the
style of teaching history, in particular the ancient periods. It was at this time that
statements about the past began to be based on archaeological, anthropological
and historical evidence. What Charles Higham has to say in the *Cambridge
Introduction to the History of Mankind* series (from the early 1970s) about the
prehistoric hunters at Shukba in the Judean Hills is based on excavation reports
and observation of present-day hunter-foragers (Higham 1974, 9). There was
now a different approach to illustrations in textbooks. They no longer just broke
up the text or tried to make the book more attractive than it actually might have
been. Macmillan's *Imagining the Past* series, for example, presents photographs,
plans and artists' impressions as an integral part of the story (e.g. Sauvain 1976,
10–11). Topic books were a usual way of supplementing other textbooks. The well-
respected series called 'Studies in Evidence' included Prehistoric Britain, with four
case studies (of Stonehenge, Star Carr, Skara Brae and Glastonbury Lake Village)
supported by a wealth of photographs, drawings, plans and artists' impressions
(Dawson 1983). However this does not mean that mistakes did not continue to
slip through. In the same publisher's series called 'Studies in Change', the front
cover of the book *The Neolithic Revolution* depicts a group of Neanderthals. Such
enormous mistakes undermine confidence in what was otherwise an excellent
development.

What finally emerged as a new key part of history textbooks was the
introduction of sources from history which were presented to young readers to
study, think about and reach conclusions on *themselves*. The pupil becomes the
archaeologist or historian. Evidence in textbooks is often referred to by the authors
as 'sources' or 'pictures' and the readers are instructed to look at the source and
answer questions. In *Ancient Britons*, Tony Triggs' primary books constantly pose
questions for the reader based on presented evidence in the form of photographs
or text which he has written himself. For example, referring to aerial photographs
of Maiden Castle and Alan Sorrell's drawn impression of the Iron Age hillfort
at Llanmelin, one of his questions was 'Which sort of entrance was harder for
attackers to reach – the sort at Llanmelin or the sort at Maiden Castle?' (Triggs
1981, 33). The most significant of the textbooks for secondary schools was the
work of Chris Culpin in the Collins' *Past into Present* series (e.g. Culpin and
Linsell 1989) which set the standard for investigation-based texts published in full
colour.

During the 1990s, textbooks for school use began to be published as history
schemes with a range of different source material, teacher's reference material

and readers for pupils (Harnett 2003, 3). After the introduction of the National Curriculum there was a rush by publishers to produce textbooks for schools, in particular secondary schools. The Oxford History Study Units, published for the new National Curriculum, included *The Roman Empire* (Coulson 1992), which had a thread of hypothesis testing running throughout, where pupils were systematically challenged with evidence to develop their understanding. The Schools History Project, backed by the publishers John Murray, continued to develop source-based investigative approaches and between 1990 and today has published four distinct generations of books that feature coherent, challenging investigations for pupils using the latest historical and archaeological research (e.g. Shephard and Corbishley 1991). Although the curriculum changed in 2000, several of the original textbooks remain available for schools. New textbooks have been produced which reflect the 2000 changes to the curriculum (e.g. Walsh 2003; Collier *et al.* 2003), and increasingly these include resources for use on computer and classroom interactive whiteboards.

Supplementary teaching resources

There is a wide range of extra resources which teachers have made use of in teaching history. They include: *books written for children* which can be seen as an extension of the class textbook or as library reference material which pupils may use on their own; *story books* to be read in class or used as school library books; *children's annuals* or 'Sunday' books; and *resources* written for the general public which could help the teacher.

Extension resources: One of the first of these resources were atlases of history and the *Visual Histories* series noted above was part of this trend. The author of one in 1903 made it clear in the preface what the book was for and how it should be used in class:

> This atlas is intended to aid the student of English History both in comprehending the leading historical facts and tendencies, and in retaining them in his memory. He will thereby both learn very instructive lessons, and incredibly strengthen his memory for historical facts. One condition is, however, absolutely indispensable: The student – (we may add the critic too) – must in no case satisfy himself with merely looking at the maps; he must invariably first trace them several times, following the text, and then try to draw each map from memory. (Reich 1903, iii–iv)

The educational publisher Wheatons produced their *Atlas of British and World History*. They remark in their preface that 'This Atlas has been designed for the use of pupils making their first study of the place of British History in the History of the World' (Rennard undated, *c.* 1915). Sketch map histories continued to be used into the 1970s but this broad sweep of the past was also evident in another type of reference book for pupils – the picture history book. Batsford's *The People's Life and Work* series was 'A Pictorial Record from Contemporary Sources' which the *Daily Express* declared 'The most fascinating volumes of history I have ever seen. I suppose the grown-ups will go for them first. But they should be the basis of the teaching in every school in the land' (Hartley and Elliot 1931, recommendation within book). Picture histories were a good source of evidence from the past – for example, *Britain's Story Told in Pictures* which had drawings made from objects in

the British Museum (Anon *c.* 1927) and *The Story of the British People in Pictures* (Odhams Press 1949) which had short introductory text for each section and large paintings, artists' impressions and photographs, each with detailed captions.

Everyday life in the past: a new approach

A new approach to children's reference books on history was conceived and executed by Marjorie and C. H. B. Quennell and published after World War I. Their books were reprinted up to the 1970s. Their two main series of books, *Everyday Life in ...* and *A History of Everyday Things in England*, included text and drawings which they produced themselves from research both of archaeological and historical sources and brought a clarity of thought lacking in many textbook and information book writers. They wrote in their introduction to *Everyday Life in Prehistoric Times*:

> Personally, we hold that History is not just about dates, but a long tale of man's life, labour, and achievement; and if this be so, we cannot afford to neglect the doings of prehistoric men, who, with flint for their material, made all the implements they needed for their everyday life.
>
> Now to describe the everyday life of prehistoric man is difficult, because there is not any history to go on. This is why we talk about these times as prehistoric.
>
> In the prehistoric period we have only the everyday things, and the physical characteristics of the earth itself; so the pick and shovel become more useful than the pen, and men dig for the information they need.
> <div align="right">(Quennell and Quennell 1921, vii–viii)</div>

The Quennells researched museums, sites and archaeological reports for their basic information, both for their text and their illustrations. Two types of illustration from the Quennells are illustrated here (see Figs. 6.1 and 6.2).

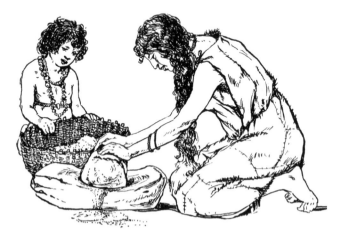

Fig. 6.1 Many of the illustrations in their books were like this one, showing how the objects discovered by archaeologists and on view in museums could be brought to life for children. This is a Neolithic saddle quern in use.

Fig. 6.2 Their books also contained impressions of scenes as here from their book *Everyday Life in Roman Britain*, showing one of the entrances into the Roman town of Silchester.

Some resources used in schools were topic books which helped extend the work being done in primary history. *Living in Caves* (Hardingham 1943) is an example of a topic book which explains the history of cave dwelling, throughout the world, in easy-to-read language. Allen & Unwin's *Understanding the Modern World* of the late 1940s and 1950s included historical titles such as *Transport, Trade and Travel* from Roman times to 1948 (Morris 1949) and *Your Local Buildings* from timber-framed houses to 1950 (Harston and Davis 1950).

Looking at buildings in the local area has been a popular topic from the 1950s to today. The *Junior Heritage Books* published by Batsford in the 1950s included *Churches* (Vale 1954) and *Houses* (Osmond 1956). By the 1970s there was a plethora of children's reference books on Roman villas, castles, abbeys and the sites of industrial archaeology. The Longman's series of *Then and There* topic books were extensively used in secondary schools from the early 1960s with line drawings eventually replaced by photographs in later editions. This type of book included the amazing drawn stories by David Macaulay in *Cathedral* (Macaulay 1973), *City: A Story of Roman Planning and Construction* (1974), *Castle* (1977), *Unbuilding* (1980: the story of the imagined deconstruction of the Empire State Building) and *Mill* (1983). The 1980s and 1990s continued the trend for books about types of buildings in the past, sometimes based on actual excavated examples, such as *West Stow Anglo-Saxon Village* (Stoppleman 1994). Specific periods of history, both world and British history, were also covered. A simplistic,

and often quite wrong, version of *Julius Caesar and Roman Britain* was published by Ladybird Books in 1959 (Du Garde Peach 1959) but by the 1980s Ladybird Histories were usually accurately written and illustrated. The publisher Dorling Kindersley's *Eyewitness Guides* to various ancient cultures are proving enduringly popular library and reference books for primary schools.

History books for very young children began to be produced in the 1970s. Althea Braithwaite's Dinosaur Publications included *Castle Life* (1977), for example. Brian Davison (formerly an Inspector of Ancient Monuments at English Heritage) wrote a number of books for children on historic monuments, including *Explore a Castle* (Davison 1983) for 4–5-year-olds.

Many children were introduced to the past through story books such as Rudyard Kipling's *Puck of Pook's Hill* (1908) or Jack London's *Before Adam*, which was serialised in 'Everybody's Magazine' in 1906–7 and subsequently published in book form – London introduced children to the 'Fire People' and the 'Tree People' and the characters of 'Lop-Ear' and 'Big-Tooth'. G. A. Henty's stories of the ancient past were popular with Edwardian children – for example, his *The Cat of Bubastes: A Tale of Ancient Egypt* (Henty 1908). New generations, in America and then in Britain, discovered prehistory through John O'Reilly's *The Glob* (1952); the delightful story of Glob coming out of the sea and evolving into a hunter, complete with his dog Pip. Puffin books, first published in 1940, included a number of story books for children about the ancient past – for example, *Tales of Ancient Egypt* (Green 1970). The tradition continued with *Britannia: 100 Great Stories*, first published in 1999 (McCaughrean 1999).

Published from as early as the 1950s and still in wide use today are stories written specifically to encourage reading. Series are graded for age and language ability and often cover historical subjects, such as *Roman Adventure* (Hunt and Brychta 1994) and are available with a teacher's book with extension exercises and language activities.

There is a large range of historical novels for children. Townsend surveyed the history of English-language children's literature which included a section on 'Historical approaches' (1974, 219–233). Reviews and lists were collated by the Schools Committee of the Council for British Archaeology from the mid-1970s and subsequently published (Hastie 1983). Stories about prehistoric and Roman Britain are quite common – for example, Rosemary Sutcliff's *Warrior Scarlet*, published in 1958 (Sutcliff 1958) about a boy from Bronze Age Britain. Children and teachers are familiar with a number of authors who have written historical novels, based on good research and archaeological evidence – authors such as Henry Treece and Kevin Crossley-Holland. New series of storybooks are now commissioned especially to cover National Curriculum history, such as Theresa Breslin's *Across the Roman Wall* (1997) in A. & C. Black's *Flashbacks* series and the Ginn *History Stories* with titles covering famous people such as *Tutkhankhamen* and *Boudicca*.

Also aimed at young children, to read or have read to them, are some overtly educational picture books which encourage visits to museums. *Visiting a Museum* sensibly tells its readers that 'It is very tiring to see everything in a museum on only one visit. It is better to look at just a few things at a time and find out about them' (Braithwaite 1981). *A Visit to the Sesame Street Museum* features Jim Henson's puppets as they tour a large museum with everything in it from dinosaurs to moon rock (Alexander 1987). In *Harry and the Dinosaurs at the*

Museum, Harry's older sister wants to visit the museum because she is studying the Romans at school but Harry is bored and hungry, until he discovers the more exciting dinosaurs (Whybrow and Reynolds 2004).

Children's annuals traditionally contained a range of moral tales, interesting facts, adventure stories, puzzles and poetry. Among these there are often examples of historical information and stories. The *Chatterbox* annual for 1921 featured an article about ancient ships (Ancient Greek, Viking, ancient British and medieval), the story of Spartacus and 'The Buried Cities of Romance' which included Great Zimbabwe. The *Ideal Book for Girls* of 1952 has a story about a group of girls in a private boarding school who are encouraged by their teacher to create a museum for the school fête (Dean 1952, 75–91).

Comics for children occasionally contain history features but the introduction of the paper *Look and Learn* in 1962 was, as its name implied, educational. It often contained pieces about the past and its first issue described the history of the towns and villages on the road from London to Dover. It sold about 300,000 copies a week during the 1960s but ceased publication in 1982. Today, issues and illustrations from *Look and Learn* and its sister publication *The Children's Newspaper* (published from 1919 to 1965 and first edited by Arthur Mee) are available on its website (Look and Learn 2010) and are proving another historical source for classroom teachers. The issue of 2 February 1929 had a story of a hoard discovered in Sussex by a farm labourer.

The cartoon style has long been used to provide an accessible format for children in books about the past. Probably the most famous is the *Asterix* series. Created by Goscinny and Uderzo, Asterix appeared in a magazine in 1959 and the first book, *Asterix the Gaul*, in 1961. It makes many references to today's world, such as the rugby match which features in *Asterix in Britain* (Goscinny and Uderzo 2005, 36–42) and nobody really believes, I suggest, that Obelix can lift a standing stone and carry it away on his back. We are used to seeing unbelievable events in cartoons. After all, we know that Popeye cannot carry out feats of such strength, with or without a can of spinach, to rescue Olive Oyl, don't we? The *Asterix* books do not claim to be instructional guides for children learning the history of the Romans.

In the 1990s the trend for 'jokey' books for children on historical subjects was introduced into the UK by Terry Deary's 'Horrible Histories' series, with such titles as *The Savage Stone Age*, *The Rotten Romans* (Deary 1994) and *The Terrible Tudors*. 'Horrible Histories' are now also available in a variety of other formats – games, audio tapes, television programmes for children, theatre plays and interactive family experiences in museums. Deary's books are also available on CD and DVD. Other similar books are John Farman's 'History in a Hurry' series (1997) and Fay Gregory's 'Interesting Bits' series – for example, *Henry VIII's Interesting Bits* (Gregory 1993). Jeremy Strong has written a number of books for young readers, some on historical themes such as the ancient Egyptians. *Viking at School* features unruly Sigurd the Viking who is sent to school to learn some modern manners (Strong 1997).

But 'jokey' text and cartoon-style illustrations should always exclude downright mistakes. It was sad to see, however, the number of basic errors in the English Heritage book for children, *The Ghastly Book of Stonehenge* (Turner 2007). The writer of the Spoilheap section in *British Archaeology* rightly fiercely criticised the sloppy way it had been written and edited, and also noted that none of the

writing, editing and illustrating team was an archaeologist. Indeed, the academic consultant for the book, Mike Allen of Allen Environmental Archaeology, told Spoilheap 'that his comments had been ignored, as, apparently, had those from staff at Stonehenge'. The article went on to say 'a chart listing "Iron Age–Medieval times" (p. 7) is illustrated with a mammoth'.

> Have we not advanced from treating cultural differences as a joke? Do we teach our children to make fun of contemporary ethnic diets and to laugh at their neighbours' funerary practices? Encouraging respect for people in the past lays foundations for an understanding of modern society. If this guide is any indication, English Heritage is out of touch with both (Anon 2008).

Most teachers are resourceful and will make use of anything which may help them help their pupils to learn. While teachers will now turn automatically to the internet to garner information and ideas, books used to be the main supplementary resource. In the past, visual sources came from popular prints (e.g. romantic views of castles) and illustrations of ancient sites and artists' impressions, especially from the 19th century.

H. G. Wells' history of the world from dinosaurs to the Great War, *The Outline of History*, was first published in parts in 1918–19 then revised and republished in 1920 (other revision and reprints followed). He had harsh words for school-taught history:

> Men and women tried to recall the narrow history teaching of their brief schooldays and found an uninspiring and partially forgotten list of national kings or presidents. They tried to read about these matters, and found an endless wilderness of books. They had been taught history, they found, in nationalist blinkers, ignoring every country but their own, and now they were turned out into a blaze. (Wells 1920, 1)

There were several other world histories published in parts from the 1920s – for example, *History of the Nations*, published by Hutchinson, and *Wonders of the Past*, published by Fleetway House. Like Wells' book these were lavishly illustrated with photographs and artists' impressions and proudly featured the latest 'finds' such as the discovery of Tutankhamen's tomb.

At the other end of the scale from the broad sweep of world history, the teacher could find books, often written by professional historians and archaeologists, from which they could gather up-to-date information about a period. In the 'Home University Library of Modern Knowledge', Robert Munro provided the latest archaeological information in *Prehistoric Britain* (Munro 1913) while R. G. Collingwood's *Roman Britain* (1923) appeared in 'The World's Manuals' series of Oxford University Press (Collingwood 1923). The Historical Association published a series of booklets for teachers and history enthusiasts, such as *Roman Britain* (Myres 1939). The discovery of famous archaeological sites was a popular subject – for example, Leonard Woolley's *Dead Towns and Living Men* (Woolley 1920). There were also books for the general public which may have been less 'academic' but were nevertheless good introductions to historical subjects – for example, Osbert Lancaster's *Pillar to Post: English Architecture without Tears*, in which the author declared 'this is not a textbook' (Lancaster 1938, xi) but which does introduce architecture, from the pyramids to 'Stockbrokers Tudor' and finishes with pre-war modernist buildings, with detailed witty drawings.

Resources for teachers from archaeologists

The 1970s and 1980s saw a significant amount of resources, services and training for teachers by archaeological organisations. The main ones are listed below but are dealt with in more details on pp. 83, 84, 91, 96.

The Council for British Archaeology, from the creation of its Schools Committee in 1975, has produced a number of printed resources and help for teachers. A regular *Bulletin of Archaeology for Schools* was launched in 1977 and replaced by the *Education Bulletin* in 1985 until 1989. Several resources handbooks for teachers were published (1979, 1983, 1992 and 1996). The early 1980s saw the publication of the nine *Archaeology for Schools* booklets which brought archaeological techniques to a wider audience of teachers (Corbishley 1982–5).

Archaeology in Education was set up in 1980 at the University of Sheffield to provide encouragement, teaching and resources for teachers. The service ran until 2000 and produced an impressive number of resources – teaching packs, artefact kits and replicas, slide sets and videos – together with a regular newsletter.

English Heritage set up a full education department in 1984 which launched a free termly magazine for teachers in 1986 to encourage the curriculum use of a full range of curriculum subjects. This was followed by free resources for all its 400 properties and books for teachers on a number of the larger ones. This was supported by a series of books for teachers called *Education on Site*, which covered most of the school curriculum subjects, types of monument, school project work and archaeological investigations. This series, as well as other topics were also supported by a number of teacher training videos and videos for classroom and family use. By 2004 there were over 600 resources for teachers dealing with the curriculum use of the historic environment.

Archaeology and Education was a project carried out by the University of Southampton from 1985 to introduce archaeology to teachers using local sites, archaeological investigations and experimental archaeology. From projects with schools across Hampshire, based at ancient monuments and landscapes and in the schools themselves, a number of publications for teachers were published. These covered a number of sites (such as Portchester Castle) and projects (such as graveyard recording and its link to curriculum subjects).

Prehistory, archaeology and the use of evidence

In the absence of a statutory curriculum in the UK until relatively recently, what defined the periods which constituted history teaching was often the textbook and supplementary teaching resources. Before the use of evidence and the posing of questions, the general approach was simply to state what were said to be facts, as for example, 'The Romans were cleverer than the Britons, for they could read and write' (Power *c.* 1940, 15) or 'No Roman ever had a beard. If a Roman saw a man who had a beard he knew that he was a stranger, and he called him a "barbarian". The word "barbarian" simply means "a man who has a beard"' (Fraser 1932, 136–7).

Prehistory and the Romans

There was no agreed starting point for history. Most textbooks, from the 19th century onwards, excluded the prehistory of Britain, or defined it only in the context of the first Roman invasion. As one textbook had it: 'The invasions of Julius Caesar are generally taken as a suitable point from which to begin the history of our land, because Caesar's own writings give us the earliest records that are of much value in an historical sense' (Warner and Marten 1923, 2).

Others, which dealt more generally with world ancient history, often included a section specifically on prehistory. One of the perceived problems came directly from the use of the chronological approach to teaching history, which is still prevalent in the UK and around the world. This approach meant that prehistory was taught to primary pupils, while modern history was reserved for older, secondary pupils. Another perception was that prehistory was a difficult period, not properly understood even by archaeologists. Sometimes the story of the past began with the Neolithic period, perhaps to avoid the difficulties of hunters and gatherers.

Although not all history textbooks included incorrect or misunderstood versions of prehistory, the majority did – in particular, those for primary schools. Text was often simplified to a point of absurdity. 'Facts' were invented; British prehistory was condensed into the story of 'cavemen' or the 'ancient Britons'. The titles of the books themselves and their chapters often display the attitudes of the writers and publishers, for example:

Table 6.1 Book and chapter titles

Date	Book title	Chapter title
1932	*Life in Early Days*	Very, Very Long Ago
1934	*Long Long Ago*	How the Caveman got his Dog
1938	*Why and When Histories*	The Ancient Britons
1954	*Visual Histories*, book 1	The Cave Hunters of the Old Stone Age
1964	*Awake to History*, book 1	
1974	*From Cavemen to Vikings*	

Prehistoric people are often depicted as crude, stupid and uncivilised (see Fig. 6.3). In her 1834 book, *Little Arthur's History of England*, Lady Callcott declares that 'the poor Britons were almost naked, and had very bad swords, and very weak spears and bows and arrows, and small shields, made of basket work covered in leather' (Callcott 1834, 7). This is how the Britons and their conquerors, the Romans, are portrayed in an 1838 rhyming history of England for children:

> These are the Britons, a barbarous race,
> Chiefly employed in war or the chase,
> Who dwelt in our native England.

> These are the Romans, a people bold,
> Most famous of all the national old:
> They conquered the Britons, a barbarous race, etc.
>
> (Cuckow 1838, 8–9)

The Ancient Britons

Fig. 6.3 Stonehenge was associated with all periods of prehistory in Britain and often used as an illustration, as here in *Pictures of English History, in Miniature*. The text says that the Britons 'led a wild and simple life; their clothes were made from the skins of animals. In warm weather they went almost naked' (Mills 1809, 1).

Charles Dickens, in his *A Child's History of England*, first published in the journal *Household Words*, 1851–3, describes the 'savage Britons' as:

> ... poor savages, going almost naked, or only dressed in the rough skins of beasts ... no roads, no bridges, no streets, no houses that you would think deserving of the name. A town was nothing but a collection of straw-covered huts ... (Dickens 1958,130)

Early Britain was a place where

> ... there were neither roads, nor bridges, nor houses, nor churches. The country was nothing but one overgrown forest. The people lived in holes in the ground, or in any miserable huts they could contrive. They had no clothes, except the skins of the animals they killed in the chase; for hunting was their chief employment. (Markham, 1886, 1)

Mrs Markham did follow this with a rather grudging admittance that by the time Caesar arrived, the tribes in Gaul had improved the south coast by introducing agriculture and trade. This view of prehistoric peoples in Britain persisted. Like many authors, Mrs Fisher, in her textbook *Life and Work in England*, gives the early periods short shrift, allowing prehistoric and Roman Britain eight out of 221 pages and in the introduction she compares the life of 'primitive man' in Britain as similar to a 'simple tribesman' brought as an African slave to England

Racism in textbooks

In *Stories of Early British Life from the Earliest Times*, which was published in 1923 the author, Scott Elliot, drew several references from British life to help his young readers understand the lives of prehistoric peoples. This was still the period of the British Empire so his readers were told that 'Just as we ourselves in India put down the burning of widows on the funeral pyre of their husbands, so the Romans stamped out these horrible human sacrifices' [by the Druids] and 'Eolithicus probably believed in some sort of Hunter's Paradise to which he would go after he died, which is very much what the Australian black-fellow thinks' (Scott Elliot 1923, 160 and 28).

At a UNESCO conference in 1978 on 'Racism in Children's and School Textbooks', one speaker listed a number of words used to describe the indigenous people of Australia:

tribe	native	savage
primitive	uncivilised	pagan
vernacular	coloured	backward

(Lippmann 1980, 68)

Lutz's study of the stereotypical presentation of Native Americans in books for German children in text and images, included:

Indians are uncivilised savages.

Indian men are fairly lazy; they only hunt and fight.

The women obey them and have to work hard.

Before the whites came, the Indians lived in numerous tribes which continually fought amongst themselves.

Their race and way of life were doomed to extinction because they stood in the way of white civilization. (Lutz 1980, 102)

Some of the criteria discussed at the UNESCO conference for the evaluation of racism in children's books included:

• Do other continents and peoples only come into the picture when they are 'discovered' by Europeans? Is the pre-colonial period mentioned at all?

• Is there an explanation of historical events of the dominated group from its own point of view? Is the history of these people prior to European contact omitted or considered non-existent?

• Is the group or country presented as having been incapable of developing and maintaining stable societies until instructed in these skills by Europeans? (Preiswerk 1980, 141–3).

(Fisher 1934, 9–11). While some books for children about the history of Britain were reasonably well researched, prehistory often got a bad deal. *A Picture History of Britain*, published in 1947, covers 'Early Britain' to the end of World War II in its 31 pages, but devotes only 134 words to the prehistoric periods (republished Hutton 2007). A similar situation occurs today with modern Turkish school textbooks (see p. 114).

A 1940s textbook revealed that 'The Romans were cleverer than the Britons, for they could read and write. While the Britons were still living in a simple way in groups of huts, the Romans had beautiful cities' (Power *c.* 1940, 15–16). The introduction, by the Romans, of Christian worship to the British pagans was considered by textbooks writers in the 19th and 20th centuries very important, 'You see, therefore, that when God allowed the Romans to conquer the Britons, He made them the means of teaching them a great many useful things; above all, how to read' (Callcott 1834, 9).

But still in the 1950s the *Visual Histories* textbook stated in text and map:

> Hundreds of years ago the Britons lived in this island. Most of them were savages, but those who lived near the coast learnt many things from lands across the sea.
>
> All the Britons worshipped the sun. Their priests were called Druids and the mistletoe was their sacred plant. They had stone temples for their sacrifices. Stonehenge is said to be one of these.
>
> SAVAGE BRITONS LIVED INLAND
>
> HALF SAVAGE BRITONS LIVED ON THE COAST
>
> (Patchett and Rose 1951, 6–7)

Any skills credited to prehistoric peoples came either from those learned from other more civilised folk from the Continent or, in some books, the skill of the Iron Age warriors who fought Caesar's invading troops on war chariots. To add to the opaqueness of prehistory, many textbooks omitted all dates for periods up to the invasion of the Romans. It was all 'long long ago', or as one question for children put it in 1938: 'The Caveman lived before writing was invented; so long ago that no one knows how long. How do we know there ever were any Cavemen?' (Madeley 1938, 6).

The civilising nature of the Roman occupation of Britain by the Romans is often stated in textbooks, as here from Mrs Cyril Ransome's book *A First History of England*, first published in 1903:

> The Britons became so civilised that they grew to be very like the Romans themselves. They spoke Latin, and copied the manners and dress and customs of their conquerors, and learned to live in towns and villas. Just as in our day the first thing we do when we conquer new lands is to make railways and roads, and open up the country, so the Romans in their time made roads and bridged rivers, and succeeded in turning wild savage countries into parts of the civilised world. (Ransome 1915, 9–10)

The 'end' of the Roman period in Britain was another opportunity for writers to laud the civilisation of the Romans at the expense of both the native peoples and the new 'invaders' – for example, 'It was called Hadrian's Wall. One of the Roman emperors, whose name was Hadrian, ordered the governor of Britain to have it built. He had heard how some wild little dark-eyed men with painted bodies were always swarming into Britain, stealing corn and cattle' (Power *c.* 1940, 52–3).

> When the Romans quitted Britain, the poor helpless inhabitants were left without leaders, or magistrates, like so many wild animals, without reason and without laws. (Markham 1886, 8–9)

In the countries Rome had ruled so well were now no longer towns and laws; the bridges and roads fell to pieces, and men did not know how to build them up again; very few people could even read or write.

(Erleigh 1948, 108)

When they were left alone the poor Britons did their best to defend themselves, but it was very hard work. Scarcely had the Romans turned their backs than the pirates came speeding across the sea.

(Power *c.* 1940, 59).

By the 1970s, however, textbooks tended to include up-to-date versions of prehistory and to credit prehistoric peoples (the phrase 'prehistoric man' has yet to be universally omitted) with intelligence and skills afforded to peoples in 'history' (Corbishley 1989a; 1994). *Living in Prehistoric Times* (Chisholm 1982), for younger primary children, is well researched and illustrated and looks at two groups of people (through the medium of a story with named characters) from the palaeolithic and neolithic periods. Curriculum-based books for pupils today include prehistory where relevant to the subject or area, subject only to the inclusion of prehistory in formal statutory curricula. *The Stone Age News* (Macdonald 2000) is a colourful presentation of evidence, ideas and activities, presented in the format and style of news items written by reporters at the time. This series covers a number of ancient peoples.

Yet the image of prehistoric people simply being simple-minded 'cavemen' still lingers. Giles Andreae's supposedly amusing, cartoon-style illustrated *Purple Ronnie's History of the World* begins with a poem about 'Cave Men':

> Cave Men who wanted a girlfriend
> Didn't know how to behave
> Instead of a candle-lit dinner
> They'd just drag one home to their cave.

(Andreae 1999, 6–9)

And it goes on in the same crude way with: 'The main thing about Cave Women is that they had incredibly floppy bosoms ... used to gather berries or hang out by the fire gossiping about their boyfriends' and 'Instead of praying, Cave Men built huge rings of stones where they would have naked hippy discos in the middle of the night'. This light-hearted approach to the past was previously criticised by Whitting (1957, 83) when he reviewed a school textbook by W. Howells called *Man in the Beginning* published in 1956, writing, 'Flatulent description is not improved by facetiousness, and at times American idiom is a handicap'.

Archaeology and the use of evidence

Often equally misunderstood, or simply ignored, was the role of archaeology in collecting and understanding the evidence for the past. In fact, very few textbooks and other resources mention archaeology at all. Some textbook authors thought that they had to adopt the tone of Mrs Markham in addressing their readers. Eva Erleigh's book *In the Beginning: A First History for Little Children*, first published in 1926 for 6–10-year-olds, is an example of this style. The author oversimplifies the early history of the world (from the formation of the planet to the Roman Empire)

and substitutes fiction for archaeological evidence when she has no knowledge of a particular period. This is what she tells her readers about:

> The First Cooking: One day a boy brought home a little pig for his mother; he was very pleased, as he had killed the pig all by himself, but as he stood by the fire in front of the tent, and called to her, by mistake he dropped the pig into the fire ... then she tried to get the pig out of the fire. The pig was far in, so it took her some time, but when she got it out it smelt very good, and she thought she would eat a bit to see if it was quite spoiled. It tasted very good – much better than raw, uncooked pig – and she called the others, and they said it was good. (Erleigh 1948, 28–9).

However, as mentioned above, the Quennells recognised that it is archaeologists who provide the evidence for prehistoric and historic periods, nicely naming the archaeologist as 'the pick and shovel historian' (Quennell and Quennell 1921, viii). The book *From Flints to Printing*, in introducing flint tools says, 'There they were found at last by an archaeologist; that is, a man who gains knowledge about "old things" by exploring places where men lived long ago, and the remains they have left behind them' (Latham 1936, 1).

Some local education authorities encouraged the use of evidence in teaching history. In 1922 the Kent Education Committee published its *Aids and Suggestions for the Teaching of Local History, with Special Reference to Rural Schools in Kent* and its author wrote:

> In this introduction I would call attention to the collecting of oddments. Museums are surely valuable, but where the exhibits are under glass their value is comparatively small. The flint-head must be handled and dreamed over ere the Palaeolithic man or Neolithic man appears; the urn must be caressed before we have the vision of a Roman soldier; the old parchment crackled before the enclosed fields can lose their hedges. Pass a 1790 French coin among your class, and tell them, and truly, that probably that was in the breeches pocket of one who saw the guillotining of Louis XVI and rioted in the taking of the Bastille: that it was purchasing wine as Napoleon passed by. Then will all the information you have to give them be sucked in with greed, and probably retained for always. But they must touch these things. So each Teacher should treasure his odds and ends, whether a snuff-box as an introduction to the circle of Samuel Johnson, a fan to the Court of Caroline, a minuet to Ranelagh, or an old clay pipe: and in my smoking cabinet by my side I have pipes of Charles I., one dug from the plague pit of 1665 and one of the reign of William III. What a talisman for those days! (Saunders 1922, 182)

But archaeological discoveries were often featured, especially in sections of books about prehistory, even if archaeologists were not credited with any work on them. In the first half of the 20th century the sites most commonly quoted were the lake villages of Switzerland (discovered when water levels dropped in 1853) and at Glastonbury (first excavated 1894–1914). Those books which dealt with earlier prehistory usually mentioned the cave at Altamira (discovered in 1879) and Lascaux (discovered in 1940). In books about British prehistory, Stonehenge was always featured or mentioned, sometimes even giving the monument its correct dates. From the 1980s onwards, books about the Saxons and Vikings also had a

section on Sutton Hoo and Jorvik, with a few featuring West Stow Anglo-Saxon village.

Illustrations in textbooks are often the most useful method of presenting evidence. Textbooks in the first three decades of the 20th century included a few photographs of objects and sites, maps and plans but also artists' impressions. Primary textbooks from the 1930s usually created their own drawings to illustrate text, quite often with no captions at all. Very few authors and their publishers saw the need to use illustrations as a specific learning resource. Pupils had to wait until the 1970s for the introduction of careful chosen pictorial resources with extended captions or classroom activity and discussion based on an archaeological or historical 'source'. The Schools Council's project 'Place, Time and Society' for 8–13-year-olds presented a detective approach to finding and understanding clues from the past and explained some of the techniques of archaeology (Waplington 1975).

A few archaeologists and local studies enthusiasts attempted to right the archaeological balance by producing books for young people about the techniques of archaeology and its discoveries. One of the first took the periods in Britain most usually credited as 'archaeological', that is Palaeolithic to the Anglo-Saxons. It was published by the Council for the Promotion of Field Studies (Garrod 1949) and explained the monuments and finds associated with each of these periods. Henri Breuil's book, *Beyond the Bounds of History*, has quaintly naïve, child-like drawings but interesting, though difficult, text about real archaeological sites from palaeolithic and Mesolithic times (Breuil 1949). Shirley Kay's *Digging into the Past* (1974) tells its young readers little about archaeological techniques but gives accounts of a number of famous archaeological discoveries in what is now Turkey, Israel, Egypt, Iraq and Iran.

There is a range of books from the 1960s to 1990s which look more at how the profession of archaeology works. Sir Leonard Woolley's *The Young Archaeologist* announces itself as 'A Practical Book' but the author raises an important point which has exercised a number of archaeologists since. He opens the book in this way:

> When I was asked to write a book which was to be called 'The Young Archaeologist', I found myself wondering how it was to be done. A book called 'The Young Chemist' can tell you how to carry out practical experiments in chemistry, and it can be an introduction to a professional career as a chemist or research student. But I should be very sorry to see any of my readers trying to do 'practical experiments' in archaeology, except under someone else's supervision; and I don't expect any of them to become professional archaeologists. (Woolley 1961, 1)

Woolley does explain how the process of archaeology works but there is much in the book about looking at and recording archaeology in the field, looking at monuments and visiting collections in museums. Other books for young people encouraged this too. Gordon Copley's *Going into the Past* provided a detailed story of Britain from palaeolithic to Norman times but included a short chapter on visiting sites and museums (Copley 1958). A quite different approach was taken by Geoffrey Grigson in his *Looking and Finding* which he announced in the book's subtitle *And Collecting and Reading and Investigating and Much Else*. He helped his readers find out about maps, look closely at buildings and make collections.

Part of his introduction perhaps sums up his intentions as 'it is not a bad thing to be inquisitive and to wonder. I hope this is a book of wonders, as well as a book against having nothing to do' (Grigson 1958, 11). Philip Randall had a similar intention for the readers of his *Treasure on Your Doorstep* but his is written as a story of some 13-year-olds who are encouraged by an aunt of two of the boys to go out on a bike ride to find 'treasure' in the form of historic buildings in the local villages. The stories of what they find, including drawings of building details, such as church windows and doors, were also intended to provide 'a sound basis for local studies work with upper juniors and lower secondary pupils' (Randall 1963).

But Randall's use of the word 'treasure' is one that has often been used by archaeologists and writers eager to show just how exciting archaeology can be – *The Wonderful World of Archaeology* (Jessup 1956) combines discoveries, such as Pompeii and finds from London, with explanation of archaeological techniques.

Archaeologist Ruth Whitehouse's *Your Book of Archaeology* (1979) deals with the usual aspects of the archaeological process and brings the reader up-to-date with a section on rescue archaeology and RESCUE. One interesting resource produced especially for pupils is a series of booklets, called *Search For the Past*, written by Robin Place in 1985. The six booklets deal with finding and digging archaeological sites, finds and environmental archaeology, famous sites and famous discoveries (e.g. *Digging Up the Past*, Place 1985). It was written for young primary pupils and the series has very good notes for teachers. Two excellent Longman series for schools on various aspects of Greek and Roman life had accurate text backed by up-to-date examples and illustrations including *Roman Archaeology* which looked at excavation, scientific techniques and interpretations of the past (Green 1983).

Published spin-offs from television programmes are commonly aimed at adult viewers and readers but less commonly at young people. The archaeologist Francis Pryor wrote *Digging up the Past* as the accompanying book for the children's TV series *Now Then* with the producer David Collison (Pryor with Collison 1993). The book outlines the sites the programme visited and contains a great deal of accurate and interesting information about the process of archaeology.

Longman's series *A Sense of History* helps young primary children to understand the physical evidence for the past. Sallie Purkis introduces places from a Roman fort to a World War II airfield (Purkis 1997) while Gail Durbin deals imaginatively with archaeology in *Under the Ground* (Durbin 1991).

But there is, perhaps, cause for optimism as publishers use up-to-date archaeological interpretations of evidence and deal with some of the issues which face archaeologists: Brassey's *Boudica* (2006) in Orion Books 'Brilliant Bits' series is accurate and interestingly written for children and clearly has an eye on curriculum requirements in the primary school; Nick Arnold has produced, in the 'Horrible Histories' style, *Awesome Archaeology* (2001) which is full of cartoon drawings and jokes but which explains how archaeology works – and it's not afraid to say: 'DON'T use a metal detector to search for finds. Say "metal detector" to archaeologists and you'll get a dirty look and a few might even burst into tears. That's because some metal detector owners have actually robbed archaeological sites' (Arnold 2001, 25).

Summary

▶ Textbooks have been a primary resource for teaching history since the 19th century.
▶ Textbooks about prehistoric people in the 19th and 20th centuries were often incorrect at best, racist at worst.
▶ In the UK a steady development towards the use of primary sources and questioning approaches in presenting history can be discerned.
▶ Teachers now have a wide range of resources to teach evidence-based history, some produced by archaeological and heritage organisations.

Conclusions

Textbooks dominated what was taught in British schools in the absence of a statutory curriculum, right up to 1988. That children in Britain had been learning about British and world history since the 19th century undoubtedly shaped the National Curriculum. There were, and still are, no state-approved lists of textbooks as there are in some countries today. The concept of state-approved (and in some cases state-printed) textbooks is anathema to UK teachers, who choose for themselves which books or other resources pupils should use in their schools.

Authors of textbooks often did not research the study of the past but wrote their books using the context of earlier books, in some cases quite clearly from books they themselves had used in schools – mistakes and misconceptions were repeated. Publishers seemed impervious to the new knowledge about the past generated by archaeological and historical research. Reprints were frequent but updated editions rare. Prehistory suffered the most from this approach. Racist remarks were rife and hunters and early farmers were called savages or uncivilised. This, I think, was often a direct result of authors' and publishers' ignorance about new discoveries.

The foundation of the Schools History Project in 1973 brought about significant changes in the 1970s in the UK. Learning resources for pupils and teachers were written by teachers who were also historians and, occasionally, archaeologists. Evidence was presented to pupils, in the form of facsimile documents, quotations and photographs of buildings and objects and they were encouraged to reach their own conclusions by questioning the evidence. Archaeological organisations also started to produce learning materials, usually for teachers. This new approach was also an important influence on the new National Curriculum and textbooks were written specially for the new history curriculum. Today, the classroom teacher has a range of resources from textbooks to websites, from printed leaflets to downloadable videos to help plan interesting and thought-provoking lessons.

The next chapter considers the use teachers may make of subjects other than history when teaching about the past. As you will see, cross-curricular teaching depends very heavily on available sources.

7 Archaeology across the Curriculum

Archaeology is an ideal cross-curricular subject. This section of the book looks in detail at tested strategies and projects which heritage educators and teachers might use to make archaeology a basis for cross-curricular activity. All curricula around the world specify a number of school subjects which are considered to be statutory. This section looks at these subjects and their relevance and links to archaeology, while citizenship is dealt with elsewhere (see p. 279). Many of the exercises and projects in this section were carried out with primary schools but can be adapted for use at other levels in education.

Those heritage and archaeological organisations in Britain and Ireland which provide education services to schools advertise specific links to the national curriculum. *Archaeology in the Classroom: it's about time!* from the Limerick Education Centre (2005 and 2009), for example, uses the terms 'linkages' and 'integration' to connect each section of this resource guide to specific curriculum subjects and subject sections (see Fig. 7.1). Archaeology Scotland has information and case studies for teachers on its website (2010b) which links aspects of archaeology to subjects in the curriculum. The Craven Museum in Skipton, North Yorkshire, advertises school group visits which are linked specifically to Schemes of Work in the History national curriculum. The National Trust provides teachers who might visit its properties with suggested curriculum links (2010a) – for example, stating that Quarry Bank Mill and Styal Estate in Cheshire are useful for studying Art and Design, Geography, Science, Design and Technology, as well as History. The Geffrye Museum in London published ideas for language work using its collections and room settings (Amos *et al.* 1996). *The Guardian* newspaper's weekly education section had, for some years, published lesson ideas and links to specific national curriculum subject areas for news items and discoveries. For example, the archaeological discovery of 'Flores woman' was presented as a school project with basic information and lesson ideas in a regular series for teachers in *Guardian Education*, a supplement of *The Guardian* newspaper (Kneen 2004). English Heritage produced a number of teacher training films to link National Curriculum subjects (history and geography, maths, science and technology, art, music, English and drama) to work at historic sites to supplement the 'Education on Site' series of books for teachers (English Heritage 1992).

History

The study of history in school has often been considered both an essential part of the curriculum and a possible danger because it allows for discussion, at least in most countries, about the way that society has been known to act, who holds power and other controversial topics (Arthur and Phillips 2000; Historical Association 2007). The story of the establishment of the National Curriculum in Britain shows that this is often an accurate assessment. The history curriculum will include those periods which a particular society deems to be a necessary part of a child's education, but the choice of periods and topics will usually also reflect the way present society feels about its past. For example, suggested changes to the

Module 1
Archaeology of the Classroom: *What will survive?*
Discover archaeology and the work of an archaeologist

Curriculum Linkages and Integration

See Teacher Guidelines for additional information

S E S E H i s t o r y

INFANT CLASSES

STRAND: Story
 Strand Unit: Stories

1st & 2nd CLASSES

STRAND: Story
 Strand Unit: Stories

STRAND: Change and Continuity
 Strand Unit: Continuity and change in the local
 environment

3rd & 4th CLASSES

STRAND: Local Studies
 Strand Unit: My school
 Strand Unit: Buildings, sites or ruins in my locality
 Strand Unit: My locality through the ages

STRAND: Story
 Strand Unit: Stories from the lives of peoples in the past

STRAND: Change and Continuity Over Time
 Strand Unit: Continuity and change in the local
 environment

5th & 6th CLASSES

STRAND: Local Studies
 Strand Unit: Schools
 Strand Unit: Buildings, sites or ruins in my locality
 Strand Unit: My locality through the ages

STRAND: Story
 Strand Unit: Stories from the lives of peoples in the past

STRAND: Change and Continuity Over Time
 Strand Unit: Continuity and change in the local
 environment

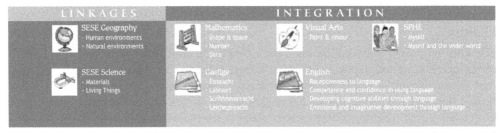

LINKAGES

SESE Geography
 - Human environments
 - Natural environments

SESE Science
 - Materials
 - Living Things

INTEGRATION

Mathematics
 - Shape & space
 - Number
 - Data

Gaeilge
 - Éisteacht
 - Labhairt
 - Scríbhneoireacht
 - Léitheoireacht

Visual Arts
 - Paint & colour

English
 - Receptiveness to language
 - Competence and confidence in using language
 - Developing cognitive abilities through language
 - Emotional and imaginative development through language

SPHE
 - Myself
 - Myself and the wider world

Fig. 7.1 The excellent work which archaeologists do with the Limerick Education Centre is demonstrated here as one page in two enormous files of a resource for teaching archaeology in and out of schools. Links are made to a number of relevant subjects across the Irish curriculum.

Why teach history?

The Nuffield Primary History Project answers this question simply:

- We all come out of the past, and what happened there influences what happens here and now – we need to know so we can understand the world today.

- Through history, we can lead children to understand how human beings behave and why people act as they do.

- By getting inside the past, we can lead children to respect and value each different period and society in its own terms.

(Nuffield Primary History 2010)

It goes on to list seven principles summarised below:

- Questioning – being curious, asking questions and discussing
- Challenge – speculation, tackling real issues
- Depth – studying in depth
- Authenticity – using real evidence
- Economy – using a few well-chosen resources
- Accessibility – working from what they know they can do
- Communication – giving a purpose to learning

secondary school history curriculum puts more emphasis on our multicultural society: 'History ... encourages mutual understanding of the historic origins of our ethnic and cultural diversity, and helps pupils become confident and questioning individuals' (Qualifications and Curriculum Authority 2007, 111).

The English, Welsh and Northern Ireland history National Curricula require the application of similar sets of skills which in summary are Understanding Chronology, Historical Understanding or A Sense of the Past, Interpretations of History, Historical Enquiry and Communication.

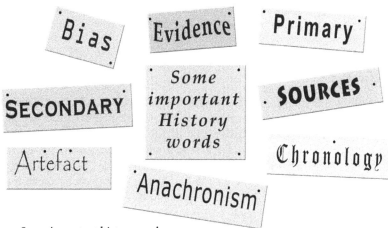

Fig. 7.2 Some important history words

On the whole, schools understand how to help pupils learn about acquiring these skills. For example, in 2005 on the wall of the history teaching room in the King's School in Ottery St Mary, Devon, I saw a number of cards which were pinned up for secondary students (see Fig. 7.2).

Using the historic environment

The skills listed above are surely those needed and used by both archaeologists and historians. How might these be applied to projects which use a visit to an historic place or an archaeological site? Perhaps the first thing to ask is: What skills do I expect students to acquire before, during and after a visit? Will they concern:

▶ Observation followed by questioning?

▶ Understanding historical and archaeological terms?

▶ Better understanding of the period or periods covered at the site?

▶ Appreciating that evidence has to be interpreted?

▶ Communicating findings?

Change over time

We must get over the message that discussion about the past is a continual process – conclusions reached today may well be disputed by others putting forward new evidence or a new *interpretation* of that evidence. Correspondence in *The Guardian* newspaper in 2006 illustrates this. An article about Vespa scooters, most popular in Britain in the 1960s, claimed that the riders (called Mods) tied rabbit tails to their bikes' aerials. A letter from a Vespa rider (ex-Mod) the next day contradicted this and claimed that the tails of foxes or similar were the norm. Further correspondence disputed this and one letter writer even claimed that (imitation) tiger tails were used ... and so on.

One of the important aspects of ancient and historic places is that they can demonstrate a sequence of changes, often over considerable periods of time. One preparation for this is to look at the familiar environment around them – for example, school, locality, town. Many places have had collections of old photographs or postcards published which may be compared with contemporary views.

Chronology

One of the complaints often raised against the 'modern' history curriculum is that, while students may know a great deal about the Romans in Britain or World War II, for example, they may not understand that these events are part of a broader, longer sweep of history. One of the school students preparing for university entrance examinations in a school, in Alan Bennett's play *The History Boys*, says facetiously to the teacher, 'How do I define history? It's just one fucking thing after another' (Bennett 2004, 85, showing that he'd read his Arnold Toynbee).

In one of the primary schools which took part in the Garbology Project (see case study p. 304), a class of 7–8-year-olds had a chronology task to carry out.

Projected onto the whiteboard and stapled in their work books was:

We are learning to put recent events into chronological order:
- ◆ I can think of things that happened before I was born
- ◆ I can think of things that have happened since I was born
- ◆ I can order them correctly.

Interpretations

Archaeologists know that anything which is discovered, from a small object to a large site, needs to be interpreted. Bonnichsen's experimental work in 1968 provides an interesting, and salutary, example which can be used with students, as I have done. The principles may be adapted and used in 'detective' approaches to objects and sites (see p. 210–15). Bonnichsen recorded a recently abandoned Indian camp site and published the findings and analysis as at any other archaeological site – features were plotted, objects recovered and plotted (Bonnichsen 1973). He interpreted the camp as having ten activity areas – cooking area, dog-tie area, tent area and so on. He met a former occupant of the camp, Millie, and tested his theories out on her; theories which often turned out to be wrong:

1. Items were misidentified and assigned to the wrong functional categories.
2. False associations were made between items.
3. Activity areas were interpreted incorrectly.
4. The relationships between activity areas were misinterpreted.
 (Bonnichsen 1973, 286)

The excavator concluded that:

... this study suggests that although the prehistorian may be able to develop logical, satisfying explanatory structure for understanding prehistoric data, there need not be any relationships between his model and the site under investigation. (Bonnichsen 1973, 287)

There are many forms of interpretation used on historic sites (see McAleavy 2000; Copeland 2004) but students may need help to understand what it means. Combining expressive arts (below) with history, you may show how artists and writers 'interpret' subjects and express them in their chosen medium, but questions of propaganda or bias will arise. War is a theme often explored by both artists and historians. For example, Picasso's *Guernica* shows the Spanish town heavily bombed by the Germans in 1937. It is not an exact representation but an artist's interpretation of the event. In the same way, Wilfred Owen, in his World War I poem *Strange Meeting*, imagines the experience of one soldier killed in war and confronting his killer:

> I am the enemy you killed, my friend.
> I knew you in this dark; for so you frowned
> Yesterday through me as you jabbed and killed.
> I parried; but my hands were loath and cold.
> Let us sleep now ...
> (Bottrall 1946, 546)

Photographs are also interpretations of events – photographers choose the subject, the angle and the exposure to create a shot. Sometimes a scene is created and posed, like a portrait in the studio. Alexander Gardner arranged the scene for dramatic effect in his photograph *Dead Confederate Soldier in the Devil's Den, Gettysburg, July 1863.*

Interpretation through creative arts

Some other examples which may be used to introduce the idea of interpretation are:

Book: Kurt Vonnegut's novel *Slaughterhouse-Five*, written in 1969 and set around the fire-bombing of Dresden in Germany during World War II.

Play: R. C. Sherriff's *Journey's End*, first performed in 1928, explored the emotions of soldiers and was based on his experiences as a soldier in World War I.

Film: David Lean's 1957 film *The Bridge on the River Kwai* was based on Allied prisoners of war forced to build bridges for a rail link to support the Japanese occupation of Burma in 1943.

Music: Benjamin Britten's *War Requiem*, written for the consecration of the new cathedral in Coventry in 1962 to replace the previous building destroyed in a German air raid. Richard Barrett's *Mesopotamia* was composed at the time of the war in Iraq and, as part of his *Resistance and Vision* series, draws musical parallels with archaeologists removing layers of the past to reach lost civilisations.

Music with words: Steve Reich's 1988 string quartet, *Different Trains*, creates sound images of the trains to the Nazi death camps interspersed with fragments of oral history recordings.

Song: 'Oh! It's A Lovely War!', satirical music hall song written in 1917 by J. P. Long and M Scott. The first verse is:

> Oh, oh, oh it's a lovely war.
> Who wouldn't be a soldier, eh?
> Oh it's a shame to take the pay.
> As soon as reveille has gone
> We feel just as heavy as lead,
> But we never get up till the sergeant brings
> Our breakfast up to bed.
> Oh, oh, oh, it's a lovely war.

Ballet: Inspired by visiting ancient sites in Italy and in particular the Colosseum in Rome, Aram Khachaturian composed a ballet based on the life of Spartacus who led a slave uprising against the Romans in the 1st century AD. The score was finished in 1954 and the ballet was first performed at the Kirov Theatre in St Petersburg two years later.

Language

Each country, naturally, considers that its mother tongue and its literature are an essential part of the school curriculum and this is usually the first listed subject in any strategies for achieving literacy (and numeracy) in future citizens. National curricula in many countries set out three areas for studying a national language in primary and secondary schools: Speaking and listening, Reading, Writing. In addition to instructions or advice for creating classroom strategies in these areas, countries will often specify which authors and books should be studied.

This section will present some tested ideas for using examples from archaeology and literature as a way of encouraging teaching and learning in a national language. Drama and role-play is used in some countries to teach history and is included in this section.

Speaking and listening

Listening need not be confined to the human voice. The historic environment may offer a range of auditory experiences for students – the quietness of a prehistoric site in the countryside broken by birdsong (or the arrival of the school party!); the echoes in an empty and ruined historic house; the sounds different building materials make; the rhythm of machinery; the bustle of an archaeological excavation in progress or the noise of an urban historic environment.

Storytelling (as well as drama and role-play, see below) can heighten students' awareness. The English national curriculum requires students to listen carefully to others and to use language imaginatively. Instructions for teachers in California (California Department of Education 1999) required kindergarten to third grade students to relate, retell and recount stories and experiences – which could, of course, come out of visits to historic sites or museums. Professional storytellers are often employed at special events on historic sites and at museums for school parties or families (see Fig. 7.3). Maddern, who works with schools and the public, explained the process to teachers with examples from the main periods of British prehistory and history, stating that: 'Children respond naturally to stories with enthusiasm and interest. Though stories should primarily be told for their own sake, they can link, or be a starting point for, other work across the curriculum' (Maddern 1992, 3).

Some stories have been written carefully from historical and archaeological evidence. There are two good examples from the Silk Road – ancient trading routes from China to the Mediterranean. Susan Whitfield's stories are based on her own researches and follow various characters, for example 'The Merchant's Tale' and 'The Courtesan's Tale' (Whitfield 1999). More recently a resource for teachers on the Silk Road has been published (Smithsonian 2004) which contains a CD with recently created stories.

Speaking and listening practice for children can be included in most activities across the subjects but on historic sites they may include

▶ Choosing an appropriate word to describe a particular feature of an historic site or building. For example, a column might be *strong* or *ornate*, a room with windows *airy* or *tranquil*, a circle of prehistoric stones *mysterious* or *exciting*. Ogilvie (2005, 281) suggests that the natural environment has 'innate qualities which are impartial and objective' which may be described as, say, 'muddy,

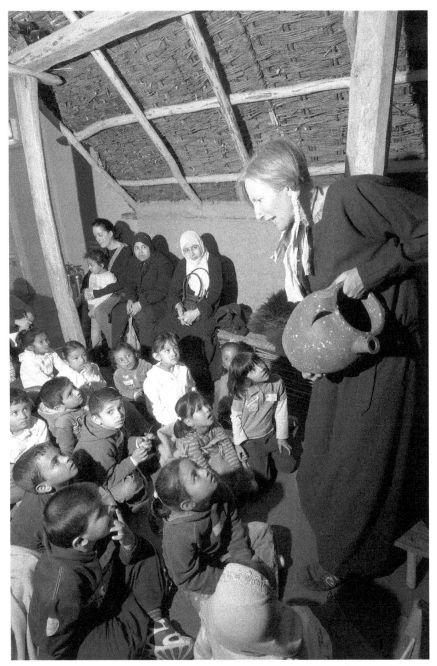

Fig. 7.3 Storytelling sessions are now a common event in museums for school groups and families. This is one in the medieval gallery of the Museum of London.

rocky or smooth' while people who are affected by natural features assign subjective qualities with descriptive phrases such as 'energy-sapping and mind-blowing';

▶ Describing part of a site (the remains of a staircase in a ruined structure, for example) or an activity (archaeologists at work, for example);

▶ Presenting their investigations of the site;

▶ Taping interviews with other children, visitors or staff on site;

▶ Giving a guided tour.

These speaking and listening activities may be presented, perhaps back at school, as written texts.

Reading

The development of children's reading clearly demands a knowledge of vocabulary which should increase in number and complexity of words and concepts as the child grows older. 'Word collecting', as Collins and Hollinshead (2000, 4) call it, is a useful exercise at historic sites which serves both the language and history curricula. Before or after the visit the teacher may, for example, use publicity material (leaflets, adverts) from sites and museums (Amos *et al.* 1996, 10), guidebooks and documents (see range below). Words may be collected by the children in various ways – for example, playing the 'I Spy' game with younger children to spot parts of buildings, using the appropriate words to describe, on site, parts of a building from a plan or the actions, tools and equipment used by archaeologists on an excavation and giving children photos or drawings to locate and name individual parts of an historic site.

These exercises may also be conducted by reluctant readers using pictograms instead of words in a 'reading-free zone' (Collins and Hollinshead 2000, 18). Beyond simply word collecting, there are opportunities to study language through plaques on buildings, gravestone inscriptions and on war memorials. For children who find reading (and writing) difficult there are opportunities at heritage sites and museums for collecting examples of pictograms – for example, those used on signage and information boards for audio tours.

Writing

A national language curriculum will often specify that teachers should allow children to develop skills in both fiction and non-fiction writing and will give examples for teachers such as letters, reports, poems, plays, fiction and non-fiction books and diaries. There may also be specific examples of documentary evidence listed in the curriculum for history. There are a number of opportunities for writing which may come out of a visit to an historic site or museum – for example, writing captions for objects or interpretation panels for parts of the site, or writing an account of the visit back in school, perhaps in the form of a report for the local newspaper. Information may be collected in groups for a particular task set by the teachers, for example a report on the defensive capabilities of a castle or other on-site activities.

Non-fiction writing may include a class writing its own guidebook or trail, an advert for the site or even, for older children, the script for an audio tour for a particular group, such as disabled visitors.

Creative writing is often stimulated by the 'I see, I hear, I feel' exercise where children can record physical features or attributes on a chart. Collins and Hollinshead (2000, 7) show how this might be extended into the past:

Table 7.1 I see, I hear, I feel (after Collins and Hollinshead 2000, 7)

I see	I hear	I feel
1	1	1
2	2	2
3	3	3
Would I have seen it then? If not, what might I have seen instead?	Would I have heard it then? If not, what might I have heard instead?	Would I have felt it then? If not, what might I have felt instead?
1	1	1
2	2	2
3	3	3

This exercise may be extended by the other 'sense' words – smell and taste.

Curricula will also demand that children acquire a knowledge of the construction of language, types of words and devices used by writers. For example, alliteration might be taught by asking children to collect alliterative pairs such as 'slender spire' and 'dusty darkness' (Johnston et al. 2004, 13).

Poetry has also been used as a stimulus for appreciating old buildings. Stevens et al. (2002) produced ideas for teachers for a project and poetry competition,

Poetry reflecting the past

A knowledge of language together with the experience of the historic place itself might be developed into writing poetry. This poem (Johnston et al. 2004, 36) was written by a child following a school visit to the church of St Mary Magdalene, Battlefield in Shropshire:

> Towering wall telling tales of great massacre,
> Cowering gravestones full of terrible pain.
> Musty damp air chilling your spine,
> And a creeky floor echoing like the wind in the trees.
> A wistful stone to mark past loved ones,
> And scarlet windows making the floor
> Shimmer blood red.
>
> Birds felicitously chirping,
> Flower buds opening for the very first time.
> A holy calmness sweeps around you,
> Seeing golden shields of honour and pride.
> (Adam Jones, The Grange Junior School)

Beloved Buildings, organised by The Society for the Protection of Ancient Buildings. Poetry has also been used as extension work for on-site projects – for example, studying World War I poets following a visit to the trenches in northern France. A form of poetry often used by teachers is the Japanese haiku which has three lines, a total of 17 syllables in a pattern of 5, 7 and 5. Collins and Hollinshead (2000, 29) wrote this haiku poem about a redundant industrial mill as an example for teachers:

> Tall, proud, high chimney
> Watching over solid walls
> And delicate sheds.

Drama and role-play

We often hear the expressions 'put yourself in my shoes' or 'look at it from my point of view', but we do not always find that easy. Putting yourself into a situation in the past is more difficult, some would argue completely impossible, yet there are ways of getting somewhere near. Young children often take themselves out of themselves in games of make-believe, sometimes by dressing up, and often with props such as dolls, toys or constructions of their own or their parents' or teachers' making. Wilson's brilliant book, *What It Feels Like to Be a Building* explains how buildings work by explaining that 'when you feel what it feels like to be a building, you can talk to buildings and they will talk to you in building body language' (1988, 2). He is asking his young readers to express empathy with the building – in this case to look back at them through the eyes of the building. On historic sites we are asking children to put themselves into the shoes, or sandals, or riding boots, or animal skins, or armour or top hats of characters in the past.

The teacher trainer Dorothy Heathcote (Johnson and O'Neill 1990, 61) defined educational drama as 'being anything which involves people in active role-taking situations in which attitudes, not characters, are the chief concern' and that using role-play in the classroom can, among other things, teach facts, challenge attitudes, pose questions and demand understanding.

Drama and role-play has long been regarded as a standard part of many curricula subjects (although the term was used as a term of abuse in attacks on the creation of National Curriculum History in the UK, see p. 121). Educators using drama and role-play will tell you that it can be a useful part of their repertoire of teaching and learning strategies at historic sites (Wilson and Woodhouse 1990, 5; Fairclough 1994, 4; Collins and Hollinshead 2000, 16) and I would support that view from my own experience (Corbishley 1988).

Role-play situations for school or college groups at historic sites must be based on firm evidence, whether it is historical or archaeological. Sometimes it is possible to base the role-play on documented situations (e.g. the arrival of European settlers in America) or 'created' situations based on archaeological analysis (e.g. a story based on an excavated and reconstructed site, such as West Stow Anglo-Saxon Village in Suffolk).

Teachers may prepare students for role-play situations on site by a 'hot-seating' exercise. Students question a teacher, who may be in role or move into role after an introduction to the class, about the character and her life in the past. Costume is not always necessary for role-play even when carried out on site, although living history projects will require a high degree of authenticity (see below).

Problem solving exercises can be carried out in role on site or be a prompt for an information-gathering exercise.

Role cards are an excellent way of encouraging role-taking and have been used in several countries. Those taking part are given information, with illustrations, if thought necessary, about a real or imaginary character. This might be to help create a drama on site (such as the solving of a murder at a medieval castle) or help to build up a picture of everyday life or help to create a discussion about a heritage issue (Anderson *et al.* 2000, 29–31). Cooksey (1992, 15–16) created a 'Who's Who?' for the inhabitants of a medieval abbey with role-cards. She devised three sections for each: Qualities, Duties and Comment. For example, the qualities of a Prior or Prioress should be 'good organiser, efficient and cautious', the duties of the Kitchener included 'catering manager, runs the kitchen and orders all the food, beer and wine from the cellarer and ensures plentiful supplies of fish every Friday', while the comment about the Infirmarer was 'is allowed to keep a fire and lamp burning all night'.

Living history projects require a great deal of thought, preparation and organisation but have proved to be an exciting way for children to learn about a period or event in the past. In Britain, pioneer work was carried out from 1978 by two educators from Suffolk County Council – Patrick Redsell (Drama Adviser) and John Fairclough (Museums Education Liaison Officer). They created a variety of drama projects in historic surroundings which culminated in large living history projects in historic houses and at state-owned castles which were subsequently published, with other projects, as examples for teachers (Fairclough and Redsell 1985; Fairclough 1994; Corbishley 1988; Corbishley 1990a; English Heritage 1986 and 1995a).

All these projects had a strong dramatic element. A storyline had been created but the interaction between the adult characters (a variety of educators and helpers) and the students themselves brought about a different conclusion each day.

The scenario at Orford Castle in Suffolk (created by Fairclough and Redsell) was based in 1173, a date chosen because the castle had not yet been completed. 120 children worked each day in groups (from stone-cutting to cooking) in a constructed encampment next to the medieval castle. The dramatic element was provided by the possible presence of spies. Some students inevitably discovered the spy and the person was brought to trial at the end of the day. Authenticity was provided by careful planning and preparation of teachers on one-day course, with time spent by teachers integrating the project into curriculum work in a number of subjects before the day. The attention to detail in costume, language, equipment and camp construction was an essential part of this project to create a 'distance' between the constructed past and a complete absence of anyone, especially the general public, wearing modern clothes and with modern attitudes.

A number of living history projects carried out by English Heritage showed that the technique could be used successfully for a range of schools, students' abilities and historic sites (from prehistoric to industrial). The projects naturally included students with special needs and in one project, at Kirby Hall in Northamptonshire, students from eight special needs schools participated (Corbishley 1988).

Using documentary sources

The word document is used here to mean both written historical evidence and examples of writing from different periods. Some site-specific resources for teachers include examples from a range of documents – from descriptions in Latin to medieval texts to modern archaeological reports. Most well-thought-out teachers' resources from museums and heritage organisations will include examples of documentary evidence with ideas of using them in the classroom or on site. The pack from the Museum of Antiquities in Newcastle upon Tyne has a particularly good section called 'Links to Literacy' with ten original texts (Catling and Rankin 2007, 38–53). All site-specific handbooks for teachers published by English Heritage included a range of documentary evidence. Teachers' resources from Colonial Williamsburg include a number of documentary sources. Teachers are also commissioned to write specific 'teaching strategies' – for example, the publications of two letters from George Washington concerning the surrender of the British army at Yorktown in 1781 together with teaching suggestions for analysing the language and the content and an exercise to create an imagined reply from the recipient, General Cornwallis, the commander of the British Army at Yorktown (Hewitt 2007).

Documents may be used in a variety of ways but should 'add to pupils' understanding of an historical period or topic rather than merely provide opportunities to add variety to lessons' (Davies and Webb 1996, 4). Documents should be presented as either primary or secondary sources of evidence and may be scrutinised for bias and reliability. But documents may also be used as part of language development and understanding. The examples given on pp. 162–6 below, which are all concerned with the historic environment, can be used to:

▶ Understand that language (its construction, words and meaning of words) changes over time;

▶ Explain that factual reports may not be unbiased;

▶ Show that creative writing (e.g. poems) can provide useful information about the past and historic sites;

▶ Provide examples for the types of documents which are listed as curricula requirements for language and history.

Science

Most archaeologists, when defining their discipline, will use the word 'scientific' at some stage. But while *Science in Archaeology* (Brothwell and Higgs 1963) explained and reviewed scientific techniques used in the laboratory and in the field, it did not contain articles on subjects such as excavation techniques or experimental archaeology. Daniel calls the last chapter of his book *The Origins and Growth of Archaeology* 'The Mature Science' because, by the 1920s, 'archaeology seemed to have become a mature and recognized discipline' (Daniel 1967, 290). But beyond archaeology, science may be defined as a disciplined study of the physical nature of our universe, testing theories through observation, recording and experiment. Barker (1977, 12) rightly points out that other 'scientific disciplines' are able to test the results of experiments by other experiments but that 'the study of a site by excavation is an unrepeatable experiment'.

Investigations

Discovering crop marks at Richborough Roman site in Kent

But now age has eras'd the very tracks of it; and to teach us that Cities dye as well as men, it is at this day a corn-field, wherein when the corn is grown up, one may observe the draughts of streets crossing one another, (for where thy have gone the corn is thinner) and such crossings they commonly call S. Augustine's cross. Nothing now remains.

> William Camden describing crop marks (perhaps the first to do so) in his book *Britannia* in 1586 (Jessup 1961, 185).

Settlers' houses in early colonial America

Those in New Netherlands and in New England who have no means to build farm-houses at first according to their wishes, dig a square pit in the ground, cellar fashion, six or seven feet deep, as long and as broad as they think proper, case the earth inside all around a wall with timber, which they line with the bark of trees or something else to prevent the caving in of the earth, floor this cellar with plank and wainscot it overhead for a ceiling, raise a roof of spars clear up and cover the spars with bark or green sods, so that they can live dry and warm ...

> Van Tienhoven writing in 1650 (quoted in Noël Hume 1982, 57) shows how his excavation of a cellar house at Martin's Hundred matches this documentary evidence.

Visiting Merv in Turkmenistan

I caught my first glimpse of the old cities of the plain – the ancient capitals of Margiana. A long line of walls and turrets, dominated by some towering domes, broke the line of the horizon ... I could scarcely express my anxiety to proceed there and then to this mysterious spot concerning which so much has been written and so little known.

> The traveller Edmund O'Donovan writing in 1882 (see case study p. 257).

Prehistoric remains

Tess at Stonehenge

Feeling sideways they encountered another tower-like pillar, square and uncompromising as the first; beyond it another and another. The place was all doors and pillars, some connected above by continuous architraves.

'A very Temple of the winds', he said.

The next pillar was isolated; others composed a trilithon; others were prostrate; their flanks forming a causeway wide enough for a carriage; and it was soon obvious that they made up a forest of monoliths grouped upon the grassy expanse of the plain. The couple advanced further into this pavilion of the night till they stood in its midst.

'It is Stonehenge!' said Clare.

'The heathen temple, you mean?'

> Thomas Hardy, *Tess of the D'Urbervilles* (1926, 510–11), written in 1891.

Vast settlement of huts linked to Stonehenge

The mysterious builders of Stonehenge have finally been tracked to their doors. Archaeologists yesterday announced that they found the largest concentration of prehistoric hut sites ever discovered in Britain, at Durrington Walls, two miles from the stone circle.

The sites of eight huts have been excavated. Each is about five metres square with a clay floor and central hearth ... Two grander buildings, surrounded by fences and ditches, may have been the homes of chieftains or priests – or possibly the spirits.

The finds back Dr Parker Pearson's belief that the stone circle was a place of the dead, linked by a broad stone-paved track to the timber circles at Durrington Walls. Dr Parker Pearson announced his discoveries at a press conference in the US, sponsored by National Geographic.

<div align="right">Part of a report by Maev Kennedy in The Guardian, 31 January 2007.</div>

What do we know about the Romans?

At a Roman baths

I live over the public baths here – you know what that means. Ugh! It's sickening. First there are the strongmen doing their exercises and swinging heavy weights about with grunts and groans. Next there are the lazy ones having a cheap massage – I can hear someone slapped on the shoulders. Then there is the noise of a brawler or a thief being arrested and the man who likes the sound of his own voice in the bath. And what about the ones who leap into the pool making a huge splash as they hit the water!

<div align="right">Letter from Seneca about a public baths in Rome in
Epistolae Morales written c. AD 63 (author's translation).</div>

Private eye Marcus Didius Falco on the way to his office in Rome AD 70

It was the usual scene in the Forum. We had the Record Office and Capitol Hill hard above us on the left; to the right the courts, and the Temple of Castor further down the Sacred Way. Opposite, beyond the white marble rostrum, stood the Senate House. All the porticos were crammed with butchers and bankers, all the open spaces filled with sweaty crowds, mainly men. The piazza rang with the curses of strings of slaves crisscrossing like a badly organised military display. The air simmered with the reek of garlic and hair pomade.

<div align="right">Lindsey Davis, 1989, from her first detective novel
The Silver Pigs, set in ancient Rome (1990, 4).</div>

Imagining the past

On the track of the Romans

From hence I determined to proceed to London all the way on the Roman road, which perhaps has not been so scrupulously travelled upon for this thousand years: the intent, which I executed, was to perform the whole sixth journey of Antoninus his Itinerary; of which I shall give as complete an account as can be expected, considering how totally most of the stations here are erased, and that I was resolved so far to imitate an ancient traveller, as to dine and lie at a Roman town all the way if possible, and sometimes faring as meanly as a Roman soldier.

<div align="right">William Stukeley writing in his Itinerarium Curiosum in 1776 (Jessup 1961, 45).</div>

The Roman Road

The Roman road runs straight and bare
As the pale parting-line in hair
Across the heath. And thoughtful men
Contrast its days of Now and Then,
And delve, and measure, and compare;
Visioning on the vacant air
Helmed legionaries, who proudly rear
The Eagle, as they pace again
The Roman Road.

But no tall brass-helmed legionnaire
Haunts it for me. Uprises there
A mother's form upon my ken,
Guiding my infant steps, as when
We walked that ancient thoroughfare,
The Roman Road.

Thomas Hardy (1978, 61).

The Flesh Scraper

If I had sight enough
Might I not find a fingerprint
Left on this flint
By Neolithic man or Kelt?
So knapped to scrape a wild beast's pelt,
The thumb below, fingers above,
See, my hand fits it like a glove.

Andrew Young, the vicar of Stoneygate, Sussex 1941–59,
died 1971 (Jones *et al.* 1969, 51).

Church visiting

The Church of St Protus and St Hyacinth, Blisland, Cornwall, 1951

A church on an unusual plan, with the tower added on to the N to the N transept. It has a stair-turret of rectangular plan rising above the parapet and pinnacles. There is no W door; a strong batter to the W wall instead. The church is essentially Norman.

Nicholas Pevsner (1951, 28).

The Church of St Protus and St Hyacinth, Blisland, Cornwall, 1948

The church is down a steep slope of graveyard, past slate headstones and it looks over the tree tops of a deep and elmy valley and away to the west where, like a silver shield, the Atlantic shines. An opening in the churchyard circle shows a fuchsia hedge and the Vicarage front door beyond. The tower is square and weathered and made of enormous blocks of this moorland granite, each block as big as a chest of drawers.

John Betjeman (1978, 141)

A church visit: diary entry 9 February 2003

To Widford in the Windrush valley near Burford for a second look at the church built on the site of a Roman villa, the mosaic floor (now covered over) once the floor of the chancel. There are box pews, aged down to a silvery grey, a three-decker pulpit, Jacobean altar rails and the remains of whitewashed-blurred medieval wall paintings.

Alan Bennet (2005, 323)

Remembering

The Byng Memorial

In loving memory of Julian Hedworth George Byng,
Field-Marshall, Viscount Byng of Vimy, who worshipped
here for 20 years. This Church was restored, redecorated and
refurnished in 1936 by his wife, his sister and some of his
closest friends. Opposite hangs his banner of the Most
Honourable Order of the Bath, which during his life hung in
King Henry VII's Chapel in Westminster Abbey and at his death
was presented to Beaumont Church by his wife.

Plaque in Beaumont-cum-Moze church, Essex.

Advertising the past

Grime's Graves, Norfolk

This is an extraordinary visit! Go underground and experience at first hand the conditions of Stone Age man 4,000 years ago. Explore the earliest major industrial site in Europe. Discover the significance of over 300 pits and shafts in these Neolithic flint mines. Descend over 10 metres to the galleries where flint was mined for weapons and domestic utensils. The unusual landscape of Grime's Graves long confused 'experts' with its series of gentle hollows and depressions – find out what wacky theories were conceived as explanations!

(English Heritage tourist leaflet 2003)

Skara Brae, Orkney, Scotland

The Village of Skara Brae was inhabited before the Egyptian pyramids were built and flourished many centuries before construction began at Stonehenge. It is some 5,000 years old.

But it is not its age alone that makes it so remarkable and so important. It is the degree to which it has been preserved.

The structures of this semi-subterranean village survive in impressive condition. And so, amazingly, does the furniture in the village houses. Nowhere else in northern Europe are we able to see such rich evidence of how our remote ancestors actually lived.

From the visitor's guide to Skara Brae (Clarke and Maguire, 1995).

Science used in archaeology

There are many examples of archaeological science which are easily available to use for curriculum studies. English Heritage publishes a number of guidelines on a variety of techniques. *Investigative Conservation* includes a case study on two wooden combs found in waterlogged deposits during on excavations at Roman Ribchester. Conservators found the bones were made of boxwood and looked similar to modern 'nit' combs. Examination under 'low-power transmitted light microscopy' revealed many fragments of human head lice. The combs were stabilised by freeze-drying (English Heritage 2008, 18).

Curriculum links

Promoting the use of archaeology to teach parts of the science curriculum can involve showing how archaeologists carry out careful and recorded work, whether in the field or in the laboratory and that archaeological scientists use a variety of techniques which have been developed by non-archaeological scientists, from geological dating methods to computer applications.

Specific topics in teaching archaeology and history can be linked to science applications – for example, studying materials through working with objects, life processes through ingredients and food used in the past and forces in buildings and machinery. Some educational writers have shown that science may be included in teaching history topics, especially at primary school. Cooper (2000a, 72) shows how replicating Archimedes' experiments with volume, for example, may justifiably be part of the Ancient Greece topic in history at primary school. Kelly (2005, 72–3) records a case study where an archaeologist visited a primary class and used the 'key ideas of science and the tools of archaeologists' by introducing the students to pollen studies, snail shells, animal bones, wheat seeds, building artefacts and aerial photographs.

The science curriculum in many countries covers the standard areas of chemistry, physics and biology but some countries may include these standard subjects in areas such as life or earth sciences, geology or the environment. The English National curriculum for science, for example, uses three main areas of study, for all children aged 5 to 16, called Scientific Enquiry, Life Processes and Living Things, Materials and their Properties, and Physical Processes, while for older students there are public examinations in chemistry, physics and biology. One public examination taken by 16–19-year-old students in the UK contains a specific module in archaeological science. The examination board Edexcel which offers an Advanced Level General Certificate in Education in Physics has a unit called 'Physics for life' which has a module 'Digging up the past: The excavation of an archaeological site, from geophysical surveying to artefact analysis and dating' (Edexcel 2006, 30–1) which covers resistivity surveying, analysis by X-ray diffraction, ionising radiation and thermoluminescence, detecting light using photomultipliers.

As with other curriculum subjects, the archaeological educator will need to make specific connections between archaeological techniques and the subject of science. The following table uses the terminology of the English science curriculum for children aged 11–14 as an example, with links to other curriculum subjects given in brackets:

Table 7.2 Links with science

Archaeological techniques	Science curriculum links
Recording field monuments/archaeological features/artefacts, e.g. site records, field surveys, laser imaging, 3D scanning	'Scientific enquiry: Obtaining and presenting evidence; Explain and interpret observations, measurements and conclusions'.
Analysis of data, e.g. computer analysis of artefact scatters	'Scientific enquiry: Use a wide range of methods to represent data; provide scientific explanations based on evidence' (Information and communication technology)
Analysis of artefacts, e.g. wear analysis of flint axes	'Scientific enquiry: Physical changes' (Design and technology)
Environmental archaeology, e.g. bone or seed analysis	'Life processes and living things: Nutrition; Living things in their environment'
Study/analysis of materials, e.g. X-rays of metal artefacts	'Materials and their properties: metals'
Aerial archaeology, e.g. photography, satellite images, air-borne radar	'Physical processes: Use of artificial satellites to observe the Earth'
Locating sites by geophysical instruments, e.g. magnetic, resistivity, sonar and ground radar	'Physical processes: electricity and magnetism'
Dating techniques, e.g. pollen, dendrochronology, radiocarbon, archaeomagnetic, thermoluminescence	'Physical processes: electricity and magnetism'
Experimental archaeology, e.g. reconstructing buildings, replicating processes	'Scientific enquiry: Explain and interpret observations, measurements and conclusions; Evaluating interpretations'
Heritage issues, e.g. conservation of ancient monuments/landscapes	'Materials and their properties: Changing materials' (Citizenship/social studies)

Archaeology, science and schools

Science methods and applications have long been used by teacher-archaeologists. One of the Council for British Archaeology's booklets for teachers specifically dealt with science projects in schools (Croft 1982), including experimental archaeology, food and cooking and conservation projects carried out from the 1960s onwards. Heritage education providers often include science projects in their services – for example, at the Archaeological Resource Centre in Toronto (Smardz 1990, 304) and the Canterbury Archaeological Trust (see below). Several archaeological projects based on the science curricula are included elsewhere in this book – forensic archaeology science projects (p. 207), bone master class (pp. 333–4) and erosion and conservation of monuments (below). Details of other tried and published projects follow.

Buried remains: A common project to carry out with schools and family groups is to investigate what happens to archaeological artefacts and other remains once they are buried below the ground. Projects range from speculation about what might remain of modern rubbish for future archaeologists to discover (Corbishley 2001 and see pp. 213–15), to observation of the rotting process through experiments. McNutt (1995, 6–11) sets out a sample lesson where fruit is placed in a variety of simulated soil conditions (frozen, dry, humid, under water and in wet clay) in clear plastic cups and observed in class over a four-week period. An experiment using metal drink cans immersed in water, salt water, damp soil and dry air posed questions to be answered from observations in the classroom (Pownall and Hutson 1992, 34). As part of the 'Science, Engineering and Technology Week '99', the Canterbury Archaeological Trust, with Canterbury Museums and the University of Kent, arranged an event for adults and families called 'Smelly Bits' where plant and animal remains and human faeces from a Norman cesspit could be safely investigated (Green 1999, 61).

Investigating structures and forces: Prehistoric megalithic monuments exist in a number of countries and these pose questions for archaeologists about how such heavy stones might have been moved and erected. Keen (1996, 28–9) and Pownall and Hutson (1992, 13–14) suggest activities for teachers. Corbishley *et al.* (2000, 26–7) outlined a scientific experiment which replicated the movement of the stones at Stonehenge using ordinary house bricks to test how they might be moved, by *weighing* one brick and measuring its length, width and height, *attempting* to push the brick along a smooth flat surface using one finger tip, *recording* how many finger tips were needed before the brick moved and *recording* how many fingers were needed for a variety of surfaces. The next test uses string to pull the brick across different surfaces, recording what happens when each surface is lifted or lowered to different gradients and how much pulling power is needed using a string balance. Finally, wooden rollers were used to *experiment* with different numbers of rollers, *record* the difference made to the amount of effort required and *investigate* the difficulties of moving the brick downhill.

Close observation of upstanding ancient and historic structures will provide ample opportunity to study forces and help to explain why these structures are still standing today. For example, the construction of an arch can be shown by making a model using wedge-shaped blocks of plasticine or wood over a shape-former,

while its weight-bearing properties may be demonstrated by using students to construct a simple arch with their own bodies: two students form an arch with their hands joined while a third hangs from the centre, while a flying buttress may be demonstrated as: two other students supporting the backs of the arch-making students. Interactive science centres often use examples of structures used in the past, such as medieval stone bridges and buttresses.

Investigating building materials: Visits to ancient sites and archaeological excavation may provide opportunities for education groups to study and record a range of materials, from quarried rocks, gravel and sand to constructed materials such as wood, mortar, bricks, tiles and metal in constructions such as: kilns of all periods and Roman under-floor heating made of heat resistant material; mounds of earth which can be formed into the appropriate shapes for burial monuments or defensive earthworks, for example; stone walls of castles built to withstand attack; hydrated lime (calcium hydroxide) mortars for buildings such as medieval churches made from water, quicklime (calcium oxide) and sand; and industrial engine houses built of solid materials on foundations which can absorb shock.

Engering provides a useful list with descriptions of the types of stone used in UK ancient monuments, for example:

Table 7.3 Properties of stone (after Engering 2002, 2).

Tufa	Formed from calcium carbonate (dissolved limestone) deposited from springs. Used extensively in some areas, now mostly worked out. Easily worked, strong, light and porous.	Romans used tufa, for example Chesters Fort (Hadrian's Wall). Used for vaulting in churches and cathedrals.

Records can be made of materials used in their natural state or altered in some way by the builders, such as by carving stone or by knapping flint. Stone similar to that used on an ancient site such as a castle (but not from the site, of course!) may be further investigated back in the classroom. Building materials may be investigated for their colour, appearance, touch and hardness – activities which can extend children's vocabulary in oral or written descriptions. Experiments may be carried out on a variety of stones and constructed building materials by scratching, chiselling, testing for water absorption or for reactions to acid. Observation of weathering or wear on ancient monuments may lead to discussion about conservation and citizenship issues. For example, wear on stone staircases in castles and forts may indicate which has most been used in the past (main stairs? servants' entrance?), their conservation needs and the safety considerations for visitors.

Science-based exercises at an historic site could involve finding and recording the different building materials. Younger students might be asked to fill in their answers or descriptions based on careful observation:

Table 7.4 Describing a building material

Name of material	Flint
Looks like	Black with white and grey bits
Feels like	Cold, very smooth in places but has some sharp edges
Why used here	Decoration

A simple chart such as the following can be used on site to record observations of different building materials:

Table 7.5 Comparing properties of building materials

Material	Natural or mixed/made?	Where used?	Prefabricated or made on site?	Properties?
Wood	natural	window frames	prefabricated	easily shaped
Mortar	mixed	between the stones	made on site	holds things together

Living things: Teachers taking educational groups to ancient sites or working in their local historic environment will encounter examples of plants and animals which may be studied as part of cross curricular work involving archaeology, history and science. Castle, abbey and historic house walls will often display wall-growing plants. Their grounds, and urban parks, will usually have a collection of trees, which either have been deliberately planted or have grown naturally. Churchyards are often important havens for plant, insect and animal communities. Gravestones and the roof and walls of a church can provide the right surfaces for lichen to thrive. One of the 1350 species of lichen growing in Britain is called *churchyard lecanactis* and grows on limestone rock, lime plaster and mortar. Codrington (2006) provides detailed suggestions for group curriculum work for 10 and 11-year-olds, on plants, animals, habitats and food chains. One exercise suggests a cross curricular activity with history, called 'Plants and where they came from', which takes as its starting point that up to 40% of plants in British cities have been introduced from outside of the British Isles in the past. Students are asked to investigate their local public garden or park to investigate:

Which are native plants, originating in Britain?

Which are exotic, originating in other countries?

When did the exotics arrive?

Which have become naturalised?

Where did they come from?

Who might have brought them? Why? How?

(Codrington 2006, 11)

Extension activities are to plot origins of plants and trees on a map of the world, and to create a wall display.

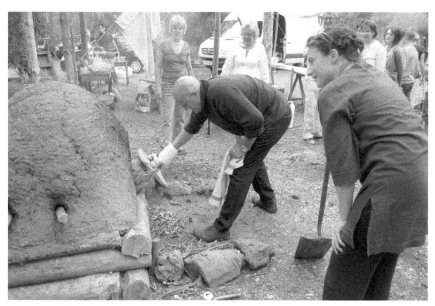

Fig. 7.4 The bread oven being heated up

Experimental archaeology: Experiments on excavated archaeological artefacts began in the early 19th century (Coles 1973, 13). Experiments include reconstructions of structures; for example, Iron Age houses at Butser (Reynolds 1979 and 1999) and Anglo-Saxon buildings at West Stow (see pp. 27–8) are now considered an important part of archaeological investigation. Some of these reconstructions are now open for public display.

Keen (1996, 15–20; 1999) shows how ancient structures worked and gives specific instructions on the building of a wooden prehistoric round house, based on those he had built with children in schools. Many teachers, and heritage education providers, conduct experiments on a smaller scale, by making replica shoes, for example, or by grinding corn using borrowed quern stones from a museum, by replicating historic recipes, by making fire with a bow drill, by dyeing material using plant extracts or by testing the efficiency of ancient oil lamps. However, the most commonly carried out experiment (on school and museum grounds or at heritage and archaeological sites) is the making and firing of pottery. A detailed account of a number of experimental Roman kiln-firings in a secondary school through the 1970s and 1980s was published by the Council for British Archaeology (Fanthorpe 1982, 16–20). The Southampton 'Archaeology and Education' scheme carried out a number of different experimental archaeology projects with schools (see p. 85).

Clamp kilns, rather than the constructed replica kilns mentioned above, are more often used for experimental firings. The Canterbury Archaeological Trust (Green 2002, 80–1) organised a project with a secondary school as part of their 'Enrichment Week' at the end of the summer term. Students made a variety of replica pots based on prehistoric and Anglo-Saxon styles from locally collected clay. A clamp kiln was built using turf, soil, logs and straw and fired overnight (see Fig. 7.4). The project and the successfully fired pots formed part of a temporary exhibition in the school.

Food processing and cooking is a tried and tested activity in schools (Corbishley 1982) and may be used to examine in more detail both the ingredients and processes which were used in the past and carry out some experimental work which will fit the requirements of a science curriculum. Examining the processes in detail, as the table below shows, may be a useful starting point to understand that ingredients have different properties and that energy produces changes.

Table 7.6 Cooking and science (after Pownall and Hutson 1992, 21)

Activities	Examples
Melting/solidifying	Jelly, chocolate
Boiling	Water from a pan of vegetables
Evaporating	Water from a pan of vegetables
Condensing	Water (use a mirror above hot cakes)
Absorbing water	Pulses or rice
Mixing	Cakes and biscuits
Separating/sieving	Tea and tea leaves
Drying	Bread

Mathematics

Maths is considered a core subject for students across the world because it impinges on many aspects of our lives. It teaches students to think logically and to solve problems as well as providing an essential element in later life. This curriculum, as the curricula of other countries do, covers three basic areas: Using and applying numbers; Shapes, space and measures; Handling data.

In fact, in each of these areas there are useful links with archaeology and history, for example,

▶ Archaeologists: survey, measure, draw and record landscapes, sites and finds; classify finds, structures and buildings; gather, handle and communicate data.

▶ Historians and archaeologists: Analyse documentary records which can provide data for work in maths in school (see Victorian maths below).

▶ Discoveries about past cultures can reveal knowledge about the long history of maths.

Shapes and patterns

We are surrounded by shapes and patterns and teachers of maths do make use of them to teach the subject (Copeland 1991, 27–34). Examples of rectangles, circles, cubes, cones and pyramids and so on, will form part of the 2D or 3D teaching kit. While some of these shapes and forms will be evident in the school building (and outside structures such football pitches and tennis courts) and the children's homes, they can also be found on historic landscapes, sites and buildings, for example:

▶ rectangles in doors, windows, plans of some buildings;

▶ arch shapes in windows, doors, vaulting and bridges;

▶ circles in some prehistoric sites such as Stonehenge;

▶ half circles in castle bastions;

▶ triangles in timber-framed houses, roofs, pediments in classical or neo-classical buildings.

Patterns can be found in:

▶ medieval fields, plans of towns, garden design and layout;

▶ roof tiles, wall construction, floor tiles;

▶ herringbone patterns in brick floors and fireplaces;

▶ decoration inside or outside historic houses;

▶ steps and staircases in buildings and monuments;

▶ crenellated battlements on castle walls;

▶ mosaic floors;

▶ window tracery and stained glass windows.

Mathematical shapes and patterns can often be traced to other cultures, such as those from the Greek, Roman or Arab worlds.

Buildings constructed specifically for military purposes in the past contain shapes which can be identified and questions asked about their purpose. Round shapes are stronger than square shapes to withstand bombardment – for example, concentric earthworks and ditches in prehistoric and later defensive sites. A medieval castle will often include a round keep as the occupant's last resort, a non-rectangular plan and projecting round towers. In 16th-century England, King Henry VIII ordered the construction of a number of forts, mainly along the south coast, to ward off an invasion from the Continent. These Tudor forts were constructed as a series of cylinders which formed the garrison's accommodations and a series of projecting semicircular gun platforms. This type of site provides ideal opportunities for work on circles, symmetry, radius, diameter and circumference. Triangular shapes become popular in 16th- and 17th-century forts in Britain and other parts of the world built to deflect cannon balls. Tilbury Fort, which was begun in 1670 to guard the river route into London, and Castillo de San Marcos facing the Matanzas River, completed in 1695 to defend Florida's eastern coast, are two well-preserved examples of triangular bastions.

Using data from the past

Archaeologists and historians reveal and research data which may be used for classroom exercises in maths. For example, Spooner (2002) showed how maths could be harnessed to help older students in primary school reach a deeper understanding of life in Victorian times in the areas of overcrowding, food and shopping, railway timetables and levels of illiteracy. He provided figures in this article for teachers as data for maths work in school. For example, the figures relating to illiteracy given below were to be used by the children to present the data in a graph.

The percentage of brides and grooms who made their mark rather than signing their names in a marriage register:

1845 42%
1850 39%
1855 36%
1860 31%
1865 27%
1875 20%
1880 17%
1885 12%

Data can be found for any site or landscape under investigation whether that is a scatter of flints in a ploughed field or the pattern of settlement across a large area. Worthy (1982, 357), for example, provides a range of figures for ceramics with makers' marks from seven different parts of the world. Apart from their use in the maths curriculum, these discoveries show trade links across the world which may be used as part of geography and citizenship work.

Figures published from archaeological work may be used as the data for students to turn into bar charts, linear or scatter graphs, histograms and frequency diagrams.

Graveyard surveys have been carried out in a number of countries, many with local volunteers and some with school groups (Dix and Smart 1982; Purkis 1995, 24–6; Mytum 2000b; Johnston *et al.* 2004, 26–7). Careful collection of records can provide data to be analysed in school for dates, family trees, size of families, frequency of vocabulary and phrases used, mortality, types of decoration, shapes of tombstones, names and occupations. Graveyard recording and the ways in which the data may be used for school work in maths in particular is published in *Dead Men Don't Tell Tales?* (Hill and Mays 1987) in the Archaeology and Education project from the University of Southampton (see p. 86).

Statistics concerned with heritage issues can also be used. Concerns in the 1970s about large areas of redevelopment of urban centres in Britain led to a number of reports. The Council for British Archaeology (Heighway 1972) reported that of the 25 small towns in England threatened at that time 14 had had no previous archaeological work carried out. The report contains a number of pie charts and analysis diagrams and a detailed appendix (1972, 64–117) which provides figures for archaeological and architectural research, population increase and redevelopment. The survival of the original use of historic buildings is discussed elsewhere in this book (see p. 273) and the figures for Anglican churches in Colchester quoted there could be used as data for creating a pie chart.

Measurements, investigation and calculation

Survey and taking measurements are crucial parts of any archaeological site or landscape investigation. Children may be introduced to measurement through any historic site, provided it can be accessed by a school group. Conserved archaeological sites and historic monuments are ideal places to carry out measurement safely and, providing care is taken, with no damage to the structures. Two types of unit of measurement can be used:

Standard measurements can be used to collect data, for example, on the height of a church tower or prehistoric standing stone or the angles of bastions along a castle or fort wall. Calculations using fixed baselines and triangulation can be

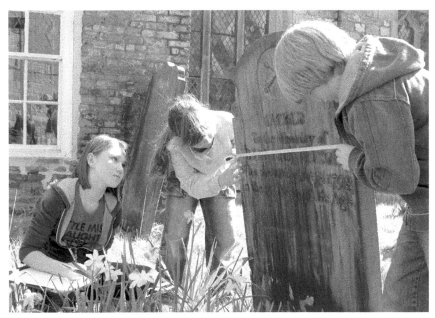

Fig. 7.5 Many schools and Young Archaeologists' Club branches have carried out graveyard surveys. This is one at Holy Trinity Church, Goodramgate, in York.

used to construct plans of buildings, the remains of an ancient site or the position of tombstones in a graveyard survey.

Non-standard units, such as hand and arm spans, body height, and paces, can be used to measure a variety of features on an historic site. Relative measurements can be calculated, such as the area of the site in comparison to the school's building or playground or a football pitch. I used non-standard units with a primary class on an educational visit to the Neolithic flint mines in Norfolk. The human scale, the 'Gavin' as we called it after the 'volunteer' boy, was later turned into a standard metric measurement and used to draw out the diameters of the filled-in hollows of the mines in the school's playground to give a feeling of their size in a context familiar to the children.

Ancient sites and historic buildings may be used to provide opportunities to investigate and calculate reasons for particular constructions. McNeill (1992, 94–6) provides calculations for the range of arrows and crossbow bolts with appropriate angles of fire and Copeland (1991, 19–21) gives the example of calculating the lines of fire from arrow slit and crenels in castle walls and exposing areas which would have been relatively safe for an enemy to attack sections of wall.

Design and Technology

Design and Technology was never taught as a specific subject in primary schools in Britain before the introduction of the National Curriculum and was only included in craft and home economics at secondary school, as is the case in some other countries today, or included in subjects such as social studies and visual arts (e.g. in Finland). Design and Technology requires students to be creative in problem-solving and to make value judgements. The historic environment provides many

examples for observation, recording and experimenting with ancient and historic technology, from landscapes, buildings and objects. There is, inevitably, some overlap between Design and Technology and science and maths.

Technology from the past

The archaeological educator will find plenty of interesting and simple examples of technology from the past which may be translated into experiments and projects for site or classroom work. Hodges (1970) provides many examples based on archaeological, historical and ethnographic evidence. Studies of experimental archaeology (see science section above) will also supply information and illustrations.

One good way of introducing children to the idea of technology in the past is demonstrated by Few and Smith (1995, 16) where examples of technology are listed under separate heading for different ancient cultures in North America. Table 7.7 shows one example.

Table 7.7 Analysis of technology (after Few and Smith 1995, 16).

	Housing	*Food*	*Containers*	*Weapons*
ANASAZI	Pithouses, pueblos	Corn, beans, squash, game animals, turkeys	Baskets, pottery	Bow & arrow

Other manuals for teachers give detailed instructions on making working replicas of ancient tools, weapons or even buildings. Keen shows how easy it is for students to construct a wooden Iron Age round house (1996, 18–19) or a drill bow for making fire (1996, 21). Bows and arrows made and used by children are a good introduction to ancient technology and past periods (as well as being good fun) and a superb resource from the Limerick Education Centre (2005, 89) shows teachers how to make them as well as providing appropriate links to curriculum subjects.

Curriculum-based projects

Curriculum requirements for this subject often state that children should acquire skills in investigation, problem solving, designing, understanding the properties of materials, making, evaluation and communication. Barnes (1999) argues that Design and Technology projects involving aspects of the historic environment carried out by school groups should be small and manageable, and gives several tested examples.

Technology in buildings: One of the questions to ask about an historic building is: how was it designed and constructed? To which might be added: are the building and its features fit for the purpose for which it was constructed? Here is a good example of an exercise for a medieval cathedral or large church where the children have to find solutions to the needs by close observation, both inside and outside the building:

Table 7.8 Technology: needs and solutions (after Barnes 1999, 21).

NEED	SOLUTION
A symbolic shape	
Visible from afar	
Large open space	
Lots of east facing altars	
Space for processions	
Grand for great occasions	
Inspiring to look at	
Strength to last centuries	
As much light as possible	
Hearing the priest	
Separation for priest and people	
Able to teach the illiterate	

Defensive structures, such as castle and forts from many periods, offer opportunities to investigate the technology needed for:

▸ defence against attack (can it withstand the latest advances in military technology?);

▸ water and food supply (how long can the inhabitants withstand a siege?);

▸ health and hygiene (has sufficient provision been made for the removal of human and animal waste?);

▸ cooking and accommodation (are the kitchens well-sited to avoid fire risk but near enough to the dining areas? How are bedrooms fitted into the round towers?)

The way the drawbridges of medieval castles work can be investigated from the remains of their features on site and models and experiments may be made back in school. Circular staircases are often a feature of castles and offer an interesting example of medieval design and technology. The stairs are constructed clockwise from bottom to top. This forces the attackers (recognising that most people are right-handed) to expose the centre part of their bodies – the sword in the right hand strikes the newel pillar in the centre – while the defenders are protected against this by their shields held in their left hands.

Alternatively, technology may be linked with role-play where instructions might be created (either by the teacher in advance or by the children during or after a visit) for builders to work on an ancient site, for example:

▸ imagining that a Roman villa has been destroyed (perhaps by fire), a builder might be commissioned to reconstruct the house;

▸ imagining that new military technology threatens the strength of a castle (perhaps the introduction of cannons), the king has asked for an engineer to draw up plans for some radical reconstruction of the defences;

▶ imagining that the new owner of the gatehouse of an otherwise ruined medieval abbey after the Dissolution wants to turn it into a house. An architect has been commissioned to draw up the plans.

These exercises allow for close observation and some measurements on site and research back at school (for the styles of villas and materials used, for the latest advances in castle design to combat the threat from cannons and for the requirements of the new gatehouse owner, for example).

Technology and visitors: Useful exercises have been carried out by asking school groups to draw up plans for new visitor facilities at ancient sites. This example, created by Walmsley (1999a, 7) of a tea-room in a new building at a monastic site suggests that plans and designs need to cover the following areas: layout to include disabled visitors; internal decoration, furniture and crockery to reflect the monastic site and recipes used to include originals used in the period.

Visitor routes for any historic site or building open to the public can be investigated and new routes suggested as an educational exercise. If interpretation panels exist they could be tested against criteria (perhaps set by the children themselves), for example:

▶ Do they help or hinder the understanding of the site?

▶ Are the height, type size, colour and reading levels suitable for visitors with a range of special needs?

▶ Are they difficult or easy to understand?

▶ Do they have illustrations? If so, are they helpful?

▶ Are they in the right places? Are they missing at any points of interest?

▶ Has exposure to the weather made them impossible to read?

Studies of on-site interpretation panels, in particular the language used (Serrell 1996; Hems and Blockley 2005; Ravelli 2006) will help take this exercise further, perhaps with older students.

Designing and making skills: While complex industrial structures, such as windmills, offer good examples to investigate past and present technology, they may be too complex to translate into the making skills demanded by the school curriculum. But a topic such as 'extracting and using water' will involve investigation into techniques used in different times and places, such as the Archimedes screw, the shaduf, aqueducts, dams and irrigation. A school may not feel up to building a model aqueduct, but testing out a small scale water wheel is a small and manageable exercise which has often been carried out by primary-age students. Equally, few schools will attempt to build a full size medieval siege house or battering ram, but many have constructed small scale trebuchets and tested them for accuracy and range.

As part of a project at Dover Castle involving an artist in residence, groups of children were given the task (Barnes 1999, 18) of designing and making ties based on drawings of small sections of the castle's walls, which included a range of materials – flint, sandstone, brick and mortar. This idea was developed into designing a range of souvenirs for visitors, such as toast or letter racks, which took their inspiration from the castle's battlements and tower, and tea towels, wrapping paper, notebooks and scarves decorated with features of the monument.

Geography

Studying geography at school is mainly about studying place and people's relationship to it. 'Place' writes Cannings (2002, 116) 'needs to be seen as an interaction of human activity with the physical environment' as part of geography teaching in schools. Geographical skills, such as creating and studying plans and maps and identifying physical and human features, are always part of this curriculum. The subject is also about the way people have, throughout time, altered the places they inhabit – often radically and sometimes to the detriment of those places. Concern for the environment is usually part of the geography curriculum, though it may also appear in other subjects such as citizenship or social studies. Heritage tourism is often part of the geography curriculum and there are links which can be made with the history curriculum (see also World Heritage Sites p. 300). Some argue that geography should be linked with history and in some schools and in some curricula they are combined.

Geographical skills

Geography curricula will always outline the kinds of skills which schools have to teach – skills which will be familiar to archaeologists, such as using maps at different scales and understanding symbols and keys used on them.

Maps: Most maps contain some reference to previous features on the landscape or townscape. Maps may be used to look for evidence of previous periods which has since disappeared. The maps may be used with documentary sources, such as prints, paintings, trade directories, parish records, census returns or ecclesiastical accounts. The area or place being investigated can then be searched on the ground for evidence of any assumptions reached.

Individual buildings, such as churches and castles, or an activity, such as farming or industry, may leave their mark on maps and other documents in the form of place names (Kirstead in Lincolnshire meaning 'site of a church' comes from the Scandinavian word for church, kirk), street names, such as Church Street or Kiln Lane, or field names, such as Barrow Field (referring to prehistoric burial mounds), Pavement Croft (probably Roman mosaic floors) and Castle Trenches. There is even a field in Shropshire named Bloody Romans (Foxall 1980, 53).

Aerial photographs: Aerial photographs allow children and students to study the landscape and its forms. Archaeological air photographs are a ready resource for investigating evidence for the past and to find out how archaeologists can identify specific sites from buried remains revealed by crop marks and other features (Corbishley 2004).

Planning space: One activity which can be used for a range of monuments is the concept of people planning spaces for different functions on a site. The area of a known site should be plotted out on to graph paper and the scale given. Simplified drawings of the different areas, at the same scale, should be provided and students can then work out how to fit them into the overall plan, taking into consideration any physical features or social considerations (Staszewska and Cocksedge 1994, 24–5). For example, on a medieval monastic site there is a need to include a range of buildings for worship, meeting, studying, sleeping, cooking, eating, washing and storage, lavatories, a hospital, and private quarters for the person in charge, but some areas have special location requirements – for

instance, lavatories need to be built over or very close by running water and the sleeping area needs to be adjacent to the church.

Route planning: Historic sites provide good opportunities for route planning – historic as well as contemporary routes. Students could, for example:

▶ trace the daily routes of a monk at the site of a ruined abbey, or those taken by a soldier compared with his commanding officer in a Roman fort, or a supplier of fuel for an industrial process or a servant in a grand 19th-century house;

▶ plan a route for disabled visitors to experience the most important elements of the site;

▶ devise a trail for a particular group of visitors – families with children, for example – or a trail which looks at a particular aspect of the site such as its wildlife.

The primary reason for the location of a site will usually be a geographical one. For example, the first requirement for a World War II airfield in Britain was a large flat area on high ground, but the general location might have been based on access to other airfields or military installations or proximity to the east coast and occupied Europe. World War II Britain also saw the construction of a large number of gun positions (called pillboxes) across southern and eastern England (see Fig. 7.6) to counter the threat of German invasion (Lowry 1995, 78–92; Dobinson *et al.* 1997). A major line of defence, known as the GHQ line, was constructed to protect London and the industrial areas of the Midlands. Questions could be used to find out more about sites in a particular area.

Location

Any research into past landscapes and individual archaeological or historic sites will involve geography. The question 'Why is this site located here?' may be applied to any human construction in the remote or recent past, for example:

Delphi, Greece

The sanctuary of the god Apollo and the place of the Oracle was built on a pre-existing sacred site in a spectacular location on the steep slopes of Mount Parnassos. The Greeks called Delphi 'the navel of the world'.

Machu Picchu, Peru

An Inca city built after AD 1438 on the saddle of land between two mountain peaks fortified by stone walls, a dry moat and sheer drops. Public buildings occupy a comparatively flat area with domestic and military buildings on terraces just below.

Ironbridge, Britain

The Severn Gorge in Shropshire had an abundant supply of raw materials which could be exploited: coal (fuel), ironstone (iron), limestone (burnt lime) and clay (pottery, tiles and bricks). The river provided transport links. A number of new industrial processes in the 18th century earned this area its reputation as the 'birthplace of the Industrial Museum'.

Fig. 7.6 World War II pillbox at the small port of Wivenhoe in Essex. This was one of the defences constructed on the River Colne to protect the route from the North Sea into the town of Colchester.

Table 7.9 The siting of pillboxes (after Barnes 1999, 21).

Where were pillboxes sited and why?	
NEED	EXAMPLES
To protect routes which the enemy might use	On roads, rivers, railway lines and along the coast
To be located in strategic positions	At road junctions and river crossings

How will I find examples of pillbox sites?
Search for likely places using the criteria above on modern large scale maps
Check your ideas for locations against existing researches
Search for surviving examples on the landscape

This exercise could be carried out in another way, using elements of role-play, to stress the geographical reasons for choosing a suitable site for a particular type of building or construction. A contemporary example might be a good place to start:

Exercise: You work for a large supermarket chain and have been asked to find a suitable location for a large new outlet in a particular town. Your criteria are:

♦ Out of town but within easy driving distance of the centre and other populated areas;

♦ Large area available for a new building with appropriate space for car parking;

♦ Allow for petrol station and recycling facilities;

♦ Easy access routes for delivery vehicles;

♦ Single site which can be bought without any obvious environmental concerns.

You can then move on to the past:

Exercise: The Cistercian monastic order wanted to follow a strict life of prayer and self sufficiency with little contact with the outside world. The date is AD 1132 and the order is eager to establish an abbey in northern England and, from there, to spread the order north and into Scotland. You are William, an abbot in charge of 12 monks from the community of Cistercians at Clairvaux in France. You were once from York and know that area and have contacts there. Your criteria are to look for somewhere which:

♦ is remote, well away from the temptations of towns;

♦ has a good supply of fresh running water;

♦ has easy access to large supplies of wood and stone for building;

♦ has enough land to earn the abbey income from farming.

In fact, Walter Espec, Lord of the nearby manor of Helmsley, gave William the land needed.

Change over time

Archaeologists and landscape historians know that any landscape is likely to reveal evidence of a number of changes which survive on the surface to be observed and recorded. But this 'horizontal' dimension has a hidden 'vertical' dimension, as Copeland states (1993, 5). The hidden vertical dimension may be penetrated by discoveries made through aerial photography or geophysical surveying. The horizontal dimension may also be exposed through excavation. The geography curriculum is mostly concerned with observation, recording and interpretation of the horizontal dimension of the landscape.

Orford Castle and town: Orford is a small town at the mouth of the River Ore on the Suffolk coast. Henry II built a castle here between 1165 and 1173 to defend a vulnerable stretch of coast from invasion and to keep in check one of the king's most troublesome barons, Hugh Bigod. The local primary school has for many years used the remains of its local historic environment for teaching a range of subjects and projects, sometimes working with the local education authority advisers, the county museum service and English Heritage. The students were used to visiting the castle and seeing the town and its landscape laid out below (see Fig. 7.7). One of these projects (published as a case study in Corbishley 2004, 22–3) aimed to use aerial photographs as a starting point for investigating change over time. The teachers posed the question 'How has Orford changed?' Students were given a clear vertical aerial photograph of the whole town taken in 1972 and

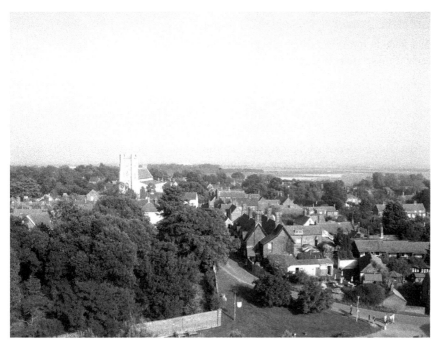

Fig. 7.7 A view from the top of Orford Castle showing its commanding position over the village (once a town) and the North Sea

were asked to orientate themselves and find some landmarks, such as their school, the castle and the church. They then had to look for and make a list of places they were familiar with, such as their houses, the river and the market place. Finally they were asked to work out any changes, based on their own knowledge, that had taken place since the photograph was taken.

Students converted the aerial photograph to a sketch map by tracing over it and used different colours to identify key features, such as buildings, open spaces and the river. They were then shown a plan taken from a map of 1799 and began to compile a list of changes since then, including the names of some of the streets. A map of the coast made in 1783 helped them identify changes to the landscape.

The teachers then posed their second question: 'Which came first, the castle or the town?' They worked on other documents in school and walked around the town to investigate and record evidence from buildings, street features and street names and they found no mention of Orford in the Domesday Book of 1086 but a record showed that there was a market here in 1102 with a church which showed clear evidence of late 12th-century build. They found clear evidence of a grid of roads common to medieval towns and they compared Orford with another medieval town, Ludlow in Shropshire, which was a Norman planned town.

Creative arts

This section examines three school subject areas – art, music and dance – and in each of these areas it is possible to take three different approaches and:

▶ examine the expressive arts of particular cultures in the past – for example, Palaeolithic painting, ancient Greek music or Aboriginal dance;

▶ investigate the ways in which artists have used ancient sources in their work;

▶ use the evidence of landscapes, monuments, buildings and objects as an inspiration for creative work by children and students.

Art

The art of particular past cultures may be specified as part of the curriculum in history or in art; the curriculum in Finland specifies that secondary school studies should be 'familiar with contemporary art and the history of visual arts' (FNBE 2004a, 204) while a study of 'artistic trends' are a requirement in the history curriculum (2004b, 182). At the same level in the English history curriculum there is a requirement to learn about the history of a range of past peoples from a number of different aspects, including aesthetic perspectives (DfEE and QCA 1999b, 151).

Looking at art

One area of investigation, which may also be used as an example of interpretations of archaeological and historical evidence in teaching school history, is into paintings, drawings and sculpture which portray historical events and places – for example, *The Temple of Olympian Zeus, Athens* painted by Walter Spencer Stanhope Tyrwhitt (1859–1932). The Grand Tour of the 18th and 19th centuries introduced many of the English nobility to archaeology of the Classical world and beyond. Artwork and archaeological objects were imported into Western Europe and formed displays in country houses and, subsequently sometimes, became major collections in public museums. A particularly rich and accessible source for study is paintings by Victorian artists who not only travelled to the Classical countries of Greece and Italy, but also into the provinces of the Roman Empire, into other lands, such as Africa, the Holy Land and the Middle East and South America. Artists, and other travellers, made measured drawings of monuments, buildings and architectural features. Examples of Victorian artists who may be used for cross curricular work are:

▶ David Roberts (1796–1864) travelled in Europe, North Africa and the Middle East, spent a year in Egypt and the Holy Land. He was a topographer who published volumes of accurate drawings (such as the Temple at Karnak) and watercolour sketches, the first of which were six volumes called *Views of the Holy Land, Syria, Idumea, Arabia, Egypt and Nubia* (1842–9).

▶ George Frederick Watts (1817–1904) spent many years in Italy in the 1840s and visited again in 1853. Watts based his painting *The Wife of Pygmalion* (1962) on a bust of Venus (a Roman copy of a Greek original) which he and the archaeologist Sir Charles Newton (a British Museum official who worked for

seven years as a diplomat) found in the cellar of the Ashmolean Museum in Oxford. It was one of a number of Classical marbles brought back to England by Thomas Howard, Earl of Arundel, in the 17th century.

▶ Sir Lawrence Alma-Tadema (1836–1912) spent his honeymoon in Italy, visiting Rome, Pompeii and Herculaneum in 1863. His work was influenced by his experiences there and by Georg Ebers, the Egyptologist and Louis de Taye, historian and archaeologist, painting scenes from ancient Greece, Rome and Egypt. He painted many studies of Roman baths in the 1890s – for example, the *Baths of Caracalla*. Alma-Tadema's paintings influenced Cecil B. DeMille's Hollywood epics.

▶ Sir Edward Poynter (1836–1919) favoured Classical and Biblical subjects for his paintings. His *Faithful unto Death* (1865) portrays a Roman soldier still on duty during the destruction of Pompeii which was based on an episode in Bulmer Lytton's novel *The Last Days of Pompeii*. In 1868 he painted *The Catapult*, which showed Roman soldiers manning a catapult during the siege of Carthage in 146 BC. Poynter's paintings were frequently used as illustrations in school textbooks.

▶ Edward Lear (1812–88), the painter and nonsense poet, spent a great deal of his life travelling, not just to the Grand Tour countries but to India, Sri Lanka and the Himalayas. He travelled, and painted a great deal in Egypt, leaving good records of monuments in their contemporary landscape, such as his *The Pyramids Road, Ghizeh* (1873).

▶ Henry Roderick Newman (1843–1917) was an American pre-Raphaelite painter who made his first trip to Egypt in 1887. 'His Egyptian watercolours are distinguished by their archaeological accuracy, meticulous craftsmanship and cool beauty' (Williams 2007, 64).

One of the effects of the Grand Tour was the influence on architecture in the West. Belsay Hall in Northumberland was begun in 1807 after the owner and his wife had returned from their honeymoon in Europe (spending a year in Athens). Their new house was modelled on the outside as an ancient Greek building in its design, form and decorations. The centre of the hall was a colonnaded court (Walker and Walmsley 2001). Many of the Greek features and decorations can be seen in town buildings today.

In the study of the local remains of the past it may be possible to match a specific view. Modern life paintings were popular in Victorian times from Derby Day to seaside resorts. William Powell Frith's *The Railway Station* (1862) is often used in school books to illustrate the new age of steam and travel. We know that the artist Atkinson Grimshaw took a number of photographs (his album is in Leeds City Art Gallery) and sometimes used them to paint exactly the same views. The location and the buildings in his *Liverpool Quay by Moonlight* (1887) can still be identified and be used as a 'then and now' exercise. Eyre Crowe's *The Dinner Hour, Wigan* (1874) clearly shows cotton mills and their workers.

There are a great number of drawings of archaeological sites and structures which continue to be used as documentary evidence for modern investigations. Frank Hamilton Cushing, for example, made a series of detailed drawings (from ceremonial dances to everyday scenes) of the Zūni native people in the American

south-west in the late 19th century (Fagan 1977, 248–55) and published originally in magazine articles and then in his book *My Adventures in Zūni*. In Britain, most, if not all, ancient monuments have been the subject for artists and printmakers. One of the most prolific was J. M. W. Turner. Bryant tells us that his painting of famous historic monuments and buildings are presented 'in their complete social and economic settings as national landmarks. The nation he paints is contemporary Britain, during and after the Napoleonic wars, where historic buildings, traditional agriculture, trades, quarrying and other labours still survive alongside the benefits of the industrial age' (Bryant 1996, 8).

Many people came to see these national monuments for the first time as prints from 800 engravings were published in Turner's lifetime. The monuments ranged from the prehistoric (he first sketched Stonehenge in about 1801) to medieval castles (Dover Castle, Kent, which he first painted in 1822) and abbeys. His view of Whitby Abbey, North Yorkshire, of about 1825 shows the church tower before it collapsed – proving the usefulness of contemporary views in understanding past buildings and landscapes (Bryant 1996, 79).

Archaeology as art

There are examples of artists working from archaeological remains and techniques to create their art. The artist Mark Dion has conducted several 'digs', using the event itself and the display of the objects retrieved to form the basis of art installations (Coles and Dion 1999). In his *History Trash Dig* (1995) he removed a 2 metre cube of soil from accumulated rubbish deposits behind the city walls of Fribourg in Switzerland. The soil was taken to the city's Fri-Art Kunsthalle gallery where the objects were removed, cleaned and catalogued. The final display consisted of the objects on shelves around the room with a pile of soil, tools and equipment and boxes of finds. Dion created a similar art installation with *History Trash Scan* (1996) from objects collected from the base of a castle in Umbertide in Italy. His *Tate Thames Dig* (1998) was more ambitious involving the collection of large amounts of debris from the Thames foreshore, cleaning and cataloguing it under large tents and finally displaying the collection in cabinets and drawers. Renfrew discusses whether Dion's work here is archaeology or art but does conclude that it 'recapitulates the archaeological process ... It raises penetrating questions' (1999, 22), a topic he raises again elsewhere (Renfrew 2006).

Many artists have taken their inspiration from landscapes but in the 20th century some artists have been attracted by historic landscapes and, in particular, historic sites. The art critic Lucy Lippard has written about modern artists whose works have included echoes of prehistoric sites (Lippard 1983) – some creating what are almost replicas in similar materials, while others are clearly influenced by the past but use modern materials. Lippard shows how artists, in particular sculptors, whose work is usually displayed on a landscape or in an urban setting rather than in galleries, try to incorporate and communicate the feeling of prehistoric mounds, earthworks and standing stones. Lippard (1983, 23) places a photograph of Michael McCafferty's 1977 work, *Stones Circles*, next to one of the prehistoric stone circle at Er Lannic in Brittany. Carl Andre's *Stone Field Sculpture* (1977) in Hartford, Connecticut (Lippard 1983, 20) is created from 36 glacial boulders placed within an urban context and the recumbent stones outside the Wadsworth Atheneum art museums, reflect the adjacent Ancient Burying Ground.

Richard Long's landscape sculptures are well known. Since 1967 he has created landscape-inspired works through walking in many parts of the world, but particularly in Britain. Renfrew discusses Richard Long's work and its relationship to archaeology in detail but does not believe that it is fundamentally influenced by prehistoric features but that 'it is rather we who are influenced when looking at prehistoric features in the landscape by the experience of knowing the work of Richard Long' (Renfrew 2006, 36). Long wrote that the walks 'provided an ideal means for me to explore relationships between time, distance, geography and measurement' (Long 2010).

Andy Goldsworthy uses natural materials, both organic and inorganic, to create artworks inspired by and placed on the landscape. These include stone mounds, arches and stone constructions. He has become well known in Britain in particular because of a commission from Cumbria County Council involving sheepfolds. The project began in January 1996 as part of the UK year of Visual Arts. In 2007 Goldsworthy created permanent sculptures and indoor exhibition pieces at the Yorkshire Sculpture Park. The outdoor sculptures continue his theme of sheepfolds and stone walls – for example, 'Outclosure' and 'Hanging Trees' (Yorkshire Sculpture Park 2007) – and his website has suggestions for schools to use his sculptures for curriculum work (Goldsworthy 2010). Cooper discusses the visual arts and the environment, and in particular Goldsworthy's work, and suggests guidelines for leading a 'land art' session (1998, 70–1).

Art inspired by the historic environment

The remnants of our historic pasts provide interesting and stimulating resources to inspire children to create their own art. Primary schools are used to combining subjects to carry out an in-depth study or project or as part of an out-of-school visit. Art will often feature as part of such work, even if only as illustration. Teachers who are not art specialists may need to acquire skills themselves before launching into a project at an ancient site or in a museum. Lockey and Walmsley explain the techniques needed for on-site work including practising skills, such as making annotated drawings and perspective, in school before the visit itself (1999, 12–13). This book goes on to look at elements in buildings, such as gates, doors, chimneys and decoration. In its case studies the authors develop topic ideas – for example, 'bringing rooms in a castle alive by creating an illusion through one of the windows or doorways' (1999, 30). One of the aims of this work was to use the view through the window to express what might have been there in the past. The whole picture could be painted, or created by collage or 3D modelling or a photograph of the window superimposed on a drawn background.

Some heritage education officers have worked with schools and family groups to create a unique piece of artwork based on a museum, an historic building or a site as part of the national Big Draw event organised by the Campaign for Drawing (2010). For example, by creating banners to hang in a church which reflected its history back to Anglo-Saxon times, a project which was part of the national Big Draw event (Dickson and Johnston 2006). Stirling Clark, a sculptor in residence at Dover Castle, created pieces for a public exhibition at this English Heritage site but also worked with school and college groups to help them use the site as a rich source of pattern, texture and form. This project was recorded in a teacher training video (English Heritage 1991a).

Tombstones and war memorials provide a rich resource to study art and design from different periods. The details of lettering, shape, form and materials may all be studied. D'Alelio (1989, 46–9) explains how barns and houses were decorated by early American settlers – for example, Pennsylvanian Dutch barns. The book provides patterns and stencils to cut out and use.

In some cases a heritage visit may not be possible but ancient art forms can be created in the classroom. One of the 2007 sessions for the Young Archaeologists' Club in the Institute of Archaeology (see p. 339) featured cave art. A cave (Lascaux III-style) was 'constructed' inside a room using cardboard to provide wall relief and a tunnel made from cardboard boxes created the illusion of moving from the present to the past. The Geology department provided the necessary resources of red and yellow ochre, charcoal and chalk which allowed the children to become real, if very messy, cave painters for a few hours.

The Kent Institute of Art and Design used the historic site of St Augustine's Abbey in Canterbury as an inspiration for groups of their students over several years whose finished works are then displayed in the abbey grounds, which are open to visitors. Each year, in the published booklet which accompanies the exhibition, the students write about their own piece of artwork. For example, Mark Simpson marked out where the missing walls once stood writing 'to illuminate the foundations of these 12th-century walls is to capture the essence of the time and space which is so vastly present within this particular site ... A deep sense of absence. A removed state' (Hampson 2000, 11).

Music and dance

'Music and dance may be a procession in a religious festival, a rhythmical game played by a child, a ball game, acrobatics, the kneading of dough. It can certainly be poetry, the gestures of the chorus in a tragedy, the wedding song, the paean of war'. This is part of the introduction to a teachers' resource (Chryssoulaki 2004, 7) which adds another element to Greek children's learning about their own ancient civilisation. It provides evidence, in the form of structures, objects and texts for the presence of music and dance in Ancient Greece together with classroom activities. For such historic periods there is usually evidence for music and dance. As archaeologists and historians find out more about these expressive arts across the world through research and experiments, the information may be used to provide education programmes for school groups or events for the general public.

But, as with the sections above, the historic environment itself has provided a basis for the creation of music and dance as part of curricula work in schools and colleges. For example, Barnes (1992) showed that even very young children can create their own music, with simple percussion and wind instruments and their hands to reflect the atmosphere within an ancient building. He worked with his primary age pupils at Dover Castle where they found one room with alcoves, windows and a fireplace as 'sunny, warm and gentle' but that their music had to include a ghost and another (the Great Hall) deserved music like 'a fanfare motif all around the room, like soldiers passing a message along a line'.

The children composed the music themselves and it was then performed in the castle (see Fig. 7.8). This exercise was recorded in a teachers' handbook for Dover Castle (Barnes and Harmsworth 1991, 33) and in a teacher training film

Fig. 7.8 Music for Dover Castle

(English Heritage 1992). Cook (1997) developed these and other ideas for making 'Monumental Music' suggesting that children write down five words which describe the monument and use them as a basis for poetry, stories or songs. From there rhythms may be developed – for example, saying the words 'Carisbrooke Castle' and clapping the words 'Ca – ris – brooke – Ca – stle'.

Dover Castle also saw a joint project between English Heritage Education and South East Dance, the National Dance Agency for the South East region of England. Children from an after-school club and a professional choreographer created six dances 'by exploring tasks and improvising their own movement in relation to the historical, social, architectural and personal aspects of the site' (Gower 2003). This joint project led to a publication for teachers which included the following task:

> How the architectural features may be used as a stimulus for the creation of solos and duets
>
> Ask students to explore interesting spatial and architectural features, such as long corridors, confined spaces, doorways, light airy windows
>
> Once the students have chosen a particular space, ask them to spend five minutes speed writing or drawing their observations and thoughts as a record of their initial ideas.
>
> Next ask them to select three words or phrases and use these to create a simple movement motif (short phrase of a movement); for example, 'arch' – create a still arched shape with a balance. Develop these motifs into solos by making physical connections with the space and exploring contrasting dynamics. For example, move slowly on a forwards and backwards

pathway along a dark corridor, or rebound away sharply from the jagged corners.

These solos can be developed into duets by exploring relationships and possible moments of contact with a partner. (after Woolley 2003, 6)

Another dance project in the same year carried out in the 12th century motte and bailey castle at Farnham in Surrey had this as an aim for Performance Studies college students – to 'devise and perform a piece that grows from research into a community-based historical story or situation' (Lusher 2003). Another dance project based on archaeological evidence is included in the Garbology case study (see p. 309).

Summary

▶ Teachers in the UK are used to teaching projects through a number of different subjects.

▶ Archaeology is clearly linked to the subject of history, especially where the teaching is evidence-based.

▶ Each main subject commonly taught in schools across the world is reviewed with suggested exercises for introducing archaeological concepts, practices and discoveries.

Conclusions

Cross-curricular projects are certainly not new in the history of education in this country. It is clearly sensible to suggest to busy teachers, especially in the primary sector, that a project for a whole class (or indeed a whole school), for a week (or a whole term or year) is based on a single study – the countryside, for example – but which covers the requirements of several subjects.

Museum and heritage education staff were not slow in promoting the idea for their own collections or sites and, in some cases, producing resources for teachers. The ideas and exercises presented in this chapter are largely combinations of accepted education practice and the way in which archaeologists would approach the primary evidence for the past.

This chapter concludes the 'Archaeology and Education', but the idea of using an archaeological approach to teaching the past, in the classroom and outdoors in continued in the next section, 'Investigating Evidence'.

A case study follows. It records the education work of the Museum of London, chosen because it has given itself a wide remit, providing services, programmes and resources for formal and informal groups. It is considered by many in the profession to be a model for museum education services. But the Museum of London is much more than a museum. It is also an archaeological organisation which has earned praise for its annual community digs.

Learning for all: The Museum of London

Background

The Museum of London was opened to the public in December 1976 but its collections, which before that date were housed in the Guildhall Museum and the London Museum, have a long and complex history.

Guildhall Museum was founded by the Corporation of London in 1826 and administered by the Corporation's Librarian. The museum was to provide 'a suitable place for the reception of such Antiquities as relate to the City of London, and Suburbs, as may be procured, or presented to the Corporation' (Cumming *et al.* 1996, 10). At that time, in various parts of Britain, construction workers sold finds to collectors. From the 1840s, large collections came to the museum. The Corporation provided funds to purchase new acquisitions from building sites. Some collections were donated but, like other museums around the country, the Guildhall also bought whole collections from amateur collectors and archaeologists. By the late 1880s the very large collections prompted the museum to provide a catalogue and in 1907 it appointed its first curator (then called the 'museum clerk'), one of whose tasks was to 'watch all excavations within the City'. The museum moved to the Royal Exchange because of bomb damage in World War II to the Guildhall and then to Gillett House.

London Museum opened in 1912 in Kensington Palace with over 18,000 artefacts and a stated aim that the 'main purpose of the Museum was to illustrate the daily life and history of London in all ages' although the *Museums Journal* in 1912 could not identify 'the guiding principle on which the collection had been assembled' (Cumming *et al.* 1996, 12). This museum had royal patronage and 'its dynamic keeper who would charm potential benefactors with a combination of lightly worn scholarship and a very real flair for press and public relations' (Cumming *et al.* 1996, 12). Among the collections were drawings and models – and a range of objects which fascinated the public, such as the 'Washing bowl from the Condemned cell, Newgate Prison'. The Frost Fair and the Great Fire of London models are still favourites. The Frost Fair model is now at the Globe Theatre, whilst the Great Fire model can be viewed in the Museum of London. The museum collections moved permanently to Lancaster House in 1914. After World War II, the government who owned Lancaster House forced the museum to move back into Kensington Palace where it reopened in 1951.

Museum of London site

One-third of the historic City of London was destroyed during the bombing of World War II and the Barbican area was virtually demolished. By 1951 there were only 48 people still living in the Barbican area. The site, covering 40 acres/16 ha was cleared after the war and discussions began in 1952 about the area. A redevelopment scheme was drawn up and a plan was accepted in 1956. Pevsner

and Cherry (1973, 215) wrote, 'It is a vast and powerful design anyway, built of concrete and dominated by three 412 ft towers, two of forty-three, one of forty-four storeys. They are the highest blocks of flats in Europe.' But Pevsner added, 'Whether this fact counts on the debit or credit side must remain doubtful. They have a roughly triangular plan and wild and wilful top features.' The Barbican site was officially opened in 1982.

The new Museum of London

Discussions about the merging of the London Museum and the Guildhall Museum ended with The Museum of London Act of 1965 with three partners – the government, the Corporation of London and the Greater London Council. After the Council's abolition in 1986 the other two remained as equal partners. Work started on the new site in 1971 and it was opened to the public in December 1976. The museum sits in the Barbican in an environment of over 2,000 apartments, restaurants, shops and large numbers of offices. It receives funds from the Corporation of London and the Greater London Authority. The museum's vision is to 'inspire a passion for London and to increase public understanding, appreciation and awareness of London's cultural heritage, histories and identities' (Museum of London 2009). A new ten-year development plan for new and newly designed galleries and new education facilities was published in 2005 (Museum of London 2005a). The main museum at London Wall has a series of permanent galleries arranged in chronological order from prehistory to the present day. There are also spaces for temporary displays and public events. The museum now has two other facilities as well as the main museum at London Wall (now known as the Museum of London Group).

Museum of London Docklands, opened in May 2003 in a converted 19th-century warehouse at West India Quay, houses objects in three main galleries which trace the history of London's river and port from the Romans to the present day. It also houses *Mudlarks*, an interactive gallery which is aimed specifically at children and their parents and the *London Sugar and Slavery* gallery, which opened in 2007.

Mortimer Wheeler House in Hackney was opened in February 2002 and has free entrance but by appointment only. Like the other Museum of London sites, it offers events and workshops (see below). It houses two main collections: the London Archaeological Archive and Research Centre (LAARC) – the finds and records from the majority of excavations in London over the last 100 years – and the Museum of London Social & Working History Collections – collections from London workshops, domestic items such as furniture, cars, carriages and toys and the ceramics and glass collection (Stephenson 2006). Museum of London Archaeology (MOLA) – a team of over 100 professional archaeologists and a team of experts in archaeological conservation, finds, environmental archaeology and buildings – is also based at Mortimer Wheeler House.

Sites in London: The museum also curates some archaeological sites in London. Some of these (such as the west gate of the Roman fort just outside the museum building) are open to the public for special tours or events. It promotes other sites to the public which are either curated by the museum (e.g. the Roman amphitheatre below the Corporation of London's Guildhall Art Gallery) or in private ownership (e.g. the Roman temple of Mithras).

There are also a series of other displays which are curated by the museum at various sites around London. These are known as 'outsites' (see also pp. 30–3) and are located mainly in offices, presenting some of the archaeological artefacts that have been discovered nearby. Others are in more public locations (e.g. London Bridge station and the Royal Opera House).

Education and outreach

The museum has always taken its educational role seriously. Its first director, Tom Hume, wrote, 'We can give young people who appear to be lost a feeling that there is something worth belonging to, and we can do this by giving them a sense of history' (Museum of London 2005b).

From the start the museum has had a large, and well respected, Learning Department staffed by 15 professional educators across two sites (Museum of London and Museum of London Docklands) in 2009. Recent visitor figures reflect the high regard the general public and educational visitors have for the museum collections and its services.

Table 7.10 Visitor figures

	2005–6	2007–8	2008–9
Total number of visitors	494,290	424,925	427,408
Number of children in organised educational programmes both on-site and outreach	78,444	78,358	99,500
Visits to the learning section of the website	623,279	783,628	800,000

The Museum of London uses the word 'learning' to include all its educational work, which it divides into four main groups: children in school groups, adults, teachers and families with children. For each group there is a dedicated section on the website and a range of information, activities, events, tours, lectures and publications. Family learning is supported by events at the weekends and school holidays and by free activity sheets and bags linked to the galleries (e.g. 'Daily Life – it's a grind!' for the *London before London* gallery). Schools across the country can also interact with the museum via video conferencing on subjects such as Roman London. There is a service to special and hospital schools which in 2007/8 reached about 2,000 students. The programmes included storytelling, object handling and artist residences.

Main galleries are being redesigned one by one – for example, *London before London* (review see Schadla-Hall 2002), which covers the prehistory of London to the coming of the Romans and opened in 2002. Like some other galleries it contains a range of built-in activities and prompts to engage visitors in thinking about the exhibits. Examples are a short video display showing a flint knapper at work in the *London before London* gallery; lift-up boards asking questions and answers; a balance for weighing goods in the Roman gallery (see Fig. 7.9).

The latest gallery to be revised and re-presented is the *Medieval London* gallery, which opened in 2005 (Swain 2005). It has some stunning audio-visuals and a replica Saxon house. There is a range of activities and information for children, ranging from press-button questions and answers to instructive interactive games on computers and the ever-popular replica historic costumes to try on. It is also

Fig. 7.9 Part of the Roman galleries has a series of reconstructed shop fronts with real objects set into replicas, such as the collection of knives with replica wooden handles set in a replica Roman display case based on a sculptured tomb in Germany. On the left is a weighing balance which visitors can try out for themselves. The Museum of London has a good record in providing physical and intellectual access to its galleries and collections.

the first gallery at the museum to include captions and text designed for children. The production process for this text involved a substantial amount of user testing. Work is on-going at the moment on the museum's new *Galleries of Modern London*, due to open in 2010.

Temporary exhibitions: There is a changing programme of exhibitions or displays on specific topics and linked to events. For example, *Urban Grime: The state of London's environment* highlighted the problems of waste management in the city and the small exhibition was supported by a debate and a series of evening lectures. In 2009 examples included portraits created by the artist Tom Hunter using objects from the museum's collection and there was a display entitled *Forward to Freedom: The Anti-Apartheid Movement and the Liberation of Southern Africa.*

Events are firmly linked to, promote and support the full range of the museum's aims and activities across its three sites. There are events for the general public, from gallery tours to handing sessions (e.g. *Touch the Past* in June 2003 presented objects from the World City gallery especially for partially sighted and blind visitors) and from craft activities to fashion shows. In 2009 there were special tours for visually impaired visitors based on a different subject each month.

Many of the events are arranged specifically for families and children, in particular during half-term and other school holidays. They include object handling sessions, designing punk T-shirts, storytelling and religious festivals. Examples are a range of Diwali events held in October and November 2005, an

exhibition and events around *Belonging: Voices of London's Refugees* held from October 2006 to February 2007 and regular guided tours of some of the visible Roman remains in the City of London.

Website: The museum's website is detailed, extensive and easy to use. It contains a large resource for all the groups which use the museum and its collections, providing the usual access information, detailed resources for specialist groups, such as lifelong learners and digital games for children (e.g. 'Time Pirates' created jointly with Port Cities London and the National Maritime Museum).

Formal education: The museum's formal education service recognises three areas in which it works: Primary and secondary schools, Further and higher education, Lifelong learning.

Most of their work is centred around a service to schools but the museum allows free entry for all its visitors, including education groups. In 2009 the extensive area for education groups was redesigned and equipped, including elearning rooms, as the Clore Learning Centre. Self-directed learning by education groups is welcomed and the museum provides a range of resources – free online – including factpacks, games, interactive whiteboard presentations, quizzes and activity sheets. Three brochures outlining services available for primary, secondary and special educational needs teachers can also be downloaded.

The museum also provides – free of charge – a number of sessions and guided gallery visits for booked school groups which cover topics and periods covered in the history curriculum, such as the Fire of London, the Romans and storytelling sessions to support English and Literacy for Key Stage 1. There are also sessions which specifically cover the links between topics such as citizenship and history and archaeology (e.g. in the 2009–10 programme, *Archaeology for all: Hidden Treasures of the Thames* for Key Stage 2). The museum also offers loan boxes to schools to investigate the six major faiths represented in London with links to the religious education curriculum (for previous loan boxes see Hall and Swain 2000). The museum has created an online Teachers' Network, INSET, for teachers and whole schools and offers a number of outreach sessions in schools.

Some services are offered to further and higher education and lifelong learning in the form of sessions in the museum (e.g. for Travel and Tourism courses), lectures and courses (e.g. through Birkbeck College, University of London), day schools at LAARC and university courses (e.g. in conjunction with the Institute of Archaeology, University College London).

Community work: The museum has a Community Access Officer, a Community Archaeologist and an Inclusion Officer. The museum has organised a number of community projects including 'London's Voices' to work with various communities in London through oral history in 2003, 'Ceramics and Glass' for schools to create their own interpretations of the museum's ceramics and glass collections in 2004 and 'Belonging: voices of London's refugees' in 2006–7.

There is also the 'Brixton Riots community project' which began in 2010 to record the experiences of people who experienced the riots in 1981.

Family activities have recently become a much stronger part of the museum's education work. The Family Learning Officer organises about 500 family activities a year and the Early Years Officer sessions for babies and toddlers.

As part of the redevelopment of the Clore Learning Centre and the Galleries of Modern London, a set of three family activity trolleys have been developed. These

are movable units containing handling objects from the collections and hands-on activities for families. Each trolley has a different theme inspired by London and the Museum's collections – for example, archaeology, fashion and home life. The trolleys are part of a wider visitor-support package developed in line with the new galleries. The trolleys are manned by a member of the visitor service team who facilitates the handling and exploration of the objects together with the families. Families then choose to borrow one of the 'take-away' activities to do in the galleries. These activities have been developed to engage the families further with the topic and to encourage them to work together.

Community archaeology

Museum of London Archaeology (MOLA) carries out archaeological investigation in London and publishes its research. The museum is unique amongst the national museums in the UK in having its own active archaeological unit. Finds and records from its work are curated in the London Archaeological Archive and Research Centre (LAARC). The LAARC has an active volunteer programme allowing students, retired, unemployed and local people to get involved in the work. This began with the Minimum Standards programme, funded by the Getty Foundation, which ran for three years. In 2006 a Heritage Lottery Fund grant allowed for another volunteer programme, called the Archive Volunteer Learning Programme, aimed specifically at recruiting volunteers from local communities. MOLA and its predecessors, the Department of Urban Archaeology and the Department of Greater London Archaeology, have always shared their findings with the public, on site, in museum displays and in publications. For example, *Archaeology of the City of London* provided a detailed but accessible summary of archaeological work from 1973 to 1980 (Schofield and Dyson 1980).

Archaeology and children: The Museum of London promotes archaeology to the public through its displays and events but is particularly enthusiastic in its work with children. Of the 195 public events held in the museum between October 2005 and April 2006, 43 dealt specifically with archaeological objects or historic sites. The museum plays an important part in the Council for British Archaeology's Festival of British Archaeology (see p. 108) and they held 24 events in 2007, 25 in 2008 and 41 in 2009.

An important part of the services provided for formal educational work for schools concerns archaeological techniques and object handling. One event which has been particularly successful is 'The Dig' (see Fig. 7.10). It won the Judges' Special Award in the Interpret Britain Awards in 2002, in recognition of outstanding interpretative practice.

Archaeology and community: The museum's Community Archaeologist, together with other museum and MOLA staff, carried out a community and research archaeological project at Shoreditch Park in Hackney, London, in July 2005. This was the first in what has become an annual activity – the community dig in 2006 was in Bruce Castle in north London and in 2007 at the Michael Faraday Primary School in Southwark. The Shoreditch dig was partly funded by the Heritage Lottery Fund. The project's justification was:

> To identify the survival of 19th- and 20th-century archaeology and ask specific research questions as to what this can tell us about the urban

Fig. 7.10 'The Dig' in use by a group of children supervised by Museum of London staff. Large wooden boxes with constructed walls and a mosaic floor are filled with sand and real objects (pottery sherds, tile and bone) from the Roman, medieval and post-medieval periods. After an introductory session, children (or pupils from school groups) excavate the sand using trowels, hand shovels and brushes and put the finds in a finds tray. The children have an instruction sheet and a trench plan on which they record the position of their finds. Objects can be compared with whole objects on display (to find a period) and there are museum archaeologists on hand to help. The walls and mosaic floor are then interpreted through discussion with the supervising archaeologist. A revised version, 'The Big Dig', was run in summer 2009 at Museum of London Docklands.

> development of London and its population at this time. To involve an Inner London community in an archaeological project, helping them to develop skills and engage with the area's past. To help commemorate the ending of the Second World War. (Simpson 2005, 4)

The project coincided with the 60th anniversary of the end of World War II. The area from which the local community who took part in this project come from is deprived, multicultural and socio-economically diverse. The history of the site is long, with evidence from prehistory to the present day. Shoreditch Park seems to have been agricultural land up to the 1800s when the city began to spread northwards into this area. What is now open parkland was dense housing along four streets, first built from 1825. Enemy bombing during World War II destroyed much of the houses here and the 'prefab' housing put up on open land for bombed-out residents were all demolished in 1980 when the area was made into parkland, known as Shoreditch Park.

Archaeologists had a number of research questions which they wanted to investigate on a site which they thought had evidence well preserved under recently constructed parkland. They asked:

▶ if archaeological investigation of deposits from the later 19th and 20th century could add anything further to the knowledge of the area already gathered from documentary and oral records;

▶ if the archaeological deposits were as well-preserved as they supposed;

▶ if there was any archaeological evidence for World War II bombing;

▶ if excavating cesspits and post-medieval houses could reveal evidence about the socio-economic conditions and ethnic origins of the inhabitants.

In addition, an Institute of Archaeology postgraduate researcher carried out oral history work with residents and visitors to the site which has added to the archaeological evidence of World War II. Gabriel Moshenska recorded residents who had been children in the war and their reactions to 'the bombing of schools, the chaos and failure of evacuation, the competitive collecting of shell shrapnel and bullet casings after an air-raid, and outrage at losing a portion of fish and chips when it was sprinkled with shattered glass during a V1 attack' (Blair, Simpson and Moshenska 2006, 489).

The oral history work at this site has subsequently been published in a separate report (Moshenska 2007). The challenge for the archaeologists was to make 'history and archaeology a community experience, by engaging the public in their past, not in the usual way of telling them what was happening in their local area,

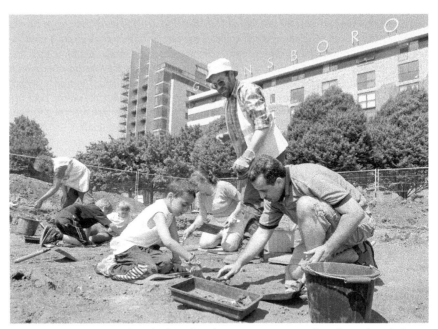

Fig. 7.11 Excavations at Shoreditch Park. A large area was opened in the park and almost 4,000 local people visited or took part in the excavation itself. 700 of the visitors were from local schools. Days were divided into two sessions – morning and afternoon. In each session the volunteer archaeologists were given an introductory talk, then divided into two groups: one group was sent out to dig, the other group processed finds. Then after 45 minutes the groups swapped over, and at the end they were debriefed together. The volunteers were from a cross-section of the community but included unemployed people, young people who had been excluded from school and disabled people.

but by encouraging them to participate in all stages of the historical investigation' (Simpson 2006, 1).

The excavation did reveal the remains of five Victorian terraced houses which had been damaged by bombing and the dates of the finds ranged from the late 15th century to the 1950s. Two of the archaeologists later wrote:

> Modern archaeological finds shed light on a not so distant past and we should not disregard them just because they are well documented. Time and traditions move quickly – some of the children who visited the site had never seen an 'old-fashioned' milk bottle and didn't know what coal was for ('a barbeque?').
>
> (Simpson and Keily 2005, 27)

Investigating Evidence

8 Archaeologists as Detectives

> Archaeology is like the design of a Roman pavement, built up of many small fragments, or tesserae. The main design is beginning to be known, but many of the details are missing. It is for this reason that research work goes on; that camps are dug over, and ancient cities uncovered. Many months' work may result in just one small piece of new knowledge. The archaeologist is delighted, and tells all his friends, and the little new tesserae is fitted into its place in the larger pattern; but first it is tested in all ways, to see that it really fits, because these people are learned, and jealous that before any new addition is made it shall be real knowledge.
>
> (Quennell and Quennell 1921, 105–6)

The authors of these words, the children's writers the Quennells, presented their readers, both children and teachers, with real evidence for their story of the past and, as the quote above shows, they stress the careful ways in which archaeologists work (see p. 134). Although this was not common in the past in children's books about archaeology, it is now usual for archaeology to be presented as a scientific process with techniques commonly used by police detectives. Shanks (1992, 53–6) likens archaeologists to fictional detectives, but the comparison was made long before this. Mann (1981, 205) quotes the amateur archaeologists in Stanley Masson's 1938 detective novel, *Murder By Burial*: 'I often think that a highly expert archaeologist would make a perfect detective' partly because he has 'the knowledge of *things*'. Collingwood in his *The Idea of History* (1946) uses his story of 'Who killed John Doe?' to illustrate the idea that reaching conclusions based on evidence is broadly similar in both criminal and historical investigations (Collingwood 1994, 266–8). Mann quotes Collingwood as writing: 'The hero of the detective novel is thinking exactly like a historian when from indications of the most varied kinds, he constructs an imaginary picture of how a crime was committed and by whom' (Mann 1981, 206).

This chapter studies the concept of the archaeologist as detective and suggests a number of exercises which encourage teachers to help their pupils develop observational and questioning skills ready for the site visit or the object handling session in a museum.

Police detectives

Policing in Britain has a long and complex history (Bunyard 1978, 1–35; Hunter *et al.* 1996, 24–38). Modern policing was not established until the 19th century but had its origins in systems of local law-enforcement by the community or appointed officials – a magistrate and a parish constable. In 1748 the author Henry Fielding became the Chief Magistrate at Bow Street in London and published lists of wanted criminals. After his death his brother, John Fielding, sent out patrols (famously known as the Bow Street Runners) on the streets to catch criminals. Attempts were made in the 18th century to set up a police force for London and by the end of the century, law and order was maintained by constables and night watchmen.

Significant change was brought about by the Home Secretary, Robert Peel, whose bill, The Metropolitan Police Act 1829, established a paid force of men organised into ranks of constables, sergeants and inspectors. The Municipal Corporations Act 1835 allowed boroughs to set up their own police forces through the watch committees of the local council. Some towns and cities were quick to set up their own forces (e.g. Bath and Bristol had their own police forces by 1836). The County Police Act 1839 allowed counties to establish police forces but did not make this compulsory. Only half of the counties did so (Bunyard 1978, 13), perhaps because these councils had to bear the full cost themselves. A later act of 1856 compelled all counties to form police forces and provided some of the costs. Kent County Council, for example, created their force of 222 men in 1857.

Although all the early police forces considered detection as part of their duties at first, no detective officers were appointed. The Metropolitan Police Force in London was formed in 1829 but the Detective Department was not created until 1842. The Staffordshire Constabulary was established in 1842 and its first ten detectives were selected from constables in 1894.

Forensic archaeology

It is clear that police forces around the world use scientific techniques to analyse evidence and solve crimes. Forensic science is, strictly, the application of scientific techniques in legal cases. Hunter and Cox rightly point out (2005, 2) that the word 'forensic' is incorrectly used when it is applied to the investigation of archaeological human remains, such as Tutankhamun, the Danish 'Bog Bodies' or the Neolithic 'Iceman'.

Archaeologists have, for time some now, assisted the police in many criminal investigations into particular murders. Archaeological advice and practical help has been offered to the police in the US since the 1970s. To an archaeologist, the careful and recorded collection of evidence is vital if the conclusions are to be accepted by others in the profession. However, Hunter *et al.* show that, in the case of the Nilsen murders in London, the excavation of the evidence in 1983 was less than satisfactory by archaeological standards (1996, 11–12). But this particular enquiry did bring about the co-opting of archaeologists onto some future murder investigations in the UK from the late 1980s – 13 case studies are discussed in Hunter *et al.* (1996, 44–60). Connor (2007, 17) discusses the connections between archaeological and forensic methods of excavating evidence.

The practice of proven archaeological methods of survey and recovery of evidence from crime scenes is now well established and published and there are academic courses for students of archaeology in the US and in the UK, as well as training for police personnel and discussion in scientific papers (for a number of citations see Hunter and Cox 2005; for Australia see Blau 2004; for the UK, USA, Italy, Spain, France, Indonesia, Canada and South America see Cox 2009). The forensic archaeological work which started with individual or serial murder cases now includes working for governments, their agencies and judiciaries on major conflicts, such as in the Balkans (Wright *et al.* 2005, 137–58), human rights violations (Ferllini 2007) and genocide enquiries, such as Rwanda (Ferllini 2002, 172–3)

Scientific forensic methods were developed from the medieval period onwards to establish, for example, the exact cause of death, the changes to a corpse after death, the detection of specific poisons in the body and the identification of a person's fingerprints, developed in 1892 in Argentina (Clegg 2004, 162). But it is in these 19th-century forces that we see a forensic approach to solving crimes. Hunter *et al.* (1996, 9) cite several examples of scientific techniques being applied to criminal investigations in the US and in Europe. New rules in 1879 for dealing with murder cases in London stated that 'the body must not be moved, nor anything about it or in the room or place interfered with, and the public must be excluded' (Metropolitan Police 2010). The Metropolitan Police was the first to have its own Fingerprint Bureau (1901) and a forensic laboratory (1934). Today the police have new techniques, such as DNA testing, as well as computer-automated systems for analysis of existing criminal records, as well as of fingerprint records. Specialist survey companies can now record crime scenes, using laser scanning instruments, with almost perfect accuracy and present them as 3D models for discussion and interpretation by police teams and the courts (Plowman Craven 2010).

Fictional detectives

Detective novels, or novels which included solving a crime, have been popular with readers since the 19th century. These books more often than not introduced named detectives such as Auguste Dupin in Edgar Allan Poe's *The Murders in the Rue Morgue* (1841), Wilkie Collins' mystery solver Walter Hartright in *The Woman in White* (1859), Sergeant Cuff in *The Moonstone* (1868) and Sherlock Holmes created by Arthur Conan Doyle in *A Study in Scarlet* (1887). Included in Charles Dickens' *Bleak House* (1853) was Inspector Bucket's investigation of the murder of the lawyer Tulkinghorn. Ousby (1997, 192–5) discusses fictional detectives in Europe.

These early detective novels paved the way for a rush of new fictional detectives which peaked in the first half of the 20th century – for example, G. K. Chesterton's Father Brown (*The Innocence of Father Brown*, 1911); Agatha Christie's Hercule Poirot (*The Mysterious Affair at Styles*, 1920) and Miss Jane Marple (*Murder at the Vicarage*, 1930); Dorothy L. Sayers' Lord Peter Wimsey (*Whose Body?*, 1923); Margery Allingham's Albert Campion (*The Crime at Black Dudley*, 1929); John Dickson Carr's Dr Gideon Fell (*Hag's Hook*, 1933) and Sir Henry Merrivale (*The Plague Court Murders*, 1934); Ngaio Marsh's Inspector Roderick Alleyn of the Yard (*A Man Lay Dead*, 1934); and Raymond Chandler's Philip Marlowe (*The Big Sleep*, 1939).

Since the heyday of British detective novels in the 1920s and 1930s, there have been a number of other detective characters which have appeared in books, television series and films. The range has increased to include medical examiners, psychologists and lawyers, as well as teams of police detectives. Cox (2001, 152–4) and Hunter and Cox (2005, 208–9) discuss police detection in popular culture, in particular in films and in television series but say, of their university students in forensic archaeology courses that 'students learn quickly the fictitious nature of TV drama and the artificiality of sedate village murders in the Home Counties. Instead, the reality is with the social sub-cultures – prostitution, drugs dealing, and paedophilia' (Hunter and Cox 2005, 3).

Television viewers in the UK have long followed series featuring individuals (e.g. *Dixon of Dock Green* from 1956), partners (e.g. Regan and Carter in *The Sweeney* from 1974) and teams (e.g. *Z Cars* from 1962). Mawby's review of police drama from 1956 to 1996 questions what 'televised dramatic images tell us about contemporary policing debates and indeed whether such images of policing reflect or refract the spirit of the times' (Mawby 1998, 39).

Fictional detection and archaeology

Of interest to archaeologists, perhaps, has been the creation of historical detective characters – for example, Ellis Peters' medieval Brother Cadfael, Lindsey Davis' Roman Marcus Didius Falco and Peter Tremayne's Celtic Sister Fidelma – each author presenting detective fiction set in well-researched period backgrounds. Murder and mystery is also the subject of

▶ Anthony Price's *Our Man in Camelot* (1975), where international political intrigue is set against the 'discovery' of King Arthur's Camelot. There is even a reference to the destruction of archaeological sites and 'Rescue – the Trust for British Archaeology' (Price 1982, 191–2);

▶ Gordon Honeycombe's *Dragon under the Hill* (1973), a modern fantasy mystery based on Lindisfarne in the Anglo-Saxon period;

▶ S. T. Haymon's *Ritual Murder* (1982), where a murder takes place on an excavation in a cathedral;

▶ Kate Mosse's *Labyrinth* (2005), a mystery story set in both the 13th century and on a modern archaeological dig.

Besides Masson (above), fictional archaeologists have appeared in other detective fiction. Glyn Daniel, former Disney Professor of Archaeology at the University of Cambridge, promoted archaeology to the general public through crime fiction as well as on radio and TV (see p. 50). Daniel added to the list of fictional university dons who solved crimes (Mann 1981) by creating Sir Richard Cherrington, Professor of Prehistory at Cambridge, in *Welcome Death* (1954). 'The landed gentry' were said to have found Cherrington peculiar on two counts – one that he 'remained obviously unmoved by the appearance and attentions of all the eligible women' and 'the second was his passion for field archaeology' (Daniel 1962, 16).

Egypt and the Near East feature in a number of detective novels. A more recent addition is Angela Peabody, created by the author Elizabeth Peters, who holds a PhD in Egyptology. Angela Peabody solves her first crime in Egypt in 1884 in *Crocodile on the Sandbank* (1999), which includes an explanation of the scientific nature of excavation and the problems of illicit digging.

But it is Agatha Christie, in particular, who uses archaeological sites and archaeologists as backgrounds for some of her detective novels, including *The Adventure of the Egyptian Tomb* (1924). When she met her future second husband, the archaeologist Max Mallowan, in 1930 while he was working for Leonard Woolley at Ur (Cholidis 2001, 338–9), she became personally familiar with archaeological sites and methods, experience she put to good use in some of her subsequent detective novels, especially *Murder in Mesopotamia* (1936). Guglielmi

(2001, 350–89) has shown that she used real archaeological sources for *Death Comes as the End* (1945), a murder mystery set in Thebes around 2000 BC, and her play *Akhnaton*, which she wrote in 1937 but which was never performed, although it was published in 1973.

Methods of detection in fiction

Fictional detectives, just like real detectives, are concerned with clues. The keen observation and questioning of objects, situations and people by Sherlock Holmes is usually credited to the surgeon Joseph Bell, with whom Conan Doyle worked in the Edinburgh Royal Infirmary. Holmes was famous for finding, identifying and interpreting the smallest of clues – for example, cigar ends in *The Resident Patient* (1893). In *The Adventures of the Blanched Soldier* (1926) Holmes says to a soldier, bewildered by what the famous detective appears to know about him, 'I see no more than you, but I have trained myself to notice what I see' (Conan Doyle 1981, 1000). In *The Mysterious Affair at Styles* (1920), Hercule Poirot explains the process of detection:

> 'One fact leads to another – so we continue. Does the next fit into that?
> A merveille! Good. We can proceed. This next little fact – no! Ah, that is curious! There is something missing – a link in the chain is not there. We examine. We search. And that little curious fact, that paltry little detail that will not tally, we put it here!' He made an extravagant gesture with his hand.
> 'It is significant! It is tremendous.' (Christie 1954, 35)

Daniel is more restrained: 'We have a few clues admittedly – like the discrepancies to which Sir Richard has drawn our attention. The timing may prove all important. Personally, I find the phone calls very difficult to fit in. But at the moment that's all we have, and from that we weave our theories' (Daniel 1962, 150).

Colin Dexter's books about the Inspector Morse Oxford mysteries were made into a long-lasting television series. In *The Silent World of Nicholas Quinn*, Morse is puzzling over the case: 'He needed more facts; and facts were facing him, here and now, in the dark-blue plastic bag containing the items found in Quinn's pockets, in Quinn's green anorak, and in Lewis's inventories' (Dexter 1978, 92).

Scientific techniques commonly used by archaeologists now crop up in crime mystery novels. Peter Robinson's character Dr Wendy Cooper, forensic anthropologist, is investigating the death of a teenager. She establishes *an estimate* of sex and age from teeth and bones and *a date* of after 1959 because the teeth contained fluoride (introduced into water supplies in the UK in 1959). She finds *clothes* from shoe leather traces and eyelets, *objects* in the grave – marbles (=?boy), pennies, half-crown, sixpence and threepenny bit are pre-decimalisation coins, therefore pre-1971 and *the identity bracelet* with the surviving letters GR-HA- (Robinson 2003).

As if to emphasise the role of detective fiction in archaeology, Pearce recently wrote a case study about the evidence found by Patricia Cornwell's character, Dr Kay Scarpetta, Chief Medical Officer for Virginia, as she finds and analyses flakes of paint in a murder investigation (Pearce 2009).

Detective techniques and the educator

The idea that archaeologists work like police detectives is now often used in educational resources and museum displays – in 1984 Richard Doughty introduced Young Archaeologists' Club members to Inspector Archie who investigated 'suspicious looking objects' (Doughty 1984, 4–5). I first used the idea with school students and with Young Archaeologists' Club members in the 1970s and published the dustbin game (see below) in 1981 (Corbishley 1981, 2) and an exercise in stratigraphy (see below) in 1986 (Corbishley 1986a, 1–4). Comparing the work, in detail, of police detectives and archaeological detectives allows children (and adults) to make a connection between knowledge of one of *their* present experiences (police dramas on TV) with archaeological work. It provides an entry into archaeological techniques (such as making accurate site plans) which will be unfamiliar to them and allows an opportunity for extension work in other areas (such as team working and science experiments).

Understanding the way police detectives operate today at a crime scene is an important starting point. Horswell sets out some of the principles adopted in Australia with 'forensic investigators' encouraged to ask a series of questions:

- ◆ Who was the deceased?
- ◆ What happened?
- ◆ When was the deceased discovered?
- ◆ Where was the body discovered?
- ◆ How did the deceased get to the death scene?
- ◆ Why was the deceased at this location?

(Horswell 2004b, 3, 9–10)

A good starting point for children to understand police detective work is in children's reference books, such as *The Usborne Detective's Handbook* (Civardi *et al.* 2008). For adults, Hunter and Cox explain the procedures and professional groups involved in major crime detection in the UK (2005, 5–7), in which a Senior Investigating Officer leads an investigative team which includes a Support Manager, Police Search Advisers, Scenes of Crime Officers and Forensic Scientists.

Another approach is to look at accounts of famous cases in history – for example, Ferllini outlines the forensic examination of the body of Che Guevara (2002, 64–5). The work of forensic scientists in the UK may be investigated through several websites (Metropolitan Police 2010; The Forensic Science Service 2010; The Forensic Science Society 2010). Examples of recording forms will be useful in showing the similarities between police and archaeological work: police examples of crime scene recording may be found in Hunter *et al.* 1996, 30, and in the Bosnian mass grave recording sheet in Wright *et al.* 2005, 153.

Table 8.1 shows, in brief, how crime detection is similar to archaeological detection. Educators will want to enlarge on each area, in particular, either in information giving or gathering or in discussion.

Table 8.1 Police and archaeologists

Police investigate a crime	*Archaeologists investigate a site*
At the crime scene or site: look for clues and collect evidence	
Record the scene in notes, photographs/ video and tapes	Record the site in notes, photographs/video and tapes
Record evidence	Excavate and/or record upstanding features
Collect samples for analysis	Continually record evidence uncovered (notes, plans and photographs)
Discuss with crime team and specialists	Collect samples
	Discuss with team and specialists
Around the site	
Take statements	Investigate the landscape, documentary evidence, record features, take samples
Collect more evidence	
Back at HQ/Laboratory	
Preliminary discussion in team	Preliminary discussion in team
Assign specific tasks	Assign specific tasks
Check criminal records	Check records and publications
Bring in experts	Bring in experts
Process samples	Process samples
Analyse scientific evidence	Analyse scientific evidence
Check evidence against databases	Check evidence against databases
Conclusions	
Preliminary conclusions	Preliminary conclusions
Put together a scenario which best fits the evidence	Put together a scenario which best fits the evidence
Verify conclusions	Verify conclusions
Arrest suspect	Write report
Presenting the story	
Gather evidence and witnesses	Gather evidence
Present evidence in court	Present evidence in publication/display
Hope to secure a conviction!	Hope other archaeologists agree!

Police

Accurate and objective recording methods which will form a major part of the presented evidence in court; scientific techniques such as DNA testing, lie detection, facial recognition, environmental sampling, trace analysis of blood, paint or fibres; the existence of databases (e.g. the Forensic Science Service's UK database of shoe imprints) of evidence and reports of earlier investigations which will support or deny conclusions reached and the presentation of a scenario first within the police authority and finally to a jury in court.

Archaeologists

An accurate and objective translation of collected archaeological evidence into records which may be re-examined by later archaeological investigations; scientific techniques such as excavation, aerial photography and geophysical detection, microscopic analysis of wear on flint tools, ancient seed and pollen analysis; archaeological reports, national and regional record databases, stored and presented finds which may be interrogated; the presentation of a scenario in published reports and books, at conferences and in museum displays.

To emphasise the detection methods used by archaeologists, educators may use other games or exercises, some of which are described below. As a preparation for those, exercises on crimes detection techniques may be useful. In the section 'Presenting the story' (above), it is worth while noting that Hunter *et al.* (1996, 35–8) and Dilley (2005, 186–90) make it clear that publishing an archaeological report is less stressful than giving expert evidence in a court case.

Science projects: An educator at the College of Education, University of North Texas, created seven science exercises for young students, from the 'Mystery of the Ink Note' to 'An Investigation of Tyre Tracks'. Here a variety of toy cars were rolled over an ink pad and then onto paper. The students, armed with rulers and magnifying glasses, matched the suspect vehicles to the one found at the crime scene. Atkins outlines the concepts, skills and inquiry questions for this exercise:

Science concepts and skills

▶ Measurement: Use a ruler to make measurement

▶ Comparison: Observe tyre tracks and determine which match and which do not

▶ Observation: Make a visual inspection of the tyre tracks

▶ Hypothesis: Write an explanation of how the tyre tracks may have been left by the door.

Inquiry questions

1. Do all the tyres have the same tread?
2. Are all tyres the same width?
3. Can tyres be compared like fingerprints?

At the end of the exercise the students are asked to write a story telling why the car was there (Atkins 2006, 28).

In 2006, secondary school students at the Ravensbourne School in Bromley, UK, carried out an enquiry exercise on the excavation and examination of the school's model skeleton (Barber 2006). The project's aim was to introduce scientific techniques and thinking to students using a dramatic event (a murder) which was popular in TV programmes such as 'Crime Scene Investigation'. The project involved:

▶ investigating archaeological techniques and then carefully excavating the school skeleton, measuring and recording it so that, together with online databases, they could try to determine, size, age, sex and diet;

▶ carrying out experiments using specially created brain (cauliflower soaked in soda crystals), stomach contents (lumpy soup), blood samples (olive oil, water and red food dye shaken together).

Archaeological detective exercises

The following exercises, or games, have all been thoroughly tested in schools, outreach projects, children's activities in museums and with adult and higher education classes. These exercises are useful to emphasise the need to look for clues, ask questions, reach conclusions only based on the evidence and test out conclusions in group discussion.

Fig. 8.1 The archaeologist as detective

The archaeologist as detective

The cartoon exercise (see Fig. 8.1) may be used to introduce younger students to the concept of the archaeologist as detective. Children are asked to list the clues indicated by the magnifying glasses and then work out what the crime was in the drawing on the left and what the evidence excavated by archaeologists on the right might indicate.

Looking at stratigraphy

An understanding of stratigraphy is crucial to understanding archaeological layers, whether on the landscape, in excavated remains or upstanding remains. Copeland (1993, 4–5) notes that the historic environment is dynamic and is seen by people today as a horizontal two-dimensional landscape, while archaeologists have to unravel it to produce the vertical dimension.

This photograph (Fig. 8.2) may be used to show that common sense tells us that the first 'layer' to be made is the sponge at the bottom and so on until the top (Corbishley 1990b). Indoor rubbish bins and dustbins (see below) demonstrate the same principle, that whatever is at the bottom is going to be laid down before whatever is above it. Another fun way to demonstrate stratigraphy to children in class was created by Elia (2010). She poured different coloured layers of jello (edible jelly) into a bowl with other food (such as grapes, raisins, other fruit). Children record each layer and then excavate and eat. A non-edible version of this

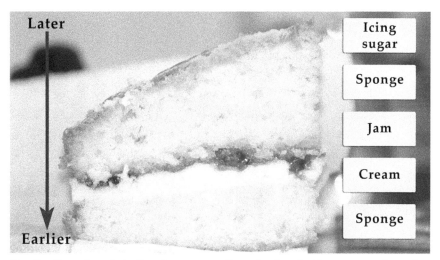

Fig. 8.2 Examples of stratigraphy can sometimes be found at home – cut through a Victoria sponge cake and you have layers which can be arranged in time sequence.

exercise was carried out by Young Archaeologists at the Institute of Archaeology (see p. 340). Our activity was Fish Tank Archaeology where the children created layers (sand, bulb fibre, clay of different colours) in perspex fish tanks and made archaeological remains of buildings and features (ruined walls, postholes and pits) using toothpicks and ice cream sticks, little stones and miniature play bricks. At a following meeting they excavated the layers, recording them in plans and notes as they went.

Visitors to excavated, preserved remains at ancient monuments are often confused by seeing several archaeological features apparently jumbled together. Few people today, other than architects, surveyors and builders, are familiar with buildings or other structures in plan form – for example, the foundation courses of walls. These layers or vertical dimension can be understood by looking at modern houses being constructed (Corbishley 1987). Children can be introduced to the processes in construction, through photographs or site visits (see Fig. 8.3) and see the modern equivalents of past features (see Fig. 8.4).

Table 8.2 Making comparisons

Today	The Past
Trenches dug for the foundations	Robber trenches to extract building materials
Footings of walls up to ground level	Remains preserved on an ancient monument
Walls partly built to include window and door spaces	Ruined building with some walls preserved
Roof on but unoccupied house	Shell of building preserved with roof structure
House furnished and lived in	Old 'country house' open to the public

Fig. 8.3 This stage of the construction of a modern house, with its foundations and the first few courses of the walls, is like a site displayed to the public shown in Fig. 8.4.

Fig. 8.4 Some of the surviving footings of the wall of Segedunum Roman Fort on Hadrian's Wall.

This exercise is useful in explaining that while archaeologists excavate from the top/latest layers they will usually present their findings the other way around (lowest/oldest) as here in the table above. Looking at modern construction 'layers' will help children understand features when they visit ancient monuments. For example, the space presented by the low foundations of an ancient building (1) will look small compared to a finished building (4) but individual rooms appear smaller when they are furnished (5) The evidence for the location of doors will be clear in the modern construction (3). Look for the same kind of evidence in the ancient monument. Modern window spaces (3) will be obvious but not necessarily so in the ancient monument if the remains of the wall do not reach window level.

Although stratigraphy is often associated purely with excavated evidence, upstanding buildings will provide many examples which are easier to find and illustrate to children. At the ancient monument there will often be other opportunities to apply these 'detective' approaches – for example, by looking for blocked windows and doors and spotting the evidence for floors (horizontal rows of holes for joists) and roof structures (corbels – roof frame supports).

Archaeology is just rubbish

Archaeologists who present their work to the general public, and especially to students, will often state that archaeologists sift through loads of old rubbish in their hunt for the clues to the past. Despite frequent references to archaeologists collecting rubbish, visitors to excavations are still surprised that this is true and are often mystified about where all the rubbish is coming from. People often do not know that in the past, rubbish was separated for recycling and the residue buried in special pits or distributed across fields with other waste as manure, perhaps to be retrieved by archaeologists field-walking.

The concept of local authority refuse collection is relatively recent. There was no refuse collection at the author's house in a rural area of Essex until 1935, which accounted for the large amount of buried rubbish across most of the garden. Rogers (2005, 30) shows that street waste in America was being systematically collected and sold to farmers for manuring in the first half of the 19th century, but by late in that century refuse collecting and recycling was being carried out in major cities.

The University of Arizona's Garbage Project has, since the early 1970s, shown that archaeological methods can be successfully used to evaluate and understand patterns of consumer societies (Rathje 2001; Rathje and Murphy 2001). Rubbish and recycling both moveable objects and buildings are also discussed elsewhere in this book.

It seemed natural to me that experiments and educational games should be devised which explained what archaeologists can or cannot discover by investigating rubbish (Corbishley 1990b, 1990c and 2001). 'The Dustbin Game' involved the use of a real dustbin, cut in half with a glass front, which allowed students to view a collection of normal household rubbish. From careful observation they might be able to answer questions like:

▶ Are there any children in this family?

▶ What kinds of food does this family eat?

▶ Do they have any pets? What sort and how many?

▶ What season of the year is it?

Wild guessing is discouraged and children are challenged to provide evidence for any statements they make. For example, clues to the questions might be a broken toy, some junk food, a dog food tin, a birthday card.

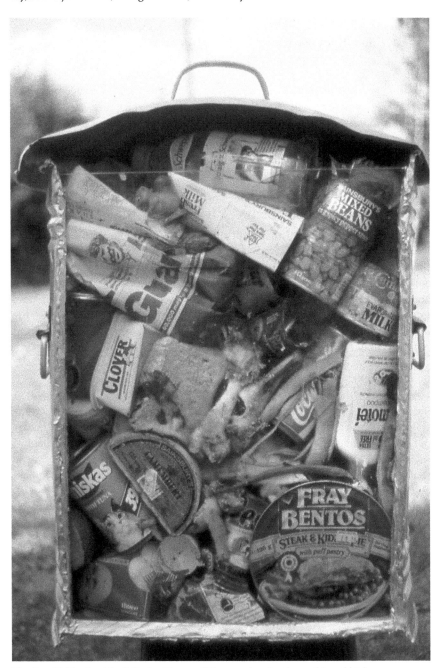

Fig. 8.5 Half a dustbin full of evidence of the people who threw this rubbish away.

Students also learn that evidence might not provide all the answers. While there may be evidence of dog food cans in the dustbin, there is no sure way of finding out whether this family has a big dog or two small ones, for example. The other main consideration in this exercise is that, if all the rubbish in the dustbin is buried, it makes it harder to evaluate any surviving evidence. Assuming that organic material will tend to rot while inorganic material may survive, or at least survive longer then: food cans will lose their labels and therefore their identity and may eventually disintegrate completely; food residue may rot quickly (e.g. banana skin), or more slowly or be preserved in the right conditions (e.g. animal bones and fruit seeds); and some wrapping may disintegrate quickly. On the other hand, glass and plastics may survive for thousands of years.

Another version of 'The Dustbin Game' (Corbishley 2001) uses drawings of four dustbins and asks students to match each dustbin to a drawing of four different families – a game similar to 'The Left Luggage Game'. 'The Dustbin Game' may also be played using less messy ingredients and in a way which demonstrates the stratigraphy of rubbish deposits. Alston (1993) showed how the rubbish collected every day from her primary school classroom was put into a fish tank. Each day's deposits were separated by a sheet of paper labelled Monday to Friday.

The Skeleton Game

There are two parts to this game, which can be played through group discussion and recording (making lists, comments or drawing). First ask a child to 'play dead' and tell the other children that they have to act as archaeologists to figure out what this person was like but without asking her. Ask them to try to figure out what kind of a person she is only from her clothes and what she is carrying. Second, assuming that she had been buried for thousands of years, ask what would they imagine might have survived and if they can they now tell if this is the skeleton, clothes and possessions of a female? In a similar way to investigating objects, the children will need to be directed to things found out by looking and things to be researched.

As an extension exercise, the children could be asked to collect or make a list of those objects which reflect their personalities and interests and which they would like to have buried with them (similar to 'My Favourite Objects', see p. 245).

Summary

▶ The idea of presenting archaeologists as detectives is now commonly used in children's books and learning resources for schools.

▶ Police detective practices (in reality and in fiction) are outlined and compared with the usual elements of an archaeological project.

▶ A range of archaeological detective exercises are presented for teachers in schools and for museum and heritage educators.

Conclusions

The concept of the archaeologist working to detect the past from clues carefully collected has been promoted for some time, perhaps over-promoted in simple statements in books for children. But the detail offered in this chapter about both real and fictional police detection is essential if teachers are going to turn the well-worn cliché into an educational exercise.

Understanding how the police work helps teachers to promote the idea of working in a team when they present current archaeological practice – a team of specialists gathering evidence and presenting their findings. That is not to say that the methods of the individual fictional detective, whether it's Sherlock Holmes or Inspector Morse, are not useful in presenting the idea of asking questions to solve problems. Examples given in this chapter show that interesting links can be made with teaching science in school, especially as forensic archaeologists are now often called in to help solve some serious crimes.

The next chapter also uses detective approaches in education visits to outdoor sites.

9 Learning Outdoors

In the past, outdoor education has been largely the realm of teachers of physical education with practical training sessions in areas such as canoeing, climbing, walking or orienteering. More recently other activities have been added such as self awareness, working with others, team building, risk taking and environmental awareness – the Royal Society for the Protection of Birds talks about 'living classrooms' in its environmental programmes. The establishment of national curricula in Britain has brought about the inclusion of elements of outdoor education in specific subjects (see p. 149) – for example, visits to historic buildings, museums, galleries and sites in history and in art and design, using the school's local environment in geography. In addition, visits to churches and other places of worship are recommended in religious education (Johnston *et al.* 2004).

Outdoor education is also seen as an activity to be undertaken by young people quite outside of the school environment – in summer camps and through weekend activities, for example, working towards the Duke of Edinburgh Award, and by the Young Archaeologists' Club (see p. 106) and museum clubs. This section of the book looks at learning outdoors and suggests ways in which we, in archaeology and education, may learn from their experiences and published activities and from their changing role in both formal and informal education.

Definition

A straightforward definition of outdoor education was provided by the Institute for Outdoor Learning and quoted by Hunt (1989, 17) as 'a means of approaching educational objectives through direct experience of the environment using its resources as learning materials'. The Institute for Outdoor Learning states that 'Outdoor Learning is a broad term that includes: outdoor play in the early years, school grounds projects, environmental education, recreational and adventure activities, personal and social development programmes, expeditions, team building, leadership training, management development, education for sustainability, adventure therapy ... and more' (IOL 2010a). The Institute is clear about the value of outdoor learning, suggesting that experiences can develop awareness, encourage responsibility for self and for one's own learning, build a sense of community and develop awareness and respect for the environment.

Current trends

About 7 million student out-of-school visits are made every year in the UK, of which about 3 million are for 'adventurous activities' (IOL 2010b). In recent years there have been increasing worries about taking students out of school. Risk assessments are now obligatory for most educational activities including, of course, any learning conducted outdoors. A few accidents, sometimes fatal (calculated to be three out of 1,420 accidents to young people up to the age of 19), have led to serious concerns from parents, governors and teachers and have led to cancellations of all school trips in some schools (IOL 2010c). Cooper (2005, 20)

pointed out that while outdoor residential centres are still popular with schools for their 'adventurous activities', there has been a decline in school-led activities. Cooper (2005, 21) lists the main reasons as an over-cautious approach by parents and governors resulting in teachers' worries about personal responsibility for accidents and increased insurance premiums, the problem of getting supply cover for visits, increased paperwork for permissions and risk assessments and an increased emphasis on National Curriculum core areas.

A more recent survey was carried out by the Countryside Alliance, formed in 1997 to champion country life. The survey showed that teachers' most frequent concerns were about health and safety (76%), lack of funding (64%) and insufficient time or flexibility in the curriculum (53%). But the report showed that 96% of the primary and secondary teachers who were interviewed believed that it was important for children to learn about the countryside in the National Curriculum and 89% believed that outdoor learning could play a greater role in cross curricular work (Southcott and Pyle 2009, 3–8).

Cooper stated that '79% of British parents believe the world is now more dangerous for children' and that 'more than 75% of British children between 11 and 16 take no exercise each week' (2006a, 22). To his previous reasons (above) for the lack of children's connection with the outdoors, he puts part of the blame on parents who provide a number of 'controlled environments' – from travel by car to school, to organised trips to theme parks. Sharp (2004a) argues that risk must be managed and balanced if outdoor education is to survive. Krinkel (2006) rightly asks 'Besides libraries and the outdoors, where are we allowed to look on our own?' and Krowell (2006) wrote 'The outdoors has ceased to be a place of wonder and stimulation. Instead of being a place to develop human capability, it's been reduced to a micro-competency factory.'

The value of students experiencing the world outside the classroom as part of a programme of active learning needed to be restated and supported, officially, by government. The Green Alliance and DEMOS (a political think-tank) carried out research in 2004 and published a report called 'A Child's Place: Why environment matters to children'. One of their conclusions was: 'Environmental education through exploration: we need to provide for children's innate sense of exploration and self discovery through out-of-school learning and greening school design' (Thomas and Thompson 2004, 11), stating that:

> Every child should be entitled to outdoor learning if we are to reconnect environmental education to children's innate delight of secret spaces and self-discovery. Entitlement in education is an established concept but rarely extended outside the classroom walls ... Out-of-classroom learning should not just be about one-off excursions to established learning institutions such as museums or galleries, though these are clearly also of value'.
>
> (2004, 12)

In January 2005 the Education and Skills Select Committee of the UK government consulted with groups working in outdoor education to provide guidelines. A draft manifesto was launched in November 2005 for public consultation. In advance of the published manifesto, a booklet with practical advice and information was published by the Real World Learning Partnership (RWLP 2006). The group was made up of subject associations (e.g. the Geographical Association), national societies (e.g. the Royal Society for the Protection of Birds)

and commercial organisations (e.g. PGL, which offers residential activity courses adventure holidays and summer camps). The interests of outdoor learning for the historic environment were represented by the Historical Association and the National Trust. The booklet promotes the advantages of outdoor learning, claiming that it 'provides part of the foundation for a fulfilled life, which every child should have access to' and that children 'are far more likely to develop into active citizens in later life, giving and receiving more from their community and participating in democratic society' (RWLP 2006, 4). Included in the booklet was the manifesto:

1. Provide all young people with a wide range of experiences outside the classroom, including extended school activities and one or more residential visits.

2. Make a strong case for learning outside the classroom, so there is widespread appreciation of the unique contribution these experiences make to young people's lives.

3. Offer learning experiences of agreed high quality.

4. Improve training and professional development opportunities for schools and the wider workforce.

5. Better enable schools, local authorities and other key organisations to manage visits safely and efficiently.

6. Provide easy access to information, knowledge, expertise, guidance and resources.

7. Identify ways of engaging parents, carers and the wider community in learning outside the classroom.

<div align="right">(RWLP 2006, 8–20)</div>

In 2009 the Department for Children, Schools and Families set up the Council for Learning Outside the Classroom (CLOtC) to take the manifesto forward and to gather support from organisations involved in outdoor learning, and to encourage schools to use the opportunities presented by the environment around us. Its website provides information and advice for planning, carrying out and evaluating visits and projects outside school (Council for Learning Outside the Classroom 2010).

The value of outdoor education

'There is a considerable body of research suggesting that good quality Education Outside the Classroom can add depth to the curriculum and promote cognitive, personal and social developments in young people' (O'Donnell *et al.* 2006, 1).

The UK government's Office for Standards in Education, Children's Services and Skills (Ofsted) regulates schools and education services in England. Its 2008 report, 'Learning outside the classroom. How far should you go?', concluded that 'When planned and implemented well, learning outside the classroom significantly raised standards and improving pupils' personal and emotional development.

Learning outside the classroom was most successful when it was an integral

element of long-term planning and closely linked to classroom activities' (Ofsted 2010, 5).

Bond (1986, 11) rightly pointed out that 'learning by direct personal experience has far more impact than being advised on the basis of someone else's experience, which is inevitably second-hand'.

Various authors have suggested that outdoor education provides young people with experiences which may help them in personal, social or educational areas (e.g. Barnett (2005) arguing for the value of fieldwork in geography). Ogilvie (2005, 75) claims that outdoor learning arranged for young people is 'mostly devoted to programmes of outdoor activities either as an end in itself or as a means to other objectives like social education'. Other authors can be quoted – for example, Sharp (2004b). In encouraging a group to carry out problem-solving exercises, Barnes (2002, 49–50) argues that the process includes these eight stages:

1. Problem (information is collected);

2. Analysis (confirmation that all the information has been collected);

3. Alternatives (strategies of problem solving discussed);

4. Evaluation (each strategy is examined);

5. Decision (one choice is made);

6. Planning (detailed plan is made);

7. Action (group or sub-groups carry out planned tasks);

8. Re-evaluation (on-going monitoring).

Hathway devised outdoor challenge days where physical tasks carried out by teams would include foundation skills such as risk-taking, problem-solving,

Experiential learning

Outdoor learning is increasingly promoted to fulfil the requirements of curricula subjects in schools, both in the UK and abroad. Commercial companies providing outdoor learning courses, for example, are careful to include curricular connections in their literature. A great deal of research into the practice and value of outdoor learning has been carried out (e.g. Rickinson *et al.* 2004 for UK; Neill 1999 for Australia) which shows that properly planned fieldwork can be of real value to young people. Some studies have been published which examined the impact of outdoor studies for particular curriculum subjects. For example, a study in California (Zwick and Miller 1996) compared experiential learning out of doors with traditional textbook and classroom-based study in science for American Indian students.; it showed that significantly higher scores were achieved during outdoor learning. From a wide range of experiences with disabled people at Churchtown Farm Field Studies Centre in Cornwall, Cotton (1981, 17) has shown that 'there are few skills which cannot be developed through the environmental approach' – stimulating the senses, for example, through the shape of buildings, trees, mountains and fields.

Fig. 9.1 A geography field trip in North Yorkshire investigates how the landscape is divided up for farming but also used for leisure activities. One young student here is noting activities which show a human impact on the landscape and which will form part of a discussion session back in the classroom.

creative thinking and presentation skills where decisions about risk might be 'based on:

- ◆ Physical risk: harming yourself and others;
- ◆ Intellectual risk: planning, creative thinking, problem solving;
- ◆ Material risk: money, possessions;
- ◆ Emotional risk: feelings, relationships, working together'.

(Hathway 2006, 2–3)

Outdoor education and the environment

In Britain, environmental education has long been part of the school curriculum, in particular at primary level (see Fig. 9.1). Environmental studies could often be found as a subject in its own right before the introduction of the National Curriculum. Ogilvie reminds us that today's society has serious concerns about its environment and that

> Learning through the environment, i.e. using it as a learning resource, is no longer enough. Whilst the environmental and field study centres have done much to promote learning about the environment, there has to be much more emphasis on learning for the natural environment – the looking after it aspect. (2005, 75)

Ogilvie adapted a former model for leadership (Adair 1983) and added an environmental aspect. He outlines his environmental needs as:

- ◆ 'active respect and care for the environment (e.g. observance of the country code);
- ◆ reduce to a minimum the impact of the group; recognise and avoid sensitive areas; sustainable usage – avoid over-use of an area;
- ◆ 'leave footprints, take only photographs': bring all litter and human waste out;
- ◆ 'on-going educational campaign to publicise and raise awareness of important issues;
- ◆ public protest and action to counter the fearful combination of the vested interests of corporate developers and power politics'.

(Ogilvie 2005, 75)

Cooper stresses the citizenship role that environmental education may take, writing that:

A Global Citizen:

- ◆ respects and values diversity
- ◆ has an understanding of how the world works
- ◆ is outraged by social injustice
- ◆ participates in the community at a range of levels from local to global
- ◆ is willing to act to make the world a more sustainable place
- ◆ takes responsibilities for their actions'.

(2006b, 15)

Managing educational visits

Most outdoor activity, environmental and heritage organisations (including museums) and Local Education Authorities produce literature and/or website information to help teachers and youth leaders manage educational visits (Cooper 1998). A good example of locally produced information for teachers is 'Looking Around Us' published by the North East Environmental Education Forum (Johnson and Muir 2002). However, few publishers have risked providing detailed information and advice in a changing educational and political climate. Smart and Wilton's book is an exception and its introduction sets out the value and the dangers of outdoor visits:

> Educational visits are an important part of the school curriculum, not only for specific National Curriculum purposes but also for the personal and social development of pupils. Visits and activities out of school of any sort require a certain amount of risk taking – from crossing the road with a class of infants to rock climbing with sixth-formers. (Smart and Wilton 1995, 4)

The book provides useful information on the practicalities of organising trips, with photocopyable forms such as a letter to parents, with details on specific activities such as abseiling and visiting farms.

Educational visits to historic sites

Visits to historic buildings, sites and landscapes require much the same sort of organisation and planning as for other outdoor learning venues. Preparation is crucial, for both the teachers or leaders and the students. Some organisations publish check lists (Corbishley 1999b, 11; Smart and Wilton 1995, 5–6) to help teachers plan a visit and assemble the right resources. Three booklets written for teachers planning visits to heritage sites provide useful introductory information (Aston 1987 and 2000; Glen 2000; English Heritage 1991b). The questions to ask before the visit are:

Table 9.1 Planning a visit

Purpose of the visit	Is the visit curriculum-based? What do you expect to achieve? Is the purpose clear to all other staff?
Practicalities	All bookings (travel, entry etc) made and checked? Risk assessment completed? Adequate staff/student ratio? Permission slips returned from all parents/guardians? Provision for special needs students/staff/helpers? First aid boxes? Medication for students? Resources gathered together? Packed lunches? Appropriate clothing & footwear? Emergency numbers and travel details left with administrative staff? Insurance cover checked? Accurate register of all pupils/staff/helpers?
Arrangements in school	Informed other staff about visit and organised cover?
Information for parents/guardians	Informed parents/guardians about the purpose of the visit?
Preparation for attending staff/helpers	Provided full information for all attending staff/helpers about: reason for visit, arrangements for the day, what is expected of them, resources they will need (activity sheets etc), composition of groups?

Some teachers are worried about making visits to ruined sites, preferring museums or historic houses to provide them with physical evidence for teaching history. Ruined sites are often seen as 'difficult' to understand for students, and adults. In fact these ruined sites, without the accumulated junk of the past, can often be more stimulating for students. It is also an opportunity to investigate interpretations that people have put on them, both in the past and in the present. One of the main keys to unlocking past remains, whether sites under excavation, remains on the surface, or ancient buildings – whether in ruins or not – is to prepare the students.

Historic sites need not just imply prehistoric landscapes, castles or historic houses. The same principles will apply to visiting a local historic environment. Several exercises in this book are directly applicable to the local environment. In England, the Commission for Architecture and the Built Environment has published guidance for teachers, with activities and resources such as *Changing*

Neighbourhoods (Williamson and Hart 2004) and *Our Street: Learning to See* (Lavers *et al.* 2007). English Heritage Education produced a teacher training video called 'Doorstep Discovery: Working on a local history study' which followed teacher training students as they investigated the environment around their own college (English Heritage 1993b). All educational visits, whether to an ancient site or museum, or to a fire station, funfair or zoo, should be curriculum-based and fall into three, not necessarily equal, parts – before the visit, at the site, follow-up activities.

Before the visit

Practising skills in the classroom before visiting the site is important. You will want the students to observe what they see, perhaps make records (descriptions, drawings, photographs) and think about what it all means. For example, if you intend to make measured drawings, make sure that the students have experience in using tape measures or other equipment. The following are examples of a few exercises which can be done back in school that will help students make that leap from their present-day surroundings to a strange-looking past.

How well do you know your school building?

Take photographs showing unusual shots of parts of your classroom and school. They could be close-up details, shot from odd angles, of things such as door handles, clothes hooks, pipes and taps, radiators, brickwork and door frames. Students could be asked to locate them (perhaps on a plan provided – see below) and draw them in context. Analogies can be drawn with the remains of structures and objects found by archaeologists. Dean (1999, 15) has a simple activity sheet called 'Investigating our School' with lists of features to spot, such as window shapes, fancy brickwork, fences and hedges.

Making a map of your classroom

Students could be asked to convert the three-dimensional space they work in to a flat map or plan. This could be done as a sketch plan or drawn out accurately, perhaps on graph paper. All features should be marked in or indicated, such as chairs, tables, cupboards, bookcases, black or whiteboards, windows and doors. Balazik (2003, 19) provides an activity sheet with symbols as well as drawings for each feature. Computers could be used to construct or present the finished plan.

Walking to school

Students could carry out this exercise in pairs, with their parents or as part of an organised outing from school. The idea is to get the students to look at their surroundings as they journey from home to school, make a sketch plan and mark on it street furniture (e.g. road signs, post boxes) as well as buildings or other features. Balazik also provides an activity sheet for this exercise with little drawings of common features (2003, 20). The skills acquired in these last two exercises can be used in locating the site on a published map and in any plans they might draw on the site itself (see below).

Orienteering

Orienteering exercises are also useful in acquiring skills and experience back in the classroom or in the students' own environment before a visit. Routes can be planned on tabletop maps and through navigating by contours (McNeill *et al.* 1998, 28–9, 51) which may be useful on site.

Games

Games can be an interesting way to encourage students to look carefully and think creatively. Turner-Bisset (2005, 112–22) analyses their uses for younger pupils and gives various examples.

The use of objects with students is discussed elsewhere in more detail (see p. 236) but there are useful exercises which can be used in preparation for a site visit where you will want the students to use observation and recording skills, at the historic site itself (perhaps with its own handling collections) or in a museum.

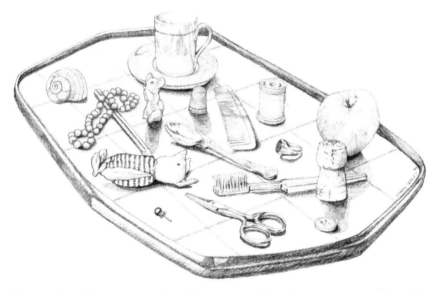

Fig. 9.2 Kim's Game uses everyday objects. Put 20 objects in a tray or on a table and let the students look at them for a minute. Cover them, then ask the students to write down as many objects as they can remember. Now vary the game – students look again but this time they must list all smooth objects or all tools or all things made of metal.

Bicycle Game

This game can actually be played with a variety of objects or machines but the bicycle is familiar to most students and adults. Ask the students to draw a bicycle from memory. Then ask them to draw a bicycle from observation. Compare the results. Which bicycle would work?

The Potato Game

This game can also be played with other objects, such as apples. Divide the students into groups of about four or five. Give each student a potato and ask them to write a description of it. Put the potatoes back in the centre of each group.

Read out the descriptions and see if the individual potatoes can be identified. Apart from making careful observations, this game is also useful in emphasising the precise use of language. The author used this game to introduce volunteers on archaeological excavations to thinking carefully and writing precise descriptions of features for the site record.

If the site you are going to visit is a ruin, such as a Roman building or a medieval monastery, then you might want to prepare students for the surprise of looking at remains in the form of low walls or just foundations. The easiest way is to present students with a building under construction. You could do this with photographs or drawings (Corbishley 1987, 2–3) or take them to the construction site itself (see Fig. 8.3) Look at foundation trenches and foundations, the low walls up to floor level. As the walls rise and the window and door spaces are created, look out for the kinds of features which may well survive in the ancient site to be visited – door sills, window frames or the supports for upper floors.

The 'detective' approach to ancient sites and buildings is outlined elsewhere but one pre-visit or post-visit exercise is to make comparisons between the plans and functions of ancient sites with buildings that students are familiar with – their schools and homes. The educational institution will usually make a plan available, or if not, students could use one prepared beforehand (see above: 'Making a map of your classroom'). Drawing or observing a plan of the school may then be compared with plans of other buildings. For example, standard plans can easily be obtained from estate agents of new houses. Comparisons can then be made, for instance, between a modern house and a Victorian house (Durbin 1993, 12; Allen *et al.* 1998, 21) and the evidence of ceremony or ritual in the layouts of cinemas, theatres, churches, chapels and law courts (Morris and Corbishley 1996, 32–3).

One thing you should avoid doing in advance of a visit is to spoil the students' excitement of discovering the real past for themselves. Detailed ground level photographs of the place they are going to see may negate the discovery element of the visit – aerial photographs may help put the site into context. However, you may want to include in your pre-visit work examples like these:

▶ research into the main defensive techniques used in building a castle and becoming familiar with the terminology used;

▶ familiarisation with aspects of Christian worship and the evidence associated with them before a visit to an abbey or parish church;

▶ finding out about the building techniques used by the Romans throughout their empire;

▶ investigating the sorts of techniques used by archaeologists to make sense of a prehistoric monument or excavation – for example, air photography or dating methods;

▶ reading descriptions of the discovery and accounts of sites and buildings from antiquity to the present day (see pp. 162–3).

Other examples are analysed in more detail under curriculum subjects (see p. 149).

At the site

Let your students discover the place for themselves in a meaningful manner. Let them walk around in small groups, perhaps giving them an initial task of finding entrances and windows. If the site is a ruin, tell them that they must only walk through the doorways, never over the walls. If the building is roofed, tell them to walk right around the outside first before going in. Once inside, people often lose the feeling of the size and shape of the building. Whatever period or periods the site might fall into there are basic questions to be answered (see Fig. 9.3). These are:

WHAT What was this place used for?

HOW How was it designed and constructed?

WHY Why was it built, and why here?

WHEN When was it built and when was it changed?

WHO Who built it and who lived here?

You might start with the site's location and compare past evidence with present evidence (Table 9.2).

Fig. 9.3 The internal face of the wall of Framlingham Castle in Suffolk shows clear evidence of both domestic and defensive evidence.

Table 9.2 Past and present (after Copeland 1993, 6).

Present	Past	Influence of the past on the present
What is this place like?	What was this place like?	What elements of the past can we still see?
Why is this place as it is? How and why does it differ from or resemble other places?	Why was this place as it was? How and why did it differ from or resemble other places?	What influence have these elements had on this place? How does this influence differ from or resemble what has happened at other places?
In what way is this place connected with other places?	In what ways was this place connected with other places?	In what ways have past connections influenced how this place is now connected with other places?
How is this place changing and why?	How did this place change and why?	How did this place change? Why and how are those changes reflected in the present?
What would it feel like to be in this place?	What would it have felt like to be in this place?	How does the past influence what it feels like to be in this place?

A useful resource for teachers has recently been published by the Nuffield History Project called 'Urban Spaces', using investigative approaches to the subjects of History, Literacy, Art and Design and Science (Nuffield Foundation 2010).

Overall, a visit to an historic site is essentially one of discovery but one which should be conducted as an archaeologist approaches evidence through observation, finding/recording and hypothesis. Some of the following activities are discussed in more detail elsewhere in the book (see pp. 181, 210).

Table 9.3 Observing, finding and recording, hypothesising (after Corbishley 2005, 34).

Observing	Finding/Recording	Hypothesising
Observational activities are good for encouraging pupils to understand ancient buildings.	Finding/Recording activities build on observation and develop the simple question of 'What can I see?' into 'What does it tell me?'	Hypothesising activities will lead pupils to use the evidence they have seen on site to make historical deductions.
Ask pupils to: Use the heading 'I see', 'I hear' and 'I feel' to record words at particular locations at the site or building. Use the lists back in the classroom to discuss the history of the site.	Ask pupils to: Record the different materials used at a particular location. What is natural? What has been made?	Ask pupils to: Look at the clues that tell them something about the owners or occupiers of the site. What do we definitely know about them? What can we reasonably guess?
Look for clues at each location you visit to explain what went on there. Write three descriptive words (adjectives), three 'doing' words (verbs) to indicate what people would have done there.	Identify ways that the site has changed over time. What has been added and why has it been added? What is now missing and why?	Work out which was the noisiest or quietest room or monument. This will help pupils link physical conditions to living conditions.
Find evidence for repairs and alterations to buildings. What has changed and why?	Measure and record the different dimensions of doors and windows. Use this data to make comparisons with modern buildings (e.g. the school).	Draw an incomplete feature, such as a wall or part of a building. Back at school get small groups to try to draw in the missing sections.
Sketch or photograph a part of the site or a part of one particular building or structure which reflects the atmosphere of the place.	Use the evidence your pupils can see to say what is the biggest, smallest, darkest, lightest, for example.	Look at an artist's impression. Identify how much of the impression is based on the evidence they have seen on site.

Out of these principles might come specific resources which may be used during the site visit such as activity sheets or group activities. You might start with some simple collection of evidence listed as:

Table 9.4 Recording evidence on site

Type of site	Evidence
This is a defensive site because ...	
This is a religious site because ...	
This is a house because ...	
This is an industrial site because ...	

This activity may be adapted to any type of site or building. However, some types of buildings – for example, castles, forts and monastic buildings – will show evidence, at the same site, of different activities. The pre-visit activity of comparing modern with ancient or old (see above) may be extended on site with an activity to discuss the function of buildings or rooms – for example, looking in Roman baths for the modern equivalents at leisure centres or swimming pools.

Table 9.5 Roman baths, modern leisure centre

Roman	Leisure Centre
Changing rooms	Changing rooms
Cold, warm, hot and steam rooms	Showers
Trays of food brought in by sellers	Vending machines

In addition, there are comparisons to be made with modern-day saunas and the similarities and differences between physical exercises undertaken by the Romans and people today.

Collecting evidence for room or building function at a monastic site, for example:

Table 9.6 Comparing the location of activities past and present (after Cooksey 1992, 19)

Activity	School	Abbey
Assembly	Hall	Chapter House
Administration	Office	Abbot's Lodgings
Work	Classroom	Cloister/fields
Illness	Sick Room	Infirmary
Reading	Library	Library
Eating	Dining Room	Frater
Toilet	Toilets	Reredorter

At some time in their school careers, most UK school students will be taken out in a class group either to investigate the environment around their school or travel to another small town as part of their work in various subjects, particularly geography. They will be carrying out a variety of surveys – looking at facilities for the local community or traffic problems, for example. Surveys of ancient monuments open to the public were also favourite activities promoted by English Heritage, their teachers' handbooks and information booklets often containing photocopiable sheets. These surveys might be undertaken to produce a report for a local radio station or newspaper which examined a site's potential for a tourist visit, a plan for an audio guide for blind visitors or a more general plan for suitable routes for disabled visitors, an imaginary report by an estate agent intending to put the castle (say) up for sale, or a report for a marketing manager wishing to exploit the potential of the site and listing improvement which might be made.

Follow-up activities

There are still some teachers who will look for a single follow-up to a visit – students simply writing up their day. This could be part of properly organised activities in creative or non-fiction writing (Collins and Hollinshead 2000) and this is discussed elsewhere (see p. 157).

Certainly any information gathered, whether observations, recording or 'detection' activity, should be brought back to school and analysed. Other activities might include:

▶ using the information gathered on the visit to provide extension activities in other subjects, such as maths, art or technology (see pp. 172, 175, 184);

▶ encouraging communication skills as students write up or present their work to others – for example, in the form of a wall display and a dramatic representation (see role-play p. 159) at a parents' evening or a new section on the school's website;

▶ discussing issues in citizenship or social studies courses (see p. 279) – for example, the wear and tear caused by visitors, the reuse of historic buildings (see p. 294) and the ways in which some communities are eager to protect and preserve their ancient structures while others are not.

Educational programmes at archaeological sites

Offering children with their families the chance to work on an excavation for a few hours on open days or during the Festival of British Archaeology (see p. 108) is becoming increasingly common in Britain. But few archaeologists have set up specific programmes for school groups to take part in archaeological work as part of their curriculum work.

Individual educational projects carried out by archaeologists at their own sites or monuments have been published and various projects are described elsewhere in this book. The Council for British Archaeology (see p. 93) has offered advice to archaeologists through its publications and newsletters for archaeologists and teachers (e.g. Cracknell and Corbishley 1986) and likewise in the USA the Society for American Archaeology and the National Park Service (e.g. National Park Service 1991). Pearson's book, *Teaching the past: a practical guide for archaeologists* (2001) includes a section on fieldwork activities and making visits to archaeological sites under excavation (Pearson 2001, 19–23) and there are case studies of archaeology and educations projects in Henson *et al.* (2004). National Parks in the UK are increasingly carrying out education projects and publishing resources related to their archaeological sites (e.g. Walmsley and King 2000). English Heritage funded a number of education programmes at archaeological sites (p. 87 and Corbishley *et al.* 2008).

Thinking about aims

Educational programmes are usually part of a wider outreach project involving public access and presentation. Working archaeological sites will always present some health and safety issues which must be addressed, as they must be in any activity, whether for students or adults. Risk assessments must be carried out. Some education services of archaeological and heritage organisations offer risk assessment advice online. For example, the York Archaeological Trust's interactive archaeology centre (DIG 2010) and Tyne and Wear Museums' Arbeia Roman Fort (Arbeia 2010) provide detailed guidance notes for teachers listing possible risks for school group visits. This created example (but based on actual site programmes run by the author) provides the main questions to ask. The site is an excavation which has some, but not too serious, health and safety issues; has a site workforce of 30 diggers/supervisors and a finds processing workforce of two. The site is on the edge of a village (with a primary school), 5 miles from a major town; has adequate parking space for large and small transport and is scheduled to run for the whole of July and August, with a post-excavation programme running in the nearby town from September to December.

The first basic questions to ask are: who will your target audiences be? what kind of resources/programmes might you run?

Any project needs aims, objectives and strategies. A good introduction to developing an education policy is in Creaser *et al.* 2004, 4–5.
The aims might be to:

▶ promote the work of the archaeological team to the public, especially, perhaps, the local community;

▶ encourage teachers to use the site and archaeology as a curriculum resource.

The objectives might be to:

▶ welcome visitors and to provide physical and intellectual access;

▶ increase the public's awareness of both archaeology and the team's work and to change, or at least to influence, attitudes to archaeology;

▶ use the archaeological work as a starting point for lifelong learning in the area;

▶ provide the resources to allow teachers to include the archaeological project in their school work.

The strategies might be to:

▶ devise and implement a local press campaign;

▶ establish set opening times for visitors and assign staff to deal with them;

▶ provide information on site in the form of signage, interpretation panels, leaflets and guides;

▶ establish links with local schools and provide special programmes and resource information.

Archaeological techniques or archaeological discoveries?

One aspect to consider is whether the programme will promote archaeological techniques or archaeological discoveries, or both.

Archaeological discoveries: if this is the primary aim then the following are important to consider:

▶ what is known about the site already – the local, regional, national (and perhaps international) context?

▶ what might be found during the course of the excavation?

▶ what has been discovered, on a day-by-day or week-by-week basis?

▶ what analysis and research (post-excavation work) might, and then does, tell us?

Archaeological techniques: the following areas are most important:

▶ why there is archaeological work going on here (is it a research excavation or, more likely, is the work being conducted before some kind of development?);

▶ how archaeologists work: how this differs from, or is similar to, other types of work (police, doctors, construction industry etc);

▶ the nature of team work in archaeology;

▶ the fragility and uncertainty of archaeological evidence; the nature of interpretation;

▶ the techniques that are *not* being employed on this site (aerial photography or radio-carbon dating, for example);

▶ post-excavation work;

▶ displaying and sharing the information gathered.

Education programmes

Education programmes should not be created without first establishing links with local schools, perhaps through the nearest heritage education specialist (at a museum or historic site) or through a national organisation (in Britain through the Council for British Archaeology). It is also vital to talk with the local schools about your ideas for offering on-site opportunities for them. Ask teachers what kind of printed resources they might like for themselves and for their pupils. Ask whether they might consider using the project to cover other subjects in the curriculum and whether they might welcome special resources to help them.

Then you need to arrange:

▶ welcome and introductory meetings with teachers (dealing with areas such as the practicalities of visiting, health and safety issues, child protection issues, special needs issues and the school timetable)

▶ in-service courses for teachers, perhaps including the opportunity to work on site

▶ resource information.

There are a number of examples of activities you might use with school groups – for example, guided tours of the site, with or without activity sheets, handling and drawing finds, filling out recording forms, taking part in the actual excavation or setting up a 'dig in a box' activity. Sorting finds and pot washing (see Fig. 9.4) are the most popular activities which school groups, as well as volunteer adults, are allowed to do at an excavation. This activity gives those taking part an opportunity to handle and scrutinise real objects from an excavation. It is also a chance for the archaeologists to show another aspect of their work and talk about the conservation of finds. There are a number of other activities listed elsewhere in this book.

Evaluation

Finally, all the elements of learning outdoors should be evaluated – by yourself, your colleagues and the students. Revisit your aims and ask if the visit achieved what you expected. For example:

▶ would the activities you organised work again, and at a different type of site?

▶ did the visit satisfy the full range of your students' abilities?

▶ did the visit gain from learning by direct experiencing of the 'real' evidence for the past?

Fig. 9.4 Washing and learning about finds from the Institute of Archaeology's training dig at West Dean, West Sussex

▶ are the new skills the students acquired transferable to other subjects or activities out of school?

Summary

▶ Outdoor education has been concerned largely with practical training sessions in areas like climbing or environmental studies.

▶ Some of the techniques used by outdoor educators are useful for teachers taking groups to visit and study the historic environment.

▶ Ideas are provided for planning visits to ancient monuments, together with a number of exercises which may be used before, during and after the visit.

▶ A specific section offers advice for archaeologists wishing to run educational programmes on on-going excavations.

Conclusions

Archaeology and heritage educators can learn a great deal from the professionals working in outdoor education. These dedicated teachers are more than just canoeists and cavers. Their publications clearly show their concern for the countryside and the effects visiting humans can, and often do, have on our environment. Outdoor educators have also developed a number of strategies and exercises for promoting team working and self-esteem, especially among vulnerable and excluded young people.

More often than not, visits to outdoor ancient sites have been badly conceived, ill planned and not followed up back in school. Teachers in the UK and elsewhere in the world have gone to the trouble of taking their classes long distances and then, at the site, with their backs to some ancient pile (as if it were the blackboard) have given a lesson about some period of history. The exercises presented here clearly show that much more can be got out of pupils (or adults for that matter) making their own discoveries, asking their own questions and recording *real* evidence in the flesh, as it were. Most teachers have not been, nor are, trained in using the outdoors to teach any subject. It is surely in the interests of heritage organisations who care for ancient sites and tracts of our landscape to take up the challenge of training teachers themselves in this aspect of teaching?

Some of these ideas presented in this chapter will be valuable in looking closely at objects, the topic of the next chapter of this book.

10 Learning from Objects

Archaeologists usually call anything made or constructed by people, in the past or the present, artefacts or objects. Objects are usually thought of as small things, from a knife to a wardrobe, which can be moved around. But an object can be as immoveable as a building. Objects are now commonly used in museums as part of learning programmes for formal education groups (especially but not exclusively for schools), as well as for informal learning for families (Hooper-Greenhill 1988). The study of real evidence is one of the requirements of National Curriculum history in the UK and in the curricula of some other countries. For example, third-graders in California are required to 'clarify and enhance presentations through the use of appropriate props (e.g. objects, pictures, charts)' (California Department of Education 1999, 95). Objects are often used by teachers themselves or through loan boxes from museums. Primary schools sometimes set up displays of objects, especially when they are studying the Victorians or 20th-century topics such as World War II and a few schools have gone further and set up their own school museum (Wilkinson *et al.* 1994). The way to use objects in the classroom is a subject now included in manuals and books for teachers and teacher trainers (Turner-Bisset 2005, 31–45; Cooper 2002, 112–22). Objects have been shown to be of real value in encouraging learning in subjects other than history – for example, Walmsley's work with pupils in drama (Walmsley 2003a, 7–9; 2003b). Jacques' research with elderly people in care homes has shown the therapeutic benefits of using objects in reminiscence work, concluding that 'We believe that, if used in a systematic way during one-to-one sessions with elderly people affected by the onset of dementia, significant objects freely handled will aid the life history review process' (Jacques 2007, 160).

This chapter examines the ways in which archaeologists and museum curators look at and come to conclusions about objects from the past. A number of exercises are presented which will allow teachers to make good use of objects, past and present, in their classrooms as part of history teaching.

Naming objects

For the moment – an eternity it must have seemed to the others standing by – I was struck dumb with amazement, and when Lord Carnarvon, unable to stand the suspense any longer, inquired anxiously, 'Can you see anything?' it was all I could do to get out the words, 'Yes, wonderful things.'

(Carter and Mace 1923, 96)

Like Howard Carter when he first looked into the tomb of Tutankhamun, most archaeologists are thrilled to be able to find and touch something made and used by someone in the past – the kind of encounter that 'transforms corroded nails into things of wonder' (Derry and Malloy 2003, 38). While to many people the word object may conjure up the ancient past, museums all over the world have collections from more recent times. Johnstone (1998) entitled her paper on the use of social history collections in Wakefield 'Your Granny Had One of Those!'. As we get older the objects we used ourselves as children, or our parents used when

we were children, now turn up in the museums we visit. These objects from our pasts we might cherish, and call heirlooms, as Alan Bennett writes:

> There are a few family heirlooms. Mam gets Grandma's yew Windsor chair, which she has always wanted and which she partly credits with setting her off liking 'nice things'. I bag two pairs of steel shears that had been used to cut lino and oilcloth in Grandpa Peel's hardware shop in Union Street, West Vale; fine, sensible objects shaped to fit the hand so that they are a physical pleasure to use, and come in handy for cutting paper. Back in 1966 I want them because they have a history which is also my history.
>
> (Bennett 2005, 82–3)

But another word for past objects might be junk. Ian McEwan describes Henry Perowne emptying his mother's house after she moved into care: 'Objects became junk as soon as they were separated from their owner and their pasts – without her, her old tea cosy was repellent, with its faded farmhouse motif and pale brown stains on the cheap fabric, and stuffing that was pathetically thin' (McEwan 2005, 274).

Interpreting objects

The job of a museum curator is to interpret objects on display or those handled by their visitors but once objects are put into a museum their purpose changes – they take on a new history as items on display. No object on display is free from some form of interpretation.

Learners, whether formal or informal, need to spot that the objects come with interpretations which are often implicit rather than explicit. For example, some museums choose to display ethnographic objects as works of art – offering minimal information to the visitor. An undated single object on a podium in a glass case with carefully designed lighting may encourage the visitor to think that, when the object was new, its owner had commissioned a work of art rather than, say, a food basket from south-west America or a brooch from Anglo-Saxon England.

Some objects are displayed in a chronological sequence, others in types or groups or related to a particular place, building or archaeological excavation. Some objects are deliberately placed with constructed settings – for example, period rooms in the Museum of London, the Geffrye Museum, London, or the Victorian Street in York Castle Museum.

Talking about objects

Outside of museums, the richest source of objects is the home. Treasured items can be anything from clothes to photographs, from crockery to hairbrushes. Some objects, however, have less chance of surviving at home. Cooking and cleaning utensils and garden equipment, for example, are often just thrown away. Those objects which are kept can be a wonderful source for children to help them to make a connection with their parents, grandparents and great grandparents and to learn about the past by handling and talking about real objects.

David (1996, 8–9), writing for teachers about school projects which encourage parents and grandparents to help children understand family and local history,

An auction catalogue

Important Artifacts and Personal Property from the Collection of Lenore Doolan and Harold Morris, including Books, Street Fashion, and Jewelry. Strachan & Quinn Auctioneers, February 14, 2009, New York.

Anyone interested in objects and what they might reveal about their owners or the societies they come from will like this long-titled book. The author, Leanne Shapton, a writer and publisher in New York, has constructed the love story of Lenore and Harold through a huge number of their belongings, supposedly put up for auction. This is a novel with no narrative. Instead there are photographs with lot numbers, brief descriptions and dates (where known), sizes (where relevant) and suggested bidding range. For example:

LOT 1030
A St, Regis Umbrella
A brown-and-white St. Regis Hotel umbrella.
Good condition, some wear. Length 29 in.
 10–20
Included in lot is a photograph of Doolan
on her street holding the umbrella, 6 × 4 in.
 (Shapton 2009, 15)

Heritage educators will find much in this book to make use of to inspire and illustrate activities with children and adults. Reading the catalogue is an exercise in detection. For example, the answer to the question 'How long did the relationship last?' can be deduced. Comparisons can be made between objects which obviously belong to men or women – for example, 'Lot 1079 A cosmetics case and contents' and 'Lot 1080 A man's traveling case and contents' (Shapton 2009, 30–1), though other groups of belongings such as the books, hats, T-shirts and other clothes might be used by both sexes.

It would be a good idea to ask a group of students to write their own auction catalogue descriptions of a range of objects and compare them with descriptions used to identify and explain objects in a museum. The objects could come from the students themselves (e.g. see the game 'My Favourite Objects' below) or from observation and recording on a visit to a museum. 'My Backyard History Book' suggests a similar approach with the activity '1890's auction a history game', which uses illustrations from the 1897 Sears, Roebuck catalogue (Weitzman 1975, 76–8).

shows how children can learn from family treasures, for example, to compare the past with the present and find out about change over time (see also English Heritage 1994). Weitzman (1975, 50–5) has good ideas for collecting, archiving and understanding family history in what he calls 'hand-me-down history' that is, family documents, photographs and heirlooms.

Teaching and learning with objects

The book which had the most influence on teachers and museum educators using objects for teaching was written by Gail Durbin, Susan Morris and Sue Wilkinson

in 1990 (with a revised edition in 1996) and is often quoted by others. They showed how using real objects with students can be important for the acquisition of skills, knowledge and concepts which archaeologists and museum curators use themselves in their everyday work.

Developing skills

The skills which can be developed by using objects include:

▶ locating, recognising, identifying, planning

▶ handling, preserving, storing

▶ observing and examining

▶ experimenting, deducing, comparing, concluding, evaluating

▶ relating structure to function, classifying, cataloguing

▶ recording through writing, drawing, labelling, photographing, taping, filming, computing

▶ responding, reporting, explaining, displaying, presenting, summarising, criticising

Extending knowledge

The fields of knowledge specifically developed by using objects include:

▶ different materials and what they were used for

▶ techniques and vocabulary of construction and decoration

▶ the social, historic and economic context within which items featured

▶ the physical effects of time

▶ the meaning of symbolic forms

▶ the way people viewed their world

▶ the existence and nature of particular museums, sites, galleries and collections

▶ symbol, pattern, colour

▶ 'appropriateness' – for example, the use of rucksacks compared to handbags

▶ appreciation of cultural values

Developing concepts

Concepts developed from the study of objects include:

◆ chronology, change, continuity and progress

◆ design as a function of use, availability of materials and appearance

◆ aesthetic quality

◆ typicality, bias, survival

- fashion, style and taste
- original, fake, copy
- heritage, collection, preservation, conservation

(Durbin *et al.* 1996, 5–6)

Batchelor demonstrated that everyday objects may be examined from a number of different points of view – techniques he developed while working at the Science Museum in London. He wrote about a mass-produced kettle made around 1910: 'I bought it at Brick Lane Market, in the East End of London about four years ago, because it was cheap and I liked its shape' (Batchelor 1994, 139). He chose six different viewpoints to investigate his kettle:

1. The idea or the invention

2. The material from which it is made

3. Making or manufacture

4. Marketing

5. Art

6. Use

Objects, unlike historical documents, are wordless. You have to work harder to make them yield information about themselves and the past. Probably the most important thing to do with an object is to make it the centre of an investigation. Encourage students to ask questions – either those you have given them or those they have devised for themselves. The question you should never start with is 'what is it?' or 'what is the name for this?' This sort of question will simply close down other observations and deductions. After all, if you already know the object is, say, a bowl used for mixing food, why make it the centre of an investigation?

Walmsley (2001, 6) has put his questioning activities into six groups

1. Observing

2. Describing

3. Comparing

4. Making deductions

5. Hypothesising

6. Carrying out research

The suggested introduction from the Limerick Education Centre (2009) to investigating the past through modern everyday objects before moving on to archaeological objects, is an approach that I would recommend. In the section called 'Our Archaeological Footprint', they provide notes for teachers on classroom activities. The first is to look at 'Lifestyle Activity Artefacts' where the teacher provides seven categories and the students come up with the names of some artefacts.

Table 10.1 Categorising objects.

EATING	Fork, plate, cup, bowl
DRESSING	Clothes, shoes, stockings
ADORNMENT	Rings, earrings, brooches
WASHING	Toothbrush, soap, washing-up liquid
RECREATION	Chess pieces, cards, dancing shoes, football
WORSHIP	Chalice, candlesticks, crosses
EDUCATION	Chalk, projector, books, locker, blackboard. Desk, chairs, pens

The following activity sheet I adapted from the one originally used in *Learning from Objects: A Teacher's Guide*, and is suitable for analysing utilitarian objects in particular.

Table 10.2 Looking at an object (after Corbishley 1999b, 17, adapted from Durbin *et al.* 1996, 12)

Think about and ask about	What you have found out by	
		... looking	... and then by researching
WHAT DOES IT LOOK AND FEEL LIKE?	Colour? Smell? Sound? Made of? Natural or manufactured? Complete? Changed or mended? New or worn?		
HOW WAS IT MADE?	By hand? By machine? Fixed together by what?		
WHAT WAS IT MADE FOR?	Used for what? Has its use changed?		
IS IT WELL DESIGNED ?	Does it do its job? Made of the best materials? Decorated? How decorated? Do you like the look of it? Do you think others would like its looks?		
WHAT IS IT WORTH?	To those who made it? To those who used it? To you? To a museum?		

You could easily adapt this activity sheet to suit your group or just use the questions to prompt discussion. A simpler sheet with fewer questions to answer

or one which allows students to circle possible answers might include something like this:

What is it *made from?*

Wood Stone Glass Fired Clay Metal Bone

Is your object: Heavy or light?
 Whole or bro...ken?
 Plain or decorated?
 Rough or smooth?

Zarmati and Cremin (1998, 14–15) suggest that school students try to answer 35 questions under the headings of: What? How? Where? When? Who? Why? Vella (2001, 101) conducted research in five learning situations in which he structured the students' activities to arouse their curiosity, help them to ask questions, encourage the formation of ideas and feelings, review what they had found out and relate their discoveries to their everyday lives.

One of Vella's conclusions (2001, 110) showed that 'Throughout this study, quite young children are continually making complex deductions and developing powerful cognitive skills'. My own work in this area, for school and adult groups and for informal education such as the Young Archaeologists' Club or museum holiday activities, clearly demonstrates that some children benefit from gentle encouragement from adult helpers to observe, discuss and make deductions. Dhanjal (2005) created interactive exhibits in trays for children to investigate and showed how children may reach a range of interpretations for archaeological objects.

One of the points raised by Durbin *et al.* was whether it was right to use replicas of objects (1996, 28). Not all teachers will be able to use real objects, at least from the distant past, in their classrooms, although they may be able to use museum loan boxes (see below). I have found that replicas can be useful and may be used to discuss the issue of fakes. A survey in 2000 of 20 teachers who used loans from the Reading Museum and Archives Service showed that 55% said that it mattered educationally that the object was real, 45% believed it didn't matter and 15% thought that replicas could be useful at times (McAlpine 2001). Replicas are now more readily available from educational suppliers and on sale in museums. Colonial Williamsburg sell specific replica resources especially for teachers called a Hands-on History Kit. The American Indian Bandolier Bag contains a number of replica objects and an activity guide for teachers (Colonial Williamsburg 2010).

There is no need here to go through all the questions originally posed by Durbin *et al.* as their book admirably deals with them. However, there are some approaches which are worth stressing.

Close observation

A good way to encourage close observation is to start with a familiar object. If the group is in a school or a museum classroom, that object might be a piece of classroom furniture, such as a chair, or perhaps something smaller, such as a pencil. You could talk through the observation and deduction stages without necessarily using the 'Looking at an object' activity sheet. You could use other objects in the room to extend observation and to reinforce deduction. For example,

if they conclude that the chair is made of wood and metal, look for other examples of those materials which surround them. Observation of completely unfamiliar objects is a useful way of generating questions (see also 'mystery objects', below). An extension of this exercise is to present familiar objects from odd angles, as outlined in the 'How well do you know your school building?' exercise on p. 224.

Recording

Although most teachers or leaders will automatically think about drawing and note-taking for making a record, there will be many students and adults who are not comfortable with this activity. They could take photographs or make audio or video recordings, for example. If the observation of objects is being carried out in a museum or on site, then these varied forms of recording may be used later for a presentation or further research.

Questioning assumptions

Less often raised by those using objects as a learning resource are the assumptions which may be made by students about the social class or gender of an object's maker or owner. Forty's book, aptly named 'Objects of Desire', gives examples from manufacturers catalogues of 'Ladies' Knives' of 1895 and hairbrushes of 1908. From a catalogue of 1907 he observes that while the men's watches had Roman numerals, the ladies watches all had Arabic numerals 'whose form – curvilinear rather than angular – may be judged more delicate' (Forty 1986, 65).

There are many everyday objects which can be used to challenge students' assumptions – for example:

▶ Does a hairbrush indicate that its owner was male or female?

▶ Is a small plain comb likely to be used by a man or a woman?

▶ Are hunting knives the prerogative of men?

▶ Are vacuum cleaners only used by women?

▶ Are neck ties only worn by men? What about skirts?

Value

This area is discussed in detail in Durbin *et al.* (1996, 10–11, 13) but it is worth stressing the monetary value (or lack of) of objects, especially those uncovered from archaeological sites. While all objects found, from animal bones to carved stone fragments, have a high value to the archaeologist (that is to archaeological research), some (but by no means all) will have a monetary value, especially if they get into the hands of antique and other dealers. Shops opposite the British Museum in London have a number of archaeological objects for sale – for example, 'Black glazed Ancient Greek vessel for oil with phallic shaped spout *c.* 4th century BC £235' (August 2007). In the 1980s I found a shop in Colchester selling fragments of Roman pottery mounted in wooden frames with plaques which read 'Roman pottery from Camulodunum (Colchester) dated to about 120 AD'. These fragments had been stolen from archaeological excavations nearby.

The question of value is particularly apt in an age of illicit digging by people using metal detectors or raids on museums during war and unscrupulous dealers and auction houses. While it rightly upsets and angers professional archaeologists and museum curators, it is a good topic to cover in the curriculum areas of citizenship or social studies (see pp. 290, 297–8). Value is always raised where objects are declared to be Treasure Trove. The largest hoard of Anglo-Saxon gold found in Britain by a treasure hunter was valued at £3,285m.

Conservation

Archaeologists and curators know that objects may deteriorate if not conserved and cared for under the right conditions. Conservation issues concerning objects (and buildings: see Corbishley 2005, 28–31, and the Merv case study p. 260) can be introduced through exercises with objects. In 'In the Nick of Time' Newbery and Fecher outline the problems and solutions in object conservation and provide a range of imaginative educational approaches, such as showing how some objects may be damaged simply by touch. This exercise used two samples of each type of object – for example, an unglazed flowerpot. Children were asked to touch and handle one of them and observe the effects by comparing it with the untouched flowerpot. The damage could then be compared with the handling of a glazed flowerpot (Newbery and Fecher 1994, 16).

Object games

Games are a good way to introduce the concept of questioning objects and to introduce the objects themselves. Objects used in games need not be very old or irreplaceable but they should be sturdy enough to be handled. Durbin *et al.* have a section on games (1996, 22–7) including an often-used game: '50 ways to look at a Big Mac box', which they adapted from one originally published in Canada (Shuh 1982). Games to encourage on site observation are listed on pp. 210–13 and the Council for British Archaeology has downloadable resource sheets and activities for a number of object-based games (Council for British Archaeology 2010a; 2010e). Games are also discussed in the section on Archaeological Detectives (see pp. 213–15). I have used all these games with a range of people, from school students to university graduates and adult education learners. Here are a few games to use with objects:

The Feely Bag Game

Put an object in a cloth bag or pillow case. Ask one student to put her hands inside and describe to the others what she can feel – but without naming the object. The others have to guess what the hidden object is. You could begin with an object familiar to the group and move onto an historic one.

The Twenty Questions Game

Show an object to one of the group and then cover it up. The group has to ask the person who has seen the object 20 questions to try to find out what the object is. This game can be played with two students, back to back – one has the object and the other asks the questions. This game could be played in a more dramatic way,

as Bond suggests in his 'Who am I?' game (1986, 133), where a label is attached to the back of one participant. This person has to guess which famous person they are. The questions can only be answered by yes or no. This game works well adapted to objects with a name label and/or photograph.

My Favourite Objects

This game may be played with a few objects or just one. The objects are displayed and the exercise is to deduce why students think they are special to the owner. Can the objects tell us something about the person? Until recently the *Guardian* newspaper in the UK was running a series called 'Pieces of time' where a well-known person displays and writes about 'the objects that matter most to them'. Objects are often chosen to depict the owner's past history. The jazz musician and surrealist George Melly chose framed photographs and said: 'These photographs were taken on a day out in Brussels, with Magritte and his wife, the very stern Madame. Magritte rather fancied my girlfriend. I used to own several important Magrittes, which are now in museums' (Melly 2005, 4–5).

Bond (1986, 48) suggests that one person (the 'detected') draws six objects they have used in the last six months which says something about their interests or job and another (the 'detective') pieces together the story of that person. An adaptation of this game is to use all the objects from a drawer at home, in school or the office and deduce what sort of person uses it. Marion Green, the Education Officer at the Canterbury Archaeological Trust, suggests that teachers use the game 'A Bagful of Clues' (Green 2010) to investigate objects from 'a handbag, shopping bag, briefcase or rucksack' to ask questions about the owners and the society they live in. A similar exercise has been tried with university students who are asked to 'excavate' and analyse the objects in a professor's drawer and wastebasket (Zimmerman 2007). The Suffolk Garbology Project (see p. 310 for the case study) uses bags of rubbish to ask similar questions.

The Mystery Object Game

One good way of encouraging observation and deduction is to provide students with a mystery object (Corbishley 1999b, 17). It is not always easy to find something which none of the students has seen before. Most contemporary objects are problematical to use but objects from a previous age or another culture often work very well – a Roman key or a 19th-century apple corer will be ideal, if you can get hold of them. Many objects from World War II (e.g. a gas mask for a baby) worked well in the UK until that period of history became a statutory part of the National Curriculum.

An object can be made more 'mysterious' if the students are only given a part of it. I have successfully used drawings of this series of partial objects: a handle of a cup, eyelet from a pair of trainers, broken chicken bones, piece of a hamburger box and the metal spiral from a notepad (Corbishley and Cooper 1999, 41). Avoiding any discussion about what the object is called and going through the questions listed above on the activity sheet usually works very well. Weitzman (1975, 65) calls his mystery object game 'Thingamajig' and begins: 'What's that? Well, a thingamajig is like a whatchimacallit or a thingamabob. You don't know its name or what it is used for.'

Try this at home

Here are three mystery objects for you to investigate: use some of the questions suggested above. As you cannot handle or smell them descriptions are provided.

Fig. 10.1 Mystery Object 1

Size: 20 cm long, 2 cm wide (underneath size shown here)
Material: Cast aluminium
Description: Smooth metal with depressions on both sides at one end. 31 round, identical projections at the other
Other features: On one side of the casting there is this **Ц 60 К**
Origin: Bought in a market in Turkmenistan but made in Russia.

What am I?

Fig. 10.2 Mystery Object 2

Size: Height 8 cm, diameter at base 11.5 cm, at top 7 cm
Material: Black malleable rubber, made in a mould
Description: Regularly ribbed exterior, smooth inside
Other features: The word SMALL is moulded on opposite sides near the base, one is slightly worn and the other is almost worn away.

What am I?

Fig. 10.3 Mystery Object 3

Size: Diameter at base (?) 5.5 cm
Material: Black, low fired ceramic, mould made
Description: Inside is bowl-like and smooth, outside has a number of circles
Other features: Inside the middle ring on the exterior there is a cylindrical map projection overlaid with the letters CCI.

What am I?

Answers to the quiz appear on p. 250.

Mystery objects which I have used successfully have been a Victorian stone hot water bottle, a golf tee and a toaster for a Primus or camping gas stove. Junk or antique shops, jumble sales and eBay are good places to find mystery objects but you could use illustrations of objects from the recent and ancient past from 19th and 20th century trade catalogues from department stores, suppliers and manufacturers (e.g. Army and Navy Stores and Sears, Roebuck & Co.) or museum catalogues and guides. Reproductions of past objects are illustrated in modern books (e.g. Fearn 2005 and other Shire (2010) books; Collins 2005; Forty 1986).

Digital access

Museums are also increasingly publishing their collections digitally. Major museums with world collections may provide ideal starting points for object activities. Smaller museums often include a range of objects from their collections to explore. Reading Museum, for example, combines information about the nearby Roman town of Silchester together with drawings and photographs of objects (Reading Museum 2010a). Museums and archaeological organisations

with established education services will usually provide advice and resources for teachers to use. For example, Reading Museum has produced a publication for teachers called 'Using Artefacts in the Primary Curriculum' with illustrations of objects and notes for teachers with links to National Curriculum subjects (Reading Museum 2010b) and the Museum of London's teacher's resources for virtual object handing (Museum of London 2010a).

Loan boxes and handling collections

Museums have for many years created boxes of objects to loan to schools. A loan box scheme for the Museum of London, in which 200 boxes were distributed to schools for trials, was evaluated in 2000 (Hall and Swain 2000). They found the scheme costly in terms of staff time and money (£41,000 grant from the Department for Education and Employment as it was then called). The Museum of London also developed loan boxes connected with four of London's major faiths, principally for religious education and citizenship studies (Warburton 2004, 27).

However, loan boxes, together with handling collections and interactive exhibits in museums and a few historic sites, are becoming more popular, especially as part of outreach services. Handley noted that a survey carried out in 1986 on 78 UK museums showed that 40% had a loans service. Handley's survey in the Southampton area showed that schools welcomed the loan box scheme from the city museum and reported that 'the loan box sessions were not only a great success, but also were the highlight in the school year, remaining in the children's memory and to be referred to again and again' (Handley 1998, 30–1).

The decision by Nottingham City Museums and Galleries to provide new loan boxes was based on a survey they carried out in 2004 where they found that '79% of Nottingham Schools cited "object loans box" as the service they would most like to use' (Trewinnard-Boyle and Tabassi 2007). With funding for museums available at that time they decided to make their extensive collections available by creating resource boxes for schools (e.g. 'Victorian Kitchen' and 'Africa Inspires!'), resource boxes for communities (e.g. 'Storytelling' and 'Personal Treasures') and the Cased Collection for displaying sets of objects such as toys. The Cased Collection was a former resource on loan which was updated and loaned out as sets.

University College London has a number of museums open to the public as well as teaching and research collections in archaeology, art, ethnography, science, medicine, zoology, biology and geology. Its teaching and learning department has set up six loan boxes for schools which have been specially developed to support the National Curriculum subjects of History, Science, Art and Citizenship. Each box has about 12–15 genuine objects, with some replicas and background information and activities (University College London 2010). Loan boxes are also available from Historic Scotland (HS 2010f) and the Canterbury Archaeological Trust (see p. 92 and CAT 2010a). Loan boxes are also popular in countries throughout the world, some with games and information rather than objects (see projects in Athens p. 254). Cerón and Mz-Recaman reported on their 'Museum Comes to Your School' project from the Museo del Ora in Columbia. Their boxes contained original objects, explanatory booklets, suggested activities and games. They explained that despite the fact that 'in a country where traditional education is still prevalent, it has been a long and difficult task to implement this project;

there is still a lack of commitment by most teachers to a change in attitude in the routine running of their social sciences courses'. Between 1986 and 1994, 20,000 school children and 1000 educational groups used their teaching packages successfully in ten cities in Columbia (1994, 157).

Handling collections are sometimes available for use at education centres at historic monuments or houses and on some archaeological sites being excavated but open to the public and education groups. There is a useful section on setting up a handling collection at an historic house (Fordham 2004, 14–15) and Walmsley (2001) shows how objects may be used to help understand Hadrian's Wall and the people who lived and worked there, as well as being an exercise in investigating objects for their own sakes. Extension exercises provide useful ideas for teachers, for example:

▶ in the resource sheet 'What do these objects look like?', one of the questions for students is 'LOST! You have lost a very special object that was given to you as a present. How would you describe it to someone who is going to help you look for it?'

▶ in the resource sheet 'Who used the objects?', one of the questions for students is 'I am a lady who has left these objects in a locker at the baths. What do my belongings tell you about me?'

Handling collections offered by museums, archaeological units and heritage organisations should always be loaned with ideas for object work, such as the extension exercises listed above.

Summary

▶ Objects may be appreciated, discussed and interpreted in different ways by different groups of people.

▶ Teaching and learning with objects is a useful way of developing skills, concepts and understanding.

▶ Exercises and games are presented for teachers and archaeological educators to encourage the close examination and questioning of both everyday contemporary and everyday ancient objects.

Conclusions

In the UK the study of objects in the classroom as part of history lessons has been rare. Objects were only encountered in museums or, occasionally on sites. The introduction of the National Curriculum encouraged the use of primary evidence for teaching history, evidence which included objects. Heritage educators in museums and on sites were not slow to see the value in promoting their collections. Teachers appreciated the way a well-presented session on handling and investigating objects helped their pupils' understanding of the past and the development of their skills of observation, recording and working with others.

The important teaching resource first published in 1996 by the education department of English Heritage 'Learning from Objects: A Teacher's Guide' (Durbin *et al.* 1996) has formed the basis for object lessons in schools and

museums across the world. It is now common to find school children working with objects and for many schools to build up their own collection of objects (from parents and grandparents) to help children learn more about their (relatively) recent past.

The ideas and concepts introduced in this section on 'Investigating Evidence' are useful across historic environment education. The final section of the book which follows is concerned with issues about the way we treat our historic environment and how they might be usefully discussed in schools.

Two case studies round off this section. The first outlines three heritage organisations in Greece which have chosen to create education services and have done so successfully with an impressive number of group visits. Impressive, too, are the number and quality of learning resources which they have created for teachers. In the second case study I describe the educational work I have carried out in Ancient Merv in Turkmenistan. Against a background of government suspicions and an under-resourced ex-Soviet education system, teachers have been enthusiastic to embrace teaching through evidence by using their own historic environment.

Answers to the 'Try this at Home' quiz

Fig. 10.1 is a fish de-scaler. The letter Ц is the first letter of the word for 'price' in Russian. In Soviet times prices for goods were fixed by the state. This kitchen implement was originally sold for 60 kopeks. I bought it for US $1.

Fig. 10.2 is an overreach boot for a horse, and comes in different sizes. It is pulled over the horse's hoof to stop a hind foot striking a front foot. This sometimes happens at speed or in sticky conditions especially if the horse has a tendency to do so due to poor conformation.

Fig. 10.3 is a clay pigeon. Clay pigeons, which come in different sizes, are fired from 'traps' which project them fast and high in the air as targets for 12-bore shotguns. The clay is formatted to smoke or dust when hit. CCI is the most well-known company producing clay pigeons.

Participating in archaeology:
education projects in Athens, Greece

Background

Athens has a number of museums which display the long history of archaeological research into its prehistoric, classical and later periods. Several museums with archaeological and historical collections were built in the late 19th century, from the Acropolis Museum (1874) to the National Archaeological Museum (1889) with others founded in the 20th century.

Educational approaches

A number of the museums in Greece run educational programmes which range from special exhibitions for children to specific projects carried out by schools (see below). Several museums and organisations also publish teaching and learning resources. In Athens, a popular way of encouraging learning, both at the museum or site and in school, is by providing kits for teachers. Information about 11 different types of teaching kits was published in an edition of *Αρχαιολογία* (Archaeology) (1991, 6–43). I have chosen three Greek heritage organisations as examples of different education approaches to programmes for schools, the in-service education of teachers and the resources offered.

Hellenic Ministry of Culture and Tourism

The Hellenic Ministry of Culture and Tourism (HMCT), founded in 1971 and formerly the Ministry of Culture, is the governmental body responsible for cultural heritage and the arts – museums and monuments in state care from prehistoric, Classical, Byzantine and recent periods. The Ministry is responsible for the Department of Educational Programmes (set up in 1985) and this department designs and implements the archaeological programmes and exhibitions for the state-run museums and archaeological sites throughout Greece. This includes a number of well-established educational programmes in Athens (Hellenic Ministry of Culture and English Heritage 2000, 14; HMCT 2010).

The department has published a range of learning resources, with 25 available at the moment. One of the latest to be made available is called 'Gifts of the Muses' (Chryssoulaki 2004) and includes booklets, posters and activities on ancient Greek music and dance. The ministry also carries out outreach projects – for example, with the Roma community living in the downgraded centre of Athens. An example of one of the ministry's projects with schools linked cultural heritage with environmental concerns (Chryssoulaki 1995) and was carried out in 1992 in one of the poorer parts of the city. This project was also published more fully in the ministry's two booklets *Culture as a Means of Social Integration: an Intercultural Approach* (Gotsis 1996 and 1997).

The children who took part in the project 'In Search of the lost Eridanos river', from 1992, examined the river's mythological, religious and ecological importance to the public and private lives of people living in 5th-century BC Athens (Theofilopoulou 2000). The river Eridanos can only be traced today in the archaeological sites of the Agora and the Kerameikos. The young participants looked carefully at the topography of ancient Athens through the archaeological sites, traced and marked the course of the river onto modern plans and explored the fauna and flora of the river and identified plants from ancient vases and sculpture in the Kerameikos Museum. The children soon became aware that their environment had been ruined and that 'filling the rivers with rubble, the deforestation of the Attic landscape and the building craze has resulted in ecological destruction and a wider degradation of the city' (Chryssoulaki 1995, 23). Games were devised in the final stages in the project to encourage role-play and discussion.

Another educational programme devised by the department centred around democracy and looked at public life of ancient Athenians and was based in the Agora, the commercial and economic centre of ancient Athens. Younger children played the 'Agoranomia Game' to investigate the way market inspectors in ancient Athens controlled traders – children taking the roles of market officials, a cheating wheat-merchant and a jury. Older students played the 'Public Life Game' which investigated the way in which citizens were ostracised by writing their names on sherds of pottery, how the length of political speeches was measured using a water clock, and how voting was done with a machine called a kleroterion.

Some educational programmes are created as part of exhibitions at specific museums, such as one called 'Agon: The spirit of competition in ancient Greece' set in 2004 in the National Archaeological Museum of Athens. A booklet to accompany the exhibition provided information, photographs and activities for 12–15-year-olds (Pini 2004) and for 7–11-year-olds (Seleli 2004) which were valuable both for family visits and for formal educational school visits.

A new project called 'Environment and Culture' started in 2008 and is now an annual campaign. The main objective of this programme is to connect culture and history with the environment and to stimulate awareness for its protection. All sites and museums which are part of the Hellenic Ministry of Culture and Tourism from all over Greece participate in this programme with various activities covering prehistoric to post-Byzantine monuments and museums, art workshops and folk culture and the National Book Centre of Greece. The programme includes national campaigns, such as 'The Tree of Life through Four Seasons' (Chryssoulaki and Seleli 2009) which investigated the symbolic values of trees throughout the history of Greece with educational activities and tours in archaeological sites, museums, monuments and art galleries nationwide. The educational visitor figures for the Environment and Culture programme all over Greece in 2008 were 18,000 educational visitors in 117 archaeological sites and museums; in 2009 they were 40,000 educational visitors in 123 archaeological sites and museums.

Acropolis Education Department

A collaboration between the Acropolis Restoration Service, the Acropolis Department and the Acropolis Museum has been providing educational programmes from 1987, originally based in the Centre for the Acropolis Studies and, since 2009, inside the New Acropolis Museum. Information and a review of some early work, especially that of Cornelia Hadziaslani, the Acropolis' main educator, has been published (Hadziaslani 1985 and 1991). As the Acropolis is an integral part of the Greek school curriculum, the interest in participating in the Department's programmes far exceeds the time and resources of the Education Department. Very early on, the Department decided to focus its efforts on the training of teachers, through intensive seminars and specially produced resource materials in the form of museum kits and publications. Over the years the Department has organised a large number of events and projects for schools as well as symposia to help teachers carry out self-conducted visits and work in school.

The Department also organises seminars for educators and students of classical architecture, art and monument restoration. All the educational services of the Department are provided free of charge.

Table 10.3 Figures for visits, training and resources, Acropolis Education Department.

Year	Educational Programmes	Museum Kits	Seminars	Educational Resources
2005	3,370 pupils participated	14,030 pupils worked with kits	940 teachers participated	1,245 teachers and 180 institutions received resources
2006	3,200 pupils participated	14,200 pupils worked with kits	555 teachers participated	250 teachers and 50 institutions received resources
2007	2,360 pupils participated	13,140 pupils worked with kits	830 teachers participated	830 teachers and 65 institutions received resources
2008	2,800 pupils participated	16,820 pupils worked with kits	300 teachers participated	300 teachers and 100 institutions received resources
2009	2,850 pupils participated	12,000 pupils worked with kits	1,680 teachers participated	1,600 teachers and 250 institutions received resources

A recent publication (Hadziaslani *et al.* 2004) outlines the current education work which includes:

Programmes for groups, in particular school classes about the Acropolis and its monuments. These programmes (for both primary and secondary school groups) have been devised through consultation with the teachers in schools. All the programmes investigate an aspect of the Acropolis and the wider Athens, including neo-Classical Athens, through active learning and workshops. A programme might involve learning about conservation, carving stone, handling objects, building models or tracing evidence on site using ancient texts as a starting point (see Fig. 10.4). During the year 2009–10, the Department provided

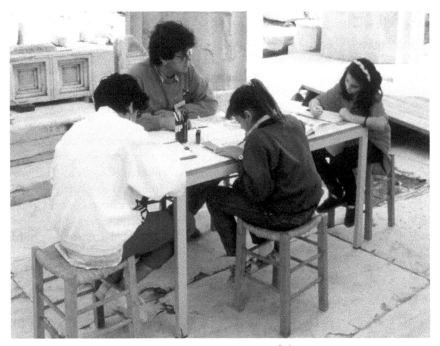

Fig. 10.4 Conservation issues are an important part of the Department's programme for teachers and for school groups. This can involve children and older students making accurate measurements with the Department's educators and conservation experts.

educational programmes and activities inside the New Acropolis Museum. The programme, entitled 'The Parthenon Sculptures', is addressed to students in both primary and secondary schools.

Educational resources include books, booklets, posters, games, teachers' packs, films, CD-ROMs and online applications. The publications are available to download from the Acropolis Education Department's website (AED 2010a). The Department has produced a number of museum kits which include a variety of creative ideas for teachers and their pupils to explore. The kits are lent mainly to schools throughout Greece (around 200 per year) and to about 4,200 in all including to schools abroad. The kits have so far been used by about 260,000 pupils. The kits vary from 'The Art of Stone Sculpture' with tools, a piece of marble and a teacher's pack, to 'Ancient Greek Dress' with replicas of clothes, sandals and jewellery and a teacher's pack, to 'The Twelve Olympian Gods' for younger pupils with paper figures, games, drawings and information. Since 2001 multiple copies of four museum kits ('Let's Go to the Acropolis', 'A Greek Temple', 'The Parthenon Frieze' and 'The Twelve Olympian Gods'), funded by the Niarchos and Bodosakis Foundations, have been offered to a range of schools in Greece and abroad based on evaluation of the use to which they would be put. By 2009, 1,174 of these museum kits had been distributed all over Greece, with another 342 to 32 different countries abroad.

In 2003, the museum kit 'The Parthenon Frieze' was enriched by a CD-ROM (available in Greek and English) in collaboration with the National Documentation Centre (EKT). In June 2003, the CD-ROM was

made available online. In 2008 the online kit was upgraded with twenty games providing access to the frieze, both as a data base for scholars and, as a digital museum kit, for pupils and children in general. (AED 2010b)

Foundation of the Hellenic World: Cultural Centre 'Hellenic Cosmos'

The Foundation of the Hellenic World (FHW), which was conceived, founded and funded by the family of Lazaros Efraimoglou in 1993, is a privately funded not-for-profit cultural institution based in Athens whose mission is:

> The preservation and dissemination of Hellenic history and tradition, the creation of an awareness of the universal dimension of Hellenism and the promotion of its contribution to cultural evolution. Its aim is the understanding of the past as a point of reference for the formation of the present and future so that contemporary thought may once again be inspired by the Hellenic spirit.

To achieve this mission, the Foundation's aims include:

> The creation of a Historical and Cultural Centre about Hellenism all over the world, while the promotion of its exhibits will be based on modern technology.

> The organization of conferences, seminars, film projections, the production of printed publications, as well as visual and sound recordings through the use of state-of-the-art technology, of scientific or educational content that is related to the Foundation's objectives.

> The management of historical and cultural information through research, writing and editing texts, collecting documentation material.

> The organization of research programmes and groups that are related to this subject matter.

> The organization and support of lessons, educational programmes and post graduate studies on Hellenism, for Greeks and foreigners alike.
>
> (FHW 2010)

Hellenic Cosmos, FHW's Cultural Centre, was inaugurated in 1998 and was created on a large industrial site in and around former factory buildings and new buildings have subsequently been added. The site itself has produced the archaeological remains of the classical and later cities – sites which the Foundation's archaeological team has excavated. The whole site now covers 65,000 square metres. The Foundation runs an active Friends Association and a volunteer programme.

The Foundation has a large staff including archaeologists, computer scientists, graphic and multimedia designers and more than 15 museum educators. It uses modern technology, in particular multimedia and computer generation, to present its exhibitions. The vast site of Hellenic Cosmos includes a multi-function theatre (the 'Theatron') where Classical and modern drama and music performances can be presented, and a 132-seat virtual reality theatre (the 'Tholos') where spectators visit the site of the Ancient Agora and, under the guidance of a special Museum

Educator, have the opportunity to choose from three different periods showing the development of the site over time. There are also large exhibition spaces, an internet café and a shop. There is a charge for entry to the centre and for educational programmes and events.

Table 10.4 Educational visitor figures for Hellenic Cosmos

Year	Educational programmes (weekdays)	Educational workshops (Sundays)
2005–6	9 separate programmes in which 52,500 pupils participated	49 workshops in which 2,025 children participated
2006–7	9 separate programmes in which 51,800 pupils participated	35 workshops in which 2,542 children participated
2007–8	9 separate programmes in which 77,276 pupils participated	33 workshops in which 2,068 children participated
2008–9	12 separate programmes in which almost 80,000 pupils participated	45 workshops in which 3,339 children participated

Its educational programmes are based on active learning in the following areas:

▶ Exhibitions on particular subjects (such as the Olympic Games, Ancient Agora of Athens and Mathematics) or themes and created 3D models of ancient Greek sites and buildings;

▶ Virtual reality experiences, such as 'A walk in Ancient Olympia' where it is possible (virtually) to throw a javelin and 'Breaking and Making Pots' where visitors can do (virtually) what the title says ;

▶ Internet-based programmes of learning and discovery;

▶ Sunday events for children and families where, for example, children can take part in the excavation of a created site in the Hellenic Cosmos' grounds. The Foundation also has a club for young people with a regular colourful newsletter with interestingly written and illustrated articles and news.

The exhibitions are promoted to the ordinary visitor but special attention is given to school-based groups. The exhibition about mathematics, 'Is there an answer to everything? A journey to the world of Greek mathematics', for example, can be accessed digitally (see FHW 2010). This exhibition includes a number of hands-on activities and a virtual reality programme about Archimedes' discoveries.

Politics, archaeology and education:
Ancient Merv, Turkmenistan

Background

Turkmenistan is a large country (as big as Spain, over twice the size of the UK), sparsely populated (unofficial estimates: 4–5 million people – see Brummell 2005, 2) in a land with one of the largest deserts in the world. In summer the temperature is rarely below 35° C and can reach 50° C in the desert, and in the winter it can fall to –15° C. The *Lonely Planet Guide* introduces its readers to Turkmenistan by saying, 'Much of the landscape recalls a spaghetti western with snaking dunes, stark mountain ranges, scrappy villages and ramshackle railway towns' (Mayhew *et al.* 2000, 453). Paul Brummell, who served as the British ambassador to the country from 2002 to 2005, has produced the most authoritative and up-to-date guide to Turkmenistan (Brummell 2005), although diplomatically silent on the regime's abuses and the state of the economy. Other writers have been less kind. The London School of Hygiene and Tropical Medicine (Rechel and McKee 2005) published a policy brief following a report which outlined serious human rights abuses and the near collapse of the health care system.

History

Immediately before 1991 and since the end of World War I, Turkmenistan was one of a number of the Soviet provinces which then became republics. Russian immigrants were sent to Turkmenistan in the 1920s to 'modernise' the country. There was fierce opposition throughout their occupation and, in the new mood of the 1980s and 1990s, Turkmenistan was given independence.

In 1990 Saparmurat Niyazov, who had been the First Secretary of the Communist party since 1985, was elected president and in 1991 he made the country independent. In 1995 he declared the country neutral and Russian troops left. Many Russian Turkmens then chose to emigrate to Russia as they had been replaced by ethnic Turkmens in their state jobs. Nyazov died in 2006 and was succeeded by his former Minister of Health, Gurbanguly Berdymukhamedov.

Huge posters and statues of President Nyazov, as well as plaques, memorial gates and arches, could be seen everywhere in Ashgabat, the capital, and in all the smaller towns, villages and in the countryside. He called himself Turkmenbashi – Father of all the Turkmens. He wrote a book, the *Ruhnama*, a mixture of history, poems, philosophy, morality and guidance for the Turkmen people. This was joined later by the *Ruhnama: Second Book* (Turkmenbashi 2002 and 2006: English translations). Turkmenbashi considered the *Ruhnama* to be on a par with the Bible and the Koran, and it was made an obligatory part of the education system. All pupils were expected to spend two hours per week studying the *Ruhnama*. The book was even commemorated in giant concrete 'statues' – favourite places were roundabouts.

As details of these matters became known, journalists, naturally, were eager to point out the actual or near collapse of state services and to highlight the president's bizarre decrees such as banning gold teeth and make-up for female TV presenters. Now after his death, the former president's photographs began to be replaced with those of President Berdimuhamedov in offices and schools but it is too early to say whether previous policies will be upheld. By September 2007 some of Turmenbashi's decrees were being overturned and the *Ruhnama* was no longer being printed. However, in late 2009, the National News Agency reported that the president called the former president's book 'an important work with high spiritual-moral values and guidelines embedded in it, which have always been characteristic to Turkmen nation and which should be followed by growing generations' (National News Agency 2009). Some Turkmens interpret this first use of the word *Ruhnama* as a prelude to the new president publishing his own book.

Ancient Merv Project

Merv is among the oldest and best preserved of the oasis cities along the Silk Roads in Central Asia. The ancient cities of Merv lie near the modern town of Mary in south-east Turkmenistan. The 19th-century correspondent Edmund O'Donovan first brought Merv to the attention of the West in 1882 when he published a vivid account of his travels:

> I caught my first glimpse of the old cities of the plain – the ancient capitals of Margiana. A long line of walls and turrets, dominated by some towering domes, broke the line of the horizon ... I could scarcely express my anxiety to proceed there and then to this mysterious spot concerning which so much has been written and so little known. (O'Donovan 1882, 202)

There were Russian excavations from 1890 onwards. In 1990 the Turkmenistan Ministry of Culture protected Merv in a state archaeological park and in 1999 it became a World Heritage Site. However in 2000 Merv was placed on the list of the world's most endangered sites by the World Heritage Watch but was taken off the list in 2005 as a result of the new Institute of Archaeology, University College London (UCL) project.

A ten-year International Merv Project began in 1992 led by the Institute of Archaeology with the British Museum and the National Institute for the History of Turkmenistan of the Cabinet of Ministers, in collaboration with the Ancient Merv State Park and the National Department for the Protection, Study and Restoration of Historical and Cultural Monuments, both within the Ministry of Culture of Turkmenistan. Interim reports of excavations have been published in the journal *Iran*, a research volume by the previous director, Georgina Herrmann, and published photographic archive (Herrmann 1999; Herrmann *et al.* 2002). The Institute of Archaeology began a new project in 2001, led by Tim Williams, with the Turkmen authorities – a project which is primarily to do with survey (Williams 2008) but with more excavations over the last three years, conservation, education and public outreach work (Williams 2002 and 2003; Durrani 2004).

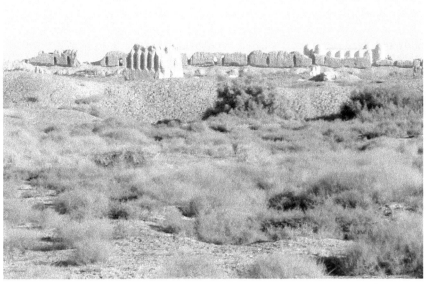

Fig. 10.5 This photograph captures a relatively small part of Ancient Merv with a variety of buildings (semi-fortified houses, defensive city walls and a modern mosque on the far right) which survive above ground from its long history. The buildings and the landscape provide an important opportunity for schools to make use of archaeological evidence as an antidote to learning in the classroom about their country's history. Studying the buildings also provides opportunities to learn about the problems of the long-term conservation of this World Heritage Site.

Archaeology and monuments

Ancient Merv covers a huge area of upstanding and buried archaeology (see Fig. 10.5) including nearly 1,000 ha (2,470 acres) inside the city walls. The oasis of Merv was part of the land of Margush or Margiana and in the Bronze Age there were a number of settlements from the early second millennium BC. However, the more visible remains are those of a number of ancient cities of Merv which provide the resource for both archaeological investigation and educational work:

▶ 6th century BC: Achaemenid city of about 12 ha about the time of the reign of Cyrus the Great, King of Persia

▶ 3rd century BC: new Hellenistic city built by Antiochus I Soter covering about 340ha

▶ *c.* 740s AD: new Islamic city founded, possibly, by the Abbasid ruler Abū Muslim eventually enclosing about 550 ha with a 'Royal Citadel' of nearly 20ha

▶ 15th century AD: new Timurid city built covering 46 ha

▶ late 18th century: suburb enclosing 30 ha added to the old Timurid city.

This resource is particularly useful because each new city was built adjacent to or surrounding the previous settlement. Upstanding monuments which can be visited include: defensive walls, towers and gates, religious buildings and mausolea, semi-fortified houses (köshk) and summer pavilions and icehouses.

Archaeological and archive resources which can be made available include: finds and excavation records, aerial photographs, archive photographs from the 1890s onwards and historic primary documentary sources.

Conservation

The protection of the upstanding monuments at Merv is a major concern. Most of the buildings are made of mud brick which was used for over 4,000 years as the main building material in Central Asia. The buildings that remain today at Ancient Merv are preserved as ruins. They are without the roofs that once protected them from rain and snow and are damaged by their exposure to sun, rain, wind and snow, the reptiles, birds and animals that nest and burrow within them, and sometimes, by the people who come to visit them.

For the majority of the time that the buildings of Merv have been abandoned, the process of erosion has been gradual but rising water caused by the Soviet authorities' digging of the Karakum Canal in the 1950s accelerated the damage to the monuments. Water seeps into the bottom of the walls and as this dries, the salts in the water crystallise on the wall surface.

Part of the work of the UCL project has been to research mud brick technology and experiment with conservation techniques using traditional materials and ways of working (Cooke 2007 and 2010, 29–42). Another problem which has arisen is from old archaeological trenches. Archaeological excavations over the last 100 years have created a lot of open and eroding trenches in the archaeological park. Several have now been identified, emptied, recorded and backfilled, conserving the walls where necessary.

Education and interpretation

One of the most important aspects of the latest UCL project at Merv has been to do with researching ways of promoting Merv to the Turkmen people and producing resources to help achieve that (Williams 2003, 40). An interpretation scheme was drawn up, some new site panels have been devised, and an orientation leaflet is now readily available at the site in Turkmen, English and Russian. In addition, archaeological park staff have now received training and information to help them guide visitors to the site (Williams 2007). Several tourism packs for the key sites of Ancient Merv are available at the park entrance, and are distributed to tourist organisations in Ashgabat which are responsible for most of the organised trips to Merv. The project team redesigned and redisplayed the small site museum at the entrance to the park. A guide book was previously published (Herrmann and Peterson 1996) and an official new guide is now available (Jepbarow 2006).

I was asked to take on the education work of the project, whose broad aims were to help local people become better informed about this World Heritage Site, and by extension about their archaeological and historical heritage, to make the public more aware of the problems of conserving their own heritage and to

encourage teachers to use Merv in their teaching, not just in history but in other subjects and to use a visit to full advantage.

This involved researching the Turkmen education system and curriculum, finding out whether local schools used the site for formal educational visits and asking if local families visited the site.

There are some serious problems with the formal education system in Turkmenistan. The first problem is that the former president was interested in history and in securing himself a place in it. In his 'sacred' book, the *Ruhnama*, he set out the main periods and peoples of Turkmenistan's history. Some of this history was slightly wrong, some deliberately altered, some pure fantasy. The second problem is they have inherited a Soviet education system which demands the use of the state-written textbook, learning by rote and an unquestioning approach from the pupils and students. The history textbooks are largely unillustrated and, in any case, do not use evidence to back-up historical statements. The third problem is that there are very limited funds for education resources in schools. Classes, which now have a maximum of 30 students, sometimes have few textbooks. However, I found individual teachers eager for new resources and willing to come from the towns and villages around Merv to the ancient site for structured educational visits. They were eager to use an evidence-based approach for their pupils' learning (see Fig. 10.6).

It was at first difficult to carry out formal research. One leftover from the Soviet system was the suspicion caused by a foreigner asking questions about schools, teaching methods and the curriculum. There are also serious problems with the amount of resources the authorities put into schools – in terms of buildings, number of teachers and teaching resources. In general, the Turkmen history curriculum follows a pattern seen in many parts of the world with an uneven split between the history of the country and some aspects of world history. Cross-curricular work is allowed but the use of primary evidence for teaching history was, as far as the author could see, non-existent. Learning in all subjects is very often by rote.

However, the Turkmen people are fiercely proud of their heritage. Merv is an iconic site known better than any other historic site and considered fundamental to their history. Images of Merv can be seen everywhere and you can even buy Merv ice cream! There was clear evidence for visits being made to the site at Merv by the 300 schools in the local authority district of Mary including the nearest small town of Bairam Ali, with the key times being for 11-year-olds studying 'My Homeland' in history and for 14-year-olds studying the 'History of Turkmenistan' in history. Schools made formal visits which included whole classes and usually spent half a day at the site. Spring and autumn are the only comfortable times of the year to visit such an exposed site. Family groups came in coaches from all over Turkmenistan to visit this famous site and local children often visited in large family groups, mainly to make formal visits to the religious sites and buildings.

Formal meetings with groups of teachers, together with the Turkmen Education Officer whom the project employed from 2005, and the guide for the Archaeological Park established that:

▶ pre-visit work dealt with Central Asian historic periods, such as the Achaemenids and the Seljuks, as well as the Silk Roads;

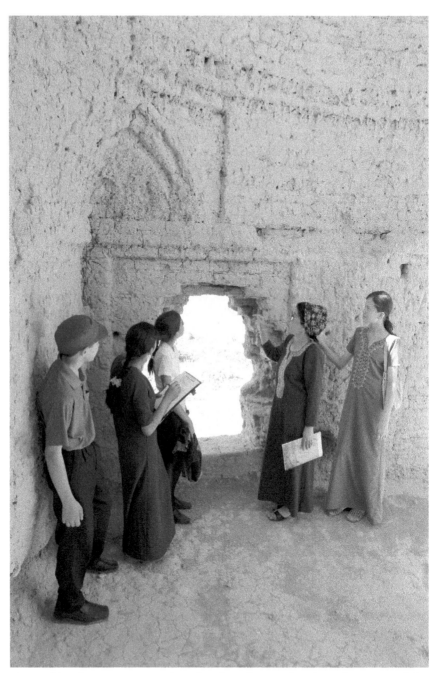

Fig. 10.6 Teachers soon warmed to the idea of using the physical resource of the buildings at Merv. Inside the köshk one of the teachers, standing by evidence of a window, is pointing out the way the corners of this mud brick square room have been constructed to form a domed roof.

▶ on-site only the main monuments were visited with the teacher talking about each one in turn. No individual or group activity took place;

▶ post-visit work was an essay by 11-year-olds about what they had seen and what made the biggest impression on them, and a discussion about the visit was conducted in classes of 14-year-olds;

▶ resources were desperately needed, both written and visual, to help teach about Merv;

▶ information about the Silk Roads would be useful as it was part of the curriculum;

▶ the idea of activity and resource sheets for pupils were welcomed although these did not form part of their usual teaching methods;

▶ teachers were interested in information about archaeological methods and the issues of conservation.

Draft ideas for teacher resource materials were then prepared and tested with a teachers' group which the author worked with in Bairam Ali and with individual teachers in Ashgabat. The results of these discussions were draft materials which were translated into Turkmen and tested on site visits with groups of students and their teachers. After corrections and amendments, the final pack was published (Corbishley 2005) which consisted of an illustrated 36-page colour book for teachers with sections on World Heritage Sites, Timeline, Silk Routes, History of Merv and its monuments, Archaeological techniques, Conservation at Merv and Teaching Strategies covering a number of curriculum subjects together with 12 resource sheets (with material which couldn't be included in the book such as a number of historic photographs) for pupils to use in the classroom and six activity sheets for use on site. These were accompanied by notes for teachers suggesting ways in which they might be used and for extension work in cross-curricular subjects.

Notes were also prepared for the Education Officer and park staff to help teachers when they visited Merv. The whole pack was free and is being distributed to local schools and elsewhere in the country. In addition, the American Peace Corps have agreed to use the English and Turkmen versions to help their volunteers, who worked in schools across the country, to learn Turkmen and to learn about the country's history. However, in 2009 the Peace Corps were not allowed to bring their volunteers into the country. Seminars were held in 2007 with English language teachers in schools in the Mary district and Turkmen and English versions of the teachers' pack were distributed. The pack, in Turkmen and in English, is available to download (Ancient Merv Project 2010).

Outreach

As part of its outreach scheme, the UCL project organised an open day for the public in 2006 in collaboration with the park staff and archaeologists of the Ministry of Culture. Activities were planned with both the needs of the day in mind and of future outreach for schools and general visitors. The open day consisted of an art competition, a site visit (which functioned as training for the guides), an interpretative movie in Turkmen (now available online, see Ancient

Merv Project 2010) and the use of handling collections and activity sheets. The handling resources subsequently assisted the park guide with explaining to visitors and school groups the current archaeological research at Merv and the accompanying activity sheets are now part of the teachers' pack.

In order to get a better understanding of local values and attitudes towards the site, the UCL project has undertaken small-scale community research at the villages around Ancient Merv, including oral interviews at key sites within the park. The interviews explore attitudes towards the ambiguities and differences in interpretation, capturing in particular people's emotional experiences. The interviews are available at the Ancient Merv Project website, and will inform the preparation of new educational and interpretive resources.

Heritage Issues

11 Recycling Past and Present

In recent times most countries have recognised the problems of the environmental damage being caused by human consumption of the world's resources and the pollution we cause to our earth. Part of the solution to this problem – recycling – is being addressed by individuals, authorities, commercial companies and states. The mantra of Reduce, Reuse and Recycle is becoming well known to children across the world. Today recycling is reusing the same material again – for example, paper recycled as paper or cardboard, the breakdown of organic materials to form something else, for example composting garden waste and using again or making a new product from waste materials, for example building materials.

This chapter outlines waste management practices today and some of the programmes created to educate the public and schools about recycling. But recycling is not just a modern concept and this chapter looks at recycling throughout the past, with examples of objects, landscapes and buildings from across the world.

Recycling and the past

The concept of local authorities recycling waste is not new, as Rogers shows – in 1895 the New York City Street-Cleaning Department was set up and its 'two-thousand strong sanitation army' enforced a more disciplined approach to the removal and recycling of waste (Rogers 2005, 52–3). A number of different materials were being recycled in and from cities in 19th-century America (reflecting what had been done in much earlier periods). For example, horse manure (in 1880 Manhattan had more than 150,000 horses), human excrement, bones, offal, kitchen waste, household ash (2005, 34) were used for fertilising fields; other materials went to factories – rags for paper making, bottles for refilling, blood for sugar refining and fertiliser manufacture, boiled flesh for tallow, hooves for gelatine, hides for leather (2005, 36).

Waste management

Plastic bags attached to trees, floating in rivers and polluting the seas have become a sad symbol of our throwaway society. Rogers (2005, 123) recorded that nearly 25% of produced plastics in the USA went into packaging in 1969, but today the USA uses 100 billion and the UK 17 billion plastic bags each year. The UK government's Department for the Environment, Food and Rural Affairs (Defra) target for household recycling for 2008/9 was 37.6% of waste. Figures (Defra 2010) show that the largest proportions of household waste are garden waste (20%), paper and cardboard (18%) and kitchen waste (17%). There are no figures for the number or type of materials which the general population in the UK recycle themselves – for example, newspapers to 'logs' for burning, garden refuse to composting, broken pots to mended pots and used building materials used again.

Many people are familiar with or at least know about other cultures which do not simply throw away materials but recycle what they can. Smart stores in Europe sell watering cans made in India from tin cans previously containing vegetables or oil. An exhibition in the Pitt Rivers Museum, Oxford, in 2000–2 called 'Transformations: The Art of Recycling' included classic objects made from recycled materials, such as Australian spearheads from bottle glass, a collection of oil lamps made from a variety of tins such as Brasso, Dipy's Mango Juice and from a light bulb and an ink bottle. These artefacts were made in India, Africa and Thailand (Coote *et al.* 2000). The debris of war, which Saunders calls 'recyclia',

Waste education

While adults are encouraged to recycle by dedicated doorstep collection and government information campaigns, students are informed through school activities and general publications. Bowden (2003) explains the problems and solutions of waste in the 'Sustainable World' series for older children, while Harlow and Morgan (1995) mix information with lively 'do it yourself' activities, such as making a composting bin or making recycled paper. Even more interesting is the book by Ebokéa. Originally from Cameroon, Ebokéa has written several books on recycling for children. She draws on her experiences in an African society where recycling is a matter of course – giving the examples of bottle tops used as counters for games of draughts and motor tyres made into sandals (Ebokéa 2005).

Education would seem to be at least one solution to our problems. The author's own survey of the local authorities' efforts in waste and recycling education showed that, although most authorities list 'waste and recycling education' on their websites, this means information about why we should recycle and where their depots are. To date only about a quarter of local councils in England actually have curriculum-linked education programmes on waste management and recycling for schools. One outstanding programme from Suffolk County Council is described in the case study below. A few other authorities have developed innovative schemes – for example, travelling recycling buses in Cambridgeshire.

Museums and heritage organisations across the world have put on special displays or events to promote recycling – for example, at the 'Summer Fun Day: Reduce, Reuse, Recycle' at Kern County Museum, California. Over 50,000 children and adults visit two museums in the USA which are devoted exclusively to waste and have good educational programmes and classroom resources – the Connecticut Resources Recovery Authority's Trash Museum in Hartford and the Garbage Museum in Stratford (CRRA 2010).

Waste material is now sometimes used by artists for their works. In 2006 the sculptor Anthony Gormley created *Wasteman* in the seaside town of Margate in England. The 25-metre-tall work, constructed of waste materials from the town, was burnt on completion as part of an arts project. *Wasteman* is, perhaps, reminiscent of *The Iron Man* written in 1968 by the poet Ted Hughes for his children. The huge Iron Man, escaping from farmers, is befriended by a boy who takes him to a scrapyard to eat metal from trucks, cars, bicycles, refrigerators, gates and stoves. This book and its sequel *The Iron Woman* (1993) would make a good starting point for a primary school project on recycling.

was also included in the exhibition but is discussed more fully in Saunders 2003. Objects such as shell cases from World War I were at times simply recycled as flower vases, but have also been used as material for the most cunningly made and elaborately decorated writing sets, crucifixes and alarm clocks.

Objects, landscape and buildings

> Near our village we had the famous ruins of Ephesus which, if I tell the whole truth, we didn't bother much with. Our houses were embellished from door frame to the top of the stairs, with decoration from the archaeological site.

Dido Sotiriou's novel *The Bloodstained Earth* (1983, 22) records the expulsion of the Greeks from Asia Minor after the sacking of Smyrna in 1922. Ephesus is only one of the many examples across the world of the recycling of buildings and building materials for later use. The 2006 list of the 100 most endangered World Heritage Sites published by the World Monuments Fund (WMF 2006) mentions three sites – Tell Mozan, Syria, Jerusalem Hospital in Malborka, Poland and Chalcatzingo, Mexico – which are in danger partly because they provide a ready quarry for building materials. Although we use the word 'recycling' today to mean waste materials no longer wanted by the owner, this was not so in the past. Indeed, the word itself may sit uneasily against some of the examples given below. Using the educational technique of starting from the child's point of view, here are some modern examples:

Table 11.1 Use and reuse today

	Original use	Subsequent use
Objects	Drinking mug	Handle broken – mug used to mix paint
	Newspaper to read	Wrapping for rubbish
Landscape	Flat plain for farming outside city	Airport
Buildings	Grocer's shop	Pizza restaurant
	One-bedroom house	House extended for family

Heritage educators can use easily accessible examples of past recycling from several periods in the past.

Objects

Excavators and finds specialists sometimes come across examples of objects showing clear evidence of reuse, either after repair (rivets or rivet holes present in domestic pottery vessels, mended high-quality Roman bowls, for example) or for a completely different use (see jewellery below). Ethnoarchaeologists Deal and Hagstrum (1995) recorded the use and reuse of ceramic vessels by the modern Tzeltal Maya (Mexico) and Wanka (Peru) communities. Usage for the vessels ranged from domestic to construction and ritual. They found that damaged pots were set aside for repair, reuse or discard – recorded in an interesting drawing (1995, 125) of a Tzeltal water-carrying jar. The information from this is presented in a chart below.

Table 11.2 Use and reuse of pottery

Use	Reuse
Rim/neck	Plant protector Pot stand
Handle	Kiln furniture Wall hanger Doorbar retainer
Large body sherd	Plate Scoop Potlid
Small body sherds	Floor paving/fill for cracks
Base	Lime mixing bowl Prop for firedog Animal feeding dish Flower pot

Many museums with Roman collections display jewellery in which coins were used. This practice became popular in the 2nd century AD especially for rings, necklaces and brooches. Reece (2002, 78) suggests that some coins from 3rd century Britain survive only because they were taken out of circulation and reused in jewellery. Like many other people before and afterwards, the Romans reused the bones of animals: bone was carved into pins and needles, for example, and the

Fig. 11.1 The church at Wroxeter in Shropshire, originally constructed in Anglo-Saxon times, was built on the site of the Roman town of *Viroconium Cornoviorum*. The builders dug out and used large stones from public buildings (even part of a column) in the north wall (pictured here) built in the late 9th century AD. Anglo-Saxon carved stone, including part of a cross, was also incorporated. The font was carved from a large Roman column base and sculpture and other stones were taken from a nearby abbey for later additions to the church (White and Barker 1998, 138–48).

Romans and the Greeks played the game of knucklebones using *astraguli* (one of the anklebones of sheep).

Few Roman structures and features survive above ground in Britain. Buildings, town walls and below-ground features such as drains were usually robbed out from Anglo-Saxon times onwards (Eaton 2000). Roman architectural fragments and inscribed stone, as well as ordinary building stone and tile, can be seen in many later buildings, especially churches and cathedrals (see Fig. 11.1). Disturbances in the Roman Empire from the early 3rd century onwards sometimes meant the hasty building or strengthening of city walls. Raw material was often robbed from existing structures, especially those, such as cemeteries, outside the city boundaries. Thus Roman tombstones ended up embedded in defensive walls, providing an exciting resource of information about named individuals. Nearly 100 tombstones of soldiers from the legionary fortress at Chester, England, were used in the strengthening of the walls in the late 3rd century. Over 1,300 inscribed and sculptured Roman panels were reused in the medieval walls at Narbonne, France. The monument for Julius Classicianus, the procurator of Roman London, was incorporated into a 4th-century bastion of the city's walls (Keppie 1991, 30–1).

The Normans used the remains and the base of the Roman Temple of Claudius to construct their castle in Colchester, Essex (see Fig. 11.2). A detailed survey of the external fabric of the castle, carried out by the Colchester Archaeological Trust, revealed that intact stacks of hypocaust tiles from Roman baths in the town had been used in the building of its walls (Crummy 1984, 4–8).

Fig. 11.2 Colchester Castle from the south, now the town's main museum. The facing wall in particular reveals stacks of hypocast tiles laid on their side to form an easily constructed level course between stone (septaria) and other Roman tiles.

Landscape

> The surface of England is a palimpsest, a document that has been written
> on and erased over and over again; and it is the business of the field
> archaeologist to decipher it. (Crawford 1954, 51).

Archaeological investigations on the ground tend to reveal evidence of change
over time. Other field archaeologists have shown that careful application of field
and scientific techniques will reveal the elements of this palimpsest from the
prehistoric to modern periods (Aston 1985; Bowden 1999). A piece of ground,
whether a building plot in a town or part of the countryside, will most likely
have been occupied time after time, each new occupant destroying, preserving
and reusing elements of previous occupation. Evidence from fieldwork and
excavations show examples of this reuse. For example, a Roman conquest
fort was built at Hod Hill, Dorset, making use of the existing Iron Age hillfort
ramparts for one of its corners. The Norfolk Broads is now a popular destination
for sailing holidays and thought of by many visitors as an example of a 'natural'
landscape. But it was pits dug to extract peat during the 10th–13th centuries, the
rise in the import of coal and higher sea levels across north-western Europe which
were responsible for its formation. The peat pits were then flooded for fisheries.
Another example is the creation of the National Forest across three counties in
the Midlands of England. Over 7 million trees have been planted in the 200
square miles (518 km²) allocated since the 1980s. Part of this new landscape uses
redundant open cast coalfields. In Britain, Richard Beeching, chairman of the
British Railways Board, 1963–5, made drastic cuts in the number of railway lines,
and many villages and towns lost their rail services. The result on the landscape
today is that some railway stations have been turned into houses, shops, small
businesses or offices. Other buildings and rails have been removed, leaving banks,
cuttings and viaducts in the countryside as archaeological monuments.

Human occupation and change

Human occupation of, and change to, landscape may be caused by:

▶ *Discovery of new materials:* The flint mining industry based in southern and
 eastern Britain in the Neolithic was eventually replaced by the discovery
 of metals for tools and weapons. Some flint extraction continued to provide
 building stones (still used today), for glass and pottery manufacture and for
 flint-lock guns. The landscapes of the mines were changed. Four important
 mines become ancient monuments and can be visited today – Cissbury,
 Harrow Hill and Long Down, West Sussex and Grimes Graves, Norfolk (Russell
 2000, 148–50).

▶ *Exhaustion of raw materials:* Ironbridge Gorge, Shropshire, is often considered
 the birthplace of the Industrial Revolution. In the 18th and 19th centuries the
 landscape offered easily accessible resources (see p. 180) for iron working
 and pottery and tile manufacture and a means of transporting the finished
 products (the River Severn). *Coalbrookdale by Night*, painted by Philip James de
 Louterbourg in 1801, shows a scene evoking a hell on earth with the various
 industries churning out steam, gas and smoke. But the exploited materials
 eventually ran out and workers looked for employment elsewhere. The site

is now a World Heritage Site with a variety of museums and sites to visit. Industrial processes have been replaced by the tourist industry (Hayman and Horton 1999).

▶ *Changes in military technology:* Dover Castle, Kent, has seen frequent changes to its landscape, partly because of changes in defence and warfare. It holds the remnants of an Iron Age hillfort, a Roman lighthouse, a Saxon fortified town and a Norman castle. The castle was altered over time to adapt to new types of weapons including gun platforms in the 16th century and the lowering of the walls and towers for artillery positions in the 19th century. Underground tunnels were dug in the Napoleonic Wars and reused in World War I. New, more extensive underground complexes were excavated and used in World War II and adapted in the 1960s as a regional seat of government in the event of a nuclear war. Like Ironbridge, it is now a much-visited ancient monument.

▶ *Reusing earlier patterns of settlement:* Excavations in the centre of Colchester, Essex, have revealed a detailed plan of the town in Roman and medieval times. The discovery of a Roman conquest fort with its annex defined the shape of the town after the Boudican rebellion until the end of the Roman period. The medieval town reused some of the Roman streets and it is still possible today to enter the town through the position of some of the gates and walk above the levels of some of the Roman streets (Crummy 1992).

Buildings

It was very common in the past to reuse or convert buildings in the countryside or the town for a new use. A barn, built for livestock or horses, might be reused with alterations for farm machinery but subsequently converted into living accommodation. Large houses, built in residential areas in the centre of town, might now be hotels, student flats, residential homes for the elderly, shops or restaurants. This process continues to the present day as the original purposes of buildings change over time. Often, economic or political changes in society cause some buildings and other structures to become redundant:

A line of forts was constructed in late 3rd–4th-century Roman Britain called the Saxon Shore Forts. One, Pevensey Castle in Sussex, was reused by the Normans when its Roman walls formed the outer bailey for the inner bailey and keep. It was still recognised as a defensive structure during World War II when in 1939–40 a machine-gun post was constructed and camouflaged in the north wall of the Roman fort.

A study of World War II public air raid shelters in Hamburg showed decline in numbers from 1,051 in 1945 to 700 in 2008. Some of these redundant above-ground shelters were permanently converted into housing or storage, while one became a disco and another in Hamm has become a museum with an exhibition about people's air raid experiences (Richardson 2008).

The issues that reuse raises are included in the section on citizenship (see p. 294). Morrison, commenting on the demise of workhouses because of their replacement by hospitals, children's homes and social security, writes that 'surviving poor-law buildings no longer pose a sinister threat to the poor: indeed, many lie empty and derelict, awaiting redevelopment or demolition, while others

have been sanitised and converted into desirable modern dwellings' (Morrison 1999, 196).

Historic buildings protected by law are usually treated with respect, and the options for reuse will rightly be restricted. While many of the historic buildings in the walled medieval town of Rhodes, Greece, have been carefully restored as historic monuments or continue in use as private houses, some have found new uses – but only as museums, meeting places for educational use, a public library and for concerts or other performances (Manoussou 2001). What follows are some examples of the more usual methods of recycling buildings which are no longer required for their original purpose as religious or public buildings.

Churches and chapels: In Britain, buildings constructed by religious groups form the largest number of buildings for which new uses have to be found if they are going to survive. Church of England (CoE) parish churches represent the largest number, about 16,000 in all, of which more than 12,000 are protected by law. Very many Anglican churches are in rural parishes with small populations – '2000 smallest rural parishes have an average population of about 200 people each' (Cooper 2004, 3). Amalgamation of parishes and shrinking church attendance puts these buildings at risk of redundancy. To these we must also add the 15,000 non-conformist chapels and churches throughout Britain, including about 2700 listed as historic buildings. Some surveys of churches and chapels, including information about their level of disrepair or ruin, have been carried out locally or regionally by archaeologists. Rodwell and Rodwell (1977, 39) showed that of the 16 churches which were once inside the historic Roman and medieval centre of Colchester in Essex, five were still used for worship, five were used for other purposes, four were demolished since the 17th century and two were demolished before the 17th century. Morris (1983, 9) reported on the 495 parish churches and chapels in Britain which had been investigated archaeologically (1955–80) and showed that by 1980, 55% existed only as a site, 26% were still in use for worship, 12% were ruins, 5% were redundant and 2% had found another use.

The Church of England recognises that there is a problem in maintaining some of its many buildings and it needs both grants and partnerships if its historic churches are to survive (CoE 2010). Since 1969, 1,780 (this figure is for the period 1969–2008; the website information is not updated every year) CoE churches have been declared redundant (a term with a legal status – see Church of England 2010). Some were preserved (mostly by the Churches Conservation Trust – see below), 386 were demolished, while 1026 have found alternative uses. Some (49) have been restored to parish use but the other categories of use were: community or civic use (256), residential use (235), monuments, museums or centres for arts and crafts, music or drama and educational use (220), places of worship for other Christian bodies, private school chapels or churches of non-Christian faiths (162), shops, offices, industry and storage (104) (Church Commissioners 2010, 13).

Art galleries, craft centres and museums are popular choices for the conversion of religious buildings, perhaps because of their large open spaces. The York Archaeological Trust converted St Saviour's Church into their Archaeological Resource Centre. The mosque in Monastiraki Square in Athens, Greece, was built by Tzisdarakis, the Turkish Woiwode of Athens in 1759. The building was subsequently used as a barracks and then a prison. It was restored in 1915 and has housed the Museum of Greek Folk Art since 1918. Some churches and chapels

have been recycled by other religious faiths (see Fig. 11.3). The Lady of the Shrine in Gibraltar was originally a mosque but was converted to a Catholic chapel in 1462. In Britain, Sikh gurdwaras were often set up in people's homes. Some are in former warehouses but many are now built as new.

Some church buildings survive for their religious community because other uses have been brought in. St Mark's in Bedford now houses a surgery, school and a police station. The local post office, previously closed, has now been established in the village church at Sheepy Magna in Leicestershire. Worshippers at St Martin's in Birmingham now help in its Centre for Health and Healing and with refugees and homeless people.

A survey of 1981 (Stell 1986) showed that of the 186 nonconformist places of worship in the English counties of Herefordshire, Warwickshire and Worcestershire, seven were closed, derelict or demolished, three had found commercial uses (workshops and a garage), three had become residential properties and one had been converted into a theatre. Many non-Anglican churches and chapels, once redundant, have been taken into care by the Historic Chapels Trust (HCT) and opened up to the public for visits and events. The Trust's remit includes non-conformist chapels, Roman Catholic churches, synagogues and private Anglican chapels (HCT 2010).

As a result of the transfer of Church of England registers to the archive services of local authorities in Britain and the provision of information about

Fig. 11.3 Modern conversions are often controversial. The Mount Zion Methodist chapel in Clitheroe, Lancashire, was opened in 1888 but had closed by 1940. It subsequently had a variety of uses, from a munitions store to a clothes factory. Against local opposition from residents and the town council, the Muslim community has succeeded, after a 30-year campaign, in winning planning permission for its reuse as a mosque.

Reusing churches

There is now an active concern by some church and church building organisations to find sympathetic and creative reuse of redundant buildings. For example, the 18th-century church of St Paul's in Bristol was taken into care by the Churches Conservation Trust (see p. 312). It was in a sorry state due to neglect and vandalism and had become a haven for drug-taking and prostitution. With a large grant from the Heritage Lottery Fund and in partnership with a local circus and community development group called Circomedia (previously based in a redundant Victorian school), the church has come back to life (see Fig. 11.4). The height and structure of the nave provides an ideal situation for a full-size aerial rig for a flying trapeze. Students and local people now have opportunities for circus and theatre training, spaces for events, meeting and prayer. The Churches Conservation Trust won a Diploma in the Architectural Heritage category of the 2006 European Union Prize for Cultural Heritage/Europa Nostra Awards 'for the careful repair of a remarkable but decayed Neo-Gothic church and its sensitive adaptation as a circus and physical theatre school, generating considerable benefits to the local community' (Europa Nostra 2010).

Fig. 11.4 An outreach tutor demonstrates her circus skills.

them and of non-conformist registers, it is possible to gather some idea of the current state of these buildings, at least regionally. For example, Durham County Record Office records information about the registers of non-conformist places of worship in their county, noting that while 182 are still open, 110 are now closed (DCRO 2010).

Churches and chapels are often converted to other uses but new uses raise sensitive issues and are often controversial (see the Sproxton example, p. 296). Some of those issues are around these 'lost' features, while some may be offset by 'gains'.

Table 11.3 Losses and gains in reuse of churches

Possible losses	Possible gains
Original religious use lost	New, but sympathetic reuse
Internal features destroyed or covered (e.g. wall-mounted memorials, grave slabs in floor)	New features uncovered during building work or archaeological investigation

The author's excavation at a redundant parish church in Essex, which was subsequently converted into a private house, revealed a timber building which pre-dated the Norman church (Corbishley 1984). However, local people regretted the loss of their church, even though it lies in fields well away from the village. Part of the churchyard is still visited by locals.

Public buildings: Buildings constructed by local or national authorities for a variety of public use often present problems if they are to be recycled, especially for housing. Some are simply huge and costly to convert – former town halls or hospitals, for example. Some people may feel that a former prison, workhouse or asylum is not suitable to live in, but many buildings like these have been recycled for other uses. Many prisons have been turned into museums or adapted for heritage administration – for example, the Imperial War Museum in London was formerly Bethlem Royal Hospital, built in 1815, commonly known as Bedlam; The former House of Recovery in Newcastle upon Tyne, built in 1804 as a hospital for infectious diseases, is now the headquarters of Museums, Libraries and Archives North East; the National Museum of Prisons is housed at Fontainbleau in France, whose prison closed in 1990; the National Prisoner of War Museum has been established at the site of Camp Sumter (Andersonville Museum), Georgia, which took in its first Union soldiers captured by Confederate forces in 1864.

Prison museums in Britain include the Nottingham Galleries of Justice (18th-century prison and Edwardian police station), the Prison and Police Museum Ripon (late 17th century) and the Wymondham Heritage Museum, Norfolk, which is housed in the former Wymondham House of Correction built in the mid-1780s.

But some prisons and hospitals have been converted for other uses. The Coldbath Fields House of Correction, built in 1794, was later called Clerkenwell Gaol. The Post Office took over the building in 1888 when the prison was closed. They decided to change the building's name to Mount Pleasant, as the postal workers disliked being associated with a prison. Oxford Prison, built 1848–56, was closed in 1996 and opened to tourists by the council on Heritage Open Days. It is now a luxury hotel with rooms named after former prison governors, and the gym is called the Exercise Yard. The West of England Eye Infirmary in Exeter was

Fig. 11.5 The former market hall in Aegion, Greece, carefully restored and used as a museum. Built in the neo-classical style in 1890, probably by the German architect Ernst Ziller, its shops, which originally opened onto the street, have became display rooms and the inner roofed courtyard used for public meetings and concerts.

built 1898–1908 but has now been sympathetically and successfully converted to Hotel Barcelona. It is even possible to book the former operating theatre as a suite.

Buildings for industry and entertainment: shops, especially in small towns in Britain, often survive intact, at least on the outside, while their original use to sell meat, fish, clothes or hardware has been taken over by supermarkets. Some may be reused as houses, while others simply sell different goods. While many industrial buildings have simply changed their industrial use, others have been successfully converted for other uses. Some of the large former warehouses in Liverpool are now apartment blocks, shops, hotels or museums and art galleries. A report on Manchester's warehouses, many of which are historic buildings protected by law, concluded that while the canal warehouses have proved difficult to adapt for new uses because of their low ceiling heights and small windows, the later cotton and export warehouses 'have greater floor-to-ceiling heights and larger areas of glazing and have proved attractive for new office, hotel, residential and mixed uses (Taylor *et al.* 2002, 48). A report on part of Britain's industrial heritage associated with the metal trades in Sheffield also reported (Wray *et al.* 2001) on the reuse of some of its buildings, including office and residential accommodation and light manufacturing industries. Bristol, London and Cardiff have all seen port buildings and landscapes refurbished and reused.

The London Canal Museum is housed in a former ice warehouse built in 1862–3 for Carlo Gatti the ice-cream maker. The museum's displays include those on the history of ice and ice cream making. Tyne and Wear Museums opened their new Discovery Museum in 1983 in an historic building in Newcastle upon

Tyne. Blandford House was built as the headquarters and distribution centre of the Northern Region of the Co-operative Wholesale Society in 1899. The building has been carefully and sympathetically restored and its original features are not masked by the modern interactive displays which form this museum. Also in Newcastle at Ouseburn is Seven Stories, the national centre for the children's book, reusing a former 19th-century mill.

Many theatres and cinemas from the 19th and 20th centuries across Britain have been demolished. Some, however, have been lovingly restored to their original use. One of the earliest cinemas, the Electric Palace in Harwich, Essex, was opened in 1911 but closed in 1956 and remained derelict until volunteers began restoring the building in 1972. The cinema reopened in 1981. The Opera House, Tunbridge Wells in Kent was opened in 1902 and was subsequently used as a cinema and bingo hall. It has been converted by the Wetherspoons pub chain (who often convert old buildings) and is still used occasionally for opera performances. The Astoria Cinema, Finsbury Park in London was opened in 1930, was reused for rock concerts and is now a church. Others have survived as nightclubs, dance or bingo halls and warehouses (Harwood 1999, 16–19).

Summary

▶ Waste management and education programmes today are outlined.

▶ An examination of recycling in the past discusses examples of objects, landscapes and buildings from across the world.

▶ The ethical concerns raised by reusing religious and public buildings, which may form the basis for school debate or project work, are listed.

Conclusions

The amount of waste generated by all countries today and the harmful and dangerous impact it is having on our environment should be a concern for us all. Some education programmes are in place to educate young people. There is an opportunity here to involve archaeology in this debate. Much of the past has been recycled for other uses, and this can provide the basis for interesting project work in schools, as the case study on the Garbology Project shows.

> *These ethical concerns are a part of citizenship or social studies classes in a number of countries, and this chapter links with the next one: 'Citizenship and the historic environment', which includes education projects that are based on the way in which we might recycle historic buildings.*

Citizenship and the Historic Environment

This chapter looks at ways in which archaeologists, heritage managers and teachers may promote their interests and concerns through citizenship and social studies. Archaeological and heritage sites and buildings are an excellent resource for citizenship work and may also be a way of introducing diversity and other cultural issues. Archaeologists have not been slow to see the link between archaeology and social responsibilities. Jacquetta Hawkes, quoted by Wheeler (1955, 219) said, 'Our subject has social responsibilities and opportunities which it can fulfil through school education, through museums and books and through all those instruments of what is often rather disagreeably called "mass communications" – the press; broadcasting, films and now television.' The chapter concludes with a section on World Heritage Sites and suggests some educational approaches which may form part of citizenship studies.

Warhurst (1999) has written about her community work at Norton Priory in Cheshire. The Runcorn Development Corporation wanted the priory to 'provide a focus for community activities and a sense of history for the new population' and one of their stated aims was to 'recognise the contribution of the past; old places are to be cherished and affectionately woven into the fabric of the new surroundings' (1999, 72–3). Warhurst and her team worked with the community – not just putting on displays and demonstrations but including local people as volunteers, running a vigorous education programme, developing an arts festival and setting out to work with groups such as those in elderly people's homes and adults with learning difficulties. Although Warhurst admits that the site of Norton Priory today is 'nothing remarkable' – indeed, it was subsumed into Runcorn New Town and surrounded by housing and a business park – still it has an 800-year history as an Augustinian priory and subsequently as a private house.

> Its strength is the continuum of history that is continuing; its special magic is being a peaceful haven within an urban landscape, allowing people time and space to experience for themselves a very specific place that has moved from a closed community through a place of privilege and is now open to all.
>
> (1999, 81)

Heritage issues

Many threats, as well as opportunities, to our historic environment which are of concern to archaeologists are just the sorts of issues which can become the topics for citizenship studies. The main issues are

▶ How can we define the historic environment and what value should we place upon it?

▶ What are the kinds of ethical questions over collection, preservation and access which should concern us?

▶ What are the main threats to the survival of our 'pasts'?

Citizenship in schools

Most countries recognise the need to create better citizens through the education process, usually through specific programmes in their statutory curricula. A British Board of Education report put it plainly: 'The purpose of education is to help each individual to realise the full powers of his personality – in and through active membership of a society' (1943, 4).

In a report presented to the government about the forthcoming National Curriculum, the Council for British Archaeology was clear that social principles could be taught through archaeology: 'Pupils, then citizens, should be aware that human actions, in the past and in the present, have created the present landscape and environment. They should be aware of the many 'threats' to this environment and how they can help protect and care for this environment' (1989, 3).

Citizenship, or social studies as it is commonly called in many countries, is taught as a subject in its own right but may also be taught through other subjects, such as history (for a European perspective see Brett *et al.* 2009). In the English national curriculum the primary aim of citizenship is to help pupils 'become informed, active, responsible citizens' (DfEE/QCA 1999a, 183). In a report to the Council of Europe in 2006 the author claimed, rightly I think, that 'the presence of lively arts and heritage sectors, and active participation by members of society in them, results in a literate, sceptical body of cultural citizens ready to confront any cultural flowing towards them from outside' (Stanley 2006, 39).

A study, carried out in 2005–6 in 14 countries across the world, revealed a range of motivations for promoting 'active citizenship'. Some countries saw citizenship as a legal 'status'. For example, in the USA courses in citizenship (or social studies or civics) 'focused on national history and political institutions'. Others countries, particularly in Europe, taught citizenship as a 'lever for social cohesion or civic engagement'. Still other countries, for example Singapore and Japan, used citizenship classes to 'reinforce a sense of national identity or patriotism' (Nelson and Kerr 2006, 14–15).

Definition and value

While there are many definitions of the 'heritage' or the 'historic environment', one from the Institute for Archaeologists proposes that

> Our historic environment is the imprint of past human activity upon the natural world from prehistoric times onwards. It is the product of innumerable interactions that have created the places where we live and work today. Its physical elements range from buildings, settlements and landscapes to individual artefacts and ecofacts, at all scales from single sites to extensive human areas. In whole or part, the historic environment is valued as a cultural, social and economic asset that makes a major contribution to the quality of people's lives. (IFA *et al.* 2007, 2)

However, Stanley reminds us that 'the authorities that now define what is heritage have to incorporate the authorities of minorities and excluded groups and have to expose their authority and their decisions to scrutiny by the broader community' (Stanley 2006, 81).

But how can we measure value? Discussions in a conference on new approaches to the past included Groube's work on assessing priorities for the protection of ancient sites in Dorset (Groube 1978) and looked at areas such as the scale of threat to a site, site frequency and local relevance. Aplin lists three criteria:

1. scale – something may be important to a local community, to a region, to a state or other administrative unit, to a nation, or globally;

2. importance – how important is it at the appropriate scale, and why;

3. either uniqueness or representativeness

(2002, 20).

Others believe that the 'measure' of 'local distinctiveness is characterised by elusiveness, it is instantly recognizable yet difficult to describe', that 'our cultural landscape is a physical thing and an invisible web' which may include 'stone walls, Wensleydale sheep and halal butchers, whiskies of Islay, bungalows and synagogues, round barrows and rapping' (Clifford and King 1993, 1). Criteria used for World Heritage Sites are discussed below.

Involving children in making decisions about their own environment is a fundamental part of citizenship studies. Copeland (1993, 32) outlines an activity in which a class (or it could be another more informal group) grades buildings or features – from visits and/or photographs – in order of priority for preservation with their reasons. For example, one group listed the bridge across the high street as the highest priority because it was '14th century and was likely to collapse if not preserved for pedestrians only'.

The Canterbury Archaeological Trust (see also p. 91) actively promotes citizenship through its comprehensive education programmes, explaining to teachers and students that social and moral responsibility, concerns of the local community and democracy feature in 'the practice of archaeology which "rescues" sites threatened by modern building development. This is a "real life" example of citizenship in action in the local community and can give children an opportunity to learn about and question a number of collective values and attitudes which affect their environment' (CAT 2010b). One Canterbury school for young people aged 4 to 19 with severe learning difficulties developed a project under the direction of English Heritage and the Canterbury Archaeological Trust. The project was based in an area of the city which had been rebuilt after bombing in World War II and was being redeveloped again. They looked at how the area had changed over time and how it could meet the needs of the local community through consultation and detailed planning. Primary-age children created a 'Big Book' of drawings, photographs and writing with symbols and a drama story (Spicer and Walmsley 2004, 66; Green 2001, 72–3).

Ethical concerns

A number of concerns about the heritage may be classed as ethical, or as conflicts between values or beliefs of different sets of people (Brisbane and Wood 1996, 42–9). These concerns may, for example, be between 'professionals', who see the need for the long-term conservation of the historic environment, and the 'public', who want access to that environment, or some of the community who want to see development to support an ailing local economy. England's Lake District is

Living inside an ancient monument

The World Heritage Site of Avebury was investigated in detail by Alexander Keiller who bought much of the stone circle (see Fig. 12.1). From 1937 to 1939 he excavated Avebury and re-erected some of its prehistoric stones. Newspaper articles published in a pack for teachers (Coupland 1988) showed that local people had mixed views about Keiller's plans to knock down modern buildings to reveal the stones. *The Times* (21 July 1937) described one building, a garage, as 'an expanse of dilapidated corrugated iron sheds. This eyesore hid from view two very fine stones in the Avebury group'. The *Swindon Evening Advertiser* (23 July 1937) carried a letter from some of Avebury's residents who complained about the effect on their own lives, protesting that 'we are informed that the proposal is to make Avebury as it was in bygone centuries, but are not told what is to happen to the inhabitants who are now living there and whose livelihood depends on the work in the district'.

Fig. 12.1 Avebury, Wiltshire. The stones of Avebury monument can be investigated by visitors outside and inside the village. Some of the monument's stones are close to or have been incorporated into houses and other buildings.

a case in point. This landscape, discovered in the 18th century and immortalised by the poets Wordsworth and Coleridge as a wild and romantic place to visit, is now visited by about 15.5 million tourists each year. A National Park since 1974, the Lake District has stringent planning controls over development. Despite a long history of rambling (the Federation of Rambling Clubs was founded in 1905) and large numbers of ramblers in the UK, a freedom, or right to roam, Act of Parliament was put forward each year from 1884 to 1914 but failed to pass into law. The six ramblers sent to jail in 1932 for leading a mass trespass on Kinder

Scout in the Peak District caused a national outcry. Since the foundation of the Ramblers Association in 1935 many mass trespasses, campaigns and various Acts of Parliament have widened public access to the countryside and coast culminating in the Countryside and Rights of Way Act 2000.

Four types of issues concerning archaeology and the heritage may be used for citizenship projects in education.

Site protection: Most people would broadly agree that, if we value a particular part of our environment whether considered historic or not, we need to protect it against change or at least inappropriate change. It is not always easy to argue for the legal protection of the remains of past human activity if it is close to present time. Places of conflict, such as battlefields, offer opportunities to discuss the ethics of war and the commemoration of those who died in battle (Purkis 1995; Planel 1995). But while no families today mourn the loss of relatives in the Roman invasion of Britain in AD 43, many people throughout the world are still affected by losses in the two 20th-century World Wars. The prison cells at Richmond Castle in North Yorkshire were used to hold conscientious objectors during both those wars. Surviving here are graffiti written by some of the men who were taken to France during World War I, court-marshalled for refusing orders and sentenced to death. Lloyd's booklet for teachers (2001) examines how the physical evidence in the cells and contemporary newspaper reports can be used to study both this period in history and citizenship issues.

The Nazi concentration camp of Auschwitz in Poland was the site of the murder of 1.1 million people. It has become a place to which large numbers of Jewish people, and many others, make a memorial journey. It is now a protected World Heritage Site. People still live in the apartments originally constructed for the SS, and residents mix with tourists, many of whom are shocked and in tears. A friend living in Poland who took me to Auschwitz posed this question from one archaeologist to another – when the 60-year-old perimeter barbed wire rusts, should we replace it with new as you might remortar the walls of a medieval castle?

Most people in the West recognise the name of the Australian 'site' of Ayers Rock. The Aboriginal name is Uluru-Kata Tjunta and it is a World Heritage Site, inscribed twice, once as Ayers Rock and once as Uluru-Kata Tjunta. Tourists like to climb the rock (80% of the daily 1000 visitors in the late 1990s). But the Anangu people, who are the traditional owners and the main constituents of the site's Board of Management, prefer visitors not climb the rock because it is an ancestral path of spiritual significance and because they have a duty to safeguard visitors – not easy given the difficulty of the climb (Wheatley 1997, 19).

But what if the monument or feature is offensive to some people or a section of the community? What is offensive to one section of the community will be seen as part of the heritage of the opposing community. Should there be legal protection for murals on housing estates painted by paramilitary organisations in Belfast, Northern Ireland? A recent government scheme is funding the redecoration of some of them with more welcoming images. Is it revisionist to alter them to remove some of the violent images? Will professionals concerned with recording and protecting heritage sites and features treat a Belfast mural simply as an historic feature? The problem faced by the Northern Irish authorities is partly concerned with legislation. The archaeological legislation has no cut-off date but

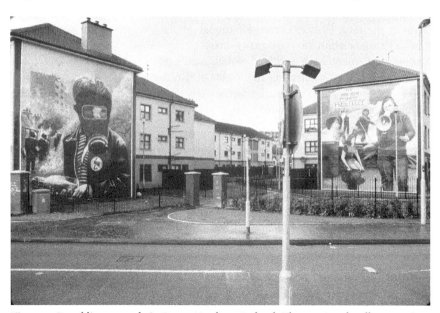

Fig. 12.2 Republican murals in Derry, Northern Ireland. These painted walls are at Free Derry Corner and commemorate the Battle of the Bogside in August 1969. The boy wearing a gas mask is holding a petrol bomb.

protection is largely based on archaeological criteria. On the other hand, historic buildings legislation generally has a 30-year cut-off date and is largely based on architectural criteria. However, the murals are renewed or repainted by artists. McCormick and Jarman (2005) discuss the creation, restoration and survival of these murals (see Fig. 12.2).

In March 2001 the Taliban destroyed two giant Buddhas in Mamiyan, Afghanistan, claiming they were 'offensive to Islam'. Ascherson pointed out that the West has examples of religious intolerance towards heritage artefacts ('Puritan hammer-men obliterated the heads of saints, prophets and angels' in Ely Cathedral) but that 'what the Taliban are doing has two aims. One is nationalist as much as religious. It is to invent a completely new, completely untrue past for Afghanistan, in which no trace of any other religion or empire or regime apart from their own can be found' (Ascherson 2001). The destruction took place despite worldwide protest which included pleas from the Secretary General of the United Nations and many Islamic nations. In an example similar to the damage to Ely Cathedral, during a wave of Calvanism in 1572 iconoclasts vandalised and destroyed ornaments, sculptures and wall paintings in the cathedral in Utrecht in Holland.

Collection and return: Damage from looting by treasure hunters is widespread across the world. Most damage is a deliberate part of the hunt for movable objects to sell to private buyers or museums. The antiquities trade is known to have been responsible for serious damage to many ancient, protected sites – almost 95% of all known sites in Costa Rica have been plundered (Brisbane and Wood 1996, 45).

Museums in the West have become familiar with the demands for the repatriation of objects, sometimes removed illegally from their locations, sometimes bought legally. The Greek government has consistently demanded that

the British Museum return the Parthenon Marbles which Lord Elgin bought from the then Turkish government of Greece. But Philip Henser wrote in an article entitled 'Honour among thieves. Our museums may be full of stolen treasures, but as long as they're cared for, why give them back?'

> It may be, too, that Lord Elgin acquired the Parthenon marbles in dubious circumstances. But even the marbles, for most of their modern history, gained authority and lustre from the fact that they were on show not in a provincial capital such as Athens, but a world city: London. (Henser 2006)

The article's title would make an interesting start for a project or discussion. Views, articles and research about the marbles' return may be investigated at the websites of, for example, the Committee for the Reunification of the Parthenon Marbles (2010), Elginism (2010) and the Acropolis Museum in Athens (2010). The British Museum sets out its views on its 'stewardship' of the sculptures on its website (2010) as well as in the museum itself.

Some museums regularly set up formal debates on controversial topics for senior secondary school students. For example, the Bolton Museum and Art Gallery recently held a debate on the ethics of keeping human remains in museums in 2007.

Objects, especially from ethnographic collections, are sometimes controversial, but human remains removed from graves are usually even more so. Excavations at Spitalfields in London retrieved the remains of about 1,000 individuals from the late 18th to early 19th centuries. Adams and Reeve (1987, 255–6) reminded us that a licence is required from the government's Home Office to remove any human remains and that a statutory Church of England Faculty covers work in churches in use and the reinterment of disturbed remains in consecrated ground. But, as the authors point out, these requirements apply only to human remains known to be Christian. The excavators also had ethical concerns and note that 'it is inadequate for the archaeologist to treat human remains simply as "artefacts"'. Some 42% of the excavated individuals were identified in the parish burial registers and information was passed to descendants who in turn were able to provide information to the archaeologists.

Webb reported on the concerns of Aboriginal communities about their skeletal remains held in study collections. As the person responsible for carrying out liaison and consultation with Aboriginal communities in 1986, the conclusion was that 'after listening to why people did not want research to continue, I could find no scientific argument to balance or equate with their moral one. Anthropologists are, therefore, being forced to re-evaluate the ethics and philosophy of the study of recent skeletal populations' (Webb 1987, 293 and 296).

Since the Spitalfields excavation the British government has passed the Human Tissues Act 2004 and issued guidance to museums which allows nine named national museums to de-accession human remains under 1,000 years old. Although the government document is not statutory it is considered to be 'recommended best practice' and goes on to say that 'the vast majority of human remains in UK museums are of UK origin excavated under uncontentious conditions within a clearly defined legal framework. Approximately 75% of these are from Christian burial grounds' (DCMS 2005, 7). However, the holding of the human remains of indigenous peoples in museums is, rightly, a contentious issue and the whole reburial issue is discussed elsewhere (Hubert and Fforde 2005;

Fforde and Hubert 2006). Archaeologists and museum curators now recognise the rights of indigenous peoples over remains and objects held in collections but are nevertheless concerned about the collection of information about the past. A case in 2006 involved the remains of 17 Tasmanian Aboriginal people held by the Natural History Museum in London. The Museum agreed to release the remains in 2006 but wanted to make a full scientific analysis, including taking DNA, beforehand. The Tasmanian Aboriginal Centre objected to this and the final agreement, reached in May 2007, means that the remains will be returned and the DNA material held under the joint control of the Centre and the Museum.

Some pagan groups in Britain have contacted a number of museums to request the 'return' of pre-Christian skeletons and grave goods for reburial. In February 2007 one Druid group demanded the return for reburial of the remains of a child excavated at Windmill Hill in 1929, now on display at the Alexander Keiller Museum at Avebury, Wiltshire. The British Association for Biological Anthropology and Osteoarchaeology issued a statement commenting that 'modern pagans have little valid status as claimants. For example, a key criterion for assessing the validity of a claimant's link with contested human remains is that continuity in customs and beliefs can be demonstrated' (Smith and May 2007, 18).

But it is clear that archaeologists and museum curators are sensitive to both public opinion and claims by various groups. The Museum of London publishes its policy on the reburial of human remains on its website (MoL 2010b) and gives examples of where reburial has taken place. A recent example, reported by the BBC and other news organisations, was the reburial, after a service at a nearby church in 2007, of a teenage Roman girl's remains in her original grave which had to be excavated in 1995 in advance of building redevelopment. The remains were buried 'in keeping with the Roman traditions between 350 and 400 AD' and the reburial was a 'humane gesture' (BBC News 2007).

Redevelopments: Some British cities, which had already seen 'slum clearances' since the 1930s, saw widespread destruction of many ancient and old buildings in World War II. Mass clearances destroyed not only houses and streets from a city's past but the communities as well. Although the idea of recycling buildings was not a new one, the opportunity to rehabilitate houses was given a boost with the UK white paper of 1969, *Old Houses into New Homes*. Power and Houghton discuss the situation in Birmingham (2007, 94) showing that in 1972 the city still had 100,000 pre-1914 houses with 40,000 in serious need of repair. Mass improvements were carried out and, five years later, the council embarked on improving 30,000 houses built between the two World Wars.

Although people are aware that developments happen all around us – roads are built, there are houses and new public buildings such as hospitals – these are more likely to be contentious as environmental concerns become increasingly important. But the least that the concerned public, as well as archaeologists, can expect is that the past is respected. A report from the Moscow Architecture Preservation Society (MAPS) and SAVE Europe's Heritage in 2007 revealed that 1,000 historic buildings in the capital would be destroyed despite strict preservation laws (MAPS 2010). More recently, the story of Moscow's loss of its architectural heritage has been publicised in Britain (Walker 2009).

Two controversial redevelopments

'CONCERNS ABOUT RE-USE OF BUILDING FROM THE PAST – Ex-Nazi camp to become resort' screamed a headline in the UK's *The Sun* newspaper on 26 October 2006 with an opening paragraph of 'A NAZI seaside holiday resort dubbed "Butlitz" is finally to open – 70 years after it was created ... By ADOLF HITLER'. The resort of Prora is on the Baltic Island of Rügen in Germany and it was here that a holiday complex of huge apartment blocks was begun in 1936 as part of Hitler's *Kraft durch Freude* (Strength through Joy) movement. The 10,000-room complex was shelved at the outbreak of war in 1939 and the building was used as a military hospital, an SS training camp and naval intelligence training centre, as well as for German families whose houses had been destroyed by bombing. Two developers (one is the son of Ernst Busch, an anti-Nazi campaigner who fled Germany) have bought part of the complex from the German government and are converting it into holiday apartments. Ulrich Busch told *The Sun*, 'I think it will be both a challenge and a chance to exorcise the ghosts of the past – and to bring modern-day holidaymakers to a beautiful part of the world.'

'Luxury hotel, equestrian centre, cinema complex – welcome to the new Maze' was the headline in *The Guardian* newspaper on 31 May 2006. The site of Long Kesh Army Barracks and Maze Prison is 10 miles from Belfast, Northern Ireland, and was developed for internment and then as a prison from 1971. It was the scene of many protests against internment without trial and the holding of political prisoners, both Republican and Loyalist, including the Hunger Strikes of 1980–1 when Bobby Sands and nine others died. The prison was closed in September 2000. As an important site in the history of Northern Ireland some parts of the prison, including an H-block, the hospital where the Republican hunger strikers died and aircraft hangars from the World War II airfield on the site have been listed for protection. McAtackney (2006) outlines the history of the site and its implications for reuse. Plans for an International Centre for Conflict Resolution to be housed inside the listed prison buildings were supported by Sinn Féin according to *The Guardian*. In 2008 the newspaper reported that a plan for a national sports stadium proposed for the Maze site had been abandoned amid opposition from Unionists.

Threats: There are a number of threats to sites around the world. The most common comes from the relentless drive for more buildings and other constructions which has to be set against the preservation, or at least the recording, of heritage sites – exacerbated especially in those rich developed countries with widespread archaeological deposits. The removal of parts of the cultural heritage, or inappropriate alterations to old buildings, ruins the integrity of the landscape and we are the poorer for their loss – even if we may never visit them. The value of statutory planning controls which include statutory archaeological investigation could become the first stage in most citizenship projects based on the historic environment.

Some of the most common threats to the heritage are as follows:

▶ *Transport links*. For example, architects working at Gaudi's Sagrada Familia Cathedral in Barcelona are very concerned about plans to construct a rail tunnel which will pass less than 2 metres from the building. In Rome the new C line metro is being constructed through the heart of the ancient city with archaeologists excavating in advance of the construction workers.

◆ *Recent moves to build* a number of new schools in Britain will mean the demolition of large numbers of Victorian schools, especially large ones in towns and cities. English Heritage has published a research document and a guidance note on the future of England's historic schools (EH 2010b; 2010c). A survey carried out by English Heritage in 2010 of 1723 adults revealed that '83% of respondents feel that local councils should do more to find new uses for old, empty schools, and almost half (47%) feel that schools with historic character provide a more inspiring educational environment than modern ones. Three in four also say that historic schools contribute to the identity of a local area' (EH 2010a).

◆ *Farming* accounts for the removal of whole sites in many countries as new land is taken into cultivation or more intrusive farming techniques are introduced. Farmers working land on and around the ancient Persian city of Jondishapour in Iran faced farming bans and criminal charges. Damage to China's Great Wall was being caused by sandstorms caused by decades of agricultural malpractice.

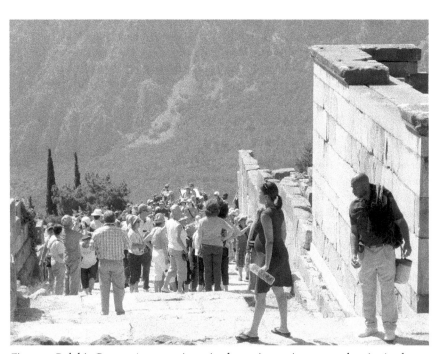

Fig. 12.3 Delphi, Greece. At some times in the main tourist season the site is almost overwhelmed with the number of visitors who arrive in their coach loads.

◆ *The popularity of visiting* ancient, exotic and environmentally sensitive sites threatens their very existence (Pinter 2005) (see Fig. 12.3). The World Tourism Organisation forecasts that the number of people travelling to a 'foreign' country will increase from 700 million in 2006 to 1.5 billion in 2020 (Antomarchi and Ardemagni 2006, 11). The article lists initiatives by ICCROM to highlight damage and suggest partial solutions, such as including statements about the fragility of cultural environments in travel guides such as the *Lonely Planet* guides, changing the visitor profile and the creation of a network which includes cultural organisations and tour operators.

▶ *Unsightly or inappropriate features* added to or within the vicinity of monuments and buildings may break laws or regulations concerning the historic environment. Satellite dishes, for example, are often banned from buildings in historic areas. In May 2007 UNESCO was considering whether to put the Tower of London on the 'at risk' register of World Heritage Sites to prevent it becoming more degraded by nearby high-rise buildings. The recent spate of wind turbines ('wind farms') is also causing concern to archaeologists and environmentalists. There were protests about the French government's plan in 2009 to allow a wind farm within sight of Mont-Saint-Michel, a UNESCO World Heritage Site.

▶ *Climate change* is now recognised as a serious threat to the world's natural and cultural heritage. The United Nations Environment Programme (UNEP 2006) published its *Atlas of Climate Change* giving examples of threats from, among others, erosion and sea level rises to famous monuments across the world, including the monuments of Alexandria, Egypt; 12,000 prehistoric, Viking and medieval archaeological sites on the coast of Scotland; the 19th-century whalers' settlement on Herschel Island, Canada and pre-Inca sites in the Huascaran National Park, Peru.

▶ *Other environmental concerns* for the heritage include air pollution, which has threatened famous sites such as the Acropolis in Athens and the Taj Mahal in India. The Iranian city of Bam in which 26,000 people died in the 2003 earthquake lost a large percentage of its heritage and was then put on the World Heritage Sites' register of monuments at risk (see below).

Clearly, war can threaten ancient landscapes and historic sites and buildings. The Hague Conventions (1899, 1907 and 1954 – this latter convention has still to be ratified by the UK) and the Geneva Convention (1949) were international attempts to stop destruction and looting of, among other things, cultural property. Nevertheless, there have been, and continue to be, many examples of destruction through war and other conflicts. Allied bombing of Lübek in March 1942 was the cause of the Baedeker raids on British cities later that year by the German Luftwaffe. The conflict in the Balkans in 1991–5 saw the destruction of many historic sites. Šulc listed of some of the destruction which included 2,271 cultural monuments, 1,537 damaged houses in historic towns, 66 museums and galleries and 481 Roman Catholic churches (2001, 162). Stanley-Price (2006, 8–9) reported on a 2005 ICCROM Forum which suggested action after wars which included the powerful need for communities to restore their monuments, quoting Coventry Cathedral in 1945 and Dubrovnik in 1993.

Even more recently the war in Iraq has caused the destruction of cultural artefacts as well as sites. Three international conferences were held in 2003 to discuss the looting of the Iraq Museum in Baghdad – conferences by UNESCO in Paris, the British Museum in London and by INTERPOL in Lyon. The work carried out by archaeologists and others prior to the invasion was discussed by Stone (2005). Two British archaeologists protested about the destruction of archaeological sites in a letter to *The Guardian* newspaper of 17 January 2005:

> The extensive cultural vandalism of archaeological sites in Iraq by US-led forces (Report, January 15) is deeply depressing, but it comes as no surprise. Archaeological organisations on both sides of the Atlantic were warning British and American governments about these issues for months in advance of the conflict, and we have repeated our concerns many times since. If we are to have any claim to international leadership we must press ahead rapidly with the ratification of the 1954 Hague convention for the protection of cultural property in the event of armed conflict, and we should use our influence to encourage the Americans to do the same. Iraq is already a signatory to the convention. We must also do more to help the Iraqi authorities to prevent looting of their archaeological sites, and also root out those illegally trading in antiquities that have been stolen from Iraq.
> Dr Mike Heyworth
> Director of the Council for British Archaeology

> We should be angry but not surprised at the destruction of Babylon. Despite the requirements of The Hague convention, aggressors throughout history have targeted the cultural treasures of occupied territories in order to undermine their opponents' national esteem and sense of cultural identity. The irreparable damage done to the ancient sites of Babylon is a criminal act whose historical precedent is to be found in the Nazis' looting of art treasures and destruction of famous monuments throughout Europe during World War II. The decision to base a military depot in one of the most important archaeological sites in the world can only have been issued from a deeply reactionary and reckless power that is utterly hostile to the cultural achievements of mankind.
> Prof. Geoffrey Wainwright
> Chairman of Wessex Archaeology
> Formerly Chief Archaeologist at English Heritage

The effects of the war on Iraq's historic environment and the looting of the Iraq Museum have been catalogued and discussed in a number of publications (e.g. Bogdanos 2005; Bogdanos with Patrick 2005; Stone and Bajjaly 2008).

Citizenship projects

A number of national heritage organisations have carried out projects and published citizenship resources for teachers (e.g. UNESCO 2002; Spicer and Walmsley 2004; Aslan and Ardemagni 2006) or encouraged teachers to use the heritage in teaching citizenship (Henson 2008). In 2007 a review of the heritage education projects in Europe from 1989 (when the Council of Europe began its heritage education programmes) to 2006 was published (Branchesi 2007).

In this report one of the recommendations to the Council of Europe was that through heritage education, with its cross-curricular approach, the Council will provide 'Education in sustainable development (including the cultural dimension of such development) and in democratic citizenship, as a means of securing empowerment and solidarity' (Cerri 2007, 21).

In the same report Copeland gives two useful 'interrelated definitions of citizenship':

 a. A citizen is a person who has rights and responsibilities in a democratic state

 b. Citizenship is about making informed choices and decisions and about taking action, individually and as part of a collective process.

<div align="right">(Copeland 2007, 68)</div>

A directory of resources and services from 32 institutions was published by Archives, Libraries and Museums London to encourage school teachers to use them for their citizenship work (Gould and Adler 2005). All the publications and resources mentioned above show that what constitutes the past and a concern for the heritage can usefully form part of citizenship, social studies and history teaching in schools and colleges. Any issue taken up as an education project will involve presenting two or more, often conflicting, points of view – for example, legislation to protect the archaeological heritage against the economic needs of communities and the needs of archaeologists and curators to collect scientific information against the rights of the 'owners'.

What follows includes examples of successful educational projects which deal with these issues.

Making connections

An important part of social studies teaching is making connections with place, culture and other people. The statement that 'Contrary to our stereotypical views of adolescents, many students between the ages of ten and fifteen have their eyes intensely focused on the world "out there". They want to know, "What kind of place is there for me – and others like me?"' is from a thoughtful book with lots of exciting ideas for teachers (Wolf *et al.* 1997, vii) which outlines work carried out in America. In it one of the contributors explained how an archaeological activity formed part of an Awareness Month at a school with a 'culturally rich and diverse student body and staff'. Students came from a variety of backgrounds – Latino 39%, European American 17%, mixed ancestry 13%, Chinese 12%, African American 8% and Filipino 7%. The activity took the students from their own identity to Maya identity by asking them to make two lists of 10–20 most important things. The first should relate to their own lives – for example, beliefs, events or people – and they were asked to bring in objects from home which represented them – for example, photographs and traditional clothes. The second list included things important to their shared culture and to bring in objects that represented those values. Students were then asked 'How can thinking about what is important to us help us better understand the Maya?' (Costello 1997, 31–3).

Other sections of this book look at the place of prehistory in education but, from a citizenship point of view, we should at least remember that prehistoric

peoples account for over 99% of the human past and made all the important pre-industrial discoveries and inventions which define the human race, including the development of speech, the modification of natural objects into tools, the use and control of fire and the domestication of plants for food and animals for food, labour and raw materials.

We also know, for example, that Hadrian's Wall was built and patrolled by people from different peoples and races from across the Roman world: from 18 modern countries from Holland to Iraq and from Germany to Morocco.

A citizenship project for secondary schools in Spain (Bardavio *et al.* 2004) used an archaeological dig of a local site to counter the sense of 'rootlessness' amongst adolescents. Residents in the area, mostly newly arrived because of the recent building of a dormitory town, were in general unaware of the rich archaeological resource there.

An education project carried out by English Heritage in Liverpool examined ways in which school pupils (at primary and secondary levels) could explore the Rope Walks, an area named after the rope makers and maritime industries of the 16th and 17th centuries. Buildings and archives were studied so that the pupils could, in particular, understand how some buildings changed to accommodate social and communal developments (Walmsley 2002; Horwich 2004).

Stewardship

Archaeologists and heritage managers often talk about *our* pasts and encourage local people to think of the sites, monuments and landscapes as their own. This is certainly a major element of my work in Turkmenistan (see p. 261). The assumption is that, if people consider that they are the actual *owners* of the remnants of the past, they will look after it as well as they would look after their own possessions. Recent research among pet owners supports this assumption. Researchers from Carnegie Mellon University in Pittsburgh, Pennsylvania (New Scientist 2007) gave a Siamese fighting fish to each of its sample group of 82 university staff and students to look after for two weeks. At the end of the two weeks, 95% of those who had been told that they were temporarily the 'owners' opted to keep the fish, but only 75% of those who had been told that they were temporarily the 'caretakers' did so.

A section of a teachers' resource for the Casa K'inich Maya Learning Centre, called 'Stewardship', aims to show how the ancient Maya saw air, water, land and living creatures as precious to them – sacred in fact. Here is part of what the resource says about one of the deities:

Air (Ik')
Do not burn your fields before the planting season.
Use compost to fertilize soil.

Burning harms our lungs and pollutes the air.
Get your car fixed if the exhaust is black.
Do not cut down large areas of trees to create new fields or to obtain firewood.
Instead, gather wood from fallen trees, and reuse old fields with composted soils.

(Docter 2005, 56)

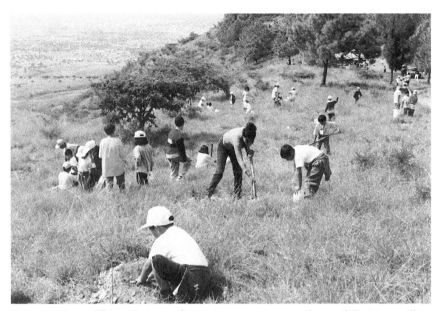

Fig. 12.4 Monte Albán, Mexico. Reforestation campaigns on slopes of the Monte Albán Archaeological Zone, under threat from erosion, vandalism, fires and illegal dumping. Students also carried out conservation work as part of their social studies course during a fieldwork season at Monte Albán.

An outline of the various educational strategies (see Fig. 12.4) at Monte Albán in Mexico reports on the creation of volunteer custodians (children and young adults) who receive 'special training to help them understand the cultural value of different elements of the site' so that they can interact with visitors to the site under the supervision of official custodians. This archaeological project also involves reforestation and recycling initiatives (Robles and Corbett 2008, 20–6).

English Heritage Education was involved in a number of stewardship projects: 'Your Past Our Future: The Conservation of Historic Buildings' with ICCROM and Accademia Italiana in 1993, 'The City Beneath the City' with ICCROM and the Council of Europe in 1995 and 'Save our Streets: Making a difference to your locality' in 2005. The 'City Beneath the City' project has been described and evaluated (Minore 2007). In 1992 the 'Schools Adopt Monuments' scheme (SAM) was created on the initiative of the Fondazione Napoli Novantanove as an in-service training project which meant that adopting a monument means not simply getting to know it but taking it to heart, so saving it from oblivion and degradation, looking after it, caring about its conservation, making it known to others, promoting an appreciation of it (SAM 2010).

In 1997 English Heritage Education took over the scheme in England and encouraged schools in eight towns to adopt a range of monuments from an air raid shelter to a cinema, from a Muslim burial ground to a church and from an almshouse to a clock tower. This project developed into 'Know your Place' and curriculum-based activities were published for teachers which included a Scheme of Work called 'What do we want the area to be like in thirty years' time?' (Fordham and Hollinshead 2000, 12). The Adopt a Monument scheme was also taken on by a variety of other organisations in the UK and Ireland. The Council for Scottish Archaeology still runs the scheme, promoting it to archaeological societies and

to schools (Bradley 2009). These projects were followed in 2001 by a large, long-term citizenship project involving all the education staff and schools, sometimes also with other heritage organisations, across the country and was published in full (Spicer and Walmsley 2004). One of the individual projects involved primary schools in towns near Huddersfield which were undergoing major regeneration work. In the project, called 'Fast Forward to the Past: Our High Street', older primary children produced a video that considered how the towns they lived in would be changing over the next ten years and whether they could have any influence on the management of their historic environment in the future. The video was included in an in-service video for teachers (English Heritage 2004). The project's specific links to Personal Social and Health Education and Citizenship in the English National Curriculum were that children were taught

- ◆ To take part in discussion
- ◆ To recognise likes and dislikes
- ◆ To share opinions and explain views
- ◆ To identify what improves and harms their environment
- ◆ To understand that economic choices affect communities and the local environment
- ◆ To collaborate to produce a final product.

(Spicer and Walmsley 2004, 58–9)

Looking at the immediate environment of a school or college will throw up various issues. For the most ordinary high streets there will be questions such as:

▶ Are there changes which spoil the overall architectural look? (For example, mobile phone masts on top of medieval church towers.)

▶ Are there inappropriate changes? (For example, shop signs out of character with the general 'feel' of the place – too big, too bright, too 'loud'.)

▶ Are new buildings designed to fit in with existing ones without merely being pastiches of the past? Contemporary architecture can sit well alongside the old – for example the glass pyramid at the Louvre in Paris – but is often controversial.

▶ Are there buildings in the high street which are already protected by national or local legislation? Are some new buildings possible contenders for protection now or in the future?

Reusing the past

Many of the types of buildings included in the section on 'Recycling and the Past' (see p. 268) have formed the resource for citizenship projects in schools. Redundant churches provide ideal subjects for discussion about their future use. Schools in Suffolk were chosen to pilot a citizenship project which was published as an example for teachers (Courtley 2001; Spicer and Walmsley 2004, 54–5). Part of the work carried out by Courtley was to write a Scheme of Work called 'What should happen to redundant churches?' as a useful guide for teachers. This included, for example:

Table 12.1 Links with citizenship (after Courtley 2001, 4–5)

Learning Objectives	Teaching Activities	Learning Outcomes	Curriculum Links
To explore why some churches become redundant and the issues and problems that arise from this. To think about whether historic churches should be preserved and if they can be reused.	Visit a redundant church. First impressions of a redundant church. Explain the term redundant and brainstorm why a church might become redundant. Discuss what happens to buildings when they are left empty – vandalism, deterioration. Discuss what should happen to these buildings – demolish or reuse?	To understand what the phrase 'redundant church' means. To recognise that there are different reasons why a church might become redundant. To express and justify opinions relating to the conservation and/or reuse of church buildings.	Citizenship: Discuss a topical issue. Consider a dilemma – demolish or reuse, when reuse may be more difficult and costly than a new building. Recognise what improves and harms the built environment. History/Geography: As a follow-up compare old and modern maps to see if changes around the church could have affected its use.

One of the schools looked at turning one redundant church into a youth club and the children gave their own for and against arguments.

Club for Brownies/Beavers etc. at St Clements

For	Against
Parking	Busy road
Easy access	Are there enough young people around here?
Open space inside and out	Not too much to change

While some communities are concerned about what the subsequent use of a church will be, they are usually unhappy to see a building which may be considered a much-loved historic building removed or destroyed. There was controversy over plans for the Methodist Chapel in Sproxton, Leicestershire, built in 1863–4. In 1990 the Grantham Methodist Circuit put in an application to demolish the chapel, which had not been in regular use for nearly a year. Baker University (founded by Methodist Union ministers in 1858) in Kansas wanted to move the chapel stone by stone, rebuild it in the university campus at Baldwin City and continue to use it as a place of worship.

Table 12.2 The Sproxton Chapel campaign

Process	Comment
Parish Council meeting	While it was clear at the parish council meeting, where the application for demolition was discussed, that a number of villagers were in favour of this application, others were very much against it (Source: circulated statement from local resident Alan McPherson September 1990). The parish council was in support of demolition despite previously discussing the need for low-cost housing in the village (the chapel could easily have been converted). The *Leicester Mercury* (26/09/1990) reported the villagers' concerns but quoted Baker University as saying that the 'chapel would be very much loved and cherished'.
Borough Council meeting	SAVE Britain's Heritage, an influential conservation group, opposed the application, pointing out that 'the chapel is exactly the sort of building that conservation area designation was set up to protect', and that historic buildings usually found new owners and new uses easily (Source: SAVE Britain's Heritage letter to Melton Borough Council 20/09/1990). Local newspapers recorded the controversy as the borough council turned down the application: 'Historic church can't go to US' (*Nottingham Evening Post* 2/10/1990).
Appeal	The owners, the Grantham Methodist Circuit, put in an appeal to the relevant government department and their wishes were upheld after some delay.
Removal	A final service was held in the church in 1995 (with a Channel 4 film, 'Holy Places: Sproxton Methodist Chapel', which looked at the final preparations for the service and the chapel's removal broadcast on 13/12/1995). In 1996 the church was dismantled and its 25,000 or so stones were numbered and shipped the 5,000 miles.
Rebuild	The chapel was rebuilt on Baker University's campus (with the addition of a basement) with a donation of £1 million from a local businessman and renamed the Clarice L. Osborne Memorial Chapel. Margaret Thatcher, the then British Prime Minister, spoke at the opening ceremony on 24 October 1996, using 'the opportunity to make a scathing attack on affirmative action' (Source: *The Guardian* 24/10/1996). Her father, Alf Roberts, had preached in the chapel in the mid-1930s.
Reuse	Regular services are now held in the chapel which is open every day. What was once the music room behind the pulpit now houses a museum display and objects from the chapel's past. The chapel's basement is 'the only place on campus where you can get a free soda anytime from the constantly restocked fridge' (source: Baker University website). The chapel has become a favourite place for weddings.
	In Sproxton part of the site of the chapel has been sold off to the next-door house owner and the other part contains a memorial put up by the Grantham Methodist Circuit.

This example could be used for a discussion or project as part of citizenship work. Speakers or groups could take opposing views, perhaps using role-play:

FOR

▶ The chapel found a new life which allowed it to go on in use as a building for worship by the same denomination. Some local Sproxton villagers and local Methodists have been pleased with the outcome.

▶ It is clearly appreciated by the university and the students who worship there, About 200 couples have been married there (Source: *Baldwin City Signal* 17/08/2006).

▶ An historic building has been carefully restored together with its fittings, such as the organ.

▶ The university and local people are proud of their heritage links with England.

AGAINST

▶ The chapel need not have left the village but could have been reused sensitively as it was in a designated conservation area. 'The Planning Officer of Melton Borough Council said that the demolition represented a watering-down of the conservation area' (Source: *The Melton Times* 27/09/1990).

▶ Its loss is a loss to the character and history of the village.

▶ Does its removal to another place negate its historic integrity? Is it just another example of a British 'antique' being exported?

This example of moving an entire historic building may be compared with that of the Weald and Downland Open Air Museum in West Sussex, to which, since 1970, about 50 historic buildings dating from the 13th to the 19th century have been brought for the public to see (Weald and Downland 2010).

Archaeology and evidence

Archaeologists know that the past is only imperfectly understood. Education about the past must include both the results of research and investigation and the processes by which that work is conducted. We must teach both children and adults that archaeologists first investigate and then present the evidence and that, without the evidence, we can make no useful statements about what might have happened in the past.

We must also be clear about why we, as archaeologists, think that the way the evidence is collected is important. Petrie wrote the following in 1885 about monuments in Egypt:

> Never before has that land of monuments been so fiercely worked upon, daily and hourly the spoils of ages are ransacked, and if of marketable value are carried off; but whether preserved or not is a small matter compared with the entire loss of their connection and history which always results in this way. If we are not to incur the curse of posterity for our Vandalism and inertness, we must be up and doing in the right way. (Drower 2004, 11)

These are sentiments which any archaeologist today would agree with. Even school textbooks, for some time, have been at pains to point out the careful way in which archaeologists must collect, analyse and interpret the evidence. We do

not dig holes and wrench objects from the ground willy-nilly. We say that objects taken from their context lose value from their contribution to understanding the past. Petrie used the phrase 'loss of connection'. But now some seem to condone treasure hunting, weakly accepting 'pretty things' into museum collections. The British Culture Minister was quoted as saying that metal detectorists were the 'unsung heroes of the UK's heritage' and the article went on to list places in Britain which had produced 'treasure', for example 'Hampshire and Wiltshire – Rich in late Roman villa sites: a retired florist found a kilo of pure gold jewellery which was Roman but dating from before the conquest, scattered across a ploughed field near Winchester' (Alberge 2007).

This rightly provoked protest from archaeologists and archaeological organisations. Rescue, the British Archaeological Trust, in an open letter in *Rescue News* (Rescue 2007, 7) to the Culture Minister at the Department of Culture, Media and Sport, pointed out that this was slighting 'the efforts of those amateur and professional archaeologists whose work is contributing in a significant way to our understanding of the past and of human society in the past' and that metal detectors are 'only capable of recovering a tiny part of the rich and diverse archaeological record which forms part of our shared heritage'. On the same letters page Brian Philip, from the Kent Archaeological Rescue Unit, wrote that '50% of artefacts taken by [treasure] hunters are never recorded, but are clearly lost into private collections'.

World Heritage Sites

In many ways, World Heritage Sites are an ideal subject for a discussion about what we should do with places which are considered special, not just by local communities but by heritage specialists across the world. Information about World Heritage Sites is easily available from both national and international organisations. Because of their special status, damage to or neglect of these sites is carefully monitored and creates headlines across the world. The International Council on Monuments and Sites (ICOMOS) publishes its concerns in its monuments at risk registers. Its detailed report for 2004/5 (ICOMOS 2005, 12–14) listed the main risks as war, development, tourism, redundancy and other risks such as neglect without recording and natural disasters. The latest available report for 2006/7 has a special section devoted to 'Global Climate Change', asking 'every cultural site at risk?' (Petzet and Ziesemer 2008, 194). Besides damage to the cultural heritage through forest fires in Greece and Australia, the report highlights threats to sites from dams in Turkey, the loss of expertise of vernacular building skills in Mexico, the numerous threats to historic town centres through demolition, renewal and traffic schemes – for example, in Budapest and several Spanish towns – and the problem of high-rise buildings ruining the visual integrity of historic sites in towns and cities – for example, in Vienna. Finally the report lists, once again, the problems of conflict.

To sum up, it can be said that the *Heritage at Risk Report 2006/2007* is proof that the situation of the cultural heritage is still highly critical in many regions of the world. While time and time again billions are being invested into the preparation of war and destruction, the responsible often lack the necessary commitment when it comes to preserving the threatened heritage of past centuries and millennia (Petzet and Ziesemer 2008, 10).

UNESCO publishes an annual list of World Heritage Sites in danger and that in 2010 includes 17 cultural heritage sites.

> Armed conflict and war, earthquakes and other natural disasters, pollution, poaching, uncontrolled urbanization and unchecked tourist development pose major problems to World Heritage sites. Dangers can be 'ascertained', referring to specific and proven imminent threats, or 'potential', when a property is faced with threats which could have negative effects on its World Heritage values. (UNESCO 2010a)

The World Monuments Fund (WMF) runs World Monuments Watch and publishes a list of the most endangered sites every two years. The Fund has been successful in using its listings to encourage awareness of the dangers to World Heritage Sites. Archaeological sites are already being excavated ahead of the construction of a new railway line from Athens to Patras in Greece. The railway was to cut through the ancient site of Eliki, which some claim to be the site of 'Atlantis'. It was first put on the World Monuments Watch's endangered list in 2004. This listing and pressure on the Greek authorities led to the proposed line of the railway being moved further north, away from the site itself, according to Dr Dora Katsonopoulou, the director of the Eliki Research Project (Katsonopoulou *pers comm* 2007). The Fund draws attention to a number of sites where resources, both human and monetary, are lacking and where conservation and management plans have not been drawn up. In 2010 the Fund listed 93 sites at risk across 47 countries and highlights the 'need for collective action and sustainable stewardship' (WMF 2010). The Fund clearly uses its list to encourage authorities and owners to counter the dangers pointed out. St Mary's Stow Church, Lincolnshire, was on their 2006 list; the Fund noted 'Watch listing intended to call attention to the critical state of St Mary's and to the plight of parish churches throughout Britain, which through population loss are being shuttered and falling into disrepair' (WMF 2006). The Fund also noted in its 2006 list the importance of public awareness and education in saving monuments at Dalhousie Square, Calcutta, India, which had good public education programmes and at Sandviken Bay, Bergen, Norway, where there was a local society fighting for the site.

My analysis of the 2006 list showed three main categories of threat: Environmental (erosion, climate, floods, earthquakes, humidity, soil salinity, industrial pollution, jungle vegetation, water infiltration), Human damage (war, looting and treasure hunting, vandalism, neglect, unauthorised occupation, removing building materials, population encroachment, development) and Conservation (no/inadequate/inappropriate conservation, little/no maintenance, lack of funds).

The 2008 Watch list (WMF 2008) has been analysed in the Architectural Record (AR) which found the sites could be categorised as:

6 Sites Threatened by Global Climate Change

7 Sites Threatened by Conflict

6 Sites Threatened by Economic and Development Pressures

5 Historic Cities

7 Modern Architecture.

 (AR 2010)

World heritage and education

Many education projects have been carried out through the World Heritage Centre of the United Nations Educational, Scientific and Cultural Organisation (UNESCO), many through their Associated Schools Project and more by schools across the world using their resource material. *World Heritage in Young Hands* is a resource pack for teachers with information about world heritage and a number of educational approaches including the themes of world heritage and identity, tourism, the environment and a culture of peace (UNESCO 2002). The theme of tourism, for example, was taken up as a project by the Oak of Finland (see p. 319).

One of the projects which the World Heritage Centre carries out are the regular meetings of the World Heritage Youth Forum which provides an opportunity to present work from around the world and suggestions for new projects and publications for UNESCO. In the 2001 World Heritage Youth Forum, which was held in Sweden, reports on a range of education projects were discussed including 'The non-tangible heritage in Sweden', 'What Angkor Wat can teach us about peace and war', 'Art and Hadrian's Wall' and 'Can World Heritage education help us overcome history?' (Swedish National Commission for UNESCO 2002).

One approach to World Heritage Site status could be to discuss which new sites should be included on UNESCO's list. Cultural and natural sites are considered for inclusion or 'inscription' and UNESCO publishes the definitions and criteria which it uses to inscribe sites on its list. For example, Article 1 in the *Convention Concerning the Protection of the World Cultural and Natural Heritage* defines the cultural heritage as

> Monuments: architectural works, works of monumental sculpture and painting, elements or structures of an archaeological nature, inscriptions, cave dwellings and combinations of features, which are of outstanding universal value from the point of view of history, art or science;
>
> Groups of buildings: groups of separate or connected buildings which, because of their architecture, their homogeneity or their place in the landscape, are of outstanding universal value from the point of view of history, art or science;
>
> Sites: works of man or the combined works of nature and man, and areas including archaeological sites which are of outstanding universal value from the historical, aesthetic, ethnological or anthropological point of view.

> (UNESCO 1972, 2)

UNESCO use the following selection criteria:

i. to represent a masterpiece of human creative genius;

ii. to exhibit an important interchange of human values, over a span of time or within a cultural area of the world, on developments in architecture or technology, monumental arts, town-planning or landscape design;

iii. to bear a unique or at least exceptional testimony to a cultural tradition or to a civilization which is living or which has disappeared;

iv. to be an outstanding example of a type of building, architectural or

technological ensemble or landscape which illustrates (a) significant stage(s) in human history;

v. to be an outstanding example of a traditional human settlement, land-use, or sea-use which is representative of a culture (or cultures), or human interaction with the environment especially when it has become vulnerable under the impact of irreversible change;

vi. to be directly or tangibly associated with events or living traditions, with ideas, or with beliefs, with artistic and literary works of outstanding universal significance. (The Committee considers that this criterion should preferably be used in conjunction with other criteria);

vii. to contain superlative natural phenomena or areas of exceptional natural beauty and aesthetic importance;

viii. to be outstanding examples representing major stages of earth's history, including the record of life, significant on-going geological processes in the development of landforms, or significant geomorphic or physiographic features;

ix. to be outstanding examples representing significant on-going ecological and biological processes in the evolution and development of terrestrial, fresh water, coastal and marine ecosystems and communities of plants and animals;

x. to contain the most important and significant natural habitats for in-situ conservation of biological diversity, including those containing threatened species of outstanding universal value from the point of view of science or conservation.

(UNESCO 2010b)

The UNESCO definitions and criteria could be used to discuss (or employ a role-play situation – see below) local, national or international sites. Students could be asked to set their own criteria. To help restrict the discussion they could decide to create their own new Seven Wonders of the World or Top Ten Sites.

Role-play

Wheatley (1997) provides the most accessible guide for teachers to World Heritage Sites with information about the process of listing, threats to the sites, detailed case studies and educational project ideas. Included in this book is the idea of using role-play to examine issues reused from a teacher's book about Stonehenge (Anderson *et al.* 2000, 29–31). Role cards were supplied for all the groups and organisations involved in a discussion about ownership and access to this World Heritage Site, especially around the Summer solstice: National Trust, English Heritage, District Council, Local landowner, Police, Druids and New Age Traveller.

The following role-play exercise is taken from notes for students taking the MA in Managing Archaeological Sites at the Institute of Archaeology, University College London (Williams 2006). The role-play activity centred around the plan to build a visitor centre at Petra in Jordan and students were given detailed

background notes and references to follow up to prepare for the focus group discussion.

The issues

a) Can the continued Bidul occupation of archaeological structures be reconciled with conservation and tourism concerns?

b) How can the management of the ecological resources be developed alongside local communities and archaeology?

c) Should there be a new visitor centre near the entrance to the Siq (leading into the central Petra basin)? If so, how should it be conceived and organised?

d) How can the needs of the local communities be reconciled with the needs of other stakeholders in the management of tourism?

Participant groups

1) Site managers (Department of Antiquities: archaeological/conservation background)

2) Bidul tribe

3) Ministry of Interior

4) Hotel industry/tourism representatives

5) The Petra National Trust

Summary

▶ The place of citizenship in the school curricula in a number of countries is outlined.

▶ Issues which are of concern to archaeologists, museum curators and the general public are raised here – for example, the collection, storage and display of ethnographical material and the reuse of buildings which have connections with atrocities from the past.

▶ Threats to archaeological landscapes and sites across the world are listed, including World Heritage Sites.

▶ A number of citizenship projects which have been used are shown here with examples from a school's local area and from world-famous sites.

Conclusions

Although the curriculum subject of citizenship is relatively new in the UK, topics which now form part of that subject have been discussed in schools from the beginning of the 20th century. Admittedly the debates that focused on the care of, or the threats to, parts of our historic environment were usually confined to older secondary school students and beyond. The difference now is that these topics are commonly used with the youngest pupils in primary school. Formal citizenship studies as part of a statutory curriculum enable archaeologists to propose to teachers that the archaeologists' concerns should form part of this new subject.

The ethical concerns which surround the issues raised in this chapter – for example, the issue whether the propaganda murals in Northern Ireland should be seen as part of a protected heritage alongside castles and abbeys – should be and are being used as topics for research and debate in schools. Archaeologists often say that they want to create a much better informed body of citizens who will be more likely to support them when they raise their concerns. The subject of citizenship is ideal for this purpose.

This section concludes with case studies about three very different organisations but which are all concerned with the promotion of heritage issues to schools. The first case study describes a project created by the archaeological service of Suffolk County Council to promote its work to schools and other groups. Central to this project is the study of recycling, past and present. The second case study describes the educational work of the Churches Conservation Trust which brings the issues around redundant churches and the ways in which this accessible historic resource may be best used in curriculum work to the attention of teachers. The last case study in this section is from Finland. It shows how three very different government organisations have created a project to help schools to use the rich cultural resources of the country. In addition, the Oak of Finland project has chosen to encourage schools to take the issues of World Heritage Sites seriously and linked those issues with curriculum subjects.

Case study

The Garbology Project: Suffolk County Council

Background

Suffolk has a strong tradition in county-funded or -supported archaeological investigation. Suffolk County Council appointed Stanley West as its first County Archaeologist in 1974 and has regularly published reports of its work in the *Proceedings of the Suffolk Institute of Archaeology and History* as well as full excavation and fieldwork reports in regional and national publications, such as *East Anglian Archaeology*, and on its website.

Within its Environment Division the council now employs a number of archaeologists and office assistants in its Archaeological Service in two teams: the Conservation Team and the Field Projects Team.

Outreach and archaeology

An important part of the council's work, not just in archaeology but across its various functions, is outreach and education. It has a commitment to increasing public awareness, access and involvement in all its environmental services. The principal stated objective of the council's Archaeological Service is 'promoting the conservation, enhancement and understanding of Suffolk's distinctive historic environment' and further defines it as 'promoting understanding of Suffolk's Heritage through publications, exhibitions, guided walks and lectures' (Suffolk County Council 2010a). The most recent available Annual Report (2006–7) for the Archaeological Service (Suffolk County Council 2007) reported on its wide range of excavations, publications and outreach activities, including work with local schools and tours of excavation for the public; an open day at the Bury St Edmunds cattle market site drew 1,100 visitors.

The council's Archaeological Service now employs a full time Outreach Officer to work in the community, promoting the county's heritage and developing links with organisations such as schools, youth organisations and community groups. Its current work includes projects in partnership with the Suffolk Wildlife Trust and West Stow Anglo-Saxon Village, funded through the Aggregates Levy Sustainability Fund (a government-funded scheme to reduce the effects of aggregrates extraction). School groups are given the opportunity to study the archaeological evidence from sites excavated prior to gravel extraction and then carry out practical projects, such as building Roman pottery kilns and Iron Age roundhouses to test their theories at Experimental Archaeology Summer Camps (see Fig. 12.5). They will also study the impact gravel extraction has on local communities, its importance as the raw material for much of the road and house-building throughout the country and how former gravel pits are subsequently regenerated, often as wildlife and leisure centres. The project was praised in the evaluation of the Aggregates Levy Sustainability Fund scheme as 'The work pursued within the experimental archaeology camps surpassed all expectations

Fig. 12.5 Building an Iron Age roundhouse

both in the success of its delivery and in the student's reaction to it' (Richards 2008, 34).

The Outreach Officer has produced a wide range of resources for teachers, including film, teachers' packs and activity notes. A number of detailed and illustrated resources for teachers can be downloaded from the website. These include archaeological resources (such as Anglo-Saxon pottery), classroom activities (such as reconstruction drawing), experimental projects on school grounds (such as pottery firing using a bonfire) and experimental archaeology how-to guides (such as How-to build a Bread Oven). On-demand sessions are also provided in schools on a number of different topics.

Waste management and education

The council's Waste Management Service aims to reduce its waste and publishes specific targets each year to reach the government's required targets. Between 1995 and 2007, Suffolk increased its household waste recycling level from 12.1% to 48.4% (Suffolk Waste Partnership 2009, 27). Its Waste Management Department employs an education officer in its School Waste Education Team whose aim is to increase awareness but also to increase recycling in schools. The team provides a free service of activities, advice and resources for Suffolk schools (Suffolk County Council 2010b). Downloadable resources and information about the service are available from their website (Suffolk County Council 2010b). The resources for primary and secondary schools support the team's activities which are firmly based on various National Curriculum subjects and include: the Compost Cycle Lesson Plan: 'Grandmother's Worms' story and discovering compost (for pupils aged 5–7), Material Detectives Lesson Plan: Find out where materials come from

and what happens to them when they are recycled (for pupils aged 7–11), Waste and Carbon Cycle Lesson Plan: Find out what happens to waste material produced by plants and animals (for pupils aged 11–16).

During the year 2008/9 the team carried out a number of events and school visits to promote awareness (Suffolk Waste Partnership 2009, 9).

The Garbology Project

The council's Garbology Project began in January 2005 as a joint project between the Archaeological Service and the Waste Management Service with the aim of pioneering the use of rubbish from recent centuries in Suffolk as a heritage and environmental awareness learning resource. The year-long project was funded by the Heritage Lottery Fund and the Waste Management Service. Duncan Allan, a former Suffolk primary school head teacher, was employed, within the Archaeological Service, as the Garbology Officer, the first in the country.

Once the project had begun to advertise to fill the post it attracted the attention of the media. The story was treated as amusing by most newspapers that covered it (see pp. 43–6). There was, however, serious coverage in some national papers and it was supported by the local and regional press. In the autumn of 2005 *The Times Educational Supplement* covered the project in a large article (Sedgwick 2005).

Aims and objectives: The project aimed to work in schools, with families, with youth groups, with home educators and to provide material for reminiscence work. The objectives were

For schools:

▶ to develop students' awareness of their local heritage through the archaeology of past domestic rubbish and develop it as a cross-curricular learning resource within the national curriculum;

▶ to develop instruction for teachers in using the archaeology of past domestic rubbish as part of the national curriculum;

▶ to raise students' awareness of the need to reduce waste.

For families:

▶ to investigate historic waste disposal as part of family learning events;

▶ to raise awareness of the need to reduce waste.

For youth groups:

▶ to explore local heritage through the excavation of a domestic occupation site;

▶ to raise awareness of the need to reduce waste.

Working in schools: The Garbology Officer worked with about 3,000 students from 45 primary and middle schools across the county, setting up and evaluating the activities. The activities included looking closely at objects from the past and discussing issues of waste management, past and present. students were able to sieve objects from soil in plastic storage containers and sort them into categories to demonstrate evidence of eating (bones, snails, shell, pottery), houses (building materials) and other activities (clay pipes). Information boards and photos were used to help students put objects in date sequence and to develop concepts of time through timelines.

Excavation projects: Some real excavations were carried out on early 20th-century domestic waste dumps with students from five schools. Heavy excavation was carried out by adults but students were allowed to use trowels to excavate small areas. On site the students also sieved soil full of finds and then washed and sorted them into different categories. The Garbology Officer, volunteer archaeologists and teachers/helpers worked with small groups of students.

Discussion on site was valuable for the students to begin work on interpretation. For example, they were finding objects imported from New York, Scotland and Germany while many other objects (such as bottles) came from Suffolk or Norfolk. The range of objects allowed discussion about lifestyles and the students were increasing their vocabulary (with words such as 'rim', 'glaze' and 'stoneware'). Students found this activity exciting and rewarding.

'I bet Mr Allan didn't anticipate he'd find a real saucepan! It's more interesting here [rather than sieving finds at school] because we're in the real environment not just in the same school hall we see every day. Here you never know what you might find next!' (ten-year-old student at Bealings School, Woodbridge).

Follow-up work for the students, after the excavation, included a visit to a modern landfill site, to contrast it with the historic dump, and a reminiscence session with older members of the village. Drama, poetry and creative writing were used in a follow-up session to reinforce the work done with the older residents. Schools also carried out a great deal of follow-up work themselves in the classroom to include a number of National Curriculum subjects.

Evaluation: Teachers found the excavation project a valuable and an absorbing addition to their work in history: 'Teachers like the work as it addresses the difficult bits of the National Curriculum (using and interpreting evidence); brings "experts" into the classroom; requires children to work co-operatively and then to discuss, justify and question their findings' (Allan 2005).

I carried out an analysis for the project on evaluation forms for on-site and in-school sessions returned from 23 schools in November 2005. An example of one of the forms is below.

Table 12.3 Evaluation of Garbology Project

School	*Murrayfield*
Teacher's Name	*Di Gooding, Headteacher*
Year Group/ No. in class	*Yr 3–6 / 23*

Was the session effective in addressing

■ The archaeological process?	*Very hands on, giving children a real opportunity to understand the process.*
■ The National Curriculum? e.g. primary sources, interpreting evidence	*The children were completely focused throughout and began to make observations/ deductions as they found objects: excellent use of primary sources.*
■ An awareness of waste issues?	*Definitely – they were fascinated by what they found.*

Did the children

■ Enjoy the session?	*Very much so! (and the staff)*
■ Feel inspired by the subject?	*The children were, and still are, enthusiastic in their responses to the objects found and subsequently to the work which followed.*

Was the activity valuable in promoting

■ Language development/ communication skills?	*Lots of discussion took place re use of objects – both child to child and child to adult.*
■ Working with others?	*Activity gave the opportunity for a real team effort and the display of items back at school also promoted this.*

Was the session content

■ Appropriate for your children's needs?	*Yes*
■ Well organised, well presented and safe?	*Very – children understood safety aspects and the need to be careful. Good organisation meant all children were active all of the time.*

Anything else you would like to add	*We feel this was a very worthwhile activity in its own right. The children were really excited by what they found and it inspired great discussions.* *Can we do more please!*

The feedback was very favourable – in fact all the schools answered 'yes' to all the questions, while only two schools were doubtful that their students had a sufficient awareness of waste issues. All schools agreed that the sessions addressed the requirements of the National Curriculum with several schools identifying specific areas in History, such as interpreting evidence, and general objectives, such as thinking skills. Two schools specifically mentioned that the sessions helped the teachers deal with other subjects – English, Personal, Social & Health Education/Citizenship, Science and Geography. One school highlighted the use of the session for special needs students. Important general points which schools consistently mentioned were that the sessions were very well organised and were at just the right level for their students. They were particularly good

because they allowed students to see, touch and discuss real evidence and were a good stimulus for further work in the classroom.

Working with communities: A community archaeology project was devised for the villagers (some of whom were members of the local history society) and children of Laxfield to help discover more about the origins and development of their village. Villagers were asked to dig test pits in their gardens and specialists from the Archaeological Service were on hand one weekend to identify finds. The information was recorded on a map and patterns of development were discussed with the children. Other projects with communities included the excavation of part of an in-filled moat of a late medieval farmhouse with the local Woodcraft Folk branch (a national educational movement for young people) and reminiscence work with older residents using objects recovered from waste tip excavations.

Working with artists: Another important part of the project was to commission and work with artists to promote 'garbology'. This included a visual artist to develop ideas on reuse during and following an excavation of a waste tip. Students used excavated pottery to make new creations, a musician to create instruments (such as wind chimes) from waste material from an excavation, and an artist to work in one school with students who extracted and identified organic material (such as seeds, fruit stones and wood fragments) from the soil residue from an excavation. Students photographed the remains and created paintings, collages and digitally manipulated images which were exhibited in the school.

The largest project which involved artists was a dance project based on reminiscence work with older people. The Suffolk County Council advisory teacher for dance worked with a number of schools to create a dance performance which was performed by pupils at the end of the summer term in 2005 in the Wolsey Theatre in Ipswich. The dance to music, but without words, had five sections:

▶ DISCARDED – in which students represented objects which had been thrown away, such as plastic bottles;

▶ FOUND – which portrayed the digging, sieving, and washing of finds;

▶ RECONNECTED – in which students portrayed pieces of objects to the whole, such as a fragment of a plate;

▶ MEMORIES – which showed the students 'questioning' an older person about objects found;

▶ WASTE – where students dressed in ragged clothes in two colours, representing organic and inorganic material, represented the last stage in the process and finally held up three placards with the words RECYCLE, REUSE, REDUCE.

Wild About Waste!: The Garbology Project joined in with a special full day of activities organised by Suffolk County Council's School Waste Education Programme at venues across the county. In 'Wild About Waste', students from a number of different schools carried out a number of activities such as how rubbish rots down: where students carrying plaques had to arrange themselves in order, for example:

FASTEST OF ALL (back)
CUCUMBER (front)

SLOWER THAN TEABAGS, FASTER THAN NETTLES (back)
SHREDDED PAPER (front)

SLOWER THAN THISTLES, FASTER THAN CARDBOARD (back)
EGGSHELLS (front)

They went on to discuss what can be recycled and what can be composted:

▶ *Find that rubbish*: where students used orienteering maps to collect rubbish in a field and sort it into different categories for recycling.

The archaeological component for these activity days was carried out in three sections:

▶ *Rubbish Sort*: where small groups of students were given a carrier bag full of modern rubbish, from tins and cartons to broken toys and sweet wrappers. The leaders for this modern rubbish bin activity (see p. 213) raised questions of interpretation using evidence (such as pet food tins and toys) but also encouraged the students to think about recycling and how much evidence there was of junk food. 'Lots of evidence of chocolate <u>and</u> soya milk' said one eight-year-old with some surprise.

▶ *Sieving for finds*: the activity described above in 'Working in schools' and 'Excavation projects'.

▶ *Saxon Shopping* was a role-play activity in which going shopping in Saxon times was compared to shopping at supermarkets today. Students were chosen to take on the roles of a Lord and Lady and two servants while another leader shopped at the supermarket. Saxon purchases were collected in a jug (for milk), pottery bowl (for fresh beans), basket (for eggs and bread) and a piece of cloth (for fresh fish) (see Fig. 12.6). The modern shopper produced elaborate packaging made from a variety of materials not used in Saxon times (e.g. paper, cardboard, waxed cartons, tin and plastic). This activity encouraged discussion of issues surrounding recycling and waste as well as providing historical information.

Fig. 12.6 Saxon shopping

Exploring churches:
The Churches Conservation Trust

Background

The Churches Conservation Trust (CCT) is the national charity protecting historic churches at risk. Founded in 1969 (formerly called the Redundant Churches Fund), it cares for and preserves Church of England churches of historic, architectural or archaeological importance that are no longer needed for regular worship. The Trust is a body sponsored by the Department for Culture, Media and Sport (DCMS) and the Church Commissioners, as well as growing financial support from visitors, church use, grant giving bodies, major donors and members of its supporters scheme. There are ten trustees and 40 members of staff (full-time equivalent), based in London and in the four Trust regions.

It currently looks after over 340 churches, promoting public enjoyment of them and their use as a community and educational resource (see Fig. 12.7). Most of the churches are open daily; some have staffing, many more rely on local volunteers to make access available with details at the church or on the Trust's website (CCT 2009a and 2010). All these churches are architecturally or historically important with most given one of the two highest levels of protection under the law as Grade I or Grade II* listed buildings. Some are Scheduled Ancient Monuments and some in Conservation Areas. In the Trust's conservation work, the principle which is generally followed, in line with other leading conservation bodies, is one of minimum intervention, acting only to preserve the fabric and prevent further deterioration. For conservation policy and recent repairs and conservation see CCT 2009b; for case studies see Johnston *et al.* 2004, 5.

Redundancy

There are many redundant churches across the country, which, like all redundant buildings, can soon fall into disrepair. They become redundant when they are no longer needed as places of worship. There are various reasons for this including population movement and declining church attendance, together with high running costs (Cooper 2004). Many churches are given a new lease of life through alternative uses such as worship by a different denomination or by secular use (see pp. 273–6).

If the building is of particular architectural or historical merit, it may go into the care of the Churches Conservation Trust or a regional preservation trust or a local group. Information about the legal technicalities is available on the Church Commissioners' website (CC 2010). The church will then remain consecrated and often unaltered. The fact that the church is redundant provides an ideal opportunity to introduce pupils to citizenship topics surrounding the care,

conservation and potential reuse of historically important buildings. A citizenship project carried out on two redundant churches in Ipswich, Suffolk, is published in Spicer and Walmsley (2004, 54–5). Citizenship projects are discussed elsewhere (see p. 294).

Fig. 12.7 Learning how to make wattle and daub on a schools' conservation day at St Lawrence, Evesham, Worcestershire

Education and outreach

The Trust's churches are often used for local activities and events – concerts and music festivals, talks, exhibitions, farmers' markets and flower festivals. Occasional services continue to be held in most churches.

I worked with the Trust to establish an Education Strategy in 2001 and their first Education Officer was appointed in the same year. In 2008 the Trust established four regional teams with the capacity and skills to develop educational initiatives in targeted initiatives. A new area of development is that of engaging with young volunteers.

Education is integral to the second of four strategic aims in the Trust's 2009 to 2015 strategic plan, namely to 'encourage people':

- ♦ We will promote visiting and a satisfying and distinctive visitor experience at historic churches, enabling wider enjoyment and understanding of historic churches, their place in the landscape and the country's history. We will support and encourage new community, education and cultural uses (see Fig. 11.4 on p. 275).

- ♦ We will support our volunteers and Friends Groups and increase the involvement of volunteers including innovative approaches to involving young people ...

A related key objective is to 'enhance the visitor experience and understanding of our heritage through innovative and sensitive interpretation' (CCT 2009c, 4).

As a Non-Governmental Organisation (NGO) supported financially by the DCMS, the CCT is required to sign a funding agreement in which their aims and objectives are agreed with government. The Strategic Priorities (DSOs) of the DCMS lead directly to the Trust's Strategic Objectives for education. For the years 2008–11 (DCMS 2009, 31–2) the objectives are:

- ♦ DSO1- Opportunity: Encourage more widespread enjoyment of culture, media and sport

- ♦ DCMS will aim to widen opportunities for all to participate in cultural and sporting activities. This will include a focus on children and young people to ensure that they have the opportunity to participate in high quality cultural and sporting activities that contribute to their wider outcomes

The CCT has agreed with the DCMS that its broad educational targets under DSO1 will be to:

- ♦ increase visitor numbers by 2% per year

- ♦ continue to seek opportunities for engaging priority groups, considering how access and interpretation can be enhanced to meet the needs of all visitors

- ♦ create 240 new youth volunteering opportunities over the three-year period

- ♦ investigate how CCT churches within the ten pilot areas can contribute to the success of the Find Your Talent programme pilots

- ♦ encourage the formation of and capacity within local friends groups

DSO2- Excellence: Support talent and excellence in culture, media and sport. DCMS will aim to create the conditions for excellence to flourish among top artists and sports stars – for example, by providing funding for elite athletes to enable them to concentrate on their sport. The Department will also champion the provision of top-class facilities and services, inspiring everyone – particularly young people – and helping them to realise their talents.

The CCT has agreed with the DCMS that its broad educational targets under DSO2 will be to:

◆ maintain the quality of conservation care of vested churches

◆ assess, maintain and increase the quality of the visitor experience, using various research methods, both internal and external, and taking timely and appropriate action to address issues raised

◆ consider how churches can be adapted to facilitate increased use, within the constraints of their historical and architectural importance, their status as consecrated churches, and the resources available

◆ consider, in collaboration with the Church Commissioners, how increased funding from 2008/9 can be used to benefit the wider church by offering CCT expertise to build capacity in communities and congregations of churches of vestable quality

In addition to targets agreed with the DCMS, the CCT have agreed a number of targets with the Church Commissioners including securing a suitable alternative use or ensuring the preservation of churches of particular historic or archaeological interest or architectural quality.

Visits: Regular progress reports on educational projects are prepared for internal use within the Trust and for DCMS.

Table 12.4 Visitor figures for CCT

	National Annual Target	Result 2008/9	Comparison with 2007/8
Public visitors	3%	1,471,098	1,369,397
Public events	3%	722	789
Heritage Open Day visitors	15,500	14, 372	14, 821
Educational visits	Sustain & increase where possible	387*	318

* This figure shows a steady rise in the number of education groups visiting CCT churches from 185 visits in 2001 when the first Education Officer was appointed to the Trust.

Formal educational work: The Trust emphasises to teachers that a visit to a church can provide a starting point for a variety of subjects and topics in the school curriculum. Churches, as with other historic buildings, provide primary source material for study. Visits are free to Trust churches and the Trust's regional teams seek to establish and maintain contacts with all the relevant Local Education Authorities as well as with the schools which are close to Trust churches. Priorities are established for the promotion to schools of particular churches each year.

Resources: The CCT has published resources to help teachers make their visits integral to the school curriculum, including: free teachers' booklets on 40 churches which include the history of the building in its landscape and ideas for using the church for specific curriculum subjects; a handbook for teachers, *Exploring Churches* (Johnston *et al.* 2004) including the practicalities of visiting, curriculum subject projects and photocopiable activity and resource sheets; exemplar Schemes of Work covering the subjects of Art, History and Religious Education; a CD-ROM about Gothic revival stone carving and stained glass with Schemes of Work, activities for use on interactive whiteboards and detailed resource information (Walmsley 2007); and downloadable resource information from the website including 'Tips for Busy Teachers: How to Use a Church' and 'Be a Church Detective'.

Activities: CCT regional teams work with local schools to promote particular churches and with other heritage, cultural and educational organisations, for example:

▶ a primary school has carried out a long term citizenship project on its local church, All Saints Church, Vange, Essex;

▶ literacy and history visits to St James's Church, Cooling, Kent in partnership with other local heritage providers as part of the Heritage Lottery Funded project managed by Medway Council;

▶ working with other heritage organisations on the Campaign for Drawing's Big Draw at St Andrew's Church, Bywell (see Wetherall Dickson and Johnston 2006);

▶ music composition workshops at All Saints Church, Harewood, West Yorkshire, together with Harewood House and Leeds Music Support Service;

▶ National Archaeology Days at St Andrew's Church, Wroxeter, Shropshire, with English Heritage and the University of Birmingham;

▶ working with a number local education providers across the country, such as schools, universities, youth and arts centres and organisations working with the homeless;

▶ the Heritage Lottery-funded 'Young Roots' project at Evesham in 2009 and, working in conjunction with the Rural Media Company and others, a group of young people scoped, wrote, produced and delivered a film called *From These Stones*;

▶ projects with residential Cathedral Camps where young people conserve, record, maintain and welcome visitors at historic churches. The camps are run in association with Community Service Volunteers and contribute to the Duke of Edinburgh's Gold Award.

Developing cultural heritage education: The Oak of Finland project

Background

Suomen Tammi (The Oak of Finland), run jointly between the National Board of Antiquities, the National Board of Education and the Ministry of the Environment is an educational programme designed to develop cultural heritage education in schools. The programme was launched in 1998 and continued until the end of 2004, funded by the three ministries with smaller additional grants from UNESCO and the Finnish Training Centre for Teachers. The project involved a large network of educational, cultural and heritage organisations. The author taught two teacher training in-service courses as part of this project.

The project

The project's goal was 'to make Finns substantially more aware of their own cultural heritage and to reinforce the role of cultural heritage in education' and aimed

- to develop students' skills in fostering and enlivening the cultural heritage
- to support co-operation between schools and experts of material cultural heritage and cultural environment
- to familiarize teachers and students with the versatile services museums provide and increase the use of museums as learning environments
- to teach means of influence on matters concerning cultural heritage
- to produce multidisciplinary teaching materials on cultural heritage
- to guide teachers and students to use and develop vocational heritage in their own work.

(Suomen Tammi 2010)

Although the Oak of Finland project officially came to a close in 2004, it continues as a heritage education network.

Teacher training

Through websites and leaflets and subsequently books, the project was designed to give teachers and students the opportunity to carry out evidence-based projects. Teachers were encouraged to make good curriculum use of objects, buildings in their locality, ancient sites (including World Heritage Sites) and landscapes. The project organisers worked through teachers, teacher centres and museums to carry out 216 separate projects between 1999 and 2004. 1,200 teachers took part

in training sessions, and 1,850 attended 55 regional seminars on eight different themes, such as 'the old buildings of Heinola' and 'toys and playing traditions'. The resources, training sessions and seminars were firmly linked to the Finnish national curriculum.

Investigative learning

Elo explains the need for teachers to help their students to use investigative learning:

> to clarify, if not solve, questions concerning the principal issues surrounding existence and life. It is not unusual to hear a child say 'How do you know that?' or 'Prove it!' and argues for the involvement of class members in planning their research, making decisions, preparing a presentation and evaluating the project. (Elo 2000, 16 and 19)

Some of the published reports of the project's activities have provided teachers and heritage educators with extremely useful guidelines. A good example of this is illustrated in Fig. 12.8, where an intensive training course introduced traditional local buildings and types of construction. This training was written up by Linnanmäki (2000), and the publication for teachers provides a number of easy-to-understand drawings, resource information and recording sheets for schools to undertake both research and recording of the school building, its individual rooms and features (such as staircases), the school grounds and traditional Finnish buildings in their local area. Kankare (2000) uses a visit by 10–11-year-old students to the castle of Turku and a Knight's tour involving drama and costumed role play to explain how it can be linked to the history curriculum and students' individual learning.

Fig. 12.8 Teacher training in the Oak of Finland project took place in the classroom and at historic sites. Here teachers are investigating the construction of traditional wooden buildings and how to record them.

World heritage sites

The study of World Heritage Sites (WHS), and the issues surrounding them, formed an important part of this project (Elo and Kauppinen 2000). This part of the project aimed to:

▶ develop new methods to help teach world heritage;

▶ establish co-operation between teachers, researchers and museum experts both nationally and across the Baltic Sea states;

▶ build a network of world heritage educators;

▶ create a better appreciation of UNESCO actions concerning WHS.

About 12,000 schools across the world are part of UNESCO's Associated Schools project and a few organisations have published material for teachers to incorporate WHS into the school curriculum. Suomen Tammi's organisers published a resource book (Elo 2001) which covers a number of different cross-curricular approaches, introduces the problems of tourism at WHS and raises the difficult issue of world heritage and human rights (using the examples of Auschwitz and the Statue of Liberty). *Turismin hallinnointi kohteissa*, 'Controlling Tourism at Sites' (Elo 2001, 91–4), looked at tourism issues in general and then explained the use of assignment cards for students to address invented proposals to build a freeway across Te Wahipounamu Park in New Zealand to join two towns. Each of the five groups were given information about the interested parties in the discussion (abbreviated below):

▶ *Director for Forest and Bird Conservation Society* – the consequences for the roads will be horrible in an area which has survived untouched.

▶ *Director for the Provincial Centre of Westland* – building the freeway will give us an opportunity to benefit from more tourism.

▶ *Forest Warden* – a freeway at the bottom of the valley will damage the fragile ecosystem of the swamps, built on the hills it will ruin the authenticity of the landscape.

▶ *Minister for Transport* – the landscapes in Te Wahipounamu are uniquely gorgeous and the view would attract a considerable number of tourists to the country.

▶ *Reporter Otago Daily Times* – all in all we cannot see many problems in the project providing there is no need for considerable funding from the government.

Elo and Kauppinen are aware of the importance of the national curriculum in this process and intend to 'create a proposal for a national heritage syllabus and national strategies to put the syllabus about World Heritage Sites into practice' (2000, 182).

Evaluation

The organisers of the project are fully aware of the problem of the sustainability of projects, whether heritage-based or not. The Oak of Finland project has shown that co-operation can be established between government ministries, that it has influenced the government in its strategies towards architectural heritage, that new teaching and learning ideas have been developed and promoted in publications for educators and a sound network set up. Salmio carried out a detailed evaluation of the project and has listed (2005, 99–100) the three ministries' own evaluation needs (summarised below):

▶ *The National Board of Antiquities* wanted to find out 'how museums benefited from the project, how museums had used the results from developing museum teaching and what sort of activities teachers wished museums to organise'.

▶ *The Ministry of the Environment* wanted to find out 'how the collaborations in the project worked out and what the ministry and environmental centres are expected to do to develop the undertakings of the project'.

▶ *The Board of Education* wanted to find out 'how effective the project was in increasing the knowledge of cultural heritage, artistic skills and values in schools and educational centres and what sort of changes have taken place in working methods, working environment and habits'.

A questionnaire designed to evaluate the project received responses from only 23.5% of the 442 participants. However, the analysis of the questionnaires and of each project and of training sessions showed that the project itself succeeded well and, in general, resulted in 'the increased motivation of students, better social skills, more active citizenship, involving forms of international relations and a broader concept of culture' (Suomen Tammi 2010):

◆ Teaching on cultural heritage was increased;

◆ The concept of culture was found to be understood in a wide context;

◆ Handling concepts and solving problems were learned;

◆ Students took an interest in their own home region and family;

◆ Elderly people and the work they do became appreciated;

◆ Schools and educational centres participated in World Heritage projects and learned to co-operate with museums and other participants and vice versa;

◆ Museum teaching developed in an active direction and they received more customers;

◆ Networking took place in an active way;

◆ Participants learned to benefit from and accept the special fields of expertise.

(Salmio 2005, 94–5)

After the project was completed, the organisations concerned with the Oak of Finland published a book of papers which related to teaching and learning about the historic environment and issues which surround the heritage, such as the use of history in advertisements for commercial products (Venäläinen 2008).

Conclusions: Celebrating Archaeology in Education

There is much in this book which demonstrates that the state of archaeological education in Britain is in good shape: archaeologists, teachers and volunteers are helping to get the message across. A recent report from the Council for British Archaeology showed that there were over 215,000 volunteer archaeologists in the UK, members of 2,030 groups and societies (Thomas 2010). This figure had more than doubled since a similar survey carried out in 1987. There is more to be done, of course. One of the areas that archaeologists ought to consider is widening participation in archaeology in higher education, and the case study for this chapter shows how university archaeology students have widened participation in archaeology through formal and informal sessions with children.

The book has covered a wide range of practice in archaeology and education. It intended to show that education should be looked at in its broadest sense, encompassing the way archaeologists get their message across to the general public as well as the way archaeology is represented in formal education.

Getting the message across

With a long tradition of generating public access to archaeological discoveries (e.g. the *Illustrated London News* reports in the 19th century) many archaeologists in the UK today are still ready to enthuse about their subject with open days on site, press releases and websites. The figures for the annual Festival of British Archaeology are impressive (see p. 108). Where archaeologists have little control over the presented outcome of their work in the media, there is still a long way to go to present a balanced view which does not just name all discoveries 'treasure' and think that all prehistoric people only uttered 'Ugh'.

Formal education and archaeology

The chapter on formal curricula showed how far there is still to go, across the world, in establishing that archaeology is a central part of teaching history. While some countries proudly look on their history as a key subject to be studied by children and students throughout their school career, others are equivocal about its importance. Archaeological, museum and teacher organisations in the UK have largely been responsible for inserting archaeology into the curriculum, influencing government thinking and action. They have also worked hard to keep it there by the provision of formal education programmes and learning resources. Textbooks still dominate and restrict teachers in many countries. In a number of countries state-written and state-approved resources are rarely written by working teachers. At least the existence of the internet is getting a variety of new resources to teachers, pupils and students across the world.

Many countries do not encourage experiential learning nor use the rich resource of the historic environments to teach history. They prefer or are told to prefer textbooks. Yet my work in Turkmenistan (and in several countries in Europe) proved that teachers, given the resources and training, were enthusiastic

about their pupils 'learning outdoors', using a number of subjects as well as history for history topics and using the teaching ideas in the section on 'Investigating Evidence'.

Heritage issues

Archaeologists need to show the public, governments and teachers that archaeology matters. I consider that the most important subject area, beyond history, is citizenship. I was proud to see that my last major project in English Heritage was finally published in 2004 after I left (Spicer and Walmsley 2004). The education team worked with schools across the country and wrote a teacher's handbook and produced a CD-ROM and teacher training video. Promoting archaeologists' concerns, and those of many other sections of society, seems to me an essential part of what both paid and unpaid members of the profession should be doing. Debate should, and indeed is, taking place in schools about what value we place on our heritage and what society should be doing about the clear and present threats. One of the threats which has yet to become very serious in the UK, but which is a problem in the USA, is that from the creationists. The latest reported uneducated outburst from one of those who believe that God created the world in 4004 BC was in Northern Ireland. In May 2010 the culture minister, born-again Christian Nelson McCausland, wrote to Ulster Museum urging them to reflect creationist and intelligent design theories of the universe's origins. The newspaper report went on to quote the evolutionary biologist Professor Richard Dawkins as saying 'If the museum was to go down that road then perhaps they could bring in the stork theory of where babies come from. Or perhaps the museum should introduce the flat earth theory' (McDonald 2010). The threat from the creationists seriously undermines the careful scientific nature of archaeological work. But the threat is greater, in my view, when creationists achieve changes to school curricula as they have done in several American states.

Three areas of good practice seem to me to be worth highlighting here in my conclusions, but I have some criticisms too. Those areas are teaching and learning, encouraging parents and encouraging governments.

Teaching and learning

Archaeologists working with educational groups and their teachers in Britain know that many excellent projects have been carried out, especially in primary schools. Although it has been said that teachers are 'uncomfortable with using the real historic environment' (Stone 2004, 4), the study of real evidence, in the classroom or in the museum with objects, is becoming much more common. Ofsted, the official government body for inspecting schools in England, recently reported on the strengths and weaknesses of history in primary and secondary schools. It found several areas which it was not happy with – pupils learning themes and periods but without understanding the overall historic narrative, for example. It did comment that teachers often encourage the youngest age group (5–7-year-olds) to become 'history detectives' by examining objects used in the past. In another school the inspectors said of one teacher's lesson that 'Not only was she teaching them to handle evidence, but she was also teaching them new words … All pupils, including those with learning difficulties, learnt a lot in this

lesson – speaking, listening, handling and interpreting evidence, developing vocabulary, drawing, writing and working together' (Ofsted 2007, 15).

But there was almost no mention of 'doing history' outside the classroom in this report, nor did Ofsted inspect any school visits to historic sites or museums. The history inspectors should have visited my granddaughters' school in North Yorkshire to see how they used part of their local historic environment to fulfil National Curriculum history (see pp. 324–5).

Not withstanding this example, it is clear that not enough is being made by schools of using the physical evidence of the historic environment by visiting state-owned sites, protected ancient monuments and historic buildings. While it is true that there are always impediments to taking classes out of school (e.g. health and safety issues and costs), teachers need to be encouraged by those organisations who manage parts of the heritage. Encouragement means making visits easy with resources to download and facilities at the sites themselves. But schools do not necessarily have to venture out on coaches to access the past. It is all around their schools. What they need is encouragement and help, perhaps from their local education authority, or the local museum, or archaeological unit.

The official national organisations which protect the historic environment in the UK are not doing enough to make this happen. They concentrate, too much, on 'properties' in their care and open to the public. Education is often within the marketing department and it shows. Charging for 'special' services in schools is not necessary. The budgets of these state-funded organisations do not need the pittance which charging brings in – and they should be brave enough to tell their relevant government department that it is their mission to promote that part of the past they are responsible for. National museums in the UK *should* provide free services for schools. It is clear from my survey (see pp. 93–108) of national organisations in the UK that their education services do not always reflect the statement made in their corporate missions or the remit given to them by the government. They seem too led by their marketing and press departments, always willing to send a group of schoolchildren to an announcement by a chief executive or government minister but less than willing to invest in formal education programmes which will have a lasting effect on society's attitudes towards the survival of our historic environment.

There is also another principle which I think should be applied to education services in heritage organisations. They should be training teachers to be confident enough *themselves* to use the historic environment in their children's and students' learning – confident enough not just at a medieval castle but also within their own local historic environment without handing over their classes to a costumed interpreter with no training or experience in classroom teaching. They must also work harder to ensure that new teachers are given help with teaching physical evidence which they are often not taught about in teacher training courses. Aston's *Learning Beyond the Classroom: Information for Newly Qualified Teachers* (1987) used to be one part of an established programme. Non-specialist history teachers are now a potential threat to children's access to the historic environment as a learning resource. A recent report from the Historical Association showed that 60% of history teachers in secondary schools were concerned about the growth of non-specialist teaching and that history was being taught in combination with other subjects (Burn and Harris 2010).

All organisations with education services and with sites open to the public

The Victorian historian

Rathmell Primary School in North Yorkshire is typical of many small rural schools in Britain, serving a few villagers and outlying farms. It has just over 50 pupils. In the summer term of 2007 its teachers looked for ways to engage all their pupils in a history project which would satisfy the criteria and periods set out in the National Curriculum. Two local visits were organised. The older pupils went to the World Heritage Site of Saltaire, near Bradford. It was here that Titus Salt opened a huge mill in 1853. Over the next 20 years Salt built an entire village for his 3,000 workers – a village which included schools, shops, churches, an adult education centre, bath houses, a hospital and a park. The mill ceased production in the 1980s and was converted into shops, offices and art galleries, including the work of David Hockney, who was born in Bradford.

Fig. 13.1 Following up the project work on the Victorians with activities for children in Craven Museum in Skipton

The younger pupils went to their nearest museum, the Craven Museum in Skipton (see Fig. 13.1). This is a small local history museum with objects from most periods in the area. The museum has a number of interactive exhibits created especially for children and their Education and Outreach Officer provides activity sheets, Discovery Boxes and sessions for schools, as well as Memory Boxes for older people (Craven Museum 2010).

Fig. 13.2 The performance of *Victorian Historian* showing the strange time machine

To draw the history project together and to show parents and grandparents their work, the school put on a production, *Victorian Historian: A Journey to Victorian Britain*. This is a musical which tells the story of two children who, through a strange time machine which they stumble across in their teacher's house, are transported with their teacher back to Victorian times (see Fig. 13.2). Here they find out about life and industry at that time, at the beginning singing a song called 'History is boring ...', but after their experiences they end up with the song 'Time Travel ...'

> So you see that history
> Is much better when it's real.
> Hear the sounds and smell the paint.
> And you feel what people feel.
>
> ... Miss can we do this next week?
>
> (James and Spencer 2001)

need to avoid devolving responsibilities for education *entirely* to staff at sites. Why should teachers visiting with their groups use another resource written by a local teacher unless it has been checked and is in line with the organisation's education policy? Sadly, some organisations even allow local custodians or wardens to write 'worksheets' for children, perhaps, of course, in the absence of anything else from headquarters.

Encouraging parents

Parents, grandparents, guardians and carers can help archaeologists to get their message across. Many heritage sites and museums now run special sessions for families, either 'fundays' or workshops or family learning weekends. These are usually one-off informal learning sessions but here are two examples of longer-term commitment to encouraging families to help their children learn about the past in a more structured way. Museums have led the way, in the UK, in introducing specific programmes for families with very young children but heritage organisations are catching up (see Fig. 13.3). The Museum of London provides special places with floor cushions in their new (2010) galleries for toddlers and their parents.

The US Department of Education has published *Helping Your Child Learn History* which is aimed directly at parents of children from pre-school to 10 years of age and in the introduction states that 'By showing interest in their children's education, families can spark enthusiasm in them and lead them to a very important understanding – that learning can be enjoyable as well as rewarding and is well worth the effort required' (USDE 2004, ii).

Fig. 13.3 Making flour the prehistoric way at a family activity session organised by Archaeology Scotland at Stanley Mills near Perth, one of the properties cared for by Historic Scotland. Perhaps this toddler will go on to become an archaeologist (or a miller)?

Helping Your Child Learn History is clear about the need to use original sources and has this to say about learning history:

> *History is hands-on work.* Learning history is best done in the same way that we learn to use a new language, or to play basketball: we *do it* as we read about it. 'Doing history' means asking questions about events, people and places; searching our town for signs of its history; talking about current events and issues; and writing our own stories about the past.
>
> (USDE 2004, 7)

The booklet deals with making structured visits to historic sites and making the most of, rather than just watching, on-site re-enactments. There are interesting and easy-to-do activities around, for example making a time capsule, historic recipes and discovering the history of their local historic environment. The book also has sensible things to say about chronology and empathy with the past.

The British government has also committed to promoting the active involvement of parents in their children's education. Countrywide initiatives began with the introduction of the National Curriculum as it was realised that parents did not understand what their children were doing in school – no parent then had been educated through the new curriculum. A number of 'quick guide' leaflets and booklets were published under the general title of *Learning Journey*; these included short paragraphs on each of the National Curriculum subjects. More recently it has concentrated on helping primary children develop skills in the basic subjects of maths and English through the booklet *Taking an Active Interest in your Child's Learning* (Department for Education and Skills 2004) and a booklet aimed specifically at grandparents called *Learning with Grandparents* (Gyllenspetz 2006).

In 1999 the government's Qualifications and Curriculum Authority (as it was then called) produced and tested leaflets for parents together with outside organisations. English Heritage Education worked with QCA to produce the leaflet 'Help Your Child Discover Roman Britain in the North East' (QCA/English Heritage 1999). The leaflets were handed out to parents at English Heritage sites on and around Hadrian's Wall along with questionnaires. The project was evaluated and 93% of those who responded to the questionnaire indicated they would like similar leaflets when visiting other historic monuments (Creasey 2000, 1).

In 1992–4 English Heritage Education worked with the Department for Teaching and Education studies at Lancaster University on a project devised by the teacher trainer Rob David. The project, called 'History at Home', aimed to encourage primary schools to work with and support the parents of their pupils with National Curriculum history. The project encouraged family involvement in finding out about family history by analysing their own family documents and photographs and creating a family tree. Working with family members, especially grandparents, they helped then to investigate objects in the home and encouraged them to read stories about the past. The project also helped them to make visits to historic monuments, museums and their local historic environment as a support for the children's learning about history at school.

The schools provided support in the form of information, activity ideas and information for parents about National Curriculum history. English Heritage

Education published two resources for schools, *History at Home*, a guide for parents and teachers (David 1996) and a video for teacher training and for showing to parent groups (English Heritage 1994).

Encouraging governments

It is one thing to provide resources for teachers to encourage them to use archaeological evidence in their teaching across a range of subjects. It is another to persuade governments that their education and curriculum departments should take positive steps to make changes in favour of archaeology and the heritage. In Britain it has been the Council for British Archaeology which has been most active in research, developing curriculum initiatives and campaigning and it is better placed than government-funded organisations in Britain to influence government. With almost constant change in school curricula in England and (short-term) government initiatives which often seem to appear daily, archaeologists and archaeological educators need to keep campaigning. As an example, in 2009 the Council for British Archaeology prepared a report for English Heritage on the alarming situation of the place of archaeology in further education. The archaeology courses offered in continuing education had plummeted from 1,360 in 1999 to 515 in 2008/9, and there were only 32 university continuing education departments offering courses in archaeology. After 1961, 26 archaeologists were employed as extra-mural university tutors (Lee 2009a, 14 and 92; Lee 2009b).

In the USA in 1987 the National Council for Preservation Education (NCPE), founded in 1973, published a report on the state of heritage education at primary and secondary school levels. Its *Heritage at Risk* report pointed out that:

> Our heritage is at risk because it does not seem to relate to most people's private everyday worlds. It appears detached from what really matters, is not part of family, learning, or life. If historic environments have any current significance in the normal course of daily existence, they are relegated to the periphery, belonging to the marginal areas of recreation, a superficial form of tourism, a mild curiosity. (NCPE 1987, 2)

The NCPE advocated radical changes to develop more partnerships between 'heritage education programs and schools' ... 'so that, ultimately large numbers of America's 45 million school-age children may learn from historic environments throughout the course of their education' (NCPE 1987, 15–16).

In September 2007 a report was delivered to the Australian Minister for Education, Science and Training by two archaeological organisations to 'encourage the Australian government to integrate an archaeological approach to the study of the past into the National History Curriculum'. The proposal was a joint submission from the World Archaeological Congress and the Australian Archaeological Association. The authors argued that students in Australian schools were largely unaware of the history of indigenous Australians and that 'Archaeology is currently strongly associated with the ancient history syllabus and involves overseas examples of popular classical sites, such as Pompeii, leading many people to assume that Australia has no long term past' (Smith *et al.* 2007, 3).

The report goes on to state a strong case for the use of archaeology teaching in schools:

Archaeology: Strengthening Australian History

One of the most exciting avenues to the past is through archaeology – the scientific study of material artefacts and the construction of long term fact-based narratives of human achievement. The crucial tool for accomplishing this is through consolidating 'historical literacy' – the evaluation and interrogation of sources, including not only artefacts but also pictures, buildings, landscapes, recordings, personal interviews and original documents, and assessing their value as evidence of the past. Archaeologists can use these sources of evidence to understand the past of their own society and the way the world around them has been constructed, as well as much more remote pasts. (Smith *et al.* 2007, 3)

Children celebrate archaeology

An entire recent issue of *Primary History*, the journal of the Historical Association, was dedicated to 'doing archaeology' with children, and was full of enthusiastic reports from teachers, archaeological and heritage education officer as well as archaeologists.

'The past is not only interesting, it is also fun and exciting. When we've got a child saying "wow", we've got them wanting to learn more. What else could a teacher ask?' (Henson 2009).

Many initiatives to encourage children to participate in archaeology outside school have been mentioned in this book – such as the Young Archaeologists' Club – but there are other examples. Children aged 13 were encouraged to enter an essay contest organised by the Society for American Archaeology as part of the Illinois Archaeology Awareness Week in 1993. Here are some excerpts from the winning essays:

For a long time I thought archaeology only existed in far-off lands, such as Troy or Pompeii ... I was wrong. Whether searching in Europe, or Asia, or even in your own backyard, it is inspiring to know all of the possibilities of what you could be fortunate enough to find. I think it is fascinating how we can learn so much about the people who lived before us. I also find it very encouraging that people of the future will be able to learn just as much, and maybe even more, about us. Nicole Seguin

When I study these artefacts, I feel kinship with these men and women whose lives are long past and I am humbled by the greatness of their achievements. Archaeology has enabled me to see the past in a whole new light. Instead of viewing the ancient world as something far removed from the present, I see it as a monument from which our modern society has much to learn. Elizabeth Romey

For an archaeologist, brushing away the soil is like taking off a layer in time. Every little piece or fragment of evidence helps create a more complete and vivid picture of the earth's past. Robyn Jablonski

(National Park Service 1983, 16)

One of the nicest things to happen to anyone who has put on programmes for school groups or activities for families is the feedback. 'That was *so* cool' and 'It's

fun' is better than a pay rise! Asking children or school pupils to put into words what archaeology is is usually fun for them and instructive for us. This is a piece of creative writing by ten-year-old Catherine Childea at the end of a project on archaeology in a primary school in Colchester (Corbishley 1986b, 7):

THE BROKEN POT

Scrape, scrape – I'm gently being discovered by the Archaeologist's trowel. I have been broken for about 2000 years now. I remember being a piece of clay on hilly fields where I was picked up by a Colchester Potter. He took me home and put me on a wheel and the wheel went round and round. He was a good, careful potter. He decorated me with little bits of clay. My patterns were very beautiful. I was sold in the market place. I fell off a shelf and broke into little pieces. 2000 years later I was washed and repaired. Then I was put into a museum and sat with other pots. A group of children from Gosbecks School were doing a Roman Project. I was picked up by a little girl and I was carefully drawn.

The last case study in the book describes the recent work carried out by students and staff at the Institute of Archaeology, University College London. It covers a number of projects devised to encourage wider participation in archaeology at local schools and in informal sessions of our Young Archaeologists' Club branch.

Case study

Widening Participation in Archaeology: Initiatives at the Institute of Archaeology, University College London

Background

University College London (UCL) was founded in 1826 and opened in 1828 (Harte and North 2004). Although it was designed as a university in itself, it became part of the federal University of London. It is now the largest of over 50 colleges and institutes in the University of London. It was the first university in England to provide an education for a wider range of students than were normally admitted into universities in the early 19th century. From the beginning, students from outside London, from overseas and of any race, class or religion were welcomed. It was the first university (in 1878) to admit women on equal terms with men. As an undenominational institution it was supported by reformers and dissidents (Lawson and Silver 1973, 257–8). Today UCL has around 19,000 students and 4,000 academic and research staff in 72 departments.

The Institute of Archaeology (IoA) at UCL was created by the efforts of the archaeologists Mortimer and Tessa Wheeler and was formally opened in 1937 as a centre for teaching and research in archaeology. Mortimer Wheeler (later Sir Mortimer) was the Institute's first Honorary Director, from 1934 until 1944 (Wheeler 1955, 83–94; Hawkes 1982, 122–43). Today it is the largest university-based archaeological institution in Britain, with nearly 600 students and over 70 academic teaching staff.

Widening participation in higher education

It has long been known that many people in certain social, economic or ethnic groups are under-represented in higher education. In 2003 the government acknowledged that 'Universities and colleges play a vital role in expanding opportunity and promoting social justice' and set a target of a 50% increase in higher education participation of those aged 18–30 (DfES 2003a, 4 and 7). Among other actions they wanted:

> outreach work to be undertaken by the Institution with schools and colleges to help raise the level of attainment, aspirations and applications ... and ... include the efforts universities are committed to making to reach out to schools and colleges with low participation rates in higher education, for example running summer schools and master classes.
>
> (DfES 2003b, 3 and 19)

A key to widening participation for higher education is through 'partnership working'. Universities attempt to reach potential students through other institutions (such as schools), employers, parents and groups within communities. A report commissioned by the Higher Education Funding Council of England outlined some of the work which is already in place but raised the question of how much was being carried out, for example:

> Widening participation workers will already be involved in partnership working with colleges, schools, employers, training providers and others. Admissions staff may also be involved in work with partners on progression routes. Some academic staff and managers may also be involved in outreach activities like summer schools and visits to schools – but how widely does this extend? (Allen and Storan 2005, 18)

Widening participation and archaeology

Archaeologists and archaeological organisations in the UK are well aware of the low level of ethnic minority representation in the profession (whether paid or volunteer sections), despite reports (CBA 2003) and calls for change (Friel 2004). Statistics from a 2008 report from the Institute for Field Archaeologists showed that, while the 2001 national census showed that 7.9% of the UK population was non-white, professional archaeologists could be broken down into the following categories:

Table 13.1 After Aitchison and Edwards 2008, 51–2.

White	98.99%
Mixed	0.16%
Black or Black British	0.04%
Asian or Asian British	0.39%
Black African	0.1%
Chinese	0.04%
Other ethnic origin	0.39%

This is also evident in the USA, where a Society for American Archaeology 1994 survey showed that only two of its 1,644 members were of African-American descent (Agbe-Davies 2003). Attempts have been made to address the issue, in the IoA's Strategic Plan 2004–6 and through educational work at UCL's Petrie Museum and the University's widening participation initiatives. Most, but not all, initiatives are carried out within the nine London boroughs which are partnered with UCL.

Widening participation in the Institute of Archaeology, UCL

UCL employed a Widening Participation and Diversity Officer in 2005, who worked with the Institute of Archaeology until 2008. Her role was to co-ordinate already existing initiatives and to create new projects. She is now a research student at the IoA and carries out Widening Participation work when possible.

Public engagement events

The IoA has been involved in the CBA's National Archaeology Day events since 2000. The IoA is open to the public for a day with events related to the Institute's research and collections for adults and families. Activities are interactive and fun. They provide a learning experience both for the visitors and the IoA. IoA has also been involved in 'Discover Archaeology LIVE' in 2008 and 'Who Do You Think You Are?' 2009, which were national shows at Olympia. Staff and students were on hand to facilitate object handling and to promote the Institute. UCL Museums and Collections events also provide another opportunity where staff and students may interact with the public. For example, staff and students provide object-based activities at annual events held for the Festival of Geology or The Big Draw.

Taster sessions

The University of London co-ordinates and advertises non-residential Taster Courses for Year 12 pupils (17-year-olds). The courses are offered by universities in London in a wide range of subjects and are half a day to five days long. Staff and students at the IoA have delivered a number of day-long courses including 'A Taste of Archaeology', 'Bio-Diversity in Urban Spaces' (with the Grant Museum of Zoology) and 'Exploring Ancient Civilisations: Egypt and Rome'. The aim of the courses is to introduce senior secondary school students to archaeology, which they are unlikely to have encountered in any detail at school.

School curriculum linked workshops

Most workshops are carried out in schools but some have been organised at IoA – for example, the 'Indus Explorer Day' for 70 students from three primary schools where students had access to Indus experts and real Indus artefacts through practical workshops. Another example is the 'Physics in Archaeology' session for A-Level pupils who were looking at the application of physics in archaeological dating techniques. Workshops held at schools have included 'Looking at Roman London' through workshops in school and a walk to look at Roman sites and 'Handling Roman Artefacts'. The Widening Participation Officer has also worked with Hackney Inspire, an Education Business Partnership, to deliver sessions on the Olympics in Ancient Greece. These sessions were both relevant to the curriculum and to developments in the area leading up to the 2012 Olympics.

In 2006, a masterclass linked to the 'Living Collections' exhibition in IoA was created by MA students as part of their coursework. Objects for the exhibition came from IoA collections in zooarchaeology, archaeometallurgy and ethnography. The master class was held in one school for 12-year-old students (see Fig. 13.4). Bones were used as the main theme because it fitted in well with the

Fig. 13.4 A master class investigating animal bone. Part of this class involved making observations and detailed recording.

Science curriculum. Masters students themselves planned, created, delivered and evaluated the school-based sessions, for example:

Table 13.2 After Wedderburn 2006, 3.

Objectives	Activities	Learning outcomes
To introduce Year 8 pupils to the concept of archaeology	Presentation, question and answer session	Pupils will have a basic knowledge of what archaeology is and what archaeologists do
To give pupils an example of the application of science outside the classroom	Presentation	Pupils will gain knowledge of the value of science and the use of science in the 'real world'
To give pupils the opportunity to handle real archaeological objects	Handling session	Pupils will gain knowledge about the objects themselves and also about what archaeologists can learn from objects
To give pupils the opportunity to infer information from objects	Handling session	Pupils will gain a broader knowledge of what information we can gain from objects specifically in relation to zooarchaeology

I attended this masterclass and found the students were engaged with the session and clearly enjoyed it. Afterwards the teachers commented that their pupils had learnt a great deal from the session. It was an area which was very relevant to the National Curriculum Science they were doing that term and, further, it was a huge benefit to the pupils that they were able to handle real bones and objects from a university collection. They also said that this was an area which they were not skilled to teach themselves and were grateful for the MA students' thoughtful planning and delivery of the session.

Archaeology on the school grounds

To introduce school pupils to another aspect of archaeology, excavations have been carried out on the grounds in, or nearby, five schools by IoA staff and students. The largest and most analysed of these excavations was at Kingsbury High School in north London.

> Like many history departments, we have an ongoing interest in local history.
> Our guiding principle is, where possible, to start from the familiar – the locality – and then to explore the more unfamiliar past. In this way, pupils are able to relate the past to their own experiences and thereby derive a greater sense of the relevance of history. (Ramsey 2005, 4)

This clear statement of the intention to include familiarisation with real evidence in history teaching was written by a teacher at Kingsbury High School. In 2004 the school's history department had contacted the Institute of Archaeology with a request for some of their students to experience some real archaeology but not by attending taught sessions in a museum or a visit to see archaeologists at work. They wanted archaeologists to excavate part of their own school grounds. The school had already identified a possible site – the back garden of a caretaker's house owned by the school. The teacher in charge had already researched the historical background of the site and discovered that the present house replaced a timber-framed building demolished in 1950 which Royal Commission on the Historic Monuments of England investigation suggested had been constructed in the early 16th century.

The Institute of Archaeology agreed to take on the project jointly with the school and Andy Agate, then an undergraduate, directed the project with the help of other students and Institute staff.

Planning and project design: The project design for the Kingsbury High School Archaeology Project included: 'The aim of this archaeological project is to provide an educational resource for sixth form students, enabling the effective teaching of archaeological field methods within the setting of their local community' (Agate 2005b, 30).

There were four stated aims of this project which, in summary, were:

1. To excavate and evaluate the archaeological remains and produce a report

2. To consolidate and enhance historical research of the site

3. To produce a public display for National Archaeology Day

4. To assess student and teacher attitudes to archaeology

After each season's work the project was evaluated and discussed with staff at the school and at the Institute of Archaeology.

Archaeology at work: The site itself, although small, produced a large number of different finds which included 12th- to 13th-century early medieval flint tempered London ware which pointed to activity on the site well before the cottage was constructed, as well as artefacts and contexts associated with the demolition of the Tudor house and the building of the caretaker's house. In the summer term of 2004 the archaeological project ran for three weeks and included students experiencing excavation, recording, planning, surveying and finds work, talks on site (about objects and interpretation, looking at finds from the excavation and research into the site's wider landscape context) and lunchtime lectures on chronology, environmental archaeology and statistics in archaeology.

An assessment of the first season at Kingsbury showed that the pupils who participated enjoyed and learnt from the on-site work and talks. About ten staff members but very few students attended the lunchtime lectures. However, pupils who took part were able to find and deal with real evidence fresh from the ground and 'to develop transferable skills such as categorising, evaluating and analysing evidence. Finally, since pupils were in the trench at the point of discovery, they were encouraged without fear of making mistakes in their interpretations. The project emphasised active participation at all stages' (Agate 2005a, 5).

After evaluation and discussion with the school, the project went ahead for a second season in 2005, but with some changes. Involvement in National Archaeology Day display idea was dropped because the school did not become involved. The project widened to include recording of the nearby redundant St Andrew's Old Church, (undertaken by Institute of Archaeology students) and students were able to see the recording in progress (Johnston 2005, 1). In order to involve more students in the project the school wanted a different, younger group of students to attend each day.

The director's assessment of this season's work was that, because the school wanted too many different groups of students to work on the site itself, the pupils' appreciation of the nature of archaeological work suffered. However, the teachers involved in the project were now clearer about the value of the project for their students.

> Given the interdisciplinary nature of archaeology, the project has also helped to promote cross-curricula links and active collaborative learning. A website was created by the ICT department with daily updates and site reports. Year 9 pupils [14-year-olds] also created their own websites and Year 12 English pupils [17-year-olds] made a highly professional radio magazine feature for the school's intranet home page. The art department helped with the creation of a mosaic made up of excavated artefacts, and this has been used as a teaching resource. (Ramsey 2005, 4)

Widening participation: Kingsbury High School is a large comprehensive in the London Borough of Brent, with an ethnically diverse population of almost 2,000 students (see Graph 13.1). Part of the intention of this project was to try to reach black and minority ethnic communities through the students' experience of both archaeology and members of a higher education institution.

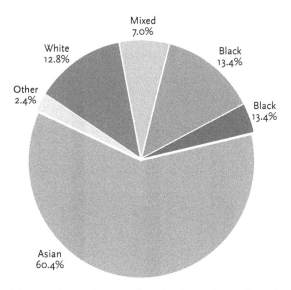

Graph 13.1 Breakdown of Kingsbury High School population by ethnicity. Figures supplied by the school (Agate 2005b, 27).

Andy Agate (Agate 2005b, 45–54) conducted an interesting and useful survey into the attitudes of pupils towards archaeology. In summary the survey showed that:

44%　had found out about an archaeological project in the newspapers or on TV in the last 6 months

28%　regularly watched an archaeological programme on TV

11%　visited an archaeological site in the last year

14%　could name an archaeologist

53%　felt that archaeology was important to them

47%　would consider studying archaeology beyond school

More specifically the pupils were asked about the importance of archaeology. The results are shown in Graph 13.2.

The project showed that a balance needed to be struck between the aims of the project and the number of students who can usefully engage in the archaeological process of excavation and recording. It was too ambitious to take a new group of students each day on a small site. The house was put up for sale and the last season of excavations at this site was in 2006. The season included two three-day 'archaeology courses' of excavation in the garden, where the students excavated test pits which they dug and recorded and were totally responsible for from start to finish, and excavations at the Churches Conservation Trust's St Andrew's Old Church and pupil involvement in this work.

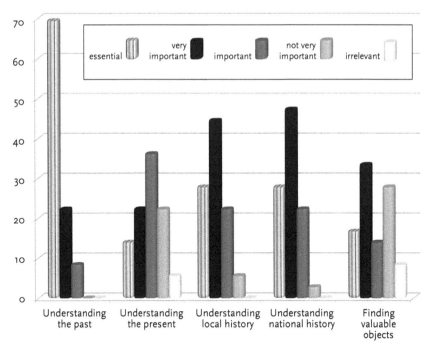

Graph 13.2 Assessment of the importance of archaeology to Kingsbury student group (Agate 2005b, 50)

Young Archaeologists' Club

Young Archaeologists' Club (YAC) is the only national club for children to be involved in archaeology (see p. 106). It is run by the Council for British Archaeology (CBA) and offers activities in a number of branches, a regular newsletter and fieldwork opportunities. In 2005 the IoA set up a branch of YAC with Camden Borough Council who provided funds from a Heritage Lottery Fund grant up to September 2007. Since then it has received small grants from UCL and continues to run branch meetings each month to the present day. Children aged 8–16 are recruited mainly from Camden schools and council play schemes although the YAC members are 8–11-year-olds from a variety of ethnic groups (see Graph 13.3).

The volunteer branch leaders also worked with Camden Council on Archaeology Summer Schools for 10–11-year-olds. The monthly meetings are organised by members of staff, students and ex-students. Activities at the meetings have included:

▶ object handling including 'Around the World in Eighty Artefacts'

▶ excavation in a fish tank

▶ conservation

▶ looking at bones

▶ investigating rubbish

▶ finding out about the Egyptians, Romans, Anglo-Saxons and Scots

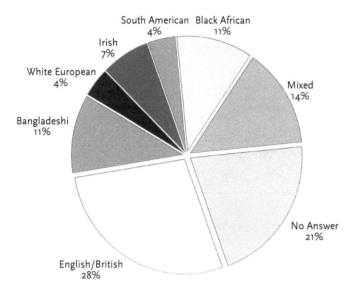

Graph 13.3 Ethnic breakdown of Young Archaeologists' Club members attending the Institute of Archaeology branch in 2006 by branch leader Sarah Dhanjal.

▶ taking part in the national Big Draw event

▶ investigating underwater archaeology

▶ collecting and investigating evidence along the Thames foreshore

▶ the archaeology of buildings

▶ creating cave art

▶ making museum displays

▶ graveyard recording

▶ visits to museums and historic sites

▶ searching for evidence of World War II bombing on the UCL campus using photographs, maps and site visits

▶ working on an excavation.

After the first six months the children were asked to fill in evaluation forms and to suggest changes, improvements and ideas for future meetings. The evaluation showed that the children enjoy YAC and in particular the fun approach to learning. They were excited by the physical and interactive sessions, especially fish tank archaeology (see Fig. 13.5) and mummification, but their favourite practical sessions were undoubtedly the archaeological processes of excavation and finds work (Dhanjal 2008).

Fig. 13.5 Young Archaeologists created layers in a fish tank with toy building blocks and garden compost and sand layers. After construction each layer was recorded and excavated.

What is the future for widening participation?

The work that has been done at the IoA has received positive feedback from the young people involved and their parents and teachers. The evaluation that has been done on some of the activities has had good responses and, where possible, the few suggestions for improvements have been taken on board. Whilst the short-term reaction to such work may be good, the long-term implications are still unknown. Widening Participation in higher education was a New Labour Government initiative, launched in 1999. A deadline of 2010 was set for 50% participation rates of 18–30-year-olds in higher education. Although this target was not reached, some progress is believed to have been made in encouraging students from under-represented backgrounds into higher education. In archaeology, wider awareness of the subject has been a priority. Under the new (2010) Conservative-Liberal Democrat Coalition, cuts to university budgets are inevitable and some have argued that the new tuition fee system will be a significant deterrent to students from poor backgrounds. The government has told universities that, in order to qualify to charge higher fee levels, they must be able to prove that they are making efforts to encourage participation through outreach. Universities are also under pressure to prove their social relevance through considering 'impact'. We must hope that this pressure will ensure that the legacy of work carried out under the Widening Participation aegis across the UK is not wasted.

Bibliography

Aboa Vetus Ars Nova, 2010. *Archaeological Excavations in Aboa Vetus*. http://www.aboavetusarsnova.fi/en/kokoelmat/arkeologiset-kaivaukset-aboa-vetuksessa [19 February 2010].

Acropolis Education Department, 2010a. *Home Page*. http://www.ysma.gr/ysma/Default.aspx [9 January 2010].

—— 2010b. *Parthenon Frieze*. http://www.parthenonfrieze.gr/#/home [9 January 2010].

Acropolis Museum, 2010. *Home Page*. http://www.theacropolismuseum.gr/default.php?pname=Home&la=2 [28 January 2010].

Adair, J., 1983. *Effective Leadership: A Self-Development Manual*. Aldershot: Gower Press.

Adams, M., and Reeve, J., 1987. Excavations at Christ Church, Spitalfields, 1985–6. *Antiquity* 61 (232): 247–56.

Adkins, L., and Adkins, R. A., 1986. *Under the Sludge: Beddington Roman Villa, Excavations at Beddington Sewage Works 1981–1983*. Carshalton: Beddington, Carshalton and Wallington Archaeological Society.

Agate, A., 2005a. Getting archaeology into class. *London Archaeologist* 11: 3–8.

—— 2005b. *Widening Participation and the Institute of Archaeology: Putting Policy into Practice at Kingsbury High School*. Unpublished BA thesis, University College London.

Agbe-Davies, A., 2003. Conversations: archaeology and the black experience. *Archaeology* 56/1.

Aitchison, K., and Edwards, R., 2008. *Archaeology Labour Market Intelligence: Profiling the Profession, 2007–08*. Reading: Institute of Field Archaeologists.

Alberge, D., 2005. New enemy menaces Hadrian's Wall. *The Times*, 11 April, 3.

—— 2007. Treasure hunters – the new heroes of national heritage. http://www.timesonline.co.uk/tol/news/uk/article1293915.ece [28 January 2010].

Alexander, L., 1987. *A Visit to the Sesame Street Museum*. New York: Random House.

Allan, D., 2005. The Suffolk Garbology Project. *Council for British Archaeology East Anglia Region Newsletter*, 2.

Allen, L., and Storan, J., 2005. *Widening Participation: A Rough Guide for Higher Education Providers*. University of Bradford, Bradford.

Allen, S., Hollinshead, L., and Wilkinson, S., 1998. *Using Houses and Homes: A Teacher's Guide*. London: English Heritage.

Alston, S., 1993. Teaching rubbish in the classroom. *Remnants* 20: 6–7.

Amos, L., Clarke, J., and Woollard, V., 1996. *English at the Geffrye Museum: Ideas for Language Work*. London: Geffrye Museum.

Ancient Merv Project, 2010. *Education*. http://www.ucl.ac.uk/merv/our%20research/Teachers%20Handbook/ [10 January 2010].

Anderson, C., Planel, P., and Stone, P., 2000. *Stonehenge: A Teacher's Handbook*. London: English Heritage.

Anderson, J., 2010. The past in your pocket: mobile media and interactive interpretation. *Research News: Newsletter of the English Heritage Research Department* 13: 17–19.

Anderson, J. M., 2006. *Jungle Dumb*. http://www.combustiblecelluloid.com/2006/apocalypto.shtml [17 January 2010].

Andreae, G., 1999. *Purple Ronnie's History of the World*. London: Boxtree.

Anon., c. 1927. *Britain's Story Told in Pictures*. Manchester: Sankey, Hudson.

—— 2005. Museum experts to lead dig in the park. *Hackney Gazette*, 9 June, 6.

—— 2006. Get out of the classroom ... and take your school on an English Heritage Discovery Visit. *Heritage Learning* 32: 4.

—— 2008. Spoilheap: Do not read this if you are sensitive [or work at English Heritage]. *British Archaeology* 103: 27.

Antomarchi, C., and Ardemagni, M., 2006. Travel operators: new partners in protecting cultural heritage. *ICCROM Newsletter* 32: 11.

Aplin, G., 2002. *Heritage: Identification, Conservation, and Management.* Oxford: Oxford University Press.

Appleby, G. A., 2005. Crossing the Rubicon: fact or fiction in Roman re-enactment. *Public Archaeology* 4: 257–65.

Arbeia, 2010. *Arbeia Roman Fort and Museum: Hazard Identification Sheet.* http://www. twmuseums.org.uk/schools/tpl/uploads/Arbeia_Hazard_ID_-_February_2004.doc [15 January 2010].

Archaeologica, 2010. *Archaeological News Stories.* http://www.archaeologica.org/ NewsPage.htm [4 February 2010].

Archaeological Data Service, 2010. *Archaeological Data Service.* http://ads.ahds.ac.uk/ [17 February 2010].

Archaeological Institute of America, 2010. *Ancient World on TV.* http://www.archaeology. org/events/tv.html [6 February 2010].

Archaeology, 1991. *Αρχαιολογία* 38 (March).

Archaeology Scotland, 2010a. *Strategic Plan 2009–2013.* http://www.archaeologyscotland. org.uk/sites/default/files/Strategic%20plan%202009-2013.pdf [20 January 2010].

—— 2010b. *Archaeology and the Curriculum for Excellence.* http://www. archaeologyscotland.org.uk/sites/default/files/Microsoft%20Word%20%20 Archaeology%20and%20the%20Curriculum%20for%20Excellence%20 UPDATED09.pdf [20 January 2010].

—— 2010c. *Education and Outreach.* http://www.archaeologyscotland.org.uk/?q=node/3 [20 January 2010].

—— 2010d. *Artefact Investigation Kits.* http://www.archaeologyscotland.org.uk/sites/ default/files/Artefact%20Investigation%20Kit%20loans%20pdf.pdf [21 January 2010].

Architectural Record, 2010. *World Monuments Fund Unveils 2008 Watch List.* http:// archrecord.construction.com/news/daily/archives/070606watch.asp [1 February 2010].

Ardren, T., 2006. Is "Apocalypto" pornography? *Archaeology, Online Reviews,* 5 December 2006 [online]. http://www.archaeology.org/online/reviews/apocalypto.html [5 February 2010].

Arnold, J., Davies, K., and Ditchfield, S. (eds.) 1998. *History and Heritage: Consuming the Past in Contemporary Culture.* Shaftesbury: Donhead Publishing.

Arnold, N., 2001. *Awesome Archaeology.* London: Scholastic.

Arthur, J., and Phillips, R. (eds.), 2000. *Issues in History Teaching.* London: Routledge.

Arvanitidi, E., 1996. *Arbeia: Activity Book.* Newcastle upon Tyne: Tyne and Wear Archives and Museums.

Ascherson, N., 2001. 'Heritage terrorism' is a way of sticking two fingers up at West. *The Observer,* 4 April, 12.

—— 2004. Archaeology and the British media. In Merriman 2004, 145–58.

Ashworth, G. J., 2004. The BBC's 'Restoration': should we cheer, laugh or cry? *International Journal of Heritage Studies* 10 (2): 209–12.

Ashworth, R., 2005. Done Roman: a day at the chariot races. *East Anglian Daily Times,* 17 March, 5.

Aslan, Z., and Ardemagni, M., 2006. *Introducing Young People to Heritage Site Management and Protection: A Practical Guide for Secondary School Teachers in the Arab Region.* Rome: International Centre for the Study of the Preservation and Restoration of Cultural Property.

Association of Jewish Refugees, 2010. *Kindertransport.* http://www.ajr.org.uk/ kindertransport [20 February 2010].

Aston, M., 1985. *Interpreting the Landscape: Landscape Archaeology in Local Studies.* London: Batsford.

Aston, O., 1987. *Learning Beyond the Classroom: Information for Newly Qualified Teachers.* London: English Heritage.

—— 2000. *Using English Heritage Sites during Residential Visits.* London: English Heritage.

Athens International Airport, 2003. *Museum: Mesogeia, Attica History and Civilisation.* Athens: Athens International Airport and Hellenic Ministry of Transport and Communications.

—— 2010. *Care for the Environment.* Athens: Environmental Services Department, Athens International Airport.

Atkins, L. S., 2006. *Crime Investigations: A Science Workshop for Teachers in Grades 1–3.* Denton: College of Education, University of North Texas.

Atkinson, K., 1996. *Behind the Scenes at the Museum.* London: Black Swan.

Baedeker, K., 1928. *Italy from the Alps to Naples: Abridged Handbook for Travellers.* Leipzig and London: Karl Baedeker, Allen & Unwin.

Bailey, G., 2009. To the sea, with bucket and trowel. *British Archaeology,* Sept/Oct, 52–3.

Balazik, D., 2003. *Outdoor & Adventurous Activities for Juniors.* London: A. & C. Black.

Banks-Smith, N., 2008. Last night's TV. *The Guardian G2,* 23 July, 31.

Barber, E., 2006. *Digging up the Past.* http://www.lgfl.net/lgfl/leas/bromley/schools/ses/ accounts/staff/science/homepage/CSI/ [19 January 2010].

Bardavio, A., Gatell, C., and González-Marcén, P., 2004. Is archaeology what matters? Creating a sense of local identity among teenagers in Catalonia. *World Archaeology* 36 (2): 261–74.

Bareham, J., 1964. *From Caves to Cities.* London: Pergamon Press.

Barker, P., 1977. *Techniques of Archaeological Excavation.* London: Batsford.

Barlow, P., 2006. *Author's Notes: The Sutton Hoo Mob Programme.* Ipswich: Eastern Angles.

Barnes, J., 1992. Castle music. *Remnants* 17: 4–5.

—— 1999. *Design & Technology and the Historic Environment: A Teacher's Guide.* London: English Heritage.

Barnes, J., and Harmsworth, A., 1991. *Dover Castle: A Handbook for Teachers.* London: English Heritage.

Barnes, J. (Julian) 1998. *England, England.* London: Jonathan Cape.

Barnes, P., 2002. *Leadership with Young People.* Lyme Regis: Russell House Publishing.

Barnes, P., and Sharp, B. (eds.) 2004. *The RHP Companion to Outdoor Education.* Lyme Regis: Russell House Publishing.

Barnett, J., 2005. The Value of Fieldwork Today. *Horizons* 30: 14–17.

Batchelor, R., 1994. Not looking at kettles. In *Interpreting Objects and Collections,* ed. S. M. Pearce, 139–43. London: Routledge.

BBC News, 2007. Remains of Roman teenager buried. http://news.bbc.co.uk/1/hi/ england/london/6563909.stm [20 January 2010].

Beavis, J., and Hunt, A. (eds.), 1999. *Communicating Archaeology: Papers Presented to Bill Putnam at a Conference Held at Bournemouth University in September 1995.* Occasional Paper no. 4. Bournemouth and Oxford: Bournemouth University School of Conservation Sciences and Oxbow Books.

Benjamin, A., 2004. Candid camera. *The Guardian,* 10 November, 2–3.

Bennett, A., 2004. *The History Boys.* London: Faber & Faber.

—— 2005. *Untold Stories.* London: Faber & Faber.

Benz, M., and Liedmeier, A., 2007. Archaeology and the German press. In Brittain and Clack 2007a, 153–73.

Berghahn, V. R., and Schissler, H. (eds.), 1987. *Perceptions of History: International Textbook Research on Britain, Germany and the United States*. Oxford: Berg.

Betjeman, J., 1978. *The Best of Betjeman*, ed. J. Guest. Harmondsworth: Penguin.

Blair, I., Simpson, F., and Moshenska, G., 2006. The archaeology of the Blitz. *Current Archaeology* 201: 486–93.

Blanchard, P., 1984. *Blue Guide for Southern Italy*. London: Ernest Benn.

Blau, S., 2004. Forensic archaeology in Australia: current situations, future possibilities. *Australian Archaeology* 58: 11–14.

Blockley, M., 1986. The Prestatyn excavation: education, presentation, and video. In Cracknell and Corbishley 1986, 17–23.

Board of Education, 1943. *Report of the Consultative Committee on Secondary Education, with Special Reference to Grammar Schools and Technical High Schools*. London: His Majesty's Stationery Office.

Bogdanos, M., with Patrick, W., 2005. *Thieves of Baghdad: One marine's Passion to Recover the World's Greatest Stolen Treasures*. London: Bloomsbury.

—— 2005. The Casualties of War: The Truth About the Iraq Museum. *American Journal of Archaeology* 109 (3): 477–526.

Bognár, M., 2006. Curriculum changes in Hungary – challenges of continuous learning. In Crişan 2006, 41–61.

Bond, T., 1986. *Games for Social and Life Skills*. New York: Nichols Publishing.

Bonnichsen, R., 1973. Millie's Camp: an experiment in archaeology. *World Archaeology* 4 (3): 277–91.

Borovikova, E., and Barnashova, O., 2006. Textbook development in the Russian Federation. In Braslavsky 2006, 315–63.

Bottrall, M., and Bottrall, R., 1946. *Collected English Verse*. London: Sidgwick & Jackson.

Bowden, M. (ed.), 1999. *Unravelling the Landscape: An Inquisitive Approach to Archaeology*. Stroud: Tempus.

Bowden, R., 2003. *Sustainable World: Waste*. London: Hodder Headline.

Bradley, H., 2009. Adopt a monument. *Past Horizons* 6: 26–9.

Braithwaite, A., 1977. *Castle Life*. London and Cambridge: Evans and Dinosaur Publications.

—— 1981. *Visiting a Museum*. Cambridge: Dinosaur Publications.

Branchesi, L. (ed.), 2007. *Heritage Education for Europe: Outcome and Perspective*. Rome: Armando Editore.

Branigan, K., 2000. All good things come to an end ... *Archaeology in Education Newsletter*, May, 1–2.

Braslavsky, C. (ed.), 2006. *Textbooks and Quality Learning for All: Some Lessons Learned from International Experiences*. Paris: UNESCO.

Brassey, R., 2006. *Boudica*. London: Orion.

Breasted, J. H., and Jones, W. H., 1927. *A Brief History of Ancient Times*. London: Ginn.

Breslin, T., 1997. *Across the Roman Wall*. London: A. & C. Black.

Brett, P., Mompoint-Gaillard, P., and Salema, M. H., 2009. *How All Teachers Can Support Citizenship and Human Rights Education: A Framework for the Development of Competences*. Strasbourg: Council of Europe.

Breuil, H., 1949. *Beyond the Bounds of History*. London: P. R. Gawthorn.

Bridal, T., 2004. *Exploring Museum Theatre*. Walnut Creek, CA: Altamira Press.

Briggs, A., and Burke, P., 2005. *A Social History of the Media: from Gutenburg to the Internet*. Cambridge: Polity.

Brisbane, M., and Wood, J., 1996. *A Future for our Past? An Introduction to Heritage Studies.* London: English Heritage.

British Archaeology, 2008. Letters. *British Archaeology* 103: 10–13.

British Broadcasting Corporation, 2010a. *History for Kids.* http://www.bbc.co.uk/history/forkids/ [17 February 2010].

—— 2010b. *Chronicle Archive.* http://bbc.co.uk/archive/chronicle/8607.shtml [6 February 2010].

British Museum, 2010. *The Parthenon Sculptures: Stewardship.* http://www.britishmuseum.org/explore/highlights/article_index/p/the_parthenon_stewardship.aspx [26 January 2010].

British Science Association, 2010. *National Science and Engineering Week – Science Events for Everyone.* http://www.britishscienceassociation.org/web/nsew/ [8 January 2010].

Brittain, M., and Clack, T. (eds.), 2007a. *Archaeology and the Media.* Walnut Creek, CA: Left Coast Press.

—— 2007b. Introduction: Archaeology and the media. In Brittain and Clack 2007a, 11–65.

Brothwell, D., and Higgs, E. (eds.), 1963. *Science in Archaeology: A Survey of Progress and Research.* London: Thames & Hudson.

Brummell, P., 2005. *Turkmenistan.* Chalfont St Peter: Bradt Travel Guides.

Bryant, J., 1996. *Turner: Painting the Nation.* London: English Heritage.

Buchli, V., and Lucas, G. (eds.) 2001. *Archaeologies of the Contemporary Past.* London: Routledge.

Buckinghamshire County Archaeological Service, 2010. *Archaeological Skills and Concepts.* http://ubp.buckscc.gov.uk/ThemeDetails.aspx?UID=TBC502 [19 February 2010].

Bunyard, R. S., 1978. *Police: Organisation and Command.* Plymouth: Macdonald & Evans.

Burn, K., and Harris, R., 2010. *Survey of History in Schools in England 2010.* London: Historical Association.

Burtt, F., 1987. 'Man the hunter': bias in children's archaeology books. *Archaeological Review from Cambridge* 6 (2): 157–74.

CABE, 2010a. *Shape the Future: Corporate Strategy, 2008/09–2010/11.* http://www.cabe.org.uk/publications/shape-the-future [18 January 2010].

—— 2010b. *Learning and Skills.* http://www.cabe.org.uk/education-skills [10 January 2010].

—— 2010c. *Engaging Places.* http://www.cabe.org.uk/education/engaging-places [19 January 2010].

—— 2010d. *Helping Communities to Improve Public Spaces.* http://www.cabe.org.uk/publications/helping-community-groups-improve-publicspaces?utm_medium=email&utm_source=Campaign%20Monitor&utm_content=838093643&utm_campaign=CABENews-October2009+_+urjjdd&utm_term=newbriefingfromCABESpace [18 January 2010].

—— 2010e. *Spaceshaper 9–14.* http://www.cabe.org.uk/public-space/spaceshaper-9-14 [18 January 2010].

—— 2011. *Archive Information.* http://www.cabe.org.uk/archive [10 February 2011].

Cadw, 2010a. *The Welsh Historic Environment: A Celebration, 2009.* http://www.cadw.wales.gov.uk/upload/resourcepool/Position%20Statement%20English%20Part%2015004.pdf and http://www.cadw.wales.gov.uk/upload/resourcepool/Position%20Statement%20English%20Part%2029610.pdf [21 January 2010].

—— 2010b. *Teachers.* http://www.cadw.wales.gov.uk/default.asp?id=133&navId=14&parentId=14 [21 January 2010].

—— 2010c. *Songs from Stones.* http://www.songsfromstones.co.uk/map/ [17 February 2010].

California Department of Education, 1999. *Reading/Language Arts Framework for California Public Schools: Kindergarten through Grade Twelve.* Sacramento, CA: California Department of Education.

—— 2005. *History-Science Framework for California Public Schools: Kindergarten Through Grade 12.* Sacramento, CA: California Department of Education.

Callcott, Lady, 1834. *Little Arthur's History of England.* London: John Murray.

Campaign for Drawing, 2010. *The Big Draw, Home Page.* http://campaignfordrawing. org/home/index.aspx [3 February 2010].

Cannings, J., 2002. Why place? *Teaching Geography* 27 (3): 115–18.

Canterbury Archaeological Trust, 2010a. *Archaeology in Education Service.* http://www. canterburytrust.co.uk/schools/aes/aespg.htm [19 February 2010].

—— 2010b. *Citizenship Education: Archaeology in the Local Community.* http://www. canterburytrust.co.uk/schools/citzen01.htm [26 January 2010].

Caro, J. J. F., Lama, P. J. R., and Prieto, J. L. R., 2008. Resources for teachers from the Educational Department of Fine Arts of Seville for archaeological sites. *Conservation and Management of Archaeological Sites* 10 (1): 64–77.

Carter, H., and Mace, A. C., 1923. *The Tomb of Tut-Ankh-Amen.* London: Cassell.

Carver, M., 1998. *Sutton Hoo: Burial Mound of Kings?* London: British Museum Press.

Castell Henllys, 2010. *Surviving the Volunteers!* http://www.castellhenllys.com/english/ bbc_surviving.htm [6 February 2010].

Catling, J., and Rankin, A., 2007. *This Way to the Northern Frontier, Tribes and Romans in Northern Britain: A Resource for Teachers.* Newcastle upon Tyne: Museum of Antiquities of the University and Society of Antiquities of Newcastle upon Tyne.

CBBC, 2007. *Relic: Guardians of the Museum.* http://www.bbc.co.uk/programmes/ b00qgvyz [6 February 2010].

Cerón, I. D., and Mz-Recaman, C. I., 1994. The museum comes to school in Columbia: teaching packages as a method of learning. In Stone and Molyneaux 1994, 148–58.

Cerri, A., 2007. The political dimension of the Council of Europe education programme. In Branchesi 2007, 19–57.

Chadwick, G., and Crummy, N., 2006. Reaching out in all directions: The Friends of the Colchester Archaeological Trust. In *A Victory Celebration: Papers on the Archaeology of Colchester and Late Iron Age-Roman Britain Presented to Philip Crummy,* ed. P. Ottoway, 129–32. Colchester: Friends of the Colchester Archaeological Trust.

Chancellor, V. E., 1970. *History for their Masters: Opinion in the English History Textbook, 1800–1914.* New York: Augustus M. Kelley.

Channel 4, 2010. *Extreme Archaeology.* http://www.channel4.com/history/microsites/E/ extremearchaeology/ [6 February 2010].

Charles, Prince of Wales, 1989. *A Vision of Britain: A Personal View of Architecture.* London: Doubleday.

Chatterbox, 1921. London: Wells, Gardner & Darton.

Chiarulli, B. A., Bedel, E. D., and Studerant, C. L., 2000. Simulated excavations and critical thinking skills. In *The Archaeology Education Handbook: Sharing the Past with Kids,* ed. K. E. Smardz and S. J. Smith, 217–33. Walnut Creek, CA: Altamira Press.

Chisholm, J., 1982. *Living in Prehistoric Times.* London: Usborne.

Cholidis, N., 2001. The glamour of the East: some reflections on Agatha Christie's *Murder in Mesopotamia.* In Trümpler 2001, 334–49.

Christie, A., 1954. *The Mysterious Affair at Styles.* London: Pan Books.

Chryssoulaki, S., 1995. Monuments and environmental education in Athens. In *The City Beneath the City,* ed. M. Corbishley, 22–3. Rome: International Centre for the Study of the Preservation and Restoration of Cultural Property.

—— (ed.), 2004. *Gifts of the Muses – Music and Dance in Ancient Greece: A Teacher's Pack.* Athens: Hellenic Ministry of Culture.

Chryssoulaki, S., and Seleli, A., 2009. *Environment and Culture: The Tree of Life through Four Seasons*. Athens: Hellenic Ministry of Culture.

Church Commissioners, 2010. *Report of the Church Buildings (Uses and Disposals) Committee to the Board of Governors for the Year to 31 December 2008*. http://www.cofe.anglican.org/about/churchcommissioners/pastoralandclosedchurches/closedchurches/cbudc/cbudcannualreporttoboard08.doc [24 January 2010].

Church of England, 2010. *Redundant Churches in the Church of England: A Guidance Note for Local Planning Authorities*. http://www.cofe.anglican.org/about/churchcommissioners/pastoralandclosedchurches/closedchurches/lpa/rcg32008.doc [24 January 2010].

Churches Conservation Trust, 2009a. *Annual Review 2008 to 2009*. London: Churches Conservation Trust.

—— 2009b. *Annual Report and Accounts for the Year Ended 31 March 2009*. London: Churches Conservation Trust.

—— 2009c. *Historic Churches at the Heart of Communities: Our Aims 2009–15*. London: Churches Conservation Trust.

—— 2010. *Home Page*. www.visitchurches.org.uk [7 January 2010].

Civardi, A., Hindley, J., and Wilkes, A., 2008. *The Usborne Detective's Handbook*. London: Usborne.

Clack, P., 1988. Archaeology and education: a review. *CBA Education Bulletin* 5: 21–6.

Clarke, A., Fulford, M., Rains, M., and Shaffrey, R., 2001. *The Victorian Excavations of 1893 Silchester Roman Town – The Insula IX Town Life Project*. http://www.silchester.reading.ac.uk/victorians [17 February 2010].

Clarke, D., and Maguire, P., 1995. *Skara Brae: Northern Europe's Best Preserved Prehistoric Village*. Edinburgh: Historic Scotland.

Cleere, H., 1984. World cultural resource management: problems and perspectives. In *Approaches to the Archaeological Heritage*, ed. H. Cleere, 129–30. Cambridge: Cambridge University Press.

—— 2000. Behind the scenes at Time Team. *Public Archaeology* 1 (1): 90–2.

Clegg, D., 2004. Fingerprint identification. In Horswell 2004a, 161–79.

Clifford, S., and King, A., 1993. *Losing Your Place*. Shaftesbury: Common Ground.

CNDP/Xo, 2002. *Qu'apprend-on au collège?* Paris: Conseil National des Programmes/Xo editions.

—— 2003. *Qu'apprend-on à l'école élémentaire?* Paris: Conseil National des Programmes/Xo editions.

Cobblestone, 2010. *Dig*. http://www.digonsite.com/ [17 February 2010].

Codrington, S., 2006. *Science in Urban Public Gardens*. London: Nuffield Foundation.

Colchester Archaeological Trust, 2010a. *Home Page*. http://www.catuk.org [9 January 2010].

—— 2010b. *Online Library*. http://cat.essex.ac.uk/ [9 January 2010].

Coles, A., and Dion, M. (eds.), 1999. *Mark Dion: Archaeology*. London: Black Dog.

Coles, J., 1973. *Archaeology by Experiment*. London: Hutchinson.

—— 1979. *Experimental Archaeology*. London: Academic Press.

Collier, M., Day, S., Doherty, B., and Marriott, B., 2003. *Think History! Changing Times, 1066–1500*. Oxford: Heinemann.

Collingwood, R. G., 1923. *Roman Britain*. London: Oxford University Press.

——1994. *The Idea of History with Lectures, 1926–1928*, ed. J. van der Dussen. Oxford: Oxford University Press.

Collins, F., and Hollinshead, L., 2000. *English and the Historic Environment: A Teacher's Guide*. London: English Heritage.

Collins, M., 2005. *Ingenious Gadgets*. Newton Abbot: David & Charles.

Colomer, L., 2002. Educational facilities in archaeological reconstructions: Is an image worth more than a thousand words? *Public Archaeology* 2: 85–94.

Colonial Willamsburg, 2010. *American Indian Bandolier Bag: Hands-On History Kit.* http://www.williamsburgmarketplace.com/webapp/wcs/stores/servlet/ProductLine View?jspStoreDir=wmarket&catalogId=12121&categoryId=14098&priceRange=&la ngId=-1&sortBy=featured&storeId=10001 [13 January 2010].

Committee for the Reunification of the Parthenon Marbles, 2010. *Home Page.* http:// www.parthenonuk.com/index.php [26 January 2010].

Conan Doyle, Sir A., 1981. *The Penguin Complete Sherlock Holmes.* Harmondsworth: Penguin.

Connecticut Resources Recovery Authority, 2010. *Education.* http://www.crra.org/pages/education.htm [24 January 2010].

Connor, M. A., 2007. *Forensic Methods: Excavation for the Archaeologist and Investigator.* Lanham, MD: Altamira Press.

Construction History Society, 2007. News story. *Construction History Society Newsletter* 78: 1.

Cook, P., 1997. *Making Monumental Music: Using a Building as a Stimulus for Music Making.* London: English Heritage.

Cooke, L., 2007. The archaeologist's challenge or despair: reburial at Merv, Turkmenistan. *Conservation and Management of Archaeological Sites* 9 (2): 97–112.

—— 2010. *Conservation Approaches to Earthen Architecture in Archaeological Contexts.* BAR International Series 2147. Oxford: Archaeo Press.

Cooksey, C., 1992. *Using Abbeys: A Teacher's Guide.* London: English Heritage.

Cooper, G., 1998. *Outdoors with Young People: A Leader's Guide to Outdoor Activities, the Environment and Sustainability.* Lyme Regis: Russell House Publishing.

—— 2005. The value of outdoor learning for schools. *Horizons* 29: 20–3.

—— 2006a. Disconnected children. *Horizons* 33: 22–5.

—— 2006b. The wider view – environment, sustainability and the outdoors. *Horizons* 35: 14–16.

Cooper, H., 2000a. Primary school history in Europe: a staple diet or a hot potato? In Arthur and Phillips 2000, 159–74.

—— 2000b. *The Teaching of History in Primary Schools: Implementing the Revised National Curriculum.* London: David Fulton.

—— 2002. *History in the Early Years.* London: Routledge.

Cooper, T., 2004. *How Do we Keep our Parish Churches?* London: Ecclesiological Society.

Coote, J., Morton, C., and Nicolson, J., 2000. *Transformations: The Art of Recycling.* Oxford: Pitt Rivers Museum University of Oxford.

Copeland, T., 1991. *Maths and the Historic Environment: A Teacher's Guide.* London: English Heritage.

—— 1993. *Geography and the Historic Environment: A Teacher's Guide.* London: English Heritage.

—— 1999. Past experience – the view from teacher education. In Beavis and Hunt 1999, 79–86.

—— 2004. Interpretations of history: constructing pasts. In Henson *et al.* 2004, 33–40.

—— 2007. Heritage education and citizenship in the Council of Europe. In Branchesi 2007, 65–83.

Copley, G. J., 1958. *Going into the Past.* Harmondsworth: Penguin.

Corbishley, M. (ed.), 1979. *Archaeological Resources Handbook for Teachers.* London: Council for British Archaeology.

—— 1981. Archaeology – just a load of rubbish? *Young Archaeology* 34: 2.

—— (ed.), 1982–5. *Archaeology for Schools* [*Archaeology in the Classroom, Archaeology in the Primary School, Archaeology in the Countryside, Archaeology in the Town, Archaeology and Science, Archaeology and Death, Archaeology and the Sea, Archaeology and Computers, Upstanding Archaeology*]. London: Council for British Archaeology.

—— 1982. Experimenting with food. In Croft 1982, 10–12.

—— (ed.), 1983. *Archaeological Resources Handbook for Teachers*. London: Council for British Archaeology.

—— 1984. Excavations at St Mary's church, Little Oakley, Essex, 1977. In *Four Church Excavations in Essex*, 15–27. Essex County Council Occasional Paper no. 4. Chelmsford: Essex County Council.

—— 1986a. The case of the blocked window. *Remnants* 2: 1–4.

—— 1986b. Presenting archaeology to young people. In Cracknell and Corbishley 1986, 3–8.

—— 1987. Miss ... please miss, why did people live underground? *Remnants* 3: 1–3.

—— 1988. The past replayed: a day at Kirby Hall. *Remnants* 5: 5–8.

—— 1989a. *Prehistoric Britain Activity Book*. London: British Museum Press.

—— (ed.), 1989b. *Archaeology for Ages 5 to 16: Proposals from the Council for British Archaeology*. London: Council for British Archaeology.

—— 1990a. The past replayed: English Heritage and living history projects for schools. In Wilson and Woodhouse 1990, 51–4.

—— 1990b. *Archaeological Detectives: Poster Games*. London: English Heritage.

—— 1990c. *Archaeological Detectives: Investigating Clues to the Past* [video]. London: English Heritage.

—— (ed.), 1992. *Archaeology in the National Curriculum*. London: Council for British Archaeology and English Heritage.

—— 1994. *What Do we Know about Prehistoric People?* London: Simon & Schuster.

—— 1999a. The National Curriculum: help or hindrance to the introduction of archaeology in schools? In Beavis and Hunt 1999, 71–8.

—— (ed.), 1999b. *Primary History: Using the Evidence of the Historic Environment*. London: English Heritage.

—— 2001. *Time Detectives: Poster Games and Teacher's Notes*. London: English Heritage.

—— 2004. *Aerial Photography: A Teacher's Guide*. London: English Heritage.

—— 2005. *Ancient Cities of Merv: Handbook for Teachers*. http://www.ucl.ac.uk/merv/our%20research/Teachers%20Handbook/ [15 January 2010].

Corbishley, M., and Cooper, M., 1999. *Real Romans: Time Traveller*, Gravesend/London: TAG Publishing/English Heritage.

Corbishley, M., Darvill, T., and Stone, P., 2000. *Prehistory: A Teacher's Guide*. London: English Heritage.

Corbishley, M., Fordham, J., Walmsley, D., and Ward, J., 2008. Learning beyond the classroom: archaeological sites and schools. *Conservation and Management of Archaeological Sites* 10 (1): 79–92.

Costello, M., 1997. You are here: a cultural exploration of the Maya and seventh graders. In Wolf, Balick and Craven 1997, 29–51.

Cotton, M., 1981. *Out of Doors with Handicapped People*. London: Souvenir Press.

Coulson, I., 1992. *The Roman Empire*. Oxford: Oxford University Press.

Council for British Archaeology, 1989. *Archaeology for Ages 5 to 16: Proposals from the Council for British Archaeology*. London: Council for British Archaeology.

—— 2003. *Participation in the Past: The Results of an Investigation by a CBA Working Party Chaired by Mike Farley*. York: Council for British Archaeology.

—— 2010a. *Looking and Observing Games*. http://www.britarch.ac.uk/yac/YAYA_01_Looking_games.pdf [14 January 2010].

—— 2010b. *Young Archaeologists' Club*. http://www.yac-uk.org [19 February 2010].

—— 2010c. *A Brief History of the CBA*. http://www.britarch.ac.uk/cba/history [19 January 2010].

—— 2010d. *Education*. http://www.britarch.ac.uk/education [19 January 2010].

—— 2010e. *Downloadable Factsheets*. http://www.britarch.ac.uk/yac/factsheets.html [19 January 2010].

Council for Learning Outside the Classroom, 2010. *Who Are the Council for Learning Outside the Classroom?* http://www.lotc.org.uk/Council-for-LOtC/CLOtC-Overview [15 January 2010].

Coupland, L., 1988. *The Avebury Monuments: A Study Pack for Teachers*. London: English Heritage.

Courtley, H., 2001. *New Uses for Old Churches: Citizenship and the Historic Environment: Notes for Teachers*. London: English Heritage.

Cox, M., 2001. Forensic archaeology in the UK: questions of socio-intellectual context and socio-political responsibility. In Buchli and Lucas 2001, 145–57.

—— 2009. Forensic anthropology and archaeology: past and present: a United Kingdom perspective. In *A Handbook of Forensic Anthropology and Archaeology*, ed. S. Blau and D. H. Ubelaker, 29–41. Walnut Creek, CA: Left Coast Press.

Cracknell, S., and Corbishley, M. (eds.), 1986. *Presenting Archaeology to Young People*. Research Report no. 64. London: Council for British Archaeology.

Craven Museum, 2010. *Education and Outreach Resources*. http://www.cravendc.gov.uk/Craven/Visitors/Craven+Museum+and+Gallery/EducationAndOutreach/ [19 February 2010].

Crawford, K., 2003. Editorial: The role and purpose of textbooks. *International Journal of Historical Learning and Research* 3 (2): 1–6 [online]. http://centres.exeter.ac.uk/historyresource/journal6/6contents.htm [7 February 2010].

—— 2006. Culture wars: Japanese history textbooks and the construction of official memory. In Foster and Crawford 2006a, 49–68.

Crawford, O. G. S., 1921. *Man and his Past*. Oxford: Oxford University Press.

—— 1954. *Archaeology in the Field*. London: Dent.

Creaser, K., Newman-Horwell, M., and Fordham, J., 2004. *Historic House Education: A Practical Handbook for HHA Members*. London: English Heritage and Historic Houses Association.

Creasey, B., 2000. *Evaluation of Parents' Leaflets*. London: Qualifications and Curriculum Authority.

Cressey, P. J., Reeder, R., and Bryson, J., 2003. Held in trust: community archaeology in Alexandria, Virginia. In Derry and Malloy 2003, 1–17.

Croft, R. (ed.), 1982. *Archaeology for Schools: Archaeology and Science*. London: Council for British Archaeology.

Crişan, A. (ed.) 2006. *Current and Future Challenges in Curriculum Development: Policies, Practices and Networking for Change*. Bucharest: Humanitas Educaţional & Editura Educatia 2000+.

Crowthers, M. E., 2008. Experimental archaeology within the heritage industry: publicity and the public at West Stow Anglo-Saxon Village. In *Experiencing Archaeology by Experiment*, ed. P. Cunningham, J. Heeb and R. Paardekooper, 37–46. Oxford: Oxbow Books.

Crummy, N., 2005. Contract archaeology and the public: a look on the bright side. *Rescue News* 97: 6.

Crummy, P., 1979. *In Search of Colchester's Past*. Colchester: Colchester Archaeological Trust.

—— 1984. Colchester Castle. *Catalogue: News of the Colchester Excavations in Colchester* 14: 4–8.

—— 1992. *Colchester Archaeological Report 6: Excavations at Culver Street, the Gilberd School, and Other Sites in Colchester, 1971–85*. Colchester: Colchester Archaeological Trust.

—— 1993. Warrior burial. *Colchester Archaeologist* 6: 1–5 [online]. http://cat.essex.ac.uk/reports/MAG-report-0006.pdf [21 February 2010].

—— 1997. *City of Victory: The Story of Colchester – Britain's First Roman Town*. Colchester: Colchester Archaeological Trust.

—— 2006a. Circus revealed. *The Colchester Archaeologist* 19: 2–7.

—— 2006b. The circus comes to Colchester. *Current Archaeology* 201: 468–75.

—— 2007. Circus update. *The Colchester Archaeologist* 20: 2–7.

Crummy, P., Crummy, N., Jackson, R., and Schädler, U., 2008. Stanway: An elite cemetery at Camulodunun. *British Archaeology* 99: 28–33.

Cuckow, J. G., 1838. Our Native England: or the Historical 'House that Jack Built': Being the History of England Made Easy. In *Familiar Verse, with Forty-Seven Wood-Cuts*. London: J. & C. Mozley.

Culpin, C., and Linsell, D., 1989. *Past into Present: AD 43–1400*, book 1. London: Collins.

Cumming, V., Merriman, N., and Ross, C., 1996. *Museum of London*. London: Scala.

D'Alelio, J., 1989. *I Know That Building!* Washington, DC: National Trust for Historic Preservation.

Daniel, G., 1962. *Welcome Death*. Harmondsworth: Penguin.

—— 1964. *The Idea of Prehistory*. Harmondsworth: Penguin.

—— 1967. *The Origins and Growth of Archaeology*. Harmondsworth: Penguin.

—— 1975. *150 Years of Archaeology*. London: Duckworth.

David, R., 1996. *History at Home: A Guide for Parents and Teachers*. London: English Heritage.

Davies, A., 2003. The cudgels are out: Does it matter if historical dramas take liberties with the facts?, *The Guardian*, 17 November, 23.

Davies, I., and Webb, C., 1996. *Using Documents: A Teacher's Guide*. London: English Heritage.

Davis, L., 1990. *The Silver Pigs*. London: Pan Books.

Davison, B., 1983. *Explore a Castle*. London: Hamish Hamilton.

Dawson, L., 1983. *Prehistoric Britain*. Edinburgh: Holmes McDougall.

Day, D. H., 1997. *A Treasure Hard to Attain: Images of Archaeology in Popular Film, with a Filmography*. Lanham, MD: Scarecrow Press.

Deal, M., and Hagstrum, M. B., 1995. Ceramic reuse behavior among the Mayas and Wanka: implications for archaeology. In *Expanding Archaeology*, ed. J. M. Skibo, W. H. Walker and A. E. Nielsen, 111–25. Salt Lake City: University of Utah Press.

Dean, 1952. *Ideal Book for Girls*. London: Dean.

Dean, J., 1999. *History in the School Grounds*. Exmouth: Southgate.

Deary, T., 1994. *The Rotten Romans*. London: Scholastic.

Delfattore, J., 1992. *What Johnny Shouldn't Read*. New Haven, CT: Yale University Press.

Dempster, S., 2008. Watch this, *The Guardian G2*, 29 July, 34.

Department for Culture, Media and Sport, 2005. *Guidance for the Care of Human Remains in Museums*. http://www.culture.gov.uk/reference_library/publications/3720.aspx [26 January 2010].

—— 2009. *Annual Report and Accounts, 2009*. London: Department for Culture, Media and Sport.

Department for the Environment, Food and Rural Affairs, 2010. *Waste and Recycling*. http://www.defra.gov.uk/evidence/statistics/environment/wastats/bulletin09.htm [24 January 2010].

Derry, L., and Malloy, M. (eds.), 2003. *Archaeologists and Local Communities: Partners in Exploring the Past*. Washington, DC: Society for American Archaeology.

Dexter, C., 1978. *The Silent World of Nicholas Quinn*. London: Pan Books.

DfEE/QCA, 1999a. *The National Curriculum: Handbook for Secondary Teachers in England*. London: Department for Education and Employment and Qualifications and Curriculum Authority.

—— 1999b. *The National Curriculum: Handbook for Primary Teachers in England*. London: Department for Education and Employment and Qualifications and Qualifications and Curriculum Authority.

DfES, 2003a. *The Future of Higher Education*. London: Department for Education and Skills.

—— 2003b. *Widening Participation in Higher Education*. London: Department for Education and Skills.

—— 2004. *Taking an Active Interest in your Child's Learning: Helping your Child do Better in Life*. London: Department for Education and Skills.

DfES/Welsh Office, 1989. *National Curriculum History Working Group Interim Report*. London and Cardiff: Department for Education and Science and Welsh Office.

Dhanjal, S., 2005, Touching the past? *Papers from the Institute of Archaeology, University College London* 16, 35–49.

—— 2008. Archaeological sites and informal education: appreciating the archaeological process. *Conservation and Management of Archaeological Sites* 10 (1): 52–63.

Dickens, C., 1958. *Master Humphrey's Clock and A Child's History of Britain*. London: Oxford University Press.

Dickson, L. W., and Johnston, V., 2006. Reading the clues at Bywell. *GEM News* 100: 8–9.

DIG, 2010. *DIG: An Archaeological Adventure*. http://www.jorvik-viking-centre.co.uk/dig/ [10 February 2010].

Dilley, R., 2005. Legal matters. In Hunter and Cox 2005, 177–203.

Dix, B., and Smart, R., 1982. Down Among the Deadmen. In *Archaeology in the Town*, ed. M. Corbishley, 18–24. London: Council for British Archaeology.

Dobinson, C., Lake, J., and Schofield, A. J., 1997. Monuments of War: Defining England's Twentieth-Century Defence Heritage. *Antiquity* 71 (272): 288–99.

Dobson, D. P., 1928. *The Teaching of Pre-History*. London: Historical Association.

Docter, C., 2005. *Casa K'inich: A Teacher's Guidebook*. Santa Barbara, CA: Copan Maya Foundation.

Doughty, L., 2007. National curricula and the politics of archaeology: the Turkish case. In Hodder and Doughty 2007, 138–40.

Doughty, R., 1984. Interrogating objects: the Cartwheel Penny. *Young Archaeology* 47: 4–5.

Drower, M. S. (ed.), 2004. *Letters from the Desert: The Correspondence of Flinders and Hilda Petrie*. Oxford: Aris & Phillips/Oxbow.

Du Garde Peach, L., 1959. *Julius Caesar and Roman Britain*. Loughborough: Wills & Hepworth.

Durbin, G., 1991. *Under the Ground*. Harlow: Longman.

—— 1993. *Using Historic Houses: A Teacher's Guide*. London: English Heritage.

Durbin, G., Morris, S., and Wilkinson, S., 1996. *Learning from Objects: A Teacher's Guide*. London: English Heritage.

Durham County Record Office, 2010. *Home Page*. http://www. durhamrecordoffice.org.uk/recordoffice/usp.nsf/pws/durham+record+office+- +durham+record+office+homepage [24 January 2010].

Durrani, N., 2004. Merv. *Current World Archaeology* 3. 18–27.

Dykes, D. W., 1980. Introduction. In *Alan Sorrell: Early Wales Re-Created*. Cardiff: National Museum of Wales.

Eaton, T., 2000. *Plundering the Past: Roman Stonework in Medieval Britain*. Stroud: Tempus.

Ebokéa, M.-F., 2005. *Recyclons nos objets!: 11 histoires insolites d'objets reutilises*. Paris: Albin Michel Jeunesse.

Economou, M., 2007. Telling children about the past using electronic games. In *Telling Children about the Past: An Interdisciplinary Perspective*, ed. N. Galandriou and L. H. Dommasnes, 125–44. Ann Arbor, MI: International Monographs in Prehistory.

Edexcel, 2006. *Advanced GCE in Physics (Salters Horners): Specification*. www.edexcel.org.uk/quals/gce/physics/adv/9552/ [3 February 2010].

Education Department of the Republic of South Africa, 2008. *National Curriculum Statement Grades 10–12 (General): Learning Programme Guidelines: History*. http://www.education.gov.za/Curriculum/LPGs2007/LPG%20HISTORY.pdf [4 February 2010].

Edwards-Rees, D., 1934. *The House of History: The Basement from the Earliest Men to the Fall of Rome*. London: Thomas Nelson & Sons.

Elginism, 2010. *Home Page*. http://www.elginism.com/20091027/2465/ [26 January 2010].

Elia, A., 2010. *Mapping and Excavating a Jello Mold*. http://www.texasbeyondhistory.net/teach/images/Jello-Mold.pdf [19 January 2010].

Elo, P., 2000. Tutkiva Oppiminen (Investigative learning). In Elo *et al.* 2000, 16–19.

—— (ed.), 2001. *Maailmanperintö* (World heritage). Helsinki: Suomen Tammi.

Elo, P., Järnefelt, H., Kylliäinen, A., and Sahlberg, M. (eds.), 2000. *Kulttuuriympäristö*. Helsinki: Suomen Tammi.

Elo, P., and Kauppinen, A., 2000. Maailmanperinnön Opetus (World heritage education). In Elo *et al.* 2000, 182–3.

Engering, S., 2002. *Building in Stone: Information for Teachers*. London: English Heritage.

English Heritage, 1986. *Living History: Using Role Play at Historic Sites* [video]. London: English Heritage.

—— 1989. *English Heritage Education Annual Plan 2006*. Unpublished internal document, London: English Heritage.

—— 1991a. *Historic Site: A Sculptor's View* [video]. London: English Heritage.

—— 1991b. *Learning from the Past* [video]. London: English Heritage.

—— 1992. *Teaching on Site: National Curriculum Work at Historic Sites* [video]. London: English Heritage.

—— 1993a. *Kenilworth Castle* [tourist leaflet]. London: English Heritage.

—— 1993b. *Doorstep Discovery: Working on a Local History Study* [video]. London: English Heritage.

—— 1994. *History at Home* [video]. London: English Heritage.

—— 1995a. *Role Up: History through Role Play* [video]. London: English Heritage.

—— 1995b. *History at Home: Family Detectives Finding the Past* [video]. London: English Heritage.

—— 2000. *Power of Place: The Future of the Historic Environment*. London: English Heritage.

—— 2004. *Our Past, Our Future: How to Use your Local Historic Environment for Citizenship* [video]. London: English Heritage.

—— 2006. *Peer Review of English Heritage June/July 2006* http://www.englishheritage.org.uk/upload/pdf/Peer_Review_final_report_with_appendices.pdf?1263970671 [20 January 2010].

—— 2008. *Investigative Conservation: Guidelines on How the Detailed Examination of Artefacts from Archaeological Sites can Shed Light on their Manufacture and Use*. London: English Heritage.

—— 2009. *Heritage Counts: The State of England's Historic Environment 2009*. http://www.english-heritage.org.uk/hc/upload/xls/using_and_benefiting_national.xls?1265887799 [10 February 2010].

—— 2010a. *New Publications Celebrate Historic Schools*. http://www.english-heritage.org.uk/server/show/ConWebDoc.17541 [26 January 2010].

—— 2010b. *The Future of Historic School Buildings*. http://www.english-heritage.org.uk/upload/pdf/HELMSchools.pdf?1264598521 [26 January 2010].

—— 2010c. *Refurbishing Historic School Buildings*. http://www.helm.org.uk/upload/pdf/Schools-refurb.pdf?1264598873 [26 January 2010].

Erleigh, E., 1948. *In the Beginning: A First History for Little Children*. London: Heinemann.

Essex County Standard, 1944. This has thrilled archaeologists more than anything in 20 years. *Essex County Standard*, 1 September, 1.

Europa Nostra, 2010. *Europa Nostra Awards 2006*. http://www.europanostra.org/laureates-2006/ [25 January 2010].

Evans, J. D., 1975. *Archaeology as Education and Profession: Inaugural Lecture Given at the Institute of Archaeology, March 19, 1975*. London: Institute of Archaeology.

Evans, J. D., Cunliffe, B., and Renfrew, C. (eds.), 1981. *Antiquity and Man: Essays in Honour of Glyn Daniel*. London: Thames & Hudson.

Evening Standard, 1994. Leader: History lessons, *Evening Standard*, 5 May, 9.

E. W. B., 1846. Recent important excavations at Pompeii. *Illustrated London News*, 13 June 1866: 381–2.

Fagan, B., 1977. *Elusive Treasure: The Story of Early Archaeologists in the Americas*. London: Macdonald and Jane's.

Fanthorpe, R., 1982. An experimental Roman kiln-firing. In Croft 1982, 16–22.

Fairclough, J., and Redsell, P., 1985. *Living History: A Guide to Reconstructing the Past with Children*. London: English Heritage.

—— 1994. *History through Role Play: A Teacher's Guide*. London: English Heritage.

Farman, J., 1997. *History in a Hurry: Vikings*. London: Macmillan.

Fearn, J., 2005. *Domestic Bygones*. Princes Risborough: Shire Publications.

Ferllini, R., 2002. *Silent Witness*. London: Quintet Publishing.

—— (ed.), 2007. *Forensic Archaeology and Human Rights Violations*. Springfield, IL: Charles C. Thomas.

Few, J., and Smith, K. C. (eds.), 1995. *Teaching Archaeology: A Sampler for Grades 3–12*. Washington, DC: Society for American Archaeology.

Fforde, C., and Hubert, J., 2006. Indigenous human remains and changing museum ideology. In Layton, *et al.* 2006, 84–96.

Finn, C., 2001. Mixed messages: archaeology and the media. *Public Archaeology* 1: 261–8.

Fisher, H. A. L., 1934. *Life and Work in England: A Sketch of our Social and Economic History*. London: Edward Arnold.

FNBE, 1994. *Framework Curriculum for the Senior Secondary School, 1994*. Helsinki: Finnish National Board of Education.

—— 2004a. *National Core Curriculum for Upper Secondary Schools, 2003*. Helsinki: Finnish National Board of Education.

—— 2004b. *National Core Curriculum for Basic Education, 2004*. Helsinki: Finnish National Board of Education.

Fordham, J. (ed.), 2004. *Historic House Education: A Practical Handbook for HHA Members*. London: English Heritage and the Historic Houses Association.

Fordham, J., and Hollinshead, L., 2000. *Know your Place: Teaching Ideas for Schools Adopt Monuments*. London: English Heritage.

Forensic Science Service, 2010. *Home Page*. http://www.forensic.gov.uk/ [19 January 2010].

Forensic Science Society, 2010. *Home Page*. http://www.forensic-science-society.org.uk/ [19 January 2010]

Forty, A., 1986. *Objects of Desire: Design and Technology since 1750*. London: Thames & Hudson.

Foster, S. J., and Crawford, K. A., 2006a. *What Shall We Tell the Children? International Perspectives on School History Textbooks*. Greenwich, CT: Information Age Publishing.

—— 2006b. Introduction: The critical importance of history textbook research. In Foster and Crawford 2006a, 1–23.

Foundation of the Hellenic World, 2010. *Home Page*. http://www.fhw.gr/fhw/index. php?lg=2; and the mathematics exhibition can be viewed at: http://www.fhw.gr/exhibitions/math/en/ [9 January 2010].

Fowler, P. J., 1992. *The Past in Contemporary Society: Then, Now*. London: Routledge.

Foxall, H. D. G., 1980. *Shropshire Field-Names*. Shrewsbury: Shropshire Archaeological Society.

Fraser, E., 1932. *Life in Early Days*. London: James Nisbet.

Fraser, G., 2007. A Christian snuff movie that links blood with salvation. *The Guardian*, 10 January, 26.

Fraser, G. M., 1988. *The Hollywood History of the World*. London: Michael Joseph.

Friel, J., 2004. Ethnic minority participation in archaeology: making it happen. *The Archaeologist* 51: 8–9.

Funari, P. P. A., 2004. Public archaeology in Brazil. In Merriman 2004, 202–10.

Gallica, 2010. *Roman Villa at Butser Ancient Farm*. http://www.gallica.co.uk/villa/ [10 February 2010].

Garrod, J. R., 1949. *Archaeological Remains*. London: Methuen.

Garton Smith, J., 1999. Learning from popular culture: interpretation, visitors and critique. *International Journal of Heritage Studies* 5 (3 & 4): 135–48.

Gasanabo, J.-D., 2006. School history and mechanisms for the construction of exclusive identities: the case of Rwanda from 1962 to 1994. In Braslavsky 2006, 365–404.

Georgescu, D., 2006. Curriculum philosophies for the 21st century: What is old and what is new? In Crişan 2006, 79–96.

Gero, J., and Root, D., 1994. Public presentations and private concerns: archaeology in the pages of *National Geographic*. In *The Politics of the Past*, ed. P. Gathercole and D. Lowenthal, 19–37. London: Routledge.

Giles, H., 2010. *A Brief History of Re-enactment*. http://www.eventplan.co.uk/history_of_reenactment.htm [10 February 2010].

Gillingham, A., Platt, A., Tisser, A., Barnett, J., Farley, R., and Tilling, S., 2001. *Trust in the Future: A KS2/3 Resource for Education for Sustainable Development*. London and Shrewsbury: National Trust and Field Studies Council.

Glen, K., 2000. *Making Successful Visits to Historic Sites*. London: English Heritage.

Goldsworthy, A., 2010. *Andy Goldsworthy Sheepfolds, Education*. http://www. sheepfoldscumbria.co.uk/html/educate/edu00.htm [3 February 2010].

Google, 2010. *Stonehenge News Stories, 2004–2008*. http://www.google.co.uk/trends?q=St onehenge&ctab=0&geo=all&date=all [5 February 2010].

Google Earth, 2010. *Discover Ancient Rome*. http://earth.google.com/rome/ [17 February 2010].

Goscinny, R., and Uderzo, A., 2005. *Asterix in Britain*. London: Orion.

Gotsis, S., 1996. *Culture as a Means of Social Integration: An Intercultural Approach*. Athens: Hellenic Ministry of Culture, Department of Prehistoric and Classical Programmes, Centre of Educational Programmes.

—— 1997. *Culture as a Means of Social Integration: An Intercultural Approach-Time*. Athens: Hellenic Ministry of Culture, Department of Prehistoric and Classical Programmes, Centre of Educational Programmes.

Gould, H., and Adler, C., 2005. *Exploring Citizenship through London's Archives, Libraries and Museums: A Directory for Teachers of Key Stages 1–4*. London: Archives, Libraries and Museums London.

Gower, C., 2003. Dance @ Dover Castle. *Heritage Learning* 26, 10.

Graham, D., with Tytler, D., 1993. *A Lesson for us All: The Making of the National Curriculum*. London: Routledge.

Graham, E., 2007. Another view: Maya archaeologist Elizabeth Graham on *Apocalypto*. *The Guardian*, 8 January, 27.

Green, M. (Miranda), 1983. *Roman Archaeology*. Harlow: Longman.

Green, M. (Marion), 1997. *Discovering Archaeology in National Curriculum History: Keys Stages 1, 2 and 3*. http://www.canterburytrust.co.uk/schools/eduindex.htm [19 February 2010].

—— 1998. *Roman and Anglo-Saxon Canterbury Reconstructed: A Teacher Resource Pack*. http://www.canterburytrust.co.uk/schools/eduindex.htm [19 February 2010].

—— 1999. *Education: Canterbury Archaeological Trust Annual Report, 1999–2000*. Canterbury: Canterbury Archaeological Trust.

—— 2001. *Canterbury Archaeological Trust Annual Report, 2000–01: Education*. Canterbury: Canterbury Archaeological Trust.

—— 2002. *Education: Canterbury Archaeological Trust Annual Report, 2001–02*. Canterbury: Canterbury: Canterbury Archaeological Trust.

—— 2010. *A Bagful of Clues*. http://www.canterburytrust.co.uk/schools/discover/discov04.htm [14 January 2010].

Green, R. L., 1970. *Tales of Ancient Egypt*. London: Penguin.

Gregory, F., 1993. *Henry VIII's Interesting Bits*. Ashtead: Barker Books.

Griffin, J., and Giles, H., 1994. Bring history alive: special events at English Heritage. In Harrison 1994, 331–2.

Griffiths, W. B., Bidwell, P., and Woodward, G. N., 2008. *Segedunum Fort, Baths and Museum*. Newcastle upon Tyne: Tyne and Wear Archives and Museums.

Grigson, G., 1958. *Looking and Finding*. London: Phoenix House.

Grimes, W. F., 1955. The Council for British Archaeology: the first decade. *The Archaeological Newsletter* 5 (8): 1–7.

Groube, L. M., 1978. Priorities and problems in Dorset archaeology. In *New Approaches to Our Past: An Archaeological Forum*, ed. T. C. Darvill, M. Parker Pearson, R. W. Smith and R. M. Thomas, 29–52. Southampton: University of Southampton.

The Guardian, 2005a. Months of war that ruined centuries of history. http://www.guardian.co.uk/world/2005/jan/15/arts.iraq [26 January 2011].

—— 2005b. Babylon wrecked by war: US-led forces leave a trail of destruction and contamination in architectural site of world importance. http://www.guardian.co.uk/world/2005/jan/15/iraq.arts1 [26 January 2011].

—— 2005c. Cultural vandalism. http://www.guardian.co.uk/world/2005/jan/15/iraq.guardianleaders [26 January 2011].

—— 2005d. American graffiti: We cannot avoid responsibility for this destructive legacy of the war, writes Francis Deblauwe. http://www.guardian.co.uk/artanddesign/2005/jan/15/heritage.iraq [26 January 2011].

Guglielmi, W., 2001. Agatha Christie and her use of Ancient Egyptian sources. In Trümpler 2001, 350–89.

Gyllenspetz, G., 2006. *Learning with Grandparents: Grandparents and Schools Working Together to Support Basic Skills Development*. London: Basic Skills Agency.

Haack, F., 2008. *Archaeological Ethics and the Roman Metro Line C*. http://www.savingantiquities.org/feature_metroC.php [19 February 2010].

Hadziaslani, C., 1985. Μια μέρα στο Μουσείο (One day in the museum). *Αρχαιολογία* 17: 74–8.

—— 1991. Ἀ Ἐφορεία Προϊστορικῶν καὶ Κλασικῶν Ἀρχαιοτήτων (First Ephorate of prehistoric and classical antiquities). Ἀρχαιόλογια 23: 11–22.

Hadziaslani, C., Kaimara, I., and Leondi, A., 2004. *Education Through the Athenian Acropolis*. Athens: Centre for Acropolis Studies.

Halinen, I., 2006. The Finnish Curriculum development process. In Crişan 2006, 41–61.

Halkon, P., Corbishley, M., and Binns, G. (eds.), 1992. *The Archaeology Resource Book 1992*. London: Council for British Archaeology and English Heritage.

Hall, J., and Swain, H., 2000. Roman boxes for London's schools: an outreach service by the Museum of London. In McManus 2000a, 87–95.

Hamilton, M. A., and Blunt, A. W. F., 1924. *An Outline of Ancient History to AD 180*. Oxford: Oxford University Press.

Hampson, D. (ed.), 2000. *Mega Creations at St Augustine's Abbey*. Canterbury: Kent Institute of Art & Design.

Handley, F., 1998. The fertile object – loan boxes from the Museum of Southampton for the schools of Southampton. In *Significant Others: Museums and Units, Museums and Community*, ed. P J. Wise, The Museum Archaeologist 25, 30–4. Colchester: Society of Museum Archaeologists.

Hardingham, B. G., 1943. *Living in Caves*. London: Thomas Nelson.

Hardy, T., 1926. *Tess of the D'Urbervilles*. London: Macmillan.

——1978. *The Selected Poems of Thomas Hardy*, ed. D. Wright. Harmondsworth: Penguin.

Harlow, R., and Morgan, S., 1995. *Rubbish and Recycling*. London: Kingfisher.

Harmsworth, A., 1992. *Roman Canterbury: A Journey into the Past*. http://www.canterburytrust.co.uk/schools/eduindex.htm [19 February 2010].

—— 2001. *A Journey to Medieval Canterbury*. http://www.canterburytrust.co.uk/schools/eduindex.htm [19 February 2010].

Harnett, P., 2003. History in the primary school: the contribution of textbooks to curriculum innovation and reform. *International Journal of Historical Learning and Research* 3 (2): 1–16 [online]. http://centres.exeter.ac.uk/historyresource/journal6/6contents.htm [7 February 2010].

Harrison, R. (ed.) 1994. *Manual of Heritage Management*. Oxford: Butterworth-Heinemann.

Harston, K., and Davis, E., 1950. *Your Local Buildings*. London: Allen & Unwin.

Harte, N., and North, J., 2004. *The World of UCL, 1828–2004*. London: University College London.

Hartley, D., and Elliot, M. M., 1931. *Life and Work of the People of England: The Eighteenth Century*. London: Batsford.

Hartley, L. P., 1958. *The Go-Between*. Harmondsworth: Penguin.

Harwood, E., 1999. *Picture Palaces: New Life for Old Cinemas*. London: English Heritage.

Hastie, T., 1983. Just a pack of lies. In Corbishley 1983.

Hathway, R., 2006. Lost at sea: Outdoor education and enterprise skills for the world of work? *Horizons* 34: 2–4.

Hawkes, J., 1982. *Mortimer Wheeler: Adventurer in Archaeology*. London: Weidenfeld & Nicolson.

Hawkins, N., 2000. Teaching archaeology without the dig: what's left. In *The Archaeology Education Handbook: Sharing the Past with Kids*, ed. K. E. Smardz and S. J. Smith, 209–16. Walnut Creek, CA: Altamira Press.

Hayman, R., and Horton, W., 1999. *Ironbridge: History & Guide*. Stroud: Tempus.

Heighway, C. M. (ed.), 1972. *The Erosion of History: Archaeology and Planning in Towns*. London: Council for British Archaeology.

Hellenic Ministry of Culture and English Heritage, 2000. *Mobility and Exchange of Educators for Training (RAPHAEL 1999 Programme)*. Athens and London: HMC and EH.

Hellenic Ministry of Culture and Tourism, 2010. *Home Page*. http://www.culture.gr/war/index_en.jsp [9 January 2010].

Hellenic Ministry of Education and Religion, 2004. *Second Common Framework of Support*. Athens: Hellenic Ministry of Education and Religion.

Hellenic Ministry of Education, Lifelong Learning and Religious Affairs, 2003. *Cross-Thematic Curriculum Framework for Compulsory Education*. http://www.pi-schools.gr/programs/depps/index_eng.php [4 February 2010].

Helmberger, W., and Wünsche, R. (eds.), 2006. *Das Pompejanum in Aschaffenburg: Amtlicher Führer*. Munich: Bayerische Schlösserverwaltung.

Hems, A., and Blockley, M. (eds.), 2006. *Heritage Interpretation*. London: Routledge.

Henry, P., 2004. The Young Archaeologists' Club: its role within informal education. In Henson *et al.* 2004, 89–92.

Henser, P., 2006. Honour among thieves. Our museums may be full of stolen treasures, but as long as they're cared for, why give them back? *The Guardian*, 20 April [online]. http://www.guardian.co.uk/artanddesign/2006/apr/24/heritage.arttheft [26 April 2010].

Henson, D. (ed.), 1996. *Teaching Archaeology: A United Kingdom Directory of Resources*. York: Council for British Archaeology.

—— (ed.), 1997. *Archaeology in the English National Curriculum: Using Sites, Buildings and Artefacts*. London and York: English Heritage and Council for British Archaeology.

—— 2006. *Television Archaeology: Education or Entertainment?* http://www.history.ac.uk/resources/history-in-british-education/first-conference/henson-paper [6 February 2010].

—— 2008. Putting people in their place: the link between citizenship and heritage. *Journal of Education in Museums* 29: 28–36.

—— 2009. The True End of Archaeology? *Primary History* 51: 7.

Henson, D., and Davidson, F., 2004. The Council for British Archaeology and the Council for Scottish Archaeology. In Henson *et al.* 2004, 79–88.

Henson, D., Stone, P., and Corbishley, M. (eds.), 2004. *Education and the Historic Environment*. London: Routledge.

Henty, G. A., 1908. *The Cat of Bubastes: A Tale of Ancient Egypt*. London: Blackie.

Heritage Lottery Fund, 2005. *Life*. London: Heritage Lottery Fund.

Herne, L. W., 1957. History textbooks for schools: II. *History* 42 (145): 130–4.

Herring, P., 2006. Giant roman chariot racing mosaic is completed!, *Colchester Archaeologist* 20: 8–9.

—— 2007. Colchester's Circus Mosaic, *Colchester Archaeologist* 19: 8–9.

Herrmann, G., 1999. *Monuments of Merv: Traditional Buildings of the Karakum*. London: Society of Antiquaries.

Herrmann, G., and Peterson, A., 1996. *The Ancient Cities of Merv, Turkmenistan: A Visitor's Guide*. London: International Merv Project.

Herrmann, G., Coffrey, H., Laidlaw, S., and Kurbansakhatov, K., 2002. *Monuments of Merv: A Scanned Archive of Photographs and Plans*. London: Institute of Archaeology, University College London and British Institute of Persian Studies.

Hewison, R., 1987. *The Heritage Industry: Britain in a Climate of Decline*. London: Methuen.

Hewitt, S., 2007. *Surrender at Yorktown, Colonial Williamsburg Resources for Teachers*. http://www.history.org:80/History/teaching/enewsletter/volume6/sept07/teachstrategy.cfm [3 February 2010].

Heyneman, S., 2006. The role of textbooks in a modern system of education: towards high-quality education for all. In Braslavsky 2006, 31–92.

Higham, C., 1974. *The Earliest Farmers and the First Cities.* Cambridge: Cambridge University Press.

Hill, J. D., with Mays, S., 1987. *Dead Men Don't Tell Tales?: A Graveyard Project for Schools.* Archaeology and Education Series no. 5 Southampton: University of Southampton.

Hills, C., 1993. The dissemination of information. In *Archaeological Resource Management in the UK*, ed. J. Hunter and I. Ralston, 215–24. Oxford: Alan Sutton and Institute of Archaeologists.

Historic Chapels Trust, 2010. *Historic Churches Trust.* http://www.hct.org.uk [24 January 2010].

Historic Scotland, 2010a. *Historic Scotland Corporate Plan, 2008–11.* http://www.historic-scotland.gov.uk/corporate-plan-2008-2011.pdf [21 January 2010].

—— 2010b. *Historic Scotland Annual Report and Accounts, 2008–2009.* http://www.historic-scotland.gov.uk/annualreport09.pdf [21 January 2010].

—— 2010c. *Learning and Resources.* http://www.historic-scotland.gov.uk/index/learning.htm [21 January 2010].

—— 2010d. *Schools Programme, 2009–2010: Early Years and Primary.* http://www.historic-scotland.gov.uk/schools-programme-2009-early-years-primary.pdf [21 January 2010].

—— 2010e. *Schools Programme, 2009–2010: Secondary.* http://www.historic-scotland.gov.uk/schools-programme-2009-secondary.pdf [21 January 2010].

—— 2010f. *Loan Kits.* http://www.archaeologyscotland.org.uk/sites/default/files/Artefact%20Investigation%20Kit%20loans%20pdf.pdf [21 January 2010].

—— 2010g. *Free Support Materials.* http://www.historicscotland.gov.uk/index/learning/education_unit/free-education-resources/free-support-materials.htm [21 January 2010].

Historical Association, 2007. *T.E.A.C.H.: Teaching Emotive and Controversial History* 3–19. London: Historical Association.

History Workshop, 1990. Feature: History, the Nation and the Schools. *History Workshop Journal* 29 (1): 92–133.

Hodder, I., and Doughty, L. (eds.) 2007. *Mediterranean Prehistoric Heritage: Training, Education and Management.* Cambridge: McDonald Institute for Archaeological Research.

Hodder, M. A., 1986. Site visits for schools: the experiences of the Sandwell Archaeological Project. In Cracknell and Corbishley 1986, 26–7.

Hodges, H., 1970. *Technology in the Ancient World.* New York: Barnes & Noble.

Holtorf, C., 2007a. *Archaeology is a Brand! The Meaning of Archaeology in Contemporary Popular Culture.* Oxford: Archaeopress.

—— 2007b. An archaeological fashion show: how archaeologists dress and how they are portrayed in the media. In Brittain and Clack 2007a, 69–88.

Home Office, 2005. *Life in the United Kingdom: A Journey to Citizenship.* London: Stationery Office.

—— 2010. *Immigrants' Examination.* http://www.lifeintheuktest.gov.uk [20 February 2010].

Hooper-Greenhill, E. (ed.), 1988. *Learning and Teaching with Objects.* Leicester: University of Leicester.

Horswell, J., 2004a. *The Practice of Crime Scene Investigation.* Boca Raton, FL: CRC Press.

—— 2004b. Crime scene investigation. In Horswell 2004a, 1–44.

Horton, M., 2008. Don't mess with me, I'm an archaeologist! *Rescue News* 105: 7.

Horwich, D., 2004. Liverpool Rope Walks (Case Study on CD). In Spicer and Walmsley 2004.

Houses of Parliament, 2010a. *English Heritage Given Unrealistic Target, Says Report.* http://news.parliament.uk/2010/01/english-heritage-given-unrealistic-targets-says-report/ [21 January 2010].

—— 2010b. *Public Accounts Committee – Fifth Report: Promoting Participation with the Historic Environment.* http://www.publications.parliament.uk/pa/cm200910/cmselect/cmpubacc/189/18906.htm [21 January 2010].

Howell, R. (ed.), 1994. *Archaeology and the National Curriculum in Wales.* York and Cardiff: Council for British Archaeology, Cadw and National Museum of Wales.

Hubert, J., and Fforde, C., 2005. The reburial issue in the twenty-first century. In *Heritage, Museums and Galleries: An Introductory Reader*, ed. G. Corsane, 107–21. London: Routledge.

Hull, M. R., 1958. *Roman Colchester: Report of the Research Committee of the Society of Antiquaries of London.* London: Society of Antiquaries and Corporation and Borough of Colchester.

Hunt, J. (ed.), 1989. *In Search of Adventure.* Guildford: Talbot Adair Press.

Hunt, R., and Brychta, A., 1994. *Roman Adventure.* Oxford Reading Tree More Owls Stage 7. Oxford: Oxford University Press.

Hunt, T., 2003. Television excites interest – the rest is up to the teachers. *The Guardian*, 21 July, 5.

Hunter, J., and Cox, M. (eds.), 2005. *Forensic Archaeology: Advances in Theory and Practice.* London: Routledge.

Hunter, J., Roberts, C., and Martin, A., 1996. *Studies in Crime: An Introduction to Forensic Archaeology.* London: Batsford.

Hutton, C., 2007 [reprinted from 1947]. *A Picture History of Britain.* Oxford: Oxford University Press.

IAA, 2010. *Inclusive Accessible Archaeology: About the Project.* http://www.britarch.ac.uk/accessible/ [17 February 2010].

ICOMOS, 2005. *Heritage at Risk: ICOMOS World Report, 2004/2005 on Monuments and Sites in Danger.* Paris: International Council on Monuments and Sites.

IFA/IHBC/ALGAO(UK), 2007. *Standard and Guidance for Stewardship of the Historic Environment.* Reading: Institute of Field Archaeologists. Institute of Historic Building Conservation, Association of Local Government Archaeological Officers (UK).

Institute for Outdoor Learning, 2010a. *What is Outdoor Learning?* http://www.outdoor-learning.org/what_is_outdoor_learning/ [15 January 2010].

—— 2010b. *How Much is Going On?* http://www.outdoorlearning.org/what_is_outdoor_learning/how_much_ol_goingon.htm [15 January 2010].

—— 2010c. *How Safe is Outdoor Learning?* http://www.outdoor-learning.org/what_is_outdoor_learning/how_safe_is_ol.htm [15 January 2010].

Institute of Archaeology, 1943. *Conference on the Future of Archaeology.* Occasional Paper no. 5. London: University of London Institute of Archaeology.

Institute for Archaeologists, 2006. *Yearbook and Directory.* Reading: Institute for Archaeologists.

—— 2009. *Yearbook and Directory.* Reading: Institute for Archaeologists.

International Affairs Office, US Department of Education, 2010. *Organization of US Education: State Role I – Primary and Secondary Education.*http://www2.ed.gov/about/offices/list/ous/international/usnei/us/elsec.doc [4 February 2010].

International Centre for Cultural and Heritage Studies, 2010. *Research Programmes in Museum, Gallery and Heritage Studies.* http://www.ncl.ac.uk/sacs/research/icchs/ [8 January 2010].

Jacques, C., 2007. Easing the transition: using museum objects with elderly people. In Pye 2007, 153–61.

James, A., and Spencer, T., 2001. *Victorian Historian: A Journey to Victorian Britain.* Kenilworth: Educational Musicals.

James, S., 2001. The Roman Galley Slave: Ben-Hur and the Birth of a Factoid. *Public Archaeology* 2: 35–49.

Jameson, J. H., 2004. Public archaeology in the United States. In Merriman 2004, 21–58.

Jenkins, S., 2006. The curse of Stonehenge will remain until it is handed back to the druids. *The Guardian*, 27 January, 34.

Jepbarow, T., 2006. *Gadymy Merw* (Ancient Merv). Ashgabat: Ministry of Culture and Television and Radio Broadcasting of Turkmenistan.

Jessup, R., 1956. *The Wonderful World of Archaeology.* London: Macdonald.

—— 1961. *Curiosities of British Archaeology.* London: Butterworths.

Johnson, K., and Muir, B., 2002. *Looking Around Us.* Ryton: North East Environmental Education Forum.

Johnson, L., and O'Neill, C., 1990. *Dorothy Heathcote: Collected Writings on Education and Drama.* Cheltenham: Stanley Thornes.

Johnston, V., 2005. The past uncovered. *Conservation* (Churches Conservation Trust), Autumn, 1.

Johnston, V., Corbishley, M., and Hollinshead, L., 2004. *Exploring Churches.* London: Churches Conservation Trust.

Johnstone, C., 1998. Your granny had one of those: how visitors use museum collections. In Arnold *et al.* 1998, 67–77.

Jones, A., 1999. Archaeological reconstruction and education at the Jorvik Viking Centre and Archaeological Resource Centre, York, UK. In Stone and Planel 1999, 258–68.

Jones, E. H., Hayhoe, M., and Jones, B. (eds.), 1969. *Pre-History and Early Man.* London: Routledge & Kegan Paul.

Jordan, P., 1981. Archaeology and television. In Evans *et al.* 1981, 207–13.

Kankare, T., 2000. Museovierailun Vaikutus Historian Ymmärtämiseen (The impact of visiting museums on understanding history). In Elo *et al.* 2000, 146–58.

Kasvikis, K., Vella, N., and Doughty, L., with Borg, J., and Conti, J. M., 2007. National curricula and the politics of archaeology. In Hodder and Doughty 2007, 129–44.

Katsonopoulou, D., 2007. Interview with author, 20 August.

Kay, S., 1974. *Digging into the Past.* Harmondsworth: Penguin.

Keen, J., 1996. *Ancient Technology: A Teacher's Guide.* London: English Heritage.

—— 1999. The Ancient Technology Centre, Cranborne, UK: a reconstruction site built for education. In Stone and Planel 1999, 229–44.

Keily, J., 2008. Taking the site to the people: displays of archaeological material in non-museum locations. *Conservation and Management of Archaeological Sites* 10 (1): 30–40.

Kelly, P., 2005. *Using Thinking Skills in the Primary Classroom.* London: Paul Chapman.

Kendall, S., Murfield, J., White, R., and Wilkin, A., 2007. Engaging Places research summary: Bridging the gap: a synthesis of research into the supply and the demand of built environment education in schools, *National Foundation for Educational Research* [online]. http://www.nfer.ac.uk/nfer/publications/BEE01/BEE01.pdf [18 January 2010].

Kenny, J., 2007. Getting Involved: Volunteers, Community Archaeology and Young Offenders at Haver Lane, Hungate. *Yorkshire Archaeology Today* 12: 10–11.

Keppie, L., 1991. *Understanding Roman Inscriptions.* London: Batsford.

Kewley, J., 1976. *British Archaeology: An Introductory Booklist.* London: Council for British Archaeology.

Kipling, R., 1908. *Puck of Pook's Hill.* London: Macmillan.

Klesert, A. L., 1998. You too can write it good: writing about archaeology for local newspapers. *Society for American Archaeology* 16 (3) [online]. http://www.saa.org/Portals/0/SAA/publications/SAAbulletin/16-3/SAA17.html [4 February 2010].

Kneen, J., 2004. The Short answer. *The Guardian Education Supplement*, 9 November, 3.

Krinkel, D., 2006. How Unicorns Learn. *Horizons* 36: 10–12.

Krowell, B., 2006. Welcome to Outdoorsland. *Horizons* 36: 28–33.

Kulik, K., 2007. British National Press Coverage of the 1998 Sterkfontein Hominin Fossil Discovery. *SAA Archaeological Record* 7 (3). 11–13.

Lancaster, O., 1938. *Pillar to Post: English Architecture without Tears*. London: John Murray.

Latham, L. C., 1936. *From Flints to Printing*. London: Ginn.

Lavers, L., Ovens, J., and Prizeman, S., 2007. *Our Street: Learning to See: A Teacher's Guide to Using the Built Environment at Key Stage 2*. http://www.cabe.org.uk/files/our-street.pdf [15 January 2010].

Lawson, J., and Silver, H., 1973. *A Social History of Education in England*. London: Methuen.

Layton, R., Shennan, S., and Stone, P. (eds.), 2006. In *A Future for Archaeology: The Past in the Present*. London: University College London Press.

Learning and Teaching Scotland, 2010a. *Social Studies Experiences and Outcomes*. [http://www.ltscotland.org.uk/curriculumforexcellence/socialstudies/outcomes/index.asp [4 February 2010].

—— 2010b. *People, Past Events and Societies*. http://www.ltscotland.org.uk/curriculumforexcellence/socialstudies/outcomes/peoplepasteventsandsocieties/index.asp [4 February 2010].

Lee, H., 1974. *To Kill a Mockingbird*. London: Pan Books.

Lee, R., 2009a. *Engaging with the Historic Environment: Continuing Education*. http://www.britarch.ac.uk/education/ehe [20 February 2010].

—— 2009b. Engaging with the Historic Environment. *The Archaeologist* 72: 12–13.

Leeuw Roord, J., van der, 2004. *Facts and Figures about History Education in Europe since 1989*. The Hague: EUROCLIO.

Leicester Museums and Galleries, 2010. *Jewry Wall Museum*. http://www.leicester.gov.uk/your-council-services/lc/leicester-city-museums/museums/jewry-wall-museum/ [19 February 2010].

Leicestershire County Council, 2009. *Annual Report for Environment and Heritage Services*. http://www.leics.gov.uk/index/community/historyandheritage/environment_heritage_annual_report.htm [18 February 2010].

Lejre, 2010. *Home Page*. http://www.sagnlandet.dk/ENGLISH.425.0.html [10 February 2010].

Levine, P., 1986. *The Amateur and the Professional: Antiquarians, Historians and Archaeologists in Victorian England, 1838–1886*. Cambridge: Cambridge University Press.

Lewis-Smith, V., 2003. Wishing on a tor. *Evening Standard*, 21 November, 35.

Liddle, P., 1983. *A Guide to 20 Archaeological Sites in Leicestershire*. Leicester: Leicestershire Museums, Art Galleries and Records Service, Leicestershire County Council.

Limerick Education Centre, 2005. *Archaeology in the Classroom – It's About Time!* http://www.itsabouttime.ie/ [3 February 2010].

—— 2009. *Archaeology in the Classroom – It's About Time 2*. http://www.itsabouttime.ie/ [14 January 2010].

Linnanmäki, S., 2000. Rakennustutkimus (Building research). In Elo *et al.* 2000, 34–61.

Lippard, L. R., 1983. *Overlay: Contemporary Art and the Art of Prehistory*. New York: Pantheon.

Lippman, L., 1980. Racism in Australian children's books. In Preiswerk 1980, 61–71.

Lloyd, V., 2001. *Richmond Castle, Conscientious Objection and the Richmond Sixteen: Information for Teachers*. London: English Heritage.

Lockey, M., and Walmsley, D., 1999. *Art and the Historic Environment: A Teacher's Guide*. London: English Heritage.

London, J., *c.* 1920s. *Before Adam*. London: Collins Clear Type Press.

Long, R., 2010. *Richard Long: Home Page*. http://www.richardlong.org/index.html [3 February 2010].

Look and Learn, 2010. *Archive: The Children's Newspaper*. http://www.lookandlearn.com/childrens-newspaper/index.php [8 February 2010].

Lovata, T., 2008. A review of The Dig by John Preston. *Public Archaeology* 7 (4): 259–61.

Lowry, B. (ed.), 1995. *20th Century Defences in Britain*. York: Council for British Archaeology.

Lusher, C., 2003. Community choreography. *Heritage Learning* 26: 11.

Lutz, H., 1980. Images of Indians in German children's books. In Preiswerk 1980, 82–102.

Macalister, R. A. S., 1925. *The Present and Future of Archaeology in Ireland: An Address Delivered at a Meeting of the Royal Society of Antiquaries of Ireland Held on 27 January, 1925*. Dublin: Falconer.

Macaulay, D., 1973. *Cathedral: The Story of Its Construction*. London: Collins.

Macdonald, F., 2000. *The Stone Age News*. London: Walker Books.

MacGregor, N., 2010. *A History of the World in 100 Objects*. London: Allen Lane.

Maddern, E., 1992. *Storytelling at Historic Sites: A Teacher's Guide*. London: English Heritage.

Madeley, H. M., 1938. *Why and When*, Book 1. Exeter: Wheaton.

Manchester Guardian, 1908. *The Classical Association. Mr Asquith's Presidential Address. 'Literature to be Studied rather than Archaeology'. 10 October 1908*. http://archive.guardian.co.uk [20 February 2010].

Mann, J., 1981. Dons and detection. In Evans *et al.* 1981, 203–6.

Manoussou, D., 2001. *Medieval Town of Rhodes: Restoration Works (1985–2000)*. Rhodes: Ministry of Culture.

Markham, Mrs, 1886. *A History of England*. London: John Murray.

Marsden, B. M., 1974. *The Early Barrow Diggers*. Princes Risborough: Shire.

Marsden, Rev J. H., 1852. *Two Introductory Lectures upon Archaeology, Delivered in The University of Cambridge*. Cambridge: John Deighton.

Mawby, R., 1998. The Changing Image of Policing in Television Drama. *Police History Society Journal* 13: 39–44.

Mayhew, B., Plunkett, R., and Richmond, S., 2000. *Central Asia*. Footscray, Aus.: Lonely Planet Publications.

McAleavy, T., 2000. Teaching about interpretation. In Arthur and Phillips 2000, 72–82.

McAlpine, J., 2001. Does it matter? Real vs replica objects as loans. *Group for Education in Museums News* 82: 9 [online]. http://www.readingmuseum.org.uk/handson/learningandloans/art-gemnews.htm [11 January 2010].

McAtackney, L., 2006. The negotiation of identity at shared sites: Long Kesh/Maze Prison site, Northern Ireland. Paper presented at the *Forum UNESCO University and Heritage 10th International Seminar* 'Cultural Landscapes in the 21st Century' Newcastle-upon-Tyne, 11–16 April 2005, paper revised 2006 [online]. http://www.ncl.ac.uk/unescolandscapes/files/MCATACKNEYLaura.pdf [1 February 2010].

McCaughrean, G., 1999. *Britannia: 100 Great Stories*. London: Orion.

McLean, G., 2008. Watch this. *The Guardian G2*, 22 July, 34.

McCormick, J., and Jarman, N., 2005. Death of a Mural. *Journal of Material Culture* 10 (1): 49–71.

McDonald, H., 2010. NI Culture Minister asks museum to reflect creationist views. *The Guardian*, 27 May, 14.

McEwan, I., 2005. *Saturday*. London: Jonathan Cape.

McGreal, C., 2005. Holy Land's 'oldest church' found at Armageddon. *The Guardian*, 25.

McManamon, F. P., 1991. The Many Publics for Archaeology. *American Antiquity* 56 (1): 121–30.

McManus, P. M., 2000a. *Archaeological Displays and the Public: Museology and Interpretation*. London: Archetype.

—— 2000b. Written Communications for Museums and Heritage Sites. In McManus 2000a, 97–112.

McNeill, C., Martland, J., and Palmer, P., 1998. *Orienteering in the National Curriculum: Key Stages 1 to 3*. Doune, Perthshire: Harveys.

McNeill, T., 1992. *Castles*. London: Batsford.

McNutt, N., 1995. What ought to rot. In Few and Smith 1995, 6–12.

Melly, G., 2005. Pieces of time: George Melly, jazz musician. *The Guardian G2*, 1 November, 4–5.

Membury, S., 2002. The celluloid archaeologist – an X-rated exposé. In *Digging Holes in Popular Culture: Archaeology and Science Fiction*, ed. M. Russell, Bournemouth University School of Conservation Sciences Occasional Paper 7, 8–18. Oxford: Oxbow Books.

Merriman, N. (ed.), 2004. *Public Archaeology*. London: Routledge.

Metropolitan Police, 2010. *History of the Metropolitan Police*. http://www.met.police.uk/history/timeline1870-1889.htm [19 January 2010].

Midwinter, E., 1970. *Nineteenth-Century Education*. London: Longman.

Mills, A., 1809. *Pictures of English History, in Miniature*. London: Darton & Harvey.

Minchinton, W., 1983. World industrial archaeology: a survey. *World Archaeology* 15 (2): 125–36.

Ministero della Publica Istruzioni (MPI), 2007. *Indicazioni per il Curricula per la Scuola dell'Infanzia e per il Primo Ciclo di Istruzioni*. http://www.pubblica.istruzione.it/normativa/2007/allegati/dir_310707.pdf [4 February 2010].

Minore, M., 2007. 'The city beneath the city': quality criteria in heritage education. In Branchesi 2007, 162–8.

Mitchell, R., 2000. *Picturing the Past: English History in Text and Image 1830–70*. Oxford: Oxford University Press.

Mitchell, S., 2004. Historic Scotland and education: a holistic approach. In Henson *et al.* 2004, 73–8.

Mitchison, N., 1931. *Boys and Girls and Gods*. London: Watts.

Morant, Rev. P., 1748. *The History and Antiquities of the Most Ancient Town and Borough of Colchester, in the County of Essex*. London: W. Bowyer.

Morris, R., 1983. *The Church in British Archaeology*. CBA Research Report 47. London: Council for British Archaeology.

Morris, R., and Corbishley, M., 1996. *Churches, Cathedrals and Chapels: A Teacher's Guide*. London: English Heritage.

Morris, R. W., 1949. *Transport, Trade and Travel through the Ages*. London: Allen & Unwin.

Morrison, K., 1999. *The Workhouse: A Study of Poor-Law Buildings in England*. London and Swindon: English Heritage and the Royal Commission on the Historical Monuments of England.

Moscow Architecture Preservation Society, 2010. *Moscow Heritage at Crisis Point!* http://www.maps-moscow.com/?chapter_id=232 [26 January 2010].

Moshenska, G., 2007. Oral history in historical archaeology: excavating sites of memory. *Oral History*, 91–7.

Mower, J. P., and Aston, M., 2000. Trench warfare? Archaeologists battle it out. *Papers from the Institute of Archaeology* 11: 1–6.

Munro, R., 1913. *Prehistoric Britain*. London: Williams & Norgate.

Murray, J., 2010. *The John Murray Archive*. http://www.nls.uk/jma/index.html [10 February 2010].

Museum of London, 2005a. *Plan for the Development of the Museum Building at London Wall, 2005–2015*. London: Museum of London.

—— 2005b. *Inspiring London: Annual Report, 2004/05*. http://www.museumoflondon.org.uk/English/AboutUs/ReportsPolicies/AnnualReport.htm [11 January 2010].

—— 2009. *Our Vision*. http://www.museumoflondon.org.uk/English/AboutUs/ReportsPolicies/ [11 January 2010].

—— 2010a. *Teacher's Guide: Virtual Object Handling*. http://www.museumoflondon.org.uk/learning/features_facts/voh/Voh_kit/index.htm [14 January 2010].

—— 2010b. *Reburial of Human Remains*. http://www.museumoflondon.org.uk/English/Collections/OnlineResources/CHB/Policies/Reburialofhumanremains.htm [26 January 2010].

Myres, J. N. L., 1939. *Roman Britain*. London: Bell and Historical Association.

Mytum, H., 2000a. Archaeology and history for Welsh primary classes. *Antiquity* 74 (283): 165–71.

—— 2000b. *Recording and Analysing Graveyards*. York: Council for British Archaeology.

National Council for Curriculum and Assessment, 1999a. *History Curriculum*. http://www.curriculumonline.ie/en/Primary_School_Curriculum/Social_Environmental_and_Scientific_Education_SESE_/History/ [4 February 2010].

—— 1999b. *Skills Development: Working as an Historian*. http://www.curriculumonline.ie/en/Primary_School_Curriculum/Social_Environmental_and_Scientific_Education_SESE_/History/History_Teacher_Guidelines/The_content_of_the_history_curriculum/ [4 February 2010].

National Council for Preservation Education, 1987. *A Heritage at Risk: A Report on Heritage Education (K-12)*. Burlington, VT: National Council for Preservation Education.

National Monuments Record, 2010. *NMR Home Page*. http://www.english-heritage.org.uk/server/show/nav.19915 [17 February 2010].

National News Agency, 2009. *Turkmenistan Pays Tribute to First President Saparmurat Niyazov*. http://www.turkmenistan.ru/?page_id=3&lang_id=en&elem_id=16051&type=event&sort=date_desc [22 December 2009].

National Park Service, 1983. *Why is Archaeology Important to Me?* Federal Archaeology Report vol. 6 no. 3. Washington, DC: US Department of the Interior, National Park Service.

—— 1991. *Archaeology and Education: The Classroom and Beyond*, ed. K. C. Smith and F. P. McManamon. Washington, DC: US Department of the Interior, National Park Service.

—— 2010. *Archaeology for Kids*. http://www.nps.gov/history/archeology/public/kids/index.htm [17 February 2010].

National Trust, 2010a *Schools and Teachers: North West*. http://www.nationaltrust.org.uk/main/w-global/w-localtoyou/w-northwest/w-northwest-learning.htm#cheshire [3 February 2010].

—— 2010b. *The History of the National Trust*. http://www.nationaltrust.org.uk/main/w-trust/w-thecharity/w-thecharity_our-past/w-history_trust/w-history_trust-1995_present.htm#ntbegincontent [21 January 2010].

—— 2010c. *Time Well Spent: Annual Report 2008/09*. http://www.nationaltrust.org.uk/main/w-access-annual-report-09.pdf [21 January 2010].

—— 2010d. *A Vision for Learning*. http://www.nationaltrust.org.uk/main/w-learning-vision-dec07-v9.pdf [21 January 2010].

—— 2010e. *Days Out and Visits: Sutton Hoo*. http://www.nationaltrust.org.uk/main/w-vh/w-visits/w-findaplace/w-suttonhoo.htm [21 January 2010].

—— 2010f. *Tracker Packs*. http://www.nationaltrust.org.uk/main/w-chl/w-learning_discovery/w-families/w-family-activity_packs.htm [21 January 2010].

—— 2010g. *Countryside and Environment*. http://www.nationaltrust.org.uk/main/w-chl/w-countryside_environment.htm [21 January 2010].

—— 2010h. *Position Statement on Countryside Education*. http://www.nationaltrust.org.uk/main/w-countrysideinformation.pdf [21January 2010].

National Trust for Scotland, 2005. *Our Future Plans, 2005–2008*. http://www.nts.org.uk/about/downloads/Corporate_Plan_Summary.pdf [22 January 2010].

—— 2010. *Learning*. http://www.nts.org.uk/Learn/ [22 January 2010].

Naumann, J., Jansen, R., Franke, N., 2006. Research findings on textbooks and education for all. In Braslavsky 2006, 93–194.

Neill, J., 1999. Summary of the effects of outdoor education programs or 'Does outdoor education work?'. *International Education* 3/4: 24–31.

Nelson, J., and Kerr, D., 2006. *Active Citizenship in INCA Countries: Definitions, Policies, Practices and Outcomes*. London and Slough: Qualifications and Curriculum Authority and National Foundation for Educational Research.

New Scientist, 2007. People see pets through rose-tinted glasses. *New Scientist* 2593: 17 [reporting from the journal *Anthrozoös* 19: 17].

Newbery, E., and Fecher, S., 1994. *In the Nick of Time*. London: Museums and Galleries Commission.

Newman, A., and McLean, F., 1999. Museums as agents of social inclusion. *Museum Professionals Group Transactions* 32: 3–8.

—— 2002. Architectures of inclusion: museums, galleries and inclusive communities. In *Museums, Society, Inequality*, ed. R. Sandell, 56–68. London: Routledge.

Nichol, J., 1979. *Evidence in History*. Oxford: Blackwell.

Nichol, J., and Dean, J., 2003. Writing for Children: history textbooks and teaching texts. *International Journal of Historical Learning, Teaching and Research* 3 (2): 1–29 [online]. http://centres.exeter.ac.uk/historyresource/journal6/6contents.htm [7 February 2010].

Nichols, S., 2006. Out of the box: popular notions of archaeology in documentary programmes on Australian television. *Australian Archaeology* 63: 36–46.

Noël Hume, I., 1982. *Martin's Hundred*. London: Gollancz.

Norman, B., 1983. Archaeology and television. *Archaeological Review from Cambridge* 2 (1): 27–32.

Northern Ireland Environment Agency, 2010a. *Corporate and Business Plan, 2009/12*. http://www.ni-environment.gov.uk/corp_plan_09-12.pdf [22 January 2010].

—— 2010b. *Teachers and Pupils*. http://www.ni-environment.gov.uk/teachers_and_pupils.htm [22 January 2010].

Nuffield Foundation, 2010. *Urban Spaces near You: Cross-Curricular Work: Fieldwork in Urban Parks, Gardens and Spaces*. http://www.primaryhistory.org/lessons/urban-spaces,290,SAR.html [15 January 2010].

Nuffield Primary History, 2010. *History in the Curriculum*. http://www.primaryhistory.org/principles/ [3 February 2010].

O'Connor, T., 1986. But what shall we tell the press? In *Archaeology, Politics and the Public*, ed. C. Dobinson and R. Gilchrist, 31–3. York: Department of Archaeology, University of York.

O'Donnell, L., Morris, M., and Wilson, R., 2006. *Education Outside the Classroom: An Assessment of Activity and Practice in Schools and Local Authorities*. http://www.dcsf.gov.uk/research/data/uploadfiles/RR803.pdf [15 January 2010].

O'Donovan, E., 1882. *The Merv Oasis: Travels and Adventures East of the Caspian during the Years 1879–80–81*. London: Smith, Elder & Co.

O'Reilly, J., 1952. *The Glob*. New York: Viking Press.

Odhams Press, 1949. *The Story of the British People in Pictures*. London: Odhams Press.

Office for Standards in Education, 2007. *History in the Balance: History in English Schools, 2003–07*. London: Office for Standards in Education.

Office for Standards in Education, Children's Services and Skills, 2010. *Learning Outside the Classroom. How far Should you go?* http://www.ofsted.gov.uk/Ofsted-home/Publications-and-research/Browse-all-by/Education/Leadership/Management/Learning-outside-the-classroom [15 January 2010].

Ogilvie, K. C., 2005. *Leading and Managing Groups in the Outdoors*. Penrith: Institute for Outdoor Learning.

Open University, 2010a. *Coast*. http://www.open2.net/coast/about.html [6 February 2010].

—— 2010b. *Seven Ages of Britain*. http://www.open2.net/coast/about.html [6 February 2010].

Osmond, E., 1956. *Houses*. London: Batsford.

Oswald, A., 2007. Involving the community in field survey. *The Archaeologist* 63: 20–1.

Ousby, I., 1997. *The Crime and Mystery Book: A Reader's Companion*. London: Thames & Hudson.

Parkes, T., 2005a. Track find boosts town heritage bid, says MP. *Colchester Evening Gazette*, 6 January, 3.

—— 2005b. Oh, what a circus! *Colchester Evening Gazette*, 7 January, 4.

Past Horizons, 2009. *The Bamburgh Research Project*. http://publications.pasthorizons.tv:80/?id=pasthorizonsmay09 [17 February 2010].

Patchett, T. S., and Rose, R. W., 1951. *The Modern School Visual Histories, Book 1: To 1485*. London: Evans.

Pausanias, 1979. *Guide to Greece, Volume 1: Central Greece*, trans. P. Levi. Harmondsworth: Penguin.

Pearce, S. M., 1990. *Archaeological Curatorship*. Leicester: Leicester University Press.

—— 1998. The construction and analysis of the cultural heritage: some thoughts. *International Journal of Heritage Studies* 4 (1): 1–9.

—— 2009. A Flake of Paint. In *The Object Reader*, ed. F. Candlin and R. Guins, 463–5. London: Routledge.

Pearson, V. (ed.), 2001. *Teaching the Past: A Practical Guide for Archaeologists*. York: Council for British Archaeology.

Peters, E., 1981. Archaeology and publishing. In Evans *et al.* 1981, 195–202.

Petzet, M., and Ziesemer, J. (eds.), 2008. *Heritage at Risk: ICOMOS World Report 2006/2007 on Monuments and Sites in Danger*. http://www.international.icomos.org/risk/world_report/2006-2007/pdf/H@R_2006-2007_web.pdf [28 January 2010].

Pevsner, N., 1951. *The Buildings of England: Cornwall*. Harmondsworth: Penguin.

Pevsner, N. and Cherry, B., 1973. *The Buildings of England, London, 1: The Cities of London and Westminster*. Harmondsworth: Penguin.

Phillips, T., and Gilchrist, R., 2009. Inclusive accessible archaeology. *Past Horizons* 7: 30–2 [online]. http://publications.pasthorizons.tv:80/?id=pasthorizonsmarch09 [17 February 2010].

Phillips, R., 1998. *History Teaching, Nationhood and the State*. London: Cassell.

—— 2000. Government policies, the State and the teaching of history. In Arthur and Phillips 2000, 10–23.

Piccini, A., 2007. Faking it: why the truth is so important for TV archaeology. In Brittain and Clack 2007a, 222–36.

Piccini, A., Armitage, R., Carveille, S., Colmer, J., Daddi, L., Fergus, S., Fox, K., Hollis, H., Ord, L., and Richardson, E., 2004. TV in BA. *British Archaeology* 75: 40–1.

Piccini, A., Carveille, S., and Fox, K., 2005. Pleasing the viewer. *British Archaeology* 80: 44–5.

Piccini, A., and Henson, D., 2006. *Survey of Heritage Television Viewing, 2005–06*. York and London: Council for British Archaeology and English Heritage.

Piggott, S., 1976. *Ruins in a Landscape: Essays in Antiquarianism*. Edinburgh: Edinburgh University Press.

Pini, E., 2004. *Agon: The Spirit of Competition in Ancient Greece: For Teenagers 12 to 15 Years Old*. Athens: Hellenic Ministry of Culture.

Pinter, T. L., 2005. Heritage tourism and archaeology: critical issues. *SAA Archaeological Record* 5 (3): 9–11.

Pitt-Rivers, Lieut-General, 1884. *An Address Delivered at the Opening of the Dorset County Museum, on Tuesday, January 7th, 1884*. Dorchester: James Foster.

—— 1887. *Excavations in Cranbourne Chase*, privately published.

—— 1892. *Journal of the Society of Arts* 40: 115–22.

Pitts, M., 2006. Sorry, ma'am we don't dig it. *The Guardian*, 28 July, 3.

—— 2008. Stonehenge. *British Archaeology* 102: 12–17.

—— 2010. Personal communication. Email exchange with the author, 5 February.

Place, R., 1985. *Search for the Past: Ginn Study Pack*. Aylesbury: Ginn.

Planel, P., 1995. *Battlefields, Defence, Conflict and Warfare: A Teacher's Guide*. London: English Heritage.

—— 1998. *Silchester Roman Town Calleva Atrebatum: Information For Teachers*. London: English Heritage.

—— 2000. Archaeology in French education: work in the département of the Drôme. *Antiquity* 74 (283): 147–51.

Plowman Craven, 2010. *Police and Emergency Services: Crime Scenes*. http://www.plowmancraven.co.uk/policeandemergency/sector-crime-scenes.php [19 January 2010].

Podgorny, I., 2000. Archaeology and education in Argentina. *Antiquity* 74 (283): 151–5.

Pokotylo, D., 2007. Archaeology and the 'educated public': a perspective from the university. *SAA Archaeological Record* 7 (3): 14–18.

Porch, D., 1987. The Graveyard and Death Project: a grave subject. *Humanities Resource* 1 (2): 6–16.

Power, A., and Houghton, J., 2007. *Jigsaw Cities: Big Places, Small Spaces*. Bristol: Policy Press.

Power, R., c. 1940. *From Early Days to Norman Times*. London: Evans Brothers.

Pownall, J., and Hutson, N., 1992. *Science and the Historic Environment: A Teacher's Guide*. London: English Heritage.

Preiswerk, R. (ed.), 1980. *The Slant of the Pen: Racism in Children's Books*. Geneva: World Council of Churches.

Preston, J., 2007. *The Dig*. London: Viking.

Pretty, K., 1979. CBA Schools Committee. In Corbishley 1979, 3.

—— 1999. Child's play: archaeology out of school. In Beavis and Hunt 1999, 87–9.

—— 2000. Facts and skills: archaeology in teacher training. *Antiquity* 74: 214–18.

Price, A., 1982. *Our Man in Camelot*. London: Futura.

Pryor, F., with Collison, D., 1993. *Now Then: Digging up the Past*. London: Batsford.

Purkis, S., 1980. The unacceptable face of history? *Teaching History* 26: 34–5.

—— 1995. *Using Memorials: A Teacher's Guide*. London: English Heritage.

—— 1997. *Historic Sites*. Harlow: Longman.

Pye, E. (ed.) 2007. *The Power of Touch: Handling Objects in Museum and Heritage Contexts.* Walnut Creek, CA: Left Coast Press.

QCA, 2007. *Secondary Curriculum Review Statutory Consultation.* London: Qualifications and Curriculum Authority.

QCA/DfEE, 1988 (updated 2000). *History: A Scheme of Work for Key Stages 1 and 2.* London: Qualifications and Curriculum Authority and Department for Education and Employment.

—— 2000. *Art and Design: A Scheme of Work for Key Stages 1 and 2.* London: Qualifications and Curriculum Authority and Department for Education and Employment.

QCA/English Heritage, 1999. *Help your Child Discover Roman Britain in the North East.* London: Qualifications and Curriculum Authority and English Heritage.

Qualifications and Curriculum Development Agency, 2009. *Historical, Geographical and Social Understanding: Programme of Learning.* http://curriculum.qcda.gov.uk/uploads/History%20POL_tcm8-16056.pdf [4 February 2010].

—— 2010a. *About the New Primary Curriculum.* http://curriculum.qcda.gov.uk/new-primary-curriculum/index.aspx [4 February 2010].

—— 2010b. *History: Programme of Study for Key Stage 3 and Attainment Target.* http://curriculum.qcda.gov.uk/uploads/QCA-07-3335-p_History3_tcm8-189.pdf [5 February 2010].

Quennell, M., and Quennell, C. H. B., 1921. *Everyday Life in Prehistoric Times.* London: Batsford.

Ramos, M., and Duganne, D., 2000. *Exploring Public Perceptions and Attitudes about Archaeology.* Washington, DC: Society for American Archaeology.

Ramsey, S., 2005. Unearthing the secrets of the soil. *Times Educational Supplement,* 2 December, 6.

Randall, P. J., 1963. *Treasure On Your Doorstep.* London: Pitman.

Ransome, C., 1915. *A First History of England.* London: Rivingtons.

Rasmussen, M., and Grønnow, B., 1999. The historical-archaeological experimental centre at Lejre, Denmark: 30 years of experimenting with the past. In Stone and Planel 1999, 136–45.

Rathje, W., 2001. Integrated archaeology: a garbage paradigm. In Buchli and Lucas 2001, 63–76.

Rathje, W., and Murphy, C., 2001. *Rubbish!: The Archaeology of Garbage.* Tucson: University of Arizona Press.

Ravelli, L. J., 2006. *Museum Texts: Communication Frameworks.* London: Routledge.

Reading Museum, 2010a. *Silchester – The Roman Town of Calleva.* http://www.readingmuseum.org.uk/collections/silchester.htm [14 January 2010].

—— 2010b. *Using Artefacts in the Primary Curriculum.* http://www.readingmuseum.org.uk/handson/pdf/Artefacts_Primary.pdf [14 January 2010].

Real World Learning Partnership, 2006. *Out-of-Classroom Learning: Practical Information and Guidance for Schools and Teachers.* http://www.lotc.org.uk/getdoc/f8891c8f-eec5-454c-b3d3-92f1aa36ae25/Manifesto [15 January 2010].

Rechel, B., and McKee, M., 2005. *Human Rights and Health in Turkmenistan.* London: London School of Hygiene and Tropical Medicine.

Redhead, N., 2005. Community archaeology: the Greater Manchester experience. *Rescue News* 97: 4–5.

Reece, R., 2002. *The Coinage of Roman Britain.* Stroud: Tempus.

Reich, E., 1903. *A New Student's Atlas of English History.* London: Macmillan.

Renfrew, C., 1999. It may be art but is it archaeology? Science as art and art as science. In Coles and Dion 1999, 13–23.

—— 2006. *Figuring It Out.* London: Thames & Hudson.

Renfrew, C., and Bahn, P., 2004. *Archaeology: Theories, Methods and Practice*, 4th edn. London: Thames & Hudson.

Rennard, T. A., n.d. (*c.* 1915). *Atlas of British and World History*. Exeter: Wheaton.

Rescue, 2007. Letters Page. *Rescue News* 101: 7.

Reynolds, P. J., 1979. *Iron-Age Farm: The Butser Experiment*. London: British Museum.

—— 1999. Butser Ancient Farm, Hampshire, UK. In Stone and Planel 1999, 124–35.

Richards, J., 2008. *Sustainable Aggregate: The Sands of Time – Aggregates Extraction, Heritage and the Public*. London: English Heritage.

Richardson, S., 2008. Destruction preserved: Second World War public air-raid shelters in Hamburg. In *Archaeology of Destruction*, ed. L. Rakoczy, 6–28. Newcastle upon Tyne: Cambridge Scholars Publishing.

Richardson, W., 1990. 'Well in the Neolithic ...': teaching about the past in English primary schools in the 1980s. In Stone and MacKenzie 1990a, 283–92.

Rickinson, M., Dillon, J., Teamey, K., Morris, M., Choi, M. Y., Saunders, D., and Benfield, P., 2004. *A Review of Research on Outdoor Learning*. Shrewsbury: Field Studies Council.

Risk, P., 1994. People-based interpretation. In Harrison 1994, 320–30.

Roberts, M. (ed.), 2004. *After the Wall: History Teaching in Europe since 1989*. Hamburg: Körber-Stiftung.

Robertshaw, A., 2006. Live interpretation. In Hems and Blockley 2006, 41–54.

Robinson, P., 2003. *The Summer That Never Was*. London: Pan Books.

Robles, N. G., and Corbett, J., 2008. Educational strategies for the conservation of the heritage at Monte Albán, Mexico. *Conservation and Management of Archaeological Sites* 10 (1): 17–29.

Rodwell, W., and Rodwell, K., 1977. *Historic Churches: A Wasting Asset*. CBA Research Report 19. London: Council for British Archaeology.

Rogers, H., 2005. *Gone Tomorrow: The Hidden Life of Garbage*. New York: New Press.

Rohde, M., 2004–7. *Archaeology and Metros*. http://mic-ro.com/metro/archaeology.html [20 February 2010].

Rojo, R., and Batista, A. A. G., 2006. School textbooks in Brazil: a general review. In Braslavsky 2006, 271–313.

Rowse, A. L., 1946. *The Use of History*. London: Hodder & Stoughton.

Rumble, P., 1989. Interpreting the built and historic environment. In Uzzell 1989a, 24–32.

Russell, M., 2000. *Flint Mines in Neolithic Britain*. Stroud: Tempus.

Salon, 2008. Of poetry and archaeology. *Salon* 193 [online]. http://www.sal.org.uk/salon/index_html?id=883#section18 [20 February 2010].

Salmio, K., 2005. Arviointiraportti (Evaluation report). In *Kulttuuria perinnöksi*, ed. P. Elo, H. Järnefelt, E. Kaila and A. Lönnblad, 94–136. Helsinki: Suomen Tammi.

Sample, I., 2009. Fossil Ardi reveals the first steps of the human race. *The Guardian*, 1 October [online]. http://www.guardian.co.uk/science/2009/oct/01/fossil-ardi-human-race [17 February 2010].

Sansom, E., 2000. Peopling the past: current practices in archaeological site interpretation. In McManus 2000a, 125–44.

Saunders, H. W., 1922. *Aids and Suggestions for the Teaching of Local History, with Special Reference to Rural Schools in Kent*. Maidstone: Kent Education Committee.

Saunders, N. J., 2003. *Trench Art: Materialities and Memories of War*. Oxford: Berg.

Sauvain, P., 1976. *Roman Britain*. London: Macmillan.

Schablitsky, J. M. (ed.), 2007. *Box Office Archaeology: Refining Hollywood's Portrayals of the Past*. Walnut Creek, CA: Left Coast Press.

Schadla-Hall, R. T., 1975. Rescue archaeology: a further comment. *Antiquity* 195: 211–12.

—— 2002. Lighting up the past. *Museums Journal* 35.

—— 2006. Public archaeology in the twenty-first century. In Layton *et al.* 2006, 75–82.

Schadla-Hall, R. T., and Morris, G., 2003. Ancient Egypt on the small screen – from fact to fiction. In *Consuming Ancient Egypt*, ed. S. MacDonald and M. Rice, 195–214. London: University College London Press.

Schissler, H., 2005. World history: making sense of the present. In Schissler and Soysal 2005, 228–45.

Schissler, H., and Soysal, Y. N. (eds.), 2005. *The Nation Europe and the World: Textbooks and Curricula in Transition*. New York: Berghahn Books.

Schofield, J., and Dyson, T., 1980. *Archaeology of the City of London*. London: City of London Archaeological Trust.

Schools Adopt Monuments, 2010. *Home Page*. http://www.napolinovantanove.org/Eng/progspec/prsp09.htm [1 February 2010].

Schools Council History Project, 1976. *What is History? 2, Detective Work: The Mystery of the Empty Grave*. Edinburgh: Holmes McDougall.

Schools History Project, 2010. *About SHP*. http://www.schoolshistoryproject.org.uk/AboutSHP/index.htm [7 February 2010].

Scoffham, S., 1988. *St Augustine's Abbey, Canterbury: A Resource Book for Teachers*. London: English Heritage.

Scott Elliot, G. F., 1923. *Stories of Early British Life from the Earliest of Times*. London: Seeley, Service & Co.

Searle, C., 2009. Engaging history with National Trust tracker packs. *Primary History* 51: 18–20.

Sedgwick, F., 2005. All muck in. *Times Educational Supplement*, 28 October, 12–13.

Seleli, A., 2004. *Agon: The Spirit of Competition in Ancient Greece: For Children from 7 to 11 Years Old*. Athens: Hellenic Ministry of Culture.

Selig, R. O., 1991. Teacher training programs in anthropology: the multiplier effect in the classroom. In National Park Service 1991, 3–8.

Serrell, B., 1996. *Exhibit Labels: An Interpretive Approach*. Walnut Creek, CA: Altamira Press.

Shanks, M., 1992. *Experiencing the Past: On the Character of Archaeology*. London: Routledge.

Shapton, L., 2009. *Important Artifacts and Personal Property from the Collection of Lenore Doolan and Harold Morris, Including Books, Street Fashion, and Jewelry: Strachan & Quinn Auctioneers, February 14, 2009, New York*. London: Bloomsbury.

Sharp, B., 2004a. Teaching and learning strategies. In Barnes and Sharp 2004, 108–15.

—— 2004b. Risk in outdoor education. In Barnes and Sharp 2004, 91–6.

Shephard, C., and Corbishley, M., 1991. *Discovering the Roman Empire: Schools History Project*. London: John Murray.

Shire Books, 2010. *Homepage*. http://www.shirebooks.co.uk/ [14 January 2010].

Shoard, M., 1980. *The Theft of the Countryside*. London: Temple Smith.

Show Me, 2010. *Homepage*. http://www.show.me.uk/ [17 February 2010].

Shuh, J. H., 1982. Teaching yourself to teach with objects. *Journal of Education, Nova Scotia Department of Education* 7 (4): 8–15.

Simpson, F., 2005. *Shoreditch Park Dorchester Street (NNRO3) Community and Research Archaeology Project, Summer 2005:Draft Project Design*. Unpublished internal document, Museum of London.

—— 2006. *History and Public: Shoreditch Park*. Unpublished conference proceedings.

—— 2008. Community archaeology under scrutiny. *Conservation and Management of Archaeological Sites* 10 (1): 3–16.

Simpson, F., and Keily, J., 2005. Today's rubbish, tomorrow's archaeology: using nineteenth and twentieth-century finds. *The Archaeologist* 58: 26–7.

Smardz, K., 1990. Archaeology in the Toronto school system: the Archaeological Resource Centre. In Stone and MacKenzie 1990a, 293–307.

Smart, J., and Wilton, G., 1995. *Practical Management: Educational Visits*. Leamington Spa: Campion Communications.

Smith, H., 2004. Beware Greeks bearing writs: legal threat over 'gay' Alexander. *The Guardian*, 22 November, 20.

Smith, H., Burke, H., and Davidson, I., 2007. *A Past for All Australians: Archaeology, Australia's Long-Term History, and the National History Curriculum*. Adelaide & South Fremantle: World Archaeological Congress & Australian Archaeological Association.

Smith, L. C., Giveen, R. L., and Brewshaer, F. W., 1914. *British History from the Earliest Times to the Present Day with a History of the Overseas Dominions*. London: Rivingtons.

Smith, L., 2003. Cheap and cheerful: socially inclusive archaeology in Hackney and Lambeth. *London Archaeologist* 10 (6): 162–6.

Smith, M., and May, S., 2007. Ancestors of us all. *Museums Journal* 18.

Smithsonian Freer Gallery of Art and Arthur M. Sackler Gallery, 2004. *Asian Art Connections The Silk Road: A Resource for Teachers*. Washington, DC: Smithsonian Institution.

SMM, 2010. *The Mysteries of Çatalhöyük*. http://www.smm.org/catal/top.php [17 February 2010].

Sobański, W., 1962. *School Textbooks in the German Federal Republic*. Warsaw: Western Press Agency.

Society for American Archaeology, 2010. *Mystery Artifact*. http://www.saa.org/publicftp/PUBLIC/fun/MaryArtifactOfTheMonth.html [17 February 2010].

Sorrell, M. (ed.), 1981. *Allan Sorrell: Reconstructing the Past*. London: Batsford.

Sotiriou, D., 1983. Ματωμένα χώματα (The bloodstained earth). Athens: Kedros.

Southcott, C., and Pyle, K., 2009. *The Countryside and the National Curriculum: The Countryside Alliance Foundation*. http://www.nfer.ac.uk/what-we-offer/teacher-voice/pdfs/countryside-alliance.pdf [19 February 2010].

South Yorkshire Archaeology Service, 2010. *Romans on the Don*. http://www.doncaster.gov.uk/Leisure_in_Doncaster/Museums_and_history/Romans_on_the_Don/Romans_on_the_Don.asp [19 February 2010].

Sparks, C., 1992. Popular journalism: theories and practice. In *Journalism and Popular Culture*, ed. P. Dahlegren, P. and C. Sparks, 24–44. London: Sage Publications.

Spicer, S., and Walmsley, D. (eds.), 2004. *Citizenship: Using the Evidence of the Historic Environment: A Teacher's Guide*. London: English Heritage.

Spooner, J., 2002. Victorian maths. *Junior Education* (Nov.): 19–22.

Staccioli, R. A., and Equini, A., 1962. *Rome Past and Present: With Reconstructions of Ancient Monuments*. Rome: Vision.

Stanley, D., 2006. *A Reflection on the Function of Culture in Building Citizenship Capacity*. Strasbourg: Council of Europe.

Stanley-Price, N., 2006. Cultural heritage in post-conflict recovery. *ICCROM Newsletter* 32: 8–9.

Staszewska, L., and Cocksedge, H., 1994. *A Teacher's Handbook to Castle Acre Priory and Castle*. London: English Heritage.

Stell, C. E., 1986. *An Inventory of Nonconformist Chapels and Meeting-Houses in Central England*. London: Royal Commission on the Historical Monuments of England.

Stephenson, R., 2006. The London Archaeological Archive & Research Centre. *The Archaeologist* 60: 50–1.

Stevens, S., Bellamy, R., and Courtley, H., 2002. *The Place of Poetry and the Poetry of Place: Buildings as a Stimulus for Writing Poetry*. London: Society for the Protection of Ancient Buildings and English Heritage.

Stewart, R., Clarke, A., and Fulford, M., 2004. Promoting inclusion: facilitating access to the Silchester 'town life' project. *World Archaeology* 36 (2): 220–35.

Stone, A., 2007. Orcs in loincloths, *Archaeology, Online Reviews*, 3 January 2007 [online]. http://www.archaeology.org/online/reviews/apocalypto2.html [5 February 2010].

Stone, P. G., 1985. Education – an opportunity and an obligation? *Rescue News* 37: 2.

—— 1986a. Prehistory through 'ears, eyes and backs'. *CBA Education Bulletin* 1: 8–12.

—— 1986b. Even older than granny? The present state of the teaching of the past to children of 8–12 years. In *Archaeology 'Objectivity' in Interpretation*. Unpublished paper to the World Archaeological Congress, Southampton, vol. 3.

—— 1986c. Foreword: archaeology and education. In *Southampton Town Walls*. Archaeology and Education no. 1. Southampton: University of Southampton.

—— 1990. *The First Farmers*, Archaeology and Education no. 8. Southampton: University of Southampton.

—— 1994. The re-display of the Alexander Keiller Museum, Avebury, and the National Curriculum in England. In Stone and Molyneaux 1994, 190–205.

—— 2004. Introduction: Education and the historic environment into the twenty-first century. In Henson *et al.* 2004, 1–10.

—— 2005. The identification and protection of cultural heritage during the Iraq conflict: a peculiarly English tale. *Antiquity* 79 (306): 933–43.

Stone, P. G. and Bajjaly, J. F. (eds.), 2008. *The Destruction of Cultural Heritage in Iraq*. Woodbridge: Boydell Press.

Stone, P. G., and MacKenzie, R. (eds.), 1990a. *The Excluded Past: Archaeology in Education*. London: Routledge.

—— 1990b. Introduction: The concept of the past. In Stone and Mackenzie 1990a, 1–14.

Stone, P. G., and Molyneaux, B. L. (eds.), 1994. *The Presented Past: Heritage, Museums and Education*. London: Routledge.

Stone, P. G., and Planel, P. (eds.), 1999. *The Constructed Past: Experimental Archaeology, Education and the Public*. London: Routledge.

Stoppleman, M., 1994. *Anglo Saxon Village*. London: A. & C. Black.

Strong, J., 1997. *Viking at School*. London: A. & C. Black.

Suffolk County Council, 2007. *Archaeological Service Annual Report, 2006–2007*. Ipswich: Suffolk County Council.

—— 2010a. *Archaeological Service*. http://www.suffolk.gov.uk/Environment/ Archaeology/ [10 January 2010].

—— 2010b. *Activities*. http://www.suffolkrecycling.org.uk/Content.asp?PID=3&SID=2 [10 January 2010].

Suffolk Waste Partnership, 2009. *2008/09 Annual Report of the Joint Municipal Waste Management Strategy*. http://www.suffolkrecycling.org.uk/Content.asp?PID=3&SID=2 [10 January 2010].

Šulc, B., 2001. The protection of Croatia's cultural heritage during war 1991–95. In *Destruction and Conservation of Cultural Property*, ed. R. Layton, P. G. Stone and J. Thomas, 157–67. London: Routlege.

Suomen Tammi, 2010. *The Oak of Finland in English*. http://www.edu.fi/page.asp? path=498,24009,24538,60241,60244,60258 [11 January 2010].

Sussman, P., 2006. *Shortcuts: How to Make it as an Archaeologist*. http://www.cnn. com/2006/WORLD/europe/12/08/shortcuts.archaeology/index.html [5 February 2010].

Sutcliff, R., 1958. *Warrior Scarlet*. Oxford: Oxford University Press.

Sutton, H. T., and Lewis, G., 1970. *People and Their Homes: Into Modern Times*. London: Cassell.

Swain, H., 2005. A new medieval gallery for the Museum of London. *The Archaeologist* 58: 22–3.

Swedish National Commission for UNESCO, 2002. *Report from The World Heritage Youth Forum: Karlskrona, September 2001*. Stockholm: Svenska Unescorådet and Ministry of Education and Science.

Sylvester, D., 1994. Change and continuity in history teaching 1900–1993. In *Teaching History*, ed. H. Bourdillon, 9–23. London: Routledge.

Tabraham, C., 2006. Interpreting historic Scotland. In Hems and Blockley 2006, 55–69.

Taylor, S. C., 2005. *Segedunum Fun Day (12/03/05), General Notes for Mike Corbishley*. Unpublished internal document.

Taylor, S., Cooper, M., and Barnwell, P. S., 2002. *Manchester: The Warehouse Legacy*. London: English Heritage.

Teaching Heritage, 2010. *History New South Wales Stage 4 History Syllabus*. http://www.teachingheritage.nsw.edu.au/4outcomes/h_outcomes_s4.html [4 February 2010].

Tees Archaeology, 2010. *Education and Community Archaeology*. http://www.teesarchaeology.com/new/Education.html [19 February 2010].

Texas Beyond History, 2010. *Kids Only?* http://www.texasbeyondhistory.net/kids/index.html [17 February 2010].

Theofilopoulou, V. (ed.), 2000. *Eridanos the River of Ancient Athens*. Athens: Hellenic Ministry of Culture, Department of Prehistoric and Classical Programmes, Centre of Educational Programmes.

Thomas, G., and Arnold, G., 1974. Rescue archaeology and the public. In *Rescue Archaeology*, ed. P. A. Rahtz, 241–55. Harmondsworth: Penguin.

Thomas, G., and Thompson, G., 2004. *A Child's Place: Why Environment Matters to Children*. London: Green Alliance and DEMOS.

Thomas, S., 2010. *Community Archaeology in the UK: Recent Findings*. York: Council for British Archaeology.

Thompson, M. W., 1977. *General Pitt-Rivers: Evolution and Archaeology in the Nineteenth Century*. Bradford-on-Avon: Moonraker Press.

Thwaite, M., 1972. *From Primer to Pleasure in Reading*. London: Library Association.

Tilden, F., 1977 (1957). *Interpreting Our Heritage*, 3rd edn. Chapel Hill: University of North Carolina Press.

Time Team, 2010. *Time Team Home Page*. http://www.channel4.com/history/microsites/T/timeteam/ [6 February 2010].

Timothy, D. J., and Boyd, S. W., 2003. *Heritage Tourism*. Harlow: Prentice Hall.

Titterton, A., 1931. *History: First Series*. London: Ginn.

Townsend, J. R., 1974. *Written for Children: An Outline of English-Language Children's Literature*. Harmondsworth: Penguin.

Treble, H. A., and King, K. M., 1930. *Everyday Life in Rome*. Oxford: Oxford University Press.

Trewinnard-Boyle, T., and Tabassi, E., 2007. Learning through touch. In Pye 2007, 191–200.

Triggs, T. D., 1981. *Ancient Britons*. Edinburgh: Oliver & Boyd.

Trümpler, C. (ed.), 2001. *Agatha Christie and Archaeology*. London: British Museum Press.

Tucker, K., 2005. *Interpretation Task*. Unpublished class exercise.

Turkmenbashi, S., 2002. *Ruhnama: Reflections on the Spiritual Values of the Turkmen*. Ashgabat: Turkmen State Publishing Service.

—— 2006. *Ruhnama: Second Book*. Ashgabat: Turkmen State Publishing Service.

Turner, T., 2007. *The Ghastly Book of Stonehenge*. Swindon: English Heritage.

Turner-Bisset, R., 2005. *Creative Teaching: History in the Primary Classroom*. London: David Fulton.

Twentieth Century Society, 2006. *Press Release and Press Digest on the De-Listing Proposal for the Commonwealth Institute, 25/05/2006.* http://www.c20society.org.uk/casework/press/release/press-digest-on-the-de-listing-prop.html [20 February 2010].

Tyne and Wear Archives and Museums, 2010a. *Annual Report, 2008–2009.* http://www.twmuseums.org.uk/about/corporatedocuments/ [8 January 2010].

—— 2010b. *Corporate Plan, 2009–2014.* http://www.twmuseums.org.uk/about/corporatedocuments/ [8 January 2010].

—— n.d. *Arbeia Roman Fort and Museum.* Newcastle upon Tyne: Tyne and Wear Archives and Museums.

Ucko, P. J., 1994. Foreword. In *The Excluded Past: Archaeology and Education*, ed. P. G. Stone and R. MacKenzie, ix–xxiv. London: Routledge.

UNEP, 2006. *The Atlas of Climate Change: Mapping the World's Greatest Challenge.* New York: United Nations Environment Programme.

UNESCO, 1972. *Convention Concerning the Protection of the World Cultural and Natural Heritage.* http://whc.unesco.org/archive/convention-en.pdf [1 February 2010].

—— 2002. *World Heritage in Young Hands: An Educational Resource Kit for Teachers.* http://whc.unesco.org/en/educationkit/ [1 February 2010].

—— 2010a. *World Heritage in Danger.* http://whc.unesco.org/en/158/ [1 February 2010].

—— 2010b. *World Heritage Sites: The Criteria For Selection.* http://whc.unesco.org/en/criteria/ [1 February 2010].

University College London, 2010. *UCL Museums & Collections: Teaching and Learning.* http://www.museums.ucl.ac.uk/info/loan.html [14 January 2010].

Unstead, R. J., 1974. *From Cavemen to Vikings.* London: A. & C. Black.

Upson-Smith, T., 2004. 1930s pre-fabricated bungalows at Wickseed Park, Kettering. *Northamptonshire Archaeology* 32: 114–24.

US Department of Education, 2004. *Helping Your Child Learn History, with Activities for Children in Preschool through Grade 5.* Washington, DC: US Department of Education, Office of Intergovernmental and Interagency Affairs.

Uzzell, D. (ed.), 1989a. *Heritage Interpretation, Volume 1: The Natural and Built Environment.* London: Bellhaven Press.

—— (ed.), 1989b. *Heritage Interpretation, Volume 2: The Visitor Experience.* London: Bellhaven Press.

—— 1989c. The hot interpretation of war and conflict. In Uzzell 1989a, 33–47.

—— 1994. Heritage interpretation in Britain four decades after Tilden. In Harrison 1994, 293–302.

Vale, E., 1954. *Churches.* London: Batsford.

Vella, N. C., Borg, J., and Conti, J. M., 2007. National curricula and the politics of archaeology: the case of Malta. In Hodder and Doughty 2007, 133–7.

Vella, Y., 2001. Extending primary children's thinking through the use of artefacts. *International Journal of Historical Learning, Teaching and Research* 1 (2): 99–112.

Venäläinen, P. (ed.), 2008. *Kulttuuriperintö ja oppiminen* (Cultural heritage and learning). Helsinki: Suomen Tammi and Suomen Museoliitto.

Vidal, J., 2007. Broader horizons. *The Guardian, Society*, 25 July, 9.

Vision TV, 2010. *The Naked Archaeologist. Who is he?* http://www.visiontv.ca/NakedArchaeologist/who_is_he.htm [6 February 2010].

Walker, S., 2009. *The Collapse of Moscow: Architectural Heritage Being Destroyed.* http://www.independent.co.uk/news/world/europe/the-collapse-of-moscow-architectural-heritage-being-destroyed-1757485.html [26 January 2010].

Walker, V., and Walmsley, D., 2001. *Belsay Hall – The Greek Legacy: Information for Teachers.* London: English Heritage.

Wallace, T., 2007. Went the day well: scripts, glamour and performance in war-weekends. *International Journal of Heritage Studies* 13 (3): 200–23.

Waller, R., 1998. Community archaeology in an urban environment. *Museum Archaeologist* 25: 45–7.

Walmsley, D., 1999a. *Rievaulx Abbey: Information for Teachers*. London: English Heritage.

—— 1999b. *Interpreting the Past: Poster Pack & Notes for Teachers*. London: English Heritage.

—— 2001. *Hadrian's Wall Handling Collection: Information for Teachers*. London: English Heritage.

—— (ed.), 2002. *Liverpool Rope Walks: Information for Teachers*. London: English Heritage.

—— 2003a. Investigating history through objects and drama. *Heritage Learning* 27: 7–9.

—— 2003b. *Investigating History through Objects and Drama: Information for Teachers*. London: English Heritage.

—— 2007. *Sacred Art: Stone and Glass: The Work of Bodley and Kempe*. London: Churches Conservation Trust.

Walmsley, D., and King, C., 2000. *Cawthorn Camps: Information for Teachers*. York and Whitby: English Heritage and North York Moors National Park Authority.

Walsh, B., 2003. *Empires and Citizens*. Cheltenham: Nelson Thornes.

Waplington, A., 1975. *Clues*. Bristol: Collins for the Schools Council.

Warburton, M. (ed.), 2004. *Wonderful Things!: London's Museums and Schools Working Together across the Curriculum*. London: London Museums Agency.

Ward, D., 2005. They came, they saw, they wore socks with sandals. *The Guardian*, 20 May, 13.

Ward, J., and Walmsley, D., 2005. *Ready for ITT! Archaeology Graduates into ITT*. York: Council for British Archaeology.

Warhurst, M., 1999. Norton Priory: a resource for the community. In *Managing Historic Sites and Buildings: Reconciling Presentation and Preservation*, ed. G. Chitty and D. Baker, 71–83. London: Routledge.

Warner, G. T., and Marten, C. H. K., 1923. *The Groundwork of British History*. London: Blackie.

Watson, F., 1998. Braveheart: more than just pulp fiction? In Arnold *et al.* 1998, 129–40.

Weald and Downland, 2010. *Weald and Downland Open Air Museum*. http://www. wealddown.co.uk/home-page-english.htm [28 January 2010].

Webb, S., 1987. Reburying Australian skeletons. *Antiquity* 61/232: 292–6.

Wedderburn, A., 2006. *Living Collections: Exhibition Project Master Classes Plan*. Unpublished work towards a MA degree, Institute of Archaeology, University College London.

Weitzman, D., 1975. *My Backyard History Book*. Boston, MA: Little, Brown & Co.

Wells, H. G., 1920. *The Outline of History*. London: Cassell.

Wells, T., 2007. UGG A DO-DO-DOO: Stonehenge builders had massive parties, dig reveals. *The Sun*, 30 January, 5.

West, A., 2004. Archaeology and television. In Henson *et al.* 2004, 113–19.

West, S., 1985. *West Stow: The Anglo-Saxon Village*. East Anglian Archaeology, Report 24. Ipswich: Suffolk County Council.

West Stow, 2010. *West Stow Country Park and Anglo-Saxon Village*. http://www. stedmundsbury.gov.uk/sebc/play/weststow-asv.cfm [10 February 2010].

Wetherall Dickson, L., and Johnston, V. M., 2006. Reading the clues at Bywell. *Group for Education in Museums News* 100: 8–9.

Wheatley, G., 1997. *World Heritage Sites: A Teacher's Guide*. London: English Heritage.

Wheeler, Sir M., 1955. *Still Digging*. London: Michael Joseph.

—— 1956. *Archaeology from the Earth*. Harmondsworth: Penguin.

—— 1966. *Alms for Oblivion: An Antiquary's Scrapbook*. London: Weidenfeld & Nicolson.

White, R., 1988. Mayer and British archaeology. In *Joseph Mayer of Liverpool, 1803–1836*, ed. M. Gibson and S. M. Wright, 118–35. Occasional Papers n.s. 11. London: Society of Antiquaries.

White, R., and Barker, P., 1998. *Wroxeter: Life & Death of a Roman City*. Stroud: Tempus.

Whitehall Villa, 2010. *An Occasional Report of the 2009 Excavation*. http://www. whitehallvilla.co.uk/htmlfiles/blog09/blog09wk1.html [17 February 2010].

Whitehouse, R., 1979. *Your Book of Archaeology*. London: Faber & Faber.

Whitfield, S., 1999. *Life Along the Silk Road*. London: John Murray.

Whitting, P. D., 1957. History textbooks for schools: I. *History* 42 (145): 81–5.

Whybrow, I., and Reynolds, A., 2004. *Harry and the Dinosaurs at the Museum*. London: Penguin.

Wickham-Jones, C., 2009. Following excavations on the web. *British Archaeology* Nov/Dec, 50.

Wilkinson, S., Mathieson, C., Matthews, J., Shaw, P., Woodcock, L., and Hampton, G., 1994. *School Museums and Primary History*. Occasional Paper 7. London: Historical Association.

Williams, B., and Camp, S., 2007. Contesting Hollywood's Chinatowns. In Schablitsky 2007, 200–222.

Williams, C., 2007. Egypt discovered by 19th-century American artists. In *Who Travels Sees More: Artists, Architects and Archaeologists Discover Egypt and the Near East*, ed. D. Fortenberry, 55–67. Oxford: Astene and Oxbow Books.

Williams, T., 2002. Ancient Merv: queen of cities. *UNESCO World Heritage* 24: 6–15.

—— 2003. Ancient Merv, Turkmenistan: research, conservation and management at a World Heritage Site. *Archaeology International, 2002/2003*, 40–3. London: Institute of Archaeology, University College London.

—— 2006. *Case Study: Petra: ICOMOS Heritage at Risk*. Unpublished teaching notes, University College London, London.

—— 2007. Training courses at the old Silk Road city of Merv, Turkmenistan. *Archaeology International* 2005/2006: 53–7.

—— 2008. The landscapes of Islamic Merv, Turkmenistan: Where to draw the line? *Internet Archaeology* 25 [online]. http://intarch.ac.uk/journal/issue25/merv_index.html [10 January 2010].

Williamson, C., and Hart, A., 2004. *Neighbourhood Journeys: Making the Ordinary Extraordinary*. http://www.cabe.org.uk/files/neighbourhood-journeys.pdf [18 January 2010].

Wilson, F., 1988. *What it Feels Like to be a Building*. Washington, DC: National Trust for Historic Preservation.

Wilson, V., and Woodhouse, J., 1990. *History Through Drama: A Teacher's Guide*. London: Historical Association.

Wolf, D. P., Balick, D., and Craven, J. (eds.), 1997. *Digging Deep: Teaching Social Studies Through the Study of Archaeology*. Portsmouth, NH: Heinemann.

Woolley, C. L., 1920. *Dead Towns and Living Men: Being Pages from an Antiquary's Notebook*. London: Oxford University Press.

Woolley, J., 2003. *Dance on Site: Information for Teachers*. London: English Heritage.

Woolley, L., 1961. *The Young Archaeologist*. Edinburgh: Thomas Nelson.

World Monuments Fund, 2006. *World Monuments Watch 100 Most Endangered Sites*. http://www.wmf.org/dig-deeper/publication/2006-world-monuments-watch [20 January 2010].

—— 2008. *World Monuments Watch 100 Most Endangered Sites*. http://www.wmf.org/dig-deeper/publication/2008-world-monuments-watch [20 January 2010].

—— 2010. *World Monuments Watch*. http://wmf.org/news/pr/world-monuments-fund-announces-2010-watch-list-including-dozens-cultural-heritage-sites-ris-o and http://www.wmf.org/watch/project-map?list=1 [1 February 2010].

Worthy, L. H., 1982. Classification and interpretation of late-nineteenth- and early-twentieth-century ceramics. In *Archaeology of Urban America: The Search for Pattern and Process*, ed. R. S. Dickens, 329–60. New York: Academic Press.

Wray, N., Hawkins, B., and Giles, C., 2001. *'One Great Workshop': The Buildings of the Sheffield Metal Trades*. London: English Heritage.

Wright, R., Hanson, I., and Sterenberg, J., 2005. The archaeology of mass graves. In Hunter and Cox 2005, 137–58.

Wright, T., 1859. *The Ruins of the Roman City of Uriconium, at Wroxeter, near Shrewsbury*. Shrewsbury: J. O. Sandford.

Wyke, M., 1994. Pompeii: the novel, the fireworks and the films. *Omnibus* 28: 9–12.

—— 1997. *Projecting the Past: Ancient Rome, Cinema & History*. London: Routledge.

Yorkshire Sculpture Park, 2007. *Andy Goldsworthy at Yorkshire Sculpture Park: Exhibition Catalogue*. West Bretton: Yorkshire Sculpture Park.

Yosser, Y. C., 2006. The Islamization of Pakistani social studies textbooks. In Foster and Crawford 2006a, 179–94.

Zarmati, L., and Cremin, A., 1998. *Experience Archaeology*. Cambridge: Cambridge University Press.

Zimmerman, L. J., 2003. *Presenting the Past*. Archaeologist's Toolkit 7. Walnut Creek, CA: Altamira Press.

—— 2007. Simple ideas to teach big concepts: 'excavating' and analyzing the professor's desk. In *Archaeology to Delight and Instruct: Active Learning in the University Classroom*, ed. H. Burke and C. Smith, 211–21. Walnut Creek, CA: Left Coast Press.

Zwick, T. T., and Miller, K. W., 1996. A comparison of integrated outdoor education activities and traditional science learning with American Indian students. *Journal of American Indian Education* 35/2: 1–9.

Index

Lightning Source UK Ltd.
Milton Keynes UK
UKHW03f0606181018

330743UK00002B/4/P